The Subcultures Reader

Subcultures are groups of people that are represented – or who represent themselves – as distinct from normative social values or 'mainstream' culture through their particular interests and practices, through what they are, what they do and where they do it. They come in many different forms, from teds and skinheads to skateboarders, clubbers, New Age travellers, graffiti artists and comic book fans.

The Subcultures Reader brings together key writings on subcultures, beginning with the early work of the Chicago School on 'deviant' social groups such as gangs and taxi-dancers, and research from the Centre for Contemporary Cultural Studies at the University of Birmingham during the 1970s on working-class youth cultures and punks. In this fully revised and updated second edition, these classic texts are combined with essential contemporary writings on a variety of subcultural formations defined through their social position, their styles and language, their bodies and their sexuality, their music and their media. Subcultures can be local and face-to-face; but they can also be global, mediated and 'virtual'. This new edition gives expression to the rich diversity of subcultural locations, from underworlds, bohemias and micro-communities to scenes, 'tribes' and the 'global underground'.

The chapters in this Reader are grouped into thematic sections, each with a comprehensive introduction by Ken Gelder. There is also a new general introduction that traces the historical development and key concerns of subcultural studies.

Ken Gelder is Professor of English and Cultural Studies at the University of Melbourne. His books include *Popular Fiction: The Logics and Practices of a Literary Field* (2004), *Reading the Vampire* (1994) and, with Jane M. Jacobs, *Uncanny Australia: Sacredness and Identity in a Postcolonial Nation* (1998). He is also editor of *The Horror Reader* (2000).

The

Subcultures

Reader

Second edition

Edited by

Ken Gelder

First edition (1997) edited by

Ken Gelder and Sarah Thornton

Routledge
Taylor & Francis Group

LONDON AND NEW YORK

First published 1997
by Routledge
2 Park Square, Milton Park, Abingdon, Oxon OX14 4RN

Simultaneously published in the USA and Canada
by Routledge
270 Madison Ave, New York, NY 10016

Second edition published 2005

Routledge is an imprint of the Taylor & Francis Group

Typeset in Perpetua and Bell Gothic by
Florence Production Ltd, Stoodleigh, Devon
Printed and bound in Great Britain by
TJ International Ltd, Padstow, Cornwall

British Library Cataloguing in Publication Data
A catalogue record for this book is available from the British Library

Library of Congress Cataloging in Publication Data
The subcultures reader/edited by Ken Gelder. – 2nd ed.
 p. cm.
 Includes bibliographical references and index.
 1. Subculture. 2. Social psychology. 3. Group identity.
 I. Gelder, Ken, 1955-
 HM646.S83 2005
 306'.1–dc22 2005000856

ISBN 0–415–34415–8 (hbk)
ISBN 0–415–34416–6 (pbk)

Contents

PART FIVE
STYLE, FASHION, SIGNATURE

PART SIX
SEXED SUBJECTS

Illustrations

Figures

Tables

Acknowledgements

My thanks to Rebecca Barden at Routledge for her help and support with this book, which sometimes went far above and beyond the normal call of duty. Many thanks, as well, to Tsara Smith for her meticulous work on the production of this book and to Peter Campbell for the preparation of the index. I am grateful to Claire Knowles at the University of Melbourne for helping me to excavate some fascinating subcultural material. And thanks (once again) to Hannah, Christian and Julian for giving me the time and space to put the whole thing together.

I must acknowledge Sarah Thornton, my co-editor for the first edition of *The Subcultures Reader* back in 1997. Although she chose not to work on this revised project, Sarah's legacy is registered here through her valuable work on the first edition and I thank her for her contribution to what was at the time the first attempt to give shape and definition to subcultural studies.

I should note, sadly, that since the first edition of *The Subcultures Reader*, two important and influential contributors – Ned Polsky and William Foote Whyte – have passed away.

This book retains 30 contributions from the first edition and adds 18 new chapters. Thanks go to all the contributors who kindly gave their permission – both for this edition and the first one – to reprint extracts from their valuable work. The best efforts were made by myself and Routledge to contact all the authors included here.

Permissions

The following were reproduced with kind permission. While every effort has been made to trace copyright holders and obtain permission, this has not been possible in all cases. Any omissions brought to our attention will be remedied in future editions.

1 Robert E. Park, 'The City: Suggestions for the Investigation of Human Behaviour in the Urban Environment', from *The City*, 1925, University of Chicago Press. Reproduced with permission of the publisher.
2 Paul G. Cressey, 'The Life-Cycle of the Taxi-Dancer', from *The Taxi-Dance Hall*, 1932, University of Chicago Press. Reproduced with permission of the publisher.
3 Milton M. Gordon, 'The Concept of a Sub-Culture and its Application' from *Social Forces*. Vol. 26. Copyright © 1947 by the University of North Carolina Press. Used by permission of the publisher.
4 'A General Theory of Subcultures' reprinted and edited with the permission of the Free Press, a Division of Simon & Schuster Adult Publishing Group, from *Delinquent Boys: The Culture of the Gang* by Albert K. Cohen. Copyright © 1955 by the Free Press. Copyright renewed © 1983 by Albert K. Cohen. All rights reserved.
5 Ned Polsky, 'Research Method, Morality and Criminology' from *Hustlers, Beats and Others*, 1967, Harmondsworth: Penguin Books. Reproduced with permission of the publisher.
6 John Irwin, 'Notes on the Status of the Concept Subculture', from *Subcultures*, ed. David O. Arnold, the Glendessary Press, 1970. Reproduced with kind permission of John Irwin.

7 Phil Cohen, 'Subcultural Conflict and Working-Class Community', University of Birmingham Centre of Contemporary Cultural Studies *Working Papers* CS 1 1972. Reproduced with the kind permission of the author and CCCS.

8 John Clarke, Stuart Hall, Tony Jefferson and Brian Roberts, 'Subcultures: Cultures and Class', from eds Hall and Jefferson, *Resistance Through Rituals*, 1993, Routledge. Reproduced by permission of the authors, publisher and Centre of Contemporary Cultural Studies, University of Birmingham.

9 Angela McRobbie and Jenny Garber, 'Girls and Subcultures', from eds Hall and Jefferson, *Resistance Through Rituals*, 1993, Routledge. Reproduced by permission of the authors, publisher and the Centre of Contemporary Cultural Studies, University of Birmingham.

10 Paul Willis 'Culture, Institution, Differentiation'. Copyright © *Learning to Labour*, 1977, Ashgate Publishing Ltd. Reproduced with permission.

11 Excerpts from Dick Hebdige, *Subculture: The Meaning of Style*, 1979, Routledge. Reproduced by permission of the author and publisher.

12 Angela McRobbie, 'Second-Hand Dresses and the Role of the Ragmarket', from *Zoot Suits and Second-hand Dresses*, 1989, Palgrave Macmillan. Reproduced by permission of the publisher.

13 Jock Young, 'The Subterranean World of Play', from *The Drugtakers: The Social Meaning of Drug Use*, 1971, Paladin. Reproduced by kind permission of the author.

14 Stanley Cohen, 'Symbols of Trouble', from *Folk Devils and Moral Panics*, 1972, Routledge. Reproduced by permission of the author and publisher.

15 Gary Clarke, 'Defending Ski-Jumpers', from eds Frith and Goodwin, *On Record*, 1990, Routledge. Reproduced by permission of the Centre of Contemporary Cultural Studies, University of Birmingham.

16 Andrew Tolson, 'Social Surveillance and Subjectification', from *Cultural Studies* 4(2) (1990) www.tandf.co.uk/journals, Taylor & Francis. Reproduced by permission of the publisher.

17 Sarah Thornton, 'The Social Logic of Subcultural Capital', from *Club Cultures: Music Media and Subcultural Capital* © 1996 by Sarah Thornton and reprinted by permission of Wesleyan University Press and Polity Press.

18 Michel Maffesoli, 'The Emotional Community' in *The Time of the Tribes*, 1996, reproduced by permission of the author and Sage Publications Ltd.

19 Frederic M. Thrasher, 'Gangland', from *The Gang*, 1927, University of Chicago Press. Reproduced with permission of the publisher.

20 William Foote Whyte, 'The Problem of Cornerville', from *Street Corner Society*, 1943, University of Chicago Press. Reproduced with permission of the publisher.

21 Erving Goffman 'Hospital Underlife: Places' from *Asylums*, copyright © 1961 by Erving Goffman. Used by permission of Doubleday, a division of Random House, Inc.

22 Peter Marsh, Elizabeth Rosser and Rom Harré, 'Life on the Terraces', from *The Rules of Disorder*, 1978, Routledge. Reproduced by permission of Rom Harré and the publisher.

38 Dave Laing, 'Listening to Punk', from *One Chord Wonders*, 1985, McGraw-Hill Education. Reproduced by kind permission of the author.

39 Paul Gilroy, 'Diaspora, Utopia and the Critique of Capitalism', *There Ain't No Black in the Union Jack*, 1987, Routledge. Reproduced by permission of the publisher and author.

40 Will Straw, 'Communities and Scenes in Popular Music', *Cultural Studies* 15(3), 1991, www.tandf.co.uk/journals, Taylor & Francis. Reproduced by permission of the publisher.

41 James Farrer, 'Disco "Super-Culture": Consuming Foreign Sex in the Chinese Disco', reproduced with permission from *Sexualities* 2(2) (1999), by permission of Sage Publications Ltd.

42 Ben Malbon, 'Moments of Ecstasy', from *Clubbing, Dancing, Ecstasy and Vitality*, 2001, Routledge. Reproduced by permission of the author and publisher.

43 Howard Rheingold, 'Introduction to *The Virtual Community*' (1994). Reproduced by permission of Abner Stein.

44 Stephen Duncombe, 'Community', from *Notes from Underground*, 1997, Verso. Reproduced with permission of the publisher.

45 Sharon Kinsella, 'Amateur Manga Subculture and the *Otaku* Incident', from *Adult Manga: Culture and Power in Contemporary Japanese Society*, 2000, RoutledgeCurzon. Reproduced by permission of the author and publisher.

46 David Bell, 'Meat and Metal', from eds Holliday and Hassard, *Contested Bodies*, 2000, Routledge. Reproduced by permission of Ruth Holliday and the publisher.

47 Paul Hodkinson, 'Communicating Goth: On-line Media', from *Goth: Identity, Style and Subculture*, 2002, Berg Publishers. Reproduced by permission of the publisher.

Ken Gelder

THE FIELD OF SUBCULTURAL STUDIES

SUBCULTURES ARE GROUPS OF PEOPLE that are in some way repre-
sented as non-normative and/or marginal through their particular interests and
practices, through what they are, what they do and where they do it. They may rep-
resent *themselves* in this way, since subcultures are usually well aware of their dif-
ferences, bemoaning them, relishing them, exploiting them, and so on. But they will
also be represented like this by others, who in response can bring an entire appara-
tus of social classification and regulation to bear upon them. Although the term 'sub-
culture' did not obtain its social and sociological application as a means of classifying
groups of people until around the early 1940s, subcultures in one form or another
have, of course, been with us for some considerable time. But just as importantly,
the social analysis and scrutiny of subcultures is also not new. This introduction will
provide a kind of prehistory to subcultural studies and a preamble to the contribu-
tions in this Reader by outlining two of the primary 'logics' through which subcultures
have been understood and identified. Subcultures are always seen in terms of their
relationship to, and function within, the broader social system – society – but a (nec-
essarily sketchy) prehistory of subcultural studies will hopefully demonstrate that
two particular ways of conceiving of subcultures have prevailed here, allowing that
relationship to gain its definition and force. After this, the introduction will look at
the main characteristics of subcultural studies as it developed as a somewhat frac-
tured and probably rather fragile discipline through most of the twentieth century:
becoming, among other things, increasingly pluralist in its interests and extensive in
its range. Finally, I shall have something to say about recent commentaries that talk
of a 'post-subcultural' moment, as if subcultural identity is now more or less a thing
of the past. I shall make the point that post-subculturalists forget the history and
prehistory of their own discipline as they enthusiastically give themselves over to
what George McKay in a slightly different context has called a 'rhetoric of newness'

(McKay 1998: 13). One of the things this Reader will show, however, is that the precursory logics of subcultural studies are not only formative but also recur over and over as an insistent reminder that subcultures are indeed here to stay.

We can begin to appreciate one of those logics by turning back for a moment to sixteenth-century England to look at the emergent genres of rogue, vagabond and 'cony-catcher' writing. In the early 1560s, John Awdeley's *The Fraternity of Vagabonds* scrupulously identified a number of vagabond 'types' who frequented the edges of early modern English society: the ruffler, the whip-jack, the palliard, the swigman, and so on. A few years later, Thomas Harman described the 'canting speech' of the rogue (a word he may himself have coined) as well as the 'cony-catcher' or swindler in his *Caveat for Common Cursitors*, in order to enlighten a general public that might not otherwise understand if and when it was being conned. An elaborate schema of classification developed to give identification to a diversity of subcultural anti-heroes in Elizabethan England. Cutpurses, doxies, walking morts, discharged soldiers, apprentice actors, brothel keepers: the list went on and on, an 'anti-commonwealth' of social types who were laid out systematically in the rogue literature of the period, popularized by Robert Greene and Thomas Dekker. Gamini Salgado had this to say about these marginal groups in his anthology, *Cony-Catchers and Bawdy Baskets*:

> Seen through the disapproving eyes of respectable citizens they were nothing but a disorderly and disorganized rabble, dropouts from the social ladder. But seen from within, they appear to be like nothing so much as a mirror-image of the Elizabethan world-picture: a little world, tightly organized into its own ranks and with its own rules, as rigid in its own way as the most elaborate protocol at court or ritual in church.
>
> (Salgado 1972: 13)

Here we have what is now a familiar expression of subcultural identity that works by juxtaposing two perspectives, the disorderly (as seen by others, from the outside) and the organized (seen internally, from the perspective of the subculture itself): producing social groups that are also anti-social. But it is grounded in early modern accounts of vagabonds, rogues and itinerants (see also Beier 1985) – and this is where we find the beginnings of an influential genealogy for subcultural studies. Salgado published his important study, *The Elizabethan Underworld*, in 1977, partly in response to a collection of writings revealed much earlier on in A.V. Judges' anthology, also called *The Elizabethan Underworld*, first published in 1930. A hitherto submerged realm of social activity is excavated here and placed in contrast to the prevailing conventions of an emergent modernity. The process of excavation itself is part of the project of enlightenment, literally so: to make those 'underworlds' visible, to shed light on their 'dark' and subterranean habits, to comprehend their difference but also to confirm or underwrite it. Craig Dionne captures a central aspect of the kind of logic that contrasts a subculture with the prevailing conventions of early modern society, when he looks at subcultural relations to property and labour: 'Stability finds its binary opposite in those migrant vagabonds' which

William Harrison in his *Description of England* (1587) had called '"caterpillars in the commonwealth" who "lick the sweat from the true laborers [*sic*] brows" and "stray and wander about, as creatures abhorring all labor and every honest exercise"' (Dionne 1997: 36). This view of subcultures as essentially unproductive – as well as itinerant, moving *across* property rather than settled within its orderly confines – provides subcultural studies with an important, formative logic, as we shall see.

Vagabond literature continued into the nineteenth century with – for example – the artist John Thomas Smith's *Vagabondiana, or Anecdotes of Mendicant Wanderers through the Streets of London* (1817), published at a time when vagrants were being increasingly policed in England. Vagabonds, rogues and so on did not seem to labour at all, which meant that they did not belong to a labouring class: the working class. For a nascent political worldview built around the revolutionary potential of the working class – the kind that Karl Marx developed around the middle of the nineteenth century – these kinds of subcultures therefore posed a real and apparently residual problem. Marx's *The Eighteenth Brumaire of Louis Bonaparte* (1851–52) was a scathing attack on the nephew of Napoleon I, who rose to power in France after his own coup d'état on 2 December 1851. For support, Louis Bonaparte had gathered together not a revolutionary working class but a ragtag of déclassé subcultures: not the proletariat, but what Marx referred to much less flatteringly as the *lumpenproletariat*:

> On the pretext of founding a benevolent society, the *lumpenproletariat* of Paris had been organized into secret sections, each section being led by Bonapartist agents, with a Bonapartist general at the head of the whole. Alongside decayed *roués* with doubtful means of subsistence and of doubtful origin, alongside ruined and adventurous offshoots of the bourgeoisie, were vagabonds, discharged soldiers, discharged jail-birds, escaped galley-slaves, swindlers, mountebanks, *lazzaroni* [Italian idlers and beggars], pickpockets, tricksters, gamblers, *maquereaux* [procurers], brothel-keepers, porters, *literati*, organ-grinders, rag-pickers, knife-grinders, tinkers, beggars, in short the whole indefinite, disintegrated mass thrown hither and thither, which the French term *la Boheme*.
> (Tucker 1972: 479)

For Marx, the *lumpenproletariat* were 'beneath' class, unenlightened because they had no class consciousness – and therefore no revolutionary potential. In fact, it seemed to Marx as if the opposite was true. The *lumpenproletariat* were, he thought, vulnerable instead to reactionary ideologies and movements, interested only in their own well-being, easily led and obedient to the wishes of the governing middle classes – even though they constantly threatened their safety and helped themselves through illegitimate means. This rather sour perspective nevertheless came to underwrite a logic or way of seeing that continues even today to tie subcultures to non-productivity. Severed from the broader and more stable category of (the working) class and tangential to labour imperatives, subcultures can often

therefore be seen negatively: as idle, self-absorbed and inwardly turned, their activities and interests usually played out while at leisure rather than at work. In part two, we shall see that during the 1970s British cultural critics from the Left charted a more complex and symbiotic relationship between subcultures and the working class, although arguably the image of the *lumpenproletariat* continues to haunt their accounts of mods and skinheads and teds. The Marxian disenchantment with subcultures as non-revolutionary also remains with these more recent commentaries, but it finds itself recast more positively through a discussion about the potential for subcultural 'resistance' or, as in the influential work of Dick Hebdige, an account of subcultural 'refusal' and '(in)subordination' (see chapters 11 and 27). On the other hand, Hebdige had seen subcultures as vulnerable to 'incorporation' by others and, besides, their 'refusals' could only take effect at a cultural, rather than a political, level. The kind of analyses directed at subcultures from the Left during the 1970s and into the 1980s can thus be both positive *and* negative, that is, ambivalent: it can in fact be difficult to tell, sometimes, which perceptions prevail.

We have seen (albeit in the briefest of sketches) that, through the figure of the vagrant and related marginal social types, subcultures were positioned precariously in relation to property, labour, class and the law – even as their identities are scrupulously charted and classified by those governing bodies that enshrine property, depend upon labour, preserve class distinctions and uphold the law. Timothy Gilfoyle has written about the 'street rats and gutter snipes' in New York City around the middle of the nineteenth century, children and adolescents who lived 'outside the paradigm of middle-class domesticity' and developed out of necessity a 'confrontational and oppositional subculture relative to adult authority' (Gilfoyle 2004: 870). Cities were increasingly inhabited by people who did indeed live outside of the paradigm of middle-class homeliness, and some of the projects of social classification around this time that reflected this migration of vagabond subcultures into the metropolis and described their living habits once they got there were thus immense in their scale. The most striking and influential of them was the work of the English newspaper journalist and social reformer Henry Mayhew, a prolonged series of interviews with 'street folk' and the criminal classes in London that were first serialized in the *Morning Chronicle* in 1849–50 and later gathered into four volumes in 1861–62 as *London Labour and the London Poor*. Mayhew's work is Andrew Tolson's topic in chapter 16 of this Reader, and it is also discussed by Hebdige in chapter 27. Among other things, it provided an elaborate system of classificatory description for the habits, practices, dress and language of the various itinerant people who moved through London by day and by night: costermongers, street-sellers, beggars, swindlers, pickpockets, various entertainers, prostitutes, and so on. As the title to his massive study suggests, Mayhew's primary concern was with labour: work and productivity. His street folk were thus classified first and foremost in terms of their *relations* to labour: from 'those who will work' to 'those who will not work', the latter 'possessing nothing but what they acquire by depredation from the industrious, provident, and civilized portion of the community' (Mayhew 1968: 3). Mayhew's account of property-less and unproductive folk as parasitic on those people who work and own property exactly reproduces the perspective of William Harrison

in 1587, noted earlier, as if this particular logic – this way of seeing itinerant subcultures – is now embedded as a permanently available discourse.

Mayhew's ethnographic project – to chronicle the itinerant subcultures of London – also linked itself up to an emergent discipline, anthropology, which came to lend subcultural studies one of its most powerful binaries. Here is the famous opening passage from the first volume of *London Labour and the London Poor*, at the beginning of a section titled, 'Wandering Tribes in General':

> Of the thousand millions of human beings that are said to constitute the population of the entire globe, there are – socially, morally, and perhaps even physically considered – but two distinct and broadly marked races, viz., the wanderers and the settlers – the vagabond and the citizen – the nomadic and the civilized tribes.
>
> (1)

This binary of the wandering (that is, street-based) vagabond and the settled and domesticated citizen consolidates what I have called first precursory logic of subcultural studies, and we shall see it expressed in one way or another throughout this Reader. Indeed, part one begins with early sociological extracts from the Chicago School that focus precisely on itinerant social groups as they migrate into major American cities, 'deviant' groups of people who inhabit 'worlds within worlds' alongside or adjacent to urban norms. In chapter 12, Angela McRobbie looks at the ragmarkets on the streets of London, recalling Mayhew's accounts of London street vendors in her treatment of subcultural trade and fashion tastes. Later on in chapter 18, Michel Maffesoli practises what he calls a 'vagabond sociology' and identifies contemporary subcultures as 'tribes', a designation that has proved remarkably seductive for subsequent work in subcultural studies (for example, Bennett 1999). In chapter 23, Kevin Hetherington gives us a road (rather than street) subculture in New Age travellers, modern incarnations of those disorderly early modern vagabonds; and in chapter 24, Iain Borden looks at skateboarders in the contemporary city precisely in terms of a logic that sees subcultures in a countercultural relationship to property and disengaged from the daily demands of work and productivity. Borden's chapter is nothing less than a tribute to metropolitan skateboarders, free from any of the negative characteristics traditionally bestowed upon vagabonds and other itinerants. Indeed, the vagrant acts of skateboarders are, for him, about as close to revolutionary as subcultures can get. The positioning of subcultures outside the framework of labour and productivity may be disenchanting for some; but here it allows for a celebration of energy, of play, of moments of felt utopia. This is quite different in kind to Marx's much earlier view of the *lumpenproletariat*; it is, we might say, romantic rather than anti-romantic in its homage to subcultural possibility. For Marx, the *lumpenproletariat* were easily led, but for Borden – and consistent with the more optimistic approaches of cultural studies – subcultures have agency and (relative) autonomy. We shall see the same kind of celebration in chapter 42 when Ben Malbon looks at rave clubbers and ecstasy use and represents the dance floor – in all its gloriously playful unproductivity – as an 'earthly utopia or dream world'.

Malbon's representation of the clubbing dance floor as a place where dancers also experience a 'sensation of oneness' gestures towards a second important precursory logic for subcultural studies. Subcultures are social groups – a point that often needs stressing these days – but their social-ness is cast in a particular way. As modernity consolidated itself, subcultures were increasingly represented (by themselves and by others) in opposition to mass culture and to massification. The social-ness of a subculture thus becomes the means by which it is distinguished from society itself. One established point of origin for the discipline of cultural studies has been the work of Frankfurt School critical theorist Theodor W. Adorno (see During 1993), who with Max Horkheimer during the 1940s outlined the primary logic of mass culture: that it homogenizes, rationalizes and standardizes cultural production and consumption, wiping away 'individuality' in the process. But for *subcultural* studies, we need to go back a little further to the work of another German scholar. Ferdinand Tonnies' *Gemeinschaft und Gesellschaft* was first published in 1887, ignored for a while and then reprinted often enough to gain Tonnies a considerable international reputation. It was a meditation on two kinds of social organization, usually translated into English as 'community' (*Gemeinschaft*) and 'society' (*Gesellschaft*). The latter term responded to the legacies of modernity: modern, globalized capitalism and the development of a centralized state government. Modern society is thus governed from above, remotely. Relationships are built around legislation, public opinion (e.g. mass media) and convention; and although people co-exist, they are now independent of one another. Modern capitalism requires a 'mechanical' relationship between people based around the exchange of money, which means that modern society therefore atomizes, individualizes and alienates its human subjects. Tonnies gives us this haunting expression of modern life: 'One goes into *Gesellschaft* [society] as one goes into a strange country' (Tonnies 1955: 38). *Gemeinschaft*, however, expresses a very different kind of social organization. Tonnies' notion of 'community' was tied firstly to kinship networks and secondly to the 'Volk', to folk culture. It offered a local sense of social organization built around family, friendship and neighbourhood. For Tonnies, *Gemeinschaft* was an expression of the social at its most original and authentic: it is 'real and organic', whereas modern society is cast as artificial (37). His view of modern society anticipates Adorno, of course, but here is the important difference: whereas Adorno juxtaposed modern society (and massification) with individuality, Tonnies juxtaposed it with *community*. Individuality – so important to Adorno – was the problem, not the solution.

Subcultural studies over the last 70 years or so has provided an ongoing engagement with Tonnies' distinction between community and society, understanding subcultures as social groups that react in some way against both massification *and* atomization. The emphasis in subcultural studies is not on homogeneity, but heterogeneity; not standardization, but difference or, to use one of the Chicago School's favourite sociological terms, 'deviance'. Subcultural studies looks at what binds groups of people together in non-normative ways, but it does this as an argument against standardization and anomie, or 'normlessness', simultaneously. (Subcultures may be non-normative, but they are not 'normless'.) The great sociologist Emile Durkheim, who saw anomie as the bane of modern metropolitan life, is also an

important part of this genealogy: believing, as Tonnies did, in 'organic solidarity' and turning for evidence of this to anthropology and its view of 'primitive' tribal life as a realm of pure (that is, unatomized, unindividualized) sociality. We have seen Henry Mayhew draw on an anthropological trope of nomadism in his account of London itinerants. But subcultural studies has also drawn on anthropological conceptions of the social and the cultural – as we shall see with Howard S. Becker in chapter 37 (Becker has also written admiringly of the empirical Polish anthropologist, Bronislaw Malinowski) and with Dick Hebdige in chapter 11 (who turns to Claude Levi-Strauss for the notion of 'bricolage'). Durkheim himself has directly influenced the work of Michel Maffesoli – see chapter 18 – through his notion, lifted from anthropology, of the 'social divine': the sense that particular kinds of communities can be bound together with something like a religious force: that to be an individual is therefore to be incomplete, to *lack*. Maffesoli also draws on Durkheim's contemporary, Georg Simmel, who I mention briefly in the introduction to part five of this Reader and whose notion of 'sociability' follows in the wake of Tonnies' distinction between *Gemeinschaft* and *Gesellschaft*: as a playful form of social interaction that possesses 'no ulterior end, no content, and no result outside itself' (Frisby and Featherstone 1997: 9).

Community, sociability, the 'social divine': these are all ways of thinking about social organization outside of or adjacent to society itself that have been useful to subcultural studies. Robert E. Park, who opens part one of this Reader with an extract from his co-authored book, *The City* (1925), was heavily influenced by Tonnies' work and saw communities in the American metropolis precisely in 'organic' terms, as something authentic and 'exceptional' in the midst of the impersonal. We shall see the term *community* itself put to use in a number of chapters that follow: for example, in Will Straw's portrayal of the alternative rock community in chapter 40, in Stephen Duncombe's account of 'Bohemian' fanzine communities across America in chapter 44, and in Howard Rheingold's influential description of online group activities as 'the virtual community' in chapter 43 – a description that represents online activity precisely as an 'organic' *Gemeinschaft* through which users can find relief from the alienation and atomization of society itself. Rheingold's notion of a 'virtual community' could not be more contemporary; but for Tonnies, the *Gemeinschaft* was a kind of relic, elements of which 'persist within the *Gesellschaft*' (Tonnies 1955: 265). Subcultural studies can sometimes reproduce this perception – I note an account of the 'anachronism' of the nineteenth-century dandy in my introduction to part five, for example – and so can be nostalgic for the communities it goes on to describe. But it can also put its communities into a critical dialectic with society. After all, as Howard S. Becker has noted, when one studies 'deviancy', one also and necessarily studies society since looking at the 'judged' means looking at the same time at those who do the judging (Becker 1973: 196). Subcultures and society may be oppositional in many respects but they are also bound together, as Robert E. Park had well understood:

> A community is not only a collection of people, but it is a collection
> of institutions. . . . There is always a larger community. Every single

community is always a part of some larger and more inclusive one. There are no longer any communities wholly detached and isolated; all are interdependent economically and politically upon one another. The ultimate community is the wide world.

(Park *et al.* 1925: 115)

This expression of interrelatedness runs the risk of breaking up a community's local discreteness as it folds it into other social formations: which is precisely the point. Subcultures are not discrete entities; they are always in the process of acting upon, and being acted on in turn by, the world around them. In this Reader we shall in fact see competing accounts which talk up the worldliness and what we might call the otherworldliness of subcultures by turns: anti-romantic accounts which fold subcultures *into* society, and romantic commentaries which distinguish them from it. For example, the otherworldliness of some modern subcultures can find expression through their anti-commercialism, a way of establishing (usually as a matter of rhetoric only, but as a romantic investment) one's opposition to the norms of modern capitalism. This is especially true of some music subcultures, as we shall see with Howard S. Becker's jazz musicians and Dick Hebdige's punks, both of which position themselves in opposition to the 'mainstream' by disavowing music's corporate/industrial/commodifying features. Stephen Duncombe similarly identifies his American fanzine communities as non-commercial through their amateurism and Bohemianism, in contrast to the professional and corporate identity of metropolitan-based mass media. Urban bohemias are themselves generally represented as anti-commercial, anti-mass cultural, 'alternative' social spaces: like the artists' colonies in New York's Soho, for example (see Kostelanetz 2003). Subcultures are so often distinguished not just from mass cultural forms – although chapter 15 answers back to this – but also from the 'executive' aspects of modern capitalism broadly speaking. On the other hand, subcultural studies can also emphasize a subculture's *immersion* in commercial activity, money-making and business practices. In his excellent and underrated book, *Grub Street: Studies in a Subculture* (1972), Pat Rogers looks at the eighteenth-century London 'Scribblers', hack writers of political pamphlets, pornography and so on. This loosely affiliated 'brotherhood' wrote and published for money first and foremost and so found itself positioned outside the more genteel and 'civilized' world of literary culture, 'the preserve of the learned, the leisured and the secure' (Rogers 1972: 281). Here, a subculture is marginalized precisely *because* its interests are commercial, as if it is *too* worldly: we might think of the relentlessly self-promoting Edmund Curll as an example here, a notorious bookseller and publisher. Jonathan Swift and Alexander Pope satirized and attacked the Scribblers in print and through the law, protecting the purity of high literary culture by consigning not just their writing but the hacks themselves to the lowest literary and social order. Rogers writes:

The fundamental technique of Augustan polemic is forcibly to enrol one's opponent in the lowest segment of society. One branded his literary effusions as criminal, as prostituted, as pestiferous; and if possible one

showed that his actual living quarters (as they might be) were set in a district whose social character partook of the same qualities. One placed him, that is, within the precincts of Grub Street.

(279)

The commercial interests and identities of subcultures are expressed in various ways by contributors to this Reader. For Angela McRobbie in chapter 12, the young women who buy their fashion in London's ragmarkets are 'subcultural entrepreneurs': the way they trade distinguishes them from corporate commercial centres, making them 'alternative' rather than oppositional. Sarah Thornton's account of club cultures in chapter 17 is more worldly still in its perspective: seeing clubbers as 'hip' on the one hand, but as 'Thatcher's children' on the other, participating in the leisure worlds of modern capitalism and being just as entrepreneurial in what they do as anybody else. For James Farrer in chapter 41, the Chinese disco scene in fact provides a point of entry *into* modern, global capitalism. It could not be any less oppositional, except for the fact, of course, that this happens in China. In Will Straw's contribution – chapter 40 – the word 'scene' is considered more appropriate to the worldliness of a subculture that participates in a global capitalist economy and is open to global influences. He accounts for dance music in this way, distinguishing it not from some broader sense of society but from the 'community' of alternative rock. Subcultures often draw perspectives that are romantic and antiromantic simultaneously. When we get to the last chapter in this Reader by Martin Roberts, we shall see contemporary subcultures fully immersed in global capitalism and transnational culture industries. Once, as I have suggested, subcultures were distinguished from the industrious and the productive. But now, for Roberts, it is possible to speak of the 'subculture industry' as social elites wander restlessly around the world searching for and investing in 'alternative' but often expensive modes of living. Even so, the romance of subcultures remains as Roberts describes an itinerant 'global underground': a postmodern revision of the 'underworld' of early modern English society.

Subcultural studies as a modern discipline begins as a response to the increasingly differentiated aspects of social life, to the recognition that 'society' is in fact host to an extensive range of social practices, some of which are 'alternative' or unconventional, others of which are transgressive and even oppositional. It is primarily empirical in its approach; although it can also be theoretically sophisticated, it is therefore quite different in kind and method to the abstracted cultural theory of Adorno and the Frankfurt School. It fixes its gaze on what Georg Simmel, around the end of the nineteenth century, had called the 'microscopic-molecular' processes in human interaction (Frisby and Featherstone 1997: 9). Simmel helped to develop a 'microsociology' that came to influence Chicago School sociologists during the 1920s and 1930s, especially through its sense that in metropolitan modernity one is constantly and necessarily interacting with otherness. A number of terminologies have since been coined to facilitate analyses of microsocial activity, all of which are essentially variants on the word *subculture*. 'Community' is foundational here as I have noted, although in its familiar usage this term by no means necessarily connotes unconventionality or oppositionality.

Tonnies had associated community with family and kinship, homeliness and domesticity – but with the 'street rats and gutter snipes' of New York we have already seen an example of a subculture positioned *against* these things. The potential broadness of the term can also be problematic – and sometimes, it is used as a synonym for society anyway, as in Henry Mayhew's remarks above about 'the civilized portion of the community'. Much later on, Paul Willis writes of 'proto-communities' and 'serial communities' (Willis 1990: 141–42), while Ulf Hannerz turns to 'micro-communities' (Hannerz 1992: 68–81), all in an attempt to give the term a more explicit application. But the otherness sometimes implied in the term *community* continues to be appealing. Twenty-odd years before Willis and Hannerz, the anthropologist Victor Turner had talked influentially about *communitas*, reconfiguring Tonnies' *Gemeinschaft* for the 1960s counterculture. *Communitas* was defined against 'structure', an expression of the orderliness and hierarchies of society which loosely recalls Tonnies' *Gesellschaft*. *Communitas* is cast as the opposite of this, an 'anti-structure': an expression of liminality, of social marginality and difference; a site of unmediated contact between people at the edges of society, unregulated by it and free from its orderly gaze, a realm of full and 'total' experience (Turner 1969: 136). Turner associated *communitas* with various tribal groups as well as – for example – Franciscan monks in terms of their relation to the 'structured Church', hippies and their spontaneous 'happenings', artist-prophets such as William Blake, and so on. The last point of identification shows that *communitas* also works as an imaginary, utopian and literary conceit; but its romantic (or even, Romantic) identity makes it no less compelling for some aspects of subcultural studies.

Several contributors to this Reader have in fact drawn on Victor Turner's work; others, however, move away from 'organic' notions of community altogether, preferring different terminologies for their representation of marginal social groups. In chapter 30, Michael Atkinson uses the term *figuration*; others, particularly in the field of information technologies, prefer *network* (for example, Wittel 2001; Jones 2002; Shaviro 2003); and we have already come across the word *scene*. This latter word was introduced into subcultural studies by Californian sociologist John Irwin in his remarkable book, *Scenes* (1977). Irwin's contribution to this Reader ends part one – on the Chicago School and urban ethnography – because it shifts away from the Chicago School's early sense that subcultures are a reaction against social pressure to conform, or an evasion of forms of social regulation. Instead, Irwin points to a very contemporary sense that subcultural identities are a symptom of democratic social pluralism: the result of lifestyle choices as much as anything else. At the same time, Irwin maintains his connection to the Chicago School through his professional interests as a criminologist, helped along by various early brushes with the law and some time spent in prison. This is how he introduces his book, in a move that takes us directly away from a theoretical interest in 'society' and into an empirical and in this case *personal* involvement with 'microsociology':

> In undergraduate and graduate schools, I attempted to penetrate the vague and esoteric abstractions of sociology. Like most students, I kept searching for concepts which my own social experiences embodied. At

16, I had been an incipient 'hot rodder'; at 17, a 'hoodlum'; at 18, a 'head'; at 19, a would-be 'safe-cracker'; at 20, a 'construction stiff'; at 21, a 'thief' (again); at 22, an almost 'dope fiend'; from 23 to 28, a 'prison intellectual'; and at 28, a 'surfer'. These were all well-known collective pursuits which were available to be tried by myself and my peers. When many of us plunged into them – which we did gleefully and some of us did voluntarily – we understood that we were not making an exclusive or lifetime commitment.

(Irwin 1977: 17)

The term *scene*, for Irwin, gives expression to a discrete 'social world', but it also recognizes the increasing mobility and flux of social identity. One's attachment to scenes can stem from choice rather than predicament; relations to them may be 'casual' rather than complete or permanent; they may change routinely, but they can also 'overlap' so that one's social identity can be associated with a *number* of scenes rather than just one. As a criminologist who had already published a major study of *The Felon* (1970), Irwin maintained the Chicago School's necessary subcultural connection between scenes and deviance. But his account helped to open up subcultural studies *after* the Chicago School, where subcultures had been treated as discrete and monocultural much in the tradition of anthropology, and where subcultural identity was determined by one's circumstances: tied to social groups which were disadvantaged or subordinate, and so condemning members to a 'career' or a 'life-cycle' without much of a future, as we see in Paul G. Cressey's account of taxi-dancer girls in chapter 2.

In this Reader we shall see subcultural studies moving back and forth between these two approaches: representing subcultures as distinct forms of sociality on the one hand, but pluralizing them and blurring their identities on the other; casting them as monocultures with a set of shared interests and beliefs that all its participants subscribe to, or emphasizing their heterogeneity, their porousness and variability, their transience. The question of how distinct or 'deviant' subcultures actually are these days preoccupies subcultural studies. In earlier Chicago School accounts, subcultures were often associated with homelessness, immigrant street gangs, criminal underworlds, homosexuality: their differences were often, although not always, strikingly apparent. Later on, as subcultural studies tied itself to cultural studies, subcultural distinctions were seen in terms of a 'refusal' of mass cultural forms and of social 'incorporation' – a 'refusal' that could at times express itself spectacularly, as it did with British punks in the late 1970s. But not every subculture is spectacular, or even 'visible'. And not every subculture, as I have already noted, is oppositional or transgressive. Even so, the precursory logics I outlined earlier – which have seen subcultures as itinerant and positioned them negatively in relation to labour, class, homeliness and property, but which have also configured them through a sometimes 'utopian' conception of 'community' – remain here, and we shall see them put to use in various ways through each of the eight parts that follow.

This Reader begins with some essential contributions from Chicago School sociology that map out subcultural identity in terms of urban movement, deviance and

'life-cycle', usually approaching their subcultures empirically and ethnographically (again, in the traditions of anthropology). This is followed with early examples of British commentaries from Birmingham University's Centre for Contemporary Cultural Studies (CCCS) which return subcultural identity to a more theoretically underpinned reading of class and develop narrative versions of what E.P. Thompson – as I note in the introduction to part two – had called 'history from below'. Part three offers some alternative positions on subcultures, each of which is critical in its own way of cultural studies approaches. Some of these are romantic in their inflection, as we shall see with Jock Young's account of 'subterranean' play in chapter 13 and Michel Maffesoli's influential contemporary use of the term *tribes* in chapter 18. Others are more worldly or anti-romantic: reintegrating subcultures back into the realm of ordinary life (chapter 14), unpacking the subcultural/mass cultural binary (chapter 15), reducing the political force of subcultures (chapter 17) and turning to Michel Foucault to see the identification of subcultures as 'social types' as a matter of governmentality and subjectification: reducing the 'otherness' of subcultures by subordinating them to classificatory schemes (chapter 16). The remaining parts of this Reader each foreground key aspects of subcultural studies: the emphasis on the subcultural inhabitation of territory (as opposed to ownership of property), the 'semiotic' turn to expressions of subcultural style and signature, the particular interest over the last 20 years in subcultural articulations of sexuality and gender, the turn to subcultural (and 'super-cultural') relations to music, and the increasing focus on the way subcultural identities are presented and transmitted in media, online (through 'virtual communities', etc.) and through the imperatives of a globalized capitalist economy.

The term *subculture* is both powerful and fragile as a designation for social identity. Some of the contributors to this Reader unpick this term and, as I have noted, other ways of conceiving of social groups jostle with it for legitimacy and relevance. But it seems to me that it is much too soon to relegate this term to the dustbins of cultural history. A few commentators have already done this, of course, and it is worth concluding this introduction with some remarks on the trend towards what is now referred to as 'post-subcultures'. The post-subcultural approach typically begins by distancing itself from the kind of British cultural studies undertaken at Birmingham's CCCS during the 1970s, especially the influential work of Dick Hebdige. It turns away from the earlier links drawn between subcultures, the working class, and subordination; and it rejects a 'semiotic' approach to subcultural studies that sees subcultures in terms of their unorthodox, even oppositional or illegitimate, use of cultural signs. The key term in this critique is *postmodernism*. Post-subcultural approaches emphasize their contemporaneity by talking up those aspects of postmodernism – fragmented and fluid identities, hybridity, transience, 'apolitical sentiments', mobility, a 'celebration of the inauthentic' (Muggleton 2000: 52) – which would seem to prevent subcultural identity from ever gaining coherence. In their co-edited anthology devoted to 'post-subcultures' (2003), David Muggleton and Rupert Weinzierl thus see the work of Hebdige and other CCCS researchers as an 'heroic phase' in subcultural studies, since it emphasized 'resistance', 'semiotic guerilla warfare', authenticity, and so on: precisely the features they now reject.

We shall see in part two of this Reader, of course, that the Birmingham researchers were in fact ambivalent about subcultural 'resistance'; they traced out the *loss* of (working class) 'authenticity' in subcultures; and for Paul Willis and Angela McRobbie in particular, subcultural identities were anything *but* 'heroic'. On the other hand, it is worth noting that for Muggleton and Weinzierl post-subcultures can occasionally seem to be more heroic than ever before. Anarchist-punks, they suggest, 'are able to embrace a radical discourse and praxis' (2003: 8), while new protest movements are 'antagonistic to the commodification of life in capitalist societies' (15): so much for a post-subculture's 'apolitical sentiments'. One of the problems here is that postmodernism is only partially able to serve its descriptive purpose. Muggleton and Weinzierl want their post-subcultures to reflect cultural hybridity and inauthenticity, topics we shall see discussed and debated elsewhere in this Reader in relation to subcultures. But they also want to acknowledge that these features 'should not blind us to continuing economic, political and ideological inequalities' (18). We find ourselves back with the preoccupations of Birmingham's CCCS here, just at the moment when we are supposed to leave them behind.

In his book, *Inside Subculture: The Postmodern Meaning of Style* (2000) – the title echoes that of Dick Hebdige's *Subculture: The Meaning of Style* (1979) – Muggleton suggests that the CCCS during the 1970s had been both totalizing about and remote from subcultures, which to some degree is true. So Muggleton's project is to become 'empirical' all over again. He talks directly to subcultural participants – many of whom, interestingly enough, are unemployed or casually employed, selected for interview 'on the basis of what I regarded as their unconventional appearance' – in order to place 'subjective meaning' back into the 'empirical frame' (Muggleton 2000: 171, 9). Muggleton calls his approach 'neo-Weberian'; but its newness is doubly compromised when we remember that the Chicago School sociologists had been equally empirical and ethnographic in their research with out-of-work gang members, homeless men, casually employed taxi-dancers and so on many years ago. We shall see that other 'post-subcultural' characteristics championed by Muggleton are also already accounted for in the following pages of this Reader: for example, 'commodity-orientation' (McRobbie, Clarke, Thornton) and performativity (Irwin, Fyvel and Young, as well as Halberstam and other more recent contributions). The point of 'post-subculturalism' is essentially a reaffirmation of what John Irwin had already outlined almost 30 years earlier in *Scenes*. But Irwin had insisted on the fact that subcultures – for all their fluidity, transience and contingency in contemporary life – are nevertheless always '*social* worlds'. In Muggleton's account, fragmentation and diffusion are talked up to such an extent that sociality is all but lost, replaced by precisely one of the things that modern subcultures have reacted *against*: individualization. For Muggleton, subcultures are now 'post-subcultures' because they must be understood 'as a symptom of postmodern hyperindividualism' (6) – a term that wipes away any trace of his interviewees' social, as well as economic, predicaments in one broad stroke. Another recent anthology, Bennett and Kahn-Harris' *After Subculture* (2004), works itself out in a similar vein, also carefully distancing its approach and position from CCCS research during the 1970s. For David Chaney in a contribution titled 'Fragmented

Cultures and Subcultures', distinctions between dominant culture and subculture now no longer hold because postmodernism has fractured dominant culture 'into a plurality of lifestyle sensibilities and preferences' (Bennett and Kahn-Harris 2004: 47). Muggleton's unemployed interviewees may have difficulty recognizing themselves in this untroubled vision of contemporary life, which once again erases social, cultural and economic differences all in the name of 'plurality'. In Chaney's postmodern world, 'any confidence in a shared space with commonly recognized features has . . . evaporated' (48). By way of a remedy to this, it might be worth recommending a visit to the local gym (see chapter 34 in this Reader), or the nearest football ground (chapter 22), or a drag king club (chapter 35), or a dance club (chapters 41 and 42), or a *manga* comic book convention in Japan (chapter 45) or online to participate in 'net.goth' activity (chapter 47) or to join Howard Rheingold's WELL (chapter 43).

Elsewhere in *After Subculture*, the post-subcultures model is much more ambivalently registered. For Ben Carrington and Brian Wilson, dance cultures 'are *not just* about individual lifestyle choices'; there are indeed 'patterns of class and racial differentiation' here (78), hardly a challenging conclusion to draw (not least because of all the work already done on subcultures, class and race at the CCCS). For Keith Kahn-Harris in a chapter titled 'Unspectacular Subculture?', extreme metal music scene participants are, as we might also expect, 'deeply committed' to the extreme metal scene (117). A point like this might only be surprising in the context of a book about life *after* subcultures. It may not be surprising at all, then, to see Kahn-Harris both upholding and betraying the logic of the book he co-edited with these closing remarks: 'Although I would argue that subculture is an inappropriate concept to use in the analysis of contemporary cultural practice, it none the less illuminates some of the more difficult problematics of creating youth culture' (118). Here, the term *subculture* is both 'inappropriate' and 'illuminating': we may be able to ask no more of any social terminology! In an 'Afterword' to Bennett and Harris's collection, the British sociologist and popular music critic Simon Frith is also ambivalent about the 'post-subculture' project. For all their rejection of CCCS approaches, he observes, a number of contributors to *After Subculture* 'still want to celebrate the lives they examine as some kind of opposition to dominant ideology' and 'hanker, despite themselves, for evidence of resistance and transgression' (176). Perhaps these nostalgias are simply generational. But they also stem here from an over-investment in 'plurality' that has now reduced subcultural distinctions to a matter of sheer relativism. The post-subcultures model turns away from a sense of subcultures as distinctive social groups; but as it abandons subculture to 'lifestyle' and atomized individuality, it paradoxically ends up underwriting *only* the 'unspectacular': as if social difference is now so fragmented and diffuse that the very notion of it has effectively dissolved away.

The British sociologist Chris Jenks, in his book *Subculture: The Fragmentation of the Social* (2005), similarly concludes by giving up the concept of a *subculture*. But he curiously heads in the opposite direction to that of the 'post-subculture' model: turning away from individualization to speak, instead, of 'the "society" that we all live in' (Jenks 2005: 145). This point of view also carries its own nostalgias along

with it, of course: 'A quarter of a century ago', Jenks writes, 'we discussed "society" as a reality with confidence' (142). But in his attempt to recover this category – with so little confidence, it must be said, that the term is now always accompanied by inverted commas – Jenks ends up replacing sheer relativism with utter sameness, as the final sentence of his book (which also does away with any sense of social difference) would seem to suggest.[1] The post-subcultural approach has complained about the way Birmingham's CCCS had been both totalizing about and remote from its subcultures, but Jenks's study barely looks at actual subcultures at all, remaining as remote from them as it is possible to be. Post-subcultural commentators have found themselves speaking up for the unspectacular, the atomized and the diffuse as they promote 'individual lifestyle choices'. But Jenks, on the other hand, seems to want to submit the 'peculiarly privatized forms' of individualization (144) to what he calls 'the constraints of the totality' (12): as if 'society' is, or should be, all-encompassing and all-enclosing. Representing a history of subcultural studies from its early formations to the present day, the second edition of *The Subcultures Reader* offers a collection of work that subscribes to neither of these positions. At the very least, it should remind us that the social worlds of subcultures out there are by no means so undistinguished, and by no means so readily constrained.

Note

1 This final sentence reads: 'What about the people who always seem to live next door, who always play their music too loud, could they comprise a subculture – or are you the people who always seem to live next door?' (Jenks 2005: 145). There is no answer to this anxiety-ridden closing question, which also has nothing much to do with subcultures.

The Chicago School and urban ethnography

Introduction to part one

■ Ken Gelder

F ROM THE EARLY PART OF THE TWENTIETH CENTURY until at least
the mid-1930s, the Department of Sociology at the University of Chicago domi-
nated sociological theory and practice in the United States. Established in 1892
when the University itself was opened, it turned its attention directly to Chicago,
America's second largest city at this time and the destination of large numbers of
(mostly European) immigrants. Sociology here meant *urban* sociology: the study of
constituent groups or social 'types' in the city – and the registering of the city's
sheer complexity. This is where subcultural studies formally begins, in empirical
urban fieldwork that recognizes the socializing imperatives of people even as it finds
itself drawn to marginal or 'unassimilated' social types: the delinquent, the recent
immigrant, gang members, the 'hobo', and so on. Durkheim, Simmel and Tonnies
were influences on important early Chicago School sociologists like Robert E. Park,
who joined the Department in 1914 and stayed through the Depression until his
retirement in 1933. Park had studied as a philosopher at Harvard and in Germany
(writing a Ph.D. titled 'The Mass and the Public'), but he had also worked as a
journalist covering urban corruption and conditions in the immigrant ghettos. Later
on, Park developed his interests in race relations in the US, meeting and working
with Booker T. Washington, president of the Tuskegee Institute in Alabama, a
leading centre for black education. His first involvement with the Chicago School
was in fact to teach a course on 'The Negro in America'. But by the 1920s, along
with Ernest W. Burgess, he had developed an influential programme of urban
research focused on Chicago itself, built around a theory of 'urban ecology' which
took the city as a series of distinctive zones to which socially/culturally similar
people were 'naturally' attracted.

 This section begins with an extract from a chapter from Park's seminal co-
authored book, *The City* (1925). The city can appear to be an impersonal, artificial

place consisting of transport routes, communication networks, buildings, and people who do not and cannot know each other as they move through its precincts. But for Park, the city also reflects nature and human nature: as a place of socialization, of social groups that come to find their own 'moral region' or 'milieu'. Social organization may very well be industrially conceived, which led Park to talk in anthropological terms about 'vocational types' in the city (such as the 'shop assistant', the 'stock-exchange speculator', etc.), people who achieve their social solidarity through the tasks they carry out. But there may also be 'divergent types' in the city, eccentric, peculiar to themselves. Park was interested in both the norm and the exception in human nature. The city for him was itself a place enabling extremes. Its ecology was the result of proximities between people on the one hand, and segregation on the other: variety and arrangement, 'organic' instabilities and social planning: a kind of disorganized organization. Far from being an homogeneous or homogenizing place, the city was therefore seen as highly variable, differentiated, stratified, active and ever-changing. Indeed, for Park the city *licenses* difference, socially, culturally and morally. Drawing on Freud among others (since the interest here is, after all, in human behaviour), Park suggests that the civilizing influences of urban life – the ways in which it disciplines people – necessarily produces, even as it tries to suppress, yearnings for something a little less restrained. The very controls and inhibitions the city puts into place 'emancipates' wilder urges among 'exceptional persons'. The city enables these people to form their own like-minded 'moral regions': places in which 'a divergent moral code prevails', but which also constitute a natural part of the city's complex ecology. This is where subcultural studies finds its subject matter.

By the time he arrived at the University of Chicago's Department of Sociology, Park had already published two important books on race, culture and immigration: *The Immigrant Press and Its Controls* (1921) and (with Herbert A. Miller) *Old World Traits Transplanted* (1921). Like so many Chicago School researchers, Park was fascinated by cultural difference, turning to the fortunes and misfortunes of ethnic groups as they migrated into American cities and established themselves as communities. But migration can be indigenous and local too, as Park also noted: when people leave home, for instance, and move to a different part of the city. The second piece in this section, from Paul G. Cressey's *The Taxi-Dance Hall: A Sociological Study in Commercialised Recreation and City Life* (1932), is a study of young women who 'break' with their families and neighbourhoods to work in the cities as taxi-dancers, that is, going with men who pay them to dance. Cressey had studied at Chicago in the 1920s, and went on to a post at New York University – where he became involved in a major study of the effects of cinema on American youth. His earlier work on the taxi-dancers is important for at least two reasons. First, it looks at women, which was unusual among the Chicago School sociologists. Second, it traces out what it calls a 'life-cycle' in the city. It maps a taxi-dancer's career in and around the dance hall, in other words, providing a structure and a trajectory to a subcultural existence. Cressey's work thus anticipates later examples of subcultural studies that describe career development: e.g. Marsh *et al.* in chapter 22. But it also anticipates later work in the Chicago School itself through its focus on status. A taxi-dancer, in Cressey's account, is a non-conformist: literally,

a deviant, in the sense that she leaves her family and neighbourhood to migrate to or across the city. Attached to the 'little isolated world' of the dance hall, the taxi-dancer finds herself in a caste system built around a set of definitive roles. She may have more prestige than she had at home, but she also has to adjust to a range of different ethnicities reflected through the men (often recent immigrants themselves) who employ the dancers and become involved with them. For white girls – reflecting their embedded racism – this can mean the loss of prestige and the beginning of a series of 'retrogressive' life-choices. What is important to Cressey is not so much a conventional story of women-in-decline in a 'mercenary' world, however, but an ongoing narrative about urban mobility and further migration – as the taxi-dancers face a future of moving from dance hall to dance hall, city to city.

By the 1940s, the term 'sub-culture' was beginning to be used to account for particular kinds of social difference in an increasingly pluralized and fractured United States. Milton M. Gordon – who came to write a canonical study of immi-grant groups and their capacity to adjust to their new surroundings, *Assimilation in American Life* (1964) – argued early on for the need to look beyond the conven-tional sociological categories of ethnic background, class, national identity, and so on, to more nuanced social arrangements. In the 1947 piece collected here, Gordon re-expresses Park's famous phrase 'marginal man' (which tends to individualize social reaction) as 'marginal sub-cultures'. Park had talked about 'cities within cities' in his account of urban social groups, but Gordon talks of 'worlds within a world' – preferring to keep the idea and location of a subculture relatively open. Subcultures may be more institutional than urban, for example. And they may not necessarily be 'deviant' from some established norm. Indeed, Gordon suggests that the deviant is precisely the person who does not conform to the *subculture*.

On the other hand, the ties between deviant behaviour and subcultural identity were strengthening as sociology increasingly joined hands with criminology. Albert K. Cohen had studied sociology at Harvard University, later joining Indiana Uni-versity's Department of Criminal Justice. His seminal study, *Delinquent Boys: The Culture of the Gang* (1955), was influenced by Chicago School sociologists such as Thrasher and Whyte, both of whom are represented in this Reader (see chapters 19 and 20). But he also engaged with anomie or 'strain' theory, criticizing Robert Merton's important essay, 'Social Structure and Anomie' (1938). Taking up Durkheim's concept, Merton had noted that society collectively regulates the poten-tially unlimited appetites of individuals; but if its collective power is weakened, then those appetites are released and deviance or 'normlessness' follows. We can recall Park's view of the city's capacity both to regulate and 'emancipate' excess, noted earlier. But Cohen, like Gordon, emphasized the social aspects of anomie. He thus saw delinquency not as something individualistic but in terms of 'gangs of boys *doing things together*', their actions 'deriving their meaning and flavor from the fact of togetherness and governed by a set of common understandings, common sentiments, and common loyalties' (Cohen 1955: 178). One's social milieu requires conformity and consensus, providing 'powerful incentives not to deviate'. If one *does* wish to deviate, one must find other, like-minded people who share the same dissatisfaction and seek the same solutions. The solution must always be social.

Cohen was the first to provide a 'general theory' of subcultural identity, and his notion that subcultures are the result of the need to find solutions to social problems anticipated subcultural studies at Birmingham 30 years later. Like the Birmingham commentators – and like Frederic Thrasher before him – Cohen also focused on the 'lower classes'. Delinquent subcultures, he noted, were the result of lower-class boys being judged by a middle-class 'measuring rod' and finding themselves unable to meet the middle-class goals society set for them. As a result, the boys create their own system of values: hedonistic, autonomous and, as Cohen described them, '*nonutilitarian, malicious* and *negativistic*' (25). Even so, he insisted, they are a 'normal' part of American society. The question of what counts as normal behaviour and what doesn't preoccupied urban ethnographers, particularly those Chicago School researchers who turned their attention to 'deviance'. Deviance is not necessarily abnormality or 'normlessness'; rather, it can be a site through which an alternative (and possibly highly organized) set of values are articulated. One of the tasks of Chicago School sociologists was to try to gain insight into the ways in which these people see the world. To do this, the sociologist becomes an ethnographer, following the procedures of anthropology. He or she studies the 'deviant' group face-to-face in what Ned Polksy called their 'natural setting', and one method for doing this became known as participant observation.

This Reader contains a number of important examples of participant observation studies of subcultures: Whyte, Humphreys, Becker and Goffman in chapters 19, 20, 21 and 32. In this section, participant observation is represented by an extract from Ned Polsky's landmark book, *Hustlers, Beats and Others* (1967). Polsky had studied literature at the University of Wisconsin and was a graduate student in sociology at Chicago, although he left without his degree. He was later a professor of sociology at the State University of New York – Stony Brook. His book examines several kinds of 'deviants', including the Greenwich Village beatnik and the pool-hall 'hustler' – a figure made famous a few years earlier in Robert Rossen's 1961 film, *The Hustler*, starring Paul Newman. But its method involved ethnographic participation, going into the places in which these subcultures flourished and cohabiting with them. One might do this covertly, as Humphreys does in chapter 20, or overtly as Polsky did, declaring himself a researcher even as he participates in pool-hall culture (becoming an excellent player). Polsky recalls Robert E. Park's edict that a sociologist must be a good reporter, who ventures into the field not so much to collect data but to *observe*. Polsky's approach is thus pragmatic and empirical – indeed, he has little time for the remote world of sociological theory, a point reflected in his often colloquial style. Even so, there are protocols the field researcher must take note of, because the interaction between observed and observer – 'insider' and 'outsider' – carries risks for both parties. How does a researcher observe criminals, for example? An outsider's values will almost certainly be very different to an insider's. Polsky asks a set of ethical and moral questions about the role of researchers here – representatives of what he calls 'the square world' – as they deal with a subculture they may disapprove of or find distasteful and/or wish to reform. But for Polsky, these things merely distract researchers from their task, which is to understand and chart the 'deviant' group's particular point of view, its *perspective*. Participant obser-

vation is vulnerable to the charge of being impressionistic or casual; but Polsky speaks up for quite the opposite features, that the researcher should work dispassionately, with disinterest and with the 'objective' approach of the scientist.

The first book to represent and historicize work in what we now call subcultural studies was David O. Arnold's collection, *Subcultures*, published in 1970. This book begins with early material on criminological behaviour from Edwin H. Sutherland, and goes on to include extracts from Albert K. Cohen and Milton M. Gordon, among several others: focusing on delinquency and the 'deviant', in line with Chicago School interests. But it also notes that the concept of a 'subculture' has since been considerably stretched. It seems, Arnold notes in his introduction, 'as if the accelerated use of the concept has caught us unawares' (Arnold 1970: 3). By the 1960s, subcultures are ubiquitous: in cities, across the country and along the coast, as bikers take to the road, surfers traverse the beaches, and so on. The middle classes can lay claim to them, too, as beats, artist colonies and hippies congregate in the inner-city areas (like Soho in New York) or move out into rural communes. For Arnold, subcultural studies no longer just applies to 'deviant behaviour' but 'to most, perhaps all, of the subfields of sociology' (3) – a discipline that had itself spread across the country's universities. John Irwin, another contributor to *Subcultures*, had completed his Masters dissertation on 'Surfers: a Study of the Growth of a Deviant Subculture' at the University of California, Berkeley, in 1965 and went on to write his Ph.D. on 'the felon', which became his first book. In a wonderful, later study, *Scenes* (1977), Irwin describes hippie and surfing subcultures and their relation to the city. In doing so, he establishes an important point of departure from the Chicago School's earlier mode of subcultural studies:

> [the Chicago School's concepts of] gangs, subcultures, and behavior systems did not approach the casualness of the worlds I was involved in. All such gangs and subcultures suggested too much commitment, determinism, instrumentality, and stability in membership. . . . Concepts such as milieu, ambience, fad, and craze, on the other hand, did not suggest enough permanence, cohesion, or complexity of form.
>
> (Irwin 1977: 18)

In the short chapter included here from *Subcultures*, Irwin responds to this predicament with the term 'scene'. A 'scene' is a 'social world' whose members have a 'shared perspective'. But there are now many of them in America – which leads Irwin to talk about both 'subcultural pluralism' and 'subcultural relativism', the sense that one social group's values may be no better or worse than another's. His chapter also recognizes that subcultural participants are increasingly *conscious* of being subcultural, as the term soaks into mainstream society. Irwin's suggestion that people self-consciously perform in a kind of subcultural 'theatre' compares with the more extensive work of his contemporary, the anthropologist Victor Turner (who also talked about hippies and the counterculture) – and anticipates the later work of cultural studies commentators like Dick Hebdige, who went on to talk about subcultural 'display' and the role of subcultural style.

This section, then, charts the rise and steady expansion of subcultural studies: from early urban ethnography and its interest in the 'marginal' and the 'deviant', to a growing sense that the subcultural field has widened its reach right across the country. Society itself is pluralized in this account, as cities within cities, worlds within worlds, begin to claim sociological attention: structured, organized alternatives within, and sometimes against, the norm.

Robert E. Park

THE CITY
Suggestions for the investigation of human behavior in the urban environment [1925]

THE CITY . . . IS SOMETHING MORE than a congeries of individual men and of social conveniences – streets, buildings, electric lights, tramways, and telephones, etc.; something more, also, than a mere constellation of institutions and administrative devices – courts, hospitals, schools, police, and civil functionaries of various sorts. The city is, rather, a state of mind, a body of customs and traditions, and of the organized attitudes and sentiments that inhere in these customs and are transmitted with this tradition. The city is not, in other words, merely a physical mechanism and an artificial construction. It is involved in the vital processes of the people who compose it; it is a product of nature, and particularly of human nature. [. . .]

Anthropology, the science of man, has been mainly concerned up to the present with the study of primitive peoples. But civilized man is quite as interesting an object of investigation, and at the same time his life is more open to observation and study. Urban life and culture are more varied, subtle, and complicated, but the fundamental motives are in both instances the same. The same patient methods of observation which anthropologists like Boas and Lowie have expended on the study of the life and manners of the North American Indian might be even more fruitfully employed in the investigation of the customs, beliefs, social practices, and general conceptions of life prevalent in Little Italy on the lower North Side in Chicago, or in recording the more sophisticated folkways of the inhabitants of Greenwich Village and the neighborhood of Washington Square, New York.

We are mainly indebted to writers of fiction for our more intimate knowledge of contemporary urban life. But the life of our cities demands a more searching and disinterested study than even Émile Zola has given us in his 'experimental' novels and the annals of the Rougon-Macquart family.

We need such studies, if for no other reason than to enable us to read the newspapers intelligently. The reason that the daily chronicle of the newspaper is so

shocking, and at the same time so fascinating, to the average reader is because the average reader knows so little about the life of which the newspaper is the record.

The observations which follow are intended to define a point of view and to indicate a program for the study of urban life: its physical organization, its occupations, and its culture.

I. The city plan and local organization

The city, particularly the modern American city, strikes one at first blush as so little a product of the artless processes of nature and growth, that it is difficult to recognize it as a living entity. The ground plan of most American cities, for example, is a checkerboard. The unit of distance is the block. This geometrical form suggests that the city is a purely artificial construction which might conceivably be taken apart and put together again, like a house of blocks.

The fact is, however, that the city is rooted in the habits and customs of the people who inhabit it. The consequence is that the city possesses a moral as well as a physical organization, and these two mutually interact in characteristic ways to mold and modify one another. It is the structure of the city which first impresses us by its visible vastness and complexity. But this structure has its basis, nevertheless, in human nature, of which it is an expression. On the other hand, this vast organization which has arisen in response to the needs of its inhabitants, once formed, imposes itself upon them as a crude external fact, and forms them, in turn, in accordance with the design and interests which it incorporates. Structure and tradition are but different aspects of a single cultural complex which determines what is characteristic and peculiar to city, as distinguished from village, life and the life of the open fields. [. . .]

. . . As the city increases in population, the subtler influences of sympathy, rivalry, and economic necessity tend to control the distribution of population. Business and industry seek advantageous locations and draw around them certain portions of the population. There spring up fashionable residence quarters from which the poorer classes are excluded because of the increased value of the land. Then there grow up slums which are inhabited by great numbers of the poorer classes who are unable to defend themselves from association with the derelict and vicious.

In the course of time every section and quarter of the city takes on something of the character and qualities of its inhabitants. Each separate part of the city is inevitably stained with the peculiar sentiments of its population. The effect of this is to convert what was at first a mere geographical expression into a neighborhood, that is to say, a locality with sentiments, traditions, and a history of its own. Within this neighborhood the continuity of the historical processes is somehow maintained. The past imposes itself upon the present, and the life of every locality moves on with a certain momentum of its own, more or less independent of the larger circle of life and interests about it. [. . .]

. . . Proximity and neighborly contact are the basis for the simplest and most elementary form of association with which we have to do in the organization of city life. Local interests and associations breed local sentiment, and, under a system which makes residence the basis for participation in the government, the

neighborhood becomes the basis of political control. In the social and political organ-ization of the city it is the smallest local unit. [. . .]

The neighborhood exists without formal organization. The local improvement society is a structure erected on the basis of the spontaneous neighborhood organ-ization and exists for the purpose of giving expression to the local sentiment in regard to matters of local interest.

Under the complex influences of the city life, what may be called the normal neighborhood sentiment has undergone many curious and interesting changes, and produced many unusual types of local communities. More than that, there are nascent neighborhoods and neighborhoods in process of dissolution. . . . [. . .]

. . . In the city environment the neighborhood tends to lose much of the signifi-cance which it possessed in simpler and more primitive forms of society. The easy means of communication and of transportation, which enable individuals to distribute their attention and to live at the same time in several different worlds, tend to destroy the permanency and intimacy of the neighborhood. On the other hand, the isolation of the immigrant and racial colonies of the so-called ghettos and areas of population segregation tend to preserve and, where there is racial preju-dice, to intensify the intimacies and solidarity of the local and neighborhood groups. Where individuals of the same race or of the same vocation live together in segre-gated groups, neighborhood sentiment tends to fuse together with racial antagonisms and class interests.

Physical and sentimental distances reinforce each other, and the influences of local distribution of the population participate with the influences of class and race in the evolution of the social organization. Every great city has its racial colonies, like the Chinatowns of San Francisco and New York, the Little Sicily of Chicago, and various other less pronounced types. In addition to these, most cities have their segregated vice districts, like that which until recently existed in Chicago, their rendezvous for criminals of various sorts. Every large city has its occupational suburbs, like the Stockyards in Chicago, and its residential enclaves, like Brookline in Boston, the so-called 'Gold Coast' in Chicago, Greenwich Village in New York, each of which has the size and the character of a complete separate town, village, or city, except that its population is a selected one. Undoubtedly the most remark-able of these cities within cities, of which the most interesting characteristic is that they are composed of persons of the same race, or of persons of different races but of the same social class, is East London, with a population of 2,000,000 laborers. [. . .]

It is a city full of churches and places of worship, yet there are no cathe-drals, either Anglican or Roman; it has a sufficient supply of elementary schools, but it has no public or high school, and it has no colleges for the higher education and no university; the people all read newspapers, yet there is no East London paper except of the smaller and local kind. . . . In the streets there are never seen any private carriages; there is no fashionable quarter . . . one meets no ladies in the principal thorough-fares. People, shops, houses, conveyances – all together are stamped with the unmistakable seal of the working class.

Perhaps the strangest thing of all is this: in a city of two millions of people there are no hotels! That means, of course, that there are no visitors.

[Besant 1912: 7–9]

In the older cities of Europe, where the processes of segregation have gone farther, neighborhood distinctions are likely to be more marked than they are in America. East London is a city of a single class, but within the limits of that city the population is segregated again and again by racial, cultural, and vocational interests. Neighborhood sentiment, deeply rooted in local tradition and in local custom, exercises a decisive selective influence upon the populations of the older European cities and shows itself ultimately in a marked way in the characteristics of the inhabitants. [. . .]

II. Industrial organization and the moral order

The ancient city was primarily a fortress, a place of refuge in time of war. The modern city, on the contrary, is primarily a convenience of commerce, and owes its existence to the market place around which it sprang up. Industrial competition and the division of labor, which have probably done most to develop the latent powers of mankind, are possible only upon condition of the existence of markets, of money, and other devices for the facilitation of trade and commerce. [. . .]

Success, under conditions of personal competition, depends upon concentration upon some single task, and this concentration stimulates the demand for rational methods, technical devices, and exceptional skill. Exceptional skill, while based on natural talent, requires special preparation, and it has called into existence the trade and professional schools, and finally bureaus for vocational guidance. All of these, either directly or indirectly, serve at once to select and emphasize individual differences.

Every device which facilitates trade and industry prepares the way for a further division of labor and so tends further to specialize the tasks in which men find their vocations.

The outcome of this process is to break down or modify the older social and economic organization of society, which was based on family ties, local associations, on culture, caste, and status, and to substitute for it an organization based on occupation and vocational interests.

In the city every vocation, even that of a beggar, tends to assume the character of a profession and the discipline which success in any vocation imposes, together with the associations that it enforces, emphasizes this tendency – the tendency, namely, not merely to specialize, but to rationalize one's occupation and to develop a specific and conscious technique for carrying it on.

The effect of the vocations and the division of labor is to produce, in the first instance, not social groups, but vocational types: the actor, the plumber, and the lumber-jack. The organizations, like the trade and labor unions which men of the

same trade or profession form, are based on common interests. In this respect they differ from forms of association like the neighborhood, which are based on contiguity, personal association, and the common ties of humanity. The different trades and professions seem disposed to group themselves in classes, that is to say, the artisan, business, and professional classes. But in the modern democratic state the classes have as yet attained no effective organization. Socialism, founded on an effort to create an organization based on 'class consciousness,' has never succeeded, except, perhaps, in Russia, in creating more than a political party.

The effects of the division of labor as a discipline, i.e., as means of molding character, may therefore be best studied in the vocational types it has produced. Among the types which it would be interesting to study are: the shopgirl, the policeman, the peddler, the cabman, the nightwatchman, the clairvoyant, the vaudeville performer, the quack doctor, the bartender, the ward boss, the strike-breaker, the labor agitator, the school teacher, the reporter, the stockbroker, the pawnbroker; all of these are characteristic products of the conditions of city life; each, with its special experience, insight, and point of view determines for each vocational group and for the city as a whole its individuality. [. . .]

. . . The division of labor, in making individual success dependent upon concentration upon a special task, has had the effect of increasing the interdependence of the different vocations. A social organization is thus created in which the individual becomes increasingly dependent upon the community of which he is an integral part. The effect, under conditions of personal competition, of this increasing interdependence of the parts is to create in the industrial organization as a whole a certain sort of social solidarity, but a solidarity based, not on sentiment and habit, but on community of interests. [. . .]

III. Secondary relations and social control

Modern methods of urban transportation and communication – the electric railway, the automobile, the telephone, and the radio – have silently and rapidly changed in recent years the social and industrial organization of the modern city. They have been the means of concentrating traffic in the business districts, have changed the whole character of retail trade, multiplying the residence suburbs and making the department store possible. These changes in the industrial organization and in the distribution of population have been accompanied by corresponding changes in the habits, sentiments, and character of the urban population. [. . .]

. . . It is characteristic of city life that all sorts of people meet and mingle together who never fully comprehend one another. The anarchist and the club man, the priest and the Levite, the actor and the missionary who touch elbows on the street still live in totally different worlds. So complete is the segregation of vocational classes that it is possible within the limits of the city to live in an isolation almost as complete as that of some remote rural community. [. . .]

In the immigrant colonies which are now well established in every large city, foreign populations live in an isolation which is different from that of the population of East London, but in some respects more complete.

The difference is that each one of these little colonies has a more or less independent political and social organization of its own, and is the center of a more or less vigorous nationalist propaganda. For example, each one of these groups has one or more papers printed in its own language. In New York City there were, a few years ago, 270 publications, most of them supported by the local population, printed in 23 different languages. In Chicago there were 19 daily papers published in 7 foreign languages with a combined daily circulation of 368,000 papers.

Under these conditions the social ritual and the moral order which these immigrants brought with them from their native countries have succeeded in maintaining themselves for a considerable time under the influences of the American environment. Social control, based on the home mores, breaks down, however, in the second generation. [. . .]

Under the conditions imposed by city life in which individuals and groups of individuals, widely removed in sympathy and understanding, live together under conditions of interdependence, if not of intimacy, the conditions of social control are greatly altered and the difficulties increased.

The problem thus created is usually characterized as one of 'assimilation.' It is assumed that the reason for rapid increase of crime in our large cities is due to the fact that the foreign element in our population has not succeeded in assimilating American culture and does not conform to the American mores. This would be interesting, if true, but the facts seem to suggest that perhaps the truth must be sought in the opposite direction. [. . .]

As a source of social control public opinion becomes important in societies founded on secondary relationships, of which great cities are a type. In the city every social group tends to create its own milieu and, as these conditions become fixed, the mores tend to accommodate themselves to the conditions thus created. In secondary groups and in the city fashion tends to take the place of custom, and public opinion, rather than the mores, becomes the dominant force in social control.

In any attempt to understand the nature of public opinion and its relation to social control it is important to investigate first of all the agencies and devices which have come into practical use in the effort to control, enlighten, and exploit it.

The first and the most important of these is the press, that is, the daily newspaper and other forms of current literature, including books classed as current.

After the newspaper, the bureaus of research which are now springing up in all the large cities are the most interesting and the most promising devices for using publicity as a means of control.

The fruits of these investigations do not reach the public directly, but are disseminated through the medium of the press, the pulpit, and other sources of popular enlightenment.

In addition to these there are the educational campaigns in the interest of better health conditions, the child-welfare exhibits, and the numerous 'social advertising' devices which are now employed, sometimes upon the initiative of private societies, sometimes upon that of popular magazines or newspapers, in order to educate the public and enlist the masses of the people in the movement for the improvement of conditions of community life.

The newspaper is the great medium of communication within the city, and it is on the basis of the information which it supplies that public opinion rests. The first function which a newspaper supplies is that which formerly was performed by the village gossip.

In spite, however, of the industry with which newspapers pursue facts of personal intelligence and human interest, they cannot compete with the village gossips as a means of social control. For one thing, the newspaper maintains some reservations not recognized by gossip, in the matters of personal intelligence. For example, until they run for office or commit some other overt act that brings them before the public conspicuously, the private life of individual men or women is a subject that is, for the newspaper, taboo. It is not so with gossip, partly because in a small community no individual is so obscure that his private affairs escape observation and discussion; partly because the field is smaller. In small communities there is a perfectly amazing amount of personal information afloat among the individuals who compose them.

The absence of this in the city is what, in large part, makes the city what it is. [. . .]

IV. Temperament and the urban environment

Great cities have always been the melting-pots of races and of cultures. Out of the vivid and subtle interactions of which they have been the centers, there have come the newer breeds and the newer social types. The great cities of the United States, for example, have drawn from the isolation of their native villages great masses of the rural populations of Europe and America. Under the shock of the new contacts the latent energies of these primitive peoples have been released, and the subtler processes of interaction have brought into existence not merely vocational, but temperamental, types.

. . . Transportation and communication have effected, among many other silent but far-reaching changes, what I have called the 'mobilization of the individual man.' They have multiplied the opportunities of the individual man for contact and for association with his fellows, but they have made these contacts and associations more transitory and less stable. A very large part of the populations of great cities, including those who make their homes in tenements and apartment houses, live much as people do in some great hotel, meeting but not knowing one another. The effect of this is to substitute fortuitous and casual relationship for the more intimate and permanent associations of the smaller community.

Under these circumstances the individual's status is determined to a considerable degree by conventional signs – by fashion and 'front' – and the art of life is largely reduced to skating on thin surfaces and a scrupulous study of style and manners.

Not only transportation and communication, but the segregation of the urban population tends to facilitate the mobility of the individual man. The processes of segregation establish moral distances which make the city a mosaic of little worlds

which touch but do not interpenetrate. This makes it possible for individuals to pass quickly and easily from one moral milieu to another, and encourages the fascinating but dangerous experiment of living at the same time in several different contiguous, but otherwise widely separated, worlds. All this tends to give to city life a superficial and adventitious character; it tends to complicate social relationships and to produce new and divergent individual types. It introduces, at the same time, an element of chance and adventure which adds to the stimulus of city life and gives it, for young and fresh nerves, a peculiar attractiveness. The lure of great cities is perhaps a consequence of stimulations which act directly upon the reflexes. As a type of human behavior it may be explained, like the attraction of the flame for the moth, as a sort of tropism.

The attraction of the metropolis is due in part, however, to the fact that in the long run every individual finds somewhere among the varied manifestations of city life the sort of environment in which he expands and feels at ease; finds, in short, the moral climate in which his peculiar nature obtains the stimulations that bring his innate dispositions to full and free expression. It is, I suspect, motives of this kind which have their basis, not in interest nor even in sentiment, but in something more fundamental and primitive which draw many, if not most, of the young men and young women from the security of their homes in the country into the big, booming confusion and excitement of city life. In a small community it is the normal man, the man without eccentricity or genius, who seems most likely to succeed. The small community often tolerates eccentricity. The city, on the contrary, rewards it. Neither the criminal, the defective, nor the genius has the same opportunity to develop his innate disposition in a small town that he invariably finds in a great city.

Fifty years ago every village had one or two eccentric characters who were treated ordinarily with a benevolent toleration, but who were regarded meanwhile as impracticable and queer. These exceptional individuals lived an isolated existence, cut off by their very eccentricities, whether of genius or of defect, from genuinely intimate intercourse with their fellows. If they had the making of criminals, the restraints and inhibitions of the small community rendered them harmless. If they had the stuff of genius in them, they remained sterile for lack of appreciation or opportunity. [. . .]

In the city many of these divergent types now find a milieu in which, for good or for ill, their dispositions and talents parturiate and bear fruit. [. . .]

. . . It is inevitable that individuals who seek the same forms of excitement, whether that excitement be furnished by a horse race or by grand opera, should find themselves from time to time in the same places. The result of this is that in the organization which city life spontaneously assumes the population tends to segregate itself, not merely in accordance with its interests, but in accordance with its tastes or its temperaments. The resulting distribution of the population is likely to be quite different from that brought about by occupational interests or economic conditions.

Every neighborhood, under the influences which tend to distribute and segregate city populations, may assume the character of a 'moral region.' Such, for example, are the vice districts, which are found in most cities. A moral region is not necessarily a place of abode. It may be a mere rendezvous, a place of resort.

In order to understand the forces which in every large city tend to develop these detached milieus in which vagrant and suppressed impulses, passions, and ideals emancipate themselves from the dominant moral order, it is necessary to refer to the fact or theory of latent impulses of men.

The fact seems to be that men are brought into the world with all the passions, instincts, and appetites, uncontrolled and undisciplined. Civilization, in the interests of the common welfare, demands the suppression sometimes, and the control always, of these wild, natural dispositions. In the process of imposing its discipline upon the individual, in making over the individual in accordance with the accepted community model, much is suppressed altogether, and much more finds a vicarious expression in forms that are socially valuable, or at least innocuous. It is at this point that sport, play, and art function. They permit the individual to purge himself by means of symbolic expression of these wild and suppressed impulses. This is the catharsis of which Aristotle wrote in his *Poetic*, and which has been given new and more positive significance by the investigations of Sigmund Freud and the psychoanalysts.

No doubt many other social phenomena such as strikes, wars, popular elections, and religious revivals perform a similar function in releasing the subconscious tensions. But within smaller communities, where social relations are more intimate and inhibitions more imperative, there are many exceptional individuals who find within the limits of the communal activity no normal and healthful expression of their individual aptitudes and temperaments.

The causes which give rise to what are here described as 'moral regions' are due in part to the restrictions which urban life imposes; in part to the license which these same conditions offer. We have, until very recently, given much consideration to the temptations of city life, but we have not given the same consideration to the effects of inhibitions and suppressions of natural impulses and instincts under the changed conditions of metropolitan life. [. . .]

. . . What lends special importance to the segregation of the poor, the vicious, the criminal, and exceptional persons generally, which is so characteristic a feature of city life, is the fact that social contagion tends to stimulate in divergent types the common temperamental differences, and to suppress characters which unite them with the normal types about them. Association with others of their own ilk provides also not merely a stimulus, but a moral support for the traits they have in common which they would not find in a less select society. In the great city the poor, the vicious, and the delinquent, crushed together in an unhealthful and contagious intimacy, breed in and in, soul and body, so that it has often occurred to me that those long genealogies of the Jukes and the tribes of Ishmael would not show such a persistent and distressing uniformity of vice, crime, and poverty unless they were peculiarly fit for the environment in which they are condemned to exist.

We must then accept these 'moral regions' and the more or less eccentric and exceptional people who inhabit them, in a sense, at least, as part of the natural, if not the normal, life of a city.

It is not necessary to understand by the expression 'moral region' a place or a society that is either necessarily criminal or abnormal. It is intended rather to apply to regions in which a divergent moral code prevails, because it is a region in which the people who inhabit it are dominated, as people are ordinarily not dominated,

by a taste or by a passion or by some interest which has its roots directly in the original nature of the individual. It may be an art, like music, or a sport, like horse-racing. Such a region would differ from other social groups by the fact that its interests are more immediate and more fundamental. For this reason its differences are likely to be due to moral, rather than intellectual, isolation.

Because of the opportunity it offers, particularly to the exceptional and abnormal types of man, a great city tends to spread out and lay bare to the public view in a massive manner all the human characters and traits which are ordinarily obscured and suppressed in smaller communities. The city, in short, shows the good and evil in human nature in excess. It is this fact, perhaps, more than any other, which justifies the view that would make of the city a laboratory or clinic in which human nature and social processes may be conveniently and profitably studied.

Paul G. Cressey

THE LIFE-CYCLE OF THE
TAXI-DANCER [1932]

TAXI-DANCE HALLS ARE RELATIVELY UNKNOWN to the general public. Yet for thousands of men throughout the United States who frequent them they are familiar establishments. Located inconspicuously in buildings near the business centers of many cities, these taxi-dance halls are readily accessible. They are a recent development and yet already are to be found in most of the larger cities of the country and are increasing steadily in number. . . . [U]nder one guise or another, they can be discovered in cities as different as New Orleans and Chicago, and as far apart as New York, Kansas City, Seattle, and Los Angeles.

In these halls young women and girls are paid to dance with all-comers, usually on a fifty–fifty commission basis. Half of the money spent by the patrons goes to the proprietors who pay for the hall, the orchestra, and the other operating expenses while the other half is paid to the young women themselves. The girl employed in these halls is expected to dance with any man who may choose her and to remain with him on the dance floor for as long a time as he is willing to pay the charges. Hence the significance of the apt name 'taxi-dancer' which has been given her. Like the taxi-driver with his cab, she is for public hire and is paid in proportion to the time spent and the services rendered. . . .

A generation ago the young girl who broke with her home and neighborhood and set out alone upon the high roads of adventure had little opportunity to do other than sink, almost immediately, into some form of prostitution. But today many legitimate avenues are open to her and, if she adopts an unconventional mode of life, many intermediate stages precede actual prostitution. The girl may organize her life in terms of an intermediate stage and never become a prostitute. The life of the taxi-dancer is one of these intermediate stages, and, like prostitution, it is an employment which can be of only short duration. The career of a taxi-dancer ends in her late twenties. It is a source of income only for the interim between later adolescence and marriage. Many young women use the taxi-dance hall in this way.

Others use it to provide for themselves during the interlude between marital ventures. Still others – married women – use it as a source of additional funds and, not infrequently, as a diversion from monotonous married lives.

All this exists because, as never before in our mobile cities, it is possible for young people to lead dual lives, with little probability of detection. Thus the young woman may 'get in' and 'out' of prostitution with a facility and rapidity which renders ineffective the traditional forms of social control. Likewise the taxi-dancer, if she so desires, has a greater opportunity than ever before afforded to such a girl to 'come back' and again fit into conventional society.

Many girls, however, do not satisfactorily readjust themselves to conventional life. A part of the explanation may be that they are the more unstable and improvident ones, who naturally would be unable to extricate themselves from any exigency in which they might find themselves. More important, it would seem, is the fact that in this little isolated world of taxi-dance halls, the young woman may very soon come to accept without great resistance the standards of life and the activities of those with whom she is inevitably associated. . . .

In the following instance, May Ferguson, a young woman of twenty-four, cut all connections with her relatives and friends in Rogers Park and, for a time, lived intensely the life revolving around the taxi-dance hall. Her reactions to the critical question of 'dating' and marrying an Oriental reflect the effectiveness of this social world in making possible a complete change in the activities and personal standards of a young woman of middle-class American society.

> It's strange how my attitudes toward the mixing of the races has changed and then changed back again in a little over a year. Two years ago I would have shuddered at the thought of dancing with a Chinaman or a Filipino and hated them just about as much as I did a 'nigger.' Then I learned that Dick had been unfaithful to me, and I wanted to get away from everything, everybody. For a while I didn't care what happened.
>
> When I first started in the dance hall on the West Side everything was exciting and thrilling. The only thing that bothered me was to have to dance with the Filipinos and the Chinamen. The first time one danced with me it almost made me sick. But after I'd been dancing there two months I even came to think it was all right to go out with Filipinos. You see, everybody else was doing it, and it seemed all right. But I never got so I would go out with a Chinaman.
>
> I didn't really think of marrying a Filipino until I met Mariano. He seemed different. I thought he was really going to school. He always treated me in a perfectly gentlemanly way, and I thought he was better than other Filipinos. For a time I let myself think seriously of marrying him, but down deep I knew I could never marry a Filipino. One thing I could never get straightened out was the question of the children. . . .
>
> Soon after, Mariano and I broke up, and I never was serious with any other Filipino. . . . Then I quit the dance hall, and went back to live my old life on the North Side.
>
> Just a few weeks ago, after I'd been away from the West Side for nearly a year, I was talking with some friends. They were telling about

a chop-suey proprietor who had married a white woman. For some reasons that made me mad, and I started in telling what I thought of anyone who would marry a 'Chink.' Then all of a sudden I stopped and bit my lip I had just realized that only the year before I was seriously considering marrying a Filipino, who was even darker than a Chinaman. And now, just a few months later, I had all the hatred toward them that I had before I went out on the West Side.

The taxi-dancer's life-cycle: fundamentally retrogressive

For those young women who do not 'get out' of the dance-hall life while still relatively new to it there appear to be rather definite and regular stages of regression which eventually lead to some form of prostitution. It may be noted also that the 'lower' the level reached by the girl, the more difficult is her re-entrance into conventional society. These stages in their life-cycle appear, on careful inspection, to be so regular and almost inevitable for those who persist in taxi-dancing that in its generalized aspects this life-cycle may be considered valuable for prediction.

The hypothesis is here suggested, with a view toward further verification, that the taxi-dancer, starting with an initial dissatisfaction in her home situation, tends to go through a series of cycles of a regressive character, i.e., the latter part of each cycle involving a continual loss of status in a given group, and the initial part of a succeeding cycle indicating a regaining of status in a new but usually lower group than the preceding ones. This cyclical theory of the taxi-dancer's life is simply a graphic way of conceiving of the difficulties of maintaining status over any span of years in a social world of the type found in the taxi-dance hall.

A very important aspect of the hypothesis has to do with the higher status granted the girl by each group during the initial period in each cycle. Finding herself losing favor in one social world, the taxi-dancer 'moves on' to the group with which, in the natural course of her life, she has recently been brought most vitally in contact. This may involve a movement from one taxi-dance hall to another, perhaps one of lower standing; and again, it may in the later stages mean a trend toward other social worlds to which the life in the taxi-dance hall is frequently but a threshold. As a 'new girl' in a new group, she is accorded a satisfactory status, and in the novelty of the situation she finds new excitement. Thus begins a new cycle in the girl's life. After a time, however, she is no longer a 'new girl' and finds herself losing caste in favor of younger and still newer girls. Her decline in any particular social world may be rapid or slow, depending upon the personality, ingenuity, and character of the individual girl, but in any case a gradual decline in status in any such dance hall seems almost inevitable. . . .

The initial position of status accorded the 'new girl' in the taxi-dance hall and the later struggle to maintain that status is indicated in the following case of Wanda, a young girl of Polish parentage, who subsequently married a Filipino youth whom she had met in the dance hall. This case also reveals the way in which the girl's scheme of life may be completely altered through a brief sojourn in the world of the taxi-dance hall.

Wanda, American-born but of Polish parents, at fifteen . . . secured work in a cigar factory, telling her employer that she was eighteen. Shortly after, she left home and no trace of her was found until four months later, when she was found married to a young Filipino. He said his wife told him that she was nineteen and that he had no reason to doubt her. Wanda met him in the taxi-dance hall in which she had been employed. They had known each other only a month before their marriage.

According to Wanda's story, she left the cigar factory because the work was monotonous. All day long she wrapped cigars until after a month she could endure it no longer. Through a friend in the factory she secured employment in the dance hall, dignified by the name of a 'dancing school for men.' . . . Wanda was rather embarrassed at first at the prospect of dancing with so many strange men, but before the end of the first evening she found herself thoroughly enjoying it and turned in more tickets than any other girl on the floor. She began to look forward to the evenings in the dance hall; she 'got a thrill' from meeting so many new people.

Her popularity continued for several evenings, much to the annoyance of the other girl employees. But one night one of her steady partners tried to 'get fresh.' Wanda left him in the middle of the floor. Her partner complained to the management, and that evening Wanda got a 'terrible bawling out.' She was made to understand that she was hired for the purpose of entertaining, not insulting the patrons. If she didn't like it, she could leave. But she didn't want to leave. She had been having too good a time, and so she agreed to be more compliant.

But her clientèle began to fall off. She learned that several of the other girls, jealous of her success, were circulating tales that she was a 'bad sport' and a prude. To rectify this Wanda resorted to the wiles of the other girls; she rouged heavily, darkened her eyes, and shortened her skirts. Again she achieved popularity, also the other girls grew more tolerant of her.

One evening she danced with Louis, a Filipino. His peculiar accent intrigued her, and she accepted an invitation to supper. Their friendship grew. He told her of his childhood on his native islands, and she confided her growing dislike for the dance hall. They agreed that they would like to 'settle down,' and so one evening Wanda 'resigned' and they drove to Indiana and were married.

[Reported by a Chicago social worker]

In the whole gamut of cycles through which the taxi-dancer tends to go, at least four may be suggested. The first cycle involves the girl's dissatisfaction with the type of life associated with the home and neighborhood. This may come about largely through a growing consciousness of economic lack in the family, through a thwarting of the desire of a type of masculine contacts which the home or the neighborhood fails to offer, through a sense of insufficient prestige in the home and the community, or through a loss of status due to the girl's supposed transgression of the established moral code. At all events, the girl, finding her way sooner or later to the taxi-dance hall, secures therein a satisfaction of certain wishes previously unfulfilled.

Here she at first finds an enhanced prestige accorded her – even though by a world which her family and her neighborhood would adjudge as lower than their own. Thus begins a second cycle for the girl. As a novice in the taxi-dance hall she is at first 'rushed,' and enjoys the thrill of being very popular. But after a time she ceases to be a novitiate and must make a deliberate effort to maintain her status. If she fails and is no longer able to secure sufficient patronage exclusively from the white group, she comes eventually to accept the romantic attentions of Filipinos and other Orientals.

Thus begins a third cycle for the girl, at the beginning of which she experiences a new prestige accorded her by the Oriental group. Here, again, a girl may continue to 'get by' with the group with which she has become associated, being consistently accorded a degree of status which to her is satisfying. But such are the hazards of maintaining standing in this social world that if she accepts the attentions of too many Orientals she is adjudged 'common' by them, and thus again loses caste.

A failure to make satisfactory adjustment in the world of Orientals may bring the girl to a fourth cycle, which is begun when she centers her interests upon the social world which in Chicago has been associated with the 'black and tan' cabarets. She usually comes into contact with these groups through her associations with Orientals. With the Negroes she again achieves temporarily the prestige accorded the novitiate. But here, too, she is doomed to a decline in status, and this seems very frequently to lead to prostitution in the Black Belt.

As has been said, the evidence to support this theory of retrogressive cycles is not conclusive, and the suggestion is offered merely as a hypothesis for further study. Yet the data which are at hand seem to be suggestive. . . .

The following case is one in which the girl ran through the whole gamut of experiences until she reached a low level of prostitution. . . .

> Tina was a Polish girl whose parents lived on the Northwest Side. When she was about sixteen she married a young man from the same neighborhood. She later left him, claiming non-support and entered a taxi-dance hall, where she was for a time quite popular. At first she would not dance with Filipinos if she could avoid it. Sometime later, however, when she had come to regard them as a lucrative source for income she became very interested in several. They frequently escorted her to 'black and tan' cabarets and in this way she made contacts with young Negroes.
>
> The Filipinos, very conscious of their anomalous racial position in this country, would tolerate no such conduct on the part of any girls with whom they associated. They immediately deserted her, leaving her in the cabaret. In this way began her activities in the South Side Black Belt, where she subsequently became known as an independent prostitute, carrying on her business chiefly with Negroes and Chinese. Occasionally she seeks to return to the taxi-dance halls and to other Filipino activities, but there are always those who remember her and warn the others that she has already 'gone African.'
>
> [Compiled from information supplied by two persons
> well acquainted with the young woman]

The theory of the retrogressive life-cycles, while only a hypothesis, can perhaps be seen best through a reference to the typical experiences of taxi-dancers before and after entering these resorts. These experiences seem so frequently to have common elements in them and to follow such a regular sequence of typical experiences that they can be conceived as a 'behavior sequence.' In any event it is clear that a better perspective can be gained by classifying these experiences and arranging them chronologically. Some of the characteristic experiences, fortunate and unfortunate, which befall the taxi-dancer can be seen in the following.

Distracting and disorganizing experiences before entering the taxi-dance hall

It is clear that the typical taxi-dancer, even though young in years, is not inexperienced. Most taxi-dancers have had varied experiences, both occupationally and sexually. They have engaged in a variety of occupations, usually of the unskilled type, such as waitress, factory operative, or salesgirl. Their experiences often include at least one marriage, usually unsuccessful and characterized by considerable infidelity on both sides, resulting in separation or divorce. In most cases there seems to be, in addition, a background of intense family conflict.

When the girl enters the taxi-dance hall she usually has already broken with many of the stable community groups, such as her family and church. Usually, she also has failed to find conventional ways of satisfying certain dominant interests, such as her need for friendship and affection, for status, and for excitement. Nor does she have a well-defined standard of conduct or a goal in life towards which she may work. The taxi-dancer enters her vocation already somewhat disorganized, often feeling herself in conflict with conventional society.

The initial period of uncertainty and distrust

The initial experiences of the taxi-dancer are so similar that it is possible to perceive a fundamental sequence in the girl's affiliation with the establishment and its personnel. With few exceptions, the primary factor attracting the girl to the establishment is the possibility of making money in an easier way than she otherwise could. A young taxi-dancer without training of any kind frequently earns as much as thirty-five or forty dollars a week. But the economic interest is paralleled by an interest in the 'thrill' and excitement of the dance hall. Yet the strangeness and uncertainty of the situation, compelled with an antagonism or disgust for the conduct of certain taxi-dancers, may cause many new taxi-dancers to remain aloof. . . .

[About half] of the young girls who attempt a career in the taxi-dance hall drop out during the first few weeks. Either they are not able to attract sufficient patronage or they are antagonized by the practices seen about the establishment. Likewise, to many taxi-dancers their work in the dance hall is purely a segmental activity, engaged in primarily to supplement an insufficient income earned as clerical office-workers, clerks in department stores, or at light industry and in laundries.

Thrills of early success: the romantic period

The successful novices among the taxi-dancers, however, very soon overcome any hesitancy they may have and throw themselves whole-heartedly into the life revolving about the establishment. Courted intensively and sought after in a manner seldom experienced in more conventional life, the 'new girl' comes to enjoy immensely these new thrills and satisfactions. A host of new men, many of them attractive, some of them strange and fascinating, present themselves and bid for her favor. She is escorted to expensive night clubs where she is served in a manner which, according to her conception, befits only the socially elect.

Out of it she very quickly gains an enhanced conception of herself. The Polish girl from 'back of the yards' is metamorphosed into a 'dancing instructress,' and frequently acquires a new name comparable to her new station in life. The following list, while disguised, nevertheless distinguishes in a true manner the characteristic original and 'professional' names, respectively, of certain Chicago taxi-dancers. These new names reveal the girl's conception of herself and suggest the ideals and aspirations by which her life is ordered.

Real Name	'Professional' Name
Christina Stranski	DeLoris Glenn
Louise Lorenz	Bobby LeMann
Sophie Zelinski	Gwendolyn Llewellen
Alma Heisler	Helene de Valle
Pearl Babcock	Melba DeMay
Eleanor Hedman	Gloria Garden
Anna Prasenski	Althea LeMar
Mary Bulonowski	LaBelle Shelley
Alice Borden	Wanda Wang
Mary Maranowski	Jean Jouette

With this new conception of herself the girl enters a series of romantic experiences, in which every consideration is sacrificed for the free play of the romantic impulse.

> I don't know what there is about the dance hall, but I never had so many serious 'cases' in such a short time as I had those few months I was on the West Side. I was always getting a flame over this fellow or that one. If it wasn't a Filipino it was a good-looking young Italian or even a Greek. I never have been able to understand what got into me. There was always someone I was crazy about. . . .

'Getting the dances' – the veteran taxi-dancer's problem

As the taxi-dancer becomes an accepted member of the dance-hall personnel and, unconsciously, has come to acquire in it a certain rôle, the problem of 'getting the dances' becomes a more pressing one. While she may remain a popular girl with a certain group of patrons, many others have abandoned her for other new and more

interesting taxi-dancers. As her pay check dwindles, she begins deliberately to use certain techniques to attract dance partners. At the same time the girl has become more aware of her standing with her co-workers. They, in turn, demand certain standards of performance from her. In response to their ridicule, jeers, and laughter, she complies with their expectations, changes her mode of dressing, of acting, and of thinking, and gradually becomes accepted into the little group of women who set the mode in the world of the taxi-dance hall. Through these contacts the novitiate gradually learns the techniques for being a successful taxi-dancer.

Learning the taxi-dancer's techniques

These techniques are often very simple in character. One of the first considerations is the question of the type of dressing and 'make-up' most advantageous in the dance hall.

> 'Say,' Lila said to me, 'why don't you blondine your hair? You know, all the Filipinos go for blondes. . . .
>
> 'You come over to my house tomorrow and I'll fix you up before we go to the dance. . . . [W]e'll put a hem in your dress and make it tighter. You aren't such a bad looker. Your shape ain't bad, but you don't know how to show it.'
>
> [*Chicago Daily Times* 1 February 1930]

. . . There is also the ruse by which the girl, who believes that a patron does not recognize her, represents herself to him as a novice with the hope that she will thereby secure more dances with him. The pretended promise of a late night engagement is also used to induce patrons to continue dancing. In this way the patron is kept in a mood for spending money until the dénouement, at the close of the evening's dancing, when the girl informs him that she has made 'other arrangements.'

A somewhat more complex technique involves the playing of the racial prejudices against each other. Especially with such incompatible groups as Filipinos and race-conscious white Americans, the shrewder taxi-dancer may devise a play by which she utilizes the racial attitudes of both groups for her own financial advantage.

> I noticed a rather attractive young woman . . . standing on the side lines beside a Filipino. As she saw me looking at her, her eyes glanced down obliquely toward him in a manner which seemed to indicate that she at least despised the rather dark-skinned youth with whom she had just been conversing. This seemed a new and interesting affection. As she moved away from the Filipino I approached her and began conversation.
>
> 'Apparently you don't like your sun-browned friend,' I commented. 'Well, no!' she replied, hesitatingly. 'You see he's a Filipino.' 'But you should worry about that,' I countered. 'The Flips [Filipinos] treat a girl better and will spend more money on her than the other fellows.' She hesitated a moment and then said in mock concern, 'But they're not white!'

Late in the evening, after she had seen me in friendly conversation with several Filipinos, this same girl approached and offered the following explanation of her conduct:

'I don't know whether you know, but I'm engaged to marry the Filipino you saw me talking to. I just acted the way I did about him to get you to dance with me. When I saw you looking at us, I decided I'd have to pretend I didn't like him, so that you would give me some tickets. . . . Most of the white fellows won't dance with me if they learn I go out all the time with Flips. So I say something against them when I'm with white fellows just so they'll give me more dances. . . .

'Even if I do go out with Filipinos, it doesn't pay to dance all the time with them. If I dance all the time with Filipinos I've got to dance with many different ones. If a girl dances with too many Flips they think she's common, so they won't keep on coming to her for dances. . . . I've got to dance with some good-looking white fellows once in a while so the Filipinos will keep on dancing with me.'

[Report of an investigation]

Discovering a profitable dance-hall personality: types among the taxi-dancers

Out of the commercial rivalry among the taxi-dancers, certain rather definitely understood 'roles' develop, by which different girls have discovered they can commercialize most efficiently their personal charm. Each of these roles has its own activities, its own patterns of behavior, its own individual techniques, its own standards, and its own scheme of life.

The highest type among these dance-hall roles is that of the so-called 'nice girl.' The 'nice girl' is the one who possesses sufficient charm, physical attractiveness, and vivacity to secure dances without transgressing the conventional standards of propriety. She may never accept dates from patrons, or may not even frequent a hall where she is expected to dance with Filipinos and other Orientals. She plays the part of the entirely virtuous girl.

> Gwendolyn Costello, as she styles herself, is the 'belle' of one of the taxi-dance halls in the Loop, where she has danced for over three years. She is a vivacious girl with a coquettish – almost roguish – manner. She is a graceful dancer, and can follow successfully any kind of dancing. In addition, she has what is called a 'good line.' Although she looks as though she were eighteen she is probably every bit of twenty-four. She is very popular with the patrons, especially with the men between twenty-five and forty. On busy nights at the establishment she is never inactive except on her own volition. Most of the men – new and old patrons – appear to like her, but she is known never to accept dates from anyone met in the hall. For most of the men who dance with her she remains as much of a mystery at the end of a year's contract as she was the first evening.
> [Records of an investigator]

While the motive toward exploitation may be found in the case of the 'nice girl,' it is more prominent in the case of the 'smart girl.' The girl of this type accepts exploitation as the order of the day and frankly sets out to utilize her attractiveness for all the material gain which can be realized therefrom. 'Fishing' and the 'sex game' become for these girls the accepted ways of earning a living; and prestige is accorded to the one who is cleverest in gaining the most. . . .

Among the more immoral young women can be distinguished a third type, the 'never-miss girl.' She is the type who is known by the more initiated patrons to be quite affectionate. Sometimes to other taxi-dancers she may represent herself as successfully 'fishing' her men friends. But to her masculine acquaintances she presents an entirely different picture. The girl of this type may occasionally have a little retinue of men who have special 'roles' or functions in her life. Towards each she has a certain romantic interest, though even with her it is sometimes coupled with a unique sense of objectivity and detachment. . . .

Always fearful lest she become notorious and thus no longer able to secure dance patronage, yet desirous of having what she chooses to consider a 'good time,' the taxi-dancer of this type is torn between the double dilemma of respectability with decreasing income and the greater hazard of becoming notorious and thus unemployable at legitimate dancing in the taxi-dance halls.

For the young woman whose character is held in question, or who for some reason cannot measure up to the requirements for the other types, there is yet one opportunity to continue in some taxi-dance halls, if she will but join the fourth class of taxi-dancers – those who engage in sensual dancing. The older, more sophisticated women, the more homely girls, and others not especially superior in beauty, ability in dancing, and who, for one reason or another, do not wish to date patrons, constitute this fourth class.

For the girl who adopts this way of 'getting along,' financial hazards are considerably reduced. In the other roles the girl is insecure, always exposed to the vicissitudes of dance-hall popularity, always uncertain of her income. But after once adapting herself to sensual dancing her income becomes more regular and more secure. . . . It is also unnecessary for her to engage in coquetry and cajolery to secure patronage. . . .

The contact of the patrons with the taxi-dancer who practices sensual dancing is almost invariably impersonal and utilitarian. Romance, even of the type found among other taxi-dancers, seldom develops between patron and girl meeting on the basis of sensuality. A cold, impersonal bargaining interest identical with prostitution characterizes these contacts. In the dance hall this type of taxi-dancer functions as a utility for her patrons.

While these roles are rather distinct at any given time, competition among the dancers, as well as the arrival of new girls, makes for continual readjustment among them. The taxi-dancer who formerly was the belle of the dance hall is forced either to work harder for her laurels or to engage in less desirable practices, i.e., accept a new and lower role for herself.

'Moving on': seeing the United States via taxi-dancing

When life and activities in the taxi-dance halls of a certain city begin to pall, the taxi-dancer may travel to another city where she can secure similar employment. She will find in almost every large city taxi-dance halls, all essentially alike. Once adjusted to the life, she can easily make her way in any taxi-dance hall. Another stimulus toward movement from city to city is her constant association with people who are in the habit of moving about frequently. She catches the spirit and also wants to 'see the country.' Among veteran taxi-dancers it is not uncommon to find girls who have been to both the Pacific and the Atlantic coasts, making their way about the country through their earnings in the taxi-dance halls. Such a story as the following is not at all uncommon.

> I've been all over the country because of these halls. My home's Chicago, but I've been in New York, New Orleans, Kansas City, Seattle, and Los Angeles. . . .
> Everywhere I went, though, I'd meet somebody I'd known some-where else. In New York I saw some Flips [Filipinos] I used to know here in Chicago. When I was in Los Angeles I met a girl that used to be out on the West Side. The other night I met a Flip here I used to know out in Seattle. It's a small world, after all.

At present there is a tendency for taxi-dancers of the Middle West to migrate east-ward toward New York. . . .

The future of this new type of feminine migration is uncertain. These young taxi-dancers, with their good incomes and the relative ease with which they can quickly secure employment in taxi-dance halls in other cities, have become a mobile group of a new variety. They have gained a freedom of movement and a ready source for a legitimate income beyond the conception of any previous generation of girls.

Milton M. Gordon

THE CONCEPT OF THE SUB-CULTURE AND ITS APPLICATION [1947]

O NE OF THE FUNCTIONS of any science, 'natural' or 'social,' is admittedly to discover and isolate increasingly smaller units of its subject matter. This process leads to more extensive control of variables in experiment and analysis. There are times, however, when the scientist must put some of these blocks back together again in an integrated pattern. This is especially true where the patterning reveals itself as a logical necessity, with intrinsic connections which create something more, so to speak, than the mere sum of the parts. Specifically, in the social sciences, this patterning is necessary where the impact of the nexus on the human being is that of a unit, and not a series of disconnected social situations. This [chapter] represents an attempt to delineate such a nexus by a logical extension of the concept of culture.

American sociologists, on the whole, have seemed reluctant to extend the concept of culture beyond the point where it has already been developed and more or less handed to us by the anthropologists. We hear an occasional reference to 'urban culture,' or 'rural culture,' or 'the culture of the middle class,' but these references have seemed to represent sporadic resting-places of semantic convenience rather than any systematic application of the term to well-defined social situations. Broadly speaking, we have been content to stop the concept of culture at national boundaries, and engage in our intra-national analyses in terms of the discrete units of ethnic background, social class, regional residence, religious affiliation, and so on. It is the thesis of this [chapter] that a great deal could be gained by a more extensive use of the concept of the *sub-culture* — a concept used here to refer to a sub-division of a national culture, composed of a combination of factorable social situations such as class status, ethnic background, regional and rural or urban residence, and religious affiliation, but *forming in their combination a functioning unity which has an integrated impact on the participating individual*. No claim is made here for origination of the term. Although its use has apparently not been extensive enough to merit it a place in the *Dictionary of Sociology*[1] . . . a recent and percep-

tive use of the term has been made in a paper by Green, where he speaks incidentally of 'highly organized subcultures,' and, in connection with the question of neuroses, phrases a query in the following manner: 'Since in modern society no individual participates in the total cultural complex totally but primarily in a series of population segments grouped according to sex, age, class, occupation, region, religion, and ethnic group – all with somewhat differing norms and expectations of conduct – how do these combine in different ways to form varying backgrounds for individual etiologies of neurotic trends?' [Green 1946: 354]

Green, by implication, uses the term 'sub-culture' and 'population segment' interchangeably. Nomenclature is relatively unimportant so long as it is consistent, but we prefer the former term since it seems to emphasize more directly the dynamic character of the framework within which the child is socialized. It is a world within a world, so to speak, but it *is* a world. The emphasis in this [chapter], then, is simply on the unifying and transmuting implications of the term 'sub-culture' for such combinations of factors as ethnic group, social class, region, occupation, religion, and urban or rural residence, and on the need for its wider application.

A primary and major implication of this position is that the child growing up in a particular sub-culture feels its impact as a unit. For instance, the son of lower-class Italian immigrants, growing up in New York's upper East Side, is not a person who is simultaneously affected by separable items consisting of ethnic background, low-economic status, and a highly urbanized residential situation. He is a person whose environmental background is an interwoven and variegated combination of all these factors. Each of the elements has been somewhat transformed by virtue of its combination with the others. This fact must be taken into consideration in research procedures dealing with environmental backgrounds and their effects. A corollary of this position is that identically named factors in different sub-cultures are not interchangeable. Thus being a middle-class Jew is not the same thing as being a middle-class Gentile except for the additional factor of being Jewish.

A wider use of the concept of the *sub-culture* would, in the opinion of this writer, give us a keen and incisive tool which would, on the one hand, prevent us from making too broad groupings where such inclusiveness is not warranted (we would, for instance, refer not so much to 'the Negro,' as to 'Southern, rural, lower-class Negroes,' or 'North, urban, middle-class Negroes,' etc.), and, on the other hand, enable us to discern relatively closed and cohesive systems of social organization which currently we tend to analyze separately with our more conventional tools of 'class' and 'ethnic group.' The writer, for instance, has been interested to observe in the city of Philadelphia a not entirely cohesive, but unmistakably present, sub-culture composed of members of the Society of Friends (Quakers), and ranging in class position from upper-middle to upper-upper. More conventional objects of sociological attention, second and third generation Jews, would seem, for the most part, to be neither 'marginal men' in the Park and Stonequist phrase, nor competitors in the social class system with white Gentiles, but rather members of highly integrated 'marginal sub-cultures' (called marginal here because, like the 'marginal man,' these sub-cultures composed of the descendants of immigrant Jews lie somewhere between the immigrant culture and the native Gentile culture and contain cultural contributions from both) whose variable elements are size of community, of residence and social class.

A distinction must, of course, be made between separate sub-cultures and separate units of the same sub-culture. Thus lower-class white Protestants in one medium-sized New England city would presumably belong to the same sub-culture as lower-class white Protestants in another medium-sized New England community hundreds of miles away, though each group would constitute a separate unit. Whether lower-class white Protestants in a medium-sized community in the Middle-West would form a different sub-culture is a more difficult point. The question of whether variation of one factor is sufficient to set up a separate sub-culture would have to be answered empirically by a field study of the community situations in question.

A comprehensive application of the sub-cultural concept to the American scene would, in time, lead to the delineation of a fairly large number of sub-cultures of varying degrees of cohesiveness and with varying patterns of interaction with each other. Among the many further research problems which such an analysis would pose, six of particular interest to the writer are mentioned here:

1 How do the various sub-cultures rank on a scale of differential access to the rewards of the broader American culture, including both material rewards and status?

2 How is the experience of growing up in a particular sub-culture reflected in the personality structure of the individual? Is there a portion of the personality which is roughly equivalent to a similar portion of the personality of every other individual who has matured in the same sub-culture, and which might, then, be referred to as the 'sub-cultural personality'? . . .

3 In what way are identical elements of the national culture refracted differentially in the sub-culture? We have been prone, perhaps, to assume uniformities which do not entirely exist. Football, to male adolescents of one sub-culture may mean the chance to hawk programs and peanuts and make some money, to those of another, enthusiastic attendance at the High School game on Saturday afternoon, and to those of still a third, inviting girls up to the campus for a houseparty week-end.

4 What are the most indicative indices of participation in a particular sub-culture? If any one had to be singled out, the writer would offer speech patterns (particularly pronunciation and inflection) as at once the easiest to 'observe' and the most revealing. Clothes would probably rank next in indicativeness and ease of discernability – contrary to casual opinion, for men as well as women.

5 What explains the 'deviant,' that is, the person who does not develop the sub-cultural or social personality characteristic of the particular sub-culture in which he was born and nurtured? An interesting question here is whether there are particular combinations of biological characteristics which would adjust more or less easily to the sub-cultural personalities specifically demanded. What about the above-average in intelligence and sensitive boy, for instance, born into a sub-culture of low-status and rather rough behavior patterns? or, conversely, the son of professional parents who cannot make the grade at college but would much rather be out tinkering with the motor of his automobile?

6 In upward social mobility, does a change of 'sub-cultural personality' invari-
 ably accompany acquisition of some of the more objective indices of higher
 status, such as wealth or more highly valued occupation? If not, what stresses
 and strains result? This last question . . . is a most interesting one, and, in the
 growing literature on social mobility, [it] has barely been touched.

Note

1 [Fairchild 1944]; the nearest concept in the *Dictionary* is that of the 'culture-sub-
 area,' which is defined as 'a sub-division of a larger culture area, distinguished by
 the comparative completeness of the development of a particular culture trait, or
 the comparative readiness with which such a trait will be diffused' (83). The
 emphasis here is obviously on *area* – physical contiguity, which factor may, or
 may not, or may only partially be present in the *sub-culture*. Thus groups of lower-
 class white Protestants may live in different sections of the same city. Or
 middle-class Jews may be scattered over a medium-sized city and still form a
 social entity. . . .

Albert K. Cohen

A GENERAL THEORY OF SUBCULTURES [1955]

Action is problem-solving

THIS IS A CHAPTER ON SUBCULTURES IN GENERAL, how they get started and what keeps them going. . . . Our point of departure is the 'psychogenic' assumption that all human action – not delinquency alone – is an ongoing series of efforts to solve problems. By 'problems' we do not only mean the worries and dilemmas that bring people to the psychiatrist and the psychological clinic. Whether or not to accept a proffered drink, which of two ties to buy, what to do about the unexpected guest or the 'F' in algebra are problems too. They all involve, until they are resolved, a certain tension, a disequilibrium and a challenge. We hover between doing and not doing, doing this or doing that, doing it one way or doing it another. Each choice is an act, each act is a choice. Not every act is a *successful* solution, for our choice may leave us with unresolved tensions or generate new and unanticipated consequences which pose new problems, but it is at least an attempt at a solution. On the other hand, not every problem need imply distress, anxiety, bedevilment. Most problems are familiar and recurrent and we have at hand for them ready solutions, habitual modes of action which we have found efficacious and acceptable both to ourselves and to our neighbors. Other problems, however, are not so readily resolved. They persist, they nag, and they press for novel solutions.

What people do depends upon the problems they contend with. If we want to explain what people do, then we want to be clear about the nature of human problems and what produces them. As a first step, it is important to recognize that all multifarious factors and circumstances that conspire to produce a problem come from one or the other of two sources, the actor's 'frame of reference' and the 'situation' he confronts. All problems arise and all problems are solved through changes in one or both of these classes of determinants.

First, the situation. This is the world we live in and where we are located in that world. It includes the physical setting within which we must operate, a finite supply of time and energy with which to accomplish our ends, and above all the habits, the expectations, the demands and the social organization of the people around us. Always our problems are what they are because the situation limits the things we can do and have and the conditions under which they are possible. It will not permit us to satisfy equally potent aspirations, e.g., to enjoy the blessings of marriage and bachelorhood at the same time. The resources it offers may not be enough to 'go around,' e.g., to send the children to college, to pay off the mortgage and to satisfy a thousand other longings. To some of us it may categorically deny the possibility of success, as we define success. To others, it may extend the possibility of success, but the only means which it provides may be morally repugnant; e.g., cheating, chicanery and bootlicking may be the only road open to the coveted promotion.

But the niggardliness, the crabbiness, the inflexibility of the situation and the problems they imply are always relative to the actor. What the actor sees and how he feels about what he sees depend as much on his 'point of view' as on the situation which he encounters. Americans do not see grasshoppers as belonging to the same category as pork chops, orange juice and cereal; other peoples do. Different Americans, confronting a 'communist' . . . have very different ideas of what kind of person they are dealing with. The political office which one man sees as a job, another sees as an opportunity for public service and still another as something onerous and profitless to be avoided at all costs. Our beliefs about what is, what is possible and what consequences flow from what actions do not necessarily correspond to what is 'objectively' true. 'The facts' never simply stare us in the face. We see them always through a glass, and the glass consists of the interests, preconceptions, stereotypes and values we bring to the situation. This glass is our frame of reference. . . .

Our really hard problems are those for which we have no ready-at-hand solutions which will not leave us without feelings of tension, frustration, resentment, guilt, bitterness, anxiety or hopelessness. These feelings and therefore the inadequacy of the solutions are largely the result of the frame of reference through which we contemplate these solutions. It follows that an effective, really satisfying solution *must entail some change in that frame of reference itself.* The actor may give up pursuit of some goal which seems unattainable, but it is not a 'solution' unless he can first persuade himself that the goal is, after all, not worth pursuing; in short, his values must change. He may resolve a problem of conflicting loyalties by persuading himself that the greater obligation attaches to one rather than to the other, but this too involves a change in his frame of reference: a commitment to some standard for adjudicating the claims of different loyalties. 'Failure' can be transformed into something less humiliating by imputing to others fraud, malevolence or corruption, but this means adopting new perspectives for looking at others and oneself. He may continue to strive for goals hitherto unattainable by adopting more efficacious but 'illicit' means; but, again, the solution is satisfying only to the degree that guilt is obviated by a change in moral standards. All these and other devices are familiar to us as the psychologist's and the psychoanalyst's 'mechanisms of adjustment' – projection, rationalization, substitution, etc. – and they are all ways of coping with problems by a change within the actor's frame of reference.

A second factor we must recognize in building up a theory of subcultures is that human problems are not distributed in a random way among the roles that make up a social system. Each age, sex, racial and ethnic category, each occupation, economic stratum and social class consists of people who have been equipped by their society with frames of reference and confronted by their society with situations which are not equally characteristic of other roles. If the ingredients of which problems are compounded are likened to a deck of cards, your chances and mine of getting a certain hand are not the same but are strongly affected by where we happen to sit. The problems and preoccupations of men and women are different because they judge themselves and others judge them by different standards and because the means available to them for realizing their aspirations are different. It is obvious that opportunities for the achievement of power and prestige are not the same for people who start out at different positions in the class system; it is perhaps a bit less obvious that their levels of aspiration in these respects and therefore what it will take to satisfy them are likely also to differ. All of us must come to terms with the problems of growing old, but these problems are not the same for all of us. To consider but one facet, the decline of physical vigor may have very different meaning for a steel worker and a physician. There is a large and increasing scholarly literature, psychiatric and sociological, on the ways in which the structure of society generates, at each position within the system, characteristic combinations of personality and situation and therefore characteristic problems of adjustment.

Neither sociologists nor psychiatrists, however, have been sufficiently diligent in exploring the role of the social structure and the immediate social milieu in determining *the creation and selection of solutions*. A way of acting is never completely explained by describing, however convincingly, the problems of adjustment to which it is a response, *as long as there are conceivable alternative responses*. Different individuals *do* deal differently with the same or similar problems and these differences must likewise be accounted for. One man responds to a barrier on the route to his goal by redoubling his efforts. Another seeks for a more devious route to the same objective. Another succeeds in convincing himself that the game is not worth the candle. Still another accepts, but with ill grace and an abiding feeling of bitterness and frustration, the inevitability of failure. Here we shall explore some of the ways in which the fact that we are participants in a system of social interaction affects the ways in which we deal with our problems.

Pressures towards conformity

In a general way it is obvious that any solution that runs counter to the strong interests or moral sentiments of those around us invites punishment or the forfeiture of satisfactions which may be more distressing than the problem with which it was designed to cope. We seek, if possible, solutions which will settle old problems and not create new ones. A first requirement, then, of a wholly acceptable solution is that it be acceptable to those on whose cooperation and good will we are dependent. This immediately imposes sharp limits on the range of creativity and innovation. Our dependence upon our social milieu provides us with a strong

incentive to select our solutions from among those already established and known to be congenial to our fellows.

More specifically, the consistency of our own conduct and of the frame of reference on which it is based with those of our fellows is a criterion of status and a badge of membership. Every one of us wants to be a member in good standing of some groups and roles. We all want to be recognized and respected as a full-fledged member of some age and sex category, as an American, perhaps also as a Catholic, a Democrat, a Southerner, a Yale man, a doctor, a man-of-the world, a good citizen of West Burlap. For every such role there are certain kinds of action and belief which function, as truly and effectively as do uniforms, insignia and membership cards, as signs of membership. To the degree that we covet such membership, we are motivated to assume those signs, to incorporate them into our behavior and frame of reference. Many of our religious beliefs, aesthetic standards, norms of speech, political doctrines, and canons of taste and etiquette are so motivated.

Not only recognition as members of some social category but also the respect in which others hold us are contingent upon the agreement of the beliefs we profess and the norms we observe with their norms and beliefs. However much we may speak of tolerance of diversity and respect for differences, we cannot help but evaluate others in terms of the measure of their agreement with ourselves. With people who think and feel as we do we are relaxed. We do not have to defend ourselves to them. We welcome them to our company and like to have them around. But in dissent there is necessarily implied criticism, and he who dissents, in matters the group considers important, inevitably alienates himself to some extent from the group and from satisfying social relationships.

Not only is consensus rewarded by acceptance, recognition and respect; it is probably the most important criterion of the *validity* of the frame of reference which motivates and justifies our conduct. The man who stands alone in holding something dear or in despising some good that others cherish, whether it be a style of art, a political belief, a vocational aspiration, or a way of making money not only suffers a loss of status; he is not likely to hold to his beliefs with much conviction. His beliefs will be uncertain, vacillating, unstable. If others do not question us, on the other hand, we are not likely to question ourselves. For any given individual, of course, some groups are more effective than others as authorities for defining the validity or plausibility of his beliefs. These are his 'reference groups.' For all of us, however, faith and reason alike are curiously prone to lead to conclusions already current in our reference groups. It is hard to convince ourselves that in cheating, joining the Christian Science Church, voting Republican or falsifying our age to buy beer we are doing the right thing if our reference groups are agreed that these things are wrong, stupid or ridiculous.

We see then why, both on the levels of overt action and of the supporting frame of reference, there are powerful incentives not to deviate from the ways established in our groups. Should our problems be not capable of solution in ways acceptable to our groups and should they be sufficiently pressing, we are not so likely to strike out on our own as we are to shop around for a group with a different subculture, with a frame of reference we find more congenial. One fascinating aspect of the social process is the continual realignment of groups, the migration of individuals

from one group to another in the unconscious quest for a social milieu favorable to the resolution of their problems of adjustment.

How subcultural solutions arise

Now we confront a dilemma and a paradox. We have seen how difficult it is for the individual to cut loose from the culture models in his milieu, how his dependence upon his fellows compels him to seek conformity and to avoid innovation. But these models and precedents which we call the surrounding culture are ways in which other people think and other people act, and these other people are likewise constrained by models in *their* milieux. *These models themselves, however, continually change.* How is it possible for cultural innovations to emerge while each of the participants in the culture is so powerfully motivated to conform to what is already established? . . .

The crucial condition for the emergence of new cultural forms is the existence, *in effective interaction with one another, of a number of actors with similar problems of adjustment.* These may be the entire membership of a group or only certain members, similarly circumstanced, within the group. Among the conceivable solutions to their problems may be one which is not yet embodied in action and which does not therefore exist as a cultural model. This solution, except for the fact that it does not already carry the social criteria of validity and promise the social rewards of consensus, might well answer more neatly to the problems of this group and appeal to its members more effectively than any of the solutions already institutionalized. For each participant, this solution would be adjustive and adequately motivated provided that he could anticipate a simultaneous and corresponding transformation in the frames of reference of his fellows. Each would welcome a sign from the others that a new departure in this direction would receive approval and support. But how does one *know* whether a gesture toward innovation will strike a responsive and sympathetic chord in others or whether it will elicit hostility, ridicule and punishment? *Potential* concurrence is always problematical and innovation or the impulse to innovate a stimulus for anxiety.

The paradox is resolved when the innovation is broached in such a manner as to elicit from others reactions suggesting their receptivity; and when, at the same time, the innovation occurs by increments so small, tentative and ambiguous as to permit the actor to retreat, if the signs be unfavorable, without having become identified with an unpopular position. Perhaps all social actions have, in addition to their instrumental, communicative and expressive functions, this quality of being *exploratory gestures*. For the actor with problems of adjustment which cannot be resolved within the frame of reference of the established culture, each response of the other to what the actor says and does is a clue to the directions in which change may proceed further in a way congenial to the other and to the direction in which change will lack social support. And if the probing gesture is motivated by tensions common to other participants it is likely to initiate a process of *mutual* exploration and *joint* elaboration of a new solution. My exploratory gesture functions as a cue to you; your exploratory gesture as a cue to me. By a casual, semi-serious, non-committal or tangential remark I may stick my neck out just a little way, but I will quickly withdraw it unless you, by some sign of affirmation, stick *yours* out. I

will permit myself to become progressively committed but only as others, by some visible sign, become likewise committed. The final product, to which we are jointly committed, is likely to be a compromise formation of all the participants to what we may call a cultural process, a formation perhaps unanticipated by any of them. Each actor may contribute something directly to the growing product, but he may also contribute indirectly by encouraging others to advance, inducing them to retreat, and suggesting new avenues to be explored. The product cannot be ascribed to any one of the participants; it is a real 'emergent' on a group level.

We may think of this process as one of mutual conversion. The important thing to remember is that we do not first convert ourselves and then others. The acceptability of an idea to oneself depends upon its acceptability to others. Converting the other is part of the process of converting oneself.

A simple but dramatic illustration may help. We all know that soldiers sometimes develop physical complaints with no underlying organic pathology. We know that these complaints, which the soldier himself is convinced are real, are solutions to problems. They enable the soldier to escape from a hazardous situation without feeling guilty or to displace his anxiety, whose true cause he is reluctant to acknowledge even to himself [see Strecker 1940]. . . . This route [of] escape [is] available only because hundreds of other soldiers [are] 'in the same boat' and in continual communicative interaction before, during and after the shelling. One soldier might be ripe for this delusion but if his buddies are not similarly ripe he will have a hard time persuading them he has been gassed, and if they persist in not being gassed he will have a hard time persuading himself. If all are ripe, they may, in a relatively short time, collectively fabricate a false but unshakeable belief that all have been gassed. It is most unlikely that these 500 soldiers would have been able to 'describe all the details with convincing earnestness and generally some dramatic quality of expression' if they had not been able to communicate with one another and develop a common vocabulary for interpreting whatever subjective states they did experience.

The literature on crowd behavior is another source of evidence of the ability of a propitious interaction situation to generate, in a short time, collective although necessarily ephemeral and unstable solutions to like problems. Students are agreed that the groundwork for violent and destructive mob behavior includes the prior existence of unresolved tensions and a period of 'milling' during which a set of common sentiments is elaborated and reinforced. It is incorrect to assume, however, that a certain magic in numbers simply serves to lift the moral inhibitions to the expression of already established destructive urges. Kimball Young observes:

> Almost all commentators have noted that individuals engaged in mass action, be it attack or panic flight, show an amazing lack of what are, under calmer conditions, considered proper morals. There is a release of moral inhibitions, social taboos are off, and the crowd enjoys a sense of freedom and unrestraint.

He goes on to add, however:

> Certainly those engaged in a pogrom, a lynching or a race riot have a great upsurge of moral feelings, the sense of righting some wrong . . .

> Though the acts performed may be viewed in retrospect as immoral, and may later induce a sense of shame, remorse and guilt, at the time they seem completely justified.
>
> [Young 1946: 398–399]

It is true that ordinary moral restraints often cease to operate under mob conditions. These conditions do not, however, produce a suspension of all morality, a blind and amoral outburst of primitive passions. The action of each member of the mob is in accordance with a collective solution which has been worked out during the brief history of the mob itself. This solution includes not only something to do but a positive morality to justify conduct at such gross variance with the mob members' ordinary conceptions of decency and humanity. In short, what occurs under conditions of mob interaction is not the annihilation of morality but a rapid transformation of the moral frame of reference.

Here we have talked about bizarre and short-lived examples of group problem-solving. But the line between this sort of thing and large-scale social movements, with their elaborate and often respectable ideologies and programs, is tenuous. No fundamentally new principles have to be invoked to explain them. . . .

The emergence of these 'group standards' of this shared frame of reference, is the emergence of a new subculture. It is cultural because each actor's participation in this system or norms is influenced by his perception of the same norms in other actors. It is *sub*cultural because the norms are shared only among those actors who stand somehow to profit from them and who find in one another a sympathetic moral climate within which these norms may come to fruition and persist. In this fashion culture is continually being created, re-created and modified wherever individuals sense in one another like needs, generated by like circumstances, not shared generally in the larger social system. Once established, such a subcultural system may persist, but not by sheer inertia. It may achieve a life which outlasts that of the individuals who participated in its creation, but only so long as it continues to serve the needs of those who succeed its creators.

Subcultural solutions to status problems

One variant of this cultural process interests us especially because it provides the model for our explanation of the delinquent subculture. Status problems are problems of achieving respect in the eyes of one's fellows. Our ability to achieve status depends upon the criteria of status applied by our fellows, that is, the standards or norms they go by in evaluating people. These criteria are an aspect of their cultural frames of reference. If we lack the characteristics or capacities which give status in terms of these criteria, we are beset by one of the most typical and yet distressing of human problems of adjustment. One solution is for individuals who share such problems to gravitate towards one another and jointly to establish new norms, new criteria of status which define as meritorious the characteristics they *do* possess, the kinds of conduct of which they *are* capable. It is clearly necessary for each participant, if the innovation is to solve his status problem, that these new criteria be shared with others, that the solution be a group and not a private solution. If he

'goes it alone' he succeeds only in further estranging himself from his fellows. Such new status criteria would represent new subcultural values different from or even antithetical to those of the larger social system.

In general conformity with this pattern, social scientists have accounted for religious cults and sects such as the Oxford Group and Father Divine's Kingdom as attempts on the part of people who feel their status and self-respect threatened to create little societies whose criteria of personal goodness are such that those who participate can find surcease from certain kinds of status anxiety. They have explained such social movements as the Nazi Party as coalitions of groups whose status is unsatisfactory or precarious within the framework of the existing order and who find, in the ideology of the movement, reassurance of their importance and worth or the promise of a new society in which their importance and worth will be recognized. They have explained messianic and revivalistic religious movements among some American Indian and other non-literate groups as collective reactions to status problems which arise during the process of assimilation into a culture and social system dominated by white people. In this new social system native [Americans] find themselves relegated to the lowest social strata. They respond by drawing closer to one another and elaborating ideologies which emphasize the glories of the tribal past, the merit of membership in the tribe and an early millennium in which the ancient glory and dignity of the tribe will be reestablished. All these movements may seem to have little in common with a gang of kids bent on theft and vandalism. It is true that they have little in common on the level of the concrete content of ideologies and value systems. . . [H]owever, . . . the general principles of explanation which we have outlined here are applicable also to the culture of the delinquent gang.

Some accompaniments of the cultural process

The continued serviceability and therefore the viability of a subcultural solution entails the emergence of a certain amount of group solidarity and heightened interaction among the participants in the subculture. It is only in interaction with those who share his values that the actor finds social validation for his beliefs and social rewards for his way of life, and the continued existence of the group and friendly intercourse with its members become values for [the] actor. Furthermore, to the extent that the new subculture invites the hostility of outsiders – one of the costs of subcultural solutions – the members of the subcultural group are motivated to look to one another for those goods and services, those relationships of cooperation and exchange which they once enjoyed with the world outside the group and which have now been withdrawn. This accentuates still further the separateness of the group, the dependence of the members on the group and the richness and individuality of its subculture. No group, of course, can live entirely unto itself. To some extent the group may be compelled to improvise new arrangements for obtaining services from the outside world. 'The fix,' for example, arises to provide for the underworld that protection which is afforded to legitimate business by the formal legal system and insurance companies.

Insofar as the new subculture represents a new status system by sanctioning behavior tabooed or frowned upon by the larger society, the acquisition of status

within the new group is accompanied by a loss of status outside the group. To the extent that the esteem of outsiders is a value to the members of the group, a new problem is engendered. To this problem the typical solution is to devalue the good will and respect of those whose good will and respect are forfeit anyway. The new subculture of the community of innovators comes to include hostile and contemptuous images of those groups whose enmity they have earned. Indeed, this repudiation of outsiders, necessary in order to protect oneself from feeling concerned about what they may think, may go so far as to make nonconformity with the expectations of the outsiders a positive criterion of status within the group. Certain kinds of conduct, that is, become reputable precisely because they are disreputable in the eyes of the 'out-group.'

One curious but not uncommon accompaniment of this process is what Fritz Redl has called 'protective provocation.' Certain kinds of behavior to which we are strongly inclined may encounter strong resistances because this behavior would do injury to the interests or feelings of people we care about. These same kinds of behavior would, however, be unequivocally motivated without complicating guilt feelings if those people stood to us in the relation of enemies rather than friends. In such a situation we may be unconsciously motivated to act precisely in those ways calculated to stimulate others to expressions of anger and hostility, which we may then seize upon as evidences of their essential enmity and ill will. We are then absolved of our moral obligations towards those persons and freer to act without ambivalence. The hostility of the 'out-group,' thus engendered or aggravated, may serve to protect the 'in-group' from mixed feelings about its way of life.

Conclusion

. . . It is to be emphasized that the existence of problems of adjustment, even of like problems of adjustment among a plurality of actors, is not sufficient to insure the emergence of a subcultural solution. The existence of the necessary conditions for effective social interaction prerequisite to such a solution cannot be taken for granted. Who associates with whom is partly a matter of 'shopping around' and finding kindred souls. But circumstances may limit this process of mutual gravitation of people with like problems and free and spontaneous communication among them. People with like problems may be so separated by barriers of physical space or social convention that the probability of mutual exploration and discovery is small. Free choice of associates may be regulated by persons in power, as parents may regulate the associates of their children. Where status differences among people with like problems are great, the probability of spontaneous communication relating to private, intimate, emotionally involved matters is small. Where the problems themselves are of a peculiarly delicate, guilt-laden nature, like many problems arising in the area of sex, inhibitions on communication may be so powerful that persons with like problems may never reveal themselves to one another, although circumstances are otherwise favorable for mutual exploration. Or the problems themselves may be so infrequent and atypical that the probability of running into someone else whose interests would be served by a common solution is negligible.

Because of all these restraints and barriers to communication, as well as the costs of participation in subcultural groups, which may sometimes be counted excessive, subcultural solutions may not emerge, or particular individuals may not participate in them. Nonetheless, the problems of adjustment may be sufficiently intense and persistent that they still press for some kind of change that will mitigate or resolve the problem. Since group solutions are precluded, the problem-solving may well take a 'private,' 'personal-social' or 'neurotic' direction and be capable of satisfactory description in primarily psycho[logical] terms.

A complete theory of subcultural differentiation would state more precisely the conditions under which subcultures emerge and fail to emerge, and would state operations for predicting the content of subcultural solutions. Such a task is beyond the scope of this chapter, and, in any case, the completion of this theory must await a great deal more of hard thinking and research. In this chapter we have tried to put on record, in a highly general and schematic way, the basic theoretical assumptions [of our model of subcultures].

Ned Polsky

RESEARCH METHOD, MORALITY AND CRIMINOLOGY [1967]

EXPERIENCE WITH ADULT, unreformed, 'serious' criminals in their natural environment – not only those undertaking felonies in a moonlighting way, such as pool hustlers, but career felons – has convinced me that if we are to make a major advance in our scientific understanding of criminal lifestyles, criminal subcultures, and their relation to the larger society, we must undertake genuine field research on these people. I am also convinced that this research can be done by many more sociologists, and much more easily, than the criminology textbooks lead us to suppose. . . .

Most sociologists find it too difficult or distasteful to get near adult criminals except in jails or other anti-crime settings, such as the courts and probation and parole systems. . . .

[But if . . . sociology is] the study of how society is really run as distinguished from how the society's civics textbooks say it is run, then . . . it is exactly the discrepancies between law breaking and law enforcement that constitute one of the most central topics of criminology. But we are never going to know much about that topic, or many another, until we get out of the jails and the courts and into the field. Of course our ignorance can remain blissful if . . . we use labelling theory as a form of verbal magic to convince ourselves that the only 'real' criminal is a caught criminal, one whom law enforcers have obligingly placed where it is convenient for criminologists to study him. . . .

It is all very well to draw a fuller quantitative picture of the numbers and kinds of criminals or criminal acts. But we cannot use this to dodge what is the ultimate qualitative task – particularly regarding career criminals, whose importance to any theorist of human behaviour, not to mention the rest of society, is so disproportionate to their numbers: providing well-rounded, contemporary, sociological descriptions and analyses of criminal life-styles, sub-cultures, and their relation to larger social processes and structures.

That is just where criminology falls flat on its face. Especially in the study of adult career criminals, we over-depend on a skewed sample, studied in non-natural surroundings (anti-crime settings), providing mostly data recollected long after the event. . . .

This means – there is no getting away from it – the study of career criminals *au naturel*, in the field, the study of such criminals as they normally go about their work and play, the study of 'uncaught' criminals and the study of others who in the past have been caught but are not caught at the time you study them. . . .

The main obstacle to studying criminals in the field, according to Sutherland and Cressey, lies in the fact that the researcher 'must associate with them as one of them'. Few researchers 'could acquire the techniques to pass as criminals', and moreover 'it would be necessary to engage in crime with the others if they retained a position once secured' (Sutherland and Cressey 1960: 69). Where Sutherland and Cressey got this alleged fact they don't say and I can't imagine. It is just not true. On the contrary, in doing field research on criminals you damned well better *not* pretend to be 'one of them', because they will test this claim out and one of two things will happen: either you will, as Sutherland and Cressey indicate, get sucked into 'participant' observation of the sort you would rather not undertake, or you will be exposed, with still greater negative consequences. You must let the criminals know who you are; and if it is done properly . . . it does not sabotage the research.

Another mistaken Sutherland–Cressey claim about field research on career criminals is that 'few of them [criminals] would permit interrogations regarding their earlier lives or would volunteer information regarding the processes by which they became criminals' (Sutherland and Cressey 1960: 69). A few won't but most will – they will, that is, if you aren't pretending to be 'one of them'. Some examples: A syndicate criminal connected with illegal control of bars and nightclubs has described to me how he entered his line of work. (The process was in all essential respects comparable to an upper-class youth 'going into daddy's business'.) A long-time professional burglar has described to me his teenage apprenticeship to an older burglar. (The apprenticeship took place with his father's knowledge and consent, the father's chief concerns being that the older burglar not make a punk out of his son and that he teach him how to stay out of jail.) . . .

Although criminologists need not 'acquire the techniques to pass as criminals', there is another matter of individual competence that excludes, or rather should exclude, a number of potential researchers. . . . The problem inheres in that requirement of telling criminals who you are. In field investigating, before you can tell a criminal who you are and make it stick, you have to know this yourself – know, especially, just where you draw the line between you and him. If you aren't sure, the criminal may make it his business to see that you get plenty shook up, really rack you up about it. I shall come back to this matter later. My point here is that field research on criminals . . . seems especially attractive to people who are still trying to find out who they are. I have had to learn to discourage converts who are going through various identity crises and to indicate bluntly that for them field research on criminals is a good thing to stay away from. Unfortunately, it is often the people best able to overcome moralism and achieve genuine empathy with criminals who are most vulnerable to allowing empathy to pass into identity.

But that 'screening' problem aside, most criminologists can intelligently, safely, and successfully undertake field study of adult criminals if they put their minds to it. In what follows I shall discuss problems connected with this research method; and counter some additional objections to this kind of research.

<div align="center">2</div>

Most difficulties that one meets and solves in doing field research on criminals are simply the difficulties one meets and solves in doing field research. The basic problem many sociologists would face in field work on criminals, therefore, is an inability to do field work. . . .

Successful field research depends on the investigator's trained abilities to look at people, listen to them, think and feel with them, talk with them rather than at them. It does *not* depend fundamentally on some impersonal apparatus, such as a camera or tape recorder or questionnaire, that is interposed between the investigator and the investigated. Robert E. Park's concern that the sociologist become first of all a good reporter meant not that the sociologist rely on gadgets to see, hear, talk and remember for him; quite the contrary, it asked the sociologist to train such human capacities in himself to their utmost and use them to their utmost in direct observation of people he wants to learn something about. But the problem for many . . . sociologist[s] today – the result of curricula containing as much scientism as science – is that these capacities, far from being trained in [them], have been trained out of [them]. . . . [They] can't see people any more, except through punched cards and one-way mirrors. [They] can't talk with people any more, only 'survey' them. Often [they] can't even talk *about* people any more, only about 'data'. Direct field study of social life, when [they are] forced to think about it at all, is something [they] fondly label 'soft' sociology, as distinguished from [their] own confrontation of social reality at several removes, which in [their] mysterious semantics is 'hard' sociology. . . .

Perhaps the largest set of problems arises from the fact that a criminal judges the judges, puts down the people who put him down. Any representative of the square world initially encounters some covert if not overt suspicion or hostility; it is best to assume such feelings are there (in the criminal) even if they don't show, and that you are not going to get far unless and until you overcome those feelings. This problem, although it exists in studying a criminal enmeshed with the law, is usually magnified in dealing with an uncaught criminal in his natural surroundings, for the following reasons: (1) You are more of an intruder. As far as he is often concerned, it's bad enough that he has to put up with questioning when in the hands of the law, and worse when squares won't even leave him in peace in his own tavern. (2) He is freer to put you down and you are more on your own; you have no authority (police, warden, judge, parole board) to back you up. (3) There is more of a possibility that he might be hurt by you, that is, he has more to lose than someone already in jail.

At least potentially going for you, on the other hand, is the fact that because you are not working in a law-enforcement setting you might *possibly* be all right; and the sooner you firmly establish in his mind that you are not any kind of cop or social worker, the sooner that fact begins going for you.

The following paragraphs will not solve for every researcher these and related problems, but will give some procedures – in no special order – that I have found useful to overcome such problems and often to prevent them from arising in the first place. They should be understood as a first attempt to state formally what I have arrived at on a more or less intuitive and trial-and-error basis in dealing with uncaught criminals. They might not work for every researcher, but I think they would work for most.

1. Although you can't help but contaminate the criminal's environment in some degree by your presence, such contamination can be minimized if, for one thing, you use no gadgets (no tape recorder, questionnaire form) and, for another, do not take any notes in the criminal's presence. It is quite feasible to train yourself to remember details of action and speech long enough to write them up fully and accurately after you get home at the end of the day (or night, more typically). . . .

2. Most important when hanging around criminals – what I regard as the absolute 'first rule' of field research on them – is this: initially, keep your eyes and ears open *but keep your mouth shut*. At first try to ask no questions whatsoever. Before you can ask questions, or even speak much at all other than when spoken to, you should get the 'feel' of their world by extensive and attentive listening – get some sense of what pleases them and what bugs them, some sense of their frame of reference, and some sense of *their* sense of language (not only their special argot, as is often mistakenly assumed, but also how they use ordinary language). . . .

Until the criminal's frame of reference and language have been learned, the investigator is in danger of coming on too square, or else of coming on too hip (anxiously over-using or misusing the argot). The result of failure to avert such dangers is that he will be put on or, more likely, put down, and end by provoking the hostility of his informant. . . .

3. Once you know the special language, there is a sense in which you should try to forget it. You cannot accurately assess any aspect of a deviant's lifestyle or subculture through his argot alone, although many investigators mistakenly try. . . . Such attempts result in many errors, because there is often a good deal of cultural lag between the argot and the reality. One cannot, for instance, assume that every important role in a deviant subculture is represented by a special term. An example: A distinctive role in the male homosexual sub-culture is played by that type of woman, not overtly lesbian, who likes to pal around with male homosexuals and often serves as a front for them in the heterosexual world; but although this role has, according to older homosexuals I know, existed for decades, it is only within the past several years that homosexual argot has developed special terms for such a woman (today homosexuals [on the east coast of America] often refer to her as a 'faghag' and [on the west coast] homosexuals refer to her as a 'fruit fly').

Conversely, the widespread use of a term for a deviant role is not always a good clue to the prevalence or even the existence of role incumbents. An example: In the American kinship system, the three basic types of incest are brother–sister, father–daughter, and mother–son. We have a common term, originating in black sub-cultures and now part of general American slang, to designate one partner in the third type ('motherfucker'), and no special terms for the other types. But the facts of American incest are the reverse of what the language might lead one to

believe: brother–sister and father–daughter incest are frequent, whereas mother–son incest is [comparatively] rare. . . .

Thus the presence or absence of special language referring to deviance is conclusive evidence for nothing except the presence or absence of such special language. It may sensitize you as to what to look for in actual behaviour, but the degree of congruence between the language and the reality of deviance is an empirical matter to be investigated in each case.

Also, the researcher should forget about imputing beliefs, feelings, or motives (conscious or otherwise) to deviants on the basis of the origins of words in their argot. Whether the etymologies are genuine or fancied (what linguists call 'folk' or 'false' etymologies), they tell us nothing about the psychic state of the users of the words. One form of analysis, a kind of parlour version of psychoanalysis, implicitly denies this. I have seen it seriously argued, for example, that heroin addicts must unconsciously feel guilty about their habit because they refer to heroin by such terms as 'shit', 'junk', and 'garbage'. Actually, the use of any such term by a heroin addict indicates, in itself, nothing whatever about his guilt feelings or the lack thereof, but merely that he is using a term for heroin traditional in his group.

At best, deviant argot is supporting evidence for behavioural phenomena that the investigator has to pin down with other kinds of data.

4. In my experience the most feasible technique for building one's sample is 'snowballing': get an introduction to one criminal who will vouch for you with others, who in turn will vouch for you with still others. (It is of course best to start at the top if possible, that is, with an introduction to the most prestigious person in the group you want to study.)

Getting an initial introduction or two is not nearly so difficult as it might seem. Among students whom I have had perform the experiment of asking their relatives and friends to see if any could provide an introduction to a career criminal, fully a third reported that they could get such introductions. . . . Moreover, once your research interests are publicly known you get volunteer offers of this sort. . . . from students, faculty . . . criminal lawyers and crime reporters (to say nothing of law enforcement personnel).

Be that as it may, there are times when you don't have an introduction to a particular scene you want to study, and you must start 'cold'. In such a situation it is easier, usually, to get acquainted first with criminals at their play rather than at their work. Exactly where this is depends on your individual play interests. Of course, initiating such contact means recognizing that criminals are not a species utterly different from you; it means recognizing . . . that you do have some leisure interests in common with criminals. It means recognizing the reality of a criminal's life (as distinguished from the mass-media image of that life), which is that he isn't a criminal twenty-four hours a day and behaves most of the time just like anyone else from his class and ethnic background.

In fact, one excellent way of establishing contact involves a small bit of fakery at the beginning, in that you can get to know a criminal on the basis of common leisure pursuits and *then* let him know of your research interest in him. (But this latter should be done quite soon, after the first meeting or two.) Where and how you start depends, other things being equal, on what you do best that criminals are also likely to be interested in. For example, in trying to make contact with crimi-

nals in a neighbourhood new to me, I of course find it best to start out in the local pool-room. But if you can drink most people under the table, are a convivial bar-room companion, etc., then you should start out in a tavern. If you know horses, start out at a horse parlour. If you know cards, ask around about a good poker game. If you know fighters, start out at the local fight gym.

5. If you establish acquaintance with a criminal on some basis of common interest, then, just as soon as possible, let him know of the differences between you if he hasn't guessed them already; that is, let him know what you do for a living and let him know why, apart from your interest in, say, poker, you are on his scene. This isn't as ticklish as it seems to people who haven't tried it – partly because of that common interest and partly because the criminal often sees, or can easily be made to see, that there may be something in it for him. For example, he may have some complaint about the outside world's mistaken view of him that you, as someone who has something in common with him, might sympathetically under-stand and correctly report. . . . Or he may want to justify what he does . . . Or he may be motivated by pride and status considerations, e.g., want to let you know that his kind of criminality is superior to other kinds. (Examples: A burglar tells me his line of work is best because 'if you do it right, there are no witnesses.' Another, indicating his superiority to pimps, told me that among his colleagues a common saying about a girl supporting a pimp is that 'Maybe she'll get lucky and marry a thief.') . . .

These and similar motives are present not far below the surface in most crim-inals, and are discoverable and usable by any investigator alert for them.

6. In studying a criminal it is important to realize that he will be studying you, and to let him study you. Don't evade or shut off any questions he might have about your personal life, even if these questions are designed to 'take you down', for example, designed to force you to admit that you too have knowingly violated the law. He has got to define you satisfactorily to himself and his colleagues if you are to get anywhere, and answering his questions frankly helps this process along.

Sometimes his definitions are not what you might expect. (One that pleased but also disconcerted me: 'You mean they pay you to run with guys like me? That's a pretty good racket.') The 'satisfactory' definition, however, is usually fairly stan-dardized – one reason being that you are not the first non-criminal he's met who didn't put him down and consequently he has one or more stereotyped exceptions to his usual definitions of squares. And with a bit of experience you can angle for this and get yourself defined as, for example, 'a square who won't blow the whistle' or 'a square who likes to play with characters' or 'a right square'.

One type of definition you should always be prepared for (though it is by no means always overtly forthcoming) is the informant's assumption that you want to be like him but don't have the nerve and/or are getting your kicks vicariously. Thus one of the better-known researchers on drug addiction has been described to me by junkies as 'a vicarious junkie', criminals often define interested outsiders as 'too lazy to work but too scared to steal', and so on. This type of definition can shake you if there is any truth in it, but it shouldn't; and indeed you can even capitalize on it by admitting it in a backhanded sort of way, that is, by not seriously disputing it.

7. You must draw the line, to yourself and to the criminal. Precisely where to draw it is a moral decision that each researcher must make for himself in each

research situation. (It is also to some extent a decision about personal safety, but this element is highly exaggerated in the thinking of those who haven't done field work with criminals.) You need to decide beforehand, as much as possible, where you wish to draw the line, because it is wise to make your position on this known to informants rather early in the game. For example, although I am willing to be told about anything and everything, and to witness many kinds of illegal acts, when necessary I make it clear that there are some such acts I prefer not to witness. (With two exceptions I have had this preference respected.) To the extent that I am unwilling to witness such acts, my personal moral code of course compromises my scientific role – but not, I think, irreparably.

. . . There is another kind of compromise that must be made, this by way of keeping faith with informants. As the careful reader of some other parts of this book will gather, in reporting one's research it is sometimes necessary to write of certain things more vaguely and skimpily than one would prefer. But that is more of a literary than a scientific compromise; there need be no distortion of the *sociological* points involved.

. . . Letting criminals know where you draw the line of course depends on knowing this yourself. If you aren't sure, the criminal may capitalize on the fact to manoeuvre you into an accomplice role.

The possibility of such an attempt increases directly as his trust of you increases. For example, I knew I was really getting somewhere with one criminal when he hopefully explained to me why I would make a fine 'steerhorse' (which in his argot means someone who fingers a big score for a share of it). To receive such indication of 'acceptance' is of course flattering – and is meant to be – but the investigator must be prepared to resist it or the results can be far more serious than anything he anticipates at the beginning of his research. . . .

8. Although I have insisted that in studying criminals you mustn't be a 'spy', mustn't pretend to be 'one of them', it is equally important that you don't stick out like a sore thumb in the criminal's natural environment. You must blend in with the human scenery so that you don't chill the scene. One consequence is that often you must modify your usual dress as well as your usual speech. In other words, you must walk a tightrope between 'openness' on the one hand and 'disguise' on the other, whose balancing point is determined anew in each investigation. Let me illustrate this with an example.

During the summer of 1960 . . . I spent much time with people involved in heroin use and distribution, in their natural settings: on rooftops, in apartments, in tenement hallways, on stoops, in the streets, in automobiles, in parks and taverns. . . . On the one hand, I did not dress as I usually do (suit, shirt and tie), because that way of dressing in the world which I was investigating would have made it impossible for many informants to talk with me, e.g., would have made them worry about being seen with me because others might assume I represented the law. But on the other hand, I took care always to wear a short-sleeved shirt or T-shirt and an expensive wristwatch, both of which let any newcomer who walked up know immediately that I was not a junkie.

9. A final rule is to have few unbreakable rules. For example: although the field investigator can, to a large extent, plan his dress, speech and other behaviour before-hand so as to minimize contamination of the environment he is investigating, such

plans should be seen as provisional and subject to instant revision according to the requirements of any particular situation. Sometimes one also must confront unanticipated and ambiguous situations for which one has no clear behavioural plan at all, and abide the maxim *On s'engage et puis on voit* [rough translation: we must wait and see].

So much for the abecedarium I have evolved in studying criminals outside jails. Obviously it is not exhaustive. But I hope it will encourage other sociologists to study adult criminals in their natural settings. A bit more needs to be said, however, about what the criminal's 'natural setting' actually means.

Studying a criminal in his natural setting means . . . studying him in *his* usual environments rather than yours, in his living quarters or streets or taverns or wherever, not in your home or your office or your laboratory. And it means you mustn't schedule him, mustn't try to influence his shifting choices among his environments or interfere with his desire either for mobility or immobility. . . . Such free-ranging study, as the animal ecologists call it, is concerned to avoid as far as possible any serious disruption of his daily routine. . . .

Sociology isn't worth much if it is not ultimately about real live people in their ordinary life-situations, yet many of the 'precise, controlled techniques of observation' introduced by the investigator produce what is for the subject anything but an ordinary life-situation. . . . [T]he 'scientific' objections to field research on criminals . . . boil down to the truism that our research methods in general fall short of perfection. The regularity with which criminologists focus on alleged scientific objections to field research, and the regularity with which they ignore or barely hint at the obvious *moral* objection to such research, suggests that the issue of morality is really what bothers them most. . . .

3

If [sociologists are] effectively to study adult criminals in their natural settings, [they] must make the moral decision that in some ways [they] will break the law [themselves]. [They] need not be a 'participant' observer and commit the criminal acts under study, yet [they have] to witness such acts or be taken into confidence about them and not blow the whistle. That is, investigators have to decide that when necessary [they] will 'obstruct justice' or have 'guilty knowledge' or be an 'accessory' before or after the fact, in the full legal sense of those terms. [They] will not be enabled to discern some vital aspects of criminal life-styles and sub-cultures unless [they] (1) make such a moral decision, (2) make . . . the criminals believe [them] and (3) convince . . . them of their ability to act in accord with [their] decision. That third point can sometimes be neglected with juvenile delinquents, for they know that professionals studying them are almost always exempt from police pressure to inform; but adult criminals have no such assurance, and hence are concerned to assess not merely the investigators' intentions but their ability to remain 'stand-up guys' under police questioning.

To my knowledge, Lewis Yablonsky is the only criminologist who has had the good sense and emotional honesty to object to such research primarily on moral grounds. He claims that the views expressed in the foregoing paragraph . . . and

any similar views, go too far from a moral standpoint. According to Yablonsky, non-moralizing on the part of the researcher, when coupled with intense interest in the criminal's life, really constitutes a romantic encouragement of the criminal (Yablonsky 1965: 72).

Not so. To be sure, the research involvement I recommend is hardly uninterested; but also obviously, it tries to be as far as humanly possible *dis*interested, a scientific undertaking concerned neither to confirm the criminal in his criminality nor to change him, but to understand him. Furthermore, if the sociologist[s themselves] have any lingering 'romantic' view of criminality, there is nothing so effective as close association with criminals to get [them] over it, because criminals themselves – at least those who are beyond the novice stage and seriously committed to crime as a career – are usually quite hard-headed and unromantic about it all. In any case, the criminal scarcely needs the sociologist to make him feel important as an object of romantic interests when, everyday, every TV set in the land blares forth such messages for those criminals interested in picking up on them.

It is possible – highly doubtful, but possible – that a few criminals might become more set in their criminality, to some minuscule degree, by the mere fact that my type of investigating is totally unconcerned to 'reform' them or 'rehabilitate' them or 'make them see the error of their ways'. But in the first place, such unconcern is qualitatively different from positive encouragement or approval. (Indeed, part of what I conceive to be proper research technique with criminals, as indicated previously, involves letting them know that your value choices are different from theirs.) Secondly, the burden of proof rests upon those who claim that abstention from moralizing by the field investigator has any significantly encouraging effect on criminals' life-styles, and they have not supplied one bit of such proof. . . .

The great majority of criminologists are social scientists only up to a point – the point usually being the start of the second, 'control of crime', half of the typical criminology course – and beyond that point they are really social workers in disguise or else correction officers *manqués*. For them a central task of criminology, often *the* central task, is to find more effective ways to reform lawbreakers and to keep other people from becoming lawbreakers.

If [people] want . . . to make that sort of thing [their] life work I have no objection; that is [their] privilege. I suggest merely that [they] not do so in the name of sociology, criminology or any social science. I suggest that [they] admit [they] are undertaking such activity not as social scientists but as technologists or moral engineers for an extra-scientific end: making [other] people obey current American criminal law. This is not to deny [their] rights as ordinary citizens to be 'engaged' and make value judgements about crime, politics, sex, religion or any other area of moral dispute. Rather, it is to deny that everything appropriate to one's role as ordinary citizen is appropriate to one's role as scientist, and to insist that making such value judgements is not only inappropriate to the latter role but highly inimical to it.

To locate such inimical effect one need look no further than Yablonsky's own admission that in his work with juvenile delinquents 'some gang boys who met with me almost daily – some over several years – never fully believed that I was not "really a cop"' (Yablonsky 1965: 56). Any student of deviance who confounds the roles of social worker and sociologist ('the dual role of practitioner-researcher', as

Yablonsky puts it) is bound to elicit that sort of response and have his research flawed by it. And if failure to solve this problem is serious in the scientific study of delinquents, failure to solve it in the study of adult career criminals is catastrophic.

The failure derives from what is truly a romantic ideology, one common to 'applied sociologists': a sentimental refusal to admit that the goals of sociological research and the goals of social work are always distinct and often in conflict. The conflict happens to be extremely sharp in the case of adult felony crime. The criminologist who refuses fully to recognize this conflict and to resolve it in *favour of sociology* erects a major barrier to the extension of scientific knowledge about such crime and such criminals.

But what of one's duty as a citizen? Shouldn't that take precedence? Well, different types of citizens have different *primary* duties. And our very understanding of 'citizenship' itself is considerably furthered in the long run if one type of citizen, the criminologist, conceives his primary duty to be the advancement of scientific knowledge about crime even when such advancement can be made only by 'obstructing justice' with respect to particular criminals in the short run.

Many anthropologists have been able to advance the state of knowledge only by keeping faith with people who radically transgress the moral norms of their society, that is, by refusing to turn people in to colonial officials and cops, so I fail to see why criminologists shouldn't do the same. Of course, if someone really wants to behave towards the 'savages' as a missionary rather than as an anthropologist, if he really wants to be a superior sort of social worker or cop or therapist rather than a sociologist, there is no denying him this right; but at least let him own up to what he really is and stop fouling the waters of science with muck about 'the dual role of practitioner-researcher'.

I would not wish to be understood as claiming that the criminologist[s], in [their] role as criminologist[s], must ignore value judgements. On the contrary, [they] might scientifically deal with them in several ways well known to sociology. For example, [they] could study how a society came to have the particular moral norms that it has, or study the unanticipated consequences of these norms for the society, or study the differential distribution and varying intensity of these norms within different sub-cultures of a complex society. The sociologist or criminologist can, as a scientist, do the foregoing things and more with respect to values. But if some people claim that whatever the law may say at the moment, it is 'right' (or 'wrong') to do this or that and they act in accord with their value judgement, one thing the sociologist[s] or criminologist[s] cannot do, directly or indirectly, is to gainsay them and interfere with their lives in the name of science. Social scientist[s have] no business attempting to 'adjust' people to the moral norms of [their] society or any other.

Max Weber, in emphasizing that sociology must be value-neutral if it is to be genuinely scientific, long ago made the key distinctions between one's role as ordinary citizen and one's role as social scientist. Our allegedly sociological students of crime, however, have forgotten Weber's lesson if, indeed, they ever learned it.

It is hard to blame them when they see other social scientists directly criticize Weber's fastidiousness . . . out of a gluttonous desire to have their cake and eat it, to be moralizers and scientists at once. But the criticism levelled at Weber on this matter, whether by 'natural law' ideologues . . . or 'applied sociology' ideologues . . . comes to no more than the statement that the value-neutral ideal is impossible

of full attainment and that even the great Max Weber could not always keep his personal values completely out of his scientific work. Such criticism is quite true and equally irrelevant: although the ideal is indeed not fully attainable, there are radically different degrees of approximation to it that are attainable, and these quantitative differences add up to a significant difference in quality; which is to say that if we try like hell we can come very close to the ideal and enormously improve the state of our science thereby. But the critics of Weber aren't interested in trying. They apparently believe that because we cannot be virgin pure with respect to value-neutral social science we might as well be whores.

Actually, two related modes of sociological inquiry can prod us toward objectivity. One, indicated above, consciously excludes value judgements to a degree that comes close to the Weberian ideal, so much so that it can even produce findings which go against the personal values of the investigator. (For example, [in my work on pornography, I come to] conclusions about highly erotic art that seem to be inescapable as a sociologist but that I personally regret having to report – because they give ammunition to censors, whom I detest [see Polsky 1967].) The related mode, suggested to me by Howard Becker . . . counterbalances the values of one's society – and the investigations by social workers or 'applied sociologists' of one's society – by using an 'anti-social' perspective, e.g., by viewing society as a 'problem' for the deviant rather than the other way round. Although such counterbalancing need not be restricted to criminology – one could, for example, sympathetically study the racist's 'problem' of how to check desegregation and increase racial discrimination. . . . This route to value neutrality I find adumbrated not in Max Weber's work but in Friedrich Nietzsche's *Genealogy of Morals*:

> It is no small discipline and preparation of the intellect on its road to final 'objectivity' to see things for once through the wrong end of the telescope; and 'objectivity' is not meant here to stand for 'disinterested contemplation' (which is a rank absurdity) but for the ability to have to pros and cons in one's power and to switch them on and off, so as to get to know how to use, for the advancement of knowledge, the *difference* in the perspectives and psychological interpretations. . . . All seeing is essentially perspective, and so is all knowing. The more emotions we allow to speak on a given matter, the more different eyes we train on the same thing, the more complete will be our conception of it, the greater our 'objectivity'.

4

My complaint, however, is basically Weberian in origin: I object not that criminologists have an anti-criminal moral code but that it is misplaced morality, acted upon within the scientific role instead of being kept firmly outside it. Such misplacement is not only inappropriate to scientific endeavour but clearly detrimental to it . . . although criminologists sometimes give lip service to the scientific ideal of dispassionately studying criminals in the open, they immediately subvert that ideal. Obviously they do so out of fear of being caught with their anti-criminal values

down. Their misplaced morality leads them, in practice, to pass up the field study of criminals, to invent various rationalizations for avoiding it, to exaggerate its diffi-culties, and to neglect some fairly obvious techniques for avoiding these difficulties.

But if . . . criminologist[s] want to help build a real science . . . [they] might ponder the reaction of Bronislaw Malinowksi, over forty years ago, to a similar situ-ation that then obtained in anthropology:

> We are obviously demanding a new method of collecting evidence. The anthropologist must relinquish his comfortable position in the long chair on the veranda of the missionary compound, Government station, or planter's bungalow, where, armed with pencil and notebook and at times with a whisky and soda, he has been accustomed to collect statements from informants, write down stories, and fill out sheets of paper with savage texts. He must go out into the villages, and see the natives at work in gardens, on the beach, in the jungle. . . . Information must come to him full-flavored from his own observations of native life, and not be squeezed out of reluctant informants as a trickle of talk. Field work can be done first or secondhand even among the savages, in the middle of pile dwellings, not far from actual cannibalism and head-hunting. Open-air anthropology, as opposed to hearsay note-taking, is hard work, but it is also great fun. Only such anthropology can give us the all-round vision of primitive man and primitive culture.
>
> (Malinowsky 1926/1954: 146–7)

Until criminologist[s] learn to suspend [their] personal distaste for the values and life-styles of 'untamed savages', until [they] go out in the field to the cannibals and head-hunters and observe . . . them without trying either to 'civilize' them or turn them over to colonial officials, [they] will be only . . . veranda anthropologist[s]. That is, [they] will be only a jail-house or court-house sociologist, unable to produce anything like a genuinely scientific picture of crime.

But if one refuses to be a sociologist of the jailhouse or court system, takes Malinowski to heart, and goes out into the field, there is risk involved. At least I have found this so in my own experience. It is the sort of risk that writers of crim-inology texts, for all their eagerness to put down field work, surprisingly don't mention: most of the danger for the field worker comes not from the cannibals and head-hunters but from the colonial officials. . . . Criminologists studying uncaught criminals in the open find sooner or later that law enforcers try to put them on the spot – because, unless they are complete fools, they uncover information that law enforcers would like to know, and, even if they are very skilful, they cannot always keep law enforcers from suspecting that they have such information.

Although communication between someone and their spouse or lawyer or doctor is legally privileged (these people cannot be required to divulge the commu-nication), there is no such status accorded to communication between anyone and the criminologist. The doctrine of legally privileged communication has so far been extended only to cover certain of those other professionals (nurses, priests, psychotherapists) who are in a 'treatment' relationship with clients. . . . If the . . . criminologist stood fast on his obligation to protect informants in the face of law

enforcers' demands that he tell all, the guiding judicial precedents most likely would be the cases of journalists who have done likewise in legally unprotected situations, and he would be held in contempt of court. . . . Should we manage . . . to get the communication between criminal and criminologist accorded the same legal status as that between criminal and lawyer, then field research on adult criminals would really come into its own, for we would at once have provided the necessary stiff-ening of criminologists' spines and have removed the biggest single obstacle to cooperation from our research subjects.

However, I see no reason to be hopeful that we will be granted this legal priv-ilege, and in fact am quite pessimistic. In the foreseeable future, field research on criminals will have to be carried out under the hazards and handicaps that now obtain. But even under present conditions such research can be done. And if we are serious about studying crime scientifically, it must be done.

John Irwin

NOTES ON THE STATUS OF THE CONCEPT SUBCULTURE [1970]

THE RECENT EMERGENCE of various folk concepts should entice us to re-examine our notion of subculture. I am speaking of such concepts as 'scene,' 'bag,' and 'thing.' The popular use of these indicates that there have been significant shifts in the phenomenon to which subculture refers. Generally, in sociology, subculture has referred to a subset of patterns recognized by social scientists. The use of the metaphors above indicates that it is presently becoming a subset of patterns that the ordinary man recognizes and responds to. This changes the phenomenon in many essential ways, some of which will be discussed in the following paragraphs.[1]

Before turning to the contemporary phenomenon, let me briefly analyze the cognitive status of subculture in its two major uses. In the first systematic defini-tional treatment of subculture, Milton Gordon defines subculture as a subset of cultural patterns carried by a population *segment* [see Chapter 3]. He argues that it would be useful to divide the American society by ethnic, economic, regional and religious variables into segments with unique subcultures. The division into cultural units is somewhat arbitrary, however, since the variables applied do not necessarily relate to other subsystems. These are not necessarily subcultures which are attached to particular social structures or are recognized by anyone except the social scientist applying these variables.[2]

In another of its major uses – subculture as a small group or the patterns carried by a small group – the question of the cognitive status of the concept in the minds of its carriers is likewise ignored. In this version, which traces back to the Chicago deviance studies [see Anderson 1923, Thrasher 1927, Shaw 1930, Shaw 1931, Sutherland 1937, Shaw *et al.*, 1938], but which received its major developments in the 1950s [see Cohen 1955, Cloward and Ohlin 1960, Becker 1963], the problem of whether or not the group which is carrying the subculture or whether a larger group who comes into contact with it recognized the distinct set of patterns is never

considered. In fact, in his milestone treatment in *Delinquent Boys*, Cohen seems to assume that the distinct set of patterns does not extend very far. He feels obliged to explain the emergence of each new set of patterns [see Chapter 4].

Subculture as a social world

In an early treatment of concepts related to subculture, Tamatsu Shibutani actually supplied a conception of subculture which is highly adaptable to the contemporary phenomenon. He did not, however, use the label. He suggested that *reference groups* should be viewed as *reference worlds*, or *social worlds* which are not tied to any particular collectivity or territory [Shibutani 1955]. He also pointed out that persons could simultaneously or alternately identify with more than one social world. Though Shibutani did not call social worlds or reference worlds subcultures, this is one of the ways in which subculture has been viewed. Subculture, rather than the subset of behavior patterns of a segment, or the patterns of a small group, is often thought of as a social world, a shared perspective, which is not attached firmly to any definite group or segment. It is this version which we will adopt here to make sense of contemporary subcultural phenomena in the United States. One dimension of social world as a subculture which Shibutani did not make explicit must be emphasized: the social world can be and often is an explicit category in the minds of a broader population than social scientists and the group carrying the subculture.

Subculture as an explicit life style

People today are becoming more aware of the existence of subcultures, variant life styles or social worlds, and are more often structuring their own behavior, making decisions and planning future courses of action according to their conception of these explicitly subcultural entities. Concrete evidence of this emerging trend is the appearance of several folk metaphors which refer to styles of life as things. The most current of these is the 'scene.' This metaphor in its present folk usage – such as, in the phrases: 'make the scene' and 'that's not my scene' – refers mainly to a style of life which is well known among insiders and outsiders to the scene. In the first phrase 'make the scene,' the scene usually has a definite location and is transitory. It is something which is occurring at a particular time and place. In the second phrase, it refers to a more permanent life style. The usages share three connotations: (1) The style of life is recognized as an explicit and shared category. In other words a particular scene is well known among some relatively large segment. It must be to be a scene, since the term connotes popularity. (2) There are various styles of life available to a particular person, since there is always more than one scene. (3) Finally, one's commitment to a particular scene is potentially tentative and variable.

Two other metaphors which reflect the explicitness of life styles are 'bag' and 'thing.' The phrases 'that's not my bag' and 'do your own thing,' for instance, both reflect that the life styles are being seen as entities.

American subcultural pluralism and relativism

Of course, these metaphors are only used in the daily speech of a small minority. But a larger segment, perhaps a majority, hears them, at least in the mass media, and recognizes their meaning. This is just one indicator that we are generally aware of the 'subcultural' pluralism of the American society. Perhaps twenty years ago most people took American culture for granted and assumed that it was the same for everyone (with a few obvious exceptions, of course, such as Indians, foreigners, and 'deviants').[3] Presently, however, because of the mass media, behavioral scientists' exposés of deviant subcultures, geographical mobility, and higher education, a larger segment of American people have recognized the extent of cultural variation in the country. Accompanying this realization is a shift in one's conception of his own values and beliefs. One may no longer take the 'goodness' or the 'rightness' of his own culture or subculture for granted. In effect, he is beginning to experience *subcultural relativism*.

Subculture as an action system

Increased subcultural pluralism and relativism have effected two important changes in the nature of interaction of the ordinary man. First, one's beliefs, values and cultural meaning have become explicit categories of action. Furthermore, the ordinary man tends to conceive of these categories as a set making up a whole – a life style or cohesive social world. So in a sense persons in interaction are involved in comparing, sharing, negotiating and imparting cultural patterns. While they are doing this they attempt, because of a general human concern for order, to bring the cultural components into a consistent relationship and to maintain boundaries around the system. It may be stated, therefore, that the subculture has become a concrete action system.[4]

Being on

The second manner in which interaction is changing is that persons are more often 'on.' All action categories are becoming more explicit and the person is more often a self conscious *actor*. In an article on the dramaturgic model Sheldon Messinger and others suggested that life is not like a theater [Messinger 1962]. They stated that natural interaction is unselfconscious and the actors did not conceive of themselves as actors in a role. The dramaturgic model is useful, they argue, as an analytical tool, but we must remember that it is seldom a concrete model. They did point out, however, that in some life contexts it approaches concreteness. For instance, the Negro is 'on' when he is in the company of whites and the mental patient, who is constantly under the surveillance of judges, is 'on' most of the time.

I would like to suggest that with the growing recognition of subcultural pluralism, the increase in subcultural relativism and the emergence of cultural categories as explicit action categories and as a cohesive system, more persons are finding themselves judged by outsiders and finding themselves marginal. They are

increasingly 'on.' They more often see themselves as performers in various 'scenes' and are becoming more aware of the dimensions of their various performances. Life is becoming more like a theater.

Summary

In former treatment of the concept subculture the cognitive status of the concept in the minds of the folk was not addressed. This is now highly important because subculture is becoming a conscious category at the folk level. The widespread use of the metaphor 'scene' reflects this trend. American people are becoming aware of the subcultural variation in their society and are experiencing subcultural relativism.

This subcultural pluralism and relativism is having two important effects on everyday interaction. One's values, beliefs, and cultural meanings are no longer taken for granted. More often one is involved in consciously comparing, negotiating and sharing these with others. Furthermore one tends to bring these components into some logically consistent relationship, and therefore, the subculture is becoming an explicit and important action system.

Secondly, action categories in general are becoming more explicit. One is more often conscious of himself as an actor in scenes. Life is becoming more like a theater.

Notes

1 Viewing culture or subculture as explicit categories or as an explicit entity in the minds of the folk sidesteps a particularly troublesome dilemma. This is the problem of circular reasoning in employing culture as an independent variable or explanatory concept. For instance, Edwin Lemert has remarked that 'inescapable circularity lies in the use of culture as a summary to describe modal tendencies in the behavior of human beings and, at the same time, as a term of designating the causes of the modal tendencies. The empirically more tenable alternative is that only human beings define, regulate, and control behavior of other human beings' [Lemert 1964: 5]. But if the folk are making the cultural summary and then defining, regulating and controling behavior of other human beings on the basis of their cultural summary, the concept takes on independence or explanatory weight.

2 In a later treatment of subculture in his book *Assimilation in American Life*, Milton Gordon relates this use of subculture to 'subsociety' which contains 'both sexes, all ages, and family groups, and which parallels the larger society in that it provides for a network of groups and institutions extending throughout the individual's entire life cycle' [1964: 39]. I find these subsocieties to be rather vague entities, however. Some communities and some ethnic segments may take on the dimensions of a subsociety, but many segments which he has designated as carriers of subcultures by his variables do not seem to.

3 The belief in the consensus of American values and beliefs was reflected in R. K. Merton's theory of *anomie* introduced in 1938. Merton suggested at that time that Americans generally shared the same 'culturally defined goals, purposes and inter-

ests' [Merton 1938: 673]. It is also revealing that in the 1950s and 1960s this assumption in his theory is one which has been most often questioned. For instance, see Lemert [1964: 64–71].

4 In a collective statement as an introduction to *Toward A General Theory of Action*, Talcott Parsons, Edward A. Shils, Gordon W. Allport, Clyde Kluckhohn, Henry A. Murray, Robert R. Sears, Richard C. Sheldon, Samuel A. Stouffer, and Edward C. Tolman write that 'the cultural tradition in its significance both as an *object* of orientation and as an *element* in the orientation of action must be articulated both conceptually and empirically with personalities and social systems. Apart from embodiment in the orientation systems of concrete actors, culture, though existing as a body of artifacts and as systems of symbols, is not in itself organized as a system of action' [Parsons *et al.* 1951: 7].

The Birmingham tradition and cultural studies

Introduction to part two

■ Ken Gelder

R ESEARCHERS FROM THE Centre for Contemporary Cultural Studies
(CCCS) at Birmingham University in England, established in 1964 (and closed
in 2002), profoundly shaped the interests and methods of subcultural studies for
the next two decades. The CCCS's first Director was Richard Hoggart, who had
previously taught English at Leicester and Birmingham and whose influential book,
The Uses of Literacy (1957), became one of three foundational texts for the disci-
pline of cultural studies in Britain. Along with Raymond Williams' *Culture and
Society* (1958) and E.P. Thompson's *The Making of the English Working Class*
(1963), Hoggart's book moved well away from the methods of urban sociology,
criminology and participant observation field work. It turned instead to analyses of
popular media, popular culture, literature, and 'everyday life': analyses that read
these things ideologically, since culture here is always taken as a matter of (class)
conflict. All of these commentators spoke from the Left, and they focused in partic-
ular – and no doubt nostalgically – on the 'organic' cultural interests of the working
class. For Williams, 'working-class culture' is 'primarily social . . . rather than indi-
vidual' (Williams 1963: 313), an example of *Gemeinschaft* in the midst of
Gesellschaft; and culture itself is tied to a sense of society as a living community.
Thompson's book was especially important for subcultural studies in its British incar-
nation. He traced the origins of the English working class back to eighteenth-century
local traditions that organized around particular codes of practice, ideas and value
systems. Culture is privileged over economics in this account, as Thompson chron-
icled the growth of a conscious and independent working class, self-making,
ceremonial, achieving solidarity under difficult conditions, distinguishing itself from
others. '[C]lass happens', he wrote, 'when some men, as a result of common experi-
ences (inherited or shared), feel and articulate the identity of their interests as
between themselves, and as against other men whose interests are different from

(and usually opposed to) theirs' (Thompson 1980: 8–9). In this account, the working class itself has a kind of subcultural identity and to tell its story is thus to write what Thompson later called 'history from below': the kind of narrative positioning seen in a great deal of work in subcultural studies.

The first piece in this section, from Phil Cohen, was published in 1972, just two years after John Irwin had responded to the 'subcultural pluralism' of the United States. But in some respects it is surprisingly close to earlier work from the Chicago School, even having something to say about juvenile delinquency. It turns to working-class communities in London's East End, the site of so much sociological and literary activity (Robert E. Park, for example, had drawn on Walter Besant's *East London* [1912] in his own work on Chicago: see chapter 1). But it traces the *end* of those communities, as urban planners 'modernize' and decentralize the area. Cohen turns his attention to youth, always the focus of subcultural studies at the CCCS, and characterizes them at the East End in three important, related ways. First, they are locked into a generational conflict with their 'parent culture'; second, they are increasingly affiliated with 'the new consumer society' that modernization brings to the East End; and third, they therefore directly register the disintegration of community and class. It might seem here as if youth, as they lose their class affiliations, are about to become a modern version of the *lumpenproletariat*. But for Cohen, subcultural identity provides working-class youth with a 'solution' to this problem – rather as it had for his namesake Albert K. Cohen in his 1955 study of delinquent gangs. Joining a subculture means that one is distinguished from one's parents and participates in a new consumer economy, but it also means that a sense of community or solidarity is preserved. For Cohen, the group identity of subcultures – skinheads, mods, rockers, teds, and so on – is expressed territorially first and foremost. As the working-class community is displaced and the city developers move in, working-class youth subcultures live out a kind of 'symbolic' or 'magical' occupation of the place their parents had once called their own.

Cohen's account of working-class youth subcultures influenced other researchers at the CCCS. For one thing, it asserted that subcultures must *always* be working class in origin. A subculture here must be subordinated, socially speaking, an expression of 'history from below'; this is why Cohen is able to say, 'I do not think the middle class produces subcultures'. But his account also positioned youth subcultures somewhere in between an increasingly displaced working-class community and the modern pressures of consumer society – between what Richard Hoggart had called the '"older" order' and 'the newer mass arts'. This meant that subcultures were seen as transitional. Cohen also invested youth subcultures with political meaning, taking them as emblematic of systemic social change. Subcultures, he writes, 'are symbolic structures and must not be confused with the actual kids who are their bearers and supports' – a view that could hardly be further away from the Chicago School's empirical, ethnographic and often criminological perspectives.

Finally, Cohen took youth subcultures as a 'compromise', with little capacity for social resistance. This last point became contentious for the broader discipline of cultural studies as it tried to identify a progressive politics in popular cultural forms. In 1975, Tony Jefferson and Stuart Hall – who had replaced Hoggart as

director of the CCCS in 1968 – edited a collection of essays titled *Resistance Through Rituals: Youth Subcultures in Post-war Britain*, and part of the introduction, written by Hall and Jefferson along with John Clarke and Brian Roberts, is included here. The focus remains on working-class youth subcultures as a subordinated group, but resistance is given more potential. These writers draw on the Italian Marxist Antonio Gramsci's concept of hegemony, the means by which the ruling classes win the 'consent' – through regulation and negotiation, as much as coercion – of those they subordinate, socially, ideologically and culturally. Yet they also want to say that a subordinated group can 'win space' back in return. Their account of working-class youth subcultures is thus more positive than Cohen's, even though they go on to suggest that subcultures don't really 'solve' working-class problems. This is because youth subcultures work their resistances out while at leisure, rather than at work: in an unproductive realm that is less constrained but more 'limited', politically speaking. John Clarke *et al.*'s piece extends Phil Cohen's discussion, seeing working-class youth subcultures as shaped by their class background (even as they are locked into generational conflict) but enmeshed in new consumer markets designed to make youth a distinctive category. They accordingly shift their focus on subcultures from territory to style, the way subcultures purchase and organize their 'look' and 'outlook' through fashion and related tastes and practices. What preoccupies CCCS researchers here – and what comes to influence so much work in subcultural studies afterwards (enough to devote a section to it in this Reader) – is the *meaning* of subcultural style. The methods of urban sociology dissolve away here, to be replaced by the ideologically informed practice of semiotics: reading the signs of subculture and understanding them as the means by which subcultures gain their social identity.

The CCCS researchers were drawn to Continental cultural theory from the Left: Gramsci, the French Marxist Louis Althusser, and the early Roland Barthes. We might say that they were textual rather than empirical in their interests: reading the signs at a distance rather than talking face-to-face to actual subcultural participants. An exception was Paul Willis, and an extract from his classic study *Learning to Labour* (1977) is presented in this section. Willis talks to a group of 'lads' at a school in the West Midlands and chronicles the ways in which these working-class boys operate as non-conformists in an institutional system built around middle-class values. In this respect, Willis also compares to Albert K. Cohen's account of working-class delinquents – although Cohen's study was itself theoretical rather than empirical. The 'lads' refuse to give their consent to the ruling authorities not because of any individual pathology but because of their social predicament as working-class boys. They are thus defined structurally by what Willis calls *differentiation*, as opposed to *integration*. The boys develop a 'counter-school culture' that empowers them, but it also condemns them to menial (rather than 'mental') jobs and thus simply reproduces pre-existing class inequalities.

Willis's account of these 'lads' was later criticized by Angela McRobbie, partly because, by situating them only in their institutional context, it seemed to seal them off from the more private aspects of their lives: what happens 'around the breakfast table and in the bedroom' (McRobbie 1991: 32), for example. More to the

point, it only looked at *boys*. McRobbie is especially important to subcultural studies as it developed at the CCCS – where she was a graduate student – because her own work has turned to the roles played out in subcultures by girls. She is represented in this part by two important articles. 'Girls and Subcultures: An Exploration', co-written with Jenny Garber, was first published in Hall and Jefferson's *Resistance Through Rituals* in 1975. The interest in this early piece is not really in class – although McRobbie has written about working-class girls elsewhere (1978) and in response to Willis has also called for a properly '*sexed* notion of working-class culture' (McRobbie 1991: 32). Rather, it discusses the structural positions girls take in relation to subcultural style ('the motor-bike girl', 'the mod girl', etc.) and popular, commercial culture: Hoggart's 'newer mass arts'. Indeed, McRobbie and Garber even have something to say here about middle-class subcultural style, usually ignored by CCCS researchers. Their article concludes with some remarks on what used to be called 'teenyboppers' and their adoration of pop music idols. Pre-teen girl culture is based at home rather than in clubs or on the street, and its capacity for resistance is obviously restricted; indeed, it may very well be a matter of confor-mity rather than non-conformity. Even so, 'teenybopper culture' is tied to the development of an 'active feminine identity' built around growing sexual awareness and consumer confidence. Although they may not be 'cool', these pre-teen girls are at least able to distinguish themselves culturally and socially 'from their younger and their older counterparts'. McRobbie's second, later piece, 'Second-hand Dresses and the Role of the Ragmarket' (1989), does, however, consider a 'cooler' form of subcultural style, bought and sold in London's ragmarkets. Here, women are actively involved in the trading of 'retro' or 'second-hand' clothing; they are 'subcultural entrepreneurs' rather than, say, alienated delinquents. Consumer culture here may not offer much in the way of 'resistance' but it is bohemian, makeshift and street-wise, juxtaposed to the larger commercial centres, the professional designers and the 'mainstream department stores'. As she describes hippie and punk tastes in second-hand clothing, McRobbie gives us a history of 'contemporary consumer culture . . . from below': a version of precisely the narrative position E.P. Thompson had called for in the writing of history.

The CCCS's fascination with subcultural style gained its most accessible – and, perhaps paradoxically, its most densely theorized – expression in Dick Hebdige's enormously influential book, *Subculture: The Meaning of Style* (1979). Hebdige begins his study with an account of the homosexual French writer and criminal Jean Genet's experiences in prison, focusing on the confiscation by the police of a jar of Vaseline. For Genet, this 'puny and most humble object' suddenly becomes ultra-significant, drawing both the hatred and the mockery of his oppressors. For Hebdige, it indicates 'the subversive implications of style', enabling him to build his analysis of the British punk subculture on a moment in the transgressive history of the French avant-garde. Subcultural style here is not so much a question of resistance as a matter of 'refusal', a 'gesture of defiance or contempt' – and British punk was the perfect subculture for its transmission. McRobbie had suggested, in 'Second-hand Dresses', that punk 'was, first and foremost, cultural'. But Hebdige defined it as *subcultural* through its treatment of style. Influenced by the semiotic theory of

Roland Barthes and Umberto Eco, as well as surrealism and Dada, Hebdige took subcultural style as a radical deployment of ordinary cultural objects – and so consolidated subcultural studies' shift away from its sociological and criminological traditions, refashioning it for the art school and the new humanities. It transforms, borrows and mixes; to give this process expression, Hebdige drew on earlier CCCS accounts (themselves borrowing from the French anthropologist Claude Levi-Strauss) of *bricolage*, a word describing the way things are adapted for uses for which they were not officially intended, dislocated from their 'normal' context. Hebdige also returns to Paul Willis's use of *homology*, suggesting that subcultures are themselves relatively orderly forms, fitting their chosen styles to their values, experiences and tastes (in music, for example). But punk style can seem to project 'noise' and 'chaos'. His work here raises problems of interpretation – once signs are dislocated, their meanings may be difficult to resolve – and is worth comparing to Dave Laing's commentary on punk music in chapter 38.

Hebdige established a number of influential ways of looking at subcultures. He retained an interest in the working class, tying it to avant-garde aesthetics through its oppositional potential and then reading subcultures in relation to both of these things. But he also saw subcultures as mobile and adaptable: capable of borrowing from a range of cultural sites, whether local or transnational (as punk borrowed from immigrant-Caribbean reggae, for example). His punks were active agents, 'ironic and self-aware': like artists. But they were also vulnerable to what he called 'incorporation' (compare Willis's term, *integration*). For Hebdige, subcultures could be incorporated in two ways: either by converting their styles into mass-produced commodities, or by labelling their participants 'ideologically', as the mass media might label punks as 'deviants'. In this respect, Hebdige's work on subcultures shares the antipathy that Richard Hoggart and Raymond Williams had felt much earlier towards the increasing dominance of mass culture and mass communication. Even so, the view that modern subcultures stand against the incorporating logics of mass culture bequeathed subcultural studies one of its most powerful, if problematic, narratives.

Phil Cohen

SUBCULTURAL CONFLICT AND WORKING-CLASS COMMUNITY [1972]

T HE 1950S SAW the development of new towns and large estates on the outskirts of east London (Dagenham, Greenleigh and so on), and a large number of families from the worst slums of the East End were rehoused in this way. The East End, one of the highest-density areas in London, underwent a gradual depopulation. . . .

As the worst effects of this . . . both on those who moved and on those who stayed behind, became apparent, the planning authorities decided to reverse their policy. Everything was now concentrated on building new estates on slum sites within the East End. But far from counteracting the social disorganization of the area, this merely accelerated the process. . . . No one is denying that redevelopment brought an improvement in material conditions for those fortunate enough to be rehoused (there are still thousands on the housing list). But while this removed the tangible evidence of poverty, it did nothing to improve the real economic situation of many families, and those with low incomes may, despite rent-rebate schemes, be worse off.

The first effect of the high-density, high-rise schemes was to destroy the function of the street, the local pub, the corner shop as articulations of communal space. Instead there was only the privatized space of family units, stacked one on top of each other, in total isolation, juxtaposed with the totally public space which surrounded them and which lacked any of the informal social controls generated by the neighbourhood. The streets which serviced the new estates became thoroughfares, their users 'pedestrians' and, by analogy, so many bits of human traffic – and this irrespective of whether or not they were separated from motorized traffic. . . .

The second effect of redevelopment was to destroy what we have called 'matrilocal residence'. Not only was the new housing designed on the model of the nuclear family, with little provision for large low-income families (usually designated 'problem families'!) and none at all for groups of young single people, but the actual pattern of distribution of the new housing tended to disperse the kinship

network; families of marriage were separated from their families of origin, espe-
cially during the first phase of the redevelopment. The isolated family unit could
no longer call on the resources of wider kinship networks or of the neighbourhood,
and the family itself became the sole focus of solidarity. This meant that any prob-
lems were bottled up within the immediate interpersonal context which produced
them; and at the same time family relationships were invested with a new intensity
to compensate for the diversity of relationships previously generated through neigh-
bours and wider kin. The trouble was that although the traditional kinship system
which corresponded to it had broken down, the traditional patterns of socialization
(of communication and control) continued to reproduce themselves in the interior
of the family. The working-class family was thus not only isolated from the outside
but also undermined from within. There is no better example of what we are talking
about than the plight of the so-called 'housebound mother'. The street or turning
was no longer available as a safe playspace, under neighbourly supervision. Mum or
Auntie was no longer just around the corner to look after the kids for the odd
morning. Instead, the task of keeping an eye on the kids fell exclusively to the young
wife, and the only safe playspace was the 'safety of the home'. Feeling herself cooped
up with the kids and cut off from the outside world, it wasn't surprising if she occa-
sionally took out her frustration on those nearest and dearest! Only market research
and advertising executives imagine that the housebound mother sublimates every-
thing in her G-plan furniture, her washing machine or her non-stick frying pans.
Underlying all this, however, there was a more basic process of change going on in
the community, a change in the whole economic infrastructure of the East End.

In the late 1950s the British economy began to recover from the effect of the
war and to apply the advanced technology developed during this period to the more
backward sectors of the economy. Craft industries and small-scale production in
general were the first to suffer; automated techniques replaced the traditional hand-
skills and their simple division of labour. Similarly, the economies of scale provided
for by the concentration of capital resources meant that the small-scale family busi-
ness was no longer a viable unit. Despite a long rearguard action, many of the
traditional industries – tailoring, furniture making, many of the service and distrib-
utive trades linked to the docks – rapidly declined or were bought out. Symbolic
of this was the disappearance of the corner shop; where these were not demolished
by redevelopment they were replaced by larger supermarkets, often owned by large
combines. . . . The local economy as a whole contracted, became less diverse. The
only section of the community which was unaffected by this was dockland, which
retained its position in the labour market and, with it, its traditions of militancy. It
did not, though, remain unaffected by the breakdown of the pattern of integration
in the East End as a whole *vis-à-vis* its sub-community structure. Perhaps this goes
some way to explaining the paradoxical fact that within the space of twelve months
the dockers could march in support of Enoch Powell and take direct action for
community control in the Isle of Dogs!

If someone should ask why the plan to 'modernize' the pattern of East End life
should have been such a disaster, perhaps the only honest answer is that given the
macro-social forces acting on it, given the political, ideological and economic frame-
work within which it operated, the result was inevitable. For example, many local
people wonder why the new environment should be the way it is. The reasons are

complex. They are political in so far as the system does not allow for any effective participation by a local working-class community in the decision-making process at any stage or level of planning. The clients of the planners are simply the local authority or the commercial developer who employs them. They are ideological in so far as the plans are unconsciously modelled on the structure of the middle-class environment, which is based on the concept of *property* and private *ownership*, on individual differences of status, wealth and so on, whereas the structure of the working-class environment is based on the concept of community or collective identity, common lack of ownership, wealth, etc. Similarly, needs were assessed on the norms of the middle-class nuclear family rather than on those of the extended working-class family. But underpinning both these sets of reasons lie the basic economic factors involved in comprehensive redevelopment. Quite simply, faced with the task of financing a large housing programme, local authorities are forced to borrow large amounts of capital and also to design schemes which would attract capital investment to the area. This means that they have to borrow at the going interest rates, which in this country are very high, and that to subsidize housing certain of the best sites have to be earmarked for commercial developers.

All this means that planners have to reduce the cost of production to a minimum through the use of capital-intensive techniques – prefabricated and standardized components which allow for semi-automated processes in construction. The attraction of high-rise developments ('tower blocks', outside the trade) is that they not only meet these requirements but they also allow for certain economies of scale, such as the input costs of essential services, which can be grouped around a central core. As for 'non-essential' services, that is, ones that don't pay, such as playspace, community centres, youth clubs and recreational facilities, these often have to be sacrificed to the needs of commercial developers – who, of course, have quite different priorities.

The situation facing East Enders at present is not new. When the first tenements went up in the nineteenth century they provoked the same objections from local people, and for the same very good reasons, as their modern counterparts, the tower blocks. What *is* new is that in the nineteenth century the voice of the community was vigorous and articulate on these issues, whereas today, just when it needs it most, the community is faced with a crisis of indigenous leadership.

The reasons for this are already implicit in the analysis above. The labour aristocracy, the traditional source of leadership, has virtually disappeared, along with the artisan mode of production. At the same time there has been a split in consciousness between the spheres of production and consumption. More and more East Enders are forced to work outside the area; young people especially are less likely to follow family traditions in this respect. As a result, the issues of the workplace are no longer experienced as directly linked to community issues. Of course, there has always been a 'brain drain' of the most articulate, due to social mobility. But not only has this been intensified as a result of the introduction of comprehensive schools, but the recruitment of fresh talent from the stratum below – from the ranks of the respectable working class, that is – has also dried up. For this stratum, traditionally the social cement of the community, is also in a state of crisis.

The economic changes which we have already described also affected its position and, as it were, *destabilized* it. The 'respectables' found themselves caught and pulled apart by two opposed pressures of social mobility – downwards, and upwards

into the ranks of the new suburban working-class elite. And, more than any other section of the working class, they were caught in the middle of the two dominant but contradictory ideologies of the day: the ideology of spectacular consumption, promoted by the mass media, and the traditional ideology of production, the so-called work ethic, which centred on the idea that a man's dignity, his manhood even, was measured by the quantity or quality of his effort in production. If this stratum began to split apart, it was because its existing position had become unten-able. Its bargaining power in the labour market was threatened by the introduction of new automated techniques, which eliminated many middle-range, semi-skilled jobs. Its economic position excluded its members from entering the artificial paradise of the new consumer society; at the same time changes in the production process itself have made the traditional work ethic, pride in the job, impossible to uphold. They had the worst of all possible worlds.

Once again, this predicament was registered most deeply in and on the young. But here an additional complicating factor intervenes. We have already described the peculiar strains imposed on the 'nucleated' working-class family. And their most critical impact was in the area of parent/child relationships. What had previously been a source of support and security for both now became something of a battle-ground, a major focus of all the anxieties created by the disintegration of community structures around them. One result of this was to produce an increase in early marriage. For one way of escaping from the claustrophobic tensions of family life was to start a family of your own! And given the total lack of accommodation for young, single people in the new developments, as well as the conversion of cheap rented accommodation into middle-class, owner-occupied housing, the only prac-ticable way to leave home was to get married. The second outcome of generational conflict (which may appear to go against the trend of early marriage, but in fact reinforced it) was the emergence of specific youth subcultures in opposition to the parent culture. And one effect of this was to weaken the links of historical and cultural continuity, mediated through the family, which had been such a strong force for solidarity in the working-class community. It is, perhaps, not surprising that the parent culture of the respectable working class, already in crisis, was the most 'productive' *vis-à-vis* subcultures; the internal conflicts of the parent culture came to be worked out in terms of generational conflict. What I think is that one of the functions of generational conflict is to decant the kinds of tensions which appear face-to-face in the family and to replace them by a generational-specific symbolic system, so that the tension is taken out of the interpersonal context, placed in a collective context and mediated through various stereotypes which have the function of defusing the anxiety that interpersonal tension generates.

It seems to me that the latent function of subculture is this: to express and resolve, albeit 'magically', the contradictions which remain hidden or unresolved in the parent culture. The succession of subcultures which this parent culture gener-ated can thus all be considered so many variations on a central theme – the contradiction, at an ideological level, between traditional working-class puritanism and the new hedonism of consumption; at an economic level, between a future as part of the socially mobile elite or as part of the new lumpen proletariat. Mods, parkas, skinheads, crombies all represent, in their different ways, an attempt to retrieve some of the socially cohesive elements destroyed in their parent culture,

and to combine these with elements selected from other class fractions, symbolizing one or other of the options confronting it.

It is easy enough to see this working in practice if we remember, first, that subcultures are symbolic structures and must not be confused with the actual kids who are their bearers and supports. Secondly, a given life-style is actually made up of a number of symbolic subsystems, and it is the way in which these are articulated in the total life-style that constitutes its distinctiveness. There are basically four subsystems, which can be divided into two basic types of forms. There are the relatively 'plastic' forms – dress and music – which are not directly produced by the subculture but which are selected and invested with subcultural value in so far as they express its underlying thematic. Then there are the more 'infrastructural' forms – argot and ritual – which are most resistant to innovation but, of course, reflect changes in the more plastic forms. I'm suggesting here that mods, parkas, skinheads, crombies are a succession of subcultures which all correspond to the same parent culture and which attempt to work out, through a system of transformations, the basic problematic or contradiction which is inserted in the subculture by the parent culture. So one can distinguish three levels in the analysis of subcultures; one is historical analysis, which isolates the specific problematic of a particular class fraction – in this case, the respectable working class; the second is a structural or semiotic analysis of the subsystems, the way in which they are articulated and the actual transformations which those subsystems undergo from one structural moment to another; and the third is the phenomenological analysis of the way the subculture is actually 'lived out' by those who are the bearers and supports of the subculture. No real analysis of subculture is complete without all those levels being in place.

To go back to the diachronic string we are discussing, the original mod life-style could be interpreted as an attempt to realize, *but in an imaginary relation*, the conditions of existence of the socially mobile white-collar worker. While the argot and ritual forms of mods stressed many of the traditional values of their parent culture, their dress and music reflected the hedonistic image of the affluent consumer. The life-style crystallized in opposition to that of the rockers (the famous riots in the early sixties testified to this), and it seems to be a law of subcultural evolution that its dynamic comes not only from the relations to its own parent culture, but also from the relation to subcultures belonging to *other class factions*, in this case the manual working class.

The next members of our string – the parkas or scooter boys – were in some senses a transitional form between the mods and the skinheads. The alien elements introduced into music and dress by the mods were progressively de-stressed and the indigenous components of argot and ritual reasserted as the matrix of subcultural identity. The skinheads themselves carried the process to completion. Their life-style, in fact, represents a systematic inversion of the mods – whereas the mods explored the upwardly mobile option, the skinheads explored the lumpen. Music and dress again became the central focus of the life-style; the introduction of reggae (the protest music of the West Indian poor) and the 'uniform' (of which more in a moment) signified a reaction against the contamination of the parent culture by middle-class values and a reassertion of the integral values of working-class culture through its most recessive traits – its puritanism and chauvinism. This double movement gave rise to a phenomenon sometimes called 'machismo' – the unconscious dynamics of the work ethic translated into the out-of-work situation; the most

dramatic example of this was the epidemic of 'queer-bashing' around the country in 1969–70. The skinhead uniform itself could be interpreted as a kind of carica- ture of the model worker – the self-image of the working class as distorted through middle-class perceptions, a metastatement about the whole process of social mobility. Finally, the skinhead life-style crystallized in opposition both to the greasers (successors to the rockers) and the hippies – both subcultures representing a species of hedonism which the skinheads rejected.

Following the skinheads there emerged another transitional form, variously known as crombies, casuals, suedes and so on (the proliferation of names being a mark of transitional phases). They represent a movement back towards the original mod position, although this time it is a question of incorporating certain elements drawn from a middle-class subculture – the hippies – which the skinheads had previ- ously ignored. But even though the crombies have adopted some of the external mannerisms of the hippy life-style (dress, soft drug use), they still conserve many of the distinctive features of earlier versions of the subculture.

If the whole process, as we have described it, seems to be circular, forming a closed system, then this is because subculture, by definition, cannot break out of the contradiction derived from the parent culture; it merely transcribes its terms at a microsocial level and inscribes them in an imaginary set of relations.

But there is another reason. Apart from its particular, thematic contradiction, all subcultures share a general contradiction which is inherent in their very condi- tions of existence. Subculture invests the weak points in the chain of socialization between the family/school nexus and integration into the work process which marks the resumption of the patterns of the parent culture for the next generation. But subculture is also a compromise solution to two contradictory needs: the need to create and express *autonomy and difference* from parents and, by extension, their culture and the need to maintain the security of existing ego defences and the *parental identifications* which support them. For the initiates the subculture provides a means of 'rebirth' without having to undergo the pain of symbolic death. The autonomy it offers is thus both real (but partial) and illusory as a total 'way of liberation'. And far from constituting an improvised *rite de passage* into adult society, as some anthro- pologists have claimed, it is a collective and highly ritualized defence against just such a transition. And because defensive functions predominate, ego boundaries become cemented into subcultural boundaries. In a real sense, subcultural conflict (greasers *versus* skinheads, mods *versus* rockers) serves as a displacement of genera- tional conflict, both at a cultural level and at an interpersonal level within the family. One consequence of this is to foreclose artificially the natural trajectory of adoles- cent revolt. For the kids who are caught up in the internal contradictions of a subculture, what begins as a break in the continuum of social control can easily become a permanent hiatus in their lives. Although there is a certain amount of subcultural mobility (kids evolving from mods to parkas or even switching subcul- tural affiliations, greasers 'becoming' skinheads), there are no career prospects! There are two possible solutions: one leads out of subculture into early marriage, and, as we've said, for working-class kids this is the normal solution; alternatively, subcultural affiliation can provide a way into membership of one of the deviant groups which exist in the margins of subculture and often adopt its protective coloration, but which nevertheless are not structurally dependent on it (such groups as pushers, petty criminals, junkies, even homosexuals).

This leads us into another contradiction inherent in subculture. Although as a symbolic structure it *does* provide a diffuse sense of affinity in terms of a common life-style, it does not in itself prescribe any crystallized group structure. It is through the function of *territoriality* that subculture becomes anchored in the collective reality of the kids who are its bearers, and who in this way become not just its passive support but its conscious agents. Territoriality is simply the process through which environmental boundaries (and foci) are used to signify group boundaries (and foci) and become invested with a subcultural value. This is the function of football teams for the skinheads, for example. Territoriality is thus not only a way in which kids 'live' subculture as a collective behaviour, but also the way in which the subcultural group becomes rooted in the situation of its community. In the context of the East End, it is a way of retrieving the solidarities of the traditional neighbourhood destroyed by development. The existence of communal space is reasserted as the common pledge of group unity – you belong to the Mile End mob in so far as Mile End belongs to you. Territoriality appears as a magical way of expressing ownership; for Mile End is not owned by the people but by the property developers. Territorial division therefore appears within the subculture and, in the East End, mirrors many of the traditional divisions of sub-communities: Bethnal Green, Hoxton, Mile End, Whitechapel, Balls Pond Road and so on. Thus, in addition to conflict between subcultures, there also exists conflict within them, on a territorial basis. Both these forms of conflict can be seen as displacing or weakening the dynamics of generational conflict, which is in turn a displaced form of the traditional parameters of class conflict.

A distinction must be made between subcultures and delinquency. Many criminologists talk of delinquent subcultures. In fact, they talk about anything that is not middle-class culture as subculture. From my point of view, I do not think the middle class produces subcultures, for subcultures are produced by a dominated culture, not by a dominant culture. I am trying to work out the way that subcultures have altered the pattern of working-class delinquency. But now I want to look at the delinquent aspect.

For during this whole period there was a spectacular rise in the delinquency rates in the area, even compared with similar areas in other parts of the country. The highest increase was in offences involving attacks on property – vandalism, hooliganism of various kinds, the taking and driving away of cars. At the simplest level this can be interpreted as some kind of protest against the general dehumanization of the environment, an effect of the loss of the informal social controls generated by the old neighbourhoods. The delinquency rate also, of course, reflected the level of police activity in the area and the progressively worsening relations between young people and the forces of law and order. Today, in fact, the traditional enmity has become something more like a scenario of urban guerrilla warfare!

There are many ways of looking at delinquency. One way is to see it as the expression of a system of transactions between young people and various agencies of social control, in the subcultural context of territoriality. One advantage of this definition is that it allows us to make a conceptual distinction between delinquency and deviancy, and to reserve this last term for groups (for example, prostitutes, professional criminals, revolutionaries) which crystallize around a specific counter-ideology, and even career structure, which cuts across age grades and often community or class boundaries. While there is an obvious relation between the two,

delinquency often serving as a means of recruitment into deviant groups, the distinction is still worth making.

Delinquency can be seen as a form of communication about a situation of contradiction in which the 'delinquent' is trapped but whose complexity is excommunicated from his perceptions by virtue of the restricted linguistic code which working-class culture makes available to him. Such a code, despite its richness and concreteness of expression, does not allow the speaker to make verbally explicit the rules of relationship and implicit value systems which regulate interpersonal situations, since this operation involves the use of complex syntactical structures and a certain degree of conceptual abstraction not available through this code. This is especially critical when the situations are institutional ones, in which the rules of relationship are often contradictory, denied or disguised but nevertheless binding on the speaker. For the working-class kid this applies to his family, where the positional rules of extended kinship reverberate against the personalized rules of its new nuclear structure; in the school, where middle-class teachers operate a whole series of linguistic and cultural controls which are 'dissonant' with those of his family and peers, but whose mastery is implicitly defined as the index of intelligence and achievement; at work, where the mechanism of exploitation (extraction of surplus value, capital accumulation) are screened off from perception by the apparently free exchange of so much labour time for so much money wage. In the absence of a working-class ideology which is both accessible and capable of providing a concrete interpretation of such contradictions, what can a poor boy do? Delinquency is one way he can communicate, can represent by analogy and through non-verbal channels the dynamics of some of the social configurations he is locked into. And if the content of this communication remains largely 'unconscious', then that is because, as Freud would say, it is 'over-determined'. For what is being communicated is not one but *two different* systems of rules: one belonging to the sphere of object relations and the laws of symbolic production (more specifically, the parameters of Oedipal conflict), the second belonging to property relations, the laws of material production (more specifically, the parameters of class conflict).

Without going into this too deeply, I would suggest that where there is an extended family system the Oedipal conflict is displaced from the triadic situation to sibling relations, which then develops into the gang outside the family. When this begins to break down the reverse process sets in. In the study of the structural relations for the emergence of subcultures the implications of this are twofold: first, changes in the parameters of class conflict are brought about by advanced technology where there is some class consensus between certain parent cultures, and that level of conflict appears to be invisible or acted on in various dissociated ways; second, the parameters of Oedipal conflict are becoming replaced in the family context but are refracted through the peer-group situation. It is a kind of double inversion that needs to be looked at not only in terms of a Marxist theory, which would analyse it simply by reference to class conflict and the development of antagonistic class fractions simply syphoning down vertically into another generational situation, but also in psychoanalytic terms, through the dynamics of Oedipal conflict in adolescence. We need to look at the historical ways in which class conflict and the dynamics of Oedipal conflict have undergone transformation and have interlocked, reverberating against each other.

John Clarke, Stuart Hall, Tony Jefferson and Brian Roberts

SUBCULTURES, CULTURES AND CLASS [1975]

S UBCULTURES MUST EXHIBIT a distinctive enough shape and structure to make them identifiably different from their 'parent' culture. They must be focused around certain activities, values, certain uses of material artefacts, territorial spaces etc. which significantly differentiate them from the wider culture. But, since they are sub-sets, there must also be significant things which bind and articulate them with the 'parent' culture. The famous Kray twins, for example, belonged both to a highly differentiated 'criminal subculture' in East London and to the 'normal' life and culture of the East End working class (of which indeed, the 'criminal subculture' has always been a clearly identifiable part). The behaviour of the Krays in terms of the criminal fraternity marks the differentiating axis of that subculture: the relation of the Krays to their mother, family, home and local pub is the binding, the articulating axis. . . .

Subcultures, therefore, take shape around the distinctive activities and 'focal concerns' of groups. They can be loosely or tightly bounded. Some subcultures are merely loosely-defined strands or 'milieux' within the parent culture: they possess no distinctive 'world' of their own. Others develop a clear, coherent identity and structure. . . . When these tightly-defined groups are also distinguished by age and generation, we call them 'youth sub-cultures'.

'Youth subcultures' form up on the terrain of social and cultural life. Some youth subcultures are regular and persistent features of the 'parent' class-culture: the ill-famed 'culture of delinquency' of the working-class adolescent male, for example. But some subcultures appear only at particular historical moments: they become visible, are identified and labelled (either by themselves or by others): they command the stage of public attention for a time: then they fade, disappear or are so widely diffused that they lose their distinctiveness. It is the *latter* kind of subcultural formation which primarily concerns us here. The peculiar dress, style, focal concerns, milieux, etc. of the Teddy Boy, the Mod, the Rocker or the Skinhead set

them off, as distinctive groupings, both from the broad patterns of working-class culture as a whole, and also from the more diffused patterns exhibited by 'ordinary' working-class boys (and, to a more limited extent, girls). Yet, despite these differences, it is important to stress that, as subcultures, they continue to exist within, and coexist with, the more inclusive culture of the class from which they spring. Members of a subculture may walk, talk, act, look 'different' from their parents and from some of their peers: but they belong to the same families, go to the same schools, work at much the same jobs, live down the same 'mean streets' as their peers and parents. In certain crucial respects, they share the same position (vis-à-vis the dominant culture), the same fundamental and determining life-experiences, as the 'parent' culture from which they derive. Through dress, activities, leisure pursuits and life-style, they may project a different cultural response or 'solution' to the problems posed for them by their material and social class position and experience. But the membership of a subculture cannot protect them from the determining matrix of experiences and conditions which shape the life of their class as a whole. They experience and respond to the *same basic problematic* as other members of their class who are not so differentiated and distinctive in a 'subcultural' sense. Especially in relation to the *dominant* culture, their subculture remains like other elements in their class culture – subordinate and subordinated.

In what follows, we shall try to show why this *double articulation* of youth subcultures – first, to their 'parent' culture (e.g. working-class culture), second, to the dominant culture – is a necessary way of staging the analysis. For our purposes, subcultures represent a necessary, 'relatively autonomous', but *inter-mediary* level of analysis. Any attempt to relate subcultures to the 'socio-cultural formation as a whole' must grasp its complex unity by way of these necessary differentiations. . . .

To locate youth subculture in this kind of analysis, we must first situate youth in the dialectic between a 'hegemonic' dominant culture and the subordinate working-class 'parent' culture, of which youth is a fraction. These terms – hegemonic/corporate, dominant/subordinate – are crucial for the analysis, but need further elaboration before the subcultural dimension can be introduced. Gramsci used the term 'hegemony' to refer to the moment when a ruling class is able, not only to *coerce* a subordinate class to conform to its interests, but to exert a 'hegemony' or 'total social authority' over subordinate classes. This involves the exercise of a special kind of power – the power to frame alternatives and contain opportunities, *to win and shape consent*, so that the granting of legitimacy to the dominant classes appears not only 'spontaneous' but natural and normal. Lukes has recently defined this as the power to define the agenda, to shape preferences, to 'prevent conflict from arising in the first place', or to contain conflict when it does arise by defining what sorts of resolution are 'reasonable' and 'realistic' – i.e. within the existing framework (Lukes 1974: 23–4). The terrain on which this hegemony is won or lost is the terrain of the superstructures; the institutions of civil society and the state – what Althusser (1971) and Poulantzas (1973), somewhat misleadingly, call 'ideological state apparatuses'. Conflicts of interest arise, fundamentally, from the difference in the structural position of the classes in the productive realm: but they 'have their effect' in social and political life. Politics, in the widest sense, frames the passage from the first level to the second. The terrain of civil and state institutions thus becomes essentially 'the stake, but also the site of class struggle' (Althusser

1971). In part, these apparatuses work 'by ideology'. That is, the definitions of reality institutionalised within these apparatuses come to constitute a lived 'reality as such' for the subordinate classes – that, at least, is what hegemony attempts and secures. . . .

Hegemony works through ideology, but it does not consist of false ideas, perceptions, definitions. It works *primarily* by inserting the subordinate class into the key institutions and structures which support the power and social authority of the dominant order. It is, above all, in these structures and relations that a subordinate class *lives its subordination*. Often, this subordination is secured only because the dominant order succeeds in weakening, destroying, displacing or incorporating alternative institutions of defence and resistance thrown up by the subordinate class. Gramsci insists, quite correctly, that 'the thesis which asserts that men become conscious of fundamental conflicts on the level of ideology is not psychological or moralistic in character but *structural and epistemological*' (our italics; Gramsci 1971: 164).

Hegemony can rarely be sustained by one, single class stratum. Almost always it requires an *alliance* of ruling-class fractions – a 'historical bloc'. The content of hegemony will be determined, in part, by precisely which class fractions compose such a 'hegemonic bloc', and thus what interests have to be taken into account within it. Hegemony is not simple 'class rule'. It requires to some degree the 'consent' of the subordinate class, which has, in turn, to be won and secured; thus, an ascendancy of social authority, not only in the state but in civil society as well, in culture and ideology. Hegemony prevails when ruling classes not only rule or 'direct' but *lead*. The state is a major educative force in this process. It educates through its regulation of the life of the subordinate classes. These apparatuses reproduce class relations, and thus class subordination (the family, the school, the church and cultural institutions, as well as the law, the police and the army, the courts).

The struggle against class hegemony also takes place within these institutions, as well as outside them – they become the 'site' of class struggle. But the apparatuses also depend on the operation of 'a set of predominant values, beliefs, rituals and institutional procedures ("rules of the game") that operate systematically and consistently to the benefit of certain persons and groups' (Bacrach and Baratz 1962). . . .

In relation to the hegemony of a ruling class, the working class is, by definition, a *subordinate* social and cultural formation. Capitalist production, Marx suggested, reproduces capital and labour in their ever-antagonistic forms. The role of hegemony is to ensure that, in the social relations between the classes, each class is continually *reproduced* in its existing dominant-or-subordinate form. Hegemony can never wholly and absolutely absorb the working-class *into* the dominant order. Society may seem to be, but cannot actually ever be, in the capitalist mode of production, 'one-dimensional'. Of course, at times, hegemony is strong and cohesive, and the subordinate class is weak, vulnerable and exposed. But it cannot, by definition, disappear. It remains, as a subordinate structure, often separate and impermeable, yet still contained by the overall rule and domination of the ruling class. The subordinate class has developed its own corporate culture, its own forms of social relationship, its characteristic institutions, values, modes of life. . . .

Working-class culture has consistently 'won space' from the dominant culture. Many working-class institutions represent the different outcomes of this intense kind of 'negotiation' over long periods. At times, these institutions are adaptive; at other

times, combative. Their class identity and position are never finally 'settled': the balance of forces within them remains open. They form the basis of what Parkin has called a '"negotiated version" of the dominant system . . . dominant values are not so much rejected or opposed as modified by the subordinate class as a result of circumstances and restricted opportunities' (Parkin 1971: 92). Often, such 'negotiated solutions' prevail, not because the class is passive and deferential to ruling class ideas, but because its perspectives are bounded and contained by immediate practical concerns or limited to concrete situations. . . .

Negotiation, resistance, struggle: the relations between a subordinate and a dominant culture, wherever they fall within this spectrum, are always intensely active, always oppositional, in a structural sense (even when this opposition is latent, or experienced simply as the normal state of affairs). Their outcome is not given but *made*. The subordinate class brings to this 'theatre of struggle' a repertoire of strategies and responses – ways of coping as well as of resisting. Each strategy in the repertoire mobilises certain real material and social elements: it constructs these into the supports for the different ways the class lives and resists its continuing subordination. . . .

We can return, now, to the question of 'subcultures'. Working-class subcultures, we suggested, take shape on the level of the social and cultural class-relations of the subordinate classes. In themselves, they are not simply 'ideological' constructs. They, too, *win space* for the young: cultural space in the neighbourhood and institutions, real time for leisure and recreation, actual room on the street or street-corner. They serve to mark out and appropriate 'territory' in the localities. They focus around key occasions of social interaction: the weekend, the disco, the bank-holiday trip, the night out in the 'centre', the 'standing-about-doing-nothing' of the weekday evening, the Saturday match. They cluster around particular locations. They develop specific rhythms of interchange, structured relations between members: younger to older, experienced to novice, stylish to square. They explore 'focal concerns' central to the inner life of the group: things always 'done' or 'never done', a set of social rituals which underpin their collective identity and define them as a 'group' instead of a mere collection of individuals. They adopt and adapt material objects – goods and possessions – and reorganise them into distinctive 'styles' which express the collectivity of their being-as-a-group. These concerns, activities, relationships, materials become embodied in rituals of relationship and occasion and movement. Sometimes, the world is marked out, linguistically, by names or an *argot* which classifies the social world exterior to them in terms meaningful only within their group perspective, and maintains its boundaries. This also helps them to develop ahead of immediate activities a perspective on the immediate future – plans, projects, things to do to fill out time, exploits . . . They too are concrete, identifiable social formations constructed as a collective response to the material and situated experience of their class.

Though not 'ideological', subcultures have an ideological dimension: and, in the problematic situation of the post-war period, this ideological component became more prominent. In addressing the 'class problematic' of the particular strata from which they were drawn, the different subcultures provided for a section of working-class youth (mainly boys) *one* strategy for negotiating their collective existence. But their highly ritualised and stylised form suggests that they were also *attempts at a*

solution to that problematic experience: a resolution which, because pitched largely at the symbolic level, was fated to fail. The problematic of a subordinate class experience can be 'lived through', negotiated or resisted; but it cannot be *resolved* at that level or by those means. There is no 'subcultural career' for the working-class lad, no 'solution' in the subcultural milieu, for problems posed by the key structuring experiences of the class.

There is no 'subcultural solution' to working-class youth unemployment, educational disadvantage, compulsory miseducation, dead-end jobs, the routinisation and specialisation of labour, low pay and the loss of skills. Subcultural strategies cannot match, meet or answer the structuring dimensions emerging in this period for the class as a whole. So, when the post-war subcultures address the problematics of their class experience, they often do so in ways which reproduce the gaps and discrepancies between real negotiations and symbolically displaced 'resolutions'. They 'solve', but in an imaginary way, problems which at the concrete material level remain unresolved. Thus the 'Teddy Boy' expropriation of an upper-class style of dress 'covers' the gap between largely manual, unskilled, near-lumpen real careers and life-chances, and the 'all-dressed-up-and-nowhere-to-go' experience of Saturday evening. Thus, in the expropriation and fetishisation of consumption and style itself, the 'Mods' cover for the gap between the never-ending-weekend and Monday's resumption of boring, dead-end work. Thus, in the resurrection of an archetypal and 'symbolic' (but, in fact, anachronistic) form of working-class dress, in the displaced focusing on the football match and the 'occupation' of the football 'ends', Skinheads reassert, but 'imaginarily', the values of a class, the essence of a style, a kind of 'fan-ship' to which few working-class adults any longer subscribe: they 're-present' a sense of territory and locality which the planners and speculators are rapidly destroying: they 'declare' as alive and well a game which is being commercialised, professionalised and spectacularised. 'Skins Rule, OK'. OK? But

> in ideology, men do indeed express, not the real relation between them and their conditions of existence, but *the way* they live the relation between them and the conditions of their existence; this presupposes both a real and an '*imaginary*', '*lived*' relation. Ideology then, is . . . the (over determined) unity of the real relation and the imaginary relation . . . that expresses a will . . . a hope, or a nostalgia, rather than describing a reality.
>
> (Althusser 1969: 233–4)

Working-class subcultures are a response to a problematic which youth shares with other members of the 'parent' class culture. . . . But, over and above these shared class situations, there remains something privileged about the specifically *generational experience* of the young. Fundamentally, this is due to the fact that youth encounters the problematic of its class culture in *different sets of institutions and experiences* from those of its parents; and when youth encounters the same structures, it encounters them at *crucially different points* in its biographical careers.

We can identify these aspects of 'generational specificity' in relation to the three main life areas we pointed to earlier: education, work and leisure. Between the ages of five and sixteen, education is the institutional sphere which has the most sustained

and intensive impact on the lives of the young. It is the 'paramount reality' imposing itself on experience, not least through the fact that it cannot (easily) be avoided. By contrast, the older members of the class encounter education in various *indirect* and distanced ways: through remembered experiences ('things have changed' nowadays); through special mediating occasions – parents' evenings, etc.; and through the interpretations the young give of their school experiences.

In the area of work, the difference is perhaps less obvious, in that both young and old alike are facing similar institutional arrangements, organisations and occupational situations. But within this crucial differences remain. The young face the problem of choosing and entering jobs, of learning both the formal and informal cultures of work – the whole difficult transition from school to work. . . .

In the broader context, the young are likely to be more vulnerable to the consequence of increasing unemployment than are older workers: in the unemployment statistics of the late [1960s], unskilled school leavers were twice as likely to be unemployed as were older, unskilled workers. In addition, the fact of unemployment is likely to be differentially *experienced* at different stages in the occupational 'career'.

Finally, leisure must be seen as a significant life-area for the class. As Marx observed,

> The worker therefore only feels himself outside his work, and in his work feels outside himself. He is at home when he is not working, and when he is working he is not at home. His labour is therefore not voluntary but coerced; it is forced labour. It is therefore not the satisfaction of a need; it is merely the means to satisfy needs external to it.
>
> (Marx 1964: 110–11)

In working-class leisure, we see many of the results of that 'warrenning' of society by the working-class discussed above. Leisure and recreation seem to have provided a more negotiable space than the tightly-disciplined and controlled work situation. The working-class has imprinted itself indelibly on many areas of mass leisure and recreation. These form an important part of the corporate culture and are central to the experience and cultural identity of the whole class. Nevertheless, there are major differences in the ways working-class adults and young people experience and regard leisure. This difference became intensified in the 1950s and 1960s, with the growth of the 'teenage consumer' and the reorganisation of consumption and leisure provision (both commercial and non-commercial) in favour of a range of goods and services specifically designed to attract a youthful clientele. This widespread availability and high visibility of Youth Culture structured the leisure sphere in crucially different ways for the young. The equation of youth with consumption and leisure rearranged and *intensified* certain long-standing parent culture orientations; for example, towards the special and privileged meaning of 'freetime', and towards 'youth' as a period for 'having a good time while you can' – the 'last fling'. This reshaping of attitudes from within the class, in conjunction with pressures to rearrange and redistribute the patterns of leisure for the young from outside, served to highlight – indeed to *fetishise* – the meaning of leisure for the young. Thus, not only did youth encounter leisure in different characteristic institutions from their

parents (caffs, discos, youth clubs, 'all nighters', etc.): these institutions powerfully presented themselves to the young as different from the past, partly because they were so uncompromisingly youthful.

Here we begin to see how forces, working right across a class, but differentially experienced as between the generations, may have formed the basis for generating an outlook – a kind of consciousness – specific to age position: a *generational consciousness*. We can also see exactly why this 'consciousness', though formed by class situation and the forces working in it, may nevertheless have taken the form of a consciousness apparently separate from, unrelated to, indeed, able to be set over against, its class content and context. . . . A 'generational consciousness' is likely to be strong among those sectors of youth which are upwardly and outwardly mobile from the workings class – e.g. [Richard] Hoggart's 'scholarship boy'. Occupational and educational change in this period led to an increase in these paths of limited mobility. The upward path, through education, leads to a special focusing on *the school and the education system* as the main mechanism of advancement: it is this which 'makes the difference' between parents who stay where they were and children who move on and up. It involves the young person valuing the dominant culture positively, and sacrificing the 'parent' culture – even where this is accompanied by a distinct sense of cultural disorientation. His experience and self-identity will be based around mobility – something specific to his generation, rather than to the over-determining power of class. One of the things which supports this taking-over of a 'generational consciousness' by the scholarship boy is, precisely, his cultural isolation – the fact that his career is different from the majority of his peers. The peer group is, of course, one of the real and continuing bases for collective identities organised around the focus of 'generation'. But a sense of generational distinctness may also flow from an individual's isolation from the typical involvement in kinds of peer-group activities which, though specific to youth, are clearly understood as forming a sort of cultural apprenticeship to the 'parent' class culture. This kind of isolation may be the result of biographical factors – e.g. inability to enter the local football game where football is the primary activity of the peer group; or being a member of a relatively 'closed' and tight family situation. A young person, who for whatever reasons, fails to go through this class-culture apprenticeship, may be more vulnerable to the vicarious peer-group experience provided by the highly visible and widely accessible commercially provided Youth Culture, where the audience as a whole substitutes for the real peer group as one, vast, symbolic 'peer group': 'Our Generation'.

'Generational consciousness' thus has roots in the real experience of working-class youth as a whole. But it took a peculiarly intense form in the post-war subcultures which were sharply demarcated – amongst other factors – by age and generation. Youth felt and experienced itself as 'different', especially when this difference was inscribed in activities and interests to which 'age', principally, provided the passport. This does not necessarily mean that a 'sense of class' was thereby obliterated. Skinheads, for example, are clearly both 'generationally' and 'class' conscious. As Phil Cohen suggested, 'subculture is . . . a compromise solution, between two contradictory needs: the need to create and express *autonomy and difference* from parents . . . and the need to maintain . . . the *parental identifications* which support them' (Cohen 1972: 26). It is to the formation of these generationally distinct working-class subcultures that we next turn. . . .

It is at the intersection between the located parent culture and the mediating institutions of the dominant culture that youth subcultures arise. Many forms of adaptation, negotiation and resistance, elaborated by the 'parent' culture in its encounter with the dominant culture, are borrowed and adapted by the young in *their* encounter with the mediating institutions of provision and control. In organising their response to these experiences, working-class youth subcultures take some things principally from the located 'parent' culture: but they apply and trans-form them to the situations and experiences characteristic of their own distinctive group-life and generational experience. Even where youth subcultures have seemed most distinctive, different, stylistically marked out from adults and other peer-group members of their 'parent' culture, they develop certain distinctive outlooks which have been, clearly, structured by the parent culture. We might think here of the recurrent organisation around collective activities ('group mindedness'); or the stress on 'territoriality' (to be seen in both the Teddy Boys and Skinheads); or the particular conceptions of masculinity and of male dominance (reproduced in all the post-war youth subcultures). The 'parent' culture helps to define these broad, historically located 'focal concerns'. Certain themes which are key to the 'parent culture' are reproduced at this level again and again in the subcultures, even when they set out to be, or are seen as, 'different'.

But there are also 'focal concerns' more immediate, conjunctural, specific to 'youth' and its situation and activities. On the whole, the literature on post-war sub-culture has neglected the first aspect (what is shared with the 'parent' culture) and over-emphasised what is distinct (the 'focal concerns' of the youth groups). But, this second element – which is, again, generationally very specific – must be taken seri-ously in any account. It consists both of the materials available to the group for the construction of subcultural identities (dress, music, talk), and of their contexts (activ-ities, exploits, places, caffs, dance halls, day-trips, evenings-out, football games, etc.). Journalistic treatments, especially, have tended to isolate *things*, at the expense of their use, how they are borrowed and transformed, the activities and spaces through which they are 'set in motion', the group identities and outlooks which imprint a style *on* things and objects. While taking seriously the significance of objects and things for a subculture, it must be part of our analysis to *de*-fetishise them.

The various youth subcultures have been identified by their possessions and objects: the boot-lace tie and velvet-collared drape jacket of the Ted, the close crop, parka coats and scooter of the Mod, the stained jeans, swastikas and ornamented motorcycles of the bike-boys, the bovver boots and skinned-head of the Skinhead, the Chicago suits or glitter costumes of the Bowieites, etc. Yet, despite their visi-bility, things simply appropriated and worn (or listened to) do not make a style. What makes a style is the activity of stylisation – the active organisation of objects with activities and outlooks, which produce an organised group-identity in the form and shape of a coherent and distinctive way of 'being-in-the-world'. Phil Cohen, for example, has tried to shift the emphasis away from things to the *modes* of symbolic construction through which style is generated in the subcultures. He identified four modes for the generation of the subcultural style: dress, music, ritual and *argot*. Whilst not wanting to limit the 'symbolic systems' to these particular four, and finding it difficult to accept the distinction (between less and more 'plastic') which he makes, we find this emphasis on group generation far preferable to the instant

stereotyped association between commodity-objects and groups common in jour-
nalistic usage.

Working-class subcultures could not have existed without a real economic base:
the growth in money wages in the 'affluent' period, but, more important, the fact
that incomes grew more rapidly for teenagers than for adults in the working-class,
and that much of this was 'disposable income' (income available for leisure and non-
compulsory spending). But income, alone, does not make a style either. The sub-
cultures could not have existed without the growth of a consumer market specifically
geared to youth. The new youth industries provided the raw materials, the goods:
but they did not, and when they tried failed to, produce many very authentic or sus-
tained 'styles' in the deeper sense. The objects were there, available, but were *used*
by the groups in the construction of distinctive styles. But this meant, not simply
picking them up, but actively constructing a specific selection of things and goods
into a style. And this frequently involved . . . subverting and transforming these
things, from their given meaning and use, to other meanings and uses. All com-
modities have a social use and thus a cultural meaning. We have only to look at the
language of commodities – advertising – where, as Barthes observes, there is no such
thing as a simple 'sweater': there is only a 'sweater for autumnal walks in the wood'
or a sweater for 'relaxing at home on Sundays', or a sweater for 'casual wear', and
so on (Barthes 1971). Commodities are, also, cultural *signs*. They have already been
invested, by the dominant culture, with meanings, associations, social connotations.
Many of these meanings seem fixed and 'natural'. But this is only because the dom-
inant culture has so fully appropriated them to its use, that the meanings which it
attributes to the commodities have come to appear as the only meaning which they
can express. In fact, in cultural systems, there is no 'natural' meaning as such.
Objects and commodities do not mean any one thing. They 'mean' only because
they have already been arranged, according to social use, into cultural codes of mean-
ing, which *assign meanings to them*. The bowler hat, pin-stripe suit and rolled umbrella
do not, in themselves, mean 'sobriety', 'respectability', bourgeois-man-at-work. But
so powerful is the social code which surrounds these commodities that it would be
difficult for a working-class lad to turn up for work dressed like that without, either,
aspiring to a 'bourgeois' image or clearly seeming to take the piss out of the image.
This trivial example shows that it is possible to expropriate, as well as to appropri-
ate, the social meanings which they seem 'naturally' to have: or, by combining them
with something else (the pin-stripe suit with brilliant red socks or white running
shoes, for example), to change or inflect their meaning. . . .

Working-class youth needed money to spend on expressive goods, objects and
activities – the post-war consumer market had a clear economic infrastructure. But
neither money nor the market could fully dictate what groups used these things to
say or *signify* about themselves. This re-signification was achieved by many different
means. One way was to inflect 'given' meanings by combining things borrowed
from one system of meanings into a different code, generated by the subculture
itself, and through subcultural use. Another way was to modify, by addition, things
which had been produced or used by a different social group (e.g. the Teddy Boy
modifications of Edwardian dress). . . . Another was to intensify or exaggerate or
isolate a given meaning and so change it (the 'fetishising' of consumption and appear-
ance by the Mods . . .; or the elongation of the pointed winkle-picker shoes of the

Italian style; or the current 'massification' of the wedge-shapes borrowed from the 1940s). Yet another way was to combine forms according to a 'secret' language or code, to which only members of the group possessed the key (e.g. the *argot* of many subcultural and deviant groups; the 'Rasta' language of black 'Rudies'). These are only *some* of the many ways in which the subcultures used the materials and commodities of the 'youth market' to construct meaningful styles and appearances for themselves.

Far more important were the aspects of group life which these appropriated objects and things were made to reflect, express and resonate. It is this reciprocal effect, between the things a group uses and the outlooks and activities which structure and define their use, which is the generative principle of stylistic creation in a subculture. This involves members of a group in the appropriation of particular objects which are, or can be made, 'homologous' with their focal concerns, activities, group structure and collective self-image – objects in which they can see their central values held and reflected. . . . The adoption by Skinheads of boots and short jeans and shaved hair was 'meaningful' in terms of the subculture only because these external manifestations resonated with and articulated Skinhead conceptions of masculinity, 'hardness' and 'working-classness'. This meant overcoming or negotiating or, even, taking over in a positive way many of the negative meanings which, in the dominant cultural code, attached to these things: the 'prison-crop' image of the shaved head, the work-image, the so-called 'outdated cloth-cap image', and so on. The new meanings emerge because the 'bits' which had been borrowed or revived were brought together into a new and distinctive stylistic *ensemble*: but also because the symbolic objects – dress, appearance, language, ritual occasions, styles of interaction, music – were made to form *a unity* with the group's relations, situation, experiences: the crystallisation in an expressive form, which then defines the group's public identity. The symbolic aspects cannot, then, be separated from the structure, experiences, activities and outlook of the groups as social formations. Subcultural style is based on the infra-structure of group relations, activities and contexts.

This registering of group identity, situation and trajectory in a visible style both consolidates the group from a loosely focused to a tightly bounded entity: and sets the group off, distinctively, from other similar and dissimilar groups. Indeed, like all other kinds of cultural construction, the symbolic use of things to consolidate and express an internal coherence was, in the same moment, a kind of implied opposition to (where it was not an active and conscious contradiction of) *other* groups *against* which its identity was defined. This process led, in our period, to the distinctive visibility of those groups which pressed the 'subcultural solution' to its limits along this stylistic path. It also had profound negative consequences for the labelling, stereotyping and stigmatisation, in turn, of those groups by society's guardians, moral entrepreneurs, public definers and the social control culture in general.

It is important to stress again that subcultures are only *one* of the many different responses which the young can make to the situations in which they find themselves. In addition to indicating the range and variation in the options open to youth, we might add a tentative scheme which helps to make clear the distinction we are drawing between youth's *position* and the cultural options through which particular responses are organised.

We can distinguish, broadly, between three aspects: structures, cultures and biographies. . . . By *structures* we mean the set of socially organised positions and experiences of the class in relation to the major institutions and structures. These positions generate a set of common relations and experiences from which meaningful actions – individual and collective – are constructed. *Cultures* are the range of socially organised and patterned responses to these basic material and social conditions. Though cultures form, for each group, a set of traditions – lines of action inherited from the past – they must always be collectively constructed anew in each generation. Finally, *biographies* are the 'careers' of particular individuals through these structures and cultures – the means by which individual identities and life-histories are constructed out of collective experiences. Biographies recognise the element of individuation in the paths which individual lives take through collective structures and cultures, but they must not be conceived as either wholly individual or free-floating. Biographies cut paths in and through the determined spaces of the structures and cultures in which individuals are located. Though we have not been able, here, to deal at all adequately with the level of biography, we insist that biographies only make sense in terms of the structures and cultures through which the individual constructs himself or herself.

Angela McRobbie and Jenny Garber

GIRLS AND SUBCULTURES [1977]

V ERY LITTLE SEEMS to have been written about the role of girls in youth cultural groupings. They are absent from the classic subcultural ethnographic studies, the pop histories, the personal accounts and the journalistic surveys of the field. When girls do appear, it is either in ways which uncritically reinforce the stereotypical image of women with which we are now so familiar . . . for example, Fyvel's reference, in his study of teddy boys [Fyvel 1961], to 'dumb, passive teenage girls, crudely painted' . . . or else they are fleetingly and marginally presented:

> It is as if everything that relates only to us comes out in footnotes to the main text, as worthy of the odd reference. We come on the agenda somewhere between 'Youth' and 'Any Other Business'. We encounter ourselves in men's cultures as 'by the way' and peripheral. According to all the reflections we are not really there.
>
> [Rowbotham 1973: 35]

How do we make sense of this invisibility? Are girls really not present in youth subcultures? Or is it something in the way this kind of research is carried out that renders them invisible? When girls are acknowledged in the literature, it tends to be in terms of their sexual attractiveness. But this, too, is difficult to interpret. For example, Paul Willis comments on the unattached girls who hung around with the motor-bike boys he was studying, as follows: 'What seemed to unite them was a common desire for an attachment to a male and a common inability to attract a man to a long-term relationship. They tended to be scruffier and less attractive than the attached girls' [Willis 1978].

Is this simply a typically dismissive treatment of girls reflecting the natural rapport between a masculine researcher and his male respondents? Or is it that the

researcher who is, after all, studying the motor-bike boys, finds it difficult not to take the boys' attitudes to and evaluation of the girls, seriously? He therefore reflects this in his descriptive language and he unconsciously adopts it in the context of the research situation. Willis later comments on the girls' responses to his questions. They are unforthcoming, unwilling to talk and they retreat, in giggles, into the background . . . Are these responses to the man as a researcher or are they the result of the girls' recognition that 'he' identifies primarily with 'them'? Is this characteristic of the way in which girls customarily negotiate the spaces provided for them in a male-dominated and male-defined culture? And does this predispose them to retreat, especially when it is also a situation in which they are being assessed and labelled according to their sexual attributes?

It is certainly the case that girls do not behave in this way in all mixed-sex situations. In the classroom, for example, girls will often display a great show of feminine strength from which men and boys will retreat. It may well be that in Willis's case the girls simply felt awkward and self-conscious about being asked questions in a situation where they did not feel particularly powerful or important, especially if they were not the steady girlfriends of the boys in question.

What follows is a tentative attempt to sketch some of the ways we might think about and research the relationship between girls and subcultures. Many of the concepts utilised in the study of male subcultures are retained: for example, the centrality of class, the importance of school, work, leisure and the family: the general social context within which the subcultures have emerged, and the structural changes in post-war British society which partially define the different subcultures. Added to these issues are the important questions of sex and gender. The crucial question is: How does this dimension reshape the field of youth cultural studies as it has come to be defined?

It has been argued recently for example that class is a critical variable in defining the different subcultural options available to middle-class and working-class boys. Middle-class subcultures offer more full-time careers, whereas working-class subcultures tend to be restricted to the leisure sphere. This structuring of needs and options must also work at some level for girls. It might be easier for middle-class hippie girls, for example, to find an 'alternative' career in the counter-culture than it would be for working-class skinhead girls to find a job in that culture. Some subcultural patterns are therefore true for both boys and girls, while others are much more gender-divergent.

It might even be the case that girls are not just marginal to the post-war youth cultures but located structurally in an altogether different position. If women are marginal to the male cultures of work, it is because they are central and pivotal to a subordinate sphere. They are marginal to work because they are central to the family. The marginality of girls in these 'spectacular' male-focused subcultures might redirect our attention away from this arena towards more immediately recognisable teenage and pre-teenage female spheres like those forming around teenybop stars and the pop-music industry. . . . Girls' subcultures may have become invisible because the very term 'subculture' has acquired such strong masculine overtones.

Are girls really absent from subcultures?

The most obvious factor which makes this question difficult to answer is the domination of sociological work (as is true of most areas of scholarship) by men. Paradoxically, the exclusion of women was as characteristic of the new radical theories of deviance and delinquency as it had been of traditional criminology. The editors of *Critical Criminology* argue that the new deviancy theory often amounted to a 'celebration rather than an analysis of the deviant form with which the deviant theorist could vicariously identify – an identification by powerless intellectuals with deviants who appeared more successful in controlling events' [Taylor, Walton and Young 1975]. With the possible exception of sexual deviance, women constituted an uncelebrated social category, for radical and critical theorists. This general invisibility was of course cemented by the social reaction to the more extreme manifestations of youth subcultures. The popular press and media concentrated on the sensational incidents associated with each subculture (for example, the teddy-boy killings, the Margate clashes between mods and rockers). One direct consequence of the fact that it is always the violent aspects of a phenomenon which qualify as newsworthy is that these are precisely the areas of subcultural activity from which women have tended to be excluded. . . .

Are girls present but invisible?

. . . Texts and images suggest . . . that girls were involved with and considered themselves as part of the teddy-boy subculture. Girls can be seen in footage from the 1950s dancing with teddy-boys at the Elephant and Castle; they can also be seen in the background in the news pictures taken during the Notting Hill race riots of 1958. There are, however, many reasons why, to working-class girls in the late 1950s, this was not a particularly attractive option.

Though girls participated in the general rise in the disposable income available to youth in the 1950s, girls' wages were not as high as those of boys. Patterns of spending were also structured in a different direction. Girls' magazines emphasised a particularly feminine mode of consumption and the working-class girl, though actively participating in the world of work, remained more focused on home and marriage than her male counterpart. Teddy-boy culture was an escape from the claustrophobia of the family, into the street and 'caff'. While many girls might adopt an appropriate way of dressing, complementary to the teds, they would be much less likely to spend the same amount of time hanging about on the streets. Girls had to be careful not to 'get into trouble' and excessive loitering on street corners might be taken as a sexual invitation to the boys. The double standard was probably more rigidly maintained in the 1950s than in any other time since then. The difficulty in obtaining effective contraception, the few opportunities to spend time unsupervised with members of the opposite sex, the financial dependency of the working-class woman on her husband, meant that a good reputation mattered above everything else. As countless novels of the moment record, neighbourhoods flourished on rumours and gossip and girls who spent too much time on the street were assumed to be promiscuous.

At the same time the expanding leisure industries were directing their attention to *both* boys and girls. Girls were as much the subject of attention as their male peers when it came to pin-up pictures, records and magazines. Girls could use these items and activities in a different context from those in which boys used them. Cosmetics of course were to be worn outside the home, at work and on the street, as well as in the dance-hall. But the rituals of trying on clothes, and experimenting with hair-styles and make-up were home-based activities. It might be suggested that girls' culture of the time operated within the vicinity of the home, or the friends' home. There was room for a great deal of the new teenage consumer culture within the confines of the girls' bedrooms. Teenage girls did participate in the new public sphere afforded by the growth of the leisure industries, but they could also consume at home, upstairs in their bedrooms.

The involvement of girls in the teddy-boy subculture was sustained therefore by a complementary but different pattern. What girls who considered themselves 'teddy-girls', did, and how they acted, was possibly exactly the same as their more conventional non-subcultural friends. It is gender therefore which structures differences rather than subcultural attachment. The same process can be seen at work in the emergence of rock and pop music. Girls and boys, in or out of subcultures, responded differently to this phenomenon. Boys tended to have a more participative and a more technically-informed relationship with pop, where girls in contrast became fans and readers of pop-influenced love comics. . . .

What broad factors might have created a situation where girls could find subcultural involvement an attractive possibility? The emergence of a softer more feminised subculture in the 1960s, might well have opened the doors to female participation. There were certainly thousands of 'mod' girls who made their appearance in the nightclubs, on the streets, at work and even on the fringes of the clashes between the mods and rockers during the various Bank-holiday weekends throughout the mid-1960s (and remembered in the film, *Quadrophenia*). It may well be that the mod preoccupation with style and the emergence of the unisex look and the 'effeminate' mod man, gave girls a more legitimate place in the subculture than had previously been the case.

This trend was confirmed and extended as mod moved towards the consumerist mainstream, and as it began to give way simultaneously to the hippy underground and psychedelia. In this space, inhabited largely though not exclusively by middle-class youth, we also find women taking on a much higher profile. . . .

Where girls are visible, what are their roles and do these reflect the general subordination of women in culture?

Three selected images – the motor-bike girl, the 'mod' girl, and the hippy – will have to do here: where girls are present, but where the way they are present suggests that their cultural subordination is retained and reproduced.

Motor-bike girl

The motor-bike girl, leather-clad, [became] a sort of subcultural pin-up heralding – as it appeared in the press – a new and threatening sort of sexuality. This image

was often used as a symbol of the new permissive sexuality of the 1960s and was encapsulated in the figure of Brigitte Bardot astride a motor-bike with her tousled hair flying behind her. More mundanely this image encoded female sexuality in a modern, bold and abrasive way. With matte pan-stick lips, an insolent expression in her eyelined eyes and an unzipped jacket, the model looked sexual, numbed and unfeeling, almost expressionless. This was an image therefore at odds with conventional femininity and suggestive of sexual deviance. At the same time this very image was utilised in advertising and in soft pornography, an example of how – within the repertoire of subcultural representations – girls and women have always been located nearer to the point of consumerism than to the 'ritual of resistance'.

In rocker or motor-bike culture this sexualised image of a girl riding a bike remained a fantasy rather than a reality. Girls were rarely if ever seen at the handles and instead were ritualistically installed on the back seat. If Paul Willis is right, few girls ever penetrated to the symbolic heart of the culture – to the detailed knowledge of the machine, to the camaraderie and competition between the riders [Willis 1978]. A girl's membership seemed to depend entirely on whose girlfriend she was. In the Hell's Angels groups, where the dynamics of the subculture were even more strenuously masculine, girls occupied particular institutionalised roles. Hunter Thompson suggests that the Angels treated their women primarily as sexual objects. If they were not objects of the 'gang-bang' the only other role open to them was that of a 'Mama' [Thompson 1966].

The mod girl

Mod culture offers a more complex subcultural opportunity for girls, if for no other reason than that it was located in and sprang from the mainstream of working-class teenage consumerism. In the mid- to late 1960s there were more teenage girls at work and there were new occupations in the distribution and service sector, particularly in the urban centres. Jobs in the new boutiques, in the beauty business and in clothing as well as in the white-collar sector all involved some degree of dressing up. It was from the mid-1960s onwards that the girls behind the counter in the new boutiques were expected to reflect the image of the shop and thus provide a kind of model or prototype for the young consumer. Glamour and status in these fields often compensated for long hours and low wages. Full employment and freedom to 'look the part' at work, encouraged greater freedom in domestic life. Tom Wolfe's accurate and vivid account of mod girls in London describes how many of these girls were living in flats and bedsits, a pattern hitherto unknown for working-class girls [Wolfe 1968]. These factors made it more likely that girls got involved in mod culture than might otherwise have been the case.

Because mod style was in a sense quietly imperceptible to those unaware of its fine nuances, involvement was more easily accommodated into the normal routines of home, school and work. There was less likelihood of provoking an angry parental reaction since the dominant look was neat, tidy and apparently unthreatening. Parents and teachers knew that girls looked 'rather odd these days, with their white drawn faces and cropped hair', but as Dave Laing noted, 'there was something in the way they moved which adults couldn't make out' [Laing 1969]. The fluidity and

ambiguity of the subculture meant that a girl could be around, could be a 'face' without necessarily being attached to a boy. Participation was almost wholly reliant on wearing the right clothes, having the right hair-style and going to the right clubs. With this combination right, the girl was a mod. Like her male counterpart, the mod girl demonstrated the same fussiness for detail in clothes, the same over-attention to appearance. Facial styles emphasised huge, darkened eyes and body-style demanded thinness.

It may be that mod girls came to the attention of the commentators and jour-nalists because of the general 'unisex' connotations of the subculture. The much mentioned effeminacy of the boys drew attention to the boyish femininity of the girls, best exemplified in the early fashion shots of Twiggy. An absence of exag-gerated masculinity like that displayed in the rocker subculture or by Willis's motor-bike boys, made the mod subculture both exciting and accessible to girls. Like their female counterparts, these boys were more likely to be employed in white-collar office work than in unskilled manual jobs. This greater visibility of girls in the subculture, single or attached, has also got to be seen in terms of the increasing visibility and confidence of teenage girls in the 1960s, working-class and middle-class. Mod culture tippled easily into 'Swinging London' whose favourite image was the 'liberated' dolly-bird. The Brook clinics opened in 1964 making the pill avail-able to single girls and this facility also affected the sexual confidence not just of the middle-class girls in the universities but also of the working-class girls living in London's bedsitter-land.

However, this new prominence and confidence should not be interpreted too loosely. The presence of 'girls' in the urban panoramas of trendy fashion photog-raphy, the new-found autonomy and sexual freedom, have got to be set alongside the other material factors which still shaped and determined their lives. This inde-pendence reflected short-term rather than long-term affluence. The jobs which provided the extra cash afforded immediate access to consumer goods, but few opportunities for promotion or further training. There is nothing to suggest that participation in the mod subculture changed the social expectations of girls, or loos-ened the bonds between mothers and daughters, even if they were temporarily living in flats. These girls had been educated under the shadow of the Newsom Report and had therefore been encouraged to consider marriage their real careers.

The hippy

The term 'hippy' is of course an umbrella term, covering a variety of diverse group-ings and tendencies. However, it is most likely that girls would have entered this subculture through the social life afforded by the universities in the late 1960s and early 1970s. Access to prolonged higher education gives the middle-class girl the space, by right, which her working-class counterpart is denied or else gains only through following a more illegitimate route. The flat or the room in the hall of resi-dence provides the female student with space to experiment, time of her own, and relatively unsupervised leisure. She also has three or four years during which marriage is pushed into the background. The lack of strict demarcation between work and leisure also allows for — indeed encourages — the development of a more

uniquely personal style. The middle-class girl can express herself in dress without having to take into account the restrictions of work.

None the less, traditional sex roles prevailed in the hippy subculture as numerous feminist authors have described. Femininity moved imperceptibly between the 'earth-mother', the pre-Raphaelite mystic, the kind of 'goddess' sere-naded by Bob Dylan, and the dreamy fragility of Marianne Faithful. Media representations and especially visual images, of course, have to be read and inter-preted with care. Moral panics around 'dirty hippies' frequently drew attention to the presence of girls and to the sexual immorality of commune-living. The images which linger tend also to suggest excessive femininity and 'quiet restraint' as demon-strated in the figure of Joni Mitchell. A still more dramatic rejection of the feminine image in the early 1970s carried a self-destructive element in it, as the addiction and eventual death of Janis Joplin shows. Although the range of available and accept-able images of femininity tended to confirm already-existing stereotypes, none the less the hippy underground, set against a background of widespread social protest and youthful revolt, also represented an empowering space for women. Within its confines and even on the pages of the underground press, the first murmurings of feminism were heard.

Do girls have alternative ways of organising their cultural life?

The important question may not be the absence or presence of girls in male subcultures, but the complementary ways in which young girls interact among them-selves and with each other to form a distinctive culture of their own, one which is recognised by and catered to in the girls' weekly comics and magazines. For example 'teenybopper' culture, based round an endless flow of young male pop stars, is a long-standing feature of post-war girls' culture. Where this kind of cultural form is markedly different from the male subcultures, is in its commercial origins. It is an almost totally packaged cultural commodity. It emerges from within the heart of the pop-music business and relies on the magazines, on radio and TV for its wide appeal. As a result it seems to carry less of the creative elements associated with the working-class youth subcultures considered by male sociologists like those mentioned above. However, teenybopper stars carry socially exclusive connotations and opportunities for their fans. . . . Even in so manufactured a form of pop culture we can locate a variety of negotiative processes at work:

1. Young pre-teen girls have access to less freedom than their brothers. Because they are deemed to be more at risk on the streets from attack, assault, or even abduction, parents tend to be more protective of their daughters than they are of their sons (who after all have to learn to defend themselves at some point, as men). Teenybopper culture takes these restrictions into account. Participation is not reliant on being able to spend time outside the home on the streets. Instead teenybopper styles can quite easily be accommodated into school-time or leisure-time spent in the home. . . .
2. There are few restrictions in relation to joining this mainstream and commer-cially-based subculture. It carries no strict rules and requires no special

commitment to internally generated ideas of 'cool'. Nor does it rely on a lot of money. Its uniforms are cheap, its magazines are well within the pocket-money weekly budget, its records are affordable and its concerts are sufficiently rare to be regarded as treats.

3. Membership carries relatively few personal risks. For girls of this age real boys remain a threatening and unknown quantity. Sexual experience is something most girls of all social classes want to hold off for some time in the future. They know, however, that going out with boys invariably carries the possibility of being expected to kiss, or 'pet'. The fantasy boys of pop make no such demands. They 'love' their fans without asking anything in return. . . .

4. The kind of fantasies which girls construct around these figures play the same kind of role as ordinary daydreams. Narrative fantasies about bumping into David Cassidy in the supermarket, or being chosen out by him from the front row of a concert, both carry a strongly sexual element, and are also means of being distracted from the demands of work or school or other aspects of experience which might be perceived as boring or unrewarding.

5. Girls who define themselves actively within these teenybopper subcultures are indeed being *active*, even though the familiar iconography seems to reproduce traditional gender stereotypes with the girl as the passive fan, and the star as the active male. These girls are making statements about themselves as consumers of music, for example. . . . Teenybopper culture offers girls a chance to define themselves as different from and apart from both their younger and their older counterparts. They are no longer little girls and not yet teenage girls. Yet this potentially awkward and anonymous space can be, and is transformed into a site of active feminine identity.

Conclusion

Female participation in youth cultures can best be understood by moving away from the 'classic' subcultural terrain marked out as oppositional and creative by numerous sociologists. Girls negotiate a different leisure space and different personal spaces from those inhabited by boys. These in turn offer them different possibilities for 'resistance', if indeed that is the right word to use. Some of the cultural forms associated with pre-teenage girls, for example, can be viewed as responses to their perceived status as girls and to their anxieties about moving into the world of teenage sexual interaction. One aspect of this can be seen in the extremely tight-knit friendship groups formed by girls. A function of the social exclusiveness of such groupings is to gain private, inaccessible space. This in turn allows pre-pubetal girls to remain seemingly inscrutable to the outside world of parents, teachers, youth workers and boys as well. Teenybopper subcultures could be interpreted as ways of buying time, within the commercial mainstream, from the real world of sexual encounters while at the same time imagining these encounters, with the help of the images and commodities supplied by the commercial mainstream, from the safe space of the all-female friendship group.

Paul E. Willis

CULTURE, INSTITUTION, DIFFERENTIATION [1977]

No MATTER HOW HARD the creation, self-making and winning of counter-school culture, it must . . . be placed within a larger pattern of working-class culture. This should not lead us, however, to think that this culture is all of a piece, undifferentiated or composed of standard clonal culture modules spontaneously reproducing themselves in an inevitable pattern.

Class cultures are created specifically, concretely in determinate conditions, and in particular oppositions. They arise through definite struggles over time with other groups, institutions and tendencies. Particular manifestations of the culture arise in particular circumstances with their own form of marshalling and developing of familiar themes. The themes are *shared* between particular manifestations because all locations at the same level in a class society share similar basic structural properties, and the working-class people there face similar problems and are subject to similar ideological constructions. In addition, the class culture is supported by massive webs of informal groupings and countless overlappings of experience, so that central themes and ideas can develop and be influential in practical situations where their direct logic may not be the most appropriate. A pool of styles, meanings and possibilities are continuously reproduced and always available for those who turn in some way from the formalised and official accounts of their position and look for more realistic interpretations of, or relationships to, their domination. As these themes are taken up and recreated in concrete settings, they are reproduced and strengthened and made further available as resources for others in similar structural situations.

However, these processes of borrowing, regeneration and return in particular social regions are not often recognised by those concerned as class processes. Neither the institutionalised, customary and habitual forms in which domination is mediated from basic structural inequality, nor the regional forms in which they are broken out of, opposed and transformed, are recognised for what they are. This is partly because social regions and their institutional supports and relationships really do

have a degree of autonomy and separateness from each other and the rest of the social system. They have their own procedures, rules and characteristic ideological balances. They have their own legitimising beliefs, their own particular circles of inversion and informality.

Despite their similarity, it is a mistake, therefore, to reduce particular social forms and regions too quickly to the obvious central class dynamics of domination and resistance. They have simultaneously both a local, or institutional, logic and a larger class logic. The larger class logic could not develop and be articulated without these regional instances of struggle, nor could, however, these instances be differentiated internally and structured systematically in relation to other instances and the reproduction of the whole without the larger logic.

The state school in advanced capitalism, and the most obvious manifestations of oppositional working-class culture within it, provide us with a central case of mediated class conflict and of class reproduction in the capitalist order. It is especially significant in showing us a circle of unintended consequences which act finally to reproduce not only a regional culture but the class culture and also the structure of society itself.

Emergence of opposition

Even if there is some form of social division in the junior school, in the first years of the secondary school everyone, it seems, is an 'ear'ole'. Even the few who come to the school with a developed delinquent eye for the social landscape behave in a conformist way because of the lack of any visible support group:

[In a group discussion]
> SPIKE In the first year . . . I could spot the ear'oles. I knew who the fucking high boys was, just looking at 'em walking around the playground – first day I was there . . . I was just quiet for the first two weeks, I just kept meself to meself like, not knowing anybody, it took me two years to get in with a few mates. But, er . . . after that, the third year was a right fucking year, fights, having to go to teachers a lot . . .

In the second to fourth years, however, some individuals break from this pattern. From the point of view of the student this break is the outstanding landmark of his school life, and is remembered with clarity and zest. 'Coming out' as a 'lad' is a personal accomplishment:

[In an individual interview]
> JOEY And in the second year, I thought, 'This is a fucking dead loss', 'cos I'd got no real mates, I saw all the kids palling up with each other, and I thought, 'It's a fucking dead loss, you've got to have someone to knock about with'. So I cracked eyes on Noah and Benson, two kids who weren't in the group, fucking Benson, summat's happened to Benson, summat terrible, he's really turned fucking ear'ole now, but I still like him, he still makes me laff. He can't say his r's properly . . . but I clocked

. . . I seen these two, 'cos our mum used to be at work then, and our dad used to go out at night, so I grabbed them and I said, 'Do you want to come down to our fucking house tonight?', and skin-heads just starting up then, and I think Benson and them had the first fucking levis and monkey boots. And I started knocking about with them, they came down the first night, and we drank a lot of whisky, and I pretended to be fucking drunk like, which we warn't, and it was from there on. We parted off from the rest . . . we always used to sit together, we used to start playing up wild, like, 'cos playing up in them days was fucking hitting each other with rulers, and talking, and it just stemmed from there. And Bill started to come with us, Fred and then Spike . . . And from then on it just escalated, just came more and more separated. We used to go out of nights, and carrying on from hitting each other with rulers we used to fucking chuck bottles at each other, so the major occupation was roaming around the streets, looking for bottles to lam at each other. And from that came a bit of vandalism, here and there like. . . .

Staff too notice these dramatic changes and are not short of explanations. Kids start 'lording it about' and develop 'wrong attitudes' because they become exposed to 'bad influences'. The 'bad influences' arise from behaviour attributed, in the first place, to individual pathology: 'He's made of rubber, there's nothing to him at all', 'If you want the truth, you just take the opposite of what he says', 'He's a mixed up lad, no idea where he's going', 'He worries me stiff, his personality is deficient'. The counter-school culture arises from permutations of these character deficiencies in relation to 'the impressionable'. We have the classic model of a minority of 'trouble-makers' being followed by the misguided majority:

> DEPUTY HEAD Joey is the outstanding one as far as follow my leader is concerned . . . Spike being the barrack room lawyer would support him, and those two did the stirring . . . and Will is easily led.

It is interesting generally to note just how much teachers personalise, and base observations about kids – themselves lost in social and class processes – on what are taken to be concrete individual characteristics. Verbal comments start with 'I like' or 'I haven't much time for', and accounts are interrupted – in a way which is presented as illuminating – with '. . . a bloody good lad too', or '. . . a bad lot altogether, have you seen his dad?' Written school leaving and other reports clearly demonstrate notions of pathology in relation to a basic social model of the leaders and the led:

> [Joey] proved himself to be a young man of intelligence and ability who could have done well at most subjects, but decided that he did not want to work to develop this talent to the full and allowed not only his standard of work to deteriorate, except for English, but also attendance and behaviour . . . too often his qualities of leadership were misplaced and not used on behalf of the school.

> [Spansky] in the first three years was a most co-operative and active member of school. He took part in the school council, school play and

school choir in this period and represented the school at cricket, football and cross-country events.

Unfortunately, this good start did not last and his whole manner and attitude changed. He did not try to develop his ability in either academic or practical skills . . . his early pleasant and cheerful manner deteriorated and he became a most unco-operative member of the school . . . hindered by negative attitudes.

[Eddie's] conduct and behaviour was very inconsistent and on occasions totally unacceptable to the school. A lack of self-discipline was apparent and a tendency to be swayed by group behaviour revealed itself.

Explanations involving random causality or pathology may or may not hold elements of truth. Certainly they are necessary explanations-in-use for teachers trying to run a school and make decisions in the contemporary situation; they will not do, however, as proper social explanations for the development of an anti-school culture.

Differentiation and the teaching paradigm

The particular process by which working-class culture creatively manifests itself as a concrete form within, and separates itself from even as it is influenced by, the particular institution I shall call *differentiation*. *Differentiation* is the process whereby the typical exchanges expected in the formal institutional paradigm are reinterpreted, separated and discriminated with respect to working-class interests, feelings and meanings. Its dynamic is opposition to the institution which is taken up and reverberated and given a form of reference to the larger themes and issues of the class culture. *Integration* is the opposite of *differentiation* and is the process whereby class oppositions and intentions are redefined, truncated and deposited within sets of apparently legitimate institutional relationships and exchanges. Where *differentiation* is the intrusion of the informal into the formal, *integration* is the progressive constitution of the informal into the formal or official paradigm. It may be suggested that all institutions hold a balance between *differentiation* and *integration*, and that *differentiation* is by no means synonymous with breakdown or failure in function. Indeed, as I will go on to argue, it is the aspects of *differentiation* in the make up of an institution, and its effects upon particular social regions, which allow it to play a successful, if mystifying, role in social reproduction. *Differentiation* is experienced by those concerned as, on the one hand, a collective process of learning whereby the self and its future are critically separated from the pre-given institutional definitions and, on the other hand, by institutional agents, as inexplicable breakdown, resistance and opposition. What is produced, on the one side, are working-class themes and activities reworked and reproduced into particular institutional forms and, on the other, retrenchment, hardening, or softening – all variants of a response to loss of legitimacy – of the formal institutional paradigm. Within the institution of the school the essential official paradigm concerns a particular view of teaching and its *differentiation* produces forms of the counter-school culture.

There are a number of possible relationships between teacher and taught. . . . I want to outline the basic teaching paradigm which I suggest locates all others – even as they attempt to go beyond it – and which, I would argue, remains massively dominant in our schools. Whether modified or not, near to the surface or not, its structure is common to all the varied main forms of classroom teaching.

Teachers know quite well that teaching is essentially a relationship between potential contenders for supremacy. It makes sense to speak of, and it does feel like, 'winning and losing':

> DEPUTY HEAD It's a funny thing . . . you get a situation where you've got a class or a boy and you think, 'God, he's beaten me', but the dividing line is so close, push a bit harder and you're over, and you're there . . . this is surprising about kids who are supposed to be dull. They will find a teacher's weakness as quickly as any lad.

Yet the teacher's actual power of direct coercion in modern society is very limited. The kids heavily outnumber the teachers and sanctions can be run through with frightening rapidity. The young teacher often wants a show of force to back him up; the experienced teacher knows that the big guns can only fire once:

> DEPUTY HEAD You see we have very few sanctions and punishments we can apply. Very few indeed. So it's a question of spacing them out and according them as much gravity as you can. And we've got a reporting system with the staff now, whereby eventually they get through as far as me, the head's the ultimate, the next ultimate in the range . . . You can't go throwing suspensions around all the time. Like the football referees today, I mean they're failing because they're reduced to the ultimate so quickly somehow . . . the yellow card comes out first of all, and once they've done that, they've either got to send the player off or ignore everything else he does in the game . . .

> HEAD If enough people set out in defiance of anything . . . if all my boys tomorrow in school decide to do something wrong, what chance have I got?

The teacher's authority must therefore be won and maintained on moral not coercive grounds. There must be consent from the taught. However, the permanent battle to assert and legitimate a personal moral supremacy, especially with limited personal power, is tiring and not really a viable strategy for the long term. Sleight of hand is involved. It is this which marks off the 'experienced' teacher. It is the learning of the relative autonomy of the teaching paradigm: the recognition that the ideal of teaching is related only variably to particular individuals. It is the *idea* of the teacher, not the individual, which is legitimized and commands obedience.

This idea concerns teaching as a fair exchange – most basically of knowledge for respect, of guidance for control. Since knowledge is the rarer commodity this gives the teacher his moral superiority. This is the dominant educational paradigm which stands outside particular teachers but enables them to exert control legitimately upon the children. It is legitimated in general because it provides equivalents

which can enter into other successive exchanges which are to the advantage of the individual. The most important chain of exchanges is, of course, that of knowledge for qualifications, qualified activity for high pay, and pay for goods and services. The educational is, therefore, the key to many other exchanges.

All of these exchanges are supported in structures which hold and help to define, as well as being themselves to some extent created and maintained by, the particular transaction. The educational exchange is held in a defining framework which establishes an axis of the superiority of the teacher in a particular way. Whilst the exchange and its 'fairness' is open to view and is the basis for consent, the framework which holds and defines the terms is both less explicit and in some ways more powerful. It must be considered as an integral part of our basic view of the teaching paradigm. The exchange spins, as it were, like a giro in this framework which it thus helps to stabilise and orientate. But the framework must be secured and ensured by other means as well. It must be capable both of enforcing definitions to some degree where the exchange itself cannot generate them (which is, of course, the case for such as 'the lads'), and to reinforce the exchange, where it is successful, by guaranteeing the equivalents, the concrete referents, external signs and visible supports. . . .

It is of the utmost importance to appreciate that the exchange relationship in the educational paradigm is not primarily in terms of its own logic a relationship between social classes or in any sense at all a self-conscious attempt on the part of teachers to dominate or suppress either working-class individuals or working-class culture as such. The teachers, particularly the senior teachers of the Hammertown school, are dedicated, honest and forthright and by their own lights doing an exacting job with patience and humanity. Certainly it would be quite wrong to attribute to them any kind of sinister motive such as miseducating or oppressing working-class kids. The teacher is given formal control of his pupils by the state, but he exerts his social control through an educational, not a class, paradigm.

It is important to realise just how far the teaching paradigm and especially the axis of control and definition which makes it possible are clearly bound up, supported and underwritten in countless small and in certain large, as it were, architectural ways by the material structure, organisation and practices of the school as we know it in our society.

In a simple physical sense school students, and their possible views of the pedagogic situation, are subordinated by the constricted and inferior space they occupy. Sitting in tight ranked desks in front of the larger teacher's desk; deprived of private space themselves but outside nervously knocking on the forbidden staff room door or the headmaster's door with its foreign rolling country beyond; surrounded by locked up or out of bounds rooms, gyms and equipment cupboards; cleared out of school at break with no quarter given even in the unprivate toilets; told to walk at least two feet away from staff cars in the drive – all of these things help to determine a certain orientation to the physical environment and behind that to a certain kind of social organisation. They speak to the whole *position* of the student.

The social organisation of the school reinforces this relationship. The careful bell-rung timetable; the elaborate rituals of patience and respect outside the staff room door and in the classroom where even cheeky comments are prefaced with 'sir'; compulsory attendance and visible staff hierarchies – all these things assert the

superiority of staff and of their world. And, of course, finally it is the staff who are the controllers most basically and despite the advent of 'resources centres' of what is implied to be the scarce and valuable commodity of knowledge. The value of knowledge to be exchanged in the teaching paradigm derives not only from an external definition of its worth or importance for qualifications and mobility but also from its protected institutional role: its disposition is the prerogative of the powerful. Teachers distribute text books as if they owned them and behave like outraged, vandalised householders when they are lost, destroyed or defaced; teachers keep the keys and permissions for the cupboards, libraries and desks; they plan courses and initiate discussions, start and end the classes. . . .

Many experienced teachers in working-class schools sense a potential weakness in the hold of the basic paradigm on their 'less able', disinterested and disaffected students and seek to modify one of its terms in some way or another. Perhaps the classic move here, and one which is absolutely typical of the old secondary modern school and still widespread in working-class comprehensives, is the revision from an objective to a moral basis of what is in the teacher's gift and is to be exchanged by him for obedience, politeness and respect from the students. This is the crucial shift and mystification in many forms of cultural and social exchange between unequal territories in late capitalist society: that the objective nature of the 'equivalents' are transmuted into the fog of moral commitment, humanism and social responsibility. A real exchange becomes an ideal exchange. The importance of all this is not, of course, that the values and stances involved might be admirable or execrable, correct or incorrect, or whatever. The point is a formal one: the moral term, unlike the objective one, is capable of infinite extension and assimilation because it has no real existence except in itself. The real world cannot act as a court of appeal. Moral definitions make their own momentum. So far as the basic teaching paradigm is concerned what it is worth the student striving for becomes, not knowledge and the promise of qualification, but somehow deference and politeness themselves – those things which are associated certainly with academic and other kinds of success but are only actually their cost and precondition. The shift implies that such qualities are desirable in their own right, detachable from the particular project and negotiable for themselves in the market place of jobs and social esteem.

The pivotal notion of 'attitudes' and particularly of 'right attitudes' makes its entry here. Its presence should always warn us of a mystificatory transmutation of basic exchange relationships into illusory, ideal ones. If one approaches school and its authority, it seems, with the 'right attitude' then employers and work will also be approached with the 'right attitude' in such a way indeed that real social and economic advances can be made – all without the help of academic achievement or success. Of course this crucial move renders the basic paradigm strictly circular and tautological since the same thing is being offered on both sides without any disjunctions or transformations occurring in the circle of the relationship. What the student gets all round is deference and subordination to authority. He could learn this for himself. The objective tautology which turns on that too little examined category 'the right attitude' does not necessarily damage the basic paradigm so long as its nature remains concealed or mystified. Indeed insofar as it maintains the tempo of apparently fair exchange, reinforces the institutionally defined axis and restrains

other tendencies, this modification strengthens the basic paradigm. It keeps its giro spinning. . . .

During *differentiation* the basic paradigm (no matter how modified) is to some extent delegitimised. The teacher's superiority is denied because the axis in which it is held has been partially dislodged. Because what the teacher offers is seen to be less than an equivalent the establishment of the framework which guarantees the teaching exchange is regarded with suspicion and is seen more and more obviously in its repressive mode. For 'the lads' other ways of valuing the self and other kinds of possible exchange present themselves. The teacher's authority becomes increasingly the random one of the prison guard, not the necessary one of the pedagogue. Where 'the private' was penetrated and controlled before it now becomes shared, powerful and oppositional. In a system where exchange of knowledge and the educational paradigm is used as a form of social control, denial of knowledge and refusal of its educational 'equivalent', respect, can be used as a barrier to control. 'The lads' become 'ignorant', 'awkward' and 'disobedient'. It should be noted that measured intelligence and exam results in general are much more likely to be based on the individual's position in this social configuration of knowledge than on his 'innate' abilities. Furthermore, many of an individual's 'personal characteristics' should be understood in this social sense rather than in an individual sense.

At any rate the challenge to the formal paradigm, and re-evaluation of the self and the group, comes from those 'private' areas now *shared* and made visible which were held in check before. These private areas are nothing more nor less, of course, than the class experiences of the working-class boy and derive basically from outside the school. Where the basic paradigm excludes class from the educational realm, its *differentiation* invites it in. . . .

Dick Hebdige

SUBCULTURE
The meaning of style [1979]

Subculture: the unnatural break

SUBCULTURES REPRESENT 'NOISE' (as opposed to sound): interference in the orderly sequence which leads from real events and phenomena to their representation in the media. We should therefore not underestimate the signifying power of the spectacular subculture not only as a metaphor for potential anarchy 'out there' but as an actual mechanism of semantic disorder: a kind of temporary blockage in the system of representation. . . .

Violations of the authorized codes through which the social world is organized and experienced have considerable power to provoke and disturb. They are generally condemned, in Mary Douglas' words (1967), as 'contrary to holiness' and Levi-Strauss has noted how, in certain primitive myths, the mispronunciation of words and the misuse of language are classified along with incest as horrendous aberrations capable of 'unleashing storm and tempest' (Levi-Strauss 1969). Similarly, spectacular subcultures express forbidden contents (consciousness of class, consciousness of difference) in forbidden forms (transgressions of sartorial and behavioural codes, law breaking, etc.). They are profane articulations, and they are often and significantly defined as 'unnatural'. . . . no doubt, the breaking of rules is confused with the 'absence of rules' which, according to Levi-Strauss (1969), 'seems to provide the surest criteria for distinguishing a natural from a cultural process'. Certainly, the official reaction to the punk subculture, particularly to the Sex Pistols' use of 'foul language' on television and record, and to the vomiting and spitting incidents at Heathrow Airport, would seem to indicate that these basic taboos are no less deeply sedimented in contemporary British society.

Two forms of incorporation

> Has not this society, glutted with aestheticism, already integrated former romanticisms, surrealism, existentialism and even Marxism to a point? It has, indeed, through trade, in the form of commodities. That which yesterday was reviled today becomes cultural consumer-goods, consumption thus engulfs what was intended to give meaning and direction.
>
> (Lefebvre 1971)

. . . The emergence of a spectacular subculture is invariably accompanied by a wave of hysteria in the press. This hysteria is typically ambivalent: it fluctuates between dread and fascination, outrage and amusement. Shock and horror headlines dominate the front page (e.g. 'Rotten Razored', *Daily Mirror*, 28 June 1977) while, inside, the editorials positively bristle with 'serious' commentary and the centrespreads or supplements contain delirious accounts of the latest fads and rituals (see, for example, *Observer* colour supplements 30 January, 10 July 1977, 12 February 1978). Style in particular provokes a double response: it is alternately celebrated (in the fashion page) and ridiculed or reviled (in those articles which define subcultures as social problems). . . .

As the subculture begins to strike its own eminently marketable pose, as its vocabulary (both visual and verbal) becomes more and more familiar, so the referential context to which it can be most conveniently assigned is made increasingly apparent. Eventually, the mods, the punks, the glitter rockers can be incorporated, brought back into line, located on the preferred 'map of problematic social reality' (Geertz 1964) at the point where boys in lipstick are 'just kids dressing up', where girls in rubber dresses are 'daughters just like yours'. . . . The media, as Stuart Hall (1977) has argued, not only record resistance, they 'situate it within the dominant framework of meanings' and those young people who choose to inhabit a spectacular youth culture are simultaneously *returned*, as they are represented on TV and in the newspapers, to the place where common sense would have them fit (as 'animals' certainly, but also 'in the family', 'out of work', 'up to date', etc.). It is through this continual process of recuperation that the fractured order is repaired and the subculture incorporated as a diverting spectacle within the dominant mythology from which it in part emanates: as 'folk devil', as Other, as Enemy. The process of recuperation takes two characteristic forms:

(1) the conversion of subcultural signs (dress, music, etc.) into mass-produced objects (i.e. the commodity form);
(2) the 'labelling' and re-definition of deviant behaviour by dominant groups – the police, the media, the judiciary (i.e. the ideological form).

The commodity form

The first has been comprehensively handled by both journalists and academics. The relationship between the spectacular subculture and the various industries which service and exploit it is notoriously ambiguous. After all, such a subculture is

concerned first and foremost with consumption. It operates exclusively in the leisure sphere. . . . It communicates through commodities even if the meanings attached to those commodities are purposefully distorted or overthrown. It is therefore difficult in this case to maintain any absolute distinction between commercial exploitation on the one hand and creativity/originality on the other, even though these categories are emphatically opposed in the value systems of most subcultures. Indeed, the creation and diffusion of new styles is inextricably bound up with the process of production, publicity and packaging which must inevitably lead to the defusion of the subculture's subversive power – both mod and punk innovations fed back directly into high fashion and mainstream fashion. . . .

. . . As soon as the original innovations which signify 'subculture' are translated into commodities and made generally available, they become 'frozen'. Once removed from their private contexts by the small entrepreneurs and big fashion interests who produce them on a mass scale, they become codified, made comprehensible, rendered at once public property and profitable merchandise. In this way, the two forms of incorporation (the semantic/ideological and the 'real'/commercial) can be said to converge on the commodity form. Youth cultural styles may begin by issuing symbolic challenges, but they must inevitably end by establishing new sets of conventions; by creating new commodities, new industries or rejuvenating old ones (think of the boost punk must have given haberdashery!). This occurs irrespective of the subculture's political orientation: the macrobiotic restaurants, craft shops and 'antique markets' of the hippie era were easily converted into punk boutiques and record shops. It also happens irrespective of the startling content of the style: punk clothing and insignia could be bought mail-order by the summer of 1977, and in September of that year *Cosmopolitan* ran a review of Zandra Rhodes' latest collection of couture follies which consisted entirely of variations on the punk theme. Models smouldered beneath mountains of safety pins and plastic (the pins were jewelled, the 'plastic' wet-look satin) and the accompanying article ended with an aphorism – 'To shock is chic' – which presaged the subculture's imminent demise.

The ideological form

The second form of incorporation – the ideological – has been most adequately treated by those sociologists who operate a transactional model of deviant behaviour. For example, Stan Cohen has described in detail how one particular moral panic (surrounding the mod-rocker conflict of the mid-60s) was launched and sustained (Cohen 1972). Although this type of analysis can often provide an extremely sophisticated explanation of why spectacular subcultures consistently provoke such hysterical outbursts, it tends to overlook the subtler mechanisms through which potentially threatening phenomena are handled and contained. As the use of the term 'folk devil' suggests, rather too much weight tends to be given to the sensational excesses of the tabloid press at the expense of the ambiguous reactions which are, after all, more typical. As we have seen, the way in which subcultures are represented in the media makes them both more and less exotic than they actually are. They are seen to contain both dangerous aliens and boisterous kids, wild animals and wayward pets. Roland Barthes furnishes a key to the

paradox in his description of 'identification' – one of the seven rhetorical figures which, according to Barthes, distinguish the meta-language of bourgeois mythology. He characterizes the petit-bourgeois as a person '. . . unable to imagine the Other . . . the Other is a scandal which threatens his existence' (Barthes 1972).

Two basic strategies have been evolved for dealing with this threat. First, the Other can be trivialized, naturalized, domesticated. Here, the difference is simply denied ('Otherness is reduced to sameness'). Alternatively, the Other can be transformed into meaningless exotica, a 'pure object, a spectacle, a clown' (Barthes 1972). In this case, the difference is consigned to a place beyond analysis. Spectacular subcultures are continually being defined in precisely these terms. Soccer hooligans, for example, are typically placed beyond 'the bounds of common decency' and are classified as 'animals'. . . . On the other hand, the punks tended to be resituated by the press in the family, perhaps because members of the subculture deliberately obscured their origins, refused the family and willingly played the part of folk devil, presenting themselves as pure objects, as villainous clowns. Certainly, like every other youth culture, punk was perceived as a threat to the family. Occasionally this threat was represented in literal terms. For example, the *Daily Mirror* (1 August 1977) carried a photograph of a child lying in the road after a punk-ted confrontation under the headline 'VICTIM OF THE PUNK ROCK PUNCH-UP: THE BOY WHO FELL FOUL OF THE MOB'. In this case, punk's threat to the family was made 'real' (that could be my child!) through the ideological framing of photographic evidence which is popularly regarded as unproblematic.

None the less, on other occasions, the opposite line was taken. For whatever reason, the inevitable glut of articles gleefully denouncing the latest punk outrage was counter-balanced by an equal number of items devoted to the small details of punk family life. For instance, the 15 October 1977 issue of *Woman's Own* carried an article entitled 'Punks and Mothers' which stressed the classless, fancy dress aspects of punk. Photographs depicting punks with smiling mothers, reclining next to the family pool, playing with the family dog, were placed above a text which dwelt on the ordinariness of individual punks: 'It's not as rocky horror as it appears' . . . 'punk can be a family affair' . . . 'punks as it happens are non-political', and, most insidiously, albeit accurately, 'Johnny Rotten is as big a household name as Hughie Green'. Throughout the summer of 1977, the *People* and the *News of the World* ran items on punk babies, punk brothers, and punk-ted weddings. All these articles served to minimize the Otherness so stridently proclaimed in punk style, and defined the subculture in precisely those terms which it sought most vehemently to resist and deny. . . .

Style as intentional communication

. . The cycle leading from opposition to defusion, from resistance to incorporation encloses each successive subculture. We have seen how the media and the market fit into this cycle. We must now turn to the subculture itself to consider exactly how and what subcultural style communicates. Two questions must be asked which together present us with something of a paradox: how does a subculture make sense to its members? How is it made to signify disorder? To answer these questions we must define the meaning of style more precisely. . . .

Umberto Eco writes, 'not only the expressly intended communicative . . . but every object may be viewed . . . as a sign' (Eco 1973). For instance, the conventional outfits worn by the average man and woman in the street are chosen within the constraints of finance, 'taste', preference, etc. And these choices are undoubtedly significant. Each ensemble has its place in an internal system of differences – the conventional modes of sartorial discourse – which fit a corresponding set of socially prescribed roles and options. These choices contain a whole range of messages which are transmitted through the finely graded distinctions of a number of interlocking sets – class and status, self-image and attractiveness, etc. Ultimately, if nothing else, they are expressive of 'normality' as opposed to 'deviance' (i.e. they are distinguished by their relative invisibility, their appropriateness, their 'naturalness'). However, the intentional communication is of a different order. It stands apart – a visible construction, a loaded choice. It directs attention to itself; it gives itself to be read.

This is what distinguishes the visual ensembles of spectacular subcultures from those favoured in the surrounding culture(s). They are *obviously* fabricated (even the mods, precariously placed between the worlds of the straight and the deviant, finally declared themselves different when they gathered in groups outside dance halls and on sea fronts). They *display* their own codes (e.g. the punk's ripped T-shirt) or at least demonstrate that codes are there to be used and abused (e.g. they have been thought about rather than thrown together). In this they go against the grain of a mainstream culture whose principal defining characteristic, according to Barthes, is a tendency to masquerade as nature, to substitute 'normalized' for historical forms, to translate the reality of the world into an image of the world which in turn presents itself as if composed according to 'the evident laws of the natural order' (Barthes 1972). . . .

Style as *bricolage*

. . . The subcultures with which we have been dealing share a common feature apart from the fact that they are all predominantly working class. They are, as we have seen, cultures of conspicuous consumption – even when, as with the skinheads and the punks, certain types of consumption are conspicuously refused – and it is through the distinctive rituals of consumption, through style, that the subculture at once reveals its 'secret' identity and communicates its forbidden meanings. It is basically the way in which commodities are *used* in subculture which marks the subculture off from more orthodox cultural formations.

Discoveries made in the field of anthropology are helpful here. In particular, the concept of *bricolage* can be used to explain how subcultural styles are constructed. In *The Savage Mind* Levi-Strauss shows how the magical modes utilized by primitive peoples (superstition, sorcery, myth) can be seen as implicitly coherent, though explicitly bewildering, systems of connection between things which perfectly equip their users to 'think' their own world. These magical systems of connection have a common feature: they are capable of infinite extension because basic elements can be used in a variety of improvised combinations to generate new meanings within them. *Bricolage* has thus been described as a 'science of the concrete' in a recent definition which clarifies the original anthropological meaning of the term:

[Bricolage] refers to the means by which the non-literate, non-technical mind of so-called 'primitive' man responds to the world around him. The process involves a 'science of the concrete' (as opposed to our 'civilised' science of the 'abstract') which far from lacking logic, in fact carefully and precisely orders, classifies and arranges into structures the *minutiae* of the physical world in all their profusion by means of a 'logic' which is not our own. The structures, 'improvised' or made up (these are rough translations of the process of *bricoler*) as *ad hoc* responses to an environment, then serve to establish homologies and analogies between the ordering of nature and that of society, and so satisfactorily 'explain' the world and make it able to be lived in.

(Hawkes 1977)

The implications of the structured improvisations of *bricolage* for a theory of spectacular subculture as a system of communication have already been explored. For instance, John Clarke has stressed the way in which prominent forms of discourse (particularly fashion) are radically adapted, subverted and extended by the subcultural *bricoleur*:

Together, object and meaning constitute a sign, and, within any one culture, such signs are assembled, repeatedly, into characteristic forms of discourse. However, when the bricoleur re-locates the significant object in a different position within that discourse, using the same overall repertoire of signs, or when that object is placed within a different total ensemble, a new discourse is constituted, a different message conveyed.

(Clarke 1975)

In this way the teddy boy's theft and transformation of the Edwardian style revived in the early 1950s by Savile Row for wealthy young men about town can be construed as an act of *bricolage*. Similarly, the mods could be said to be functioning as *bricoleurs* when they appropriated another range of commodities by placing them in a symbolic ensemble which served to erase or subvert their original straight meanings. Thus pills medically prescribed for the treatment of neuroses were used as ends-in-themselves, and the motor scooter, originally an ultra-respectable means of transport, was turned into a menacing symbol of group solidarity. In the same improvisatory manner, metal combs, honed to a razor-like sharpness, turned narcissism into an offensive weapon. Union jacks were emblazoned on the backs of grubby parka anoraks or cut up and converted into smartly tailored jackets. More subtly, the conventional insignia of the business world – the suit, collar and tie, short hair, etc. – were stripped of their original connotations – efficiency, ambition, compliance with authority – and transformed into 'empty' fetishes, objects to be desired, fondled and valued in their own right.

At the risk of sounding melodramatic, we could use Umberto Eco's phrase 'semiotic guerrilla warfare' (Eco 1972) to describe these subversive practices. The war may be conducted at a level beneath the consciousness of the individual members of a spectacular subculture (though the subculture is still, at another level, an intentional communication . . .) but with the emergence of such a group, 'war – and it

is Surrealism's war – is declared on a world of surfaces' (Annette Michelson, quoted Lippard 1970).

The radical aesthetic practices of Dada and Surrealism – dream work, collage, 'ready mades', etc. – are certainly relevant here. . . . The subcultural *bricoleur*, like the 'author' of a surrealist collage, typically 'juxtaposes two apparently incompatible realities [i.e. "flag": "jacket"; "hole": "teeshirt"; "comb": "weapon"] on an apparently unsuitable scale . . . and . . . it is there that the explosive junction occurs' (Ernst 1948). Punk exemplifies most clearly the subcultural uses of these anarchic modes. It too attempted through 'perturbation and deformation' to disrupt and reorganize meaning. It, too, sought the 'explosive junction'. . . . Like Duchamp's 'ready mades' – manufactured objects which qualified as art because he chose to call them such, the most unremarkable and inappropriate items – a pin, a plastic clothes peg, a television component, a razor blade, a tampon – could be brought within the province of punk (un)fashion. Anything within or without reason could be turned into part of what Vivien Westwood called 'confrontation dressing' so long as the rupture between 'natural' and constructed context was clearly visible (i.e. the rule would seem to be: if the cap doesn't fit, wear it). . . .

Style as homology

The punk subculture . . . signified chaos at every level, but this was only possible because the style itself was so thoroughly ordered. The chaos cohered as a meaningful whole. We can now attempt to solve this paradox by referring to another concept originally employed by Levi-Strauss: homology.

Paul Willis (1978) first applied the term 'homology' to subculture in his study of hippies and motor-bike boys using it to describe the symbolic fit between the values and life-styles of a group, its subjective experience and the musical forms it uses to express or reinforce its focal concerns. In *Profane Culture*, Willis shows how, contrary to the popular myth which presents subcultures as lawless forms, the internal structure of any particular subculture is characterized by an extreme orderliness: each part is organically related to other parts and it is through the fit between them that the subcultural member makes sense of the world. For instance, it was the homology between an alternative value system ('Tune in, turn on, drop out'), hallucinogenic drugs and acid rock which made the hippy culture cohere as a 'whole way of life' for individual hippies. In *Resistance Through Rituals* Clarke *et al.* crossed the concepts of homology and *bricolage* to provide a systematic explanation of why a particular subcultural style should appeal to a particular group of people. The authors asked the question: 'What specifically does a subcultural style signify to the members of the subculture themselves?'

The answer was that the appropriated objects reassembled in the distinctive subcultural ensembles were 'made to reflect, express and resonate . . . aspects of group life' (Clarke *et al.*, 1993). The objects chosen were, either intrinsically or in their adapted forms, homologous with the focal concerns, activities, group structure and collective self-image of the subculture. They were 'objects in which (the subcultural members) could see their central values held and reflected' (Clarke *et al.*, 1975). . . .

The punks would certainly seem to bear out this thesis. The subculture was _ing if not consistent. There was a homological relation between the trashy cut-up clothes and spiky hair, the pogo and amphetamines, the spitting, the vomiting, the format of the fanzines, the insurrectionary poses and the 'soulless', frantically driven music. The punks wore clothes which were the sartorial equivalent of swear words, and they swore as they dressed — with calculated effect, lacing obscenities into record notes and publicity releases, interviews and love songs. Clothed in chaos, they produced Noise in the calmly orchestrated Crisis of everyday life in the late 1970s — a noise which made (no)sense in exactly the same way and to exactly the same extent as a piece of *avant-garde* music. If we were to write an epitaph for the punk subculture, we could do no better than repeat Poly Styrene's famous dictum: 'Oh Bondage, Up Yours!', or somewhat more concisely: the forbidden is permitted, but by the same token, nothing, not even these forbidden signifiers (bondage, safety pins, chains, hair-dye, etc.) is sacred and fixed.

This absence of permanently sacred signifiers (icons) creates problems for the semiotician. How can we discern any positive values reflected in objects which were chosen only to be discarded? For instance, we can say that the early punk ensembles gestured towards the signified's 'modernity' and 'working-classness'. The safety pins and bin liners signified a relative material poverty which was either directly experienced and exaggerated or sympathetically assumed, and which in turn was made to stand for the spiritual paucity of everyday life. In other words, the safety pins, etc. 'enacted' that transition from real to symbolic scarcity which Paul Piccone (1969) has described as the movement from 'empty stomachs' to 'empty spirits — and therefore an empty life notwithstanding the chrome and the plastic . . . of the life style of bourgeois society'.

We could go further and say that even if the poverty was being parodied, the wit was undeniably barbed; that beneath the clownish make-up there lurked the unaccepted and disfigured face of capitalism; that beyond the horror circus antics a divided and unequal society was being eloquently condemned. However, if we were to go further still and describe punk music as the 'sound of the Westway' or the pogo as the 'high-rise leap', or to talk of bondage as reflecting the narrow options of working-class youth, we would be treading on less certain ground. Such readings are both too literal and too conjectural. They are extrapolations from the subculture's own prodigious rhetoric, and rhetoric is not self-explanatory: it may say what it means but it does not necessarily 'mean' what it 'says'. In other words, it is opaque: its categories are part of its publicity. . . .

To reconstruct the true text of the punk subculture, to trace the source of its subversive practices, we must first isolate the 'generative set' responsible for the subculture's exotic displays. Certain semiotic facts are undeniable. The punk subculture, like every other youth culture, was constituted in a series of spectacular transformations of a whole range of commodities, values, common-sense attitudes, etc. It was through these adapted forms that certain sections of predominantly working-class youth were able to restate their opposition to dominant values and institutions. However, when we attempt to close in on specific items, we immediately encounter problems. What, for instance, was the swastika being used to signify?

We can see how the symbol was made available to the punks (via Bowie and Lou Reed's 'Berlin' phase). Moreover, it clearly reflected the punks' interest in a

decadent and evil Germany – a Germany which had 'no future'. It evoked a period redolent with a powerful mythology. Conventionally, as far as the British were concerned, the swastika signified 'enemy'. None the less, in punk usage, the symbol lost its 'natural' meaning – fascism. The punks were not generally sympathetic to the parties of the extreme right. On the contrary, . . . the conflict with the resurrected teddy boys and the widespread support for the anti-fascist movement (e.g. the Rock against Racism campaign) seem to indicate that the punk subculture grew up partly as an antithetical response to the re-emergence of racism in the mid-1970s. We must resort, then, to the most obvious of explanations – that the swastika was worn because it was guaranteed to shock. (A punk asked by *Time Out* [17–23 December 1977] why she wore a swastika, replied: 'Punks just like to be hated'.) This represented more than a simple inversion or inflection of the ordinary meanings attached to an object. The signifier (swastika) had been wilfully detached from the concept (Nazism) it conventionally signified, and although it had been re-positioned (as 'Berlin') within an alternative subcultural context, its primary value and appeal derived precisely from its lack of meaning: from its potential for deceit. It was exploited as an empty effect. We are forced to the conclusion that the central value 'held and reflected' in the swastika was the communicated absence of any such identifiable values. Ultimately, the symbol was as 'dumb' as the rage it provoked. The key to punk style remains elusive. Instead of arriving at the point where we can begin to make sense of the style, we have reached the very place where meaning itself evaporates.

Style as signifying practice

> We are surrounded by emptiness but it is an emptiness filled with signs.
> (Lefebvre 1971)

It would seem that those approaches to subculture based upon a traditional semiotics (a semiotics which begins with some notion of the 'message' – of a combination of elements referring unanimously to a fixed number of signifieds) fail to provide us with a 'way in' to the difficult and contradictory text of punk style. Any attempt at extracting a final set of meanings from the seemingly endless, often apparently random, play of signifiers in evidence here seems doomed to failure.

And yet, over the years, a branch of semiotics has emerged which deals precisely with this problem. Here the simple notion of reading as the revelation of a fixed number of concealed meanings is discarded in favour of the idea of *polysemy* whereby each text is seen to generate a potentially infinite range of meanings. Attention is consequently directed towards that point – or more precisely, that level – in any given text where the principle of meaning itself seems most in doubt. Such an approach lays less stress on the primacy of structure and system in language ('langue'), and more upon the *position* of the speaking subject in discourse ('parole'). It is concerned with the *process* of meaning-construction rather than with the final product. . . .

Julia Kristeva's work on signification seems particularly useful. In *La Révolution du Langage Poétique* (1974) she explores the subversive possibilities within language

through a study of French symbolist poetry, and points to 'poetic language' as the 'place where the social code is destroyed and renewed' (Kristeva 1984). She counts as 'radical' those signifying practices which negate and disturb syntax . . . and which therefore serve to erode the concept of 'actantial position' upon which the whole 'Symbolic Order' is seen to rest.[1]

Two of Kristeva's interests seem to coincide with our own: the creation of subordinate groups through *positioning in language* (Kristeva is especially interested in women), and the disruption of the process through which such positioning is habitually achieved. In addition, the general idea of signifying practice (which she defines as 'the setting in place and cutting through or traversing of a system of signs') can help us to rethink in a more subtle and complex way the relations not only between marginal and mainstream cultural formations but between the various subcultural styles themselves. For instance, we have seen how all subcultural style is based on a practice which has much in common with the 'radical' collage aesthetic of surrealism and we shall be seeing how different styles represent different signifying practices. Beyond this I shall be arguing that the signifying practices embodied in punk were 'radical' in Kristeva's sense: that they gestured towards a 'nowhere' and actively *sought* to remain silent, illegible.

We can now look more closely at the relationship between experience, expression and signification in subculture; at the whole question of style and our reading of style. To return to our example, we have seen how the punk style fitted together homologically precisely through its lack of fit (hole:tee-shirt::spitting:applause::bin-liner:garment::anarchy:order) – by its refusal to cohere round a readily identifiable set of central values. It cohered, instead, *elliptically* through a chain of conspicuous absences. It was characterized by its unlocatedness – its blankness – and in this it can be contrasted with the skinhead style.

Whereas the skinheads theorized and fetishized their class position, in order to effect a 'magical' return to an imagined past, the punks dislocated themselves from the parent culture and were positioned instead on the outside: beyond the comprehension of the average (wo)man in the street in a science fiction future. They played up their Otherness, 'happening' on the world as aliens, inscrutables. Though punk rituals, accents and objects were deliberately used to signify working-classness, the exact origins of individual punks were disguised or symbolically disfigured by the make-up, masks and aliases which seem to have been used, like Breton's art, as ploys 'to escape the principle of identity'.

This working-classness therefore tended to retain, *even in practice, even in its concretized forms*, the dimensions of an idea. It was abstract, disembodied, decontextualized. Bereft of the necessary details – a name, a home, a history – it refused to make sense, to be grounded, 'read back' to its origins. It stood in violent contradiction to that other great punk signifier – sexual 'kinkiness'. The two forms of deviance – social and sexual – were juxtaposed to give an impression of multiple warping which was guaranteed to disconcert the most liberal of observers, to challenge the glib assertions of sociologists no matter how radical. In this way, although the punks referred continually to the realities of school, work, family and class, these references only made sense at one remove: they were passed through the fractured circuitry of punk style and re-presented as 'noise', disturbance, entropy.

In other words, although the punks self-consciously mirrored what Paul (1969) calls the 'pre-categorical realities' of bourgeois society – inequality, lessness, alienation – this was only possible because punk style had made a break not only with the parent culture but with its own *location in experienc* break was both inscribed and re-enacted in the signifying practices emboured ... punk style. The punk ensembles, for instance, did not so much magically resolve experienced contradictions as *re-present* the experience of contradiction itself in the form of visual puns (bondage, the ripped tee-shirt, etc.). Thus while it is true that the symbolic objects in punk style (the safety pins, the pogo, the ECT hairstyles) were 'made to form a "unity" with the group's relations, situations, experience' (Clarke *et al.*, 1975), this unity was at once 'ruptural' and 'expressive', or more precisely it expressed itself through rupture.

This is not to say, of course, that all punks were equally aware of the disjunction between experience and signification upon which the whole style was ultimately based. The style no doubt made sense for the first wave of self-conscious innovators at a level which remained inaccessible to those who became punks after the subculture had surfaced and been publicized. Punk is not unique in this: the distinction between originals and hangers-on is always a significant one in subculture. Indeed, it is frequently verbalized (plastic punks or safety-pin people, burrhead rastas or rasta bandwagon, weekend hippies, etc. versus the 'authentic' people). For instance, the mods had an intricate system of classification whereby the 'faces' and 'stylists' who made up the original coterie were defined against the unimaginative majority – the pedestrian 'kids' and 'scooter boys' who were accused of trivializing and coarsening the precious mod style. What is more, different youths bring different degrees of commitment to a subculture. It can represent a major dimension in people's lives – an axis erected in the face of the family around which a secret and immaculate identity can be made to cohere – or it can be a slight distraction, a bit of light relief from the monotonous but none the less paramount realities of school, home and work. It can be used as a means of escape, of total detachment from the surrounding terrain, or as a way of fitting back in to it and settling down after a week-end or evening spent letting off steam. In most cases it is used, as Phil Cohen suggests, magically to achieve both ends. However, despite these individual differences, the members of a subculture must share a common language. And if a style is really to catch on, if it is to become genuinely popular, it must say the right things in the right way at the right time. It must anticipate or encapsulate a mood, a moment. It must embody a sensibility, and the sensibility which punk style embodied was essentially dislocated, ironic and self-aware. . . .

Note

1 The 'symbolic order' to which I have referred throughout should not be confused with Kristeva's 'Symbolic Order' which is used in a sense derived specifically from Lacanian psychoanalysis. I use the term merely to designate the apparent unity of the dominant ideological discourse in play at any one time.

Angela McRobbie

SECOND-HAND DRESSES AND THE ROLE OF THE RAGMARKET [1989]

Introduction

SEVERAL ATTEMPTS HAVE been made recently to understand 'retro-style'. These have all taken as their starting point that accelerating tendency in the 1980s to ransack history for key items of dress, in a seemingly eclectic and haphazard manner. Some have seen this as part of the current vogue for nostalgia while others have interpreted it as a way of bringing history into an otherwise ahistorical present. This [chapter] will suggest that second-hand style or 'vintage dress' must be seen within the broader context of post-war subcultural history. It will pay particular attention to the existence of an entrepreneurial infrastructure within these youth cultures and to the opportunities which second-hand style has offered young people, at a time of recession, for participating in the fashion 'scene'.

Most of the youth subcultures of the post-war period have relied on second-hand clothes found in jumble sales and ragmarkets as the raw material for the creation of style. Although a great deal has been written about the meaning of these styles little has been said about where they have come from. In the early 1980s the magazine *iD* developed a kind of *vox pop* of street style which involved stopping young people and asking them to itemise what they were wearing, where they had got it and for how much. Since then many of the weekly and monthly fashion publications have followed suit, with the result that this has now become a familiar feature of the magazine format. However, the act of buying and the processes of looking and choosing still remain relatively unexamined in the field of cultural analysis.

One reason for this is that shopping has been considered a feminine activity. Youth sociologists have looked mainly at the activities of adolescent boys and young men and their attention has been directed to those areas of experience which have a strongly masculine image. Leisure spheres which involve the wearing and display-ing of clothes have been thoroughly documented, yet the hours spent seeking them

out on Saturday afternoons continue to be overlooked. Given the emphasis on street culture or on public peer-group activities, this is perhaps not surprising, but it is worth remembering that although shopping is usually regarded as a private activity, it is also simultaneously a public one and in the case of the markets and second-hand stalls it takes place in the street. This is particularly important for girls and young women because in other contexts their street activities are still curtailed in contrast to those of their male peers. This fact has been commented upon by many feminist writers but the various pleasures of shopping have not been similarly engaged with. Indeed, shopping has tended to be subsumed under the category of domestic labour with the attendant connotations of drudgery and exhaustion. Otherwise it has been absorbed into consumerism where women and girls are seen as having a particular role to play. Contemporary feminism has been slow to challenge the early 1970s orthodoxy which saw women as slaves to consumerism. Only Erica Carter's work [1979] has gone some way towards dislodging the view that to enjoy shopping is to be passively feminine and incorporated into a system of false needs.

Looking back at the literature of the late 1970s on punk, it seems strange that so little attention was paid to the selling of punk, and the extent to which shops like the *Sex* shop run by Malcolm McLaren and Vivienne Westwood functioned also as meeting places where the customers and those behind the counter got to know each other and met up later in the pubs and clubs. In fact, ragmarkets and second-hand shops have played the same role up and down the country, indicating that there is more to buying and selling subcultural style than the simple exchange of cash for goods. Sociologists of the time perhaps ignored this social dimension because to them the very idea that style could be purchased over the counter went against the grain of those analyses which saw the adoption of punk style as an act of creative defiance far removed from the mundane act of buying. The role of McLaren and Westwood was also downgraded for the similar reason that punk was seen as a kind of collective creative impulse. To focus on a designer and an art-school entrepreneur would have been to undermine the 'purity' or 'authenticity' of the subculture. The same point can be made in relation to the absence of emphasis on buying subcultural products. What is found instead is an interest in those moments where the bought goods and items are transformed to subvert their original or intended meanings. In these accounts the act of buying disappears into that process of transformation. Ranked below these magnificent gestures, the more modest practices of buying and selling have remained women's work and have been of little interest to those concerned with youth cultural resistance. . . .

The role of the ragmarket

Second-hand style owes its existence to those features of consumerism which are characteristic of contemporary society. It depends, for example, on the creation of a surplus of goods whose use value is not expended when their first owners no longer want them. They are then revived, even in their senility, and enter into another cycle of consumption. House clearances also contribute to the mountain of bric-à-brac, jewellery, clothing and furniture which are the staple of junk and second-hand shops and stalls. But not all junk is used a second time around. Patterns

of taste and discrimination shape the desires of second-hand shoppers as much as they do those who prefer the high street or the fashion showroom. And those who work behind the stalls and counters are skilled in choosing their stock with a fine eye for what will sell. Thus although there seems to be an evasion of the mainstream, with its mass-produced goods and marked-up prices, the 'subversive consumerism' of the ragmarket is in practice highly selective in what is offered and what, in turn, is purchased. There is in this milieu an even more refined economy of taste at work. For every single piece rescued and restored, a thousand are consigned to oblivion. Indeed, it might also be claimed that in the midst of this there is a thinly-veiled cultural élitism in operation. The sources which are raided for 'new' second-hand ideas are frequently old films, old art photographs, 'great' novels, documentary footage and textual material. The apparent democracy of the market, from which nobody is excluded on the grounds of cost, is tempered by the very precise tastes and desires of the second-hand searchers. Second-hand style continually emphasizes its distance from second-hand clothing.

The London markets and those in other towns and cities up and down the country cater now for a much wider cross-section of the population. It is no longer a question of the *jeunesse dorée* rubbing shoulders with the poor and the down-and-outs. Unemployment has played a role in diversifying this clientele, so also have a number of other less immediately visible shifts and changes. Young single mothers, for example, who fall between the teen dreams of punk fashion and the reality of pushing a buggy through town on a wet afternoon, fit exactly with this new constituency. Markets have indeed become more socially diverse sites in the urban landscape. The Brick Lane area in London, for example, home to part of the Bangladeshi population settled in this country, attracts on a Sunday morning, young and old, black and white, middle-class and working-class shoppers as well as tourists and the merely curious browsers. It's not surprising that tourists include a market such as Brick Lane in their itinerary. In popular currency, street markets are taken to be reflective of the old and unspoilt; they are 'steeped in history' and are thus particularly expressive of the town or region.

The popularity of these urban markets also resides in their celebration of what seem to be pre-modern modes of exchange. They offer an oasis of cheapness, where every market day is a 'sale'. They point back in time to an economy unaffected by cheque cards, credit cards and even set prices. Despite the lingering connotations of wartime austerity, the market today promotes itself in the language of natural freshness (for food and dairy produce) or else in the language of curiosity, discovery and heritage (for clothes, trinkets and household goods). There is, of course, a great deal of variety in the types of market found in different parts of the country. In London there is a distinction between those markets modelled on the genuine flea-markets, which tend to attract the kind of young crowd who flock each weekend to Camden Lock, and those which are more integrated into a neighbourhood providing it with fruit, vegetables and household items. The history of these more traditional street markets is already well documented. They grew up within the confines of a rapidly expanding urban economy and played a vital role in dressing (in mostly second-hand clothes), and feeding the urban working classes, who did not have access to the department stores, grocers or other retail outlets which catered for the upper and middle classes. As Phil Cohen [1979] has shown, such

markets came under the continual surveillance of the urban administrators and authorities who were concerned with 'policing the working class city'. The street-markets were perceived by them as interrupting not only the flow of traffic and therefore the speed of urban development, but also as hindering the growth of those sorts of shops which would bring in valuable revenue from rates. These were seen as dangerous places, bringing together unruly elements who were already predis-posed towards crime and delinquency; a predominantly youthful population of costermongers had to be brought into line with the labour discipline which already existed on the factory floor.

The street market functioned, therefore, as much as a daytime social meeting place as it did a place for transactions of money and goods. It lacked the imperson-ality of the department stores and thrived instead on the values of familiarity, com-munity and personal exchange. This remains the case today. Wherever immigrant groups have arrived and set about trying to earn a living in a largely hostile envi-ronment a local service economy in the form of a market has grown up. These offer some opportunities for those excluded from employment, and they also offer some escape from the monotony of the factory floor. A drift, in the 1970s and 1980s, into the micro-economy of the street market is one sign of the dwindling opportunities in the world of real work. There are now more of these stalls carrying a wider range of goods than before in most of the market places in the urban centres. There has also been a diversification into the world of new technology, with stalls offering cut-price digital alarms, watches, personal hi-fis, videotapes, cassettes, 'ghetto-blasters' and cameras. The hidden economy of work is also supplemented here by the provi-sion of goods obtained illegally and sold rapidly at rock-bottom prices.

This general expansion coincides, however, with changing patterns in urban consumerism and with attempts on the part of mainstream retailers to participate in an unexpected boom. In the inner cities the bustling markets frequently breathe life and colour into otherwise desolate blighted areas. This, in turn, produces an incentive for the chain stores to reinvest, and in places such as Dalston Junction in Hackney, and Chapel Market in Islington, the redevelopment of shopping has taken place along these lines, with Sainsbury's, Boots the Chemist and others, updating and expanding their services. The stores flank the markets, which in turn line the pavements, and the consumer is drawn into both kinds of shopping simultaneously. In the last few years many major department stores have redesigned the way in which their stock is displayed in order to create the feel of a market place. In the 'Top Shop' basement in Oxford Street, for example, there is a year-round sale. The clothes are set out in chaotic abundance. The rails are crushed up against each other and packed with stock, which causes the customers to push and shove their way through. This intentionally hectic atmosphere is heightened by the disc jockey who cajoles the shoppers between records to buy at an even more frenzied pace.

Otherwise, in those regions where the mainstream department stores are still safely located on the other side of town, the traditional street market continues to seduce its customers with its own unique atmosphere. Many of these nowadays carry only a small stock of second-hand clothes. Instead, there are rails of 'seconds' or cheap copies of high street fashions made from starched fabric which, after a couple of washes, are ready for the dustbin. Bales of sari material lie stretched out on coun-ters next to those displaying make-up and shampoo for black women. Reggae and

funk music blare across the heads of shoppers from the record stands, and hot food smells drift far up the road. In the Ridley Road market in Hackney the hot bagel shop remains as much a sign of the originally Jewish population as the eel pie stall reflects traditional working-class taste. Unfamiliar fruits create an image of colour and profusion on stalls sagging under their weight. By midday on Fridays and at weekends the atmosphere is almost festive. Markets like these retain something of the pre-industrial gathering. For the crowd of shoppers and strollers the tempo symbolises time rescued from that of labour, and the market seems to celebrate its own pleasures. Differences of age, sex, class and ethnic background take on a more positive quality of social diversity. The mode of buying is leisurely and unharassed, in sharp contrast to the Friday afternoon tensions around the checkout till in the supermarket.

Similar features can be seen at play in markets such as Camden Lock on Saturday and Sunday afternoons. Thousands of young people block Camden's streets so that only a trickle of traffic can get through. The same groups and the streams of punk tourists can be seen each week, joined by older shoppers and those who feel like a stroll in the sun, ending with an ice cream further along Chalk Farm road. Young people go there to see and be seen if for any other reason than that fashion and style invariably look better worn than they do on the rails or in the shop windows. Here it is possible to see how items are combined with each other to create a total look. Hairstyles, shoes, skirts and 'hold-up' stockings; all of these can be taken in at a glance. In this context shopping is like being on holiday. The whole point is to amble and look, to pick up goods and examine them before putting them back. Public-school girls mingle with doped-out punks, ex-hippies hang about behind their Persian rug stalls as though they have been there since 1967, while more youthful entrepreneurs trip over themselves to make a quick sale.

Subcultural entrepreneurs

The entrepreneurial element, crucial to an understanding of street markets and second-hand shops, has been quite missing from most subcultural analysis. The vitality of street markets today owes much to the hippy counter-culture of the late 1960s. It was this which put fleamarkets firmly back on the map. Many of those which had remained dormant for years in London, Amsterdam or Berlin, were suddenly given a new lease of life. In the years following the end of World War Two the thriving black markets gradually gave way to the fleamarkets which soon signalled only the bleakness of goods discarded. For the generation whose memories had not been blunted altogether by the dizzy rise of post-war consumerism, markets for old clothes and jumble sales in the 1960s remained a terrifying reminder of the stigma of poverty, the shame of ill-fitting clothing, and the fear of disease through infestation, rather like buying a second-hand bed.

Hippy preferences for old fur coats, crêpe dresses and army great-coats, shocked the older generation for precisely this reason. But they were not acquired merely for their shock value. Those items favoured by the hippies reflected an interest in pure, natural and authentic fabrics and a repudiation of the man-made synthetic materials found in high street fashion. The pieces of clothing sought out by hippy

girls tended to be antique lace petticoats, pure silk blouses, crêpe dresses, velvet skirts and pure wool 1940s-styled coats. In each case these conjured up a time when the old craft values still prevailed and when one person saw through his or her production from start to finish. In fact, the same items had also won the attention of the hippies' predecessors, in the 'beat culture' of the early 1950s. They too looked for ways of by-passing the world of ready-made clothing. In the rummage sales of New York, for example, 'beat' girls and women bought up the fur coats, satin dresses and silk blouses of the 1930s and 1940s middle classes. Worn in the mid 1950s, these issued a strong sexual challenge to the spick and span gingham-clad domesticity of the moment.

By the late 1960s, the hippy culture was a lot larger and much better off than the beats who had gone before them. It was also politically informed in the sense of being determined to create an alternative society. This subculture was therefore able to develop an extensive semi-entrepreneurial network which came to be known as the counter-culture. This was by no means a monolithic enterprise. It stretched in Britain from hippy businesses such as Richard Branson's Virgin Records and Harvey Goldsmith's Promotions to all the ventures which sprang up in most cities and towns, selling books, vegetarian food, incense, Indian smocks, sandals and so on. It even included the small art galleries, independent cinemas and the London listings magazine *Time Out*.

From the late 1960s onwards, and accompanying this explosion of 'alternative' shops and restaurants, were the small second-hand shops whose history is less familiar. These had names like 'Serendipity', 'Cobwebs' or 'Past Caring' and they brought together, under one roof, all those items which had to be discovered separately in the jumble sales or fleamarkets. These included flying jackets, safari jackets, velvet curtains (from which were made the first 'loon' pants) and 1920s flapper dresses. These second-hand goods provided students and others drawn to the subculture, with a cheaper and much more expansive wardrobe. (The two looks for girls which came to characterise this moment were the peasant 'ethnic' look and the 'crêpey' bohemian Bloomsbury look. The former later became inextricably linked with Laura Ashley and the latter with Biba, both mainstream fashion newcomers.) Gradually hippie couples moved into this second-hand market, just as they also moved into antiques. They rapidly picked up the skills of mending and restoring items and soon learnt where the best sources for their stock were to be found. This meant scouring the country for out-of-town markets, making trips to Amsterdam to pick up the long leather coats favoured by rich hippy types, and making thrice-weekly trips to the dry cleaners. The result was loyal customers, and if the young entrepreneurs were able to anticipate new demands from an even younger clientele, there were subsequent generations of punks, art students and others.

The presence of this entrepreneurial dynamic has rarely been acknowledged in most subcultural analysis. Those points at which subcultures offered the prospect of a career through the magical exchange of the commodity have warranted as little attention as the network of small-scale entrepreneurial activities which financed the counter-culture. This was an element, of course, vociferously disavowed within the hippy culture itself. Great efforts were made to disguise the role which money played in a whole number of exchanges, including those involving drugs. Selling

goods and commodities came too close to 'selling out' for those at the heart of the subculture to feel comfortable about it. This was a stance reinforced by the sociologists who also saw consumerism within the counter-culture as a fall from grace, a lack of purity. They either ignored it, or else, employing the Marcusian notion of recuperation, attributed it to the intervention of external market forces. It was the unwelcome presence of media and other commercial interests which, they claimed, laundered out the politics and reduced the alternative society to an endless rail of cheesecloth shirts.

There was some dissatisfaction, however, with this dualistic model of creative action followed by commercial reaction. Dick Hebdige [1979] and others have drawn attention to the problems of positing a raw and undiluted (and usually working-class) energy, in opposition to the predatory youth industries. Such an argument discounted the local, promotional activities needed to produce a subculture in the first place. Clothes have to be purchased, bands have to find places to play, posters publicising these concerts have to be put up . . . and so on. This all entails business and managerial skills even when these are displayed in a self-effacing manner. The fact that a spontaneous sexual division of labour seems to spring into being is only a reflection of those gender inequalities which are prevalent at a more general level in society. It is still much easier for girls to develop skills in those fields which are less contested by men than it is in those already occupied by them. Selling clothes, stage-managing at concerts, handing out publicity leaflets, or simply looking the part, are spheres in which a female presence somehow seems natural.

While hippy style had run out of steam by the mid-1970s the alternative society merely jolted itself and rose to the challenge of punk. Many of those involved in selling records, clothes and even books, cropped their hair, had their ears pierced and took to wearing tight black trousers and Doctor Marten boots. However, the conditions into which punk erupted and of which it was symptomatic for its younger participants were quite different from those which had cushioned the hippy explosion of the 1960s. Girls were certainly more visible and more vocal than they had been in the earlier subculture, although it is difficult to assess exactly how active they were in the do-it-yourself entrepreneurial practices which accompanied, and were part of, the punk phenomenon. Certainly the small independent record companies remained largely male, as did the journalists and even the musicians (though much was made of the angry femininity of Poly Styrene, The Slits, The Raincoats and others). What is less ambiguous is the connection with youth unemployment, and more concretely, within punk, with the disavowal of some of the employment which was on offer for those who were not destined for university, the professions or the conventional career structures of the middle classes.

Punk was, first and foremost, cultural. Its self-expressions existed at the level of music, graphic design, visual images, style and the written word. It was therefore engaging with and making itself heard within the terrain of the arts and the mass media. Its point of entry into this field existed within the range of small-scale youth industries which were able to put the whole thing in motion. Fan magazines (fanzines) provided a training for new wave journalists, just as designing record sleeves for unknown punk bands offered an opportunity for keen young graphic designers. In the realm of style the same do-it-yourself ethic prevailed and the obvious place to start was the jumble sale or the local fleamarket. Although punk

also marked a point at which boys and young men began to participate in . unashamedly, girls played a central role, not just in looking for the right clothes bu also in providing their peers with a cheap and easily available supply of second-hand items. These included 1960s cotton print 'shifts' like those worn by the girls in The Human League in the early 1980s (and in the summer of 1988 'high fashion' as defined by MaxMara and others), suedette sheepskin-styled jackets like that worn by Bob Dylan on his debut album sleeve (marking a moment in the early 1960s when he too aspired to a kind of 'lonesome traveller' hobo look), and many other similarly significant pieces.

This provision of services in the form of dress and clothing for would-be punks, art students and others on the fringe, was mostly participated in by lower middle-class art and fashion graduates who rejected the job opportunities available to them designing for British Home Stores or Marks and Spencer. It was a myth then, and it is still a myth now, that fashion houses were waiting to snap up the talent which emerges from the end-of-term shows each year. Apart from going abroad, most fashion students are, and were in the mid-1970s, faced with either going it alone with the help of the Enterprise Allowance Schemes (EAS), or else with joining some major manufacturing company specialising in down-market mass-produced fashion. It is no surprise, then, that many, particularly those who wanted to retain some artistic autonomy, should choose the former. Setting up a stall and getting a licence to sell second-hand clothes, finding them and restoring them, and then using a stall as a base for displaying and selling newly-designed work, is by no means unusual. Many graduates have done this and some, like Darlajane Gilroy and Pam Hogg, have gone on to become well-known names through their appearance in the style glossies like *The Face*, *Blitz* and *iD*, where the emphasis is on creativity and on fashion-as-art.

Many others continue to work the markets for years, often in couples and sometimes moving into bigger stalls or permanent premises. Some give up, re-train or look round for other creative outlets in the media. The expansion of media goods and services which has come into being in the last ten years, producing more fashion magazines, more television from independent production companies, more reviews about other media events, more media personalities, more media items about other media phenomena, and so on, depends both on the successful and sustained manifestation of 'hype' and also on the labour power of young graduates and school leavers for whom the allure of London and metropolitan life is irresistible. For every aspiring young journalist or designer there are many thousands, however, for whom the media remains tangible only at the point of consumption. Despite the lingering do-it-yourself ethos of punk, and despite 'enterprise culture' in the 1980s, this bohemian world is as distant a phenomenon for many media-struck school-leavers as it has always been for their parents. 'Enterprise subcultures' remain small and relatively privileged metropolitan spaces.

Outside cultural studies

Critiques and alternatives

Introduction to part three

■ Ken Gelder

SOCIOLOGISTS AT THE CHICAGO SCHOOL and researchers at the Centre
for Contemporary Cultural Studies at the University of Birmingham provided
a number of influential paradigms for subcultural studies: turning to the changing
social complexities of the modern city; identifying forms of disadvantage and
'deviance' there; examining 'worlds within worlds'; looking at the subcultural 'life-
cycle'; turning to working-class youth and thinking about their capacity for resistance
or 'refusal'; writing 'history from below'; distinguishing subcultural interests from
mass cultural forms; and, as we saw with the CCCS, shifting away from empirical
sociological methods to deploy a theoretically informed semiotic approach that
turned its attention to style as the key to subcultural 'meanings' and subcultural
distinction. But subcultural studies has gone in other directions too over the last
30 or so years. The extracts in this section offer alternative perspectives on what
produces subcultural difference, what divides 'them' from 'us' or 'us' from 'them'.
Here, subcultural solidarities are differently conceived: as not necessarily progres-
sive or resistant, for example, even though they may continue to react against the
homogenizing pressures of mass culture. We might say that the contributors in this
section increasingly respond to postmodern forms of sociality, which means among
other things that they are less willing to talk up the discrete extraordinariness of
subcultures and more inclined, instead, to treat them as symptoms of the fractured
and fragmented – but no less social – nature of contemporary life.

Two of the extracts here are early, focused critiques of the CCCS's descriptions
of subcultures – critiques that so many subsequent articles and books on subcultures
(as well as 'post-subcultures') seem condemned to repeat. Stanley Cohen's piece
comes from the introduction to the second edition of his classic study, *Folk Devils
and Moral Panics* (1972, 1980). This book had looked at media, social and police
reactions to mods and rockers in the 1960s, two subcultures notorious for fighting

with each other at the time, usually at southern English beachside resorts during Bank Holidays. For Cohen, those reactions in fact worked to intensify the antagonisms between mods and rockers, creating rather than defusing further conflict. The 'moral panic' generated by an emotionally charged media over these 'folk devils' – and Cohen coined both of these influential terms – exaggerated the scale of events and ensured that these subcultures *remained* a social problem. The piece included in this section, 'Symbols of Trouble', can be seen in this context; here, however, the concern is not with public media but with CCCS accounts of subcultures, which may also have exaggerated the case and heightened the problem. As a sociologist and a criminologist, Cohen is not sympathetic to the CCCS's tendency – more in tune with the humanities – to see subcultural participants as performers in 'a drama of profound symbolic resonance'. This is the sociologist's objection to an approach that is essentially textual or literary, where researchers such as Dick Hebdige seemed to embark on 'exercises of decoding', fascinated by 'exquisite aesthetics'. The subcultural participant is cast as a 'cultural innovator and critic', self-aware and ironic, and loaded up with historical and political significance. But for Cohen, this approach is far too eager to symbolize with far too little evidence for doing so, and he advocates instead a return to the more sober realities of ordinary, everyday life. Gary Clarke takes a similar view in his article 'Defending Ski-jumpers', which was in fact first published at the CCCS just two years after Hebdige's *Subculture: The Meaning of Style*. For Clarke, Hebdige slices 'style' away from any sense of lived culture, of a whole 'way of life' (a point that saw Clarke returning to the influence of Raymond Williams). Subcultures accordingly become 'essentialist and non-contradictory', an orderly or 'homologous' refuge in an otherwise disorderly and fractured world. Clarke suggests, as Cohen had done, that the CCCS overstated the creative potential of subcultures and underrated the meaningfulness of other aspects of everyday life. But he also says that subcultures had been wrongly cast – in the spirit of the avant-garde art world, which had so influenced Hebdige – in opposition to mass cultural forms and commercial imperatives. For Hebdige, subculturalists are innovators while the consumers of mass cultural goods (like ski-jumpers) are imitators: a powerful narrative in the cultural field. But Clarke's article wants to complicate this simple binary between subcultures and 'straights', not least by suggesting that subcultures these days are 'diffuse, diluted, and mongrelized in form'. His piece thus recalls John Irwin's in its emphasis on 'the current diversity of styles' in contemporary culture, and anticipates the views of 'post-subculturalists' much later on.

One of the problems for subcultural studies has been, how best to conceive of the lifestyles and practices of a 'deviant' group – or even, how best to understand 'deviancy' itself – without becoming too essentialist or 'aesthetic' about it in the process. Criminologist Jock Young's influential study *The Drugtakers* (1971) arrived at a time at which he could claim that drug-taking was ubiquitous across all social strata, so much so that the deviant and the 'straight' now seem to have swapped places: the 'totally temperate individual is statistically the deviant'. Young's work takes us back to Robert E. Park and the Chicago School as he responds to capitalism's capacity to produce 'normative' or 'straight' values on the one hand, and 'subterranean values' on the other – the kind of values that license drug-taking. But

his influences combine the economic/sociological and the literary/cultural: Marx, as well as Freud and Herbert Marcuse (a Freudian commentator associated with the Frankfurt School), the novelist Aldous Huxley and Johann Huizinga. Huizinga's *Homo Ludens: A Study of the Play Element in Culture* was published in 1938 and generated an influential 'countercultural' account of the role of play in society. Play is a little different to leisure, which itself serves a normative function. Here, however, play unfolds at one remove from the normative; the world it opens up is hedonistic and yet 'authentic'. Following Marx, Young suggests that normative values (underwriting work *and* leisure) alienate people from their true selves. But play allows a genuine expression of human yearning and creates a seductive alternative to modern capitalistic realities. Importantly, its domain is both social and ideological: 'subterranean values' are shared by groups (the 'bohemian young', for example) and reflect their 'world view'. Jock Young's account is romantic but no less valuable for that, and we shall see a version of it again in Iain Borden's discussion of 'ludic' skateboarders in chapter 24 and Ben Malbon's account of the 'playful vitality' of ecstasy-taking clubbers in chapter 42.

Subcultural studies can indeed be either romantic or anti-romantic, depending on the case, and two of the most influential post-CCCS commentaries on subcultures well illustrate these contrary positions. Sarah Thornton's *Club Cultures: Music, Media and Subcultural Capital* (1995) also turns to clubbers, but her conception of them is very different to Malbon's. Drawing on Howard S. Becker's work on Chicago dance musicians (see chapter 37), Thornton sees that British club cultures are invested in their 'hipness'. But her primary influence is the cultural sociology of Pierre Bourdieu. Club cultures, for Thornton, are '*taste* cultures' and their hipness is a form of 'subcultural capital', tied to style and fashion but also to clubbing knowledges (to being 'in the know'). For CCCS researchers, class had been an originating and determining category for subcultures. For Thornton, however, clubbers live out a 'fantasy of *classlessness*', free from work and responsibility. But the scene here is one of leisure rather than play, limiting its romantic appeal. Clubbers are not subordinated and oppositional as subcultures were for the CCCS. Indeed, for Thornton they are instead '[Margaret] Thatcher's children', radical only through their entrepreneurialism. Like Stanley Cohen, she therefore suggests that the CCCS had over-politicized subcultures. Her own work turns instead to 'subcultural ideologies' – that is, the ways in which subcultures imagine themselves and their relation to others – as well as to subcultural media, which further defines and intensifies subcultural distinctions, both externally (i.e. from others, from mass culture) and internally (from different clubs and clubbers, different clubbing ideologies).

We might say that, in Thornton's work, subcultures are ideological communities. In the work of Michel Maffesoli, on the other hand, subcultures are '*emotional* communities'. Maffesoli's work, in particular *The Time of the Tribes: The Decline of Individualism in Mass Society* – first published in France in 1988 and translated into English in 1996 – has been extraordinarily influential on contemporary subcultural and countercultural studies. It is both postmodern and archaic, in that it turns back to Tonnies' early, formative distinction between the rural community and modern society – but recovers the former as an outcome of the post-industrial world,

transient and affective but always *social*. Maffesoli is influenced by the sociology of Weber, Durkheim and Simmel (but certainly not Bourdieu), the symbolic anthropology of Gilbert Durand, and the philosophy of Henri Bergson and Nietzsche, drawing on the latter for a sense of postmodern life's vitalist, Dionysian qualities. He thus emphasizes pleasure and enjoyment in the midst of flux and change, but he always casts this as a social experience: 'sociality' in the midst of an otherwise alienating mass society. Indeed, individuals *need* sociality: Maffesoli returns here to Durkheim's argument that, by becoming social, individuals transcend themselves to participate in something 'divine'. The archaic aspect of Maffesoli's account is indicated by his preferred term for sociality or community, '*tribus*' or 'tribes'. It is used in the broadest sense here, to account for social groups as diverse as the Mafia, environmental lobbyists, sports enthusiasts and the National Rifleman's Association. For Maffesoli, these groups all find their sociality in a combination of ethics and aesthetics, in an 'art of living' that is both adaptable and unchanging. In fact, Maffesoli can be breathtakingly essentialist in his account of subcultural tribalism, as if ephemera and permanence are two sides of the same coin. He juxtaposes the 'barbarity' of subcultures with the civilized nature of the social and the 'rigidity' of social institutions: this is his romance, the kind we also see in Jock Young's account of play and 'subterranean values'. Mass society is rationalized and alienating, but sociality provides a bond that is 'emotional' and 'empathetic'. Maffesoli thus provides a counter-commentary to the Enlightenment, tying his sense of tribalism to an 'organic sense of solidarity' that is postmodern in its diversity and (testifying to the role anthropology plays in his work) 'primitive' in its reliance on ritualized performances and shared customs.

The very different approaches of Thornton and Maffesoli return us to Stanley Cohen's juxtaposition of the everyday and the 'aesthetic' or, we might say, the sociological and the literary/cultural – even though Maffesoli describes his own project (romantically enough) as 'vagabond sociology'. For Cohen, the exemplary researcher at the CCCS was Paul Willis, an ethnographer who spoke face-to-face with the 'lads' at his school, refusing the romantic trajectories of semiotics, symbol making and 'subterranean values'. But ethnographic accounts of subcultures have a long history, as Andrew Tolson's piece in this part reminds us. Tolson takes us away from the study of contemporary subcultures by returning to Henry Mayhew's magisterial *London Labour and the London Poor* (1861–62). As I have already noted, the work in this book first saw the light of day as a series of articles in the *Morning Chronicle* in 1849–50, with Mayhew interviewing an astonishing range of marginal characters in the city: street vendors, itinerant labourers, street performers, vagrants and vagabonds, prostitutes, rat-catchers, and so on. For Tolson, Mayhew helps to establish the interview as a 'special journalistic genre', a way of giving expression to 'lived culture' – a point that recalls (or anticipates) Robert E. Park's edict that a good sociologist must be a good reporter. Indeed, Tolson suggests that Mayhew is a foundational figure for sociology, since his interviewees are always taken as 'social types', 'representing the particular features of their class to the world'. This is also a founding moment for subcultural studies, allowing subordinated and marginal folk to speak as if for the first time. The cultural aspect of their lives is privileged here;

but Mayhew's work is also tied to the reformist agendas of criminology and govern-ment. His method might therefore seem in one sense to be an early version of Michel Maffesoli's 'vagabond sociology', the result of a romantic venture into the darker realms of London. But Tolson's account gives it an anti-romantic spin, regarding it instead as part of a larger project of governmentality and – drawing on the work of Michel Foucault – subjectification. Mayhew's work classifies and typifies, reducing rather than celebrating the 'otherness' of his subjects. The 'rigidity' of social insti-tutions is never far away, a feature that makes Mayhew's Watercress Girl very different in kind and demeanour to Hebdige's noisy punks.

Studies of subcultures slide back and forth between discrete socio-cultural iden-tities and a sense of the diffuse, mobile and diverse nature of contemporary – and historical – life. The contributors to this part offer different ways of registering these contrary features, giving expression to the particularity of a subculture while retaining a sense of the complexity of the world that subculture inhabits. In some cases, the sheer otherness of a subculture will be emphasized, while in others it will be compromised. For Tolson, Henry Mayhew emerges as a contemporary in this respect, introducing a 'modern technique' – the face-to-face interview – that responds to otherness with anthropological zeal, while bringing with it a set of disciplinary procedures to which otherness is inevitably subjected. But it is not just a question of allowing the subcultural subject to speak; these contributors also raise the ques-tion of what position, what disciplinary location, they themselves might properly and productively speak *from*.

Jock Young

THE SUBTERRANEAN WORLD
OF PLAY [1971]

I T IS NECESSARY, in order to explain the phenomenon of drugtaking, to relate it to factors existing in the wider society. It is simply not sufficient to state that drug use is a behaviour associated with certain disturbed personalities – to talk as the absolutist does of a monolithic body of 'normal' people contrasted with a few deviants condemned to the fringes of society because of their abnormal psyches or genetic make-ups. For this does not cast any light on why whole categories of people – ghetto blacks, middle-class youth, merchant seamen, Puerto Ricans and doctors for instance – have peculiarly high propensities to take drugs. Rather, one must explain such behaviour in terms of the particular subcultures to which each of these groups belong. The *meaning* of drugtaking has to be sought in the context of the group's values and world view. For an item of behaviour cannot be understood in isolation from its social milieu: man is the only animal that gives meaning to his actions and it is his system of values which provides these meanings.

Furthermore, we must relate subcultures to the total society: for they do not exist in a vacuum, they are a product of or a reaction to social forces existing in the world outside. Drugtaking is almost ubiquitous in our society – the totally temperate individual is statistically the deviant; it is only the type and quantity of psychotropic drugs used which varies. There must be fundamental connections between drugtaking and the configuration of values, ways of life and world views prevalent throughout our society. It is with this in mind that I wish to examine the nature of work and leisure in advanced industrial societies and the position that drugs play in the modern world.

The theory of subterranean values

In 1961 Matza and Sykes evolved a critique of a central part of absolutist theory. First they noted that it was preposterous to assume that everyone within society

adhered to middle-class standards of behaviour and attitudes. But this was, by that time, a commonplace criticism of sociological theory. More significantly, they went on to argue that this revised picture of society as being composed of a heterogeneous collection of strata each with different values did not go far enough. If the divisions between social groups were important, so also were the inconsistencies within the values of specific groups themselves. Society was not only split horizontally into strata, it was divided vertically within each group. For there was, they suggested, a fundamental contradiction running through the value systems of all members of society. Coexisting alongside the overt or official values of society are a series of *subterranean* values. One of these, for example, is the search for excitement: for new 'kicks'. Society, they argue, tends to provide institutionalized periods in which these subterranean values are allowed to emerge and take precedence. Thus we have the world of leisure: of holidays, festivals and sport in which subterranean values are expressed rather than the rules of workaday existence. A particularly apposite value is the saturnalia of the ancient world, which involved behaviour the very opposite of that allowed normally. The West Indian carnival is a modern illustration of this. Thus they write: 'the search for adventure, excitement and thrill is the subterranean value that . . . often exists side by side with the values of security, routinization and the rest. It is not a deviant value, in any full sense, but must be held in abeyance until the proper moment and circumstances for its expression arrive' [Matza and Sykes 1961: 716]. The juvenile delinquent then, in this light, is seen as: 'not an alien in the body of society but representing instead a disturbing reflection or caricature'. He takes up the subterranean values of society: hedonism, disdain for work, aggressive and violent notions of masculinity, and accentuates them to the exclusion of the formal or official values. Moreover, he is encouraged in this process by the fictional portrayals in the mass media (for example, Westerns, crime stories, war adventures) of heroes who epitomize precisely these values.

All members of society hold these subterranean values; certain groups, however, accentuate these values and disdain the workaday norms of formal society.

What is the precise nature of the subterranean values? This is perhaps best brought out by constructing a table in which one can contrast subterranean values with the formal, official values of the workaday world [see Table 13.1].

Now the formal values are consistent with the structure of modern industry. They are concomitant with the emergence of large-scale bureaucracies embodying a system of economic rationality, high division of labour, and finely woven, formalized rules of behaviour. These values are functional for the maintenance of diligent, consistent work and the realization of long-term productive goals. They are not, however, identical with the Protestant ethic. For whilst the latter dictated that a man realized his true nature and position in the world through hard work and painstaking application to duty, the formal values insist that work is merely instrumental. You work hard in order to earn money, which you spend in the pursuit of leisure, and it is in his 'free' time that a man really develops his sense of identity and purpose.

The Protestant ethic has, outside the liberal professions, entered into a remarkable decline. Berger and Luckmann have argued that the growth of bureaucracies in almost every sphere of social life have enmeshed the workaday world in a system

Table 13.1 Formal and subterranean values contrasted

Formal work values	Subterranean values
1. deferred gratification	short-term hedonism
2. planning future action	spontaneity
3. conformity to bureaucratic rules	ego-expressivity
4. fatalism, high control over detail, little over direction	autonomy, control of behaviour in detail and direction
5. routine, predictability	new experience, excitement
6. instrumental attitudes to work	activities performed as an end-in-themselves
7. hard productive work seen as a virtue	disdain for work

of rules which have precluded to a large extent the possibility for the individual to express his identity through his job [Berger and Luckmann 1964: 331]. The high division of labour and rationalization of occupational roles have made them inadequate as vehicles of personal desires and expressivity. Work has come to be regarded instrumentally by nearly all sections of society, middle class as much as working class [Dublin 1962]. Thus Bennett Berger writes: 'whether it is the relatively simple alienation so characteristic of assembly-line work in factories, or the highly sophisticated kind of alienation we find in the folk ways of higher occupations, one thing is clear: the disengagement of self from occupational role not only is more common than it once was but is also increasingly regarded as "*proper*"' [Berger 1963: 34]. It is during leisure and through the expression of subterranean values that modern man seeks his identity, whether it is in a 'home-centred' family or an adolescent peer group. For leisure is, at least, purportedly non-alienated activity.

It must not be thought, however, that contemporary man's work and leisure form watertight compartments. The factory-belt worker experiencing boredom and alienation does not come home in the evening to a life of undiluted hedonism and expressivity! The world of leisure and of work are intimately related. The money earned by work is spent in one's leisure time. It is through the various life styles which are evolved that men confirm their occupational status. Leisure is concerned with consumption and work with production; a keynote of our bifurcated society, therefore, is that individuals within it must constantly consume in order to keep pace with the productive capacity of the economy. They must produce in order to consume, and consume in order to produce. The interrelationship between formal and subterranean values is therefore seen in a new light: hedonism, for instance, is closely tied to productivity. Matza and Sykes have oversimplified our picture of the value systems of modern industrial societies: true, there is a bifurcation between formal and subterranean values, but they are not isolated moral regions; subterranean values are subsumed under the ethos of productivity. This states that a man is justified in expressing subterranean values if, and only if, he has earned the right to do so by working hard and being productive. Pleasure can only be legitimately

purchased by the credit card of work. For example, unlike the 'leisure classes' depicted by Veblen, modern captains of industry feel duty bound to explain how the richness of their leisure is a legitimate reward for the dedication of their labour.

The ethos of productivity, then, attempts to legitimize and encompass the world of subterranean values. But there are cracks and strains in this moral code. People doubt both the sanity of alienated work and the validity of their leisure. For they cannot compartmentalize their life in a satisfactory manner: their socialization for work inhibits their leisure, and their utopias of leisure belittle their work. . . .

Both the values of work and those of leisure are . . . viewed ambivalently. For the socialization necessary to ensure incessant consumption conflicts with that necessary to maintain efficient production. The hedonistic goals conjured up in the media are sufficient as a carrot but contain no mention of the stick. 'Through television we are encouraging, on the consumption side, things which are entirely inconsistent with the disciplines necessary for our production side. Look at what television advertising encourages: immediate gratification, do it now, buy it now, pay later, leisure time, hedonism' [Antony Downs, quoted in *Newsweek* 6 October 1969: 31–2].

Play and subterranean values

The subterranean values of expressivity, hedonism, excitement, new experience and non-alienated activity are identical with the customary definition of *play*. Thus A[nthony] Giddens defines play as the aspect of leisure which is:

(i) Self-contained, non-instrumental: it is an end-in-itself.
(ii) Cathartic.
(iii) Ego-expressive.

[Giddens 1964: 73]

Similarly, Huizinga in *Homo Ludens* defines play as:

(i) Voluntary activity.
(ii) It is not ordinary or real life, 'It is rather a stepping out of "real" life into a temporary sphere of activity with a disposition all of its own'.
(iii) Play is distinct from ordinary life both as to locality and duration and it contains its own course and meaning.

[Huizinga 1969]

Now as to the status of play, various authorities vary in their assessment of its importance. For some it is a mere recreation from work, whilst for others, 'man only plays when in the full meaning of the word he is a man, and he is only completely a man when he plays' [Schiller 1793]. It is such a world of play that Marx envisages in his future utopia where it will 'be possible for me to do this today and that tomorrow, to hunt in the morning, to fish in the afternoon, to raise cattle in the evening, to be a critic after dinner, just as I feel at the moment: without ever being a hunter, fisherman, herdsman, or critic' [Marx 1938]. This is a world without alienation, a world where work itself is synonymous with leisure.

Play, the demesne of subterranean values, occurs when man steps out of the workaday world, beyond the limitations of economic reality as we know it. The bifurcation between formal and subterranean values has a Freudian parallel in the distinction between pleasure and reality principles. Herbert Marcuse summed this up well when he wrote:

> The change in the governing value system may be tentatively defined as follows:
>
from	*to*
> | immediate satisfaction | delayed satisfaction |
> | pleasure | restraint of pleasure |
> | joy (play) | toil (work) |
> | receptiveness | productiveness |
> | absence of repression | security |
>
> [Marcuse 1956: 12]

The socialization of a child involves a transition from the pleasure principle to the reality principle, from a world of free expression and hedonism to one of deferred gratification and productivity. Every man having tasted the paradise of play in his own childhood holds in his mind as an implicit utopia a world where economic necessity does not hold sway and where he is capable of free expression of his desires. This is the psychological basis of the subterranean values, and it is in one's leisure time that a watered-down expression of 'free time' and play holds sway. Marcuse would go on from this point and argue that the increased productivity of advanced technological societies has created the potentiality for the abolition of scarcity, of harsh economic necessity. Thus he writes:

> No matter how justly and rationally the material production may be organized it can never be a realm of freedom and gratification; but it can release time and energy for the free play of human faculties *outside* the realm of alienated labor, the greater the potential of freedom: total automation would be the optimum.
>
> [156]

Modern industrial society creates, then, the productivity for the development of a leisure which would give full rein to the expression of subterranean values. But such a development would threaten vested interests. For:

> The closer the real possibility of liberating the individual from the constraints once justified by scarcity and immaturity, the greater the need for maintaining and streamlining these constraints lest the established order of domination dissolve. Civilization has to defend itself against the specter of a world which could be free. If society cannot use its growing productivity for reducing repression (because such usage would upset the hierarchy of the *status quo*), productivity must be turned *against* the individuals, it becomes itself an instrument of universal control.
>
> [93]

Thus Marcuse, unlike Marx, sees the bifurcation between work and leisure as inerad-icable. What is necessary is that productivity should be harnessed in order to provide a material basis for the realization of subterranean values. The ethos of hedonism must hold sway over the world of productivity: the present order must be reversed.

The Age of Leisure, often heralded as an imminent possibility by social commen-tators throughout the last decade, has instead involved Western man in an increasing spiral of consumption and production. Formal values – the ethos of productivity – still rule the roost over the subterranean values of freedom. Consumption has become, according to Marcuse, a sophisticated form of social control. Thus, in *One-Dimensional Man*, he writes:

> We may distinguish both true and false needs. 'False' are those which are superimposed upon the individual by particular social interests in his repression: the needs which perpetuate toil, aggressiveness, misery and injustice. . . . Most of the prevailing needs to relax, to have fun, to behave and consume in accordance with the advertisements to love and hate what others love and hate, belong to this category of false needs.
>
> The people recognize themselves in their commodities; they find their soul in their automobile, hi-fi set, split-level home, kitchen equip-ment. The very mechanism which ties the individual to his society has changed; and social control is anchored in the new needs which it has produced.
>
> [Marcuse 1964: 93]

Consumer needs, as Galbraith . . . argued, do not spring directly out of some myste-rious 'urge to consume' implicit in man's nature. They are created by the ethos of production, rather than the latter emerging to meet an innate demand. Advertising stimulates and creates desires in order to ensure a secure market for future produc-tion. And the ethos itself creates a calculus in which men are judged by their ability to possess:

> Because the society sets great store by ability to produce a high living standard, it evaluates people by the products they possess. The urge to consume is fathered by the value system which emphasizes the ability of the society to produce. The more that is produced the more that must be owned in order to maintain the appropriate prestige.
>
> [Galbraith 1962: 133]

Our leisure, then, is closely geared to our work, it is not 'play' in the sense of a sharply contrasting realm of meaning to the workaday world. It is merely the arena where just rewards for conscientious labour are enacted, where occupational status is confirmed by appropriate consumption, and where the appetites which spur on productivity and aid social control are generated. Children from the age of about five are socialized by school and family to embrace the work ethic. For the young child play is possible, for the adolescent it is viewed ambivalently, but for the adult play metamorphoses into leisure. This process of socialization engenders in the adult a feeling of guilt concerning the uninhibited expression of subterranean values. He

is unable to let himself go fully, release himself from the bondage of the perform-ance ethic and enter unambivalently into the world of 'play'. . . .

In short, our socialization is only appropriate for leisure commensurate with the work ethic: it is inappropriate to a world of 'play'. . . .

Drugs and subterranean values

In [my book *The Drugtakers*] I analysed the factors which determined the social valu-ation of a particular form of drugtaking. I concluded that it was not the drug *per se*, but the reason why the drug was taken that determined whether there would be an adverse social reaction to its consumption. The crucial yardstick in this respect is the ethos of productivity. If a drug either stepped up work efficiency or aided relax-ation after work it was approved of; if it was used for purely hedonistic ends it was condemned [see Table 13.2].

For a moment let us focus on the legitimate psychotropic drugs, remembering that over 12p in the pound of British consumer spending is devoted to the purchase of alcohol and tobacco alone, not counting coffee, tea and prescribed barbiturates, amphetamines and tranquillizers.

Kessel and Walton see the function of drinking as a means of relieving the tensions created by the need in advanced industrial societies for conforming to an externally conceived system of rules [Kessel and Walton 1965] . . . I would agree with the[m] . . . up to a point. It is true that alcohol is used to break down the inhi-bitions inculcated by modern society, but it does not result in an asocial response consisting of indiscriminate aggressive and sexual urges. Rather, it leads to a social area where hedonistic and expressive *values* come to the fore, replacing the bureau-cratic rules of the workplace. Alcohol, in short, is used as a *vehicle* which enhances the ease of transition from the world of formal values to the world of subterranean values. And the same is true for many of the myriad other psychotropic drugs used by humanity. As Aldous Huxley put it:

Table 13.2 Personal motivation for use of drug

Personal motivation for use of drug	Drugs
1. to aid productivity	caffeine (coffee and tea) cigarettes (nicotine) amphetamine use by soldiers, students, astronauts etc.
2. to relax after work	'social' drinking prescribed barbiturates cigarettes (nicotine)
3. purely hedonistic ends	'problem' drinking marihuana heroin non-prescribed amphetamines

That humanity at large will ever be able to dispense with Artificial Paradises seems very unlikely. Most men and women lead lives at the worst so painful, at the best so monotonous, poor, and limited that the urge to escape, the longing to transcend themselves if only for a few moments, is and has always been one of the principal appetites of the soul. Art and religion, carnivals and saturnalia, dancing and listening to oratory – all these have served, in H. G. Wells's phrase, as Doors in the Wall. And for private, for everyday use, there have always been chemical intoxicants. All the vegetable sedatives and narcotics, all the euphorics that grow on trees, the hallucinogens that ripen in berries or can be squeezed from roots – all, without exception, have been known and systematically used by human beings from time immemorial. And to these natural modifiers of consciousness modern science has added its quota of synthetics – chloral, for example, and benzedrine, the bromides, and the barbiturates.

Most of these modifiers of consciousness cannot now be taken except under doctor's orders, or else illegally and at considerable risk. For unrestricted use the West has permitted only alcohol and tobacco. All the other chemical Doors in the Wall are labelled Dope, and their unauthorized takers are Fiends.

[Huxley 1959: 51–2]

These Doors in the Wall open into the world of subterranean values. They allow us to step out into a world free of the norms of workaday life; not, let me repeat, to an asocial world. For there are norms of appropriate behaviour when drunk or 'stoned', just as there are norms of appropriate behaviour when sober. For . . . the effects of drugs, although physiologically induced, are socially shared. We have definite expectations or roles as to appropriate and reprehensible behaviour whilst 'under the influence'. It may be that some individuals imbibe so much that they completely lose control, but this merely underlines my argument in that loss of control is defined precisely in terms of deviation from the appropriate norms of drug-induced behaviour.

It is fallacious to think of these episodes as escapes from reality; rather we must view them as escapes into *alternative* forms of reality. For social reality is socially defined and constructed and the world of subterranean values, however ambivalently it is viewed by 'official' society, is as real as the world of factories, workbenches and conveyor-belts. In fact, many authors such as Huxley would argue that the world behind the Doors in the Wall is more substantial and realistic than that of the formal world.

Alcohol, then, is a common vehicle for undermining the inhibitions built up by our socialization into the work ethic. It is the key to an area of subterranean values which are, however, in our society tightly interrelated and subsumed by the work ethic. It is as if the Door in the Wall merely led on to an antechamber of the World of Work, a place to relax and refresh oneself before the inevitable return to 'reality'. But other drugs, in the hands of groups who disdain the ethic of productivity, are utilized as vehicles to more radical accentuations of subterranean reality. It is drug use of this kind that is most actively repressed by the forces of social order. For it

is not drugtaking *per se* but the culture of drugtakers which is reacted against: not the notion of changing consciousness but the type of consciousness that is socially generated.

Groups that exist beyond the ethos of productivity

Socialization into the work ethic is accomplished by inculcating into individuals the desirability of the various material rewards which the system offers, and the efficacy of work as a means of achieving them. There are two possible ways in which this process can break down and prove unsuccessful:

1 If the means of obtaining these goals are unobtainable: if work suitable to realize the material aspirations of certain groups is not forthcoming.
2 If the material rewards or goals are not valued by the individuals, sections of the community which are beyond the work ethos.

Two sections of the community are prominent examples of groups which are beyond the strict dictates of the work ethos: the ghetto black community and the bohemian young. The former lack the means of achieving society's rewards, the latter disdain the rewards themselves. For different reasons, therefore, they share similar values and both are – very revealingly – particularly prone to illicit drug use. [Here, we need] to examine, first, the *general* factors which precipitate the emergence of subcultures of youth in advanced industrial societies, and then analyse the different styles of life which specific youth cultures have evolved as a solution to their problems. In particular [we should] focus on the various roles drugs play in the formulation of such solutions.

Stanley Cohen

SYMBOLS OF TROUBLE [1980]

TRADITIONAL SUBCULTURAL THEORY of delinquency is too well known to have to expound here. The intellectual offspring of two oddly matched but conventional strands of American sociology – functionalist anomie theory and the Chicago school – and the political offspring of the end of ideology era, it has shaped sociological visions of delinquency for twenty-five years. Like all intellectual departures – particularly those influenced by political considerations and particularly those in the deviancy field – when new subcultural theory appeared in Britain at the beginning of the 1970s it was concerned to show how radically it differed from tradition. And it could hardly have *looked* more different.

It was not just the switch from functionalist to Marxist language but the sense conveyed of why this switch 'had' to take place. The context was light years away from America in the mid-1950s: a sour, post welfare state Britain which had patently not delivered the goods; the cracking of all those interdependent myths of classlessness, embourgeoisement, consumerism and pluralism; the early warnings of economic recession and high (particularly juvenile) unemployment; the relative weakness of recognizably political resistance.

No tortuous sociology of knowledge is needed to see how this context 'influenced' the theories; the context was explicitly woven into the theories' very substance. History and political economy became open rather than hidden; the 'problem' of the working-class adolescent was seen not in terms of adjustment, or providing more opportunities to buy a larger share of the cake, but of bitter conflict, resistance and strife. The delinquent changed from 'frustrated social climber' to cultural innovator and critic. What was really happening on the beaches of Brighton and Clacton – as well as earlier at the Teddy Boy dance halls and later on the football terraces and punk concerts – was a drama of profound symbolic resonance. Subculture was, no less, a political battleground between the classes.

I will come back in more detail to this framework. It is worth noting, though, that for all its obvious novelty and achievement – it is now simply not possible to talk about delinquent subcultures in the same way – the new theory shares a great deal more with the old than it cared to admit. Both work with the same 'problematic' (to use the fashionable term): growing up in a class society; both identify the same vulnerable group: the urban male working-class late adolescent; both see delinquency as a collective solution to a structurally imposed problem. For example, while its tone and political agenda are distinctive enough, Willis's statement of what has to be explained is not too far away from the original theories: 'the experience and cultural processes of being male, white, working class, unqualified, disaffected and moving into manual work in contemporary capitalism' [Willis 1977: 119]. These common assumptions must be emphasized precisely because they do *not* appear in the rhetoric of moral panics or in conventional criminology or in the official control culture.

Beyond this, of course, there are the novelties and differences to which [I shall] now turn. These lie primarily in the levels of sophistication and complexity which the new theories have added, in the location of delinquency in the whole repertoire of class-based negotiations and in the rescuing of traditional subcultural theory from its historical flatness by placing both the structural 'problem' and its subcultural 'solution' in a recognizable time and place. Of course – as I will point out again – most delinquency is numbingly the same and has never had much to do with those historical 'moments' and 'conjunctures' which today's students of working-class youth cultures are so ingeniously trying to find. But whatever the object of attention – 'expressive fringe delinquency' (as I originally called it) or ordinary mainstream delinquency – the new theories distinguish three general levels of analysis: *structure*, *culture* and *biography*. I will adopt (and adapt) these headings to organize my review.

(i) *Structure* refers to those aspects of society which appear beyond individual control, especially those deriving from the distribution of power, wealth and differential location in the labour market. These are the structural 'constraints', 'conditions', 'contingencies' or 'imperatives' which the new theory identifies in general terms – and then applies to the group most vulnerable to them, that is, working-class youth. In old subcultural theory, these conditions constitute the 'problem' to which (ii) the *culture* is the solution. More broadly, culture refers to the traditions, maps of meanings and ideologies which are patterned responses to structural conditions; more narrowly, *sub*culture is the specific, especially symbolic form through which the subordinate group negotiates its position. Then (iii) there is *biography*: broadly, the pattern and sequence of personal circumstances through which the culture and structure are experienced. More narrowly: what the subculture means and how it is actually lived out by its carriers.

Much of the new work of British post-war youth cultures is a teasing out of the relationships between these three levels. And all of this work is more or less informed by the Marxist categorization of structure, culture and biography as the determinate conditions ('being born into a world not of your own choosing') to which the subculture is one of the possible working-class responses ('making your own history').

1. Structure/history/problem

In the more one-dimensional world of the original theories, working-class kids somehow hit the system – as represented variously by school, work or leisure. To use the common metaphor: the theories explained how and why kids would kick a machine that did not pay; no one asked how the machine was rigged in the first place. The new theories are very much concerned with how the machine got there. From a general analysis of post-war British capitalism, specific features – particularly the pervasiveness of class – are extracted and historicized. Their impact on the working class – and more particularly, its community and its most vulnerable members, adolescents – is then identified as a series of pressures or contradictions stemming from domination and subordination.

To determine what the old theories would classify as the 'problem' to which delinquency is the 'solution', one must 'situate youth in the dialectic between a "hegemonic" dominant culture and the subordinate working-class "parent" culture of which youth is a fraction' [Clarke et al. 1993: 38]. The conventional assumptions of the old theories are thus politically (and alas, linguistically) retranslated. In so doing, the individualistic bias of those theories (the assumption that status frustration, alienation or whatever, somehow had to be psychologically recognized) is removed. By stating the problem in historical or structural terms, there is no necessary assumption that it has to be present in a realized conscious form. Ethnographic support (in the form of statements about the 'system', the 'authorities', the 'fucking bosses') is occasionally cited but clearly the theories would not be embarrassed without this support. . . .

Let me list three representative such attempts to find the structural problem; each is a Marxist revision of the liberal or social-democratic assumptions behind the equivalent traditional theories.

Phil Cohen's influential work [Cohen 1972] is a radicalized and historically specific rendering of traditional accounts of working-class culture and community. He uses a particular delinquent youth culture, the Skinheads, and a particular place, the East End of London, to analyse the destruction of the working-class community and the erosion of its traditional culture. Kinship network, neighbourhood ecology, local occupational structure, depopulation, the destruction of communal space, immigration, post-war redevelopment and housing, the stress on the privatized space of the family unit . . . all these vectors of life so commonly ignored in standard delinquency theory, are assembled into a model of the internal conflicts in the parent (i.e. adult) culture which come to be worked out in terms of generational conflict. These conflicts (or contradictions) register most acutely on the young and might appear at all sorts of levels: at the ideological, between the traditional working-class puritanism and the new hedonism of consumption; at the economic, between the future as part of the socially mobile élite (the future 'explored' by the Mods) and the future as part of the new lumpen (represented by the Skinhead inversion of the glossy element in Mod style). The latent function of the subculture is 'to express and resolve, albeit magically, the contradictions which remain hidden or unresolved in the parent culture' [Cohen 1972: 23]. Delinquent cultures retrieve social cohesive elements destroyed in the parent culture.

My next example is Corrigan [1979] – and this time, the target is the social democratic view of educational disadvantage. The persistent theme in his ethnography of 14–15-year-old boys in two Sunderland working-class schools, is power and subordination. Far from being a public sports track in which the earnest working-class youth's striving for status and mobility is thwarted by his deprived background, the school is a hidden political battleground, a setting in which the historical role of compulsory state education in attacking working-class culture is re-enacted each day. Bourgeois morality, values, discipline and surveillance, on the one hand; the continuous 'guerrilla warfare' of truancy, mucking about, 'dolling off' and getting into trouble, on the other. The kids simply do not *see* the world in the same way as the school; their 'problem' is how to resist and protect themselves from an alien imposition, not how to attain its values.

Then there is Willis [1977] – whose target is also liberal ideologies about education, opportunity and work (and who provides the most sophisticated theory of the interplay between structure, culture and biography). His ethnographic picture – based on two years work with boys in a Midlands comprehensive school, 'Hammertown', and then another year as they moved into work – is similar to Corrigan's, but even bleaker and darker. Again, there is the metaphor of a 'permanent guerrilla war' – and the bland sociological notion of a 'counter culture' is replaced by 'caged resentment which always stops just short of outright confrontation' [Willis 1977: 12–13]. The boys' class culture is devoted to subverting the institution's main aim: making them work. But – and here lies the subtlety and originality of Willis's thesis – this culture, with its values of chauvinism, solidarity, masculinity and toughness, contains also the seeds of the boys' defeat. The same transcendence of the school system – the refusal to collude in the elaborate pretence of qualifications, useless certificates, vocational guidance and careers advice – signals insertion into a system of exploitation through the acceptance of manual labour. (Willis's view of culture – 'not simply layers of padding between human beings and unpleasantness' – as a creative appropriation in its own right, in fact undermines the whole solution/problem framework. The solution, ironically, is the problem: the boys eventually collude in their own domination.)

Each of these formulations – and other allied work – needs, and no doubt will receive, separate criticism. I want to mention here just one general problem: the over-facile drift to historicism. There are too many points at which the sociological enterprise of understanding the present is assumed to have been solved by an appeal to the past. No doubt it is important to see today's school in terms of the development of state education in the nineteenth century; to specify the exact historical transformations in the working-class neighbourhood; to define football hooliganism in terms of the erosion of the sport's traditions by bourgeois entertainment values, or to explain an episode of 'Paki-bashing' by Skinheads not in terms of a timeless concept of racial prejudice but by the place of migrant workers in the long historical drama of the collapse and transformation of local industry [Taylor 1971; Clarke 1978; Pearson 1976]. In each case the connections sound plausible. But in each case, a single and one-directional historical trend is picked out – commercialization, repression, bourgeoisification, destruction of community, erosion of leisure values – and then projected on to a present which (often by the same sociologist's own admission) is much more complicated, contradictory or ambiguous.

The recent enthusiasm with which criminologists have taken up the new 'history from below' derives from a common spirit [Pearson 1978]. The enterprise of bestowing meaning to certain contemporary forms of deviance was identical to the rescuing of groups like Luddites from (in E. P. Thompson's famous ringing phrase) 'the enormous condescension of posterity'. The appeal to history, though, is a hazardous business – especially in the form I will later discuss of trying to find actual continuities in resistance. I am less than convinced that any essentialist version of history – such as the dominant one of a free working class interfered with since the eighteenth century by the bourgeois state apparatus – is either necessary or sufficient to make sense of delinquency or youth culture today. It also leads to such nonsense as the assertion that *because* of this historical transformation, each working-class adolescent generation has to learn anew that its innocent actions constitute delinquency in the eyes of the state.

2. Culture/style/solution

Above all else, the new theories about British post-war youth cultures are massive exercises of decoding, reading, deciphering and interrogating. These phenomena *must* be saying something to us – if only we could know exactly *what*. So the whole assembly of cultural artefacts, down to the punks' last safety pin, have been scrutinized, taken apart, contextualized and re-contextualized. The conceptual tools of Marxism, structuralism and semiotics, a Left-Bank pantheon of Genet, Levi-Strauss, Barthes and Althusser have all been wheeled in to aid this hunt for the hidden code. The result has been an ingenious and, more often than not, plausible reading of subcultural style as a process of generating, appropriating and re-ordering to communicate new and subversive meaning.

Whether the objects for decoding are Teddy Boys, Mods and Rockers, Skinheads or Punks, two dominant themes are suggested: first, that style – whatever else it is – is essentially a type of *resistance* to subordination; secondly, that the form taken by this resistance is somehow *symbolic* or *magical*, in the sense of not being an actual, successful solution to whatever is the problem. The phrase 'resistance through ritual' clearly announces these two themes.

The notion of resistance conveys – and is usually intended to convey – something more active, radical and political than the equivalent phrases in old subcultural theory. It is not a question any more of passive adaptation or desperate lashing out in the face of frustrated aspirations, but of a collective (and, we are sometimes asked to believe) historically informed response, mediated by the class-culture of the oppressed. The following is a list of the terms actually used in the literature to convey this reaction:

> *in relationship to dominant values*:
> either: *resistance*: attack, subversion, overturning, undermining, strug-
> gle, opposition, defiance, violation, challenge, refusal, contempt
> or: *transformation*: transcendence, reworking, adaption, negotiation,
> resolution, realization

in relationship to traditional working-class values:
either: *defend:* safeguard, protect, preserve, conserve
or: *recapture:* reappropriate, retrieve, reassert, reaffirm, reclaim,
 recover

Clearly, the nuances of these words convey somewhat different meanings but there are common threads particularly in the recurrent theme of *winning space.* Territoriality, solidarity, aggressive masculinity, stylistic innovation – these are all attempts by working-class youth to reclaim community and reassert traditional values.

Sociologically more opaque than this notion of resistance is the reciprocal idea that this process (whether conceived as defence, re-working, re-assertion or whatever) is somehow a symbolic one. Again it is instructive to list the actual words used to convey this meaning: ritualistic; imaginary; mythical; fantastic; metaphorical; magical; allegorical; ideological; suppressed; displaced; dislocated. There appear to be three contexts in which such concepts are invoked:

(i) When the target for attack is inappropriate, irrational or simply wrong in the sense that it is not logically or actually connected with the source of the problem. Thus Teddy Boys attacking Cypriot cafe owners, Mods and Rockers attacking each other, Skinheads beating up Pakistanis and gays, or football hooligans smashing up trains, are all really (though they might not know it) reacting to other things, for example, threats to community homogeneity or traditional stereotypes of masculinity. To quote Cohen and Robins on the Arsenal youth end, 'It's as if for these youngsters, the space they share on the North Bank is a way of magically retrieving the sense of group solidarity and identification that once went along with living in a traditional working-class neighbourhood' [Cohen and Robins 1978: 137].

(ii) The second (and allied) meaning is that the solution is 'always and only' magical in that it does not confront the real material bases of subordination and hence lacks the organization and consequences of a genuinely political response. Such attempts to deal with contradictions and subordination 'crucially do not mount their solutions on the real terrain where the contradictions themselves arise and . . . thus fail to pose an alternative, potentially counter hegemonic solution' [Clarke 1975: 189]. The gestures are as effective as sticking pins into kewpie dolls or as neurotic defence mechanisms like displacement or suppression. The bosses, educational disadvantage, unemployment, the police, remain where they were. Relations with the state are conducted at an imaginary level '. . . not in the sense that they are illusory, but in that they enfold the human beings who find themselves in confrontation in a common misrecognition of the real mechanisms which have distributed them to their respective positions' [Cohen and Robins 1978: 113]. It is a staged shadow boxing, a very bad case indeed of false consciousness.

(iii) The final (and more conventional) meaning of symbolic, is simply that the subcultural style stands for, signifies, points to or denotes something beyond its surface appearance. The Mods' scooters, the Skinheads' working boots, the Punks' facial make-up are all making oblique, coded statements about relationships – real or imaginary – to a particular past or present. Objects are borrowed from the world of consumer commodities and their meanings transferred by being reworked into a new ensemble which expresses its opposition obliquely or ironically.

Hebdige captures all these three meanings:

> These 'humble objects' can be magically appropriated; 'stolen' by subordinate groups and made to carry 'secret' meanings which express, in code, a form of resistance to the order which guarantees their continued subordination.
>
> [Hebdige 1979: 18]

Both these themes of *resistance* and *symbols* are rich and suggestive. I have only the space to mention, somewhat cryptically, a few of the problems they raise.

The first arises from the constant impulse to decode the style in terms *only* of opposition and resistance. This means that instances are sometimes missed when the style is conservative or supportive: in other words, not reworked or reassembled but taken over intact from dominant commercial culture. Such instances are conceded, but then brushed aside because – as we all know – the style is a *bricolage* of inconsistencies and anyway things are not what they seem and so the apparently conservative meaning really hides just the opposite.

There is also a tendency in some of this work to see the historical development of a style as being wholly internal to the group – with commercialization and co-option as something which just happens afterwards. In the understandable zeal to depict the kids as creative agents rather than manipulated dummies, this often plays down the extent to which changes in youth culture are manufactured changes, dictated by consumer society. I am not aware of much evidence, for example, that the major components in punk originated too far away from that distinctive London cultural monopoly carved up between commercial entrepreneurs and the lumpen intellectuals from art schools and rock journals. An allied problem is the often exaggerated status given to the internal circuit of English working-class history. The spell cast on the young by American cultural imperialism is sometimes downgraded. Instead of being given a sense of the interplay between borrowed and native traditions (Hebdige, of course, does just this; see also Cohen and Robins [1978: 96–103]) we are directed exclusively to the experiences of nineteenth-century Lancashire cotton weavers.

This is inevitable if the subculture is taken to denote some form of cumulative historical resistance. Where we are really being directed is towards the 'profound line of historical continuity' between today's delinquents and their 'equivalents' in the past. And to find this line, we have to ask questions like 'How would "our" hooligans appear if they were afforded the same possibilities of rationality and intelligibility say as those of Edward Thompson?' [Pearson 1978: 134] . . . Historical evidence is cited [by these theorists] to prove that mass proletarian resistance to the imposition of bourgeois control did not after all die out. It lives on in certain forms of delinquency which – though more symbolic and individualistic than their progenitors – must still be read as rudimentary forms of political action, as versions of the same working-class struggle which has occurred since the defeat of Chartism. What is going on in the streets and terraces is not only not what it appears to be, but moreover is really the same as what went on before. And to justify this claim, a double leap of imagination is required. In Pearson's example, the 'proof' that something like Paki-bashing is a 'primitive form of political and economic struggle'

lies not in the kids' understanding of what it is they are resisting (they would prob-ably only say something like, 'When you get some long stick in your 'and and you are bashing some Paki's face in, you don't think about it') but in the fact that the machine smashers of 1826 would *also* not have been aware of the real political signifi-cance of their action [Pearson 1976].

This seems to me a very peculiar sort of proof indeed. If ever Tolstoy's remark applied, it might be here: 'History is like a deaf man replying to questions which nobody puts to him.'

This leads on to the vexing issue of consciousness and intent, a problem present even when the appeal is to symbols rather than history. Now it would be as absurd to demand here that every bearer of symbols walks around with structuralist theory in his head, as it would be to expect the oppressed to have a detailed knowledge of dialectical materialism. It seems to me, though, that *somewhere* along the line, symbolic language implies a knowing subject, a subject at least dimly aware of what the symbols are supposed to mean. To be really tough-minded about this, our crite-rion for whether or not to go along with a particular symbolic interpretation should be Beckett's famous warning to his critics: 'no symbols where none intended'.

And at times, the new theories would seem to accept such a tough criterion. Clarke, for example, insists at one point 'that the group self-consciousness is suffi-ciently developed for its members to be concerned to recognize themselves in the range of symbolic objects available' [Clarke 1975: 179]. More often than not, though, this tough criterion of a fit, consonance or homology between self-consciousness and symbolism is totally ignored and the theory is content to find theoretical meanings (magic, recovery of community, resistance or whatever) quite independent of intent or awareness. Indeed Hebdige – who is more sensitive than most to this problem – ends up by conceding 'It is highly unlikely . . . that the members of any subcultures described in this book would recognize themselves reflected here' [Hebdige 1979: 139].

Some inconsistencies arise – I think – from a too-literal application of certain strands in structuralism and semiotics. Hebdige, for example, uses Barthes' contrast between the obviously intentional signification of advertisements and the apparently innocent signification of news photos to suggest that subcultural style bears the same relationship to conventional culture as the advertising images bear to the less consciously constructed news photo. In other words, subcultural symbols are, obvi-ously and conspicuously, fabricated and displayed. This is precisely how and why they are subversive and against the grain of mainstream culture which is unreflexive and 'natural'. But in the same breath, Hebdige repeats the semiotic article of faith that signification need not be intentional, that Eco's 'semiotic guerrilla warfare' can be conducted at a level beneath the consciousness of the individual members of a spectacular subculture – though, to confuse things further 'the subculture is still at another level an intentional communication' [Hebdige 1979: 101, 105].

This leaves me puzzled about the question of intent. I doubt whether these theories take seriously enough their own question about how the subculture makes sense to its members. If indeed not all punks 'were equally aware of the disjunc-tion between experience and signification upon which the whole style was ultimately based' or if the style made sense for the first wave of self-conscious innovators from the art schools 'at a level which remained inaccessible to those who became punks

after the subculture had surfaced and been publicized' [Hebdige 1979: 122] – and surely all this must be the case – then why proceed as if such questions were only incidental? It is hard to say which is the more sociologically incredible: a theory which postulates cultural dummies who give homologous meanings to all artefacts surrounding them or a theory which suggests that individual meanings do not matter at all.

Even if this problem of differential meaning and intent were set aside, we are left with the perennial sociological question of how to know whether one set of symbolic interpretation is better than another – or indeed if it is appropriate to invoke the notion of symbols *at all*. Here, my feeling is that the symbolic baggage the kids are being asked to carry is just too heavy, that the interrogations are just a little forced. This is especially so when appearances are, to say the least, ambiguous or (alternatively) when they are simple, but taken to point to just their opposite. The exercise of decoding can then only become as arcane, esoteric and mysterious as such terms as Hebdige's imply: 'insidious significance', 'the invisible seam', 'secret language', 'double meaning', 'second order system', 'opaque sign', 'secret identity', 'double life', 'mimes of imagined conditions', 'oblique expression', 'magical elisions', 'sleight of hand', 'present absence', 'frozen dialectic', 'fractured circuitry', 'elliptic coherence', 'coded exchanges', 'submerged possibilities', etc.

This is, to be sure, an imaginative way of reading the style; but how can be we sure that it is also not imaginary? When the code is embedded in a meaning system already rich in conscious symbolism, then there are fewer problems. For example, when Hebdige is writing about black rasta culture, the connections flow smoothly, the homology between symbols and life could hardly be closer. The conditions in the original Jamaican society, Rastafarian beliefs, the translation of reggae music to Britain . . . all these elements cohere. A transposed religion, language and style create a simultaneously marginal and magical system which provides a subtle and indirect language of rebellion. Symbols are *necessary*: if a more direct language had been chosen it would have been more easily dealt with by the group against which it was directed. Not only does the system display a high degree of internal consistency – particularly in its references to the historical experience of slavery – but it refers directly to patterns of thought which are *actually* hermetic, arcane, syncretic and associative.

If such patterns have to be forced out of the subject-matter, though, the end result is often equally forced. When any apparent inconsistencies loom up, the notion of 'bricolage' comes to the rescue: the magic ensemble is only *implicitly* coherent, the connections can be infinitely extended and improvised. And even this sort of rescue is too 'traditional' and 'simple' we are now told: instead of a reading being a revelation of a fixed number of concealed meanings, it's really a matter of 'polysemy': each text is seen to generate a potentially infinite range of meanings. Style fits together precisely because it does not fit; it coheres 'elliptically through a chain of conspicuous absences' [Hebdige 1979: 117–20].

This is an aesthetics which may work for art, but not equally well for life. The danger is of getting lost in 'the forest of symbols' and we should take heed of the warnings given by those, like anthropologists, who have searched more carefully in these same forests than most students of youth culture. Thus in trying to interpret what he calls these 'enigmatic formations', Turner is aware of certain frontiers to

the anthropologist's explanatory competence [Turner 1967]. Some method or rules of guidance are needed. It would do no harm, for example, to follow his distinction between the three levels of data involved in trying to infer the structure and property of symbols and rituals: first, the actual observable external form, the 'thing'; secondly, the indigenous exegetics offered either by ritual specialists like priests (esoteric interpretations) or by laymen (exoteric interpretations); and finally the attempt by the social scientist to contextualize all this, particularly by reference to the field: the structure and composition of the group that handles the symbol or performs mimetic acts with reference to it.

Having made a simple enough distinction like this, it is then possible to proceed to the interesting complications: the problem of intent; of polysemy (a single symbol standing for many things); how people's interpretations of what they are doing might contradict how they actually behave; under what conditions the observer must go beyond indigenous interpretations because of what he knows of the context. All this requires great care. Much decoding of youth cultures simply does not make the effort – and often does foolish things like taking a priestly exegesis (for example, by a rock journalist) at its face value, or alternatively, offering a contextualization that is wholly gratuitous.

Let me conclude this [section] by giving an example of the dangers of searching the forest of symbols without such a method – or indeed any method. This is the example often used by Hebdige and other theorists of punk: the wearing of the swastika emblem. Time and time again, we are assured that although this symbol is 'on one level' intended to outrage and shock, it is *really* only being employed in a meta-language: the wearers are ironically distancing themselves from the very message that the symbol is usually intended to convey. Displaying a swastika (or singing lyrics like 'Belsen was a gas') shows how symbols are stripped from their natural context, exploited for empty effect, displayed through mockery, distancing, irony, parody, inversion.

But how are we to know this? We are never told much about the 'thing': when, how, where, by whom or in what context it is worn. We do not know what, if any, difference exists between indigenous and sociological explanations. We are given no clue about how these particular actors manage the complicated business of distancing and irony. In the end, there is no basis whatsoever for choosing between this particular sort of interpretation and any others: say, that for many or most of the kids walking around with swastikas on their jackets, the dominant context is simple conformity, blind ignorance or knee-jerk racism.

Something more of an answer is needed to such questions than simply quoting Genet or Breton. Nor does it help much to have Hebdige's admission (about a similar equation) that such interpretations are not open to being tested by standard sociological procedures: 'Though it is undeniably there in the social structure, it is there as an immanence, as a submerged possibility, as an existential option; and one cannot verify an existential option scientifically – you either see it or you don't' [Hebdige 1979: 131].

Well, in the swastika example, I don't. And, moreover, when Hebdige does defend this particular interpretation of punk, he does it not by any existential leap but by a good old-fashioned positivist appeal to evidence: punks, we are told, 'were not generally sympathetic to the parties of the extreme right' and showed 'wide-

spread support for the anti-Fascist movement' [116]. These statements certainly constitute evidence, not immanence – though not particularly good evidence and going right against widespread findings about the racism and support for restrictive immigration policies among substantial sections of working-class youth.

I do not want to judge one reading against the other nor to detract from the considerable interest and value of this new decoding work. We need to be more sceptical though of the exquisite aesthetics which tell us about things being fictional and real, absent and present, caricatures and re-assertions. This language might indeed help by framing a meaning to the otherwise meaningless; but this help seems limited when we are drawn to saying about Skinhead attacks on Pakistani immigrants: 'Every time the boot went in, a contradiction was concealed, glossed over or made to disappear' [58]. It seems to me – to borrow from the language of contradictions – that both a lot more and a lot less was going on. Time indeed to leave the forest of symbols; and '. . . shudder back thankfully into the light of the social day' [Turner 1967: 46].

3. Biography/phenomenology/living through

In one way or another, most of the problems in the 'resistance through rituals' framework are to be found at the theory's third level: how the subculture is actually lived out by its bearers. The nagging sense here is that these lives, selves and identities do not always coincide with what they are supposed to stand for.

What must be remembered first is that the troubles associated with stylistic and symbolic innovation are not all representative of all delinquency (let alone of all post-war British youth). Mundane day-to-day delinquency is and always has been predominantly property crime and has little to do with magic, codes or rituals. I doubt that many of the intricate preoccupations of these theorists impinge much on the lives, say, of that large (and increasing) number of juveniles in today's custodial institutions: the 11,638 sent to detention centres, 7,067 to Borstals, 7,519 to prisons in 1978.

I fear that the obvious fascination with these spectacular subcultures will draw attention away from these more enduring numbers as well as lead to quite inappropriate criticisms of other modes of explanation. This, of course, will not be entirely the fault of the theorists themselves: the Birmingham group, for example, makes it absolutely clear that they are only concerned with subcultures which have reasonably tight boundaries, distinctive shapes and cohere around specific actions or places. As they are very careful to point out, the majority of working-class youth never enter such subcultures at all: 'individuals may in their personal life careers move into one and out of one, or indeed, several subcultures. Their relations to the existing subcultures may be fleeting or permanent, marginal or central' [Clarke et al. 1975: 16].

Despite these disavowals, though, the *method* used in most of this work detracts us from answering the more traditional, but surely not altogether trivial sociological questions about these different patterns of involvement. Why should some individuals exposed to the same pressures respond one way rather than another or with different degrees of commitment? As one sympathetic criticism [Murdock and

McCron 1976] suggests, the problem arises from *starting* with groups who are already card-carrying members of a subculture and then working backwards to uncover their class base. If the procedure is reversed and one starts from the class base, rather than the cultural responses, it becomes obvious that an identical location generates a very wide range of responses and modes of accommodation.

Thus time and time again, studies which start in a particular biographical location – school, neighbourhood, work – come up with a much looser relationship between class and style. They show, for example, the sheer ordinariness and passivity of much working-class adolescent accommodation and its similarities to, rather than dramatic breaks with, the respectable parent culture. In the cultural repertoire of responses to subordination – learning how to get by, how to make the best of a bad job, how to make things thoroughly unpleasant for 'them' – symbolic innovation may not be very important.

Such studies are also needed to give a sense of the concrete – some feeling of time and space; when and how the styles and symbols fit into the daily round of home, work or school, friendship. Without this, it becomes difficult, for example, to meet the same standard objection levelled against traditional subcultural theory: the assumption of overcommitment and the fact that apart from the code itself, these young people may be models of conventionality elsewhere. The intellectual pyrotechnics behind many of these theories are also too cerebral, in the sense that a remote, historically derived motivational account (such as 'recapturing community') hardly conveys the immediate emotional tone and satisfaction of the actions themselves. Indeed the action (for example, fighting or vandalism) is often completely ignored except when historicism is temporarily abandoned. A good example of this might be Corrigan's wholly believable account of the context and sequence in which trouble emerges among kids in the street corner of Sunderland: how 'doing nothing' leads to 'weird ideas' which lead to trouble. Another example would be Robins and Cohen's account of growing up on a council estate. The sense of imprisonment running through the different biographies they collect (under the heading 'We Gotta Get Out of This Place') relates closely with their theoretical explanation of what the street groups are actually doing.

Willis stands alone in showing how that (now) abused sociological task of linking history to subjective experience can be attempted. Structure is not left floating on its own – but a commitment to ethnography need not produce a series of disembodied phenomenological snapshots. He can retain the Marxist insistence that not everything is lived out at the level of practical consciousness – a level that is a poor guide to contradictions – and refuse 'to impute to the lads individually any critique or analytic motive', but still try to show what the 'giving of labour power' actually means subjectively. The struggle against subordination is lived out in the daily round of school life, in the rituals about dress, discipline, smoking, drinking, rules.

Gary Clarke

DEFENDING SKI-JUMPERS[1]
A critique of theories of youth subcultures
[1981]

SINCE ITS PUBLICATION, the 'new subcultural theory' contained in the Centre for Contemporary Cultural Studies' collection *Resistance Through Rituals* [1975] has become the new orthodoxy on youth; the collection and its spinoffs are firmly established on course reading lists at a time when youth has become a major focal concern of the state and parties across the political spectrum. To a large extent, the acceptance of the literature and its acclaim are justified: the authors realistically outlined the lived experience of postwar working-class youth subcultures in a sympathetic manner which was hitherto unknown. However, the approach has not been without its critics.

The major emphasis of the Centre for Contemporary Cultural Studies has been to explain the emergence of particular youth styles in terms of their capacity for problem solving. Phil Cohen's . . . complex analysis takes into account the full interplay of economic, ideological, and 'cultural' factors which give rise to subcultures. Subcultures are seen as 'a common solution between two contradictory needs: the need to create and express autonomy and difference from parents . . . and the need to maintain parental identifications' [Cohen 1972].

Cohen explains the development of subcultures on the basis of the redevelopment and reconstruction of the East End of London, which resulted in the fragmentation and disruption of the working-class family, economy, and community-based culture. Cohen suggests that the subcultures among working-class youth emerged as an attempt to resolve these experiences. Subcultures are seen as collective solutions to collectively experienced problems. Mods are seen to correspond to, and subsequently construct a parody of, the upwardly mobile solution, while skinheads are read as an attempt to recover magically the chauvinisms of the 'traditional' working-class community.

However, Cohen (and adherents) are imprecise on the necessary extent of the connection between actual structural location and the problem-solving option. Is it

possible, say, to have an upwardly mobile skinhead? Also, we are given little explanation as to how and why the class experiences of youth crystallize into a distinct subculture. The possible constituency of a new style is outlined, but where do the styles come from? Who designed the first fluorescent pink or leopardskin drape suit, for example, and how do we analytically leap from the desire for a solution to the adoption of a particular style? This is a significant problem when it seems that *both* skins and teds seek to revive and defend the 'traditional' working-class community, but through different styles. Furthermore, since any discussion of life chances is regarded as a 'Weberian deviation,' we are given no clues as to how we can explain the different degrees of commitment to a subculture other than through some neopositivist reference to the extent of the problems which stimulate the emergence of subcultures. The subcultures as discussed in *Resistance Through Rituals* are essentialist and non-contradictory. As Chris Waters [1981] has argued, the subcultures are treated as static and rigid anthropological entities when in fact such reified and pure subcultures exist only at the Centre's level of abstraction which seeks to explain subcultures in terms of their genesis. Hence there is an uncomfortable absence in the literature of any discussion as to how and with what consequences the pure subcultures are sustained, transformed, appropriated, disfigured, or destroyed. It is extremely difficult to consider the individual life trajectories of youth within the model laid down by Cohen. If each subculture is a specific problem-solving option, how are we to understand how individuals move in and out of different subcultures? . . .

The fundamental problem with Cohenite subcultural analysis is that it takes the card-carrying members of spectacular subcultures as its starting point and then teleologically works backward to uncover the class situation and detect the specific set of contradictions which produced corresponding styles. This could lead to the dangerous assumption that all those in a specific class location are members of the corresponding subculture and that all members of a subculture are in the same class location. A basic problem is that the elements of youth culture (music, dancing, clothes, etc.) which are discussed are not enjoyed *only* by the fully paid-up members of subcultures. If we reverse the methodological procedure adopted by the Centre and start with an analysis beginning with the social relations based around class, gender, and race (and age), rather than their stylistic products, we have to examine the whole range of options, modes of negotiation, or 'magical resolution' (and the limitations of access and opportunity that exist) that are open to, and used by, working-class youth. Such an approach would require a break from the Centre's paradigm of examining the 'authentic' subcultures in a synthetic moment of frozen historical time which results in an essentialist and noncontradictory picture. Any empirical analysis would reveal that subcultures are diffuse, diluted, and mongrelized in form. For example, certain skins may assert values of 'smartness' which are considered by the authors to be restricted to the mods. The anthropological analysis of unique subcultures means that descriptions of the processes by which they are sustained, transformed, and interwoven are absent. Similarly, the elitist nature of the analysis (that is, the focus on 'originals') means that we are given no sense of how and why the styles became popular (and how and why they eventually cease to be in vogue) other than through a simplistic discussion of the corruption and incorporation of the original style.

By focusing on subcultures at their innovatory moment, the authors are able to make elaborate and generalized readings of the symbols from a few scant observations of styles and artifacts. Youth subcultures are seen not simply as 'imaginary solutions' but also as symbolic resistance, counter-hegemonic struggle, a defense of cultural space on a 'relatively autonomous' ideological level. For example, Hebdige considers the mods to have won a magical 'victory':

> The style they created therefore, constituted a parody of the consumer society in which they were situated. The mod delivered his blows by inverting and distorting the images (of neatness, of short hair) so cherished by his employers and parents which while being overtly close to the straight world was nonetheless incomprehensible to it.
> [Hebdige 1975: 93]

Similarly, the teds' 'reworking' of Edwardian dress is seen as a reassertion of traditional working-class values in the face of affluence, and the model-worker image of the skins is interpreted as part of a symbolic return to the 'traditional' working-class community.

The paradigm developed in *Resistance Through Rituals* [is] taken to extremes in *Subculture: The Meaning of Style* [1979], in which Dick Hebdige presents a detailed analysis of postwar subcultures. Hebdige is the theorist of style and subculture *par excellence*: wheeling in the entire left-of-field gurus of art, literature, linguistics, and semiotics 'to tease out the meanings embedded in the various post-war youth styles'. Springing from the art-school tradition himself, Hebdige prioritizes the creativity of subcultures, their 'art', 'aesthetics', the 'signs of forbidden identity' contained in the styles. This lies in the *bricolage* of subcultures, in their ability to create meaning and transform 'everyday objects' as if they were a walking Andy Warhol exhibition. Since Hebdige's problem is to witness and understand the transformative moment in which new meanings are created . . ., the resultant 'semiotic guerrilla warfare' is restricted to a flashpoint of rebellion. This is necessary by definition in Hebdige, since it seems that the symbolic potency of a style rests entirely upon the innovatory and unique nature of a subculture's 'appearance'. Hence, for all the discussions of 'the subversive implications of style . . . the idea of style as a form of refusal . . . a gesture of defiance or contempt,' when it all boils down, the power of subcultures is a temporary 'power to disfigure.' The politics of youth is not only restricted to a consideration of the symbolic power of style, but this is also confined to the moment of innovation since . . . stylistic configurations soon lose their shock potential in Hebdige's analysis.

But what is the symbolic power of style in Hebdige's analysis? Quite simply it is a case of 'shocking the straights': the power of subcultures is their capacity to symbolize Otherness among an undifferentiated, untheorized, and contemptible 'general public.' Subcultures 'warn the straight world in advance of a similar presence – the presence of differences – and draw upon themselves vague suspicions, uneasy laughter, white and dumb rages'.

This dichotomy between subcultures and an undifferentiated 'general public' lies at the heart of subcultural theory. The readings of subcultural style are based on a necessary consideration of subcultures at a level of abstraction which fails to

consider subcultural flux and the dynamic nature of styles; second, and as a result, the theory rests upon the consideration of the rest of society as being straight, incorporated in a consensus, and willing to scream undividedly loud in any moral panic. Finally, the analysis of subculture is posited upon the elevation of the vague concept of style to the status of an objective category. In *Subculture* the degree of blackness of a subculture provides the yardstick, but generally, the act of basic consideration (like the old song) is that 'you either have or you haven't got style'. . . .

Any future analysis of youth must transcend an exclusive focus on style. The Centre's subculturalists are correct to break away from a crude conception of class as an abstract relationship to the forces of production. However, subcultures are conceived as a leisure-based career, and the 'culture' within 'youth subculture' is defined in terms of the possession of particular artifacts and styles rather than as a whole 'way of life' structured by the social relations based on class, gender, race, and age. Consequently we are given little sense of what subcultures actually *do*, and we do not know whether their commitment is fulltime or just, say, a weekend phenomenon. We are given no sense of the age range, income (or source of income), and occupations of the members of a subculture, no explanation as to why some working-class youths do not join. Individual subcultural stylists are, ironically, reduced to the status of dumb, anonymous mannequins, incapable of producing their own meanings and awaiting the arrival of the code breaker.

Even if we accept that it is possible to read youth styles as a form of resistance, the Centre's claims that subcultures 'operate exclusively in the leisure sphere' mean that the institutional sites of hegemony (those of school, work, and home) are ignored. Surely these are the sites in which any resistance is located, and they need to be considered in order to examine the relationship between working-class youth and working-class culture in general. Paul Willis's *Learning to Labour* [1977] presents such an analysis, examining boys' resistance at school to explain the reproduction of a shopfloor culture of masculinity. Unfortunately, Willis's categories of the 'lads' and the 'earoles' reproduce the dichotomy between deviant and 'normal' working-class youth which underlies the rest of the literature. The 'lads' are the focus of attention in the study, while the modes of negotiation (probably based on instrumentalism) adopted by the 'earoles' are ignored since they are presumed to be unproblematically incorporated into state schooling.

I would argue generally that the subcultural literature's focus on the stylistic deviance of a few contains (albeit implicitly) a similar treatment of the rest of the working class as unproblematically incorporated. This is evident, for example, in the distaste felt for youth deemed as outside subcultural activity – even though most 'straight' working-class youths enjoy the same music, styles, and activities as the subcultures – and in the disdain for such cults as glam, disco, and the ted revival, which lack 'authenticity.' Indeed, there seems to be an underlying contempt for 'mass culture' (which stimulates the interest in those who deviate from it) which stems from the work of the Marxism of the Frankfurt School and, within the English tradition, to the fear of mass culture expressed in *The Uses of Literacy* [Hoggart 1957]. . . .

Subcultural theory concerns itself with the original authentic members of a subculture and *their* creativity rather than how the styles dissipate and become used among working-class youth more generally. . . . Hence, we are to presume that the subcultures are brought back into line, rendered meaningless, 'incorporated'

within the consensus, as their creativity is adopted by the ranks of the 'artless' working-class.

It is true that subcultures do lose their potency, but the discussions of the 'incorporation' of styles are inadequate for various reasons. First, the 'creativity' of the initial members of a subculture is overstated and the 'relative autonomy' of youth from the market is inadequately theorized. Within these accounts, the 'moment' of creative assemblage is *before* the styles become available. However, such innovations usually have a firm stake in the commodity market themselves. For example, the partnership of Malcolm McLaren and Vivienne Westwood was central in the manufacturing and selling of both punk ('cash from chaos') and the 'warrior chic' of the 1980s. If we are to speak of the creativity of working-class youth in their appropriations from the market, the journey from stylistic assemblage to mass selling must be reversed. In light of Hebdige's [1979] admission that, 'in the case of the punks, the media's sighting of punk style virtually coincided with the invention of punk deviance,' I can see little point in any analysis which worships the innovators yet condemns those youth who appropriate that style when it becomes a marketed product and splashed across the *Sun*'s center page. Surely, if we are to focus on the symbolic refusal contained in items of clothing such as bondage trousers, we ought to focus on the moment when the style becomes available – either as a commodity or as an idea to be copied (for example by attaching zips and straps to a pair of old school trousers); any future analysis of youth should take the breakthrough of a style as its starting point. It is true that most youths do not enter into the subcultures in the elite form described in the literature, but large numbers do draw on particular elements of subcultural style and create their own meanings and uses of them. The concept of *bricolage* does not apply simply to an exclusive few – most working-class youths (and adults) combine elements of clothing to create new meanings. If anything, what makes subcultures outstanding is *not* their obvious *bricolage* (as Hebdige argues), but the lack of any fashion confusion as a style becomes a 'uniform.' An examination of male working-class youth quietly reveals that 'normal' dressing means using elements drawn from government surplus stores, sportswear (such as training shoes, track suits, rugby shirts, 'Fred Perry' tops, hunting jackets, rally jackets, flying suits, etc.), subcultural clothing appropriated from different historical eras via the secondhand clothing markets, and, finally, mass market fashion, which itself contains forms of recontextualized meaning, be it ski jumpers or work overalls. Girls are less free to experiment, but a closer examination is required here, since women's fashion cannot be simply conflated with an unchanging cult of femininity. In particular, it may be possible for our semioticians to make detailed readings of the *bricolage* which passes off as 'accessories' on the fashion pages.

If we are to consider the 'symbolic refusals' contained in items of clothing, we should not be content to read the styles of subcultural mannequins during their leisure time while dismissing other styles as if they were merely bland. Instead we should focus on the diluted 'semiotic guerilla warfare' in certain sites: in particular, those of school, home, and the workplace. This is evident, for example, in the stylistic disruptions of school uniform, the nonregulation jumper; earrings (on boys and girls); hair that is too long or too short; the trousers that are too wide, too straight, or that should be a skirt; the shirt or blouse of an unacceptable color or with a collar that is too short or long; the wearing of sneakers in class, and so forth. Similarly,

a youth does not have to adopt the complete uniform of a subculture to be sent home from work or a training course, to annoy parents, to be labeled 'unmasculine' or 'unfeminine,' to be refused service in a bar or café, to be moved on by the police, and so forth. Clearly, the diffusion of styles cannot be classed as a simple defusing of the signifying practice of an elite few. . . . [Besides,] the absolute distinction between subcultures and 'straights' is increasingly difficult to maintain: the current diversity of styles makes a mockery of subcultural analysis as it stands.

Note

1 Ski-jumpers are cheap, imported, acrylic sweaters depicting a row of three skiers as a band across the chest. The origin of the style or the cult is impossible to trace, yet they are worn by a large majority of working-class youth, regardless of race or gender.

Andrew Tolson

SOCIAL SURVEILLANCE AND SUBJECTIFICATION
The emergence of 'subculture' in the work of Henry Mayhew[1] [1990]

1. IN A SHORT, but very interesting section of his essay on 'youth surveillance and display' [see Chapter 27], Dick Hebdige draws attention to the fact that a history of concern for problems of juvenile delinquency can be traced back at least as far as the mid-nineteenth century (Hebdige 1983a: 19–22). Hebdige specifically mentions the work of Henry Mayhew as a 'celebrated' instance of this concern. A man of many parts and several careers, Mayhew was primarily a journalist who began to publish his own survey of urban poverty and conditions of labour in the London *Morning Chronicle* during 1849–50. Subsequently, in his book *London Labour and the London Poor* (1861), Mayhew extended his poverty survey to include details of domestic life, moral attitudes and what today might be defined as aspects of the 'lived culture' of sections of the metropolitan working class. Another commentator on Mayhew, Eileen Yeo, has suggested that this later work, especially its study of costermongers, amounts to a 'full blown cultural study, treating them at length as a group with distinctive social habits.' She argues that Mayhew was groping 'towards the concept of sub-culture which he could not, in the end, successfully formulate' (Thompson and Yeo 1973: 97–98).

It is significant that Yeo and Hebdige have located the discovery of subcultures in this mid-nineteenth-century context. For in one respect, this is radically to question the assumption, in several cultural studies accounts, that the emergence of spectacular urban subcultures is a distinctively post-war phenomenon. It suggests that subcultures are not an effect of the new consumer society, nor are they a symbolic response to the post-war restructuring of working-class communities. However, I also want to suggest that it is possible to develop Hebdige's argument, and to trace the public visibility of subcultures to the formation of a particular kind of social perspective, a 'sociological gaze,' which begins to emerge in the 1830s and 1840s. In the post-war period, youth subcultures may have *re-emerged* in their

distinctive modern forms; but the conditions and criteria for their recognition seem to have a much more extended history.

For, as Hebdige observes, the conditions within which subcultures first appear as spectacular are themselves related to a variety of strategies for social intervention, in nineteenth-century practices of philanthropy, education and moral reform. The important point here is that an early form of cultural research is developed within what Foucault has defined as the modern approach to 'governmentality' (Foucault 1979b). Mayhew himself was at the liberal, reformist end of the spectrum, but he was nonetheless operating within the 'domain of the social,' which Paul Hirst has characterised as a distinctively new discursive formation, opening up a range of approaches to the classification, supervision and policing of urban populations (Hirst 1981). In this light, subcultures can be regarded as one way in which such populations become socially visible and in terms of which they can be categorised. And hence, this early form of (sub)cultural studies, in its concern for the identification and classification of different urban 'ways of life,' is bound up with the exercise of new forms of social power. . . .

Having mentioned Mayhew's pioneering study of the costermongers, Hebdige goes on to discuss the most novel nineteenth-century technique for 'surveillance and display,' namely, the use of photography. But Mayhew, of course, was not a photographer; rather, his principal method for making his subjects socially visible was the interview, more or less faithfully recorded. On the pages of *London Labour*, and since then in innumerable similar studies, what appears for public examination and scrutiny is the *speech* of working-class people, spoken in very particular and somewhat peculiar circumstances. Looking at some examples from Mayhew's work, I want to make some critical observations about the emergence of the interview as a research technique. In particular, my attention will be focused on the criteria through which working-class people have become visible in interviews, to the extent that particular kinds of social and (sub) cultural *identity* have been attributed to them.

2. . . . According to one historical account of the origins of interviewing, it was in the mid-nineteenth century that the term 'interview' was first defined as a 'special journalistic genre' (Nilsson 1971). Previously it had been used to describe records of meetings or conversations, but now it became a professional technique for journalistic inquiry. . . . However, it is important also to note that in this period techniques of interviewing were not only pioneered by journalists. Simultaneously, in Britain at least, prototypical forms of interviewing were being developed in two emerging fields of social research: (i) in the reports of various parliamentary select committees, factory inspectors etc. into the moral condition of the working class; and (ii) in the development of new kinds of 'criminological' interest in the reform of 'delinquents.' It was these areas of social research which Mayhew merged and popularised in the 1850s and within which new forms of cultural visibility were constructed.

Mayhew's debt to the first area of social research is well established, [since] it is the focus for Yeo's discussion of his importance as a social investigator. Here, the interview was used as a technique to elicit public testimony, in the course of a formal, quasi-legal practice of cross-examination. However, in the second, 'criminological' context, the interview was developed not so much as a public ritual, but more as an intensive, individualised and private practice of *confession*. Here the insti-

tutional prototype was not the formal cross-examination, but rather the ongoing interpersonal relationship between an individual and his/her parish priest. Indeed, in this context, as James Bennett (1981) has shown, it was the clergyman, and specifically, the prison chaplain, who became the first 'oral historian'. . . .

The point here is that Mayhew's methodology seems to develop from several simultaneous sources, through a variety of routes, which are independent of each other, but which overlap to some extent. To adopt another Foucaultian concept, it seems appropriate to recognise that Mayhew was working within a mid-nineteenth-century *discursive formation*, – that is a 'systematic dispersion of statements' (see Cousins and Hussain 1984), which can be located in newspapers, in literary discourse, in official reports and essays. It is the configuration of these various elements in Mayhew's work that makes possible a certain kind of 'subcultural' interest, within the developing context of the 'domain of the social.'

In the end, any search for the 'origins' of the sociological interview is probably fruitless. It is not possible to privilege any one of these various sources (legal interrogation; journalistic 'human interest'; social investigation; 'cell confession') over the others. What we have in Foucaultian terms are various 'surfaces of emergence' for the interview. Of course, it does not diminish the significance of Mayhew's achievement to recognise that it was accomplished on the basis of these prior institutional conditions. There have been, in histories of journalism, protracted debates about which particular journalist can be regarded as the 'inventor' and even as the 'father' of the newspaper interview (see Turnbull 1936). The suggestion that Mayhew was a pioneer of the sociological interview need not take us that far. He was simply in the right place at the right time; but the scope of his achievement is certainly worthy of close examination.

3. For it is under these general conditions that new forms of public statement begin to appear in the mid-nineteenth century. In order to appear in this new context, public statements must follow certain conventions: they must be professionally mediated (by journalists, inspectors, social investigators etc.); but they must also appear in particular, socially recognisable forms. In Mayhew's work, however, such recognisable forms of statement neither follow a single, standardised protocol, nor are their discursive functions identical. To some extent, as James Bennett has shown, Mayhew achieved a certain public recognition for a 'naturalistic' approach to social inquiry, and what came to be known as the 'life history' interview. Similarly, from a more literary standpoint, Anne Humphreys has located Mayhew's achievement 'in the magnification of facts in the life histories he reported,' such that 'each individual grew in stature until he became a full-size human being for the reader' (Humphreys 1977: 61–62). But it is also necessary to observe that in Mayhew's work the interview can serve very different purposes, sometimes on adjacent pages of text; and that for each purpose, a different kind of public speech is relevant. We are, I think, at a stage in the development of social inquiry where the different sociological paradigms have yet to demarcate their methodologies.

For instance, Mayhew begins his investigations in the *Morning Chronicle* series as a political economist conducting a poverty survey. Here, as Eileen Yeo has argued, Mayhew inherited an established discourse of social investigation (Royal Commissions and Select Committees) into the condition of the working class. To

be sure, Mayhew not only inherited this discourse but also extended it, conducting 'the first empirical survey into poverty as such' (Thompson and Yeo 1973: 60); developing an original theory of the causes of low wages; and most important, improving the methods of investigation of the survey tradition. But these points do not take Mayhew out of political economy altogether; he does not immediately transcend its discursive protocols, at least as far as the function of the interview is concerned. For political economy is essentially dedicated to statistical calculation: the first purpose of the interview is fact-finding. Mayhew did, from the outset, involve workers themselves in the investigation, but as Yeo has pointed out, it is the *representative* individual who is interviewed:

> Before entering upon my investigations, I consulted several of the most experienced and intelligent workmen, as to the best means of arriving at the correct opinion, respecting the state of the trade. It was agreed among us that first, with regard to an estimate of the amount of wages, I should see a hand employed at each of the different branches of the trade. After this I was taken to a person who was the captain or leading man of the shop; then to one who, in the technicality of the trade, had a 'good chance' of work; and, finally, to one who was only casually employed. It was considered that these classes, taken in connection with the others, would give the public a correct view of the condition, earnings and opinions of the trade.
>
> (Thompson and Yeo 1973: 220)

To this extent then, Mayhew took up the position of an 'official' nineteenth-century social investigator, and he seems to have gone about his business with particular scientific care. It is significant, as Richard Johnson observes, that it was the evidence of middle-class professionals, and not the working classes themselves, that was routinely sought in the public tribunals and reports of the mid-nineteenth century: it was not until 1887 that three 'representatives of the working classes' appeared in a series of Commissions relating to education (Johnson n.d.: 4). It would seem then that there were social and political conventions which predetermined who could be counted as a 'representative' individual for official purposes. Perhaps the initial popularity of Mayhew's survey with the workers who participated was related to the fact that it challenged such conventions.

Nevertheless, what the *Morning Chronicle* survey had in common with previous social investigations was that it sought to bring certain facts into the public domain. In this context, as we have suggested, the survey acted as a kind of public tribunal: individuals were recruited as representative witnesses – literally, they made public 'representations' whether it be to a Parliamentary Commission, or in this case, to a newspaper journalist. What the representative witness produces when he or she speaks in these circumstances is counted as 'testimony'; and as such it must exhibit the appropriate epistemological guarantees – either through the social credibility of the witness, or through the consistency of evidence in the face of cross-examination. Social identities are not really *constructed* in this type of interview; rather, they are pre-supposed. They are defined in terms of the individual already possessing a certain role or . . . status which provides a prior qualification from which to speak.

4. However, consider the following [letter from Mayhew, dated 11 December 1849]. It indicates a subtle shift in the focus for Mayhew's inquiries, and another kind of function for the interview:

> to prevent the chance of error . . . I begged to be favoured with such accounts of earnings as would be procured from the operatives. This I thought would place men in a fair condition to judge of the incomings and physical condition of the class, but still I was anxious to arrive at something like a criterion of the intellectual, political, and moral character of the people, and I asked to be allowed an interview with such persons as the parties whom I consulted might consider would fairly represent these peculiar features of their class to the world. The results of my inquiry I shall now proceed to lay before the public.
>
> (Thompson and Yeo 1973: 221)

It seems to me that there is an ambiguity here in the meaning of the word 'represent,' which is indicative of another kind of 'social inquiry' which is beginning to emerge in Mayhew's work. For when it comes to representing 'the moral character of the people,' an individual does not so much speak by virtue of social status or prior qualification about something of which he or she has knowledge; rather, in this formulation, the individual *is* a representation – embodying and exhibiting 'the particular features of their class to the world.' It is at this point that the social individual begins to appear in terms which come to be defined as 'cultural,' or perhaps 'sub-cultural'; and Eileen Yeo argues that this develops more fully in *London Labour*, in Mayhew's second study of the costermongers. But I would suggest that the seeds are sown very early in the *Morning Chronicle* series, alongside his poverty survey.

Crucially, what seems to occupy a pivotal place in the shift from the social survey to the 'cultural' study is the concept of *character*. As used by Mayhew, this is a complex concept with several nineteenth-century connotations – 'intellectual, political and moral,' as the above quotation puts it. In all these contexts, however, the key point is that *character* is the quality which is embodied and exhibited rather than spoken about in interviews; and it is detected in certain *ways* of speaking rather than facts to be reported and verified. The social investigator now looks for *signs* of character in the speech of the interviewee, and the methodological requirement is that people are now interviewed in such a way that they might 'represent' such 'features' in their attitude, demeanour, or manner of speaking.

I have two examples, from *London Labour*, of the way Mayhew's discourse begins to incorporate this new form of cultural interest. The first is his encounter with a representative poor Irishwoman:

> I have before had occasion to remark the aptitude of the poor Irish in the streets of London not so much to lie, which may be too harsh a word when motives and idiosyncrasy are considered, but to exaggerate, and misrepresent, and colour in such a way that the truth becomes a mere incident in the narrative, instead of being the animating principle throughout. I speak here not as regards any direct question or answer on one specific point, but as regards a connected statement. Presuming

that a poor Irishwoman, for instance, had saved up a few shillings, very likely for some laudable purpose, and had hidden them about her person, and was asked if she had a farthing in the world, she would reply with a look of most stolid innocence, 'Sorra a fardin, Sir.' This of course is an unmitigated lie. Then ask her *why* she is so poor and what are her hopes for the future, and a very slender substratum of truth will suffice for the putting together of a very ingenious history, if she think the occasion requires it.

(Mayhew 1985: 31)

There are two points which clearly mark the difference between this kind of encounter and the research which Mayhew conducted for his poverty survey. The first point is that there is a level of disingenuity in the way Mayhew conducts this discussion. For he is no longer principally concerned with the real facts about the Irishwoman's poverty: in this context whether she actually has several shillings or a farthing is immaterial. Nor is this a moment for a true confession and a show of repentance such as the criminological discourse might require. From the perspective which is now in dominance, that is, the interest in social 'character,' Mayhew is much more fascinated with the *way* the Irishwoman speaks, and with the kinds of stories she tells, which now become signs of 'Irishness.'

Possibly, we might say, the interest has shifted from the 'content' to the 'form' of the discourse; but also, in methodological terms, a key shift in the nature of the evidence has occurred. For there is no guarantee that this particular poor Irishwoman is representative of the Irish in general – indeed this seems unlikely. We are simply (as often in *London Labour*) being invited to take Mayhew's word for it. In short, the second methodological point is that the relationship between the cultural generalisation and the evidence cited has become *rhetorical*.

What is constructed in this process is a new kind of social identity which is quite different from the representative witness, and indeed from the penitent individual. I will define this as the 'typical individual': the *type*. That is to say, the emerging sociology of culture in Mayhew's work is no longer simply concerned to deduce, or calculate, or reform – it is concerned to *typify*. Typification does not need to look for representative facts; what it requires are signs, which can be read to support cultural generalisations. In this way a certain kind of interest in language becomes possible – in so far as linguistic differences signify cultural variation (cf. Mayhew's interest in coster-slang, etc.). Other signs of 'culture' which fall within the purview ('gaze') of this discourse are dress, domestic environment, leisure activities (cf. the 'penny gaff') and that nineteenth century favourite, physiognomy.

Again, however, it is important to emphasise that in this transition to the cultural, the criminological focus does not simply disappear. Indeed, it is firmly in place in Mayhew's attitude to the poor Irishwoman, where some sense of 'normal'/'civilised' behaviour is implicated in the discussion from the start. I want to suggest therefore that although, in the shift from individual penitence to cultural typification, the interview becomes a different kind of technique (i.e. it is no longer a confession); nevertheless it borrows something from criminology – a certain stance, a position, perhaps a 'gaze,' which continues to see the interviewee as more or less 'other.' This is the condition in which it is possible to represent 'character,'

as defined by its signs or characteristics. But whereas the criminological gaze indi-
vidualises, and confronts the delinquent with his life history, the cultural gaze
collectivises and typifies the individual within a class. In this respect Mayhew's
cultural sociology seems to have effected a particular kind of synthesis between the
discourses of criminology and political economy which he inherited.

5. The most interesting thing, however, is that individuals do not simply disappear
from this culturalist discourse; they are manifestly present in Mayhew's work, but
within a further set of discursive conventions:

> The little watercress girl who gave me the following statement, although
> only eight years of age, had entirely lost all her childish ways, and was,
> indeed, in thoughts and manner, a woman. There was something cruelly
> pathetic in hearing this infant, so young that her features had scarcely
> formed themselves, talking of the bitterest struggles of life, with the
> calm earnestness of one who had endured them all. I did not know how
> to talk with her. At first I treated her as a child, speaking on childish
> subjects; so that I might, by being familiar with her, remove all shyness,
> and get her to narrate her life freely. I asked her about her toys and her
> games with her companions; but the look of amazement that answered
> me soon put an end to any attempt at fun on my part.
>
> (Mayhew 1985: 64–65)

Mayhew's vocation as a writer and journalist needs to be taken into account, not
simply as a biographical milieu, but also because it constitutes yet another purpose
for the interview. For in so far as various criminological and socio-cultural concerns
are popularised in Mayhew's journalism, a very interesting but also very tricky effect
is produced. Fundamentally, this hinges around a further ambiguity in the word
'character,' which on the one hand is located firmly within an evaluative moral
framework (an individual is of good or bad character, etc.), but on the other slips
into something like its more usual contemporary meaning, as a feature of narrative
discourse. In this sense, *London Labour* contains a wealth of 'characters,' like the
Watercress Girl.

It is not a novel – for one thing, Mayhew's characters are anonymous; and
Eileen Yeo has argued forcefully that Mayhew's work cannot be reduced to the
'genre of literary rambles' which includes 'characters and scenes of London'
(Thompson and Yeo 1973: 74). Nevertheless, as Humphreys shows, Mayhew's jour-
nalistic style (its descriptive passages, its representation of direct speech) has much
in common with the novelistic (e.g. Dickens). None of Mayhew's commentators,
however, has considered the exceedingly complex effects this produces for his repre-
sentations of character. For in place, simultaneously, there is the possibility of an
individual character analysis (criminology), an identification of cultural traits or
'characteristics' (cultural sociology), and the representation of characters to the
reader of a literary/journalistic narrative.

Today, we can identify in Mayhew certain discursive strategies which have
become institutionalised, not only in literary journalism, but also in documentary
broadcasting:

The 'they' that is always implied and often stated in direct address forms becomes an other, a grouping outside the consensus that confirms the consensus. Certain characteristic attitudes are taken towards these outsiders: patronisation, hate, wilful ignorance, pity, generalised concern, indifference. These are encouraged by the complicity that broadcast TV sets up between itself and its viewers.

(Ellis 1982: 139–40)

But we can observe that this mode of documentary address is already established in Mayhew, and it is this which permits the attitude of patronisation and pity towards the Watercress Girl. The journalistic discourse is predicated on a community of address: the direct address form ('I' am speaking to 'you') is in place, and the journalist surveys the streets on 'our' behalf. Moreover, in so far as his survey is represented in a narrative form – for instance, as Mayhew visits the street market, the penny gaff, the homes of the Irish etc. – the journalist also becomes a narrator. He is no longer simply the objective reporter – rather, a persona, a *personality*, is constructed for him.

It is at this moment, it seems to me, as Mayhew's survey and/or cultural study is narrativised, that the conditions are established for the appearance of another form of social identity. For in her representation as a character, the Watercress Girl is no longer simply a social type – like the poor Irishwoman. The cultural type essentially confirms our expectations; all Irishwomen are like this. But the narrative discourse, in its representation of a specific encounter, permits the narrator to register his *surprise*. He is confronted with circumstances which he (and we, his readers) did not at first anticipate. It is at this point that the contained reference to, and quotation of, culturally typical ways of speaking, passes on into a form of *dialogue*:

I then talked to her about the parks, and whether she ever went to them. 'The parks!' she replied in wonder, 'where are they?' I explained to her, telling her that they were large open places with green grass and tall trees, where beautiful carriages drove about, and people walked for pleasure, and children played. Her eyes brightened up a little as I spoke; and she asked, half doubtingly, 'Would they let such as me go there – just to look?' All her knowledge seemed to begin and end with watercresses, and what they fetched.

(Mayhew 1985: 65)

Mayhew did not transcribe his interviews precisely, but as Anne Humphreys suggests, it is frequently possible to infer a dialogic form to the interview, if only from the representation of replies. It is at this moment that the social character is no longer merely an object – Mayhew's other is also a subject; or rather (and this is the really tricky effect of characterisation), the social character becomes a subject *on the grounds that she is already objectified*. The Watercress Girl clearly is already cast as other – this is a precondition; but at certain moments this otherness is not simply and easily containable. It breaks through to produce a new kind of social recognition.

What kind of recognition is given to the social characters encountered in interviews? It seems to me that this element of surprise, the unexpected, never really amounts to a serious disturbance of the cultural consensus. It is capable of being read in a way which, although on one level shocking, on another level seems to reaffirm the validity of the norms which it disturbs. In the case of the Watercress Girl these are clearly certain middle-class norms about childhood innocence. So paradoxically a dominant cultural framework is confirmed, even though the individual encountered in the interview does not, at first sight, conform to it. But perhaps she does deep down, because 'her eyes brightened up a little' at the mention of play.

6. Some general critical questions are raised about the practices of interviewing in some forms of sociology and cultural studies. Specifically, interviewing must be regarded as taking an active part in the *construction* of social identities. That is to say, interviews do not simply discover and transparently reflect pre-given social experiences; rather, in their various forms of articulation, these experiences are defined and recognised according to different social criteria. Arguably these criteria, in common circulation, will begin to have material effects: having been interviewed by Mayhew, the Watercress Girl now enters the public sphere, the domain of the social, where it is quite easy to imagine that her plight might be the focus for philanthropic concern. But equally, it should not be possible to overlook the ambiguities in these constructions, to the extent that the social identity of the Watercress Girl is predicated on her objectification, and the philanthropic intervention itself assumes a pre-existing social distance from her (subcultural) world.

From this point of view, the sociological interview is not so much a methodology as a discursive *technology*, which produces, through the recognition it gives to certain forms of speech, specific forms of social identity. The perspective I am adopting here is of course derived from Foucault's work, and so I think it is appropriate to close with a quotation which will identify the terrain of questions I have discussed. This comes from Foucault's remarks on the question of 'subjectification':

> This form of power applies itself to immediate everyday life which categorises the individual, marks him by his own individuality, attaches to him his own identity, imposes a law of truth on him which he must recognise and which others have to recognise in him. It is a form of power which makes individuals subjects.
>
> (Foucault 1982: 210)

In these terms I would suggest that interviewing in general can be defined as a pervasive, modern technique for 'subjectification,' with the sociological interview (in its 'culturalist' mode) as one specific variant.

Note

1 This chapter was edited and revised by the author for this publication in 1997.

Sarah Thornton

THE SOCIAL LOGIC OF SUBCULTURAL CAPITAL [1995]

'CLUB CULTURE' is the colloquial expression given to the British youth cultures for whom dance clubs and their offshoot, raves, are the symbolic axis and working social hub. Club culture is not a unitary culture but a cluster of subcultures which share this territorial affiliation, but maintain their own dress codes, dance styles, music genres and catalogue of authorized and illicit rituals. Club cultures are *taste cultures*. The crowds generally congregate on the basis of their shared taste in music, their consumption of common media and, most importantly, their preference for people with similar tastes to themselves. Taking part in club cultures, in turn, builds further affinities, socializing participants into a knowledge of (and frequently a belief in) the likes and dislikes, meanings and values of the culture. Clubs and raves, therefore, house *ad hoc* communities with fluid boundaries which may come together and dissolve in a single summer or endure for several years.

Club nights continually modify their style, change their name and move their location. Club cultures are faddish, fragmented and heavily dependent on people 'being in the know' – on being 'hip', 'cool', or 'happening'. In fact, if one had to settle on one term to describe the cultural organization or social logic by which most clubs operate, it would have to be 'hipness'. But what is this willfully arcane attitude? This cultural value? How is it embodied? How is it displayed? Why is it most important to young people and something older people readily or reluctantly give up? What are its social uses, its demographics, its biases and discriminations?

Although this study is indebted to the subcultural studies associated with the Centre for Contemporary Cultural Studies, University of Birmingham, it is nevertheless distinctly 'post-Birmingham' in several ways. First, it doesn't position youthful consumer choices as proto-artistic and/or proto-political acts, ultimately explaining the logic of their cultural consumption in terms of its 'opposition' to vague social bodies variously called the parent culture, the wider culture or the term I find most revealing (and will discuss at length below), the 'mainstream'.

Vague opposition is certainly how many members of youth subcultures characterize their *own* activities. However, we can't take youthful discourses literally; they are not a transparent window on the world. Many cultural studies have made the mistake of doing this. They have been insufficiently critical of subcultural ideologies, first, because they were diverted by the task of puncturing and contesting dominant ideologies and, second, because their biases have tended to agree with the anti-mass society discourses of the youth cultures they study. While youth have celebrated 'underground', the academics have venerated 'subcultures'; where young people have denounced the 'commercial', scholars have criticized 'hegemony'; where one has lamented 'selling out', the other has theorized 'incorporation'. In this way, the Birmingham tradition has both over-politicized youthful leisure and at the same time ignored the subtle relations of power at play within it.

Subcultural ideologies are a means by which youth imagine their own and other social groups, assert their distinctive character and affirm that they are not anonymous members of an undifferentiated mass. They are not innocent accounts of the way things really are, but ideologies which fulfill the specific cultural agendas of their beholders. In this way, I am not simply researching the beliefs of a cluster of communities, but investigating the way they make 'meaning in the service of power' – however modest these powers may be (Thompson 1989: 7). Distinctions are never just assertions of equal difference; they usually entail some claim to authority and presume the inferiority of *others*.

In pursuit of this theme, I found it productive to return to the work of Chicago School subculturalists, particularly Howard Becker and Ned Polsky. Becker offers a compelling analysis of 'distinction' under another name in his study of a 'deviant' culture of musicians in the 1940s [see Chapter 37]. The aspirant jazz musicians of his study saw themselves as possessing a mysterious attitude called 'hip' and disdained other people, particularly their own audience, as ignorant 'squares'. Similarly, in 1960, Ned Polsky researched the social world of Greenwich Village Beatniks, finding that the Beats distinguished not only between being 'hip' and 'square', but added a third category of the 'hipster' who shared the Beatnik's fondness for drugs and jazz, but was said to be a 'mannered show off regarding his hipness' (Polsky 1967: 149).

In trying to make sense of the values and hierarchies of club cultures, I've also drawn extensively but critically from the work of the French sociologist, Pierre Bourdieu, particularly his book *Distinction* (1984) and related essays on the links between taste and the social structure. Bourdieu explores what he calls *cultural capital* or knowledge that is accumulated through upbringing and education which confers social status. It is the linchpin of a system of distinction in which cultural hierarchies correspond to social ones and people's tastes are first and foremost a marker of class. For instance, in Britain accent has long been a key indicator of cultural capital and university degrees have long been cultural capital in institutionalized form. Cultural capital is different from *economic capital*. High levels of income and property often correlate with high levels of cultural capital, but the two can also conflict. Comments about the '*nouveau riche*' disclose the possible frictions between those rich in cultural capital but relatively poor in economic capital (like academics) and those rich in economic capital but less affluent in cultural capital (like professional football players).

One of the many advantages of Bourdieu's schema is that it moves away from rigidly vertical models of the social structure. Bourdieu locates social groups in a highly complex multi-dimensional space rather than on a linear scale or ladder. His theoretical framework even includes discussion of a third category – *social capital* – which stems not from *what* you own or know, but from *who* you know (and who knows you). Connections in the form of friends, relations, associates and acquaintances can all bestow status. The aristocracy has always privileged social over other forms of capital, as have many private members' clubs and 'old boy's networks'.

In addition to these three major types of capital – cultural, economic and social – Bourdieu elaborates many subcategories of capital which operate within particular fields such as 'linguistic', 'academic', 'intellectual', 'information' and 'artistic' capital. One characteristic that unifies these capitals is that they are all at play within Bourdieu's *own* field, within *his* social world of players with high volumes of institutionalized cultural capital. However, it is possible to observe sub-species of capital operating within other less privileged domains. In thinking through Bourdieu's theories in relation to the terrain of my empirical research, I've come to conceive of 'hipness' as a form of *subcultural capital*.

Although subcultural capital is a term that I've coined in relation to my own research, it is one that jibes reasonably well with Bourdieu's system of thought. In his essay, 'Did You Say Popular?', he contends that 'the deep-seated "intention" of slang vocabulary is above all the assertion of an aristocratic distinction' (Bourdieu 1991: 94). Nevertheless, Bourdieu does not talk about these popular 'distinctions' as 'capitals'. Perhaps he sees them as too paradoxical in their effects to warrant the term? In response, I would argue that clubs are refuges for the young where their rules hold sway and that, inside and even outside these spaces, subcultural distinctions have significant consequences.

Subcultural capital confers status on its owner in the eyes of the relevant beholder. It affects the standing of the young in many ways like its adult equivalent. Subcultural capital can be *objectified* or *embodied*. Just as books and paintings display cultural capital in the family home, so subcultural capital is objectified in the form of fashionable haircuts and carefully assembled record collections (full of well-chosen, limited edition 'white label' twelve-inches and the like). Just as cultural capital is personified in 'good' manners and urbane conversation, so subcultural capital is embodied in the form of being 'in the know', using (but not over-using) current slang and looking as if you were born to perform the latest dance styles. Both cultural and subcultural capital put a premium on the 'second nature' of their knowledges. Nothing depletes capital more than the sight of someone trying too hard. For example, fledgling clubbers of 15 and 16 years old wishing to get into what they perceive as a sophisticated dance club will often reveal their inexperience by over-dressing or confusing 'coolness' with an exaggerated cold blank stare.

A critical difference between subcultural capital (as I explore it) and cultural capital (as Bourdieu develops it) is that the media are a primary factor governing the circulation of the former. Several writers have remarked upon the absence of television and radio from Bourdieu's theories of cultural hierarchy (Frow 1987; Garnham 1993). Another scholar has argued that they are absent from his schema because 'the cultural distinctions of particular taste publics collapse in the common

cultural domain of broadcasting' (Scannell 1989: 155). I would argue that it is impossible to understand the distinctions of youth subcultures without some systematic investigation of their media consumption. For within the economy of subcultural capital the media is not simply another symbolic good or marker of distinction (which is the way Bourdieu describes films and newspapers vis-à-vis cultural capital), but a network crucial to the definition and distribution of cultural knowledge. In other words, the difference between being *in* or *out* of fashion, high or low in subcultural capital, correlates in complex ways with degrees of media coverage, creation and exposure.

It has been argued that what ultimately defines cultural capital as *capital* is its 'convertibility' into economic capital (Garnham and Williams 1986: 123). While subcultural capital may not convert into economic capital with the same ease or financial reward as cultural capital, a variety of occupations and incomes can be gained as a result of hipness. DJs, club organizers, clothes designers, music and style journalists and various record industry professionals all make a living from their subcultural capital. Moreover, within club cultures, people in these professions often enjoy a lot of respect not only because of their high volume of subcultural capital, but because of their role in defining and creating it. In knowing, owning and playing the music DJs, in particular, are sometimes positioned as the masters of the scene, although they can be overshadowed by club organisers whose job it is to know who's who and gather the right crowd.

Although it converts into economic capital, subcultural capital is not as class-bound as cultural capital. This is not to say that class is irrelevant, simply that it does not correlate in any one-to-one way with levels of youthful subcultural capital. In fact, class is willfully obfuscated by subcultural distinctions. For instance, it is not uncommon for public school educated youth to adopt working-class accents during their clubbing years. Subcultural capitals fuel rebellion against, or rather escape from, the trappings of parental class. The assertion of subcultural distinction relies, in part, on a fantasy of classlessness. This may be one reason why music is the cultural form privileged within youth's subcultural worlds. Age is the most significant demographic when it comes to taste in music, to the extent that playing music in the family home is the most common source of generational conflict after arguments over the clothes sons and daughters choose to wear (Euromonitor 1989).

After age, the social difference along which subcultural capital is aligned most systematically is, in fact, gender. On average, girls invest more of their time and identity in doing well at school. Boys, by contrast, spend more time and money on leisure activities like going out, listening to records and reading music magazines (Mintel 1988; Euromonitor 1989). But this doesn't mean that girls do not participate in the economy of subcultural capital. On the contrary, if girls opt out of the game of 'hipness', they will often defend their tastes (particularly their taste for pop music) with expressions like 'It's crap but I like it'. In so doing, they acknowledge the subcultural hierarchy and accept their lowly position within it. If, on the other hand, they refuse this defeatism, female clubbers and ravers are usually careful to distance themselves from the degraded pop culture of 'Sharon and Tracy'; they emphatically reject and denigrate a feminized mainstream.

The 'hip' versus the 'mainstream'

Hipness is not a single unified style, nor is it captured definitively by any one scene.[1] Not all youth have it, but the majority are concerned about it. Within club worlds, there is much less consensus about what's 'hip' than what's not. Although most clubbers and ravers characterize their own crowd as mixed or impossible to classify, they are generally happy to identify a homogenous crowd to which they don't belong. And while there are many 'other' scenes, most clubbers and ravers see themselves as outside and in opposition to the 'mainstream'.

When I began research in 1988, hardcore clubbers of all kinds located the mainstream in the 'chartpop disco'. 'Chartpop' did not refer to the many different genres that make it onto the top forty singles sales chart as much as to a particular kind of dance music which included bands like Erasure and the Pet Shop Boys but was identified most strongly with the music of Stock, Aitken and Waterman (the producers of Kylie Minogue, Jason Donovan, Bananarama and other dance-oriented acts). Although one was most likely to hear this playlist at a provincial gay club, the oft-repeated, almost universally accepted stereotype of the chartpop disco was that it was a place where 'Sharon and Tracy dance around their handbags'. This crowd was considered unhip and unsophisticated. They were denigrated for having indiscriminate music tastes, lacking individuality and being amateurs in the art of clubbing. Who else would turn up with that uncool feminine appendage, that burdensome adult baggage – the handbag?

Toward the middle of 1989, in the wake of extensive newspaper coverage of acid house culture, clubbers began to talk of a new mainstream – or rather, at first, it was described as a second-wave of media-inspired, sheep-like acid house fans. This culture was populated by 'mindless ravers' or 'Acid Teds'. Teds were understood to travel in same-sex mobs, support football teams, wear kicker boots and be 'out of their heads'. Like Sharon and Tracy, they were white, heterosexual and working class. But unlike the girls, the ravers espoused the subterranean values proper to a youth culture at least in their predilection for drugs, particularly Ecstasy or 'E'.

However, when the culture came to be positioned as *truly* 'mainstream' rather than just behind the times, it was feminized. This shift coincided with the dominance of house and techno in the compilation album top twenty throughout 1991 and 1992. By the end of this period, talk of 'Acid Teds' was superseded by disparagement of raving Sharons and 'Techno Tracys'. The genre had even come to be called 'handbag house'. As one clubber explained to me, 'The rave scene is dead and buried. There is no fun in going to a legal rave when Sharons and Tracys know where it is as soon as you buy a ticket'.

Some clubbers and ravers might want to defend these attitudes by arguing that the music of Stock/Aitken/Waterman, then acid house-come-techno respectively dominated the charts in 1987–88, and 1989–91. But there are a couple of problems with this reasoning. First, the singles sales chart is mostly a pastiche of niche sounds which reflect the buying patterns of many taste cultures, rather than a monolithic mainstream (Crane 1986). Moreover, buyers of the same records do not necessarily form a coherent social group. Their purchase of a given record may be contextualized within a very different range of consumer choices; they may never occupy the same social space; they may not even be clubgoers.

Second, whether these 'mainstreams' reflect empirical social groups or not, they exhibit the burlesque exaggerations of an imagined 'other'. *Teds* and *Tracys*, like *lager louts*, *sloanes*, *preppies* and *yuppies*, are more than euphemisms of social class and status; they demonstrate 'how we create groups with words' (Bourdieu 1990: 139). So the activities attributed to 'Sharon and Tracy' should by no means be confused with the actual dance culture of working-class girls. The distinction reveals more about the cultural values and social world of hardcore clubbers because, to quote Bourdieu again, 'nothing classifies somebody more than the way he or she classifies' (Bourdieu 1990: 132).

It is precisely because the social connotations of the mainstream are rarely examined that the term is so useful; clubbers can denigrate it without self-consciousness or guilt. However, even a cursory analysis reveals the relatively straightforward demographics of these personifications of the mainstream. First, the clichés have class connotations. Sharon and Tracy, rather than, say, Camilla and Imogen, are what sociologists have tended to call the 'respectable working class'. Still, they are not envisaged as *beneath* the class of clubbers as much as being *classed*, full stop. In other words, they are guilty of being trapped in their class. They do not enjoy the classless autonomy of hip youth. The obfuscation of class goes some way toward explaining why straight white youth so frequently borrow tastes and fashions from gay and black cultures (Becker 1963; Hebdige 1979; Lee 1988; Polsky 1967; Savage 1988).

Age, the dependence of childhood and the accountabilities of adulthood are also signalled by these visions of the mainstream. The recurrent trope of the handbag is something associated with mature womanhood or with pretending to be grown up. It is definitely *not* a sartorial sign of youth culture, nor a form of objectified subcultural capital, but rather a symbol of the social and financial shackles of the housewife. Young people, irrespective of class, often refuse the responsibilities and identities of the work world, choosing to invest their attention, time and money in leisure. In his classic article from the 1940s, 'Age and Sex in the Social Structure of the United States', Talcott Parsons argues that young people espouse a different 'order of prestige symbols' because they cannot compete with adults for occupational status (Parsons 1964: 94). They focus less on the rewards of work and derive their self-esteem from leisure – a sphere which is more conducive to the fantasies of classlessness which are central to club and rave culture. In *Distinction*, Bourdieu identifies an analogous pattern for French middle-class youth alone: 'bourgeois adolescents who are economically privileged and (temporarily) excluded from the reality of economic power, sometimes express their distance from the bourgeois world which they cannot really appropriate by a refusal of complicity whose most refined expression is a propensity towards aesthetics and aestheticism' (Bourdieu 1984: 55).

But a 'refusal of complicity' might be said to characterize the majority of British youth. Having loosened ties with family but not settled with a partner nor established themselves in an occupation, youth are not as anchored in their social place as those younger and older than themselves. By investing in leisure, youth can further reject being fixed socially. They can procrastinate what Bourdieu calls 'social aging' or that 'slow renunciation or disinvestment' which leads people to 'adjust their aspirations to their objective chances, to espouse their condition, become what they are and make do with what they have' (Bourdieu 1984: 110–11). This is one reason

why youth culture is often attractive to people well beyond their youth. It acts as a buffer against social aging – not against the dread of getting older, but of resigning oneself to one's position in a highly stratified society.

The material conditions of youth's investment in subcultural capital (which is part of the aestheticized resistance to social aging) results from the fact that youth, from many class backgrounds, enjoy a momentary reprieve from necessity. According to Bourdieu, economic power is primarily the power to keep necessity at bay. This is why it 'universally asserts itself by the destruction of riches, conspicuous consumption, squandering and every form of gratuitous luxury' (Bourdieu 1984: 55). But 'conspicuous', 'gratuitous' and 'squandering' might also describe the spending patterns of the young. Since the 1950s, the 'teenage market' has been characterized as displaying 'economic indiscipline'. Without adult overheads like mortgages, pension plans and insurance policies, youth are free to spend on goods like clothes, music, drink and drugs which form 'the nexus of adolescent gregariousness outside the home' (Abrams 1959: 1).

Freedom from necessity, therefore, does not mean that youth have wealth so much as that they are exempt from adult commitments to the accumulation of economic capital. In this way, British youth can be seen as momentarily enjoying what Bourdieu argues is reserved for the bourgeoisie, that is the 'taste of liberty'. British youth cultures exhibit that 'stylization of life' or 'systemic commitment which orients and organizes the most diverse practices' that develops as the objective distance from necessity grows (Bourdieu 1984: 55–56). This is a possibility for all but the poorest sections of the youth population, perhaps the top 75 per cent. While youth unemployment, homelessness and poverty are widespread, there is still considerable discretionary income amongst the bulk of 16–24 year olds. The 'teenage market', however, has long been dominated by the boys. In the 1950s, 55 per cent of teenagers were male because girls married earlier and 67 per cent of teenage spending was in male hands because girls earned less (Abrams 1959). In the 1990s, the differential earnings of young men and women have not changed all that much – a fact which no doubt contributes to the masculine bias of subcultural capital (Euromonitor 1990; Mintel 1988).

Although clubbers and ravers loathe to admit it, the femininity of these representations of the mainstream is hard to deny. Girls and women are, in fact, more likely to identify their taste in music with pop. Moreover, they spend less time and money on music, the music press and going out, and more on clothes and cosmetics (Mintel 1988; Euromonitor 1989). One might assume, therefore, that they are less sectarian and specialist in relation to music because they literally and symbolically invest less in their taste in music and participation in music culture.

The objectification of young women, entailed in the 'Sharon and Tracy' image, is significantly different from the 'sluts' or 'prudes', 'mother' or 'pretty waif' frameworks typically identified by feminist sociologists (Cowie and Lees 1981; McRobbie 1991). It is not primarily a vilification or veneration of girls' sexuality (although that does come into it), but a position statement made by youth of both genders about girls who are not culturally 'one of the boys'. Subcultural capital would seem to be a currency which correlates with and legitimizes unequal statuses.

Conclusions

Subcultural capital is the linchpin of an alternative hierarchy in which the axes of age, gender, sexuality and race are all employed in order to keep the determinations of class, income and occupation at bay. Interestingly, the social logic of subcultural capital reveals itself most clearly by what it dislikes and by what it emphatically isn't. The vast majority of clubbers and ravers distinguish themselves against the mainstream which, to some degree, can be seen to stand in for the masses – the discursive distance from which is a measure of a clubber's cultural worth. Interestingly, the problem for *underground subcultures* is a popularization by a gushing *up* to the mainstream rather than, say, the artworld's dread of 'trickle down'. These metaphors are not arbitrary; they betray a sense of social place. Subcultural ideology implicitly gives alternative interpretations and values to young people's, particularly young men's, subordinate status; it re-interprets the social world.

These popular distinctions are a means by which young people jockey for social power; they are discriminations by which players are both assigned social statuses and strive for a sense of self-worth. This perspective envisages popular culture as a multi-dimensional social space rather than as a flat folk culture or as simply the bottom rung on some linear social ladder. Rather than characterizing cultural differences as 'resistances' to hierarchy or to the remote cultural dominations of some ruling body, it investigates the micro-structures of power entailed in the cultural competition that goes on between more closely associated social groups.

Youthful interest in distinction is not new. One could easily re-interpret the history of post-war youth cultures in terms of subcultural capital. In a contemporary context, however, dynamics of distinction are perhaps more obvious for at least two reasons. First, unlike the liberalizing 1960s and 1970s, the 1980s were 'radical' in their conservatism. Change was experienced as a move to the right, while the left was effectively positioned as reactionary in its intent to preserve the past. Unlike Jock Young's drugtaking hippies or Dick Hebdige's stylish punks [portrayed in two classic texts which capture the spirit of British youth in their respective periods and which are excerpted in Chapters 13 and 11 of this Reader], the youth of my research were, to cite the cliché, 'Thatcher's children'. Well versed in the virtues of competition, their cultural heroes came in the form of radical young entrepreneurs who had started up clubs and record labels, rather than the poets and activists of yesteryear.

The second reason that the pursuit of distinction may be more noticeable today is because sociological debates have shifted our vision of *difference*. For example, despite their many disparate opinions, both Young and Hebdige see the assertion of cultural difference as an essentially progressive gesture, a step in the right direction away from conformity and submission. Difference was cast positively as *deviance* and *dissidence*. If one believes that it is in the nature of power to homogenize – be it in the form of Young's 'consensus' or Hebdige's 'hegemony' – then difference can be seen as a good thing in itself. But if one considers the function of difference within an ever more finely graded social structure, its political tendencies become more ambiguous. In a post-industrial world where consumers are incited to individualize themselves and where the operations of power seem to favour classification and segregation, it is hard to regard difference as *necessarily* progressive. The flexibility of new modes of commodity production and the expansion of multiple media

support micro-communities and fragmented niche cultures. Today, it is easier to see each cultural difference as a potential distinction, a suggestion of superiority, an assertion of hierarchy, a possible alibi for subordination.

These two senses of difference – deviance/dissidence and discrimination/distinction – clarify the politics of the youthful will to classlessness. At one level, youth do aspire to a more egalitarian and democratic world. On the other hand, classlessness is a strategy for transcending being classed. It is a means of obfuscating the dominant structure in order to set up an alternative and, as such, is an ideological precondition for the effective operations of subcultural capital. This is the paradoxical cultural response of youth to the problem of age and the social structure.

Note

1 An interest in distinction would seem to be the norm in all kinds of club cultures. Nevertheless, the subcultural capitals I investigate are those of predominantly straight and white club and rave cultures. Similar 'underground' discourses operate in gay and lesbian clubs but, as the alternative values involved in exploring sex and sexuality complicate the situation beyond easy generalization, I concentrate on their heterosexual manifestation. Moreover, 'campness' rather than 'hipness' may be a more appropriate way to characterize the prevailing cultural values of these communities (Sontag 1966; Savage 1988). And, although I did substantial research in Afro-Caribbean and mixed-race clubs, my account more thoroughly (but not exclusively) analyses the cultural worlds of the white majority. Despite the fact that black and white youth cultures share many of the same attitudes and some of the same musics, race is still a conspicuous divider.

Michel Maffesoli

THE EMOTIONAL COMMUNITY
Research arguments [1996]
Translated by Don Smith

1. The aesthetic aura

AT THE RISK OF SOUNDING DOGMATIC, it will be necessary to return regularly to the problem of individualism, if only because it obscures, in a more or less pertinent way, the whole of contemporary thinking. Individualism, either properly speaking or in its derivative form of narcissism, is central to many books, articles and theses which, naturally enough, take a psychological, as well as historical, sociological or political perspective. This is a kind of obligatory rite of passage for those wishing to build a knowledge of modernity. While certainly not without its uses, this approach becomes increasingly questionable when used in countless newspaper articles, political speeches or moral posturings as a kind of magical key to understanding. So-called experts, untroubled by caution or scholarly nuance, disseminate a body of conventional, and somewhat disastrous, wisdom about the withdrawal into the self, the end of collective ideals or, taken in its widest sense, the public sphere. We then find ourselves face to face with a kind of *doxa*, which may perhaps not endure but which is nevertheless widely received, and at the very least, has the potential to mask or deny the developing social forms of today. While some of these new forms are quite obvious, others remain underground; moreover, the spectacular aspect of the former leads one to dismiss them as irrelevant, a criticism that seems to flourish during times of crisis. This of course paves the way for the lazy tendency inherent in any *doxa*.

I don't intend to confront the question of individualism head-on; however I will be regularly addressing it *a contrario*. The main thrust of my arguments will be to show, to describe and to analyse the social configurations that seem to go beyond individualism, in other words, the undefined mass, the faceless crowd and the tribalism consisting of a patchwork of small local entities. These are of course metaphors that aim above all to accentuate the untidy aspect of sociality. Here . . . we may

turn to the emblematic figure of Dionysus. In the guise of fiction, I intend to assume that the category that has served us well over two centuries of social analysis is completely exhausted. It is often said that truth is stranger than fiction; let us therefore try to measure up to the truth. Perhaps we ought to show, as certain novelists have, that the individual is no longer as central as the great philosophers since the age of the Enlightenment have maintained. This naturally represents a bias, but one that I will adopt in any case, clarifying it along the way with notations, remarks or anecdotes which, while impertinent, will not be unfounded.

Beckett's plays shatter our illusions of the individual in control of himself and his destiny. In a paroxysmal[1] and premonitory way, he shows the contingent and ephemeral nature of all individualism and underlines the factitiousness inherent in the process of individuation which can only lead to a prison. Individualism is an outdated bunker and as such deserves abandonment, according to the playwright. This attitude is not without its stimulating originality in an era where the consensus likes its thinking ready-made. Of course, this view must have escaped many of his sycophants; but it is nevertheless in perfect congruence with the ancient wisdom that sees every individual as the single link [*puntum*] in an uninterrupted chain, multifaceted and microcosmic, the *crystallization* and *expression* of the general macrocosm. Here we can recognize the idea of the *persona*, the changeable mask which blends into a variety of scenes and situations whose only value resides in the fact that they are played out by the many.

The multiplicity of the self and the communal ambience it induces will serve as a backcloth to these reflections. I have proposed calling this the 'aesthetic paradigm', in the sense of fellow-feeling. Indeed, whereas the individualist logic is founded on a separate and self-contained identity, the person (persona) can only find fulfilment in his relations with others. Gilbert Durand, in looking at several modern authors (Thomas Mann, William Faulkner) speaks from a sociological perspective in which we exist only in the 'minds of others' [Durand 1986: 207, 219]. Such a point of view obliges us to go beyond the classical subject/object dichotomy that is fundamental to the entire bourgeois philosophy. The accent is then on that which unites, rather than that which separates. No longer is my personal history based on a contractual arrangement with other rational individuals; rather it is a myth in which I am an active participant. Heroes, saints or emblematic figures may be real, however they exist more or less as ideal types, empty 'forms', matrices in which we may all recognize ourselves and commune with others. Dionysus, Don Juan, the Christian saint or Greek hero – we could go on and on listing the mythical figures and social types that enable a common 'aesthetic' to serve as a repository of our collective self-expression. The multiplicity inherent in a given symbol inevitably favours the emergence of a strong collective feeling. Peter Brown put his finger on the question when he analysed the cult of the saint of late Antiquity [Brown 1981: 51]. By creating a chain of intermediaries, this cult allowed one to reach God. The fragmented persona and the specific link represented by the saints are thus the main elements forming the deity and the ecclesiastical collective that serves as its vector.

We may apply this analysis to our research: there are times when the social 'divine' is embodied in a collective emotion that recognizes itself in one or another typification. In this scenario, the proletariat and the bourgeoisie could be 'histor-

ical subjects' with a task to accomplish. A certain scientific, artistic or political genius could deliver a message indicating the path to follow; however, they could remain abstract and inaccessible entities, setting a goal to be achieved. In contrast, the mythical type has the simple role of collector, a pure 'container'. Its sole purpose is to express, for a precise moment in time, the collective spirit. This is the main distinction to be drawn between abstract, rational periods and 'empathetic' periods of history. The rational era is built on the principle of individuation and of separation, whereas the empathetic period is marked by the lack of differentiation, the 'loss' in a collective subject: in other words, what I shall call neo-tribalism.

There are many examples in our everyday life to illustrate the emotional ambience exuded by tribal development. Moreover, it is noteworthy that such examples are no longer shocking to us: they are a part of the urban landscape. The many punk or 'paninari'[2] looks, which are the expressions of group uniformity and conformity, are like so many punctuations in the permanent spectacle offered to us by the contemporary megalopolis. With respect to the tendency to examine the *orientation* of existence evident in the cities of the West, one may be reminded of Augustine Berque's analysis of the 'sympathetic' relationship between the self and the other in Japan. Such a weak demarcation – to the point of indistinguishability, even – between the self and the other, the subject and the object, gives pause for reflection. The idea of the extensibility of the self ('a relative and extensible ego') may be a pertinent methodological tool for understanding the contemporary scene [Berque 1982: 54]. It is almost not worth mentioning the fascination that Japan holds for us today; nor is it necessary to refer to its economic or technological supremacy in order to underscore the fact that, although *distinction* is perhaps applicable to modernity, it is by contrast totally inadequate in explaining the varied forms of social groupings that are today at the forefront. Their outlines are ill-defined: sex, appearance, lifestyles – even ideology – are increasingly qualified in terms ('trans', 'meta') that go beyond the logic of identity and/or binary logic. Briefly, and taking the terms in their most accepted sense, we can say that we are witnessing the tendency for a rationalized 'social' to be replaced by an empathetic 'sociality', which is expressed by a succession of ambiences, feelings and emotions.

For example, it is interesting to note that the German Romantic idea of *Stimmung* (atmosphere) is more and more often used on the one hand to describe relations between social micro-groups, and on the other to show the way these groups are situated in spatial terms (ecology, habitat, neighbourhood). The same holds true for the constant use of the term 'feeling'[3] to describe interpersonal relationships. It will be a useful criterion for measuring the quality of the exchanges, for deciding on how far and how deep they go. If we are referring to a rational organizational model, the most unstable notion we can employ is sentiment. In fact, it seems necessary to make a change in the way we consider social groupings; in this respect, Max Weber's socio-historical analysis of the 'emotional community' (*Gemeinde*) can be put to good use. He specifies that this emotional community is in fact a 'category', that is, something that has never existed in its own right but that can shed light on present situations. The major characteristics attributed to these emotional communities are their ephemeral aspect; 'changeable composition'; 'ill-defined nature'; local flavour; their 'lack of organization' and routinization (*Veralltäglichung*). Weber also points out that we find these groupings under many different names,

in all religions and in general, alongside the rigidity of institutions [Weber 1978: 452–56]. In the eternal riddle of the chicken and the egg, it is difficult to determine which comes first; however, his analysis makes clear that the link between shared emotion and open communal relationships leads to this multiplicity of groups which manage, at the end of the day, to form a rather solid social arrangement. This adjustment, like a common thread through the social fabric, is no less permanent for all that. Permanency and instability are the two poles around which the emotional will navigate.

It should be pointed out right away that the emotion in question is not to be confused with any common or garden pathos. It seems to me a mistake to interpret the Dionysian values, to which this thematic refers, as the ultimate manifestation of a collective bourgeois activism. According to this interpretation, the common march towards the Enlightenment came first, followed by the attempt to master nature and technology, and culminating in the coordinated orchestration of social affects. But this perspective is far too closed or dialectical; of course, certain examples, such as the paradigm represented by 'Club Med', may lead to this conclusion. Nevertheless, this analysis must be careful to consider the fact that the key characteristics of the group attitude are its expenditure, the notion of chance and disindividuation.

This does not allow us to regard the emotional community as yet another stop along the pathetic and linear march of the history of humanity. I was much drawn to this point through conversations I had with the Italian philosopher Mario Perniola [1982]. To extend his work from a sociological point of view, I would say that the aesthetic of the 'we' is a mixture of indifference and periodic bursts of energy. In a paradoxical way, we exhibit singular disdain for any projectivist attitude, and experience an undeniable intensity in whatever action we take: Thus can be characterized the impersonal nature of proxemics.

Durkheim underlined this fact also, and although he retains his wonted caution, he still speaks of the 'social nature of sentiments' and shows its effectiveness. 'We are indignant together,' he writes, referring to the proximity of the neighbourhood and its mysterious, formative 'force of attraction'. It is within this framework that passion is expressed, common beliefs are developed and the search for 'those who *feel and think as we do*' takes place [Durkheim 1964: 102]. These remarks, ordinary as they may appear, are applicable to many objects, and reinforce the insurmountable nature of the everyday substrate. This is the matrix from which all representations are crystallized: the exchange of feelings, conversation in the restaurant or shop, popular beliefs, world views and other insubstantial chit-chat which constitute the solidarity of the community's existence. Contrary to what has been previously considered good form, we can agree on the fact that reason plays only a small part in the formation and expression of opinions. Their expression, whether by the early Christians or the socialist workers of the nineteenth century, owes considerably more to the mechanisms responsible for the spread of commonly held feelings or emotions. Whether in the context of the network of tiny convivial cells or at a favourite local pub, the collective emotion becomes concrete, playing on the multiple facets of what Montaigne called the 'hommerie': that blend of greatness and turpitude, generous ideas and venal thoughts, of idealism and convinced worldliness – in a word: man.

Nevertheless, it is precisely this mixture that assures a form of solidarity, of continuity across the various histories of humanity. I have previously mentioned the community of destiny that sometimes may find expression within the framework of a rational and/or political project but that at others takes the more hazy and ill-defined path of the collective sensibility. In this latter case, the emphasis is placed on the disordered aspect of the small group which, in interaction with other forms of organisation, guarantees the perdurability of the species. The first case produces what Halbwachs calls the 'view from without', which is History, and the second, the 'view from within', or collective memory [Halbwachs 1968: 78].

To stretch this paradox even further, the collective memory is on the one hand tied to the immediate surroundings and, on the other, transcends the group itself, which is located in a long 'line' that we can take either *stricto sensu* or from an imaginary perspective. In any case, whatever we call it (emotion, sentiment, mythology, ideology) the collective sensibility, by superseding the atomization of the individual, creates the conditions necessary for a sort of aura that characterizes a certain period: the theological aura of the Middle Ages, the political aura of the eighteenth century or the progressive aura of the nineteenth. We might possibly be witnessing the development of an *aesthetic* aura containing varying proportions of elements related to the communal drive, mystical propensity or an ecological perspective. However it should appear, there is a strong link between these various terms; each in its own way takes into account the organicity of things, the *glutinum mundi* from which, despite (or because of) such diversity, a whole emerges. This organic sense of solidarity expresses itself in a multitude of ways, and it is surely from this angle that we must interpret the resurgence of the occult, syncretism and, more commonly, a heightened appreciation of the spiritual or astrological. This latter phenomenon especially is no longer the exclusive preserve of the credulous or naive. Researchers are now finding a double layer of meaning attached to astrology, both cultural and natural. Gilbert Durand has shown how individually centred astrology is of relatively recent origin, for classical astrology 'concerned itself above all with the *destiny of the group*, of the earthly domain' [Durand 1983: 222]. Astrology can be placed in an ecological perspective, represented by the 'houses' which predispose all of us to live in a natural and social environment. Without going too deeply into the matter, we may note that it has something of the aesthetic aura (*aisthétikos*) which is found in the union, however tenuous, of the macrocosm and the microcosms, and the union between these microcosms. What should be remembered from this and related examples is that they serve to reveal the holistic climate underlying the resurgence of solidarity and the organicity of all things. Thus, despite the connotation all too often attributed to them, emotion or sensibility must in some way be treated as a blend of objectivity and subjectivity. I propose calling this a material spirituality, a somewhat Gothic expression that refers to what Berque termed, in referring to the effectiveness of the milieu, the 'transubjective' (subjective and objective) relationship. It is indeed time to note that the *binary logic of separation* that once predominated in all domains is no longer applicable as such. The soul and the body, mind and matter, the imagination and economics, ideology and production – the list could go on – are no longer seen as complete opposites. In fact, these entities, and the minuscule concrete situations they represent, come together to produce a day-to-day life that more and more resists the simplistic taxonomy to which we had

been accustomed by a certain reductionist positivism. Their synergy produces the complex society that is deserving of its own complex analysis. The 'multidimensional and the inseparable', to borrow Morin's phrase, take us into a 'continuous loop' which will render out of date the tranquil and terribly boring practices of the accountants of knowledge [Morin 1986].

With the necessary precautions and clarifications out of the way, it becomes possible to attribute to the metaphor of sensibility or collective emotion a function of knowledge. This methodological tool allows us to travel to the heart of the organicity that so characterizes the contemporary urban scene. Thus, the following apologia becomes possible: 'Imagine for a moment that the Lord wishes to call up to heaven a typical house from Naples. Before his amazed eyes would amass a column of all the houses of Naples, one behind the other, trailing their laundry, complete with singing women and noisy children' [cited by Médam 1979: 202]. This is the emotion that cements the whole. This whole may be made up of a plurality of elements, but there is always a specific ambience uniting them all.

At first, experience is lived in its own right and the scholarly observer should realize this. To summarize, it may be said that the aesthetics of sentiment are in no way characterized by an individual or 'interior' experience, but on the contrary, by something essentially open to others, to the Other. This overture connotes the space, the locale, the proxemics of the common destiny. It is this which allows us to establish a close link between the aesthetic matrix or aura and the ethical experience.

2. The ethical experience

[. . .]

As we have seen, the emotional community is unstable, open, which may render it in many ways anomic with respect to the established moral order. At the same time, it does not fail to elicit a strict conformity among its members. There is a 'law of the milieu' that is difficult to escape. The more paroxysmal elements of this are well known: the Mafia, the underworld; but what is often forgotten is that a similar conformity reigns in the business world, the intellectual realm, and many others. Of course, since in these different milieux the degree of belonging varies, fidelity to the often unstated rules of the group shows just as many signs of variability. However, it is difficult to ignore this conformity altogether. Whatever the case, it is important, in a non-normative way, to appreciate its effects, its richness and perhaps its prospective dimension. Indeed, from the point of view of the individualist *doxa* mentioned earlier, the persistence of a group ethos is very often considered a fading anachronism. It would seem that an evolution is under way today. Thus, from the small productive groups best symbolized by Silicon Valley, up to what we call the 'groupism' operating within Japanese industry, it becomes clear that the communal tendency can go hand-in-hand with advanced technological or economic performance. Drawing on various studies that confirm this, Berque notes that 'groupism differs from the herd instinct in that each member of the group, consciously or otherwise, attempts above all to serve the interests of the group, instead of simply seeking refuge there' [Berque 1982: 167, 169]. The term 'groupism' may not be particularly sonorous, but it does have the merit of under-

lining the strength of this process of identification which allows for the attachments that reinforce our common bonds.

It is perhaps premature to extrapolate on the basis of a few isolated examples or from a particular situation such as that of Japan; however, these examples are at least as relevant as those that give greater importance to the current narcissism. What is more, they are related to the economic sphere, which remains, for the moment in any case, the main fetish of the dominant ideology. I see this as one more illustration of the holism taking shape before our eyes: throwing wide the doors of privacy, sentiment takes over, and in certain countries its presence is reinforced in the public sphere, thus producing a form of solidarity that can no longer be denied. Of course, we must note that this solidarity reinvigorates, quite apart from technological developments, the communal form that seemed to have been left behind.

We may wonder about the community and the nostalgia underlying it or about the political uses to which it is put. For my part, and I reiterate it, this is a 'form' in the sense that I have defined this term [Maffesoli 1985a]. Whether or not it exists independently is of little importance; it is enough that it serves as a backcloth, allowing us to highlight a particular social phenomenon. No matter that it is imperfect or even *ad hoc*, it is no less the expression of a particular crystallization of shared feelings. From this 'formist' perspective, the community is characterized less by a project (*pro-jectum*) oriented towards the future than by the execution *in actu* of the 'being-together'. In everyday language, the communal ethic has the simplest of foundations: warmth, companionship – physical contact with one another. Psychologists have pointed out that there is a *glischomorphic* tendency in all human relationships. Without wishing to judge in any way, it seems to me that it is this viscosity which is expressed in the communal being-together. Thus, and I must stress this rigorously in order to avoid any moralizing digression, it is by force of circumstance; because of proximity (promiscuity); because there is a sharing of the same *territory* (real or symbolic) that the communal idea and its ethical corollary are born.

It is worth remembering that this communal ideal can be seen in the populist and later anarchist ideology whose basis is to be found in the proxemic crowds. For these people, especially Bakunin and Herzen, the village community (*obschina* or *mir*) is at the very heart of working socialism. Supplemented with the artisans' associations (*artels*), it paves the way for a civilization built on solidarity. The interest of such a romantic vision goes well beyond the habitual dichotomy of the latest bourgeois ideal, as much in its capitalist version as its Marxist version. Indeed, human destiny is seen as a whole, giving the *obschina* its prospective aspect. I should reiterate that this social form has, with good reason, been closely identified with Fourierism and the phalanstery. Franco Venturi, in his now classic book on Russian populism of the nineteenth century, points out this connection; moreover, and more to the point in our reflections, he notes the link between these social forms and the search for 'a different system of morality'. He does this with some reticence; for him, especially with regard to the phalanstery, this search lies somewhat in the realm of 'eccentricity' [Venturi 1972: 230]. What the esteemed Italian philosopher failed to notice was that, beyond their apparent functionalism, all social groups include a strong component of shared feeling. It is these feelings that give rise to this 'different morality' which I prefer to call here an ethical experience.

To pick up again on the classic opposition, we might say that society is concerned with history in the making, whereas the community expends its energy in its own creation (or possibly recreation). This allows us to establish a link between the communal ethic and solidarity. One of the most striking aspects of this relationship is the development of the ritual. As we know, this is not strictly speaking finalized, that is, goal-oriented; it is, on the other hand, repetitive and therefore comforting. Its sole function is to confirm a group's view of itself; Durkheim's example of the 'corroboree' festivities is very helpful in this respect. The ritual perpetuates itself, and through the variety of routine or everyday gestures the community is reminded that it is a whole. Although it does not need putting into words, it serves as an anamnesis of solidarity and, as L.-V. Thomas remarks, 'implies the mobilization of the community'. As I have just stated, the community 'exhausts' its energy in creating itself. In its very repetitiveness, the ritual is the strongest proof of this expenditure and by so doing it guarantees the continued existence of the group. In the anthropological view of death, it is this paradox with regard to the funeral ritual that reintroduces 'the community ideal which attempts to reconcile man to death as well as to life' [Thomas 1985: 16, 277]. As I will explain more fully, there are times when the community of destiny is felt more acutely, and it is through gradual condensation that more attention is focused on uniting factors. This union is a pure one in some ways, with undefined contents; a union for confronting together, in an almost animal way, the presence of death, the presence at death. History, politics and morality *overtake death* in the drama (*dramein*) that evolves as problems arise and are resolved or at least confronted. Destiny, aesthetics and ethics, however, *exhaust death in a tragedy* that is based on the eternal moment and therefore exudes a solidarity all its own.

Experiencing death matter-of-factly may be the outcome of a collective sentiment that occupies a privileged place in social life. This communal sensibility favours a proximity-centred ethos; that is, simply put, a way of being that offers an alternative to both the production and distribution of goods (economic or symbolic). In his occasionally perfunctory but usually rich analysis of crowds, Gustave Le Bon notes that 'it is not with rules based on theories of pure equity' that the crowd is to be led and that, generally speaking, impressions play a considerable role [Le Bon 1960: 20]. What can we assume from this other than that justice itself is subordinate to the experience of closeness; that abstract and eternal justice is relativized by the feeling (whether hate or love) experienced in a given territory? Many everyday occurrences, whether examples of carnage or generosity, illustrate this general point. The doctrinally racist shopkeeper will protect the neighbourhood Arab; the contented bourgeois will fail to denounce the petty thief, and all in the most natural way. The code of silence is not confined to the Mafia; police officers who have had occasion to make inquiries in such and such a village or neighbourhood can testify to that. The common denominator of these attitudes (which are deserving of further elaboration) is the solidarity derived from a shared sentiment.

If we were to expand the field somewhat, with help from the media, we would find similar reactions throughout the 'global village'. It is not an abstract sense of justice that gives rise to soup kitchens, leads us to help the unemployed or other charitable endeavours. We could even say that, from a linear and rational view of justice, these activities appear somewhat anachronistic or even reactionary. In a very

ad hoc and haphazard way, without attacking a given problem head-on, they risk serving as an excuse and being nothing more than a Band-Aid solution, While no doubt true, such activities nevertheless accomplish their aim, as well as mobilize the collective emotions. We may wonder about the significance or the political repercussions of these actions; we may also note – and this is the point of these remarks – how we no longer expect the all-pervasive state to remedy by itself the problems whose effects we see around us, as well as how the synergy of these activities brought home to us through the medium of television can exert its own influence. In both cases, that which I see around me, or which is brought closer to me through an image, strikes a chord in all of us, thus constituting a collective emotion. The mechanism in question is far from being of minor importance, which brings us back to the holistic principle underlying these reflections: the common sensibility at the heart of the examples cited is derived from the fact that we *participate in* or *correspond to*, in the strictest and possibly most mystical sense of these words, a common ethos. In formulating a sociological 'law', I will state as a leitmotif that less weight shall be given to what each individual will *voluntarily adhere to* (contractually or mechanically) than to that which is *emotionally common to all* (sentimentally and organically).

This is the ethical experience that had been abandoned by the rationalization of existence; it is also what the renewed moral order falsely portrays, since it tries to rationalize and universalize *ad hoc* reactions or situations and present them as new *a priori*, whereas their strength is derived from the fact that they are grounded in a local sensibility: it is only *a posteriori* that they can be linked in an overall structure. The community ideal of the neighbourhood or the village acts more by permeating the collective imagination than by persuading the social reason. To employ a term Walter Benjamin used in his reflections on art, I would say that we are in the presence of a specific aura, which in a process of feedback comes out of the social body and determines it in return. I will summarize this process in the following way: *the collective sensibility which issues from the aesthetic form results in an ethical connection*.

It would be useful to insist on that fact, if only to relativize the positivist ukases which insist that the collective imagination is superfluous and can be dispensed with in times of crisis. In fact, it can be shown that it assumes the most varied guises: at times it is manifested on the macroscopic level, spurring on great mass movements, varied crusades, occasional revolts or political or economic revolutions. At other times, the collective imagination is crystallized in a microscopic way, providing deep nourishment to social groups. Finally, there is on occasion a continuum between this latter process (esoteric) and the just-mentioned general manifestations (exoteric). Whatever the case, there is a wide-ranging aura which serves as a matrix to the always and freshly astonishing reality that is sociality.

It is from this perspective that the community ethos must be considered. What I here call *aura* spares us from deciding on its existence or non-existence; it so happens that it functions 'as if' it existed. It is in this way that we can understand the ideal type of the 'emotional community' (Max Weber), the 'orgiastic-ecstatic' (Karl Mannheim), or that which I have termed the dionysiac form. Each of these examples caricatures, in the simplest sense of the term, this exit from the self, ex-stasis, which is part of the social logic [Weber 1978: 554; Mannheim 1954: 192; Maffesoli 1985b]. This 'ecstasy' is much more effective in smaller groups, when it becomes

more perceptible to the social observer. In order to account for this complex entity, I propose to use, in the metaphorical sense, the terms 'tribe' and 'tribalism'. While refraining from overuse of quotation marks, I will insist on the 'cohesive' aspect of the social sharing of values, places or ideals which are entirely circumscribed (localism) and which can be found, in varied forms, at the heart of numerous social experiences. It is this constant interplay of the static (spatial) and the dynamic (becoming), the anecdotal and the ontological, the ordinary and the anthropological, that makes the analysis of the collective sensibility such a potent tool. To illustrate this epistemological remark, I will give but one example: the Jewish people.

Without wishing, nor indeed being able, to make a specific analysis, and confining ourselves to indicating a course of research, we can show that the Jewish people are particularly representative of the antinomy I mentioned. On the one hand, they have an intense experience of the tribe's collective sentiment which, on the other hand, has not prevented them throughout the centuries from assuring the existence of general and (without any pejorative connotations) cosmopolitan values. This sentiment includes a tribal religion that has enabled them to resist assimilation; tribal customs, which are the very basis of the community of destiny; and of course, tribal sexuality which assured the survival of the race through the carnage and vicissitudes of the ages. The flow of words, goods and sex: these are the three anthropological pivots around which social life generally turns. In essence, they have a strong tribal component. Many historians and sociologists have highlighted the vitality, the ambience and strong cohesiveness, in many countries, of the 'ghetto', the shtetl, the synagogue [Wirth 1966]. And like a reserve of energy, these places were the source of a good portion of what was to become the medieval city, the modern metropolis and, perhaps, the megalopolis of today. Thus, the ethos of the Gemeinschaft, of the tribe, regularly permeates the evolution of Western civilization. As I have said, this is but a course of inquiry; indeed, many domains, whether intellectual, economic or spiritual, have been influenced, in a prospective way, by what came out of the stockpot of the Jewish emotional culture.

There is no better way of expressing this 'concrete universal', which was one of the principal tenets of nineteenth-century philosophy. By extrapolating, in a heuristic manner, the aforementioned example, it is possible to state that, paradoxically, it is the tribal values which on occasion characterize an epoch. . . . The tribal moment may be compared to a period of gestation: something that is perfected, tested and tried out, before taking flight into the great beyond. In this way, everyday life could be, to use the words of Benjamin, 'the most extreme concrete'. This short description lets us see the shared lives and experiences as the purifying fires of the alchemical process in which the transmutation takes place. The nothing or near-nothing becomes a totality. The minuscule rituals are inverted until they become the basis of sociality – multum in parvo. Of course, it is difficult to predict what will be transformed from minuscule to macroscopic, as long as there are so many extraneous elements. However, this is not the essential factor; it is enough, as I have said, to indicate the 'form' in which the growth of social values is born. We may then say that the ethic is in some way the glue that holds together the diverse elements of a given whole.

Nevertheless, if one is to understand what I have just said, it is necessary to lend this term 'ethic' its simplest meaning: not an indifferent a priori theorizing but

one which on a daily basis serves as a vessel for the collectivity's emotions and feelings. In this manner, with varying degrees of success and in a given territory, we all adjust to one another and to the natural environment. This accommodation is of course relative; carried out in happiness and sadness, the product of often conflictual relationships, it exhibits a certain necessary flexibility, but nevertheless is astonishingly long-lived. This is certainly the most characteristic expression of the social 'will to live'. It is therefore necessary to take the time to consider, if only for an instant, several manifestations of this ethic of the everyday, since as an expression of the collective sensibility it gives us wide access to the life of these tribes that, *en masse*, constitute contemporary society.

3. Custom

From Aristotle to Mauss, by way of Thomas Aquinas, many have examined the importance of the *habitus* (*exis*), a term which has since passed into the sociological *doxa*. This is all to the good, for this thematic is of primary importance. It is related to the common aspects of everyday life, in a word the customs, which are, according to Simmel, 'one of the most typical forms of everyday life'. Since we know the importance and effectiveness he attached to 'form', it becomes possible to imagine that we are dealing with more than the empty word. Further on, he is more specific: 'custom determines the social life as would an ideal power' [Simmel 1974: 17, 20]. We are led back to a persistent action that instills in beings and things their way of seeing the world; it is practically a matter of genetic coding, limiting and delineating, in a much more profound manner than the economic or political situation, their way of being with others. Thus, together with the aesthetic (the shared sentiment) and the *ethic* (the collective bond), *custom* is surely a good way of characterizing the everyday life of contemporary groups.

I will adopt the following concern of Mallarmé: 'to give a purer sense to the words of the tribe'. And like all other 'mini-concepts' used previously, I will use the term 'custom' in its most widely held sense, one that is also closest to its etymological roots (*consuetudo*): the collection of common usages that allow a social entity to recognize itself for what it is. This link is a mysterious one, only rarely and indirectly put into so many words (for example in the treatises on manners and customs). Nevertheless, it is at work in the deepest layers of any society. Custom, in this way, is the unspoken, the 'residue' underlying the 'being-together'. I have proposed calling it the *underground centrality* or the social *puissance* (as opposed to power), an idea found in Goffman (*The Underlife*) and later on in Halbwachs (*La Société silencieuse*). These expressions emphasize the fact that a large part of social existence cannot be accounted for by instrumental rationality; nor does it let itself be finalized or reduced to a simple logic of domination. Duplicity, subterfuge and the will to live are all expressed through a multitude of rituals, situations, gestures and experiences that delineate an area of liberty. A tendency to see life as alienation or to hope for a perfect or authentic existence makes us forget that daily routine is stubbornly founded on a series of interstitial and relative freedoms. As has been seen in economics, it is possible to demonstrate the existence of a *black-market sociality*, which is easily tracked through its diverse and minuscule manifestations.

I am adopting the perspective of Durkheim and his followers, who always placed the greatest weight on the sacredness of social relationships. As I have often said: I consider that any given entity, from the micro-group to the structure of the state, is an expression of the social divine, of a specific, even immanent, transcendence. But as we know, and many religious historians have shown, the sacred is mysterious, frightening, disturbing; it needs to be coaxed and cajoled, and customs fulfil this function. They are to everyday life what the ritual is to religious life, strictly speaking [see Otto 1921]. Moreover, it is striking that in popular religion especially it is very difficult, as the ecclesiastical hierarchy was obliged to do, to draw the distinction between customs and canonical rituals. Thus, just as the liturgical ritual renders the Church visible, custom makes a community exist as such. Furthermore, at a time when the division was not yet firmly established, according to Peter Brown, it was by ritually exchanging relics that the various local churches were constituted as a network. These relics are the bond that held a small community together, allowing them to unite and, in so doing, to transmute 'the distance from the holy into the deep joy of proximity' [Brown 1981: 90].

Any organization *in statu nascendi* is fascinating to the sociologist; relations between individuals are not yet fixed and social structures retain the suppleness of youth. At the same time, it is useful to find points of comparison in order to formalize our observations. In this respect, the analysis carried out by the scholars of Christianity is very apposite. It is certainly possible, if only as a working hypothesis, to apply the double process of social *reliance* and of negotiation with the holy characteristic of the early Christian communities to the various tribes that are made and unmade *in praesenti*. In more than one respect, the comparison is illuminating: the organization, grouping around an eponymous hero; the role of the image; the common sensibility, and so on. But it is fundamentally the local membership, the spatial emphasis and the mechanisms of solidarity which are their corollaries that creates the whole. This, moreover, characterizes what I previously termed the increased sacredness of social relationships: the complex mechanism of give and take that develops between various persons, on the one hand, and between the entity thus created and the milieu on the other. Whether these are real or symbolic exchanges is of little importance; indeed, communication, in its widest sense, takes the most varied routes.

The term 'proxemics' proposed by the Palo Alto School appears to me a good way of accounting for both the cultural and natural elements of the communication under consideration. For his part, Berque emphasizes the 'transubjective' (subjective *and* objective) aspect of such a relationship. Perhaps we should just resort to the old spatial notion of the neighbourhood and its affective connotation. It is an old-fashioned term, but one that is making a reappearance today in the writings of many observers of the social scene – a sure sign that it is at the forefront of many minds [see Winkin 1982; Noschis 1983]. This 'neighbourhood' can be manifested in many diverse ways: it can be delineated by a collection of streets, it may be invested with a libidinal dimension (a 'red-light district', for example), refer to a commercial entity or a public transit hub. The detail is unimportant; what matters is that it represents the overlapping of a certain functionality with an undeniable symbolic weight. An integral part of the collective imagination, the neighbourhood is nevertheless only constituted by the intersection of ordinary situations, moments,

spaces and individuals; moreover, it is most often expressed by the most common stereotypes. The town square, the street, the corner tobacconist, the bar at the PMU,[4] the newsagent, centres of interest or necessity – just so many trivial examples of sociality. Nevertheless, it is precisely these instances that give rise to the specific aura of a given neighbourhood. I use this term deliberately, as it translates beautifully the complex movement of an atmosphere emitted by places and activities, giving them in return a unique colouring and odour. And so it may be for spiritual materialism. Morin speaks poetically of a certain New York neighbourhood that shines with brilliance while at the same it is founded on the 'lack of brilliance of the individual'. In widening his scope, the whole city becomes a *chef-d'oeuvre* whereas its 'lives remain pitiful'. However, he continues, 'if you allow yourself to be possessed by the city, if you really get into its sense of energy, if the forces of death which exist only to crush you instead awaken in you an intense will to live, then New York will dazzle you' [Morin and Appel 1984: 64].

This metaphor is an effective expression of the constant interplay of the customary stereotype and the founding archetype. It is this process of constant reversibility which seems to me to constitute what Durand calls the 'anthropological course'; in essence, the close connection that exists between the great works of culture and this 'culture' experienced on an everyday level constitutes the critical bond in any society's life. This 'culture', to the amazement of many, is made up of the varied 'nothings' which, through sedimentation, form a meaningful system. It is impossible to give a complete list, although such a project would have much merit for us today. It would range from the culinary fact to the fantasy world of home appliances, without forgetting advertising, mass tourism and the resurgence and multiplication of festive occasions: in other words, all those things that describe a collective sensibility which no longer has much connection with the politico-economic domination characteristic of modernity. This sensibility is no longer part and parcel of a finalized, directed rationality (Weber's *Zweckrationalität*), but is rather experienced in the present tense, inscribed in a defined space – *hic et nunc*. Thus we have everyday 'culture'; it permits the emergence of true values, surprising or shocking as they may be, expressive of an irrefutable dynamic (perhaps closely paralleling what Weber calls the *Wertrationalität*).

In understanding custom as a cultural fact we may appreciate the vitality of the metropolitan tribes. They are responsible for that aura (informal culture) which surrounds, *volens nolens*, each of us. There are many instances one could cite as an example; however they all possess the common trait of being derived from proxemics. Thus, it is possible to explain all those friendship networks which have no other goal than of congregating, with no fixed purpose, and which more and more cut across the everyday lives of all collectivities. Some studies have shown that these networks are rendering associative structures obsolete [Kaufmann 1988]. These structures are supposedly flexible, easily accessible to the users, giving them a direct line on their problems; however, they are too finalized, organized, founded for the most part on a political or religious ideology, in the abstract (remote) sense of the term. In the friendship networks, *reliance* (the link) is experienced *for its own sake*, without any projection; moreover, it may be *ad hoc* in nature. With the help of technology, as in the groups fostered by the 'Minitel', an ephemeral framework for a specific occasion is provided, so that a certain number of individuals can

(re)connect. Such an occasion may lead to continuing relationships or it may not. In any case, it is certain to create friendship 'chains' which, following the formal model of networks studied by American sociology, give rise to multiple relationships based solely on the device of proxemics: so-and-so introduces me to so-and-so who knows someone else, and so on.

Such a proxemical concatenation, without a project, is bound to produce offspring: mutual aid, for example. This is a product of ancient wisdom, a wisdom it is no longer considered trendy to heed and which holds that 'life is hardest on the poor . . . money is difficult to come by and therefore we have an obligation to pull together and help one another' [Poulat 1977: 58]. Poulat thus sums up the popular substrate of the 'democratic-Christian' ideology. In many respects, this is a model that merits a further look, for beyond the Christian democracies *stricto sensu*, there is an echo of what for years was the Thomist social doctrine and which was a significant factor in the development of a common symbolism. Therefore, alongside a socio-political analysis, we can also underline the socio-anthropological dimension and emphasize the close links between proxemics and solidarity. In some ways, such mutual aid exists by force of circumstance, not out of purely disinterested motives: the help given can always be redeemed whenever I need it. However, in so doing, we are all part of a larger process of correspondence and participation that favours the collective body.

This close connection is also discreet; indeed, we give veiled accounts of our personal, family and professional successes and failures and this orality works as a rumour with an essentially intrinsic function: it delineates the territory where the partaking takes place. There is no place here for the stranger, and if necessary, we may remind the press, the public authorities or the merely curious that 'dirty laundry does not get washed in public'. This survival mechanism works just as well for happy news as for unsavoury information. Indeed, in various ways, the customary word or the shared secret are the primordial glue of all sociality. Simmel showed the example of secret societies, but it can also be found in studies on traditional medicine which show that the individual body can be healed only with the help of the collective body [see Rosny 1981: 81, 111; Simmel 1977]. This is an interesting metaphor since we know that this approach to medicine considers each body as a whole that must be treated as such. But we must also note that this overall vision is often augmented by the fact that the individual body is but an offshoot of the community. This observation allows us to give full weight to the term 'mutual aid' as it refers not only to the mechanical actions that constitute neighbourly relations; indeed, mutual aid as we understand it here is part of an organic perspective in which all the elements through their synergy reinforce life as a whole. Mutual aid could thus be said to be the 'unconscious' animal response of the social 'will to live'; a sort of vitalism that 'knows' implicitly that '*unicity*' is the best response to the onslaught of death – a challenge laid down, in a sense. Let us leave such thoughts to the poet:

> To be one with all living things! On hearing these words . . . Virtue abdicates, death leaves the realm of creatures and the world, relieved of separation and old age, shines with new light.
>
> (Hölderlin, *Hyperion*)

This collective feeling of shared *puissance*, this mystical sensibility that assures continuity, is expressed through rather trivial vectors. Without being able to go into detail here, these are found in all the places where chit-chat and conviviality are present. Nightclubs, cafés and other public spheres are 'open areas', in other words those places where it is possible to speak to others and, in so doing, address alterity in general. I took as a point of departure the idea of the sacredness of social relationships. This can best be seen in the transmission of the word that in general accompanies the flow of food and drink. Let us not forget that the Christian eucharist which underlies the union of the faithful is just one of the developed commensal forms found in all word religions. Thus, in a stylized way, when I am sitting in the café, eating a meal or addressing the other, I am really addressing the deity. This leads back to the confirmation, expressed countless times, of the link between the divine, the social whole and proximity. Commensality, in its various forms, is only the most visible evidence of this complex relationship. However, it is worth remembering that the divine issues forth from daily realities and develops gradually through the sharing of simple and routine gestures. The *habitus* or custom thus serves to concretize or *actualize* the ethical dimension of any sociality.

One need only remember that custom, as an expression of the collective sensibility, permits, strictly speaking, an ex-stasis within everyday life. Having a few drinks; chatting with friends; the anodyne conversations punctuating everyday life enable an exteriorization of the self and thus create the specific aura which binds us together within tribalism. As we can see, it is important not to reduce this ecstasy to a few highly stereotyped and extreme situations. The dionysiac refers of course to sexual promiscuity, as well as to other affectual or festive outbursts; but it also allows us to understand the development of shared opinions, collective beliefs or common *doxas*: briefly, those 'collective frameworks of memory', to borrow Halbwachs' expression, which allow one to emphasize what is lived, the 'tides of experience' [Halbwachs 1968: 51].

Alongside a purely intellectual knowledge, there is a knowledge [*connaissance*] which encompasses the feeling dimension, an awareness that, taken to its etymological origins, we are 'born with' ['*co-naissance*'].[5] This embodied knowledge is rooted in a corpus of customs deserving of analysis in its own right. We would then be able to appreciate the contemporary formulation of the 'palaver' whose varied rituals played an important role in the social equilibrium of the traditional village or community. It is not impossible to imagine that, correlatively with technological developments, the growth in urban tribes has encouraged a 'computerized palaver' that assumes the rituals of the ancient agora. We would no longer face the dangers, as was first believed, of the macroscopic computer disconnected from reality, but on the contrary, thanks to the personal computer and cable TV, we are confronted with the infinite diffraction of an orality disseminated by degrees; the success in France of the Minitel should be interpreted in this light. In a number of domains – education, leisure time, job-sharing and culture – the close communication engendered by this process forms a network with all the attendant social effects imaginable.

At first, the growth and multiplication of the mass media led to the disintegration of the bourgeois culture founded on the universality and the valuing of a few privileged objects and attitudes. We may well ask ourselves whether this pursuit

of growth and the generalization to which it leads may bring the mass media closer to everyday life. In this way, they could be said to reinvest a certain traditional culture whose orality is an essential vector. In so doing, the contemporary media, by presenting images of everyday life rather than visualizing the great works of culture, would be playing the role that used to fall to the various forms of public discourse: to ensure by means of myth the cohesion of a given social entity. This myth, as we know, may be of several types; for my part, I believe that there is a mythic function which runs transversely through the whole of social life. A political event or harmless, trivial fact, the life of a star or a local guru, can all take on mythic proportions. In his study of these mass media, Fernant Dumont subtly underlines that these myths, whatever their precise contents, serve mainly to 'nourish, as in days gone by, gossip and normal conversation . . . what we used to say about the parish priest or the notary, we now say about such and such a film star or politician' [Dumont 1982: 39]. It is impossible not to be struck by the appropriateness of this remark, at least to those of us who have had the experience of overhearing office, factory or playground conversations; even the notorious café conversations can be instructive for the observer of the social scene. I would go even further and say that it is within the logic of the media to set themselves up as a *simple pretext* to communication, as may have been the case with the ancient philosophical diatribe, the medieval religious sermon or the political speech of the modern era.

In some cases, the content of these varied forms is not inconsiderable. But it is because they reaffirm the feeling of belonging to a larger group, of getting out of oneself, that they apply to the greatest number. Thus, we pay more attention to the form that serves as a backcloth; which creates an ambience and therefore unites. In any case, it is a question, above all, of allowing for the expression of a common emotion, which causes us to recognize ourselves in communion with others. It would be worth examining whether the expansion of local television or radio has had any effect in this regard. This is at least a possible hypothesis, one which does not completely deprive custom of its important role. By revealing our near neighbours, custom secretes a 'glue' holding a given community together. Neighbourhoods or even buildings with access to cable TV will perhaps experience values not so far removed from those which guided the clans or tribes of traditional societies.

Consequently, and taking the term 'communication' in its narrowest sense – that which structures social reality and which is not an offshoot – we can see custom in the light of one of its particular manifestations, a manifestation that takes on increased importance when, as a consequence of the saturation[6] of organizations and overarching social representations, proxemic values (re)surface. One might even say that at this stage of the game, the scale tilts more towards the communications mode, since it is experienced for its own sake, without any sort of finalization as a pretext. There is a direct link between this emphasis on communication for its own sake and the surpassing of the critical attitude that is tied to a more instrumental, mechanical and operational approach to society. With the communications mode predominant, the world is accepted as it is. I have already proposed calling this 'the social given', to explain the link that can be made between custom and communication. The world accepted for what it is lies of course within the realm of the natural 'given', part of a two-way flow common to the ecological perspective. But it is also part of the social 'given', in whose structure each of us fits and which leads

to an organic sense of commitment between individuals, in other words, tribalism. This is certainly where the theme of custom leads us; the *individual* counts for less than the *person* who is called upon to play his or her role on the global scene, according to some very precise rules. Can we thus speak of regression? Perhaps, if we consider individual autonomy as the base-line of any existence in society. But, aside from the fact that anthropology has shown us that this is a value which is immutable neither in time nor in space, then we may grant that the *principium individuationis* has become increasingly contested in the very heart of Western civilization. The poet's or novelist's sensibility can serve as a barometer (cf. Beckett's plays, for example) of this tendency or, more empirically, we can see evidence of it in the various group attitudes that colour the life of our societies.

Finally, it is worth noting that certain countries which have not developed from a tradition of individualism nevertheless are currently exhibiting signs of an undeniable *vitality* that, moreover, seems to exert a lasting fascination for us. Japan is just such a country and so, paradoxically, is Brazil. We must take both these countries to be prototypes whose auras are essentially ritualistic, whose inner structures are the 'tribe' (or the organic grouping, to be less blunt), and which are, for at least one if not both, poles of attraction for the collective imagination, whether from the existential, economic, cultural or religious point of view.

Of course, it is not a matter of presenting them as finished models, but rather of demonstrating that, as an alternative to the *principle of autonomy*, or however we wish to call it (self-direction, autopoeïsis, etc.), we can posit a principle of allonomy[7] which is based on adjustment, accommodation, on the organic union with social and natural alterity [Berque 1982: 52; Da Matta 1983]. This principle goes against the activist model built by modernity. Under the present hypothesis, this principle is a customary one, and it reinvests, in a prospective way, the traditional values long since thought to be surpassed. In fact, after the period of 'disenchantment with the world' (Weber's *Entzauberung*), I am suggesting that we are witnessing a veritable re-enchantment with the world, whose logic I will try to make clear. For the sake of brevity, let us say that, in the case of the masses which are diffracted into tribes, and the tribes which coalesce into masses, the common ingredient is a shared sensibility or emotion. I think back to . . . the prophetic meditations of Hölderlin on the peaceful banks of the Neckar, where he made the connection between the 'nationel',[8] the shared sentiment which holds a community together, and the 'shades of the Greek gods [who] are returning to earth just as they were'. Upon revisiting this oasis of calm, he found it imbued in these gods. It is also in the solitude of that footpath in Eze that the other 'madman' Nietzsche experienced the dionysian irruption. His vision was no less premonitory:

> Now solitary, living in isolation from one another, some day you will be one people. Those who have chosen themselves will one day form a chosen people from whom will emerge an existence which surpasses man.

Our own *Philosophenweg* passes over beaches crammed with holidaymakers, department stores thronged with howling consumers, riotous sporting events and the anodyne crowds milling about with no apparent purpose. In many respects, it would seem that Dionysus has overwhelmed them all. The tribes he inspires

demonstrate a troublesome ambiguity: although not disdaining the most sophisti-
cated technology, they remain nonetheless somewhat barbaric. Perhaps this is a sign
of postmodernity. Be that as it may, the principle of reality, on the one hand, forces
us to accept these hordes, since they are there, and on the other, urges us to
remember that time and again throughout history it was barbarity that brought many
moribund civilizations back to life.

Notes

1 *Transl. note*: Maffesoli uses this term throughout to mean 'extreme' or 'acute'.
2 *Transl. note*: A kind of Italian preppy, or as the French would say, 'bon-chic, bon
genre'.
3 *Transl. note*: This word appears in English in the text.
4 *Transl. note*: PMU = *pari-mutuel urbain* (race-track betting).
5 *Transl. note*: This etymological observation is not really translatable, The French
for knowledge is 'connaissance' and birth 'naissance', hence 'co-naissance' = 'born
with'.
6 *Transl. note*: here and elsewhere, Maffesoli uses the term 'saturation' to describe
the worn-out nature of institutional power, just as a sponge saturated with water
can absorb no more.
7 The law as an external force.
8 Referring to the popular substrate.

Territories, space, otherness

Introduction to part four

■ Ken Gelder

F OR HENRY MAYHEW around the middle of the nineteenth century, as we have seen, people were either 'wanderers' or 'settlers', nomadic or residential, tribal or civilized. This particular binary, inherited from anthropology and related, racializing human sciences, has proved immensely influential in its capacity to identify and distinguish different social groups. Mayhew's innovation was to bring this binary into the modern city, looking at urban 'wanderers', itinerant labourers, street performers, and so on. These are people without property – yet they are still able to claim certain kinds of urban space as theirs. Rather than owning parts of the city, we might say that they *territorialize* it. Even the homeless can territorialize. One of the early, classic studies from the Chicago School was Nels Anderson's *The Hobo* (1923), an ethnographic study of homeless men on Madison Street in Chicago that conveys a vivid sense of lived street culture ('hobohemia'). Much later on, Dick Hebdige wrote about the Polish-American artist Krzysztof Wodiczko's 'homeless vehicle project', a mobile shelter/trolley for homeless people in New York (Hebdige 1993; see also Wodiczko 1999) designed to produce a sense of homeless-homeliness on the street. Territory is often thought of as local, but territorialization can also be the result of displacement, of deviating *from* the local and inhabiting some place elsewhere (a street, a club) or even someone else's place. For subcultures, it expresses a sense of social belonging-*without*-ownership, and in this sense it can be as intensely tied to place as homeliness itself.

Part four begins with an extract from one of the foundational (and most remarkable) studies of subcultural territory, the wonderfully named Frederic M. Thrasher's *The Gang: A Study of 1,313 Gangs in Chicago* (1927). This work was published in a series overseen by Robert E. Park, and Thrasher – a professor of educational sociology at New York University – was influenced by Park's notion of a 'human ecology' in the city. His exhaustive study of Chicago gangs was published around

the same time as Herbert Asbury's sensationalist *The Gangs of New York* (1928), a book that claimed that gangs had 'now passed from the metropolitan scene' (Asbury 2002: xiii). For Thrasher, however, gangs – far from being some kind of relic – were a thriving feature of modern urban development. They may, however, be relatively invisible, escaping the gaze of 'society' by occupying the city's unregulated or unsupervised areas. Thrasher's terminology comes in the wake of Mayhew's sense of the urban 'wanderer' as someone set apart from civilization, someone who doesn't obey modernity's rules: gangs are thus 'tribal and intertribal', occupying 'jungles' and 'wilderness' and 'badlands', and presiding over 'kingdoms' and 'feudal estates'. But he also saw them as a product of contemporary urban immigration patterns, poverty and slum-dwelling, formed out of their habitat and so falling into the 'cracks' and 'fissures' of the city. 'The gang', he wrote,

> is an interstitial group originally formed spontaneously, and then integrated through conflict. It is characterized by the following types of behaviour: meeting face to face, milling, movement through space as a unit, conflict, and planning. The result of this collective behaviour is the development of tradition, unreflective internal structure, *esprit de corps*, solidarity, morale, group awareness, and attachment to a local territory.
>
> (Thrasher 1927: 57)

For Thrasher, gangs (which he took as almost exclusively male in membership) are a social 'alternative' to society itself, but they are turned inward in their worldview to the extent of being utterly 'unreflective' about their predicament: quite the opposite of Hebdige's ironic/creative punks, for example. The problem was, and still is for the most part, a criminological-sociological one. Thrasher's view was a reformist one, that, rather than try to break up the gang ('taking the boy out of the gang'), efforts should be directed to making its members useful and socially productive. In William Foote Whyte's classic study, *Street Corner Society: The Social Structure of an Italian Slum* (1943), youth gangs are divided precisely along these lines: in terms of their inwardness on the one hand, and their broader social aspirations on the other. Whyte – who went on to become a highly regarded specialist in organizational behaviour in the workplace, teaching for over 30 years at Cornell University – undertook his research for *Street Corner Society* while still a graduate student at Harvard and then Chicago. He called the site for his research 'Cornerville': in fact, it was Boston's North End. In this slum district – a 'mysterious, dangerous and depressing' place just 'a few minutes' walk from fashionable High Street' (Whyte 1943: xv) – Whyte looked at second-generation Italian youth gangs, part of an often demonized ethnic community during the Second World War. He divided the boys he met there into two groups: a corner boy gang called the Nortons, led by 'Doc', and the college boys, led by Chick Morelli (a division that anticipates Paul Willis's work with the 'lads' in chapter 10). The former continue to identify as a street gang, local and Italian, while the latter are focused on a college education, upward social mobility and recognition as Americans. Doc's gang thus remains disenfranchised in broader American society,

but it gains status through its loyalty to its community and its territorial claim on the street corner.

Thrasher and Whyte both produced the kind of ethnographic studies that literally enlightened, that is, shed light on those parts of the city that otherwise seemed both off-limits and obscure. They also reveal gangs to be organized, socially and culturally – for example, through Whyte's notion of 'reciprocal obligations' between gang members and other groups (racketeers, politicians). No subculture is isolated from the broader public world it inhabits, no matter how inward-looking its participants might be, but it might try to carve out a space for itself that can *seem* to be isolated. The third contribution to this part comes from Erving Goffman's *Asylums* (1961), and certainly, asylums themselves can seem remote from the public gaze. Goffman had studied at the University of Chicago and went on to a distinguished career as a social anthropologist. For a time, he was a visiting scientist for the National Institute of Mental Health and his work here led to *Asylums*. Goffman is associated with what is often called 'symbolic interactionism', a sociological approach that goes back to Max Weber, the American pragmatist George H. Mead, and the Chicago School (particularly, Herbert Blumer, who had studied with Mead). Symbolic interaction understands human events as the result of people continually adjusting their actions in response to the actions of other people. To do this, actions must be interpreted and made meaningful, that is, treated symbolically. This approach therefore sees people as actors, as creative participants in the act of socialization. In his asylum, Goffman looks at the inmates' 'adjustments', or lack of them, to what is registered as normal behaviour – perhaps recalling Albert K. Cohen's work on delinquents in chapter 4. Social interaction here might involve a certain amount of improvisation or what Goffman calls 'make-do's', a term which anticipates Hebdige's use of *bricolage* later on in his account of the creative responses of punks. The asylum is a place under strict surveillance and (unlike the gang in the city) it can be difficult to escape its gaze by finding isolated or 'alternative' places to occupy. But Goffman notes that what he calls 'free places' do indeed exist, even here. His account of asylum 'underlife' is close to a 'history from below', drawing a geographical divide in this institution that allows for the possibility of carved-out social places in the midst of a highly regulated and constraining 'total institution'.

Some subcultures can indeed refuse social regulations and seek places (public or private) where their own often excessive or 'de-regulated' activities can flourish: think, for example, of S&M clubs or, in the case of our next contribution, of some of the more unruly parts of British football terraces. Peter Marsh *et al.*'s 'Life on the Terraces' comes from their book, *The Rules of Disorder* (1978), a social psychological study of places or 'microsocieties' (the football terraces, school) often thought to be *difficult* to regulate. For these authors, however, places which can seem disorganized or 'impulsive' to outsiders are in fact structured by ritual and an orderly process of meaning-making (albeit, meanings that may be very different in import to those outside of that microsociety). Influenced in part by Goffman, they look at the use Oxford United football fans make of their terraces and map out a set of zones here based on internal 'microsocial' distinctions ('novices', 'rowdies',

'town boys') that are meaningful only to the fans themselves. These distinctions are hierarchical, and a fan can move through them progressively (depending on their level of commitment to football), to pursue what Marsh *et al.* call a *career* – rather like Paul G. Cressey's notion of a 'life-cycle' in chapter 2. Football fans territorialize their terraces in distinctive and exclusive ways; indeed, these authors emphasize that exclusivity is necessary in order for the 'discrepant behaviour' of this particular microsociety to find its fullest expression.

As we have seen with Thrasher, gangs can be cast as 'tribal' – so can football fans and many other unruly or threatening subcultures. In recent times, however, we have seen the term 'tribe' used more affirmatively, as in the work of Michel Maffesoli (see chapter 18). The primitivism of this designation can also be deployed by subcultures themselves, especially those wishing to distinguish themselves from – and even protest about – certain aspects of modernity. Kevin Hetherington's *New Age Travellers: Vanloads of Uproarious Humanity* (2000) looks at a subculture that turns its attention away from the modern city and, instead, traverses the countryside and congregates at festivals and – in Britain – heritage sites such as Stonehenge. New Age travellers are a road (not a street) subculture, often involved with 'grass-roots' political activity and affiliated to pre-modern or pagan religious beliefs and practices, as George McKay has also chronicled (McKay 1996). For Hetherington, they can also become 'folk devils' attracting the interest of police and government legislation. In the extract in this part, Hetherington in fact draws on Stanley Cohen's work to describe the 'moral panic' New Age travellers caused in Britain during the 1980s and 1990s. He also draws on Simmel and Victor Turner, to give a sense of this subculture as liminal, a kind of anti-community bringing 'disorder' to the villages they visit. At the same time, the social identity of New Age travellers coheres around a 'spatial politics' that reads the British landscape mythically, which is why Stonehenge is such an important site. For Hetherington, rural Britain is represented in a set of conventional ways (in terms of conservation, heritage, property, boundaries, issues of public order, and so on). New Age travellers, however, offer an 'outsider's' view of the landscape, defamiliarizing it, turning it into a 'place of otherness'.

Iain Borden's work returns us to the city, but retains Hetherington's sense that the subcultural use of space is non-normative. Borden, a professor of architecture at University College, London, looks at urban skateboarders and sees that they territorialize the city under quite a different rationale to urban architecture and the 'homogeneous' world of business. Skateboarders use city spaces in extraordinary ways, riding across steps, over benches, along walls. Talking to skateboarders and reading their micromedia – their fanzines (including the interestingly named *Thrasher*) – Borden suggests that this subculture uses the city creatively, outside the logics of daily labour and commodification. His account recalls Hebdige on the improvisations of punks; he also recalls Jock Young when he suggests that skateboarders quite literally play in the city, releasing 'ludic' energy and investing city space with their 'counter-rhythms'. Borden is heavily influenced here by the work of the French sociologist of everyday life, Henri Lefebvre, as well as the Situationist International movement with whom Lefebvre had been associated (and which,

according to Greil Marcus, had inspired punk aesthetics in the 1970s: see Marcus 1989). These writers saw, among other things, that the modern city – structured spatially by commodity capitalism – impoverished the experience of everyday life. Yet this impoverishment paradoxically releases desires and yearnings that could become revolutionary, even though they may last only a moment. The student uprisings in Paris in May 1968 provided an example, and in fact Lefebvre's students led the occupation of the Sorbonne and other key sites at this time. Revolution here is also an act of the imagination, ludic, playful, libidinal – characteristics Borden ascribes to his urban skateboarders as they reinvent city spaces and reorient the objectives of city planners.

This part moves from early sociological studies of gangs in the city – disadvantaged, tied to the poverty belts, unruly – to creative acts of urban inhabitation by a subculture characterized here by bodily energy and attitude. The modern city is seen as increasingly homogeneous, literally (in a phrase used by Lefebvre) a 'concrete abstraction', a *rationalization* of space and its use. Borden's account of the skateboarders may therefore very well provide a romantic narrative designed to counter his sense of the way urban architecture is symptomatic of the domination of corporate and commodity capitalism over everyday life. Even so, he continues a sociological tradition that turns to the way spaces and places are occupied through a set of distinctive practices, which, from an outsider's point of view, may seem *irrational*: the unproductive, the ludic, the 'discrepant', the excessive, the unregulated, the improvised, the unconventional, and of course, always the social.

Frederic M. Thrasher

GANGLAND [1927]

N O LESS THAN 1,313 GANGS have been discovered in Chicago and its environs! A conservative estimate of 25,000 members – boys and young men – is probably an understatement, for the census taken in connection with this study is not exhaustive.

The favorite haunts and hang-outs of these 1,300 and more gangs have been definitely ascertained. Their distribution . . . makes it possible to visualize the typical areas of gangland and to indicate their place in the life and organization of Chicago.

It must be remembered in reading the following description of gangland that the writer is presenting only one phase of the life of these communities. There are churches, schools, clubs, banks, and the usual list of wholesome institutions in these areas as well as gangs. The gangs and the type of life described here may not even be apparent to the average citizen of the district, who is chiefly occupied in his own pursuits.

The reader should also bear in mind that the gang is a protean manifestation: no two gangs are just alike; some are good; some are bad; and each has to be considered on its own merits. Many of the gangs mentioned by name in the following account are delinquent groups, for they are usually of the picturesque sort, attracting more attention and receiving names more readily than other types.

The empire of gangland

The broad expanse of gangland with its intricate tribal and intertribal relationships is medieval and feudal in its organization rather than modern and urban. The hang-out of the gang is its castle and the center of a feudal estate which it guards most jealously. Gang leaders hold sway like barons of old, watchful of invaders and ready

to swoop down upon the lands of rivals and carry off booty or prisoners or to inflict punishment upon their enemies. Sometimes their followers become roving, lawless bands, prowling over a large territory and victimizing the community.

The feudal warfare of youthful gangs is carried on more or less continuously. Their disorder and violence, escaping the ordinary controls of the police and other social agencies of the community, are so pronounced as to give the impression that they are almost beyond the pale of civil society. In some respects these regions of conflict are like a frontier; in others, like a 'no man's land,' lawless, godless, wild.

In Chicago the empire of the gang divides into three great domains, each of which in turn breaks up into smaller kingdoms. They are natural areas, differentiated in the processes of human interaction, and having their own characteristic place in the mosaic of the city's life.

The first of these we may call the 'North Side jungles'; the second, the 'West Side wilderness'; and the third, the 'South Side badlands' – names which well characterize the regions so far as gang life is concerned. Gangland stretches in a broad semicircular zone about the central business district (the Loop) and in general forms a sort of *interstitial* barrier between the Loop and the better residential areas.

The North Side jungles

The North Side jungles of gangland lie north of the Loop and the Chicago River, and east of the north branch of that stream, constituting a portion of the unique area known as the 'Grand Canyon of Chicago' because of the great diversity of its 'social scenery.' Here is a 'mosaic of little worlds which touch but do not interpenetrate' [Park et al. 1925: 40]. Along the lake front northward is the 'Gold Coast,' representing the extreme of wealth and fashion, while in the southern portion we find 'Bohemia,' the North Side artists' colony. West of these two areas is a cosmopolitan and rooming-house district which includes the haunts of a gang of dope-peddlers serving North Side addicts; the north stem of 'Hobohemia' [Anderson 1923: 8]; and 'Bughouse Square,' a center for hobo intellectuals. This region serves also as a base for such notorious bootlegging groups as the Clark and Erie gangs. Formerly it was the bailiwick of Chicago's most notorious gangster, the leader of the powerful ZZZ gang of 'hijackers' and rum-runners, who was assassinated by unknown enemies.[1]

The gangs are most numerous, however, between this region and the north branch of the river, in 'Little Sicily,' a community of southern Italians. Certain immigrant customs color the gang life of the region. The vendetta is often carried into the quarrels of juvenile gangs, while the Mafia of southern Italy takes the form among criminal groups of secret gangs of the Black Hand, such as the 'Gloriannas' and 'Little Italy' gang. So notorious are these gang conditions that the southern portion of the colony has sometimes been called 'Little Hell.' In this area is 'Death Corner,' the scene of frequent murders. Recently many negro families have invaded 'Little Hell,' and a colored church now stands two blocks from 'Death Corner.'

North and westward of 'Little Sicily' gangland fringes the industrial properties along the river. Here is a Polish colony called by the gang boy 'Pojay Town,' in contradistinction to 'Dago Town' described above. All the gangs of this region

together are known as the 'North Siders,' and they wage continual warfare across
the river bridges with their enemies the 'West Siders.'

The West Side wilderness

Most extensive of gangland domains is the West Side wilderness which lies south
and west of the north branch of the Chicago River, west of the Loop, and north
and west of the south branch of the river.

Across these turbid, sewage-laden waters lie the crowded river wards. In the
drab hideousness of the slum, despite a continuous exodus to more desirable
districts, people are swarming more than 50,000 to the square mile. Life is enmeshed
in a network of tracks, canals, and docks, factories and breweries, warehouses, and
lumber-yards. There is nothing fresh or clean to greet the eye; everywhere are
unpainted, ramshackle buildings, blackened and besmirched with the smoke of
industry. In this sort of habitat the gang seems to flourish best.

The gangs of the northern portion of the West Side wilderness center in
'Bucktown,' a Polish colony adjoining the north branch of the Chicago River, and
the home of the widely known 'Blackspots,' long a community terror.

Bucktown

> I. Bucktown has long been known as one of the toughest neighborhoods
> on the northwest side. A few years ago you couldn't pass through there
> without taking a trimming. There are plenty of fights still, but it is quieter
> now. Most of the boys what used to cause the trouble are older and have
> learned better. Some of them are married, but the younger fellows, 17
> and 18! They haven't learned nothing yet![2]

The gangs of this area have formed a general alliance, the 'West Siders' against
their rivals in 'Pojay Town' across the river.

South from Bucktown, the Polish colony continues along Milwaukee Avenue,
the great Polish business street. Here there is a gang in almost every block. The
majority of gangs in Chicago are of Polish stock, but this may be due to the fact
that there are in the city more than 150,000 more persons of Polish extraction than
of any other nationality except the German.

South of this Polish settlement is 'Little Italy,' with gangs of all ages. With the
exception of a few, like the 'Spark-Plugs,' the 'Beaners,' or the hard-boiled 'Buckets-
of-Blood,' they are either anonymous or adopt the names of the streets where they
'hang out.'

Below the Chicago and North-Western railroad tracks, the southern boundary
of Little Italy, lies a region with relatively few gangs. Immediately back of the Loop
the continuity of gangland is broken by a central industrial district, and farther south
and west by a rooming-house area, where two-thirds of the residents are said to be
transients. Once the abode of Chicago's 'Four Hundred,' the fashionable dwellings
have become the headquarters of labor unions or tenements which house a shifting

population of all nationalities. Here, too, are hospitals, clinics, and adjuncts of the medical schools, and also the main stem of 'Hobohemia' with 'Bum Park' and the 'slave market,' as the numerous employment bureaus for the migratory workers are called by the men who patronize them [Anderson 1923: 4, 5]. Although the gangs are relatively few in this region, some of them, like the 'Night Riders,' are composed of anemic rooming-house children, a distinct type bordering on degeneracy.

West of the industrial section of this area is a negro colony whose gangs, known to the boys of the vicinity as the 'Coons from Lake Street,' are marooned among hostile gangs of whites. Many of these negro groups are crap-shooting gangs, and some of them, such as the 'Bicycle Squad,' engage in thievery.

South of the colored district and extending westward to Garfield Park is a so-called 'American' area, with many gangs in the poorer sections which abut the elevated lines, the railroad tracks, and the business streets. The notorious and daring 'Deadshots' and the adventure-loving Irish and Italian boy 'Blackhanders' are among the groups which carry on hostilities with the negro gangs from Lake Street and the Jews to the west and south.

South of the cosmopolitan district described above lies a greatly congested immigrant community where gangs are numerous. In popular parlance this area (the old Nineteenth Ward) has been known as 'Moonshine Valley' or the 'Bloody Nineteenth.' When Jane Addams established Hull-House at Polk and Halsted streets in 1889, the residents were largely German and Irish, but these nationalities have gradually moved out before the influx of Italians, Russians, Jews, and Greeks. Here we find both a 'Little Italy' and a 'Little Greece,' and, recently, gypsies, negroes, and Mexicans have come into the community.

In the northwest portion of this area a gang of dope-peddlers ply their trade. Here, too, the notorious 'Cardinellis' are still said to have their rendezvous, though their leaders and two of their members have been hanged. Although dominantly Italian, these groups often include men and boys of other nationalities. It was in the heart of Little Italy that the powerful Genna gang had its chain of stills from which flowed much of Chicago's illicit liquor. Halsted, the main business street of the West Side, which is a favorite playground for gangs both young and old, is unusually varied and colorful in this particular section.

West of the Hull-House community and extending south across Roosevelt Road to Fifteenth Place, is the Ghetto. The Jewish gangs, which belong to this region are less numerous than those of other slum areas, due, it is said, to the 'more individualistic spirit of the Jews,' but more likely to better organized recreation and family life than is found among the poorer classes of other immigrant groups. Those gangs which do thrive in the Ghetto, of which the old 'Boundary Gang' was probably the best known, carry on intermittent warfare with the groups of adjacent regions. They are known as the 'Jews from Twelfth Street.'

In the heart of the Ghetto is the crowded Maxwell Street market, one of the liveliest and most picturesque spots in Chicago. Some of the Jewish gangs, like Itchkie's 'Black Hand Society,' a pickpocket 'outfit' find excellent opportunity for sport and prey along this thronging Rialto; nor is it overlooked by the gangs of other regions.

West of the Ghetto is Lawndale, an area of second settlement for the Jewish immigrant. Lawndale, with its 75,000 Jews, is typically a middle-class community

into which the Ghetto in its growing prosperity has poured three-fourths of its population until more Jews live here than in any other local community in America outside of New York City. Most of the boys' groups of this community take the form of basement clubs. Along Roosevelt Road, however, which appears to be an interstitial business street – a tentacle of gangland extending its baleful influence into an orderly residential area – several notorious gangs of criminals, bootleggers, and rum-runners under Jewish leadership hang out in the restaurants, poolrooms, and gambling dens. One of the most dreaded of these, the WWW's, is noted for the pugilistic prowess of its members; another powerful group, the TTT's, is said to have succeeded the Gennas in the control of illicit liquor manufacture on the West Side.

In the southern portion of the Ghetto is an area known as the 'Valley' – the cradle of a powerful gang of robbers, bootleggers, and beer-runners and the present territory of the notorious 'Forty-Twos,' who started as automobile 'strippers' and who have prospered as window-smashing burglars under the energetic leadership of one of their members nicknamed 'Babe Ruth' (not a ball player). Several blocks in the western portion of the Valley are now occupied by Chicago's new commission produce market which was formerly on South Water Street. South of the Valley, in a Lithuanian colony, are a large number of street gangs.

West of the Lithuanian settlement and north of the river is 'Little Pilsen,' a Bohemian area from which many of the residents are rapidly moving before an influx of Croatians and Poles. The houses are becoming dilapidated, and the many basement flats are damp and unsanitary. Here are many gangs of the formally organized type, such as athletic and social clubs. Some have a political complexion, and one vicious gang, whose leader is the son of an office-holder, enjoys practical immunity from prosecution.

West of Little Pilsen is an extensive Polish colony and farther on, a second Bohemian settlement. The numerous gangs in these areas form a widespread group known as the 'West Siders,' who wage war back and forth over the bridges against the 'South Siders,' or the 'Brightoners,' across the river to the south.

The South Side badlands

South of the Loop and southeast of the south branch of the Chicago River lies the third major division of gangland – the South Side badlands.

A number of gangs largely Italian in membership hang out on the streets between the Loop and Roosevelt Road. Coming from homes above the stores in a quasi-business district on South State Street, most of the boys, like the 'So So's,' the 'Onions,' and the 'Torpedoes,' lead an irregular life in the street, which is their playground.

South of the Loop, beginning about Sixteenth Street, is the 'Black Belt,' Chicago's most extensive negro area which stretches southward with varying breadth to Sixty-third Street, a distance of about six miles. In this region of contrasting social conditions are high-class colored residential neighborhoods, as well as 'black and tan' cabarets, white and colored vice resorts, and the worst type of slum. Gangs are most numerous in the poorer sections and especially in the so-called 'crime spots' where gambling, robbery, and murder are prevalent. The gangs of the Black Belt include: those for whom a pool hall serves as a clubroom and center of interest; gangs of mixed

membership, like the 'Dirty Sheiks and Wailing Shebas'; and at least one group which specializes in dope-peddling. The 'Wolves,' 'Twigglies,' and 'Royal Eclipse' are well known in the area.

Immediately beyond Wentworth Avenue, which is the general boundary of the Black Belt on the west, are the 'Shielders,' a group of several gangs who possess a long, narrow stretch of territory extending from the river on the north southward as far as Sixty-third Street. West of the railroad tracks along Stewart Avenue is a corresponding area about four blocks in width held by their archenemies the 'Dukies.' As the Turks called all Westerners 'Franks,' so their colored rivals to the east call the gangs from both of these regions the 'Mickies,' for this was originally an Irish district. At present the northern portion is dominantly Italian, but the gangs maintain the traditional names. The southern part of the Dukies' territory, Canaryville, which is still Irish, has been notorious for its many gangs which are so 'hard-boiled' that gangsters who come out of the district are known as graduates from the 'Canaryville school of gunmen.'

West of the 'Dukies' and south of the river is the old settlement of Bridgeport with its 'Archy Road' (Archer Avenue), made famous in the dialogues of 'Mr. Dooley' and 'Mr. Hinnissey.' It is now a Polish and German community, hemmed in by industry on all sides but the south. The history of the region is interesting, in the light of gang development, for here the first gang of which we have secured a record had its beginnings.

Early gangs

2. The earliest settlers in Bridgeport were the Irish who retreated before the influx of Germans. The latter in turn gave way to the Poles who are in the majority today.

In the sixties everybody had cabbage patches, chickens, and even cows about their places. Most of the mischief committed by neighborhood gangs was breaking fences and stealing cabbages, for there was not much else to take. The men of the community worked near Bubbly Creek at the rolling mills which had about 200 employees, or at the stockyards which employed 1,000.

In 1867 there was a gang of about a dozen fellows, 17 to 22 years of age, who hung around at Ashland and Bubbly Creek. They were fond of gambling at cards. They did not work regularly and waited here to rob the men as they came home with their pay. It is said that they disposed of many a victim by throwing him into the creek. Some of them were sent to the Bridewell, but none ever went to the state's prison.

In the eighties there was a gang of Irish and German lads who had their clubroom in the basement of a saloon on Ashland. Another group about the same time was the Hickory Street gang – about a dozen fellows from 12 to 18 years of age who met in a basement. Here they used to read 'dime novels,' play cards, study and drink their beer. Sometimes they copped peaches or bought a pie which they would cut with a safety pin from their suspenders. Some of this group have since become contractors, and one an alderman.[3]

The gangs in Bridgeport which followed the period of the eighties were very active and wielded great political power, but with a few exceptions those of the present time, although numerous, are not so well organized.

South and east of the older portion of Bridgeport is a Lithuanian colony in which many of the boys belong to lawless gangs, which break windows, steal, and hold up children and drunken men on the street.

West of the odorous expanse of pens and packinghouses of the Union Stock Yards is an immigrant colony, dominantly Polish, known as 'Back-of-the-Yards.' In the northern portion of this area is one of the grimiest, most congested slums of the city. Here, besides the numerous street groups, there are a large number of gang clubs which rent rooms in times of prosperity but give them up in summer or when work is slack. Some indulge in gambling, 'moonshine,' and sex irregularities as well as in athletics. In this general region and south of it, a long-enduring gang, the XXX's, carries on beer-running and other criminal activities, and holds its power by means of bribery, intimidation, and murder.

Southwest of the 'Back-of-the-Yards' area proper, the majority of gangs, organized as athletic clubs, center their activities around Cornell Square, a small park and playground. East of this group and south of Forty-seventh Street are numerous gangs of the 'hard-boiled' variety – such as the much feared 'White Rocks' and the 'Murderers.' This region is called the 'Bush,' and its reputation is such that policemen are sometimes put on duty there, it is said, for punishment.

East and southeast of the Bush is an Irish community including a part of the territory of the 'Dukies.' This is the aristocracy of gangland. Gangs of all kinds are numerous in the South Halsted Street vicinity and around Sherman Park. Many of the well-known athletic clubs, such as Ragen's Colts, are influential in this region where they own or rent clubrooms.

The South Halsted Street district is also the operating territory of another major gang of notorious criminals and rum-runners, the YYY's. This group has at times warred with the XXX's for control over the affairs of the underworld.

Borderlands and boundary lines

In addition to the three major divisions of gangland, certain boundary lines and borderlands between the non-gang areas of the city develop gangs. Threads of social disintegration tend to follow alongside rivers, canals, railroad tracks, and business streets whose borders are manifestly undesirable for residential purposes and permit gangs to thrive in the interstices between very good residence areas.

In Hyde Park, one of the best residential districts in the city, there are a number of gangs along the business streets and in the sections adjacent to the Illinois Central Railroad. On Fifty-fifth Street, where a rather heterogeneous, congested population lives above the stores and behind the business buildings, we find about a dozen gangs, including the 'Kenwoods,' who have been a problem in the community for years. On Lake Park Avenue the situation is similar; on Forty-seventh Street are the 'Bat-Eyes,' while Sixty-third has the 'Dirty Dozen.'

These interstitial areas formerly comprised a saloon district with, it is said, a gang in every two blocks. One of these, meeting on Lake Park Avenue, had a cave

with a subcellar used for keeping stolen goods and disciplining unruly members. There were benches around the walls where members sat in solemn conclave, each in his appointed place. About fifty boys were included in this group [Breckinridge 1912: 434].

Appended ganglands

In the satellite communities near Chicago, areas develop, under certain conditions, not unlike those of the central empire of gangland. Purely residential and well-organized suburbs of the better type such as Oak Park and Evanston, are practically gangless, for the activities of the children are well provided for in family, school, church, and other established institutions. Even in these regions, however, gangs develop in interstitial zones. In Evanston, along Railroad Street and in 'Toad Town,' are found characteristic interstitial groups such as 'Honey's' gang.

In 'West-Town,' on the contrary, where life is not well organized there are more gangs on the order of the 'Hawthorne Toughs' and the 'hard-boiled Crawfords.' West-Town, with a population of 55,000, while an integral part of Chicago socially, has a separate municipal government, which seems unable or indisposed to cope with lawless elements. When Chicago's criminal gangs first began to find life difficult within the city limits, they in-grafted themselves into West-Town, and made it 'wide-open' with saloons, cabarets, gambling houses, and vice resorts.

South and east of Chicago in the industrial suburbs, such as Blue Island, South Chicago, and West Pullman, gangs are numerous in the immigrant colonies. Hammond, Indiana, an industrial satellite of larger size, has twenty-six gangs, among them the 'Bloody Broomsticks,' the 'Night Hawks,' the 'Pirates,' and the 'Buckets-of-Blood,' who duplicate the activities of Chicago gangs in little kingdoms of their own.

Gangland is an interstitial area

The most important conclusion suggested by a study of the location and distribution of the 1,313 gangs investigated in Chicago is that *gangland represents a geographically and socially interstitial area in the city*. Probably the most significant concept of the study is the term *interstitial* – that is, pertaining to spaces that intervene between one thing and another. In nature foreign matter tends to collect and cake in every crack, crevice, and cranny – interstices. There are also fissures and breaks in the structure of social organization. The gang may be regarded as an interstitial element in the framework of society, and gangland as an interstitial region in the layout of the city.

The gang is almost invariably characteristic of regions that are interstitial to the more settled, more stable, and better organized portions of the city. The central tripartite empire of the gang occupies what is often called 'the poverty belt' – a region characterized by deteriorating neighborhoods, shifting populations, and the mobility and disorganization of the slum. Abandoned by those seeking homes in the better residential districts, encroached upon by business and industry, this zone is

a distinctly interstitial phase of the city's growth. It is to a large extent isolated from the wider culture of the larger community by the processes of competition and conflict which have resulted in the selection of its population.[4] Gangland is a phenomenon of human ecology [see Park *et al.* 1925]. As better residential districts recede before the encroachments of business and industry, the gang develops as one manifestation of the economic, moral, and cultural frontier which marks the interstice.

This process is seen, too, in the way in which a business street, stream, canal, or railroad track running through a residential area tends to become a 'finger' of the slum and an extension of gangland. Borderlands and boundary lines between residential and manufacturing or business areas, between immigrant or racial colonies, between city and country or city and suburb, and between contiguous towns – all tend to assume the character of the intramural frontier. County towns and industrial suburbs which escape the administrative control and protection of the city government and whose conditions of life are disorganized, as in the case of West-Town, develop into appended ganglands. The roadhouses fringing the city, and those occupying positions between its straggling suburbs, represent an escape from society and become important factors in maintaining the power and activities of the gang. The region of 155th Street and South Halsted has been representative of these conditions in the southern part of Cook County.

The city has been only vaguely aware of this great stir of activity in its poorly organized areas. Gang conflict and gang crime occasionally thrust themselves into the public consciousness, but the hidden sources from which they spring have not yet been understood or regulated. Although their importance in the life of the boy has sometimes been pointed out, the literature of the subject has been meager and general. This region of life is in a real sense an *underworld*, through whose exploration the sociologist may learn how the gang begins and how it develops, what it is and what it does, the conditions which produce it and the problems which it creates, and ultimately he may be able to suggest methods for dealing with it in a practical way.

Notes

1 Names of gangs are omitted and disguises used whenever such procedure seems advisable. Major criminal gangs are designated throughout the study by triple letters.

2 From an interview with a gang boy. Many documents of this sort are presented in part or *in toto* in the text. For ease of reference, they are numbered consecutively.

3 Interview with a very old resident of the district.

4 The prevalence of gangs in the so-called 'poverty belt' or 'zone of transition' is further indicated by a survey (made by a private agency) of 173 eighth-grade boys attending schools in one of these areas. It was found that over 82 per cent of these boys (from twelve to fifteen years of age) were not connected in any way with constructive recreational activities. 'With the exception of a small number of boys industrially occupied, this 82 per cent passed their leisure time in streets and alleys, shooting craps, playing "piggy wolf," and other games, participating in gang

activities, or were members of independent unsupervised clubs of their own. While boys would hesitate about acknowledging membership in a "gang" when it was called by that name, practically all of them did belong to groups that were essentially gangs.'

William Foote Whyte

THE PROBLEM OF CORNERVILLE
[1943]

T HE TROUBLE WITH the slum district, some say, is that it is a disorganized community. In the case of Cornerville such a diagnosis is extremely misleading. Of course, there are conflicts within Cornerville. Corner boys and college boys have different standards of behavior and do not understand each other. There is a clash between generations, and, as one generation succeeds another, the society is in a state of flux – but even that flux is organized.

Cornerville's problem is not lack of organization but failure of its own social organization to mesh with the structure of the society around it. This accounts for the development of the local political and racket organizations and also for the loyalty people bear toward their race and toward Italy. This becomes apparent when one examines the channels through which the Cornerville man may gain advancement and recognition in his own district or in the society at large.

Our society places a high value upon social mobility. According to tradition, the workingman starts in at the bottom and by means of intelligence and hard work climbs the ladder of success. It is difficult for the Cornerville man to get onto the ladder, even on the bottom rung. His district has become popularly known as a disordered and lawless community. He is an Italian, and the Italians are looked upon by upper-class people as among the least desirable of the immigrant peoples. This attitude has been accentuated by the war. Even if the man can get a grip on the bottom rung, he finds the same factors prejudicing his advancement. Consequently, one does not find Italian names among the leading officers of the old established business of Eastern City. The Italians have had to build up their own business hier-archies, and, when the prosperity of the 1920s came to an end, it became increasingly difficult for the newcomer to advance in this way.

To get ahead, the Cornerville man must move either in the world of business and Republican politics or in the world of Democratic politics and the rackets. He cannot move in both worlds at once; they are so far apart that there is hardly any

connection between them. If he advances in the first world, he is recognized by society at large as a successful man, but he is recognized in Cornerville only as an alien to the district. If he advances in the second world, he achieves recognition in Cornerville but becomes a social outcast to respectable people elsewhere. The entire course of the corner boy's training in the social life of his district prepares him for a career in the rackets or in Democratic politics. If he moves in the other direction, he must take pains to break away from most of the ties that hold him to Cornerville. In effect, the society at large puts a premium on disloyalty to Cornerville and penalizes those who are best adjusted to the life of the district. At the same time the society holds out attractive rewards in terms of money and material possessions to the 'successful' man. For most Cornerville people these rewards are available only through advancement in the world of rackets and politics.

Similarly, society rewards those who can slough off all characteristics that are regarded as distinctively Italian and penalizes those who are not fully Americanized. Some ask, 'Why can't those people stop being Italians and become Americans like the rest of us?' The answer is that they are blocked in two ways: by their own organized society and by the outside world. Cornerville people want to be good American citizens. I have never heard such moving expressions of love for this country as I have heard in Cornerville. Nevertheless, an organized way of life cannot be changed overnight. As the study of the corner gang shows, people become dependent upon certain routines of action. If they broke away abruptly from these routines, they would feel themselves disloyal and would be left helpless, without support. And, if a man wants to forget that he is an Italian, the society around him does not let him forget it. He is marked as an inferior person – like all other Italians. To bolster his own self-respect he must tell himself and tell others that the Italians are a great people, that their culture is second to none, and that their great men are unsurpassed. It is in this connection that Mussolini became important to Cornerville people. Chick Morelli expressed a very common sentiment when he addressed these words to his Italian Community Club:

> Whatever you fellows may think of Mussolini, you've got to admit one thing. He has done more to get respect for the Italian people than anybody else. The Italians get a lot more respect now than when I started going to school. And you can thank Mussolini for that.

It is a question whether Mussolini actually did cause native Americans to have more respect for Italians (before the war). However, in so far as Cornerville people felt that Mussolini had won them more respect, their own self-respect was increased. This was an important support to the morale of the people.

If the racket–political structure and the symbolic attachment to Italy are aspects of a fundamental lack of adjustment between Cornerville and the larger American society, then it is evident that they cannot be changed by preaching. The adjustment must be made in terms of actions. Cornerville people will fit in better with the society around them when they gain more opportunities to participate in that society. This involves providing them greater economic opportunity and also giving them greater responsibility to guide their own destinies. The general economic situation of the Cornerville population is a subject so large that brief comments would be worse than useless.

One example, the Cornerville House recreation-center project, will suggest the possibilities in encouraging local responsibility. The center project constituted one of the rare attempts made by social workers to deal with Cornerville society in its own terms. It was aimed to reach the corner gangs as they were then constituted. The lesson which came out of the project was that it is possible to deal with the corner boys by recognizing their leaders and giving them responsibility for action.

The social workers frequently talk about leaders and leadership, but those words have a special meaning for them. 'Leader' is simply a synonym for group worker. One of the main purposes of the group worker is to develop leadership among the people with whom he deals. As a matter of fact, every group, formal or informal, which has been associated together for any period of time, has developed its own leadership, but this is seldom recognized by the social workers. They do not see it because they are not looking for it. They do not think of what leadership is; instead they think of what it should be. To outsiders, the leading men of the community are the respectable business and professional men – people who have attained middle-class standing. These men, who have been moving up and out of Cornerville, actually have little local influence. The community cannot be moved through such 'leaders'. Not until outsiders are prepared to recognize some of the same men that Cornerville people recognize as leaders will they be able to deal with the actual social structure and bring about significant changes in Cornerville life.

So far this discussion sounds much like the anthropologist's prescription to the colonial administrator: respect the native culture and deal with the society through its leaders. That is certainly a minimum requirement for dealing effectively with Cornerville, but is it a sufficient requirement? Can any program be effective if all the top positions of formal authority are held by people who are aliens to Cornerville? What is the effect upon the individual when he has to subordinate himself to people that he recognizes are different from his own?

Doc once said to me:

> You don't know how it feels to grow up in a district like this. You go to the first grade – Miss O'Rourke. Second grade – Miss Casey. Third grade – Miss Chalmers. Fourth grade – Miss Mooney. And so on. At the fire station it is the same. None of them are Italians. The police lieutenant is an Italian, and there are a couple of Italian sergeants, but they have never made an Italian captain in Cornerville. In the settlement houses, none of the people with authority are Italians.
>
> Now you must know that the old-timers here have a great respect for schoolteachers and anybody like that. When the Italian boy sees that none of his own people have the good jobs, why should he think he is as good as the Irish or the Yankees? It makes him feel inferior.
>
> If I had my way, I would have half the schoolteachers Italians and three-quarters of the people in the settlement. Let the other quarter be there just to show that we're in America.
>
> Bill, those settlement houses were necessary at first. When our parents landed here, they didn't know where to go or what to do. They needed the social workers for intermediaries. They did a fine job then, but now the second generation is growing up, and we're beginning to sprout wings. They should take that net off and let us fly.

Erving Goffman

HOSPITAL UNDERLIFE
Places [1961]

I N CENTRAL HOSPITAL, as in many total institutions, each inmate tended to find his world divided into three parts, the partitioning drawn similarly for those of the same privilege status.

First, there was space that was off-limits or out of bounds. Here mere presence was the form of conduct that was actively prohibited – unless, for example, the inmate was specifically 'with' an authorized agent or active in a relevant service role. For example, according to the rules posted in one of the male services, the grounds behind one of the female services were out of bounds, presumably as a chastity measure. For all patients but the few with town parole, anything beyond the institution walls was out of bounds. So, too, everything outside a locked ward was off-limits for its resident patients, and the ward itself was off-limits for patients not resident there. Many of the administrative buildings and administrative sections of buildings, doctors' offices, and, with some variations, ward nursing stations were out of bounds for patients. Similar arrangements have of course been reported in other studies of mental hospitals:

> When the charge [attendant] is in his office, the office itself and a zone of about 6 square feet outside the office is off limits to all except the top group of ward helpers among the privileged patients. The other patients neither stand nor sit in this zone. Even the privileged patients may be sent way with abrupt authority if the charge or his attendants desire it. Obedience when this order occurs – usually in a parental form, such as 'run along now' – is instantaneous. The privileged patient is privileged precisely because he understands the meaning of this social space and other aspects of the attendant's position.
>
> (Belknap 1956: 179–90)

Second, there was *surveillance space*, the area a patient needed no special excuse for being in, but where he would be subject to the usual authority and restrictions of the establishment. This area included most of the hospital for those patients with parole. Finally, there was space ruled by less than usual staff authority; it is the varieties of this third kind of space that I want to consider now.

The visible activity of a particular secondary adjustment may be actively forbidden in a mental hospital, as in other establishments. If the practice is to occur, it must be shielded from the eyes and ears of staff. This may involve merely turning away from a staff person's line of vision. The inmate may smile derisively by half-turning away, chew on food without signs of jaw motion when eating is forbidden, cup a lighted cigarette in the hand when smoking is not permitted, and use a hand to conceal chips during a ward poker game when the supervising nurse passes through the ward. These were concealment devices employed in Central Hospital. A further example is cited from another mental institution:

> My total rejection of psychiatry, which had, after coma, become a fanatical adulation, now passed into a third phase – one of constructive criticism. I became aware of the peripheral obtuseness and the administrative dogmatism of the hospital bureaucracy. My first impulse was to condemn; later, I perfected means of maneuvering freely within the clumsy structure of ward politics. To illustrate, my reading matter had been kept under surveillance for quite some time, and I had at last perfected a means of keeping *au courant* without unnecessarily alarming the nurses and attendants. I had smuggled several issues of *Hound and Horn* into my ward on the pretext that it was a field-and-stream magazine. I had read Hoch and Kaslinowski's *Shock Therapy* (a top secret manual of arms at the hospital) quite openly, after I had put it into the dust jacket of Anna Balakian's *Literary Origins of Surrealism*.
> (Solomon 1959: 177–78)

In addition, however, to these temporary means of avoiding hospital surveillance, inmates and staff tacitly cooperated to allow the emergence of bounded physical spaces in which ordinary levels of surveillance and restriction were markedly reduced, spaces where the inmate could openly engage in a range of tabooed activities with some degree of security. These places often also provided a marked reduction in usual patient population density, contributing to the peace and quiet characteristic of them. The staff did not know of the existence of these places, or knew but either stayed away or tacitly relinquished their authority when entering them. Licence, in short, had a geography. I shall call these regions *free places*. We may especially expect to find them when authority in an organization is lodged in a whole echelon of staff instead of in a set of pyramids of command. Free places are backstage to the usual performance of staff–inmate relationships.

Free places in Central Hospital were often employed as the scene for specifically tabooed activities: the patch of woods behind the hospital was occasionally used as a cover for drinking; the area behind the recreation building and the shade of a large tree near the centre of the hospital grounds were used as locations for poker games.

Sometimes, however, free places seemed to be employed for no purpose other than to obtain time away from the long arm of the staff and from the crowded, noisy wards. Thus, underneath some of the buildings there was an old line of cart tracks once used for moving food from central kitchens; on the banks of this underground trench patients had collected benches and chairs, and some patients sat out the day there, knowing that no attendant was likely to address them. The underground trench itself was used as a means of passing from one part of the grounds to another without having to meet staff on ordinary patient–staff terms. All of these places seemed pervaded by a feeling of relaxation and self-determination, in marked contrast to the sense of uneasiness prevailing on some wards. Here one could be one's own man.

Peter Marsh, Elizabeth Rosser and Rom Harré

LIFE ON THE TERRACES [1978]

Territory

Young supporters at every football league ground (and at many non-league grounds) have defined sections of the terracing as their own territory – an area from which they always watch the football game. Although, to the casual observer, the terraces may seem unremarkable slabs of tiered concrete, certain areas within them are sacrosanct to the fans who habitually occupy them. The chosen section is usually in the open areas behind the goals – areas of the ground which have traditionally been occupied by working-class men since the grounds were built. Such areas also tend to be the cheapest to get into. These territories are known by the generic term *Ends* and each ground has a distinctive name for its End. The 'Kop' of Liverpool and the 'Shed' of Chelsea are two well-known examples. In addition, many Ends are known by the name of the road which runs past the turnstile entrance to them – e.g. the 'Stretford End' at Manchester United and the 'London Road End' at Oxford.

Ends such as these are reserved by the home fans solely for their own use – visiting fans being relegated to other areas of the ground. These 'away' areas are often behind the opposite goal to the home End and are recognized by the visiting supporters as their 'spots'.

The distinctive nature of Ends is further reinforced by the subsequent actions of club officials and police. Once territories have been established by young fans, occupants are physically confined within them for the entire duration of the match. Barriers have been erected at all Football League grounds in the light of recommendations made in the Lang Report (1969) – their purpose being 'the segregation of young people from other spectators'. In most cases this has meant that steel fences and wire grilles have been built around the Ends and the areas most frequently occupied by young visiting supporters. At some grounds (notably Manchester United's)

security fencing and iron grilles of the type that zoo cages are made of have been installed. . . .

The net effect of the fortifications around Ends, and of the strategies to keep people in them, is, of course, the highlighting of their distinctive nature. The police and officials have succeeded in delineating fans' territories in a way that the fans themselves could never have done. Another by-product of official strategy is one which involves the fans and the police acting in a concerted and co-operative manner. The maintenance of territorial integrity has become a joint enterprise. Invading fans are not only repulsed by the occupants in defence of their home 'turf', but also by the police in their pursuit of law and order and the *status quo*. It thus comes as little surprise to find that police and fans share similar commonsense conceptions of territoriality, and that their accounts of what goes on during 'raids' on Ends have much in common.

The notion of territoriality here is quite critical to an understanding of social action on the terraces and to the social structures that exist. Territories here are seen as action-facilitating in the sense that many of the patterns of action we have observed rely for their appropriateness on the fully defined context in which they take place. Using the notion provided by Erving Goffman (1971), and further elaborated by Lyman and Scott (1970) football Ends are viewed as 'free' territories. As Lyman and Scott explain:

> Free territory is carved out of space and affords the opportunities for idiosyncrasy and identity. Central to the manifestation of these opportunities are boundary creation and enclosure. This is because activities that run counter to expected norms need seclusion or invisibility to permit unsanctioned performance, and because the peculiar identities are sometimes impossible to realise in the absence of the appropriate setting. Thus the opportunities for freedom and action – with respect to normatively discrepant behaviour and maintenance of specific identities – are intimately connected with the ability to attach boundaries to space and to command access to or exclusion from territories.

The free territories of the Ends become 'converted', through regular use, into 'home' territories. A special kind of relationship comes to exist between users of such a territory and the physical space itself such that new conceptual and linguistic markers are attached to the space. Unlike most forms of home territory, however, Ends are not colonized in opposition to authority. In reality, the guardians of authority collude in the maintenance of the territory once it has been colonized, and as a result enter into the social framework on the terraces. Police at football matches are not seen as the immediate enemy in the way that they might be, say, in dealing with trespassers or others laying false claim to an essentially public area. They may be seen as obstructive when restraining rival groups of fans, but the venom and anger characteristic of, for instance, thwarted political demonstrators, is noticeably absent at most football matches.

During the 1974 and 1975 seasons young supporters of Oxford United were concentrated in an area of terracing known as the 'London Road End'. During the close season in 1974 a dry moat had been constructed and new barriers installed.

The setting in some ways was a little unusual in that rival fans occupied the other half of the same block of terracing. In 1974 the two rival groups were separated by a corridor of barriers patrolled by police. In 1975, a steel fence was added on the visiting supporters' side of the corridor to further restrict access between the two halves. . . .

Most football grounds now divide their rival fans by placing them at opposite ends of the ground and by preventing access between the ends. At Leeds, for example, not only are fans separated in this way, but a wedge-shaped piece of terracing at the corner of the visiting fans' terrace is designated a 'no-man's-land', surrounded by high fencing, and kept empty. Any fan trying to get from one end to the other would have to pass through this area and would be immediately arrested. Strategies at other grounds are often even more elaborate. With the Oxford system, however, a distinct interface existed between the two sets of rival fans, and although kept apart by police and fences, it was still possible to 'get at' the opposition with determined effort. The system also resulted in chants and songs being directed sideways to the rival fans, rather than across the pitch to the other end.

The fact that visiting supporters were allowed in to the same terracing, even though distinctly segregated, was a constant source of irritation to many Oxford fans, and it was often pointed to as an explanation for the occurrence of 'bovver'. The label 'London Road End' was carefully used to refer only to the half of the terrace occupied by Oxford fans.

Social groupings at Oxford United

Initial research work at Oxford United's ground consisted mainly of making a large number of video-recordings of fans in the London Road End. These were made discreetly with the aid of a telephoto lens and with the full co-operation of the club. Early analysis of these tapes revealed a grouping pattern in the London Road End which remained quite static over a considerable period of time. Later reports from the fans themselves revealed that they were very aware of such groupings and were able to attribute a number of salient behavioural and social characteristics to them. . . .

Group A comprised boys mainly between the ages of 12 and 17. The mean age of a sample of thirty-four boys in this group who were to contribute greatly to the later stages of the research was 15.1 years. The most distinctive aspect of this group was the pattern of dress. . . . The presence of flags, banners and emblems of allegiance was also very marked. When the newspapers and television hold forth about football hooligans it is usually to members of groups like this that they are referring. Not only are they the most identifiable group in terms of their appearance, but also in terms of the high level of activity among the group which is apparent even to the casual observer. They make the most noise – singing, chanting and shouting imprecations against the opposition fans – they run the most and they can represent a rather awesome spectacle to their rivals. For this reason we refer to this group as the 'Rowdies', rather than the media appellation of hooligans, for as we shall see, the label 'hooligan' carries special meaning within the soccer microculture.

Group C, in contrast to the Rowdies group, consisted of rather older boys and young men up to the age of about 25. The mean age of a sample of fourteen was 18.7. The style of dress within this group was unremarkable and differed little from that worn by people of this age group in most social contexts. Nor were any banners or flags visible. In fact, members of this group would not be identifiable as football fans at all outside of the ground. Younger fans referred to this group as the 'Town Boys' and were clearly deferential to them.

Group B, lying between the Rowdies and the Town Boys on the right-hand side of the London Road Terrace, was a much less distinct group which varied in composition from game to game. One consistent characteristic, however, was the presence of a disproportionately high number of boys with a record of arrests, probation and care orders. Out of a total of seventeen boys from this group interviewed over a period of one year, no fewer than ten had been in trouble with the police for offences not connected with activities at football matches. This compares with an overall average of about 8 per cent for the London Road End as a whole.

Apart from this characteristic, the group seemed to have features of both the Rowdies and the Town Boys groups. The average age was about 16.5 and some of the more distinctive dress elements were present. The activity level, however, was much lower than that of the Rowdies and some of the fans in this group were only infrequent attenders at football matches.

Groups D and E were much less homogeneous than any of the others and effectively marked the edges of the active arena in the London Road End with which we are concerned. In the main, they both consisted of boys and young men who were rather more reluctant to join in the ritual chanting and singing and were even less keen to get mixed up in the aggro. The only difference between the groups was that those in E were generally a little older and a few females were also to be found there. Both groups contained a number of fans who were scathingly referred to as 'part-time' supporters by those in the Rowdies and Town Boys groups. Among such part-timers were a few public-school boys playing at being football fans but failing really to understand what it was all about. The left-hand boundaries of these groups were totally undefined.

In Group F were to be found young children (average age about 10) who sat, when they were not moved off by police, on the wall in the front of the terrace, overlooking the dry moat. Their major occupation consisted of watching the antics of those at the back in the Rowdies group. Because of the age and inexperience of these boys, we refer to this group as the 'Novices'. Other fans simply call them little kids, but they are to be distinguished from other 'little kids' in other areas of the ground.

The pattern of grouping described here is probably unique to Oxford United's ground, but analogues of such groups appear to be present at all league club grounds – with the possible exception of some of the very small Fourth Division grounds. What is most striking about such groupings is that they provide for *careers* on the football terraces. The Novices, Rowdies and Town Boys provide a fairly linear hierarchy. Fans may aspire to progress through this hierarchy, and within each group certain role positions are open. The role positions enable demonstrations of character and worth, leading to the attainment of status, to take place within an ordered and rule-governed framework. 'Becoming somebody' on the terraces is a highly

structured affair, and an understanding of this structure is the first step in rendering the apparently anomic behaviour at football matches intelligible.

Careers

In using the by no means original sociological concept of 'careers' we do not wish to imply that action on the part of the soccer fans is somehow *determined* by a restricting set of institutional restraints. We would certainly want to use the term 'careers' in a rather different way from some criminologists who speak of 'delinquent careers' in which young deviants are inescapably forced along the path of community school, borstal and prison. Rather we see careers in a much less mechanistic way – as available structures in a youth culture for the establishment of self. At this point we are seeking only to explain the social frameworks which render certain actions intelligible, and we do not wish to imply causal links between social frames and social action. The extent to which fans will carve out careers for themselves on the terraces will, to a large extent, reflect their commitment to the soccer culture and to their immediate peer group. The greater the commitment, the more a fan has at stake. But, as we shall see, the richness of the soccer social world provides for commitments to be expressed in many different ways.

We have suggested that the Novices–Rowdies–Town Boys groups provide a distinct hierarchical framework for careers. Such a framework has more than a passing similarity with the career structure observed by Howard Parker in his study of young delinquents in Liverpool [1974]. Although his groups, 'Tiddlers', 'Ritz', and 'Boys', reflected increasing involvement in delinquent activities, they served the same function of enabling young people to achieve the sort of reputations and images denied them in mainstream society. On the football terrace, however, the other groups mentioned serve as side channels to the main career framework. They provide for the less committed who still wish to enjoy some of the fruits of the soccer culture. Groups D and E can certainly be seen to have this function. A fan who was totally uncommitted to the culture, who simply wanted to watch the match, would probably choose not to go into the London Road End at all but rather to one of the quieter side terraces. Group B, on the other hand, seems a little anomalous. To some extent we see members of this group as 'failures' in the career development process. They occupy fringe positions to both the Rowdies and Town Boys but have status in neither. Their high delinquency level also puts them at a further distance. . . .

In charting the progress of fans' careers, two types of data have been used. The first, and the easiest to collect, consisted of biographical material obtained from samples of fans in each of the groups, with special attention given to the Rowdies and Town Boys. The second type of data was obtained from close observation of the changes in the compositions of the groups and in the holders of clearly defined role positions within the groups. Both types of data, however, are problematic in that the whole structure within which careers are established changes over time. . . .

Other changes in structure developed more slowly, but although the pattern *looked* different over a period of a few years, analogues of the basic groups seem to have been present ever since the phenomenon of the contemporary football fan

arose in the middle to late 1960s. There has always been the equivalent of the Novices group, for example, allowing entrance to the soccer microculture for any boy willing to learn the rules of being a fan. Similarly, the Rowdies have always made their present felt – as any 'old-timer' will eagerly tell you. At one time the Rowdies were mainly skinheads for whom the terraces were but one of a number of arenas for collective action. Those most dedicated to soccer culture became known as 'Terrace Terrors', but their successors are currently moving away from the baggy trouser and braces image that they fostered. Rowdies today often have quite elaborately coiffeured hairstyles – contrasting markedly with the heavy Dr Marten footwear which they still retain. Finally, Rowdies have always had the more manly and mature equivalent of the Town Boys to join once they had proved their worth and their masculinity.

In interpreting data, then, the gradual changes in the social framework at Oxford United have been taken into account. Note has also been taken of where particular groups have positioned themselves at various times in their evolution, and of their differences in style which have characterized such groups over time.

Two distinct aspects of the career process are to be distinguished. The first of these, the between-group *graduation* process, is concerned with movement from one group to another and with the fact that membership of a particular group affords a certain status in relation to members of other groups. The second, the within-group *development* process, is concerned with the establishment of certain well-defined status positions within each group and with the acquisition of the appropriate social knowledge to equip a member to 'carry off' the performances required by such roles.

Social roles

Social roles within each of the groups have been isolated primarily from the accounts given by fans and from prolonged observation in the London Road End. In many cases fans were able to attach labels to certain positions, but in some cases the role was defined only by the range of behaviours required of it. The Rowdies group provided by far the widest range of available roles, and it is with a discussion of these that we start.

Chant leader

During the 1974 season about six individuals occupied such a position within the group. The role of such a person was simply to initiate songs and chants and to act as 'caller'. The job of a caller is rather like that of a priest who intones, line by line, the words of a prayer and to whom the congregation responds, at each stage, using the appropriate replies. A simple example of this calling takes the following form:

> Give us an 'O'
> [O]
> Give us an 'X'
> [X]

> Give us an 'F'
> [F]
> etc.
> What have we got?
> [OXFORD]

At other times the chant leader is required to initiate chants in reply to a chant from the opposition fans. A common example of this occurs in the interposing of an imprecation in between a chant of allegiance by the rival group. Thus, a chant of '*Chelsea! – Chelsea!*' is transformed into '*Chelsea! (Shit) Chelsea! (Shit)*'. The job of the chant leader is simply to make sure that '*Shit!*' comes in at exactly the right time. . . .

One other major aspect of the chant leader's role is related to the creation of new chants and songs. The vast majority of chants are common to virtually all football grounds, with slight variations. Liverpool supporters would have us believe that they all originate from the Kop, but this is doubtful. One reason for the ubiquity of chants lies in the fact that a large number of fans move around the country to support their team at away games. A rapid and widescale communication network is thus provided, and good chants can be taken over from one set of fans and used against a different set the following week. From time to time, however, songs and chants of a completely novel kind are heard. The origins are often to be found by watching and listening to what goes on in the Soccer Specials – the trains and coaches which fans hire to transport themselves to away games. To fill in the travelling time chant leaders are actively engaged in trying out new versions of old chants or making them up from scratch. Those that meet with approval are then usually tried out on the terraces, and if found to have some power, make their way into the repertoire. . . .

Aggro leader

An aggro leader is not to be confused with a 'good fighter' for, because of the peculiar nature of aggro, he might never have to do any fighting at all. At Oxford United a person occupying such a role would have been one of six or seven boys who were always at the front when conflicts arose with the rival fans. In 'running battles' they would always be the last to retreat. For these purposes they would also tend to wear the most heavily reinforced boots and might occasionally carry weapons of some kind.

Within the Rowdies group, there was some confusion as to who was and who was not an aggro leader and also with regard to the characteristic behaviours expected of such a person. Three fans were placed in this category on the basis of lengthy observation and in accord with what were taken to be the appropriate criteria for judging such people. These boys, however, turned out not to be aggro leaders at all. This was because a very important dimension had been ignored – one which, in keeping with everyday social talk, we refer to as 'Bullshit'. In order to prove himself as an aggro leader, a fan has not only to prove his ability to lead charges but also the fact that he really means what he is doing. The manner in which he must do this, however, is not always clear. He may do it by actually 'clobbering'

somebody, but this would imply a rather drastic escalation of the conflict situation and happens too rarely for everyone in the aggro-leader role to prove themselves. Instead, there simply has to be some consensus among the Rowdies that if things got really bad he would still maintain his stance and be man enough to deal with it. Evidence for such qualities might come from other areas of youth culture. Thus a boy with a reputation for challenging the authority of his teacher in school, or with a record of resisting the restraints of the police, might find it easier to be accepted in the aggro-leader role. Without a reinforcing reputation he might simply be classed as a 'Bullshitter' – the boy who thinks he's hard but isn't – and rejected accordingly. . . .

In general, an aggro leader has to show a distinct sense of fearlessness – he has to be a 'hard case'. But his lack of fear must not be too great, for total fearlessness, the issuing of challenges against impossible odds, is the prerogative of the nutter. And fans are in no doubt as to where bravery ends and sheer lunacy begins.

Nutter

There are usually about five or six nutters in the London Road End at any one time. These are individuals whose behaviour is considered to be so outrageous as to fall completely outside the range of actions based on reasons and causes. Typical of their behaviour would be 'going mad', 'going wild' or 'going crazy'. Attempting to beat someone to a pulp would be described in these terms. It is the existence of this kind of role, and the presence of notions of 'unreasoned' action, which is taken as strong corollary evidence for assuming the existence of a tacit awareness among fans of the rules governing social behaviour on the terraces.

To call someone a nutter, however, is not to use what they would see as a term of abuse. It is simply to make a comment about their style of doing things. Blackpool fans even have a chant which runs: 'We are the Nutters – we come from the sea'. The implication would seem to be that the opposition fans had better watch out because Blackpool fans might not be restricted by normal conventions. The chant 'There's gonna be a Nasty Accident' probably expresses a similar sentiment.

We talked to nutters frequently over a period of two years and some were 'interviewed' in a more structured manner. All of them were aware of their role and didn't seem to mind too much that their peers thought them to be crazy. . . . The function of their role we see as being, like that of the deviant in relation to society, the visible demonstration of the limits to 'legitimate' action. The nutter is acceptable in that he demonstrates to other fans what they should not do, and provides living proof of their own propriety. It is at this point that we can begin to see how deviant groups – even evil Folk Devils – construct an order which in many ways is based closely on the order of the society which makes them outcasts.

Although the behaviour of nutters is clearly different from that of other fans in the Rowdies group, there is still a sense of order in what they do. Even 'going crazy' involves the following of certain conventions and restrictions. . . . In many ways, their crazy actions are analogous to the hysteria of young girl pop fans, who on first sight seem to be totally out of control, but can clearly be shown to be engaging in an intentional, conscious and structured activity. . . .

Hooligan

The term 'hooligan' derives from the name 'Houlihan', a noticeably anti-social Irish family in nineteenth-century east London. Since 1970, the media in this country have become very attached to the label, judging by the extent to which they increasingly use it. Before this time, fans were referred to mainly as 'ruffians' or 'tearaways' and the use of 'hooligan' marks a distinct stage in the media's contribution to deviancy amplification. But as Laurie Taylor and others have shown (Taylor 1976), terms which originally begin life as terms of abuse or disapproval often become used by the victims of the term to mean something quite different. Thus football fans have incorporated the term 'hooligan' into their own social talk and use it as a term for referring to boys who commit acts generally thought worthy of some praise. Such acts often involve minor damage to property or disruption of certain routine social events. The main characteristic, however, is not the act itself, but rather the manner in which it is carried out – in particular it has to be funny. Picking up a bubble-gum machine from outside of a shop and running off with it, for example, would be generally thought rather dull. Picking it up and pretending to do a rather elaborate waltz along the road with it, on the other hand, would be thought of as a much more creditable act of hooliganism. The object is not to create damage and disorder per se, but to carry out an act which is guaranteed to enrage the victim without doing what he thinks you are doing, i.e. stealing his machine. In all probability the machine would be replaced once the 'laugh' was over, and failure to do so might well lead to censure from others in the Rowdies group. Those most skilled in carrying out such activities and getting away with them come to be recognized within the group as hooligans. . . .

Becoming a hooligan within the Rowdies group is not a simple matter. Powers of witty innovation have to be developed which enable a fan to change the whole nature of a social situation. In a sense he must be a jester – a player of practical jokes and a bit of a 'devil'. But he must never be simply a 'clown'. Clowns in the social world of soccer fans, are the pathetic figures who will never make it. They are the ones who aspire to being hooligans but lack the 'bottle' to succeed in such a role.

Organizer

The London Road End always seems to have at least one organizer, and usually two. Their function is simply that of dealing with the business aspects of terrace life and of negotiating with the outside world. Chiefly they are responsible for hiring coaches to away matches and for getting occasional petitions signed. . . .

Like the other roles we have sketched, being an organizer required a particular set of skills and a particular commitment to the group. It demanded a lot of work and the carrying of a great deal of responsibility. But it provided the occupant of this role with a very central and secure position within the group via a means that required no conflict with the rest of society. . . .

The major purpose in outlining the roles within the Rowdies group has been to demonstrate that football fans of this type are not simply to be viewed as a disor-

dered bunch of maniacs. But a demonstration of orderliness must also involve appeal to an existing social structure which serves to 'institutionalize' action – that is, to impose a set of constraints on behaviour and, at the same time, to endow action with meaning. For this purpose, we need to show that the roles serve as a focus for patterns of social relationships and for a framework enabling social development. With this in mind, one must be concerned with how fans gain admission to the Rowdies group, how they are able to progress socially within the group, and with how they are able to graduate out of the group.

Admission to the Rowdies group can be obtained in one of two ways. The first method involves graduation from the Novices group. Having spent some time as a 'little kid' at the front of the terrace, and having learned through close observation the most rudimentary rules of conduct appropriate to being a Rowdy, the young fan simply shifts his location to the back of the End and to the fringes of the Rowdies group. Here he will have to serve a form of apprenticeship before he is accepted or even noticed. An exception to this might arise if a young fan has, as a Novice, shown special merit which has come to the attention of others. He might, for example, have shown himself to be a little 'hard-nut'. A small boy of 8 called Louis had done just this. His diminutive figure was always to be seen during battles with the opposition, and for this reason he gained exceptionally early admission to the Rowdies as a kind of unofficial mascot. Apart from Louis, however, most Novices moved quietly up when they felt ready for it. Within their own group there was little to strive for since there were no clearly identifiable roles available. Nor was there much in the way of a social structure. Novices 'hung around' together but there were few strong ties between them.

The other method of entry to the Rowdies was by joining one's mates from school or local housing estate. In this way many fans were able to miss out the first graduation step and serve a short probation at the back of the terrace. It should be remembered that there are no formal rules for admission to the Rowdies. Anyone who is prepared to wear the right 'gear' and to join in the singing and chanting will be accepted. Identification with the team and engaging in the correct patterns of support for it are sufficient. (So long as one isn't a 'creep' of course.) Having gained admission, the way is then open to choose the direction of one's career and to become known by name to others within the group. . . .

The Rowdies group represents the most salient stage in the fan's career. It is within this group that he comes to establish both personal social bonds within his particular sub-group, but also comes to feel part of a wider social collective, as witnessed by the 'we're all in it together' type of accounts given by members. It is also within this group that a fan has the most obvious opportunities for becoming somebody special. By the time he has reached the age of 17 of 18, however, a new decision has to be made. By this time a fan will be working and will be getting too mature to maintain the style of dress and behaviour that membership of the Rowdies group requires. Two choices present themselves. He can either 'retire' to less active parts of the ground (assuming he wishes to continue watching football) or he can seek acceptance with the Town Boys.

The Town Boys in a way are an enigma, and how one joins them is by no means easy to discover. They speak disparagingly of the Rowdies, yet many of them were once Rowdies themselves. They have a reputation for being tough but rarely give

any evidence of being so. In fact, at most matches, they do very little at all except set up a few chants when things are a bit quiet. Despite this, however, it was possible to isolate two major roles within the group and to gain some insight concerning the requirements of anyone wishing to graduate into this group.

Fighter

About six members of the Town Boys were consistently referred to as people with reputations for fighting. Stories were told about how they had actually done considerable damage to some visiting fans when situations had got out of hand. There was no indication that they, unlike the aggro leaders, were actively engaged in inciting other fans to join in the scraps or that they led concerted attacks against the opposition. Rather, when trouble had boiled over, which was pretty rare, they were the ones who stood and slugged it out. Two such fighters were persuaded, over several pints of beer, to talk about themselves and the reputations they had acquired. (One doesn't simply interview a fighter.) One fighter had been a Skinhead and had worn the appropriate 'gear' of his time but had now grown out of this kind of thing. (He was 22.) The other fighter came from Nottingham four years ago and had seen much worse than one ever saw at Oxford. . . . They totally dissociated themselves from the Rowdies, who they thought of as kids, who, by mouthing off all the time, started trouble which was left to them to finish off. One of the fighters later became a club steward and, dressed in a white coat with a red armband, was officially hired to sort out the Rowdies.

Heavy drinker

A number of other young men in the Town Boys group were well known for their ability to drink impossible-sounding quantities of beer. Estimates of the volume varied, but a figure of fifteen pints in one evening was common. Many appeared to be visibly drunk at matches and were often thrown out by the police for this reason. They did, however, provide a good deal of entertainment for the rest of the group and would be missed if they did not turn up for a game.

The common feature of all members of the Town Boys group was that they had all held dominant roles within the Rowdies group or its equivalent at some stage in their careers. . . .

Membership of the Town Boys represents the last promotion in the career of the football fan at Oxford and only the most committed are eligible. Having got this far they can rest on their laurels for as long as they wish. No more will they be called upon to prove themselves by engaging in certain prescribed activities and no longer need they safeguard their hard-won reputations. Eventually they will retire to other parts of the ground to watch the match with their wives and girlfriends. . . .

We have been suggesting that career structures can serve well in the explanation of social behaviour which might otherwise appear to have little rationality. The activities of a fan become intelligible if we can interpret them as being instrumental in establishing him in a particular role, or if such activities can be shown to be

acceptable demonstrations of character and worth among his peers. This is not in any way to imply any moral or ethical stance on our part. The task is not one of excusing behaviour or of attributing condemnation to it — only one of rendering it explicable in terms of a revealed social order. We may not like what fans do and we may view aggro leaders and their like as unhappy reminders of a violent society in which we live. Similarly we may see the nutter as a pathetic figure who has to resort to self-humiliation in order to establish an identity for himself. But at the same time, we must pay careful attention to what such young people are actually *doing* rather than to the easy caricatures of them which some seem to prefer. Whilst we may feel that it is unfortunate that such career structures exist at all we might do well to examine our own mechanisms for getting ahead. In doing so, we might, to our discomfort, recognize that football fans are playing a very similar game to the rest of us in society.

Kevin Hetherington

BLANK FIGURES IN THE COUNTRYSIDE [2000]

Joker, devils, strangers

BY THE MID-1980S New Age travellers had not only developed a way of life that was all about freedom and expression, but they had also become a prominent source of anxiety in the British media, in government concerned about public order and in the localities where they were to be found. There had been a good deal of concern by the government and public authorities over free festivals some ten years earlier during the 1970s; however, things never reached the stage that they did in the 1980s [Clarke 1982]. A Festival Welfare Service group was set up in 1972 to help coordinate basic services at festivals and to liaise with local authorities when a festival was being staged so that health, welfare and public order provision could be planned in advance. The aim in the 1970s was to contain rather than suppress festivals, except in the case of the festival held on Crown land at Windsor. By the mid-1980s the 'hippy convoy' had become synonymous with the problem of the free festival, and the government and police were no longer prepared to tolerate it. Convoy hysteria, as we have seen, reached its peak in 1986, around the time of the Stony Cross incident when the then Home Secretary, Douglas Hurd, made a statement in the House of Commons denouncing the Travellers as 'medieval brigands'.

Whereas prior to this, drug use, illegal squats and noise had been the most common complaints about festivals, now a distinct group could be identified as embodying all that was seen as threatening in the festival and the way of life associated with it. These were unkempt strangers who in their large, slow convoy passed through the villages of Wiltshire, Dorset and Hampshire, threatening to stay and hold a festival (a fear often expressed most clearly by farmers on whose land the Travellers would often camp). They had a dirty, dishevelled look that was taken as a sign that they had transgressed the boundary of respectability and should be given

no quarter. They were fast becoming one of the most prominent and notorious 'folk devils' in Britain, and were to be singled out for special clauses in Conservative government legislation, notably in the 1986 Public Order Act and the 1994 Criminal Justice Act.

The term 'folk devil' was introduced into sociology by Stan Cohen in 1972 in his now-famous book *Folk Devils and Moral Panics*. The case study central to his work was that of the mods and rockers of the 1960s. The mods and rockers became notorious during the early 1960s for their pitched battles at seaside resorts on the English south coast on Bank Holiday weekends. Media reporting of these fights reached such a point that they became a matter of major public concern.

Cohen's argument is that the media turn particular groups, whose activities they see as delinquent or deviant into folk devils or scapegoats [see Girard 1979, 1986] in order to highlight and amplify anxieties about deviant behaviour in society as a whole. This leads to the creation of what he calls a moral panic. Once a moral panic has been created and focused around a particular folk devil, it becomes much easier for the government of the day to introduce specific legislation to deal with the 'cause' of the panic and to assuage outraged public opinion. There have been many instances of moral panic in Britain since the days of the mods and rockers. These include: mugging and street crime during the 1970s when young black men were singled out as the folk devil; football hooligans and lager louts during the 1980s; benefit fraud and the dole scrounger; child abusers; absent fathers who refuse to pay child maintenance; 'devil-dogs' such as pit bull terriers and Rottweilers that get out of control and savage innocent passers-by; and single mothers seen as weak parents and thus the cause of youth crime. These recent examples of folk devils have all become the focus of some form of media moral panic, often leading to subsequent legislation that has much wider consequences than for the particular group singled out as the problem. The list could continue, and no doubt will. New Age travellers are just one instance among many who have achieved this folk devil status in post-war British society.

For the theory behind his argument, Cohen drew on models developed in the study of disasters to describe the process by which a moral panic was constructed and resolved. Moving through the stages from warning and threat to impact from inventory and rescue to remedy and recovery, Cohen built a model of moral panic which in effect mirrors that identified by anthropologists as a ritual process of creating a crisis through some form of liminal transgression of norms followed by the subsequent re-establishment of social order on a new footing [see Turner 1969]. In the works of Victor Turner and René Girard, written around the same time as Cohen, we can see a more explicitly anthropological model of the process of social ordering around ambivalent figures that has come to be associated with the idea of the folk devil. It is also one that does not lead to highlighting the role of the media as the main social space in which folk devils and moral panics are played out.

Cohen's analysis of the folk devil as the focus for a moral panic, therefore, largely resembles the model of the scapegoat in the anthropological study of sacrifice. A scapegoat is a figure which represents social anxieties about social order. It is an ambivalent figure that is somehow underdetermined, or relatively blank, within that social order. It is around this uncertain status that a crisis of order is allowed to coalesce. This crisis is often described as a sacrificial crisis and a media moral

panic would be one example of this. A sacrificial crisis occurs within society when social order is thought to be in the process of breaking down from within, with violence threatening to spill over and affect the whole community. In order to avert this crisis a sacrificial victim, a scapegoat, is found, who then becomes the focus of aggressive attention. Rather than seeing the breakdown of order within society as a product of the social relations of the community in which that order is found (and we should not forget the cultural changes brought about in Britain by Thatcherism in the 1980s), the figure of a scapegoat is instead seen as the source of the trouble. The scapegoat comes to represent a crisis through its ambivalent position within a social order and is subsequently 'sacrificed' in order that stability might thereby be achieved. Once the sacrifice has taken place, order is restored, and the community can go about its daily business as usual. Much of this takes place at the level of symbolism; ritual practices develop through which scapegoats might be symbolically sacrificed.

There are still instances where the 'sacrifice' that takes place is real, in the sense of an actual scapegoat being sacrificed by being put to death or driven out of the community. Lynchings, racist murders, arson attacks on the homes of unpopular outsider figures within a community are all extreme examples, not sanctioned by society and outside of the law. The real significance of sacrifice within contemporary society is at the symbolic level. This is where its real power resides. Cohen's analysis of the moral panic is a mix of the symbolic and the actual in the sense that the particular sacrificial crisis, the moral panic, will not be known in advance and be dealt with through an established ritual, but once it has emerged and a sacrificial victim or folk devil has been identified, it can take on a ritual form in the way the news media report it and in the way that legislation often follows. Folk devils, underdetermined outsiders, become significant to the maintenance of order because they allow a crisis of order to be contained at the symbolic level.

Cohen's model of the moral panic also follows Victor Turner's description of liminal rituals and social dramas. For Turner, liminality is not just the transitional stage in a *rite de passage*, as the French anthropologist van Gennep had suggested in his work written during the early years of the twentieth century [Van Gennep 1960], but an important part of the process of social reproduction and renewal within small-scale societies. Within a *rite de passage*, associated with life-stage rituals like coming of age, marriage or funerals, there are three stages: separation, margin and re-aggregation. Individuals shed their old status and identity (separation) and undergo some form of initiation ceremony (margin) before being reintegrated back into society (re-aggregation). Societies too, Turner [1969] suggested, can also undergo this process, moving through three phases: social structure, anti-structure and social structure. The anti-structure stage is associated with a transgressive middle or liminal stage in which the rules of society are overturned, mocked and transgressed, often through festival and carnival forms where the social world is momentarily turned upside-down in some kind of drama ritual of disordering [see Bakhtin 1984].

It would be easy to celebrate cultural forms, like New Age travellers, as figures of anti-structure who occupy this transgressive middle or liminal condition. However, as both Turner and Cohen were aware, figures who occupy this space come to be used as devils through which a crisis is not only made visible (as a moral panic, for instance) but also resolved into an altered social order, notably through

legislation that is more far reaching than just affecting those ascribed the status of folk devil. Social order is not something that exists in a static state; instead it is continuous, and the folk devil, the figure that is strange, uncertain and outside has an important part to play in that making of order.

In the case of New Age travellers, if we were to follow Cohen's lead and analyse the events surrounding them, we would see that the source of anxiety was largely about public order, in particular that associated with the convoy and the festival and the ensuing issues of nuisance, trespass and illicit behaviour. Certainly much of the media reporting did take these as the main issues and the legislation that followed was about public order and the control of travelling people and their festivals. However, the events surrounding the Travellers were much broader than this and it was not just in the media that a moral panic (better described as a sacrificial crisis) occurred. For others too, a crisis had occurred that was about more than just issues of public order. If we are to develop these arguments here, and it is my intention to do so to help in the understanding of both Travellers and the events surrounding them, we must move away from the priority that Cohen and others have given to the role of the scapegoat figure within media reporting. In recent writing on Travellers by geographers, this emphasis on media reporting has been apparent [Cresswell 1996: 62–96]. Instead we should look at the whole issue of the sacrificial crisis, of which a moral panic in the media is just one instance, in a broader social context, restoring to it its full anthropological significance. For the many who were horrified by all that the Travellers stood for, it was not, on the whole, public order in the narrow sense of criminal disruption of public life that was seen as the main problem, but rather that a sense of place or locale was being challenged by their presence. In other words, rather than focus on narrowly defined issues like trespass by a group of people on to a piece of privately owned land, we might say that what that place meant to people was being trespassed. The perceived threat that Travellers posed – to local people, the police, the National Trust, English Heritage and so on – was a symbolic threat just as much as a threat of physical presence, and we should look at the level of symbolism and representation if we are to locate New Age travellers fully in the events that have taken place around them over the past twenty years. Thus, rather than simply regarding the Travellers in terms of a moral panic in the sense of media reporting and government legislation, I want to consider them instead in terms of how we understand the symbolic ways in which social order is established and maintained within society and the role of outsider figures within that society. In this instance the key issues have to do with the symbolic production of social space, and in particular the spatial orderings that are created through representations of English rural life around the figure of the New Age traveller.

To look at the events surrounding New Age travellers we have to think of them in terms of the *making* of place, community, boundaries, and through an analysis of the symbolic properties that social space contains within our sense of a social order. We should not assume that orders or places already exist. They are processes rather than things. Public order is a part of this process, but it is a part and not the whole of the process. Whether we continue to think of New Age travellers as folk devils will depend on to what extent that term can be applied in this broader context of understanding social order through its spatial dynamics. There are many other terms

that have been used in ways that are similar to the folk devil within the writings of sociologists and anthropologists: jokers, the trickster, coyote, the blank figure, scapegoat and the stranger are just some of them. I want to develop the account [here] around an analysis of the role of such figures in the making of social order as a process.

New Age travellers are at home in ambivalent places, what anthropologists describe as liminal spaces [Van Gennep 1960; Turner 1969]. Everyone else, however, is generally not at home in such spaces. Rather they have settled ideas about the spaces in which they live and the social orders through which those spaces are organized. But those places are not real, in the sense that they emerge from the physical landscape; rather, they are created through social processes associated with ideas of order and disorder. What New Age travellers reveal, and this is the main reason why they can assume certain powers which others cannot, is that orders are never fixed, and this would include such things as a sense of place. Such senses of order are always in the process of being made, yet are never completed. We do not see this much of the time, we see stability around us and we assume that things do not change or that change is slow or intentional. We often do not want them to change, unless it is to go back to some earlier unchanging state that has now changed! But when a stranger rides into town and starts doing things differently, that sense of stability is disrupted. It is not that the stranger brings disorder but that he or she reveals order to always be a process rather than a thing, and processes have a habit of being associated not only with keeping things the same but also of changing them. Perhaps the best way to proceed is to think about how such figures are located within the representations of space that we make and the importance that these have within our lives. By this I mean such spaces as those in which we make our homes and what they mean to us, our ideas about the countryside, famous landmarks like Stonehenge, what the heritage industry makes of such sites, as well as perceptions of space by the police and local authorities.

One of the first people to consider such an issue was the German sociologist Georg Simmel writing in the 1890s about the figure of the stranger. For Simmel, strangers are very important figures who reveal a good deal about society, particularly about the issue of symbolic boundaries. Simmel defines the stranger as follows:

> the man who *comes today and stays tomorrow* – [italics added] the potential wanderer, so to speak, who, although he has gone no further, has not quite got over the freedom of coming and going. He is fixed within a certain spatial circle – or within a group whose boundaries are analogous to spatial boundaries – but his position within it is fundamentally affected by the fact that he does not belong in it initially, and that he brings qualities into it that are not and cannot be, indigenous to it.
>
> [Simmel 1971a: 143]

The stranger is an underdetermined figure, somewhat blank or in shadow. He or she is a representation of someone who is not from around here but who comes from afar and is recognizable as such. Their strangeness may be registered by the fact that they look different or have a culture that is visibly different. As figures, they represent the unknown that is usually symbolized through the idea of being far away. However, physically they are not far away. Rather, they are present here and

now within this locality, knocking on my door. In this sense they appear to have brought the unknown with them and in so doing they have introduced an element of uncertainty. As figures, they represent uncertainty and ambivalence, particularly the ambivalence associated with the mixing together of the near and far.

Because the figure of the stranger is therefore both near and far, familiar and unfamiliar, he or she is never quite fully a member of any particular group. For Simmel, one result of this is that strangers can bring a degree of objectivity with them in their understanding of the local situation. They are able to see what is going on without observing events through the lenses of tradition and local custom. In doing this they acquire a greater degree of freedom and objectivity in the interactions they undertake within a particular locality. Simmel's ideal of the stranger is what we would describe as a cosmopolitan type, someone who is objective, open and interested in cultural variety and novelty and does not prejudge a culture beforehand based on his or her own experiences. For Simmel, the cosmopolitan stranger is the norm in modern large cities and a key type of persona that we all have to accept as part of the condition of modern, urban life [see Simmel 1971b]. Such a city is, in effect, formed around the figure of the cosmopolitan type whom Simmel takes to be characteristic of the urban individual. For the host group, especially in cities where most people encounter others, or are themselves encountered as strangers, their role can, according to Simmel, be of positive significance to all involved. Greater group self-understanding, cultural innovation, trust and individuality can be formed through observation of the distance created by the detached objectivity of the stranger.

Simmel does mention, however, that the stranger can also be perceived negatively, notably where a group believes that harmony and closeness can be derived exclusively from its own sociability without the need for reference to a more objective outsiderness [Simmel 1971a: 148]. In this case, Simmel suggests, the stranger is treated as alien and not quite human; as a disruptive element to the exclusivity of the group. Where there is a community in which most people are either known to one another or are recognizable as a part of that community, anyone from outside or some of the more eccentric people from within will often be treated with suspicion and will generate a considerable degree of fear.

Communities are symbolic; while not always associated with particular social spaces, they are defined by the drawing of boundaries and through the policing of those constructed, bounded spaces as if they were real. Boundaries are invariably the most policed areas within any society. While this is obviously the case with points of entry into a country or with sensitive sites like military establishments where control of access is formalized in law, in other cases that control is less well established. There are laws of trespass in England and Wales (different from those in Scotland) where a certain amount of legal definition and control is given to questions of who has access to where. This has created tension on occasions, as when those who believe they have right of access to a particular place are denied it. Landowners, ramblers, farmers, house-owners and local authorities amongst others sometimes find themselves in the conflict zone of rights to certain pieces of land. Certainly issues of trespass have also figured prominently around the activities of New Age travellers, as we have seen above through the example of the events in the mid-1980s. However, the figure of the stranger does not just physically cross legally protected boundaries; more significantly, *they help to establish and maintain*

those boundaries through the very act of crossing. In so doing, they both challenge and help to make the order that is established through such a symbolic practice of bringing the near and far together rather than maintaining their apartness.

Imagine an English village nestling in folded downland countryside, characterized by thatched roofed cottages, a village pond, cricket pitch and a nearby crystal-clear trout stream. That representation, no doubt more myth than reality, is one of rural idyll, peace and tranquillity. Nowadays we try to protect that peace with speed cameras and rumble strips in the road, and ever-increasing house prices and the attempt by estate agents to find the 'right sort' to move in help to protect the commu(ter)nity. Even if now populated more by commuters than farm labourers, such commuters often try to knit themselves into the idealization of the community that they have bought into. Thinking back ten or twenty years, things were not so different. The affluent have been moving into the countryside for a long time, and have settled alongside many who have always lived there. There have certainly been conflicts between the more established and the newer arrivals, but they have largely shared a similar view of the countryside even if their uses of it have differed. They have both bought into this image of rural life that is an important element in the idea of English national identity [see Williams 1985]. Imagine the reaction, then, when in a layby in some quiet country lane on the edge of the village, there appear two or three battered old buses full of people with matted hair and scruffy clothes, pots and pans strewn everywhere, naked children playing outside and a couple of evil-looking, unattended mongrels barking at passers-by. It is at the level of symbolism and boundary making that the uncertainties surrounding the stranger and the anxieties they can raise within a community are felt most strongly. The sense of place of such a village is made, not so much through its presence (it never actually exists except in the imagination) as when it appears to be absent, and it is the uncertain figure of the stranger who introduces this absence and comes to signify its presence. What is significant is the way in which they do this. The role of the stranger, and indeed of the folk devil, is to introduce absence *as presence. By introducing something that is not expected, a sense of order is established in its breaching.*

Symbolic boundaries and the representations of place they help to create and protect are very strong in the sense that they play an important part for many in the shaping and maintenance of their identities and in ideas of belonging [see Cohen 1985]. Whether at the national or local level, for something to cross a boundary, especially one that is marked by a strong and commonly held symbolism, is to pollute the space. The space of pollution is the space of the stranger. When anthropologists like Mary Douglas talk about the category of pollution, they refer to the transgression of boundaries by a figure that should not have crossed a boundary [Douglas 1984]. To transgress a boundary, in this account, is to break a taboo, and therefore to threaten the rules that help to maintain the social order of a community. From the many forms of control that are placed on behaviour, from that of children in public places through to threats of prosecution and deportation for illegal entry into a country, the transgressive act of crossing a symbolic boundary is seen as polluting.

That pollution, while it is often represented in the form of dirt and filth, as is suggested by Mary Douglas' famous definition of dirt as 'matter out of place' [ibid.: 35], is, in fact, a moral category that is expressed in symbolic form. When a stranger unexpectedly enters a strongly defined communal space, the main reason he or she

is often seen as a threat is that he or she unsettles an established sense of order that prevails within that community. Where I would disagree with this established and widely held anthropological view is in the sense of fixity that it gives to the idea of order represented by the boundary. Rather than see the symbolic space of the boundary as already there and threatened when something crosses it, I suggest instead that *the boundary is continually made to exist when it is being crossed, or when we imagine it being crossed by something or someone strange who should not be there*. Strangers, real or imagined, make boundaries by crossing them. It follows that we should see order as something processional rather than static; proximal rather than distal [see Law 1994]. We should also recognize the role of the underdetermined in the making of order/disorder. Strangers do not represent the totally unknown but rather the not quite known. As a consequence, no one knows exactly what will be the outcome of their presence. In particular, as Simmel clearly suggests, it is the idea that they might stay and bring about change within the community that is most feared.

In many societies, the threat of disorder within a community becomes a matter of ritual control. We see this in particular where a person moves from one life stage to another. Initiation rites, such as a marriage ceremony or a funeral, involve an intermediate or liminal stage where the initiand (the special name given to the person while they are in this in-between state) no longer has their original status but nor have they yet acquired their new status. They have to go through a recognizable ceremony for this transition through uncertainty to be achieved safely and for the social order to be maintained. If this fails to happen, if the person does not pass through the ritual, or takes some other course, he or she becomes a stranger, often described in this instance as an outsider.

The pollution that such figures bring is often described as shame. In Britain until fairly recently, it was common for a woman who gave birth to a child outside of marriage to be seen as such an outsider, bringing shame on herself, the 'bastard' child, her family, even her community. In some respects New Age travellers are seen as such polluting outsiders. To accept them is to bring shame to one's locality, whether that be through the tolerant response of local people or county councils. Alternatively, they are castigated as work-shy, drug-using, dirty scroungers and beggars living on state benefits who do not contribute to society through its work ethic. There are indeed some Travellers, who do adopt a highly hedonistic lifestyle supported by the state, often revelling in their outlaw status and seeing it as an anti-state form of anarchist resistance, who live up to this stereotype. But there are many others who live by alternative ethics and whose lifestyles are often work-intensive, involving artistic and creative work for little financial reward. Indeed, there is a whole spectrum of different approaches taken by Travellers between these two positions.

There is also another set of rituals associated with the figure of the stranger that I have alluded to above that are somewhat different from those of rites of passage for individuals, but which is equally useful when considering the responses to New Age travellers. There are rituals in which a stranger figure is symbolically sacrificed in order to establish social order against a disordering potential. Internal tensions within a community often lead to the uncertainties it creates being focused on a scapegoat which is then symbolically sacrificed so that social order may be renewed. New Age travellers have also become scapegoats in that they are seen as the bringers of disorder and chaos and therefore have to be dealt with harshly by the law and

sometimes with threats of violence to themselves and their property. While the responses to Travellers as strangers who come and stay within a locality, either for a festival or just to park-up for a while, often take the ritual form of denunciation in the local newspapers, court injunctions and eviction, as well as actual violence on some occasions, these are not part of a pre-established ritual. The threat they pose to a community is perceived as real rather than symbolic and has to be dealt with. By dealing with it, order, reputation rights and respectability within that community are not so much protected as performed through the process of scapegoating.

Certainly Travellers can cause nuisance, as was the case with the convoy and with the large festivals, but by and large they keep to themselves and try and live their own lives in the way they have chosen in out-of-the-way places. There are often claims that incidents of crime have gone up when a festival has taken place in a locality. While some acts can be put down to Travellers, it is often just as likely to be crime by local people using a festival as cover for their own criminal activities. What is undeniable, however, is that New Age travellers do indeed pose a symbolic challenge. It may not always be intentional, but the figure of the stranger cannot help but challenge social order. After all, they help to make that order through an act of challenge. Their challenge, above all, is to reveal social order as a process that has to be continually made rather than a thing that exists to be maintained as if it were some kind of garden shrub. Within a social order the stranger represents a very specific thing: the presence of absence and its role in creating conditions both of stability and change – the two things that define the conditions of possibility for social order.

As a figure, the stranger is underdetermined and blank. In the language of the philosopher Michel Serres, the stranger, folk devil or scapegoat is a blank figure [Serres 1991]. The blank figure is like a joker in a pack of cards: while it is recognizable as a card that can be played in a game, the way that card is played is different from all the other cards. The joker can represent any number and any suit. It is like a chameleon; it is an underdetermined figure that has special powers to alter the order of the game. It has greater scope in the process of ordering than do the other cards because of its chameleon-like ability to transform itself. Many New Age travellers would say that they want to live in a different way within society; they may even go so far as to suggest that their lifestyle might be emulated by others and become the model for a better, alternative and sustainable future type of society; even so, they cannot escape society altogether. Like the wild card, they are enmeshed within it because of the underdetermined characteristics they have assumed. These characteristics are associated with the way they look and the ways they live.

The joker is a motile figure: not only can it change as it moves within a social order (what we call a game), but in the process it has the power to change the *conditions of possibility* for that order. It not only brings change or novelty, it also allows for the continuation of that order. While Stan Cohen did not address this point in his analysis of moral panics, we can see that the folk devil is an example of a blank figure, an uncertain and underdetermined figure whose presence represents a figural absence within the moral order of society, that not only challenges that order but, through the role it plays within a moral panic, allows that order to be generated again, even if it has changed its direction slightly.

The folk devil is not a hero of the people who breaks all the rules to reveal the weaknesses and injustices of a social order. Rather, it is a blank figure around which

the conditions of possibility – or a mode of social ordering – are developed in terms of both social reproduction and social change. The blank is transformed through sacrifice from a figure of uncertainty to one for the resolution of that uncertainty [Girard 1979]. The blank, as an underdetermined figure, is indifferent to questions of heterogeneity such as that of the presence of disorder where order is expected; its presence reveals an absence, a blank space through which modes of social ordering are constituted. We can call that blank space 'impact', as does Cohen in his work, or 'liminality', as does Turner in his, or 'sacrificial crisis', as does Girard, or even 'heterotopic' as Foucault suggests [Foucault 1986], but it all amounts to the same thing. The folk devil/stranger is a blank that represents the presence of the absence within a regime of ordered certainty which tries to deal with everything in terms of the category of presence. Through the introduction of symbolic criteria that come to represent what should not be there, such a figure has the ability to take on certain forms within that social order and to give blankness a presence. The blank figure/folk devil/sacrificial victim is like a joker in a pack of cards; it can alter the pattern of play and help determine who wins a particular hand, thus affecting the course of the game, but it can never destroy the game altogether, only switch it to a new path.

For Cohen, the folk devil is called on to play a particular role within a limited aspect of society, its use of the media as a means of witnessing and helping to control what is seen as deviant behaviour. The blank figure, however, is not restricted to that role alone, but can be 'played' in other games too. One such game has to do with issues of space, place and community, issues that are central to questions of social identity and belonging. New Age travellers are located within issues associated with deviance, moral panics and subsequent public order legislation; they also figure strongly in questions associated with the representation of space: community and home, town and country, tourism and heritage, secular places and earth mysteries. . . .

Iain Borden

PERFORMING THE CITY [2001]

You self-righteous, blind, arseholes.
YOU CANNOT CONTROL THE USE OF PUBLIC SPACE.

[*Sidewalk Surfer*, 23, Jan.-Feb. 1998]

Commodity critique

ZERO DEGREE ARCHITECTURE is a field of the meaningless, a series of signals, a code reductive in individual signs and complex in its multitudinous instructions. Yet the architecture and spaces of the modern city are not wholly constraining, for there is a contradiction between the homogenizing reduction of space by business, and the open differentiation of urban space in the city as a whole [Lefebvre 1991b: 18–19; Lefebvre 1996: 140–41] – and it is this contradiction that skateboarding works within. While advertisements and controlled spaces contribute to the 'terrorism' of everyday life [Lefebvre 1984: 143–93], part of the intensification of the everyday as a mode of production and of administering society [Lefebvre 1988: 79–80], skateboarding offers both an apparently non-commercial realm of compensation and a confrontation of the instructive mechanics of signals.

There are no more white lines to stay within, sidewalks to conform to or bases to tag. It's all an open highway with hydrants, curbs, bumpers, shopping carts, door handles and pedestrians.

[*Thrasher*, 5, Aug. 1985]

Skateboarding counters signal architecture with a body-centric and multi-sensory performative activity, and with an indifference to function, price and regulation, creating new patterns of space and time, and turning the signals of the city into ephemeral symbols of everyday meaning and duration. . . .

Consider also that signals are not there for their own sake, so that when skaters confront these signals they are also necessarily critiquing their underlying logic of profit, exchange, efficiency, control, normalcy, predictability, regulated space and time. / Skateboarding, therefore, challenges the notion that space is there to be obeyed, and that we exist solely as efficient automata within the processes of exchange and accumulation. Furthermore, if skateboarding suggests the move from things to works, from design to experiential creativity, there should also be a corresponding shift in production and labour and in consumption, exchange and use. It is to these areas which we now turn.

Beyond the shiny product

Architecture is intended for the production of things – either products as commodities in factories, knowledge in universities and museums, labour power in housing, information and decisions in offices, and so on. In this sense all buildings are places of the expenditure of energy, engaged in the production and distribution of things. Skateboarding, however, offers no such contribution, consuming the building while not engaging with its productive activity. Consequently, it implicitly denies both that labour should be productive of things and that architecture should be directed toward that purpose.

> They'll never get out of that grind except by dying. I wonder why they ever wanted to get in.
>
> [cited in Mulshine 1987: 120]

> Life's not a job, it's an adventure.
>
> [*Thrasher*, 9, Jan. 1989]

For example, *Thrasher* [6, Mar. 1986] ridiculed in a spoof advertisement the labour of a 'pool service technician' attending to the maintenance of empty, skateable swimming pools. The clear implication is that, by contrast, [the] productive labour of skateboarding produces neither things nor services, but is a pleasure-driven activity of its own.

Furthermore, this productive-of-nothing labour is disruptive to the optimal management of urban space. Where business invades not only economics and politics but also social experience, setting itself up as model for social administration in general [Lefebvre 1984: 66] skateboarding rejects the 'efficiency' and 'economic' logic of urban space, undertaking an activity which, by business standards, has an entirely different rationale.

> In a culture that measures progress in terms of cost per square foot, the street stylist takes matters into his own hands. He dictates his own terms and he makes his own fun.
>
> [*Action Now*, 8, Sept. 1981]

This is particularly evident in the city centre, which is increasingly becoming the centre of *decision-making*, and the new centrality of power [Lefebvre 1996: 73].

Skateboarding is here irrational, for why would one spend so much time balancing on a piece of wood with four wheels? Why would one confront the logic of walking and looking by going up as well as along, touching as well as seeing, impacting as well as remaining apart?

> The true skater surveys all that is offered, takes all that is given, goes after the rest and leaves nothing to chance. In a society on hold and planet on self-destruct, the only safe recourse is an insane approach.
>
> [*Skateboarder*, 6, May 1980]

This irrationality is particularly evident if we consider that the basic spatial plane of street skating is 2–4 feet above the conventional urban ground of the pavement. Furthermore, its architecture is frequently vertical, as in street skating moves such as allies or wallriding.

> Wallriding is the most nonsensical facet of skateboarding, an art of mind over matter.
>
> [*Thrasher*, 11, Nov. 1991]

This 'irrationality' pervades skateboarding practices. For example, when the Vans Warped competition tour came to London's Canary Wharf in the summer of 1996, skaters spent as much time skating the surrounding banks, steps, blocks, gaps, walls and pathways of this decision-making centre as on the competition site itself. Given that Canary Wharf is one of the great centres of the global city [Fainstein 1994: 197–201] skateboarding in such places also helps deny the logic of the city as pre-eminently existing solely for the benefit of global forces and flows of information and capital. It reminds us that the city is also a series of diverse place-specific phenomena [Lefebvre 1996: 111–12], ignorance of the global serving to heighten awareness of the local.

Episodes like this, enacted in the heart of the business city, show that skateboarding is part of that great dialectic between labour and non-labour. Mike Vallely's attitude to waged labour is typical to that of many skaters: 'I've told myself from the age of twelve, "I'll never work a day in my life"' [*TransWorld Skateboarding*, 14, Jan. 1996]. In reaction to such attitudes, one critic railed that skateboarding 'appears to serve no known purpose in life and does nothing to raise national productivity' [*Skateboarder*, 6, Jan. 1980]. That, however, is exactly the point.

Nonetheless, the triumph of non-labour does not entail so much an absence of effort [Lefebvre 1976: 16] as a redefinition of what 'production' might mean, and it is here too that skateboarding offers some insights. At first sight, skateboarders' labour produces no 'products' beyond the move, a 'commodity' exchangeable only by means of performative action, so appears to waste effort and time. But that 'principle of economy' which sees a 'waste' of energy as abnormal is itself a reduction of life to mere survival [Lefebvre 1991b: 176–79]. Skateboarding, in contrast, undertakes a release of energy that either creates or modifies space, espousing play (*ludo*), art and festival – Eros (the pleasure principle) opposed to Thanatos (the reality or productivity principle) [177].

> When they work, we'll skate.
>
> [*Sidewalk Surfer*, 15, Apr. 1997]

The labour of skateboarding is then not the production of commodities but the effort of play, the ludic.

> Each trick is the result of the dedication that you've put into skate-boarding, years and years of concentration and commitment to increasing your abilities and potential for enjoyment, because you genuinely want to, not because you've been brainwashed into wanting.
> [*Sidewalk Surfer*, 13, Jan.-Feb. 1997]

Or as one skateboarder put it, skaters have 'moved beyond shiny products and consumerism'.

> All of us we're all existing beyond their shit stained grasp. They (the outside world) can't understand us now, they can't even rip us off anymore. Fuck the fashion theft, you know it doesn't matter. Everyone has the ability to use skating to rise above the repressive, hassle filled, cess pit world. We can all become higher types.
> [*Sidewalk Surfer*, 3, Jan.-Feb. 1996]

Unlike the machine, aimed at the production of things [Lefebvre 1991b: 344], the skateboard-tool aims to produce new moves and spaces, creating new kinds of labours as uses and pleasures outside of normative work. Production becomes 'liber-ating actions of pure creativity/giving' [*Thrasher*, 3, June 1983], generating qualities, experiences, phenomenal encounters, relations of body and thing, pain and fun [Lefebvre 1996: 171].

> You earn quality when you skate.
> [*Thrasher*, 5, Feb. 1985]

> Happiness and fun are our staple experiences and, thank christ, they always will be.
> [*Sidewalk Surfer*, 14, Mar. 1997]

Similarly, the reproduction of labour power becomes not reproduction of future workers [Marx 1976: 717–18] but of energetic desiring bodies, capable of creative expenditures of effort. Skateboarders, as young adults, see themselves not as the reserve army waiting to serve in industry, but as living according to a different ratio-nale. The totality with which skateboarders conceive of their opposition to work and career patterns is crucial, for . . . skateboarders do not so much temporarily escape from the routinized world of school, family and social conventions as replace it with a whole new way of life.

> Forget about the mainline and the fast line; the edge of the glide is all that is of value.
> [*Skateboarder*, 6, May 1980]

> I'm not gonna be stuck in an office someday.
> [cited in Mulshine 1987: 126]

/Skateboarding, particularly for those in their twenties or older, thus becomes far more than leisure or respite from school or work; it is considered to be a way of life outside of 'labour' altogether.\

One contradiction here is that the extraordinary architectural wealth of the city, from which skateboarding is born, is itself a product of waged labour. It could be argued here that skateboarding is a revival of the 'dead labour' (Marx) contained in the city's means of production [Lefebvre 1991b: 348]. On the one hand, this might relate to the reuse of derelict city spaces, as with many UK 1970s skateparks such as Rolling Thunder in the disused Brentford Market, Chiswick, The Cage in a former Brighton fish market, or Mad Dog Bowl (London), Malibu Dog Bowl (Nottingham) and others built in old cinemas. But these are rare instances compared to the globally dispersed and locally focused activity of 1980s-1990s street skating, and so it is, above all, skateboarders' production of space that facilitates this revival of dead labour and so promotes use over exchange:

> Through the production of space . . . living labour can produce something that is no longer a thing, nor simply a set of tools, nor simply a commodity. In space needs and desires can reappear as such . . . spaces for play, spaces for enjoyment, architectures of wisdom or pleasure. In and by means of space, the work may shine through the product, use value may gain the upper hand over exchange value.
>
> [Lefebvre 1991b: 348]

Skateboarding is a resurrection of the dead labour of construction, either as a new use for an unused building, as a new use for a building simultaneously being used for something else, or a new use space with an ambiguous purpose. Thus skateboarding's revival of 'dead labour' occurs from the moment the building is constructed, and does not have to await the end of its constructional or functional life-cycle.

There is, then, a temporal production also at work here. Capitalism is a mixture of production and speculation alternatively sacrificing long-term social benefits to short-term profits or short-term social needs in favour of programmed investment schedules [335–36]. Skateboarding time, in contrast, is immediate, no more than a second (single move), minute (run), weeks and months (repeated visits), or few years (a skater's individual activity). Skateboarding time is also discontinuous, composed of a few minutes here and there, spread over space, and in between the socially programmed activities of production and exchange. It is an alternating rhythm within the regular cyclical rhythm of the city [Lefebvre 1996: 221]. For example, the long temporality of property ownership, the medium temporality of lease arrangements or the short temporality of the parking meter are all avoided by skateboarders. While 'economic space subordinates time to itself', and 'political space expels it as threatening and dangerous' [Lefebvre 1991b: 95], skateboarding promotes an appropriative recovery of time as well as of space. Skateboarding reasserts the here-ness and now-ness of architecture.

> Performance transportation is the present and the future. Take it where you want and make it go where you want to take it. Tomorrow is today and you are it.
>
> [*Action Now*, 8, Sept. 1981]

Time has come . . .

[*Thrasher*, 16, Mar. 1996]

Skateboarding is 'one rythmical (*sic*) expression in a multitude of rythmical (*sic*) expressions' [*Skateboard*, 39, Jan. 1990] and thus helps to restore the oeuvre by creating a schizophrenic coexistence of space-times of play, exchange, circulation, politics and culture [Lefebvre 1996: 170–72].

> The citizen resists the State by a particular use of time. A struggle there-
> fore unfolds for appropriation in which rhythms play a major role.
> Through them social, therefore, civil time, seeks and manages to shield
> itself from State, linear, unirhythmical measured and measuring time
> . . . Time is hence linked to space and to the rhythms of the people who
> occupy this space.
>
> [237]

In this coexistence of urban time-spaces we see the dialectic of labour and non-labour at work, wherein skateboarding shows that the production of space is exactly that, and not a production of things in space. And it shows that time as well as space is produced through appropriation, resisting by entangled polyrhythms the domi-nation of space on the part of State power.

Gifts of freedom

Skateboarding involves a critique of the processes of exchange and consumption in the modern city, and, above all else, proposes a reassertion of use values as opposed to exchange values. Again, this requires elaboration.

Capitalist space, as commodity, can be likened to any goods – simultaneously abstract and concrete, and produced for the purposes of exchange [Lefebvre 1991b: 306–7]. We have already seen how a different attitude to labour and production leads skaters to negate the productive labour and routinized work that goes on inside buildings. Thus by the simple act of reasserting use values – using space without paying for it – skateboarding is similarly indifferent to the exchangeability of these places through rents, leases and freeholds. As *Sidewalk Surfer* [14, Mar. 1997] put it, skaters oppose 'the real criminals, who despoil the world in their never ending quest for capital'.

> The oeuvre is use value and the product is exchange value. The eminent
> use of the city, that is, of streets and squares, edifices and monuments,
> is *la Fête* (a celebration which consumes unproductively, without other
> advantage but pleasure and prestige and enormous riches in money and
> objects).
>
> [Lefebvre 1996: 66]

> Any place you have concrete you can excel. You don't need anything
> else to do it, you don't need teams, you don't need much money, and
> it's infinitely adaptable to circumstances.
>
> [*Thrasher*, 2, May-June 1982]

Skateboarding thus works, like the *fête*, through the great wealth of objects at its disposal but, unlike the *fête*, without the squandering of money and without actually owning them.

> The streets are owned by everyone. Streets give the gift of freedom, so enjoy your possession.
>
> [*Slap*, 6, Jan. 1997]

Abstract space, beyond a commodity in itself, is also the 'medium of exchange' [Lefebvre 1991b: 307], and this is increasingly the model for the city, where all buildings and spaces are considered as opportunities for commodity exchange and purchase, such that 'exchange value is so dominant over use and use value that it more or less suppresses it [Lefebvre 1996: 73]. But it is precisely this focus on the medium of exchange which skateboarding rejects. Where the managers and owners of abstract space wish that society was solely directed at commodity production, exchange and consumption, by occupying those spaces immediately external to stores and offices skateboarders refuse to engage in such processes and instead insert use values where there are supposed to be none – in the *places* of exchange. Skateboarders, then, 'represent more than just secondary users; they essentially redefine business and governmental spaces' [cited in Garchik 1994]. This kind of attitude is also evident in skaters' frequent refusal in the 1990s to pay skatepark charges, preferring to skate elsewhere in the city.

> London skaters aren't willing to pay. They'd rather go and skate the streets, there's sick spots everywhere.
>
> [*Sidewalk Surfer*, 9, Aug. 1996]

As such, skateboarding is a small fragment of that utopian conception of the urban as use, not exchange. . . .

> Urban society, a collection of acts taking place in time, privileging a space (site, place) and privileged by it, in turn signifiers and signified, has a logic different from that of merchandise. It is another world. The *urban* is based on use value.
>
> [Lefebvre 1996: 131]

This is one of the main reasons why urban street skating is more 'political' than 1970s skateboarding's use of found terrains; street skating generates new uses that at once work within (in time and space) and negate the original ones.

The opposition of this city of use to the abstract space of economic rationalism is further emphasized if we consider that society itself is being ever more organized for the purposes of the consumption of goods [Lefebvre 1988: 79–80], and that use values are increasingly denied in the act of consumption – we are encouraged to consume signs and ideologies rather than uses.

In architectural terms, this process of the consumption of signs is to be found in the increasing spectacularization of architectural function into pure form, whereby history, meaning and politics alike are reduced to the thin surface of 'popularist'

postmodern imagery, creating an urban realm more akin to the theme park than to a lived city. Such a lack of distinction between things, and images and signs derived from things, leads to a great dissatisfaction in their consumption [Lefebvre 1984: 90]. Skateboarders, like everyone else, are confronted with the heightening intensification of advertising in new places and lines of vision [see Borden 2000: 235–40].

> I grabbed my skateboard and started rolling towards downtown. All around me there were billboards with new cars, cell phones, fast food, giant heads smoking six foot long cigarettes. Posters advertised movies and TV shows, clothes I couldn't afford being worn by people who looked too good to be human. Everyone wanted my attention.
>
> [*Slap*, 4, Sept. 1995]

But in the face of such commodification, street skating does not consume architecture as projected image but as a material ground for action and so gives the human body something to do other than passively stare at advertising surfaces; its motility creates an interest in other things, materials, forms and in the skater's own physical presence in the city.

> There was all sorts of craziness going on around me, all over the city, but I skimmed above it on my skateboard. Just gliding along, protected by my board.
>
> [ibid.]

Skateboarding in this sense is not only a reassertion of use values, but also of the spatiality and temporality of human needs, desires and actions. As skater Ewan Bowman put it,

> Happiness is a state of mind that takes years to achieve, an equilibrium that comes about after hard work and commitment to following your own directions, and acting on your own personal desires, not those thrust upon you by multi corporate entities. There are only a few routes to authentic happiness left that haven't been turned into theme parks for the brain dead, or criminalised out of existence. Thankfully, skateboarding is one those alternative routes to fulfilment.
>
> [*Sidewalk Surfer*, 13, Jan.-Feb. 1997]

The tactics here are both spatial and temporal, seizing specific spaces for small periods of time; skateboarding is thus rhythmically out-of-step with the dominant routines of the city, 'inconsistent with the adapted pace and uses of our molded environment' [*Warp*, 4, Apr. 1995], creating a counter-rhythm of moves and runs. Skateboarding shows that the temporality of appropriation is different to that of ownership, seeking an active, moving time related to the specific needs and actions of urban dwellers.

> Appropriated space must be understood in relation to time, and to rhythms of time and life.
>
> [Lefebvre 1991b: 166, 356]

For example, Bowman explained his urban experience of London as a mixture of different speeds, actions and emotions.

> The raddest thing about skating here is skating on the roads in amongst the traffic, the fear and the adrenalin mixing as you skate from spot to spot nearly being hit by cars. That's a mad rush going through your body, over-taking the cars, being overtaken, going through a red light in a junction, dicing with big metal f**kers that would probably kill you.
>
> [*Sidewalk Surfer*, 13, Jan.-Feb. 1997]

Or as an American skater reflected:

> If you haven't dodged traffic in the urban jungle, then you haven't lived . . . Whatever gets in my way is skated and vacated as I weave through the throngs of suit-wearing mutards that do their best to get in the way.
>
> [*Thrasher*, 15, Sept. 1995]

Significantly, this spatiality and temporality is different to that of 1970s found terrains; whereas the latter colonized a specific place for a weekend or afternoon, and so mimicked the idea of ownership, urban street skating is more ephemeral, taking over a number of sites for shorter periods, often just a few minutes or seconds. 'Always move on' [*R.A.D.*, 79, Sept. 1989]. For example, New York skaters considered 20 minutes to be a lengthy session on a single site [*TransWorld Skateboarding*, 9, Nov. 1991].

> Stagnating at the same spot is a step backward to a place where the regular world will always know where to find us.
>
> [*Thrasher*, 12, Jan. 1992]

Urban skateboarding is not so much a colonization as a series of rolling encounters, an eventful journey. It is also, consequently, the reverse of the temporal logic of built-in obsolescence; where capitalism produces objects which wear out faster than necessary (a light-bulb), or which become technically out-of-date (audio formats), skateboarding creates a use which is shorter than the life-time of the object.

> Televisions, file cabinets, and cars are the offal of a disposable society. Wasted resources alone are a crime, but not recycling is high treason . . . From now, it's search and destroy.
>
> [ibid.]

Skateboarding here is a critique of ownership, but not of wealth. If society should involve the rehabilitation of wealth as the socialized sharing of amenity, possession is not private ownership but the ability to 'have the most complex, the "richest" relationships of joy or happiness with the "object" – we should own not nothing but more of things, without recourse to legal relations' [Lefebvre 1991a: 154–58]. And it is this which street skating addresses, being concerned with those parts of the city 'which people own but no one possesses' [*Skateboard*, 5, Jan. 1978].

> The important thing is not that I should become the owner of a little
> plot of land in the mountains, but that the mountains be open to me.
>
> [Lefebvre 1991a: 158].

Or as one skater put it: 'Just because you own it doesn't mean you're in charge of it' [*Thrasher*, 11, Nov. 1991].

If the relation between the skater and the city is not one of production or exchange, what is it? For the skateboarder, consider that 'primary relationships are not with his fellow man, but with the earth beneath his feet, concrete and all' [Mulshine 1987: 120] – the relation is of the self to the city, where human needs are rescued from the blind necessity of staying alive to become the appropriation of the self and the city together. Thus where possession focuses on the sense of having, the rejection of ownership enables the resurrection of all the senses [Lefebvre 1991a: 173–74]; and where some have seen the modern architecture of the city as alienating of the self [Sennett 1992] this architecture can also be the means by which social relations are constructed. Practices such as skateboarding therefore suggest not only the re-distribution of urban space according to the maxim 'to each according to his needs' [Lefebvre 1982: 115], but also the reformulation of the self according to the physical potential of the built environment. The experience of the self in relation to the city is, then, neither production nor consumption, but having that 'mad rush' described . . . above. 'It's all amazing, an unexplainable feeling that you have to feel to understand' [*Sidewalk Surfer*, 13, Jan.–Feb. 1997].

This occurs emotionally as well as physically, so that just as the skater's body is developed perceptually and physiologically, so the relation to the city becomes one of attraction and respect. Our relations with cities are like our relations with people [Burgin 1996: 7], and as one Brighton skater described this town – known as 'Pig City' – this was a conceptual and not purely geographic relationship.

> Not everyone who lives here and skates, lives in Pig City. It's a place
> that you live in your head.
>
> [*Skateboard*, 18, Feb. 1979]

In this context, it is unsurprising that the Red Hot Chili Peppers, a band closely associated with skateboarding, often include what amount to love songs to cities in their recordings, including, in 'Under the Bridge', one to Los Angeles and the individual's movement through it. In 'Under the Bridge', the city is a place of love, desire, turmoil and uncertainty. It is not owned, but related to.

In terms of social relations with others, the Self and the Other are not cut off but mediated by the city [Lefebvre 1996: 236]. Where the city frequently tries to dictate the social identity of its inhabitants, a spatialized version of the 'marketing orientation' which encourages people to play a role [see Fromm 1967: 75–89], skateboarders use their particular appropriation of the city to construct themselves and their relations with others; the rhythm of the city as external to the self and the rhythm of the self as intimate forms of consciousness and behaviour are counterposed [Lefebvre 1996: 235–36].

> The skater is not a separate entity from his terrain . . . he is the terrain with all its intricate pieces.
>
> [*Thrasher*, 5, Aug. 1985]

> It's the only thing that I know how to do, and if I ever stopped doing it I would be no one . . . Skateboarding is my only identity for better or worse.
>
> [*Sidewalk Surfer*, 13, Jan.-Feb. 1997]

In particular, for the skater it is the outdoor spaces, not interiors, which form the socio-space of self-identity and construction – a theme implicit throughout both Lefebvre's writings and skateboarding subcultural practice.

> Our home life is exposed on the pavement. Everybody joins in with us, let's get rid of the cars and put all the furniture into the street. One big living room, and everyone's welcome.
>
> [*R.A.D.*, 100, Sept. 1991]

> Skaters are a different breed. Not a breed apart. A breed that exists within a steel, asphalt and concrete framework.
>
> [*Thrasher*, Feb. 1983]

The meaning of skateboarding, then, comes from its engagement with the spatial nature of production, exchange, consumption and its reassertion of use values, together with the subcultural values of a generalized rejection of society already identified above. Significantly, when *Thrasher* first showed the new street skating, it was not the skaters as individuals but their performance of moves which they promoted as 'studies in non-conformity' [*Thrasher*, 6, Mar. 1986]. We must therefore consider that the spatial act of skateboarding is meaningless devoid of its subcultural attitudes, while, conversely, its subcultural attitudes have no substance except as produced in space in relation to urban architecture. This is a true dialectic of the social and the spatial, each produced through the other. Rather than allowing architecture and the city to dictate who he or she is, the skateboarder poses in response the question of 'who am I?' . . .

In terms of the kind of society this might indicate, clearly skateboarders as a group of young people are not about to take over the revolutionary mission of the proletariat; as 'small bait in a sea of corporate sharks' [*Thrasher*, 8, June 1988] they in no way seek to fundamentally alter anything. 'We're not out to fight the world' [*Thrasher*, 12, June 1992]. A *Thrasher* cover proclaiming 'Skaters of the World Unite' over an image of Lenin was simply rhetoric, highlighting a feature on skaters in different countries worldwide [*Thrasher*, 9, Feb. 1989].

Nor do skateboarders undertake in any way a self-critique, relying instead on an adolescent marginal negation of the adult world [Lefebvre 1984: 91]. They offer only an 'infra-politics' of resistance, a 'hidden transcript' intelligible only to other skaters [Beal 1995: 261]. On the other hand, young people prefigure the horizon of the future, becoming increasingly dominant in UK inner cities and new towns such as London, Slough and Luton (while retirement towns like Christchurch, Worthing and Eastbourne absorb older populations), so allowing their beliefs and

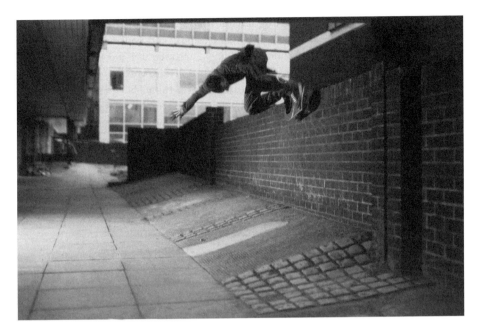

Figure 24.1 Skateboarder: Howard Cooke by Wig Worland
 Source: Wig Worland

activities to become explicit in these areas. In particular, this prefiguration is enacted through an 'ironic' assault on the rest of the world, exploiting their position of weakness to become 'aggressive whenever the opportunity arises' and so to defiantly 'irritate giants' [Lefebvre 1995: 359]. Thus through highlighting certain conflicts (especially private property and social use, rational efficiencies and social space), skaters utilize their position of weakness (youth) to irritate authority and convention, thereby making comments regarding the whole nature of the city: 'always question authority' [*TransWorld Skateboarding*, 14, Jan. 1996].

As such, although a 'counter-culture' or 'alternative society' is always difficult to define, skateboarding concurs with Lefebvre's idea that a new society might include a primacy of use over exchange, a countering of quantity by quality, and that the centralized rationale of capitalism and state can be challenged through 'local powers', however small [Lefebvre 1991b: 381–82]. Skateboarding is 'an infinite postmodern mutant' [*Sidewalk Surfer*, 14, Mar. 1997], a critical tactic that denaturalizes the city of abstract space and exchange. It suggests that changing the manner of consumption can help identify new, radical requirements that the city must meet; that confronting needs and desires – not products and things – creates change [Williamson 1988: 229–33]; and it proposes a return to art not as aestheticism but adaptation of time and space, an engagement with objects unrestricted to their use qua commodities but as the common property of social experience [Lefebvre 1984: 89].

> Skateboarding is an adaptation to the concrete jungle, a sport for the evolving American landscape . . . streetstyle is about turning the ugly urban shit around you into fodder for fun.
>
> [Gabriel 1987: 50–52]

Skateboarding shows that pre-existing uses of space are not the only possible ones, that architecture can instead be productive of things, and consumed by activities, which are not explicitly commodified. Buildings, architecture and urban space, we might propose, should be thought of as places of use, lived experiences, love, objects and concepts all at once. Here, architecture is not a thing, but part of the appropriation of the world, life and desires, space and time [Lefebvre 1969: 22]. Correspondingly, socio-spatial freedom becomes not the negative, bourgeois right of separation from others, but Marx's 'development of human powers as an end in itself' [Lefebvre 1991a: 170–71].

PART FIVE

Style, fashion, signature

Introduction to part five

■ Ken Gelder

D ICK HEBDIGE'S BOOK, *Subculture: The Meaning of Style*, helped to estab-
lish style as a key subcultural identifier. Subcultures develop a particular 'look',
and they express themselves in particular ways: linguistically, musically, and so on.
The way subcultural participants dress, the way they might talk or write (their
'argot' or slang), the sounds they might produce or listen to, the media they might
create, the designs and technologies they might use – these all work to produce
social identity for the participants themselves and distinguish those people from
others. Fashion provides perhaps the most immediately recognizable example of
subcultural style, and we have already seen one aspect of it discussed by Angela
McRobbie in chapter 12. We have also seen a debate over claims about the distinc-
tive innovations of subcultural fashion on the one hand and mass cultural styles on
the other, in Gary Clarke's defence of the 'ski-jumper' in chapter 15. The socio-
logical interest in fashion is not new, of course. Georg Simmel published his famous
essay, 'Fashion', in 1904, taking what seemed to be a proliferation of different
clothing styles at the time as symptomatic of the increasing pace of modern consumer
capitalism, an immediately registered manifestation of contemporary life. For
Simmel, fashion broadly speaking

> is the imitation of a given pattern and thus satisfies the need for social
> adaptation. . . . At the same time, and to no less a degree, it satisfies
> the need for distinction, the tendency towards differentiation, change and
> individual contrast.
>
> (cited in Frisby and Featherstone 1997: 189)

This sense that fashion answers the needs of these otherwise opposing social tenden-
cies – imitation and differentiation – establishes an important cultural logic for

subcultural studies and the contributions in this part will each put it to use in their own way.

Simmel had also seen fashion as primarily the prerogative of the upper classes, a means of preserving their own difference from 'those standing in a lower position'. When the latter begin to appropriate their fashion styles and thus transgress established class divisions, the upper classes adopt new styles in order to reaffirm their distinctive social identity: 'And thus', says Simmel, 'the game goes merrily on' (190). We might think in this context of the 'dandified styles of behaviour' among fashionable aristocratic young men during the early and mid-nineteenth century (Breward 2004: 39), which attracted the interest of commentators like Thomas Carlyle and Charles Baudelaire. These social types were defined by what Christopher Breward describes as the love of conviviality and decadent club life, as well as the conspicuous consumption of refined but extravagant clothes – all of which distinguished the dandy from the 'higher mission' of the aristocratic estate (trade, banking, estate development, and so on), an early example of subcultural 'refusal' from *above*, as it were. For Christopher Lane, the dandy's 'refusal' is more broad-based: an elitist, déclassé response to modern society and mass consumption, 'disdaining labour and affecting an indifference to economic advantage' almost to the point of 'anachronism' (Lane 1994: 36). The first contribution to this part might recall studies of dandification elsewhere; but by turning to the zoot suit, it offers a perspective from *below*. The zoot suit developed as a fashion for young African American men in the United States during the late 1930s, linked in particular to dance culture and consisting of ultra-large trousers and long, big jackets. Requiring a great deal of fabric, the zoot suit thus also signalled an act of conspicuous consumption. But the repercussions were quite different in this case: in the early 1940s, during the war, when America introduced rationing regulations, wearing a zoot suit was effectively an act of national political defiance. As Shane White and Graham White note in their book *Stylin': African American Expressive Culture from its Beginnings to the Zoot Suit* (1998), 'at a time of crisis . . . a significant number of young men from the non-white underclasses thumbed their noses at their country's patriotic demands' (White and White 1998: 249). In their contribution here, Ralph H. Turner and Samuel J. Surace – two distinguished Californian sociologists – look at the infamous 'zoot suit' riots in Los Angeles during the summer of 1943, which saw mobs of American servicemen assault and strip African Americans and Mexican Americans caught wearing these extravagant clothes. Their focus is on the latter group, and they offer an early media analysis of the resultant 'moral panic' over zoot suiters that also anticipates the later semiotic approach of CCCS researchers. For Turner and Surace, zoot suiters become political 'symbols' that carry certain connotations, evoking a particular response. Some symbols are politically ambiguous: the 'Mexican' is one of these, since for Americans the designation evokes prejudice but also a sense of romance and nostalgia. But some symbols are *unambiguous*, and their analysis of newspaper reports traces out the way the 'zoot suiter' displaced the 'Mexican' as a symbol evoking only American hostility.

The example of the zoot suit shows that (to recall Simmel's phrase) 'those standing in a lower position' can produce their *own* dandified styles of dress. The

London-based journalist T.R. Fyvel – who had worked with George Orwell during the 1940s – offers an example from England in his influential book, *Insecure Offenders: Rebellious Youth in the Welfare State* (1961, 1963): namely, the Teddy-boy movement. During the 1950s, metropolitan working-class boys began to appropriate the Edwardian retro-fashion of the upper classes, which they then exaggerated to 'theatrical' effect. For Fyvel, however, this was not a momentary aberration. The Teddy boys began as an 'anti-society', a well-dressed but sometimes threatening underclass which was itself short-lived. But for Fyvel, 'the chief point about the Teddy-boy cult was that it went on: the dandyism it had brought into working-class life remained there'. Teddy-boy culture signalled the beginnings of a new working-class affluence, an interest in styles of dress outside of traditional class frameworks. The Teddy boys may very well have lived out a form of subcultural 'refusal'; in other respects, however, they were a symptom of, and participants in, social change in the English post-war metropolis.

For Fyvel, the theatricality of the teds combines with their fashion sense to turn them into an urban spectacle. Dick Hebdige's contribution to this part charts a longer history of subcultural spectacle, returning to Henry Mayhew and the early use of photography to register often radically different social types – underclasses, for example – through a series of posed 'character studies'. (We might also think of Sigmund Krausz's *Street Types of Chicago* [1892] in this respect or, later on, the photography of someone like Diane Arbus.) Hebdige's article comes several years after *Subculture: The Meaning of Style*, and his theoretical influence now shifts to the work of Michel Foucault on governmentality and social classification. For Hebdige, youth subcultures are the contemporary inheritors of dominant culture's classificatory and governmental, criminalizing imperatives, which commodify them, identify them as 'trouble', exoticize them, and so on. His earlier work might have seen all this as a form of incorporation; here, however, he suggests that youth subcultures might very well *relish* their spectacularization as 'objects' to be looked at. In this post-CCCS model subcultures are still seen as subordinated, but their subcultural styles – their fashion, their look, their 'poses' – are empowering enough to make them *in*subordinate as they stare back. Subcultural style is no longer an act of refusal here, but rather a way of playing (albeit defiantly) dominant culture's classificatory game.

Hebdige turns to the visual here – fashion, poses, 'looks' – and his approach remains semiotic, reading style for its cultural significances, for what it says about a subculture. Kobena Mercer's contribution to this part – from his book, *Welcome to the Jungle: New Positions in Black Cultural Studies* (1994) – brings a semiotic approach to bear on 'black hairstyles' from the recent past: in particular, the Afro, and Dreadlocks. Mercer's sense of the black hairstyle as a 'key *ethnic signifier*' might recall Turner and Surace's account of the 'Mexican' and the 'zoot suiter' as political/cultural 'symbols' – and in fact, Mercer discusses the zoot suiter's red-dyed cone hairstyle along the way. The Afro, for example, signified a political identification with the Black Pride movement for metropolitan African American youth, important during the campaigns for civil rights. In its refusal to be cut or straightened it also tied its 'African' referent to a 'natural' black look. Mercer looks at the

entanglement of the natural and the artificial, or the stylized, in these black hair-styles, which redefined blackness as a modern political/cultural category but at the same time evoked something diasporic or *cross*-cultural. For Mercer, 'there was nothing particularly African' about them, for example, and their 'naturalness' was purely rhetorical and strategic. His chapter draws on Hebdige's earlier work on cross-cultural influences on British punk to suggest that subcultural styles are hybrid, not essentialist. But his focus on black cultural expression leads him to reconfigure in an interesting way Simmel's notion that fashion is a question of differentia-tion/imitation and involves the continual appropriation of upper-class styles by the lower classes. For Mercer, the appropriation is ethnic, not classed: it is white culture that appropriates black culture. Like Paul Gilroy in chapter 39, he uses the para-digm of 'white imitation/black innovation' in his discussion of style and fashion. But in contemporary postmodern culture, as Mercer also notes, it can sometimes be difficult to tell who is appropriating whom.

The semiotic approach to style and fashion seeks to understand the manner of its composition, its meanings, its cultural significance. The last two contributors to this part, however, move away from semiotics and return to the kind of empirical sociology – and ethnography – we had seen practised by Chicago School researchers. Both Nancy Macdonald and Michael Atkinson reject the desk-bound, theoretical approaches of CCCS researchers to see (as Macdonald puts it) 'what was going on out there on the subcultural streets', working face-to-face with subcultural partici-pants, documenting their responses and charting their perspectives. Macdonald's contribution, from her book *The Graffiti Subculture* (2001), looks at graffiti writers in New York and London, and her approach is 'ethnogenic': that is, she treats her interviewees (mostly male) as 'self-directing agents' and, in this case, gives them 'interpretational input' into the study (Macdonald 2001: 30–1). Graffiti art, of course, is still usually viewed as a criminal act, as what Jeff Ferrell, in his study of Denver graffiti artists, calls 'crimes of style' (Ferrell 1993). In Macdonald's account, graffiti writing leads into 'another world' in the city; the results are there for everyone to see, but the practitioners remain invisible. The artwork is also heavily coded, on public display and yet impossible for outsiders to interpret. The 'distancing' effect of graffiti, however, is liberating for the writers themselves, releasing a set of 'alter egos' or 'virtual selves' which then participate in the subculture itself. Lettering styles on a wall replace fashion on bodies; this is the graffiti writer's signa-ture, and it works as a kind of subcultural disembodiment, to be read and responded to by others even though writers may never actually meet one another. The 'inter-pretational input' in this study brings a semiotic approach back to read these obscure signs, and to see why graffiti writers produce them. For Macdonald, they are expres-sions of masculinity rather than, say, class: a sometimes inflated and aggressive mode of expression that unfolds outside the sometimes limited framework of the male body.

Macdonald is a female researcher working with male graffiti writers, an outsider. Michael Atkinson, on the other hand, is a participant observer. His book, *Tattooed: The Sociogenesis of a Body Art* (2004), is partly a meditation on his own social differentiation as a heavily tattooed man and teacher in Canada. But it

also looks at a number of what he calls 'tattoo enthusiasts', taking this particular body artform away from the context of deviance or 'personal pathology' to see it instead as a social and socializing form of expression. Another recent book on tattooing by Margo DeMello uses the term 'tattoo community', applying it both in a local sense and a mediated or discursive one – since tattooed people can also cohere imaginatively through micromedia, internet activity, tattoo shops, and so on (DeMello 2000: 18). But Atkinson offers a looser sense of a subculture through his notion of 'figuration'. Drawing on Norbert Elias as well as Simmel, he looks at social life in terms of 'chains of interdependency' and 'webs' of affiliation. His notion of 'sociogenesis' involves tracing out the way tattooed people *become* interdependent and affiliated, beginning with their first experience of tattooing and then communicating to and with others who have gone through the same process. We might think in these terms of the 'career' or 'life-cycle' of tattooed people as they accumulate tattoos and so extend the range of their sociality. A heavily tattooed body remains non-normative, and in the extract here Atkinson also discusses how such enthusiasts respond in normative situations, such as the workplace. We have seen Dick Hebdige talk about a defiantly produced sense of subcultural display and theatricality, but in normative situations heavily tattooed people may very well conceal their difference rather than flaunt it.

Simmel's sense of fashion as a combination of imitation (one wears clothes that are associated with a particular social group) and differentiation (that social group is then distinguished from others) is obviously important to subcultural studies, and the contributions to this part respond to this logic in various ways. Imitation will suggest subcultural affiliation on the one hand, and the appropriation of subcultural styles on the other, for example. In Atkinson's contribution, 'tattoo enthusiasts' do indeed distinguish themselves from the non-tattooed, but they may imitate them in normative settings. Style and territory are connected, of course: one's subcultural distinctions can flourish in one place and go utterly unnoticed in another.

Ralph H. Turner and Samuel J. Surace

ZOOT-SUITERS AND MEXICANS
Symbols in crowd behavior [1956]

T HE PURPOSE OF THIS CHAPTER is to test a hypothesis concerning the symbols with which a hostile crowd designates the object of its action. The hypothesis is that hostile crowd behavior requires an unambiguously unfavorable symbol, which serves to divert crowd attention from any of the usual favorable or mitigating connotations surrounding the object. The hypothesis has been tested by a content analysis of references to the symbol 'Mexican' during the ten-and-one-half-year period leading up to the 1943 'zoot-suit riots' in Los Angeles and vicinity.

Theory and hypothesis

The hypothesis under examination is related to two important characteristics of crowd behavior. First, crowd behavior is *uniform* behavior in a broad sense, in contrast to behavior which exposes the infinitely varied attitudes of diverse individuals. Many attitudes and gradations of feeling can be expressed in a group's actions toward any particular object. However, the crowd is a group expressing *one* attitude, with individual variations largely concealed.

In non-crowd situations uniform behavior may be achieved by majority decision, acceptance of authority, or compromise of some sort. But crowd behavior is not mediated by such slow and deliberate procedures. Within the crowd there is a readiness to act *uniformly* in response to varied suggestions, and, until such readiness to act has spread throughout the crowd's recruitment population, fully developed and widespread-acting crowd behavior is not possible.

The response in the community to shared symbols is crucial to this uniformity of action. Ordinarily, any particular symbol has varied connotations for different individuals and groups in the community. These varied connotations prevent uniform community-wide action or at least delay it until extended processes of

group decision-making have been carried out. But, when a given symbol has a relatively uniform connotation in all parts of the community, uniform group action can be taken readily when the occasion arises. To the degree, then, to which any symbol evokes only one consistent set of connotations throughout the community, only one general course of action toward the object will be indicated, and formation of an acting crowd will be facilitated.

Second, the crowd follows a course of action which is at least partially sanctioned in the culture but, at the same time, is normally inhibited by other aspects of that culture. Mob action is frequently nothing more than culturally sanctioned punishment carried out by unauthorized persons without 'due process.' Support of it in everyday life is attested to in many ways. Organizations such as the Ku Klux Klan and other vigilante groups act as self-appointed 'custodians of patriotism' and are fairly widely accepted as such. The lynching of two 'confessed' kidnappers in California in 1933 was given public sanction by the then governor of the state on the grounds of its therapeutic effect on other would-be criminals. The legal system in America implicitly recognizes these supports by including statutes designed to suppress them.

Hostile acting crowd behavior can take place only when these inhibiting aspects of the culture cease to operate. Conflict between the norms sanctioning the crowd's action and the norms inhibiting it must be resolved by the neutralization of the inhibiting norms.

There is normally some ambiguity in the connotations of any symbol, so that both favorable and unfavorable sentiments are aroused. For example, even the most prejudiced person is likely to respond to the symbol 'Negro' with images of both the feared invader of white prerogatives and the lovable, loyal Negro lackey and 'mammy.' The symbol 'bank robber' is likely to evoke a picture of admirable daring along with its generally unfavorable image. These ambiguous connotations play an important part in inhibiting extreme hostile behavior against the object represented by the symbol.

The diverse connotations of any symbol normally inhibit extreme behavior in two interrelated ways. First, the symbol evokes feelings which resist any extreme course of action. A parent, for example, is normally inhibited from punishing his child to excess, because affection for him limits the development of anger. Pity and admiration for courage or resolute action, or sympathy for a course of action which many of us might like to engage in ourselves, or charity toward human weakness usually moderate hostility toward violators of the mores. So long as feelings are mixed, actions are likely to be moderate.

Second, the mixed connotations of the symbol place the object *within the normative order*, so that the mores of fair play, due process, giving a fair hearing, etc., apply. Any indication that the individual under attack respects any of the social norms or has any of the characteristics of the in-group evokes these mores which block extreme action.

On the other hand, unambiguous symbols permit immoderate behavior, since there is no internal conflict to restrict action. Furthermore, a symbol which represents a person as outside the normative order will not evoke the in-group norms of fair play and due process. The dictum that 'you must fight fire with fire' and the conviction that a person devoid of human decency is not entitled to be treated with decency and respect rule out these inhibiting norms.

We conclude that a necessary condition for both the uniform group action and the unrestricted hostile behavior of the crowd is a symbol which arouses uniformly and exclusively unfavorable feelings toward the object under attack. However, the connotations of a symbol to the mass or crowd do not necessarily correspond exactly with the connotations to individuals. The symbol as presented in the group context mediates the overt expression of attitudes in terms of sanction and the focus of attention. The individual in whom a particular symbol evokes exclusively unfavorable feelings may nevertheless be inhibited from acting according to his feelings by the awareness that other connotations are sanctioned in the group. Or the individual in whom ambivalent feelings are evoked may conceal his favorable sentiments because he sees that only the unfavorable sentiments are sanctioned. He thereby facilitates crowd use of the symbol. Furthermore, of all the possible connotations attached to a symbol, the individual at any given moment acts principally on the basis of those on which his attention is focused. By shielding individuals from attending to possibly conflicting connotations, the unambiguous public symbol prevents the evocation of attitudes which are normally present. Thus, without necessarily undergoing change, favorable individual attitudes toward the object of crowd attack simply remain latent. This process is one of the aspects of the so-called restriction of attention which characterizes the crowd.

While unambiguous symbols are a necessary condition to full-fledged crowd behavior, they may also be a product of the earlier stages of crowd development. In some cases sudden development of a crowd is facilitated by the pre-existing linkage of an already unambiguous symbol to the object upon which events focus collective attention. But more commonly we suspect that the emergence of such a symbol or the stripping-away of alternative connotations takes place cumulatively through interaction centered on that object. In time, community-wide interaction about an object takes on increasingly crowd-like characteristics in gradual preparation for the ultimate crowd action. It is the hypothesis of this [chapter] that *overt hostile crowd behavior is usually preceded by a period in which the key symbol is stripped of its favorable connotations until it comes to evoke unambiguously unfavorable feelings.*

The 'zoot-suit' riots

Beginning on June 3, 1943, Los Angeles, California, was the scene of sporadic acts of violence involving principally United States naval personnel, with the support of a sympathetic Anglo community, in opposition to members of the Mexican community which have come to be known as the 'zoot-suit riots.' 'Zooter' referred mainly to two characteristics. First, zoot suits consisted of long suit coats and trousers extremely pegged at the cuff, draped full around the knees, and terminating in deep pleats at the waist. Second, the zooters wore their hair long, full, and well greased.

During the riots many attacks and injuries were sustained by both sides. Groups of sailors were frequently reported to be assisted or accompanied by civilian mobs who 'egged' them on as they roamed through downtown streets in search of victims. Zooters discovered on city streets were assaulted and forced to disrobe amid the jibes and molestations of the crowd. Street-cars and buses were stopped and

searched, and zooters found therein were carried off into the streets and beaten. Cavalcades of hired taxicabs filled with sailors ranged the East Side districts of Los Angeles seeking, finding, and attacking zooters. Civilian gangs of East Side adolescents organized similar attacks against unwary naval personnel.

It is, of course, impossible to isolate a single incident or event and hold it responsible for the riots. Local, state, and federal authorities and numerous civic and national groups eventually tried to assess blame and prevent further violence. The most prominent charge from each side was that the other had molested its girls. It was reported that sailors became enraged by the rumor that zoot-suiters were guilty of 'assaults on female relatives of servicemen.' Similarly, the claim against sailors was that they persisted in molesting and insulting Mexican girls. While many other charges were reported in the newspapers, including unsubstantiated suggestions of sabotage of the war effort, the sex charges dominated the precipitating context.

Method

In the absence of any direct sampling of community sentiment in the period preceding the riots, it is assumed that the use of the symbol 'Mexican' by the media of mass communication indicates the prevalent connotations. Any decision as to whether the mass media passively reflect community sentiment, whether they actively mold it, or whether, as we supposed, some combination of the two processes occurs is immaterial to the present method. Ideally we should have sampled a number of mass media to correct for biases in each. However, with the limited resources at our disposal we chose the *Los Angeles Times*, largest of the four major newspapers in the Los Angeles area. It is conservative in emphasis and tends away from the sensational treatment of minority issues. In the past a foremost romanticizer of Old Mexico [Harry Carr] had been a prominent member of the *Times* editorial staff and board of directors.

In order to uncover trends in the connotation of the symbol under study, one newspaper per month was read for the ten and one-half years from January, 1933, until June 30, 1943. These monthly newspapers were selected by assigning consecutive days of the week to each month. For example, for January, 1933, the paper printed on the first Monday was read; for February, the paper printed on the first Tuesday was read. After the seven-day cycle was completed, the following months were assigned, respectively, the *second* Monday, the *second* Tuesday, etc. To avoid loading the sample with days that fell early in the first half of the month, the procedure was reversed for the last half of the period. Then, to secure an intensive picture of the critical period, consecutive daily editions were read for one month starting with May 20, 1943, through June 20, 1943. This covered approximately ten days before and after the period of violence. Any editorial, story, report or letter which had reference to the Mexican community or population was summarized, recorded, and classified. The articles were placed in five basic categories: favorable themes, unfavorable themes, neutral mention, negative-favorable mention, and zooter theme.

1. *Favorable*: (a) Old California Theme. This is devoted to extolling the traditions and history of the old rancheros as the earliest California settlers. (b) Mexican Temperament Theme. This describes the Mexican character in terms of dashing romance, bravery, gaiety, etc. (c) Religious Theme. This refers to the devout religious values of the Mexican community. (d) Mexican Culture Theme. This pays homage to Mexican art, dance, crafts, music, fifth of May festivities, etc.

2. *Unfavorable*: (a) Delinquency and Crime Theme. This theme includes the specific mention of a law violator as 'Mexican,' associating him with marihuana, sex crimes, knife-wielding, gang violence, etc. (b) Public Burden Theme. This attempts to show that Mexicans constitute a drain on relief funds and on the budgets of correctional institutions.

3. *Neutral*: This is a category of miscellaneous items, including reports of crimes committed by individuals possessing obvious Mexican names but without designation of ethnic affiliation.

4. *Negative-Favorable*: This category consists of appeals which *counter* or *deny* the validity of accusations against Mexicans as a group. For example: 'Not all zoot-suiters are delinquents; their adoption by many was a bid for social recognition'; 'At the outset zoot-suiters were limited to no specific race . . . The fact that later on their numbers seemed to be predominantly Latin was in itself no indication of that race' (*Los Angeles Times*, July 11, 1943).

5. *Zooter Theme*: This theme identifies the zooter costume as 'a badge of delinquency.' Typical references were: 'reat pleat boys,' 'long coated gentry,' coupled with mention of 'unprovoked attacks by zoot-suited youths,' 'zoot-suit orgy,' etc. Crime, sex violence, and gang attacks were the dominant elements in this theme. Almost invariably, the zooter was identified as a Mexican by such clues as 'East Side hoodlum,' a Mexican name, or specific ethnic designation.

If the hypothesis of this [chapter] is to be supported, we should expect a decline in the favorable contexts of the symbol 'Mexican.' The change should serve to produce the type of symbol suggested by the hypothesis, a symbol dominated by unambiguously unfavorable elements.

Findings

The favorable and unfavorable themes are reported alone in Table 25.1 for the ten and one-half years. The table by itself appears to negate our hypothesis, since there is no appreciable decline in the percentage of favorable themes during the period. Indeed, even during the last period the mentions appear predominantly favorable, featuring the romanticized Mexican. However, there is a striking decline in the total number of articles mentioning the Mexican between the second and third periods. Treating the articles listed as a fraction of all articles in the newspapers sampled and using a sub-minimal estimate of the total number of all articles, the t test reveals that such a drop in the total number of articles mentioning Mexicans could have occurred by chance less than twice in one hundred times. We conclude, then, that

the decline in total favorable and unfavorable mentions of 'Mexican' is statistically significant.

While the hypothesis in its simplest form is unsubstantiated, the drop in both favorable and unfavorable themes suggests a shift away from *all* the traditional references to Mexicans during the period prior to the riots. If it can be shown that an actual substitution of symbols was taking place, our hypothesis may still be substantiated, but in a somewhat different manner than anticipated.

From the distribution of all five themes reported in Table 25.2 it is immediately evident that there has been no decline of interest in the Mexican but rather a clear-cut shift of attention away from traditional references. The straightforward favorable and unfavorable themes account for 89, 74, and 30 per cent of all references, respectively, during the three periods. This drop and the drop from 61 to 25 per cent favorable mentions are significant below the 1 per cent level. To determine whether this evidence confirms our hypothesis, we must make careful examination of the three emerging themes.

The *neutral* theme shows a steady increase throughout the three periods. While we have cautiously designated this 'neutral,' it actually consists chiefly of unfavorable presentations of the object 'Mexican' without overt use of the symbol 'Mexican.' Thus it incorporates the unfavorable representation of Mexican, which we assume was quite generally recognized throughout the community, without explicit use of the symbol.

Table 25.1 Favorable and unfavorable mention of 'Mexican' during three periods

Period	Favorable themes	Unfavorable themes	% favorable
January, 1933-June, 1936	27	3	90
July, 1936-December, 1939	23	5	82
January, 1940-June, 1943	10	2	83
Total	60	10	86

Table 25.2 Distribution of all themes by three periods

Period	% favorable	% unfavorable	% neutral	% negative-favorable	% zooter	Total %	Total number
January, 1933–June, 1936	80	9	11	0	0	100	34
July, 1936–December, 1939	61	13	23	3	0	100	38
January, 1940–June, 1943	25	5	32	8	30	100	40

The *negative-favorable* theme, though small in total numbers, also increased. At first we were inclined to treat these as favorable themes. However, in contrast to the other favorable themes, this one documents the extent of negative connotation which is accumulating about the symbol 'Mexican.' By arguing openly against the negative connotations, these articles acknowledge their widespread community sanction. When the implicitly favorable themes of romantic Mexico and California's historic past give way to defensive assertions that all Mexicans are not bad, such a shift can only reasonably be interpreted as a rise in unfavorable connotations.

The most interesting shift, however, is the rise of the *zoot-suit* theme, which did not appear at all until the third period, when it accounts for 30 per cent of the references. Here we have the emergence of a new symbol which has no past favorable connotations to lose. Unlike the symbol 'Mexican,' the 'zoot-suiter' symbol evokes no ambivalent sentiments but appears in exclusively unfavorable contexts. While, in fact, Mexicans were attacked *indiscriminately* in spite of apparel (of two hundred youths rounded up by the police on one occasion, very few were wearing zoot suits), the symbol 'zoot-suiter' could become a basis for unambivalent community sentiment supporting hostile crowd behavior more easily than could 'Mexican.'

It is interesting to note that, when we consider only the fifteen mentions which appear in the first six months of 1943, ten are to zooters, three are negative-favorable, two are neutral, and none is the traditional favorable or unfavorable theme.

In Table 25.3 we report the results of the day-by-day analysis of the period immediately prior, during, and after the riots. It shows the culmination of a trend faintly suggested as long as seven years before the riots and clearly indicated two or three years in advance. The traditional favorable and unfavorable themes have vanished completely, and three-quarters of the references center about the zooter theme.

From the foregoing evidence we conclude that our basic hypothesis and theory receive confirmation, but not exactly as anticipated. The simple expectation that there would be a shift in the relative preponderance of favorable and unfavorable contexts for the symbol 'Mexican' was not borne out. But the basic hypothesis that

Table 25.3 Distribution of all themes from May 20 to June 20, 1943

Theme	Percentage of all mentions*
Favorable	0
Unfavorable	0
Neutral	3
Negative-favorable	23
Zooter	74
Total	100

*Total number = 61.

an unambiguously unfavorable symbol is required as the rallying point for hostile crowd behavior is supported through evidence that the symbol 'Mexican' tended to be displaced by the symbol 'zoot-suiter' as the time of the riots drew near.

The conception of the romantic Mexican and the Mexican heritage is deeply ingrained in southern California tradition. The Plaza and Olvera Street in downtown Los Angeles, the Ramona tradition, the popularity of Mexican food, and many other features serve to perpetuate it. It seems quite probable that its force was too strong to be eradicated entirely, even though it ceased to be an acceptable matter of public presentation. In spite, then, of a progressive decline in public presentation of the symbol in its traditional favorable contexts, a certain ambivalence remained which prevented a simple replacement with predominantly unfavorable connotations.

Rather, two techniques emerged for circumventing the ambivalence. One was the presenting of the object in an obvious manner without explicit use of the symbol. Thus a Mexican name, a picture, or reference to 'East Side hoodlums' was presented in an unfavorable context. But a far more effective device was a new symbol whose connotations at the time were exclusively unfavorable. It provided the public sanction and restriction of attention essential to the development of overt crowd hostility. The symbol 'zoot-suiter' evoked none of the imagery of the romantic past. It evoked only the picture of a breed of persons outside the normative order, devoid of morals themselves, and consequently not entitled to fair play and due process. Indeed, the zoot-suiter came to be regarded as such an exclusively fearful threat to the community that at the height of rioting the Los Angeles City Council seriously debated an ordinance making the wearing of zoot suits a prison offense.

The 'zooter' symbol had a crisis character which mere unfavorable versions of the familiar 'Mexican' symbol never approximated. And the 'zooter' symbol was an omnibus, drawing together the most reprehensible elements in the old unfavorable themes, namely, sex crimes, delinquency, gang attacks, draft-dodgers, and the like and was, in consequence, widely applicable.

The 'zooter' symbol also supplied a tag identifying the object of attack. It could be used, when the old attitudes toward Mexicans were evoked, to differentiate Mexicans along both moral and physical lines. While the active minority were attacking Mexicans indiscriminately, and frequently including Negroes, the great sanctioning majority heard only of attacks on zoot-suiters.

Once established, the zooter theme assured its own magnification. What previously would have been reported as an adolescent gang attack would now be presented as a zoot-suit attack. Weapons found on apprehended youths were now interpreted as the building-up of arms collections in preparation for zoot-suit violence. In short, the 'zooter' symbol was a recasting of many of the elements formerly present and sometimes associated with Mexicans in a new and instantly recognizable guise. This new association of ideas relieved the community of ambivalence and moral obligations and gave sanction to making the Mexicans the victims of widespread hostile crowd behavior.

T. R. Fyvel

FASHION AND REVOLT [1963]

1st wv

I F THE TEDDY-BOY MOVEMENT is looked on . . . as a symptom of prole-tarian rebellion, a piece of defiant flag-flying, then it is interesting to note that the actual post-war Edwardian fashion was from the start a symbol of revolt, but on two extremely separate social levels.

The full Edwardian fashion actually started in Mayfair. It was said to have been launched from Savile Row soon after the war as an answer to American styles. For the young exquisites-about-town, who first and briefly took it up, its extravagance was also like a gesture against the war that was past, against mass culture, the Labour Government, the notion of England's decline. In its exaggerated form (curled bowlers worn over long hair, long Edwardian coats, ultra-tight trousers) the style was also short-lived, vanishing from Mayfair as it reached suburbia.

Meanwhile, however, the fashion had utterly unexpectedly been transported across the Thames, to the tough and swarming working-class riverside areas around the Elephant, Southwark, and Vauxhall, and this was quite an event – a symbol of social revolt on another level, though at first not recognized as such.

To the public eye, the new thorough-going proletarian Teddy boys, standing about at the Elephant in their full regalia, looked at first like music-hall caricatures – and at the same time somewhat ominous. From all accounts, these first pioneers were certainly 'a pretty rough lot'. In terms of age-groups, they still had their links with the older cloth-capped gangs which in earlier periods had dominated areas like the Elephant, keeping the police on the run and razors in their pockets. A social worker from the Elephant area told me, 'As I recall it, the local Teddy-boy fashion in its first bloom had few law-abiding members. It was definitely the submerged tenth who popularized the new clothes. They were the groups who were not respectable, not socially acceptable'. A young man who was briefly in one of the earliest gangs described its members as almost entirely un-skilled workers or just drifters. 'They were market porters, roadworkers, a lot of van boys, all in jobs that

didn't offer much – labourers could cover the lot'. Some of them were out of work but had their own methods of keeping up.

> They just went in for thieving. Many of the Teds thought nothing of it: they call it having a bit of business. I remember how they'd always try to bring in words they didn't know the meaning of, like calling somebody they didn't like 'bombastic'.

Not very promising material from which to start a new 'Movement', yet this is precisely what the first few hundred Teddy boys from south of the Thames achieved. Through similar gangs which soon spread elsewhere in London, they created a subculture whose mark was certainly its utter unexpectedness. There was the dressing-up which among the first Teds seemed simply weird. For one thing, they were still proletarians: their faces did not go with the dandified clothes; they had not yet the smooth look of the later generation of English working-class boys accustomed to money. For another thing, as determined innovators, the first Teddy boys carried the eccentricity of their garb to an extreme which had an effect of masquerade.

Was it, as it seemed, un-English? The influences were mixed. In hair-styles they derived plainly from America and the films. The most common consisted of aggressive sideboards, with masses of hair at the back and a fuzzy shock of it above the brow. Other styles favoured were the jutting Tony Curtis, the Boston, the fiercely shaved Mohican. These fancy hair-styles, involving appointments with special barbers and expensive to come by and maintain, were to their wearers clearly symbols of masculinity. Among the clothes the jacket of the suit, long and fully draped with flaps and velvet collar, came nearest to true 'Edwardian'. With it went knitted ties, plain or flowery waistcoats, tight-fitting trousers or 'strides', and – incongruously at first – blunt shoes with enormous crêpe soles. The whole theatrical outfit might cost upwards of £20; considerably less than such smart clothes cost a few years later, but in this first phase, when cash and credit were not so easy to come by, an unprecedented sum for a low-paid young manual worker to spend on himself.

Given the ingrown conservatism of English working-class life and its hostility towards any dandyism or hint of effeminacy it must have taken special determination for the first Teddy boys of south London to swagger along their drab streets in their exaggerated costume. What lay behind their impulse? The rest of the charade gave the clue to this act of self-assertion. For with the clothes went a special Teddy-boy manner – dead-pan facial expressions which delighted caricaturists, and an apparent lassitude of bearing which seemed a cover for the tensions among the gang. It was a point of honour for Teddy boys to be more interested in themselves than in girls. In dance-halls – this was before the arrival of rock-'n'-roll – they did not deign to dance, or only in a condescending manner. This lassitude was, of course, only a surface affectation. If girls were scorned as real companions, they were very much in the Teddy boys' minds as objects and as prey. In fact, one could say that this whole dressing up in groups by young unskilled wage-earners was only a means of furthering the usual aim of such young men – the nightly prowl for girls. And, just as the sartorial fashion was like a romantically stylized assertion of being

important, 'being somebody', so the primitive romanticism which inspired the clothes was applied to the night-life, too. The result was the organization of Teddy boys in gangs, some quite large, to defend territories defined as 'theirs'; or, when the mood came, to raid those of other gangs for girls. In this way the police and public around 1953 and 1954 first became aware of a new type of Teddy-boy disorder in the late night hours. This disorder was also formalized, rather like a ragged fantasy of warfare. A bus conductor told me that in a certain public house at the end of his run, which was something of a frontier post, he could on Saturday nights see huddled groups from different gangs watching each other like cats, or in the words of the old song 'Tread on the tail of my coat'.

In fact, before long the Teddy boys seemed to have created a little world of their own: a subculture with its own laws of dress, behaviour, and territory, in which they strutted about, looked challengingly at outsiders, chased girls, occasionally fought each other, and planned the occasional larceny. There were perhaps a few thousand of them in inner London, and in its peculiarly organized form the cult went on for a few years. On the whole, it was a primitive performance. The early Teddy boys were working-class youths with an itch to assert themselves against society – this was the new element – but since their little 'anti-society' did not help them to get on, it remained in this respect unreal. There might be some satisfaction in the obsessive banding together, in wreaking violent vengeance against anyone who disparaged the uniform, in the occasional large-scale fights, in baiting the police and being in on the knowledge of local crime: but since all this did not help the individual Teddy boys to get anywhere as adolescence passed, most of them, in fact, led a dreary life. . . . Driven on by boredom, by the need for spending money or just by anger against society, a good many of them landed up in the dock and went on to Borstal or prison. Others vanished vaguely into adult life, and that was the end.

Winds of change

It was easy enough to scoff at the whole performance, as most people did, yet in view of what has subsequently happened in English society it is now possible to see it was more than a joke – that the early Teds were on to something, early figures in a process of far-reaching social change. The way in which these working-class youths maintained their stylized dress and gang-life for several years, regardless of what society thought or the jeers they encountered, showed that the winds of change were blowing not only through Africa but through the English slums. The very fact that the early Teds came from the 'submerged tenth' was significant: it showed that in the new post-war English generation even unskilled young workers were no longer ready to be excluded from society and what were deemed its pleasures.

For the chief point about the Teddy-boy cult was that it went on: the dandyism it had brought into working-class life remained there. True, the sartorial fashion itself changed. Step by step, through various deviations, the clothes and haircuts grew less eccentric and extreme, until at the end of the 1950s they had become unified in the rather attractive 'Italian style', which had become normal walking-out wear for the working-class boy; and by 1960 this had blended with 'conservative cool', or just very ordinary but well-cut clothes.

By this time, it is true, the strange pioneers, the original Teddy boys, had long been superseded. Their gangs had broken up, the very term 'Ted' had become one of derision, denoting ill-mannered behaviour. Yet it was also possible to see what the movement they started off had finally achieved. Towards the end of the 1950s one could say that for the first time English working-class youths had in their great majority become meticulous about their persons and highly fashion-conscious. This dandyism, moreover, was not one in which they imitated their middle-class betters. Quite the contrary, it was rather more in line with what was worn by young people on the Continent. Other barriers, too, were being lowered. English working-class youths had also broken away from the old shirtsleeves or Sunday best into the weekend informality of jeans and sports clothes. Altogether, this added up to quite a revolution, illustrating the new affluence of working-class life, and it is interesting to see how far this social revolution went down the rigid English class-scale. My young informant from east London, who as a teenager had been among the early Teddy boys, found when he came out of the Navy at the end of the 1950s that his area was still a tough working-class 'manor', yet the whole atmosphere had subtly changed.

> The gangs were definitely smaller. For one thing the pin-table Arcades where the fellows used to hang out had mostly disappeared. And a good thing, too. They had been depressing places, dirty and moribund.
>
> The fellows in the gangs were different, too. Where early on it had only been about two out of ten, now five out of ten of all boys were dress-conscious. I noticed flick knives had come in much more, but I still think most of the fellows carried them only out of bravado. Mostly they happened to know someone who knew how to use a knife genuinely, who'd got a name for it, so all the others would back him up.
>
> The big change was, the average fellow had more money – you had to have more money now to be in the swim. Things cost more but there was a lot more cash about. For one thing, all the chief gangs now had fellows with cars and motor-bikes. The special motor-bike mob who wore black leather jackets thought of themselves as the top lot; they met by themselves in their own pub. In general, the fellows now met not only in cafés but in dance-halls and saloon bars, and the older ones had started drinking again. You could go to all kinds of clubs – that was new, too – and there were lots of parties. Some of the fellows had record players and you'd have a party going on all Sunday, with fellows and girls and drink and dozens of records.

That is, even in the dead-end districts of London, there had been radical social change. Boys and youths working in unskilled jobs were no longer loutish but searching to take part in ordinary mid-twentieth-century city life. This was the positive side of the social revolt whose flag had been raised by the Teddy boys half a dozen years earlier.

Dick Hebdige

POSING ... THREATS, STRIKING ... POSES
Youth, surveillance, and display [1983]

FOUCAULT'S DEFINITION [OF POWER] entails a shift in focus away from the familiar monolith of the State as the sole 'source or point of confluence of power' [Foucault 1980: 188], away from the State as the overbearing Master of (all oppressive) Ceremonies. Instead it directs attention down towards particular issues, particular instances, to the *micro*-relations of domination and resistance. Foucault writes:

> Between every point of a social body, between a man and a woman, between the members of a family, between a master and his pupil, between every one who knows and every one who does not, there exist relations of power which are not purely and simply a projection of the sovereign's great power over the individual; they are rather the concrete, changing soil in which the sovereign's power is grounded, the conditions which make it possible for it to function.
>
> [187]

This recognition that power always takes place, always functions in particular ways in particular locales, draws on local resources, is produced through strategies which are not co-ordinated from some pre-existent center by an individual or collective 'will,' requires us to rethink how and where power functions and is generated because, to use Foucault's own words again, 'where there is power there is resistance, not in the sense of an external, contrary force, but by the very fact of [the] existence [of power]. Power relations *depend* on a multiplicity of points of resistance, which serve at once as adversary, target, support, foothold' [190].

As Foucault puts it, power comes from everywhere, 'there is a capillarity from below to above' [201], as well as vice versa, a channel in which a countervailing force is generated. And this is a crucial point: it qualifies Foucault's celebrated

'pessimism.' For, despite the apparent closure of Foucault's universe with its vast technologies of power that interpellate whole epochs, that both engender and contain the relations of forces which characterize those epochs and the apparent 'truths' produced within them, nonetheless in Foucault's writing there is this other potential, an immanence altogether more positive, for at the same moment that Foucault charts the ineluctable progression of power from one point on the surface of the social body to the next, he also allows for the possibility that change can be effected from beneath. He documents the spread of the carceral system, the rise, from the eighteenth century onwards, of those institutions which mark the official boundaries of the public domain – the factory, the school, the prison, the asylum, the clinic, the regulated environment. But at the same time, he reinstates the forbidden discourses of the lunatic, the criminal, the patient and the pervert within the general economy of power and knowledge which produced them in the first place and which, paradoxically, serves to guarantee their 'logic' and their 'truth.' He brings another history into speech, one which, as he put it at an earlier stage in his writing [Foucault 1978], takes place below the level of power on the other side of legality – the history, through their statements and expressions, their testimonies and confessions, of those groups and individuals who have again and again been consigned to the margins, incarcerated, disciplined and punished, their exile insured through the one law which unites all discourse and which endows all 'official' discourse with its peculiar punitive effects: the rule that speech is both enabling and proscriptive, that it creates new objects, new relations to existing objects and yet does so, first and foremost, by operating as a system of exclusion, that is, according to the basic rule of language, that which is not nominated remains unsaid.

In this [chapter] I explore some of the implications of the adjustment in priorities and procedures laid down by Foucault's micro-physics of power in relation to sexuality and the public realm. The vectors of power I want to trace cut across a number of heterogeneous sites – discursive categories, institutions, and the spaces between institutions. Those sites are youth, sexuality, fashion, subculture, display, and its corollary, surveillance. Clearly, although many of these sites are themselves quite literally superficial, to propose to glide across them in even the most cursory way in the space available is absurd. A conventional presentation of history in which selected themes are carefully pursued along a single line leading from a finished past to a yet-to-be completed present will have to be abandoned. Instead I want to posit each site as a terminus in a circuit within which a different kind of knowledge, a different kind of truth can be generated, a knowledge and a truth which cannot be encapsulated within the confines of a discrete historical period, one which skirts around the logic of defensible positions, one which sets out instead with the best of intentions – to pull the Father's beard.

I shall start at the most obvious point of departure for any discussion of public space which proposes, as this one does, to address problems of *genealogy* – the Industrial Revolution. The scenario is a familiar one and includes the following. In Western Europe during the eighteenth and nineteenth centuries, the enormous expansion of productive forces opened up by technological innovation and change in the mode of production served to accelerate the process of urbanization, concentrating human and capital resources into larger and larger units and introducing a degree of social and geographical mobility that was unprecedented in any other

epoch. A new phenomenon emerges – the giant industrial conurbation, Spengler's daunting megalopolis, an architectural cacophony inhabited by the new and alien species we call the urban mass. As depicted in contemporary novels, in crusading magazines and newspaper articles about proletarian housing conditions, and in all manner of concerned cultural criticism, the modern city appears monstrous, ill proportioned, and grotesque. It is a threatening place.

The threat is variously represented but one of the perceptions around which this threat revolves is that the rules which formerly governed social interaction in public places have been disrupted, that a harmonious demarcation between the public and private domains is no longer possible. One image recurs: the silent crowd, anonymous, unknowable, a stream of atomized individuals intent on minding their own business. Wrote Engels in 1844:

> The restless and noisy activity of the crowded streets is highly distasteful, and it is surely abhorrent to human nature itself. Hundreds of thousands of men and women drawn from all classes and ranks of society pack the streets of London. . . . they rush past each other as if they had nothing in common. They are tacitly agreed on one thing only – that everyone should keep to the right of the pavement so as not to collide with the stream of people moving in the opposite direction. . . . this narrow-minded egotism – is everywhere the fundamental principle of modern society. But nowhere is this selfish egotism so blatantly evident as in the frantic bustle of the great city.
>
> [Engels 1958: 30–31]

That passage, that image, is no doubt familiar enough. The crowd functions here as a metaphor for the law of private interest which Engels regards as the fundamental principle of capitalism. The crowd is seen as a symptom. It is the literal embodiment of Engels' thesis that the workers' alienation from the means of production is replicated elsewhere, everywhere; that it reverberates across every other category of social life producing other and parallel alienations.

When attention is directed to the trajectory inscribed within this passage from the particular to the general, from particular observations via metaphor to general causes, to the unraveling of what Engels thinks his observation means, then the analysis begins to tilt away from the question of *what* Engels said to *why* he felt compelled to say it in the first place. For one of the major threats which the silent urban crowd seems to have posed to literate bourgeois observers of all political persuasions lay in its other silences – the possibility that the urban crowd might be *illegible* as well as *ungovernable*. Indeed, the two threats were inextricably linked, the link guaranteed by the complicity between power and knowledge. The urban crowd's opacity and its potential for disorder were imbricated one upon the other.

The link between the impetus to penetrate and supervise, to control the urban mass and to render it intelligible becomes clearer if we close in on one section of the crowd – youth – and begin to examine the historical construction of 'modern youth' as a category within the social sciences and more generally as a privileged focus for philanthropic and juridical concern. It should be possible through such an examination to assess the effects of this dual inheritance – the philanthropic and the

juridical, the benevolent and the punitive – on contemporary documentation of youth. Finally this process may lead to a questioning of some of the distinctions which now operate across the field of youth studies and which serve to articulate youth as a meaningful category.

The definition of the potentially delinquent juvenile crowd as a particular urban problem can be traced back, in Britain at least, to the 1780s and the beginnings of the Sunday School movement, an attempt on the part of the Church to extend its moderating influence downwards in terms both of social class and biological age. A more concentrated group of sightings occur during the mid-nineteenth century when intrepid social explorers began to venture into the 'unknown continents,' the 'jungles,' and the 'Africas' – this was the phraseology used at the time – of Manchester and the slums of East London.

We could cite as an example Henry Mayhew's observations of the quasi-criminal London costermongers. The costers were street traders who made a precarious living selling perishable goods from barrows. The young coster boys were distinguished by their elaborate style of dress – beaver skin hats, long jackets with moleskin collars, vivid patterned waistcoats, flared trousers, boots decorated with hand-stitched heart and flower motifs, a red 'kingsman' kerchief knotted at the throat. This style was known in the coster idiom as looking 'flash' or 'stunning flash.' The costers were also marked off from other equivalent groups by a developed argot – backwards slang and rhyming slang. In coster speech, beer was 'reeb,' the word 'police' was carved up, turned back to front and truncated into 'escop,' later 'copper,' finally 'cop.' This symbolic assault on the newly formed police force (introduced by Sir Robert Peel in 1840) was frequently complemented by gang attacks on solitary policemen. The police were resented because their supervision of public space in working-class ghettoes was already jeopardizing the survival not only of coster culture but of their very livelihoods. Charged with the mission of imposing uniform standards of order throughout the metropolis irrespective of local circumstances, the police actively disrupted the casual street economy upon which the costers depended. The mass of detailed observations of urban street life assembled and collated by social explorers like Mayhew eventually formed the documentary basis for legislative action, for the formation of charitable bodies and the mobilization of public opinion through newspaper articles on the plight of what were called the 'wandering tribes' of London. In these ways the social explorers served to articulate and direct a growing moral impetus towards the education, reform, and civilization of the working-class masses, an impetus which was itself underwritten by a generalized concern with the problems involved in disciplining and monitoring the shifting urban population. The initiatives taken to improve the impoverished classes on the one hand and to control them on the other were indistinguishable.

Foucault, working with archive material emanating from northern French towns, dates the beginning of a concerted campaign of intervention in the working-class milieu, particularly through education, from the period 1825–30, and refers specifically to the legislative measures introduced by Guizot. In Britain, Mary Carpenter performed a similar role lobbying for the establishment of government-funded programs devoted to the education and reform of juvenile offenders. Mary Carpenter's war on 'ignorance, want and parental incompetence' centered on the

compartmentalization of working-class youths into three categories – those destined for the Ragged Schools, the industrial schools, and the reformatories. Further, in 1852 her submission to a Parliamentary committee on the treatment of juvenile offenders was designed to institutionalize a set of distinctions which recur again and again in official documents produced on crime and punishment during the mid-nineteenth century; the distinctions were between the 'respectable' and 'criminal' classes, the 'deserving' and 'undeserving' poor, the 'delinquent' and 'perishing' juveniles. Eventually these distinctions were to be replicated in the educational and punitive provisions made for working-class youths during the period. The Ragged Schools were open to all street urchins irrespective of their criminal inclinations. The industrial schools were designed to wrest potentially redeemable children from the clutches of corrupting parents, to inculcate the virtues of factory time-discipline and orderly behavior, and to give young people an opportunity of learning a useful trade. The reformatories were reserved for the recalcitrants – the hardened young criminals who would previously have been committed to adult prisons. By 1859, only four years after the Youthful Offenders Act authorized their establishment, there were over fifty reformatory schools in England. The progression is clear: from reportage to action, from description to intervention, from the construction of a concerned polemic to the erection of a penal institution. The traces left by a 'gathering of the facts,' motivated by compassion as far as the fact gatherers themselves were concerned, are real enough.

Here is a candidate for the Ragged School [see Figure 27.1]. The fact that a photographic record has survived is important. It indicates a new departure – the systematic monitoring by means of photographic plates and daguerrotypes of potentially delinquent nomadic juveniles. The 'scientific' administration of the urban setting required a mass of evidence, statistics, and documentation of details about the most intimate aspects of individual lives. It required a supportive, efficient bureaucracy. As John Tagg has ably demonstrated [Tagg 1981], the camera played its part in this process, supplanting earlier systems of classification employed by the police to identify known criminals and record the distinctive features of new ones. It replaced systems like Alphonse Bertillon's unwieldy 'anthropometric' method which required an intricate web of interlocking statistical and verbal portraits. By drawing representation closer to reality, photography seemed to make the dream of complete surveillance possible. Inscribed into photography and photographic practice from its very inception were these official documentary uses, this potential for surveillance, by no means natural, representing, rather, a particular point of view, particular interests, embodying a desire and a will to know the alien-in-our-midst, the Other, the victim, and the culprit.

The technology was adaptable. It translated to new contexts of control. For example, it served the needs of a charitable institution like Doctor Barnado's Home for Working and Destitute Lads (founded in the late nineteenth century) as efficiently, as competently as it served the police. Barnado amassed some 55,000 photographic portraits of the inmates of his homes. This documentation served two main purposes. First, it was used to publicize the good works of the Barnado organization and hence to elicit funds from a sympathetic public and secondly, to monitor and classify potential delinquents and runaways (the police were given routine access to Barnado files).

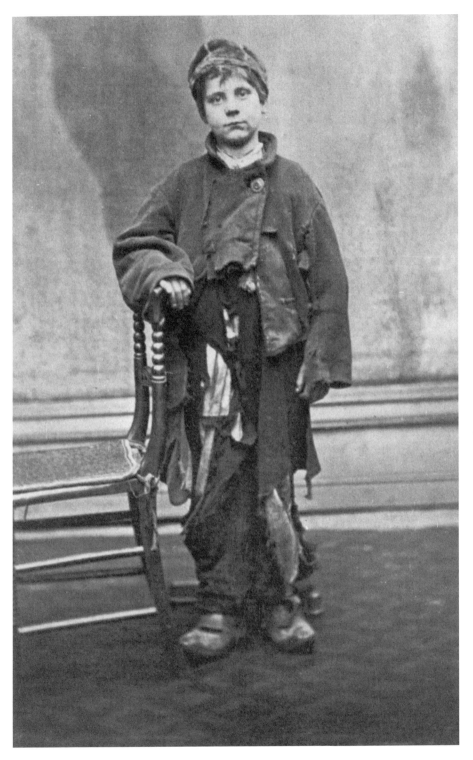

Figure 27.1 A candidate for the Ragged School
Source: Metropolitan Borough of Stockport Library

These relations, this set of positions – Us and Them, us as concerned and voyeuristic subjects, them as brutalized and wayward objects – have persisted in documentary photographs of contemporary victims, contemporary culprits, the new criminal class, the new undeserving poor. After the Other Victorians have come the Other Elizabethans, the roundheads, the skinheads, and the punks, the rockabillies, the mods, the rastas, and the rest – the black and white trash of Britain's declining inner cities. An enormous 'explanatory' literature has developed round the fringes of the 'youth problem' and this literature has its visual corollary in the tasteful anthologies of photographs of every British subculture, anthologies which abound in British bookshops. Unlike the powerful who opt for anonymity, these people make a pretty picture, make a 'spectacle' of themselves, respond to surveillance as if they were expecting it, as if it were perfectly natural. They make interesting 'character studies.' These portraits, as carefully cropped as the heads of the skins themselves, fix crime on a pin for us. We can gawp, indulge our curiosity from the safety of our positions out here. The skinhead, for example, as object of our pity, our contempt, our fear. The skinhead fixed in our compassionate and punitive gaze. The skinhead as victim, the skinhead as culprit. The skinhead 'at home,' placed in a context which immediately fits – the urban ghetto, the underpass, the day out at the beach, the life inside the factory, the tiled public bathroom. Places we wouldn't dare to venture in. These are our 'unknown continents,' our 'Africas,' our 'jungles.' These are people we wouldn't dare to stare at in the street. These are the signs of our times.

If we turn from documentary photography to the construction of youth within sociology, a similar pattern, a similar set of relations, is disclosed. The category 'youth' emerges in sociology in its present form most clearly around the late 1920s and the responsibility for that construction is generally attributed to the American tradition of ethnographic research, particularly to the work produced by the Chicago school of deviancy. Robert Park and his colleagues at the University of Chicago were concerned with developing a broadly based theory of the social ecology of city life [see Chapter 1]. The high incidence of juvenile crime in inner city areas and the significance of peer group bonding in distinctive juvenile gangs were explained by these writers through organic metaphors – the metaphors of social pathology, urban disequilibrium, the breakdown of the organic balance of city life. This tradition is largely responsible for establishing the equation, by now a familiar one in the sociology of youth, between adolescence as a social and psychological problem of particular intensity on the one hand and the juvenile offender as the victim of material, cultural, psychological or moral deprivation on the other. These two enduring images – the more general one of youth as a painful transitional period, the more particular one of violent youth, of the delinquent as the product of a deprived urban environment – are fixed within sociology largely through the work of the Chicago school and of those American researchers who, throughout the 1950s and 1960s, continued to publish 'appreciative' studies of marginal groups based on the Chicago model.

It is this tradition which produces or secures the frames of reference which then are applied to the study of youth in general and which define what is going to be deemed significant and worth studying in the area: the links between deprivation and juvenile crime, and the distinctive forms of juvenile bonding (youth culture, the

gang, the deviant subculture, the masculinist emphasis) are carried over intact into social scientific discourse. Youth becomes the boys, the wild boys, the male working-class adolescent out for blood and giggles – youth-as-trouble, youth-in-trouble.

By the 1950s, relative affluence brings the other face of British youth into focus – youth at its leisure; exotic, strange, youth-as-fun. The term 'teenager,' invented in the United States, is imported into Britain and applied by popular weekly journals like the *Picture Post* to those cultures of the 'submerged tenth' of working-class youth whose consumption rituals, musical tastes, and commodity preferences are most clearly conditioned by American influences. The word 'teenager' establishes a permanent wedge between childhood and adult-hood. The wedge means money. The invention of the teenager is intimately bound up with the creation of the youth market. Eventually a new range of commodities and commercial leisure facilities is provided to absorb the surplus cash which working-class youth is calculated to have, for the first time, at its disposal to spend on itself and to provide a space within which youth can play with itself, a space in which youth can construct its own identities untouched by the soiled and compromised imaginaries of the parent culture. Eventually: boutiques, record shops, dance halls, discotheques, television programs, magazines, the 'Hit Parade.'

The new images are superimposed on the old images – youth-as-trouble, youth-as-fun. During the 1950s, the distinction between 'respectable' and 'criminal' classes was transmuted into the distinction between 'conformist' and 'nonconformist' youth, the workers and the workshy, 'decent lads' and 'inverts,' 'patriots' and 'narcissists.' The new youth cultures of consumption were regarded by the arbiters of taste and the defenders of the 'British way of life,' by taste-making institutions like the BBC and the British design establishment, as pernicious, hybrid, unwholesome, 'Americanized.' When the first rock 'n roll film, *Blackboard Jungle*, was shown at a cinema in South London in 1956, Britain witnessed its first rock riot. The predictions were fulfilled. Teenage sexuality dissolved into blood lust. Seats were slashed. Teddy boys and girls jived in the aisles. Those expelled from the cinema vented their rage on a tea-stall situated on the pavement outside. Cups and saucers were thrown about. It was a very English riot. It represented a new convergence – trouble-as-fun, fun-as-trouble.

The two image clusters – the bleak portraits of juvenile offenders, the exuberant cameos of teenage life – reverberate, alternate, sometimes get crossed. By the mid-1960s, at the height of the mod craze, youth culture had become largely a matter of commodity selection, of publicly stated taste preferences: this rather than that type of music or style or dress or brand of cigarette, 'mod' not 'beat,' 'mod' not 'rocker,' 'mod' not 'ted.' For youths in search of an expressive medium, goods could function symbolically as 'weapons of exclusion' [Douglas and Isherwood 1979: 85], as boundary markers, as a means of articulating identity and difference. Converting themselves into objects, those youths immersed in style and the culture of consumption seek to impose systematic control over the narrow domain which is 'theirs' and within which they see their 'real' selves invested, the domain of leisure and appearance, of dress and posture. The posture is auto-erotic: the self becomes the fetish. There is even a distinctive mod way of standing. According to one original mod, 'feet had to be right. If you put your hands in your pocket, you never pulled the jacket up so it was wrinkled. You'd have the top button done up and the

jacket would be pulled back behind the arm so that you didn't ruin the line. You'd only ever put one hand in your pocket if you were wearing a jacket' [Barnes 1980: 10]. The circle has now been fully described: fractions of youth now aspire to the flatness and the stillness of a photograph. They are completed only through the admiring glances of a stranger. This is the other side of affluence – a rapacious specularity, the coming of the greedy I. Henri Lefebvre calls it the Display Myth, describing its circularity thus: 'consuming of displays, displays of consuming, consuming of displays of consuming, consuming of signs, signs of consuming. . . .' [Lefebvre 1971: 114] . . .

I end with three propositions on youth, sexuality, subculture: propositions which, like much else in this [chapter], remain lodged at the level of assertion, speculative assertion.

Proposition one: that in societies such as ours, youth is present only when its presence is a problem, or rather when its presence is *regarded* as a problem. The category 'youth' only gets activated, is only mobilized in official documentary discourse in the form of editorials, magazine articles, in the supposedly disinterested tracts on 'deviance,' 'cognitive dissonance,' and 'maladjustment' emanating from the social sciences, when young people make their presence felt by going out of bounds, by dressing strangely, by resisting through rituals, by breaking bottles, windows, heads, by confounding surveillance, by confronting the police, by issuing challenges, by striking . . . bizarre poses.

When they adopt these strategies, they get talked about, taken seriously, their grievances are acted upon. They get arrested, harassed, arraigned before the courts. They get interrogated, interviewed, photographed, admonished, disciplined, incarcerated, applauded, punished, vilified, emulated, listened to. When they riot, they get defended by social workers and other concerned philanthropists, they get explained by sociologists, social psychologists, by pundits of every political complexion, they get visited by senior police officials, by Mrs. Margaret Thatcher. They get noticed. Their portraits appear in the right-wing press and the left-wing little magazines. They become visible. In other words, the reactive machinery is set in motion. When adolescents, most particularly when disaffected inner city and unemployed adolescents resort to violence – symbolic and actual violence – they are playing with the only power at their disposal – the power to discomfit, the power, that is, to pose . . . to pose a threat. Far from abandoning good sense, they are acting in accordance with a logic which is manifest: that as a condition of their entry into the adult domain, the field of public debate, the place where real things really happen, they must break the laws which order that domain, which order the distribution of significance within that field, that place. They must exceed consensual definitions of the proper and the permissible. They must challenge the symbolic order which guarantees their subordination by nominating them 'children,' 'youngsters,' 'young folk.' And there is pleasure in transgression.

Proposition two: that the kind of micropolitics, the politics of pleasure in which youth subcultures habitually engage, cannot be collapsed into existing forms of organized political activity. Quite clearly there are new forces at work here. We are witnessing the formation of new collectivities, new forms of social and sexual being, new configurations of power and resistance. We see the continuing trend toward the concentration of power and resources, the fragmentation of the industrial work-

force, the tendency towards privatization in leisure, specialization in the labor process, de-skilling, the expansion of new technologies, the systematic de-manning of industry, the increasingly important role played by the mass media in forming opinion, organizing consent, providing a common national, even international focus; the accelerated move in both Britain and the United States into militarism; the move away from indirect to overtly authoritarian forms of social control, crowd management, and monitoring; the extension of police powers, the formation of specialist guerrilla squads (in Britain, the Special Patrol Group and the Special Air Service). All these shifts in power mean that older cultural traditions which provided the basis for collective forms of identity and action are being disrupted and eroded and that new ones are beginning to emerge. As power is deployed in new ways, so new forms of powerlessness are produced and new types of resistance become possible.

The riots we witnessed in England in the summer of 1981 occupy just one end of a spectrum of possible strategies – civil disobedience, dissidence, sexual politics, role refusal, alternative life styles, the dispersal of personal identity, deviance, symbolic transgression, the exhumation of dead or buried traditions, the mobilization of taboos, in short, the return of the repressed. Viewed from this perspective, even the spectacular subcultures of the young (whose resistance is most clearly and easily contained because it is expressed primarily through consumption, posture, through *symbolic* disaffection) take on some subversive value. They can be seen as attempts to win some kind of breathing space outside the existing cultural parameters, outside the zone of the given. They can be seen as collective responses on the part of certain youth fractions and factions to dominate value systems, as forms through which certain sections of youth oppose or negotiate, play with and transform the dominant definitions of what it means to be powerless, on the receiving end.

Proposition three: that the politics of youth culture is a politics of gesture, symbol, and metaphor, that it deals in the currency of signs and that the subcultural response is, thus, always essentially ambiguous. I have tried to suggest that its very nature and form, the very conditions which produce it, dictate that it should always slip beneath any authoritative interpretation. For the subcultural milieu has been constructed underneath the authorized discourses, in the face of the disciplines of the family, the school, and the workplace. Subculture forms at the interface between surveillance and the evasion of surveillance. It translates the fact of being under scrutiny into the pleasures of being watched, and the elaboration of surfaces which takes place within it reveals a darker will towards opacity, a drive against classification and control, a desire to exceed.

Subculture is, then, neither simply an affirmation or a refusal, neither simply resistance against symbolic order nor straightforward conformity with the parent culture. It is . . . a declaration of independence, of Otherness, of alien intent, a refusal of anonymity, of subordinate status. It is an *in*subordination. And at the same time, it is also a confirmation of the fact of powerlessness, a celebration of impotence. Subcultures are both a play for attention and a refusal, once attention has been granted, to be read according to the Book.

It is appropriate that Foucault should provide us with a metaphor on which we can close, but not close off. For something of the ambiguity and paradox of the subcultural response can be seen in Foucault's description of the chain gangs

which, until the 1830s, provided the French peasantry a dramatic entertainment, a celebration of criminality, an image of a world turned upside down:

> In every town it passed through, the chain-gang brought its festival with it; it was a saturnalia of punishment, a penalty turned into a privilege. And, by a very curious tradition which seems to have escaped the ordinary rites of the public execution, it aroused in the convict not so much the compulsory marks of repentance as the explosion of a mad joy that denied the punishment. To the ornaments of the collar and the chain, the convicts themselves added ribbons, braided straw, flowers or precious stuffs. The chain was the round and the dance; it was also a coupling, a forced marriage in forbidden love [Quoted from a contemporary account] 'They ran in front of the chains, bunches of flowers in their hands, ribbons or straw tassels decorated their caps and the most skilful made crested helmets. . . . And throughout the evening that followed the riveting, the chain-gang formed a great merry-go-round. . . . [One commentator remarked:] Woe betide the warders if the chain-gang recognized them; they were enveloped and drowned in its rings; the prisoners remained masters of the field of battle until nightfall . . . [when the warders re-established their control].
>
> [Foucault 1979a: 261]

I think that is a suitable image on which to end, an image of contained revolt, of spectacular transgressions circumscribed, of crime as carnival, of resistance and chains. A nice point on which to end: to end on an image which rounds things off, framed, as it is, by the consecrating words of Michel Foucault who is also said to have said the following: 'I heard someone talking about power the other day – it's in fashion' [Foucault 1980: 207]. In *fashion* precisely. For power is inscribed even in the most 'superficial' *sartorial* flourishes. Power is inscribed in the look of things, in our looking at things. In this [chapter], I have attempted to outline how the inconsequential, how that which is regarded as without consequence has, on the contrary, its effects, how those places where we feel least inclined to say what it is we see and from what angle we see it, stand in the way of our really saying it, constitute blind spots, a space to look dumb in. And more than this: a larger project. For we are engaged in the production of a discourse which is cut against the grain of science, a discourse which is informed by a peculiar sense of urgency, a sense of the emergent, one tilted to deliver a particular knowledge, a knowledge of the particular, a knowledge which threatens within the academic sphere to present a simulacrum of those other kinds of knowledge generated underneath, outside, within (for instance) the subcultural milieu, a knowledge which cannot be systematized, generalized, a knowledge that doesn't travel at all well.

Engaged in deconstructions, reflexive deconstructions, discursively promiscuous, we aim to fabricate a logic which is diverse and discontinuous, a science, if you like, a science of the concrete, which is to say an unscience, a science of things happening, a discourse which breaks a silence in order to produce dis . . . quiet, this quiet.

Kobena Mercer

BLACK HAIR/STYLE POLITICS [1987]

Tangled roots and split ends: hair as symbolic material

A S ORGANIC MATTER produced by physiological processes, human hair
seems to be a natural aspect of the body. Yet hair is never a straightforward
biological fact, because it is almost always groomed, prepared, cut, concealed and
generally worked upon by human hands. Such practices socialize hair, making it the
medium of significant statements about self and society and the codes of value that
bind them, or do not. In this way hair is merely a raw material, constantly processed
by cultural practices which thus invest it with meanings and value.

The symbolic value of hair is perhaps clearest in religious practices – shaving
the head as a mark of worldly renunciation in Christianity or Buddhism, for example,
or growing hair as a sign of inner spiritual strength for Sikhs. Beliefs about gender
are also evident in practices such as the Muslim concealment of the woman's face
and hair as a token of modesty. Where 'race' structures social relations of power,
hair – as visible as skin color, but also the most tangible sign of racial difference –
takes on another forcefully symbolic dimension. If racism is conceived as an ideo-
logical code in which biological attributes are invested with societal values and
meanings, then it is because our hair is perceived within this framework that it is
burdened with a range of negative connotations. Classical ideologies of race estab-
lished a classificatory symbolic system of color, with white and black as signifiers of
a fundamental polarization of human worth – 'superiority/inferiority.' Distinctions
of aesthetic value, 'beautiful/ugly,' have always been central to the way racism
divides the world into binary oppositions in its adjudication of human worth.

Although dominant ideologies of race (and the way they dominate) have
changed, the legacy of this biologizing and totalizing racism is traced as a presence
in everyday comments made about our hair. 'Good' hair, when used to describe
hair on a black person's head, means hair that looks European, straight, not too

curly, not that kinky. And, more importantly, the given attributes of our hair are often referred to by descriptions such as 'woolly,' 'tough' or, more to the point, just plain old 'nigger hair.' These terms crop up not only at the hairdresser's but more acutely when a baby is born and everyone is eager to inspect the baby's hair and predict how it will 'turn out.' The pejorative precision of the salient expression, *nigger hair*, neatly spells out how, within racism's bipolar codification of human worth, black people's hair has been historically *devalued* as the most visible stigmata of blackness, second only to skin. . . .

Stuart Hall . . . emphasizes the composite nature of white-bias, which he refers to as the 'ethnic scale,' as both physiological and cultural elements are intermixed in the symbolization of one's social status. Opportunities for social mobility are therefore determined by one's ranking on the ethnic scale, and involve the negotiation not only of socioeconomic factors such as wealth, income, education and marriage, but also of less easily changeable elements of status symbolism such as the shape of one's nose or the shade of one's blackness (Hall 1977: 150–82). In the complexity of this social code, hair functions as a key *ethnic signifier* because, compared with bodily shape or facial features, it can be changed more easily by cultural practices such as straightening. Caught on the cusp between self and society, nature and culture, the malleability of hair makes it a sensitive area of expression. . . .

With its organizing principles of biological determinism, racism first politicized our hair by burdening it with a range of negative social and psychological meanings. Devalorized as a 'problem,' each of the many stylizing practices brought to bear on this element of ethnic differentiation articulate ever so many 'solutions.' Through aesthetic stylization each black hairstyle seeks to *revalorize* the ethnic signifier, and the political significance of each rearticulation of value and meaning depends on the historical conditions under which each style emerges. The historical importance of Afro and Dreadlocks hairstyles cannot be underestimated as marking a liberating rupture, or 'epistemological break,' with the dominance of white-bias. But were they really that 'radical' as solutions to the ideological problematization of black people's hair? Yes: in their historical contexts, they *counter*politicized the signifier of ethnic and racial devalorization, redefining blackness as a desirable attribute. But, on the other hand, perhaps not: because within a relatively short period both styles became rapidly *de*politicized and, with varying degrees of resistance, both were incorporated into mainstream fashions within the dominant culture. What is at stake, I believe, is the difference between two logics of black stylization – one emphasizing *natural* looks, the other involving straightening to emphasize *artifice*.

Nature/culture: some vagaries of imitation and domination

Our hair, like our skin, is a highly sensitive surface on which competing definitions of 'the beautiful' are played out in struggle. The racial overdeterminations of this nature/culture ambivalence are writ large in this description of hair-straightening by a Jamaican hairdresser:

> Next, apply hot oil, massaging the hair well which prepares it for a shampoo. You dry the hair, leaving a little moisture in it, and then apply

grease. When the hair is completely dry you start *cultivating* it with a
hot comb. . . . Now the hair is all straight. You can use the curling iron
on it. Most people like it curled and waved, not just straight, not just
dead straight.

(quoted in Henriques 1953: 55)

Her metaphor of 'cultivation' is telling because it makes sense in two contradictory
ways. On the one hand, it recuperates the brutal logic of white-bias: to cultivate is
to transform something found 'in the wild' into something of social use and value,
like domesticating a forest into a field. It thus implies that in its natural given state,
black people's hair has no inherent aesthetic value: it must be worked upon before
it can be beautiful. But on the other hand, all human hair is 'cultivated' in this way
insofar as it merely provides the raw material for practices, procedures and ritual
techniques of cultural writing and social inscription. Moreover, in bringing out other
aspects of the styling process which highlight its specificity as a cultural practice –
the skills of the hairdresser, the choices of the client – the ambiguous metaphor
alerts us to the fact that nobody's hair is ever just natural, but is always shaped and
reshaped by social convention and symbolic intervention.

An appreciation of this delicate 'nature/culture' relation is crucial if we are to
account both for the emergence of Dreadlocks and Afro styles as politicized state-
ments of pride *and* their eventual disappearance into the mainstream. To reconstruct
the semiotic and political economy of these black hairstyles we need to examine
their relation to other items of dress and the broader historical context in which
such ensembles of style emerged. An important clue with regard to the Afro in
particular can be found in its names, as the Afro was also referred to, in the United
States, as the 'natural.'

The interchangeability of its two names is important because both signified the
embrace of a 'natural' aesthetic as an alternative ideological code of symbolic value.
The 'naturalness' of the Afro consisted in its rejection both of straightened styles
and of short haircuts: its distinguishing feature was the *length* of the hair. With the
help of a pick or Afro-comb the hair was encouraged to grow upwards and outwards
into its characteristic rounded shape. The three-dimensionality of its shape formed
the signifying link with its status as a sign of Black Pride. Its morphology suggested
a certain dignified body posture, for to wear an Afro you have to hold your head
up in pride, you cannot bow down in shame and still show off your 'natural' at the
same time. . . .

In its 'naturalistic' logic the Afro sought a solution that went to the roots of
the problem. By emphasizing the length of hair when allowed to grow 'natural and
free,' the style countervalorized attributes of curliness and kinkiness to convert stig-
mata of shame into emblematics of pride. Its names suggested a link between 'Africa'
and 'nature' and this implied an oppositional stance *vis-à-vis* artificial techniques
of any kind, as if any element of artificiality was imitative of Eurocentric, white-
identified, aesthetic ideals. The oppositional economy of the Afro also depended on
its connections with dress styles adopted by various political movements of the time.

In contrast to the Civil Rights demand for equality within the given framework
of society, the more radical and far-reaching objective of total liberation and freedom
from white supremacy gained its leverage through identification and solidarity with

anticolonial and anti-imperialist struggles of emergent Third World nations. At one level, this alternative political orientation of Black Power announced its public presence in the language of clothes.

The Black Panthers' 'urban guerrilla' attire – turtlenecks, leather jackets, dark glasses and berets – encoded a uniform of protest and militancy by way of the connotations of the common denominator, the color black. The Panthers' berets invoked solidarity with the violent means of anti-imperialist armed struggle, while the dark glasses, by concealing identity from the 'enemy,' lent a certain political mystique and a romantic aura of dangerousness.

The Afro also featured in a range of ex-centric dress styles associated with cultural nationalism, often influenced by the dress codes of Black Muslim organizations of the late 1950s. Here, elements of 'traditional' African dress – tunics and dashikis, head-wraps and skull caps, elaborate beads and embroidery – all suggested that black people were contracting out of Westernness and identifying with all things African as a positive alternative. It may seem superficial to reread these transformative political movements in terms of style and dress: but we might also remember that as they filtered through mass media, such as magazines, music, or television, these styles contributed to the increasing visibility of black struggles in the 1960s. As elements of everyday life, these black styles in hair and dress helped to underline massive shifts in popular aspirations among black people and participated in a populist logic of rupture.

As its name suggests, the Afro symbolized a reconstitutive link with Africa as part of a counter-hegemonic process helping to redefine a diaspora people not as Negro but as Afro-American. A similar upheaval was at work in the emergence of Dreadlocks. As the Afro's creole cousin, Dreadlocks spoke of pride and empowerment through their association with the radical discourse of Rastafari which, like Black Power in the United States, inaugurated a redirection of black consciousness in the Caribbean. Walter Rodney drew out the underlying connections and 'family resemblances' between Black Power and Rastafari (Rodney 1968: 32–3). Within the strictures of Rastafari as spiritual doctrine, Dreadlocks embody an interpretation of a religious, biblical injunction that forbids the cutting of hair (along the lines of its rationale among Sikhs). However, once 'locks were popularized on a mass social scale – via the increasing militancy of reggae, especially – their dread logic inscribed a beautification of blackness remarkably similar to the 'naturalistic' logic of the Afro.

Dreadlocks also embrace 'the natural' in the way they valorize the very materiality of black hair texture, for black people's is the only type of hair that can be 'matted' into such characteristic configurations. While the Afro's semiotics of pride depended on its rounded shape, 'locks countervalorized nappy-headed blackness by way of this process of matting, which is an option not readily available to white people because their hair does not 'naturally' grow into such organic-looking shapes and strands. And where the Afro suggested an articulating link with Africa through its name and its association with radical political discourses, Dreadlocks similarly implied a symbolic link between their naturalistic appearance and Africa by way of a reinterpretation of biblical narrative which identified Ethiopia as 'Zion' or Promised Land. With varying degrees of emphasis, both invoked 'nature' to inscribe Africa as the symbol of personal and political opposition to the hegemony of the

West over 'the rest.' Both championed an aesthetic of nature that opposed itself to any artifice as a sign of corrupting Eurocentric influence. But nature had nothing to do with it! Both these hairstyles were never just natural, waiting to be found: they were stylistically *cultivated* and politically *constructed* in a particular historical moment as part of a strategic contestation of white dominance and the cultural power of whiteness.

These styles sought to liberate the materiality of black hair from the burdens bequeathed by racist ideology. But their respective logics of signification, positing links between the natural, Africa and the goal of freedom, depended on what was only a *tactical inversion* of the symbolic chain of equivalences that structured the Eurocentric system of white-bias. . . . The biological determinism of classical racist ideology first politicized our hair by burdening it with 'racial' meanings: its logic of devalorization of blackness radically devalued our hair, debarring it from access to dominant regimes of the 'truth of beauty.' This aesthetic denegation logically depended on prior relations of equivalence which posited the categories of *Africa* and *Nature* as equally other to Europe's deluded self-image which sought to monopolize claims to human beauty.

The equation between these two categories in Eurocentric thought rested on the fixed assumption that Africans had no culture or civilization worthy of the name. Philosophers like Hume and Hegel validated such assumptions, legitimating the view that Africa was outside history in a savage and rude 'state of nature.' Yet, while certain Enlightenment reflections on aesthetics saw in the Negro only the annulment of their ideas of beauty, Rousseau and later, in the eighteenth and nineteenth centuries, romanticism and realism in the arts, saw Nature on the other hand as the source of all that was good, true and beautiful. The Negro was none of these. But by inverting the symbolic order of racial polarity, the aesthetic of 'nature' underpinning the Afro and Dreadlocks could negate the negation, turn white-bias on its head and thus revalorize all that had been so brutally devalorized as the very annulment of aesthetics. In this way, the black subject could accede – and only in the twentieth century, mind you – to that level of self-valorization or aesthetic idealization that had hitherto been categorically denied as unthinkable. The radicality of the 1960s' slogan, Black is Beautiful, lay in the function of the logical copula *is*, as it marked the ontological affirmation of our nappy nigger hair, breaching the bar of negation signified in that utterance from the Song of Songs which Europe had rewritten (in the King James version of the Bible) as, 'I am black *but* beautiful.'

However radical this countermove was, its tactical inversion of categories was limited. One reason why may be that the 'nature' invoked in black counterdiscourse was not a neutral term but an ideologically loaded *idea* created by binary and dualistic logics within European culture itself. The 'nature' brought into play to signify a desire for liberation and freedom so effectively was also a Western inheritance, sedimented with symbolic meaning and value by traditions of science, philosophy and art. Moreover, this ideological category had been fundamental to the dominance of the West over 'the rest'; the nineteenth-century bourgeoisie sought to legitimate the imperial division of the world by way of mythologies that aimed to universalize, eternalize and hence 'naturalize' its power. The counterhegemonic tactic of inversion appropriated a particularly romanticist version of nature as a means of empowering the black subject; but by remaining within a dualistic logic

of binary oppositionality (to Europe and artifice) the moment of rupture was delimited by the fact that it was only ever an imaginary 'Africa' that was put into play.

Clearly, this analysis is not to write off the openings and effective liberations gained and made possible by inverting the order of aesthetic oppression; only to point out that the counterhegemonic project inscribed in these hairstyles is not completed or closed, and that this story of struggles over the same symbols continues. Nevertheless, the limitations underline the diasporic specificity of the Afro and Dreadlocks, and ask us to examine, first, their conditions of commodification and, second, the question of their *imaginary* relationship to Africa and African cultures as such.

Once commercialized in the marketplace the Afro lost its specific signification as a 'black' cultural-political statement. Cut off from its original political contexts, it became just another fashion: with an Afro wig anyone could wear the style. Now the fact that it could be neutralized and incorporated so readily suggests that the aesthetic interventions of the Afro operated on terrain already mapped out by the symbolic codes of the dominant white culture. The Afro not only echoed aspects of romanticism, but shared this in common with the 'countercultural' logic of long hair among white youth in the 1960s. From the Beatles' mop-tops to the hairy hippies of Woodstock, white subcultures of the sixties expressed the idea that the longer you wore your hair, somehow the more 'radical' and 'right-on' your lifestyle or politics. This *far-out* logic of long hair among the hippies may have sought to symbolize disaffection from Western norms, but it was rapidly assimilated and dissimulated by commodity fetishism. The incorporation of long hair as the epitome of protest, via the fashion industry, advertising and other economies of capitalist mediation, culminated at one point in a Broadway musical that ran for years – *Hair*.

Like the Afghan coats and Kashmiri caftans worn by the hippy, the dashiki was reframed by dominant definitions of ethnic otherness as 'exotica:' its connotations of cultural nationalism were clawed back as just another item of freakish exoticism for mass consumption. Consider also the inherent semiotic instability of militant chic. The black leather jackets and dark glasses of the Panthers were already inscribed as stylized synonyms for rebelliousness in white male subcultures from the 1950s. There, via Marlon Brando and the metonymic association with macho and motor bikes, these elements encoded a youthful desire for freedom, in the image of the American highway and the open road, implying opposition to the domestic norms of their parent culture. Moreover, the color black was not saturated by exclusively 'racial' connotations. Dark, somber colors (as well as the occasional French beret) featured in the downbeat dress statements of the 1950s boho-beatniks to suggest mystery, 'cool,' outsider status, anything to alienate the normative values of 'square society.'

The fact that these white subcultures themselves appropriated elements from black American culture (rock 'n' roll and bebop respectively) is as important as the fact that a portion of the semiotic effectiveness of the Panther's look derived from associations already embedded by previous articulations of the same or similar elements of style. The movement back and forth indicates an underlying dynamic of struggle as different discourses compete for the same signs. It shows that, for style to be socially intelligible as an expression of conflicting values, each cultural nucleus or articulation of signs must share access to a common stock or resource

of signifying elements. To make the point from another point of view would amount to saying that the Afro engaged in a critical dialogue between black and white Americans, not one between black Americans and Africans. Even more so than Dreadlocks, there was nothing particularly African about the Afro at all. Neither style had a given reference point in existing African cultures, in which hair is rarely left to grow 'naturally.' Often it is plaited or braided, using weaving techniques to produce a rich variety of sometimes highly elaborate styles that are reminiscent of the patternings of African textiles and the decorative designs of African ceramics, architecture and embroidery. Underlying these practices is an African approach to the aesthetic. In contrast to the separation of the aesthetic sphere in post-Kantian European thought, this is an aesthetic sensibility which incorporates practices of beautification in everyday life. Thus artifice – the agency of human hands – is valued in its own right as a mark of both invention and tradition, and aesthetic skills are deployed within a complex economy of symbolic codes in which communal subjects recreate themselves collectively.

Neither the Afro nor Dreadlocks operate within this context as such. In contemporary African societies, such styles would not signify Africanness ('locks in particular would be regarded as something 'alien,' precisely the tactical objective of the Mau Mau in Kenya when they adopted such dread appearances in the 1950s); on the contrary, they would imply an identification with First World-ness. They are specifically diasporean. However strongly these styles expressed a desire to 'return to the roots' among black peoples in the diaspora, in Africa *as it is* they would speak of a modern orientation, a modelling of oneself according to metropolitan images of blackness [see Figure 28.1].

If there was nothing especially 'African' about these styles, this only goes to show that neither was as natural as it claimed to be. Both presupposed quite artificial techniques to attain their characteristic shapes and hence political significance: the use of special combs in the case of the Afro, and the process of matting in the case of 'locks, often given a head start by initially plaiting long strands of hair. In their rejection of artifice both styles embraced a 'naturalism' that owed much more to Europe than it did to Africa. . . .

Style and fashion: semiotic struggles in the forest of signs

Having alighted on a range of paradoxes of 'race' and aesthetics via this brief excursion into the archeology of the Afro, I want now to reevaluate the symbolic economy of straightening in the light of these contradictory relations between black and white cultures in diaspora societies. Having found no preexisting referent for either hairstyle in 'actually existing' African cultures, I would argue that it should be clear that what we are dealing with are New World creations of black people's culture which, in First World societies, bear markedly different relations with the dominant Euro-American culture from those that obtain in the Third World.

By ignoring these differences, arguments that hold straightened styles to be slavish imitations of Western norms are in fact complicit with an outmoded anthropological view that once tried to explain diasporean black cultures as bastard products of unilateral 'acculturation.' By reversing the axes of traditional analysis

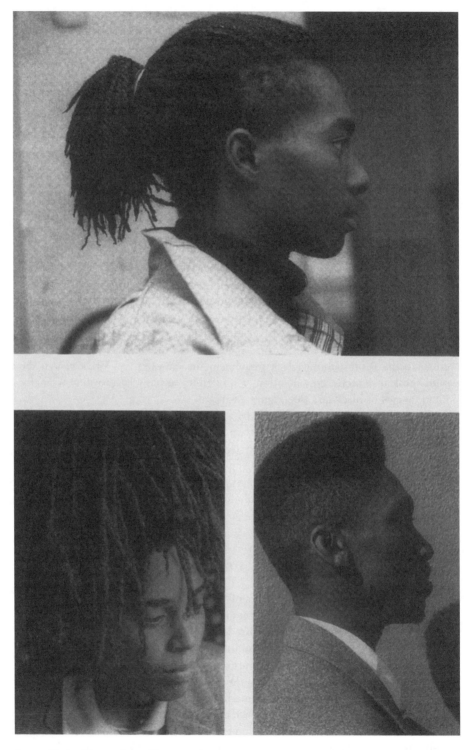

Figure 28.1 Triptych by Christine Parry

we can see that throughout the era of cultural modernity it is white people who have been doing a great deal of the imitating while black people have done much of the innovating. . . .

Diaspora practices of black stylization are intelligible at one 'functional' level as dialogic responses to the racism of the dominant culture, but at another level involve acts of appropriation from that same 'master' culture through which 'syncretic' forms of cultural expression have evolved. Syncretic strategies of black stylization, 'creolizing' found or given elements, are writ large in the black codes of modern music like jazz, where elements such as scales, harmonies or even instruments like the piano or saxophone from Western cultural traditions are radically transformed by this neo-African, improvisational approach to aesthetic and cultural production. In addition there is another 'turn of the screw' in these modern relations of interculturation when these creolized cultural forms are made use of by other social groups and then, in turn, are all incorporated into mainstream 'mass' culture as commodities for consumption. Any analysis of black style, in hair or any other medium, must take this field of relationships into account.

Hairstyles such as the conk of the 1940s or the curly-perm of the 1980s are syncretic products of New World stylization. Refracting elements from both black and white cultures through this framework of exchange and appropriation, imitation and incorporation, such styles are characterized by the *ambivalence* of their meaning. It is implausible to attempt a reading of this ambivalence in advance of an appreciation of the historical contexts in which they emerged alongside other stylized surfaces of syncretic inscription in speech, music, dance and dress.

As a way into this arena of ambiguity, listen to this voice, as Malcolm X describes his own experience of hair-straightening. After recounting the physical pain of the hot-lye and steel-comb technology, he tells of pride and pleasure in the new, self-stylized image he has made for himself:

> My first view in the mirror blotted out the hurting. I'd seen some pretty conks, but when it's the first time, on your *own* head, the transformation, after a lifetime of kinks, is staggering. The mirror reflected Shorty behind me. We were both grinnin' and sweating. On top of my head was this thick, smooth sheen of red hair – real red – as straight as any white man's.
>
> (Malcolm X 1966: 134–9)

In his autobiographical narrative the voice then shifts immediately from past to present, wherein Malcolm sees the conk as 'my first really big step towards self-degradation.' No attempt is made to address this mixture of feeling: pleasure and pride in the past, shame and self-denigration in the present. The narrative seems to 'forget' or exclude from consciousness the whole life-style of which the conk was a part. By invoking the idea of 'imitation' Malcolm evades the ambiguity, and his discourse cancels from the equation what his 'style' meant to him at that moment in front of the mirror.

In this context the conk was but one aspect of a modern style of black American life, forged in the subaltern social bloc of the northern ghettos by people who, like Malcolm Little, had migrated from southern systems of segregation only to find

themselves locked into another more modern, and equally violent, order of oppression. Shut out from access to illusions of 'making it,' this marginalized urban formation of modern diaspora culture sponsored a sense of style which answered back against these conditions of existence.

Between the years of economic depression and World War II, big bands like Duke Ellington's, Count Basie's and Lionel Hampton's (who played at the Boston dancehall where Malcolm worked as a shoeshine boy) accelerated on rhythm, seeking through 'speed' to preempt the possibility of white appropriations of jazz, as happened in the 1920s. In the underground music scene incubated around Kansas City in the 1940s, the accent on improvisation, which later flourished as bebop, articulated an 'escape' – simultaneously metaphysical and subterranean – from that system of socioeconomic bondage, itself in the ruins of war. In the high-energy dance styles that might accompany the beat, the lindy hop and jitterbug traced another line of flight: through the catharsis of the dance a momentary release might be obtained from all the pressures on mind and body accumulated under the ritual discriminations of racism. In speech and language, games like signifyin', playing the dozens and what became known as jive-talk, verbal style effected a discursive equivalent of jazz improvisation. The performative skills and sheer wit demanded by these speech-acts in black talk defied the idea that Black English was a degraded 'version' of the master language. These games refuted America's archetype of Sambo, all tongue-tied and dumb, muttering 'Yessa massa' in its miserable abjection. In the semantic play of verbal stylization, hepcats of the cool world greeted each other as Man, systematically subverting the paternalistic interpellation – boy! – of the white master code, the voice of authority in the social text of the urban plantation.

In this historical moment style was not a substitute for politics. But, in the absence of an organized direction of black political discourse and in a situation where blacks were excluded from official channels of 'democratic' representation, the logic of style manifested across cultural surfaces in everyday life reinforced the terms of shared experience – blackness – and thus a sense of collectivity among a subaltern social bloc. Perhaps we can trace a fragile common thread running through these styles of the 1940s: they encoded a refusal of passivity by way of a creolizing accentuation and subtle inflection of given elements, codes, and conventions.

The conk involved a violent technology of straightening, but this was only the initial stage in a process of creolizing stylization. The various waves, curls and lengths introduced by practical styling served to differentiate the conk from the conventional white hairstyles which supposedly constituted the 'originals' from which this black style was derived as imitation or 'copy.' No, the conk did not copy anything, and certainly not any of the prevailing white male hairstyles of the day. Rather, the element of straightening suggested resemblance to white people's hair, but the nuances, inflections and accentuations introduced by artificial means of stylization emphasized *difference*. In this way the political economy of the conk rested on its ambiguity, the way it played with the given outline shapes of convention only to disturb the norm and hence invite a 'double take,' demanding that you look twice.

Consider also the use of dye, red dye: why red? To assume that black men conked up *en masse* because they secretly wanted to become 'red-heads' would be way off the mark. In the chromatic scale of white-bias, red hair is seen as a mild

deviation from gendered norms which hold blonde hair as the color of 'beauty' among women and brunet hair among men. Far from an attempted simulation of whiteness, I think the dye was used as a stylized means of defying the 'natural' color codes of conventionality in order to highlight artifice, and hence exaggerate a sense of difference. Like the purple and green wigs worn by black women, which Malcolm mentions in disgust, the use of red dye seems trivial: but by flouting convention with varying degrees of artifice such techniques of black stylization participated in a defiant 'dandyism,' fronting out oppression by the artful manipulation of appearances. Such dandyism is a feature of the economy of style statements in many subaltern class cultures, where 'flashy' clothes are used in the art of impression management to defy the assumption that to be poor one necessarily has to 'show' it. The strategic use of artifice in much stylized modes of self-presentation was also written into the reat pleats of the zoot suit which, together with the conk, constituted the *de rigueur* hepcat look in the black male 'hustler' lifestyles of the 1940s ghettos. With its wide shoulders, tight waist and baggy pants – topped off with a wide-brimmed hat, and worn with slim Italian shoes and lots of gold jewels – the zoot suit projected stature, dignity and presence: it signified that the black man was 'important' in his own terrain and on his own terms.

The zoot suit is said to have originated within the *pachuco* subcultures of Chicano males in California – whatever its source, it caused a 'race riot' in Los Angeles in 1943 as the amount of cloth implicated in its cut exceeded wartime rations, provoking ethnic resentment among white males [see Chapter 25]. But perhaps the real historical importance of the zoot suit lies in the irony of its appropriation. By 1948 the American fashion industry had ripped it off and toned it down as the new, post-war, 'bold look' marketed to the mainstream male. By being commodified within such a short period, the zoot suit demonstrated a reversal in the flow of fashion diffusion, as now the style of the times emerged from social groups *below*, whereas previously regimes of taste had been set by the *haute couture* of the wealthy and then translated back down, via mass manufacturing, to the popular classes. This is important because, as an aspect of interculturation, this story of black innovation/white imitation has been played out again and again in post-war popular culture, most markedly in music and, in so far as music has formed their nucleus, a whole procession of youth subcultures from teddy boys to B-boys.

Once we recontextualize the conk in this way, we confront a series of 'style wars,' skirmishes of appropriation and commodification played out around the semiotic economy of the ethnic signifier. The complexity of this force field of interculturation ambushes any attempt to track down fixed meanings or finalized readings and opens out instead onto inherently ambiguous relations of economic and aesthetic systems of valorization. On the one hand, the conk was conceived in a subaltern culture, dominated and hedged in by a capitalist master culture, yet operating in an 'underground' manner to subvert given elements by creolizing stylization. Style encoded political messages to those in the know which were otherwise unintelligible to white society by virtue of their ambiguous accentuation and intonation. But, on the other hand, that dominant commodity culture appropriated bits and pieces from the otherness of ethnic differentiation in order to reproduce the 'new' as the emblem of modernity and so, in turn, to strengthen its dominance and revalorize its own symbolic capital. Assessed in the light of these paradoxical rela-

tionships, the conk suggests a covert logic of cultural struggle operating *in and against* hegemonic cultural codes, a logic quite different from the overt oppositionality of the naturalistic Afro or Dreadlocks. At one level this only underlines the different historical conditions, but at another the emphasis on artifice and ambivalence rather than the inversion of equivalence strikes me as a particularly modernist way in which cultural utterances may take on the force of 'political' statements. Syncretic practices of black stylization, such as the conk, zoot suit or jive-talk, recognize themselves self-consciously as products of a New World culture, that is, they incorporate an awareness of the contradictory conditions of interculturation. It is this self-consciousness that underscores their ambivalence, and in turn marks them off as stylized signs of blackness. In jive-talk the very meanings of words are made uncertain and undecidable by self-conscious stylization which sends signifiers slipping and sliding over signifieds: bad means good, superbad means better. Because of the way blackness is recognized in such strategems of creolizing intonation, inflection and accentuation, these practices of stylization can be said to exemplify 'modernist' interventions whose economy of political calculation might best be illustrated by the 'look' of someone like Malcolm X in the 1960s.

Malcolm always eschewed the ostentatious, overly symbolic dress code of the Muslims and wore 'respectable' suits and ties, but unlike the besuited Civil Rights leaders his appearance was always inflected by a certain *sharpness*, an accentuation of the hegemonic dress code of the corporate business suit. This intonation in his attire spelt out that he would talk to the polity on his terms, not theirs. This nuance in his public image echoed the 'intellectual' look adopted by jazz musicians in the 1950s, but then again, from another frame, Malcolm looked like a mod! And in the case of this particular 1960s subculture, white English youth had taken many of the 'found objects' of their stylistic bricolage precisely from the diasporic cultural expression of black America and the Caribbean. Taking these relations of appropriation and counterappropriation into account, it would be impossible to argue for any one 'authoritative' interpretation of either the conk in the past or the curly-perm today. Rather, the complexity of these violent relations of interculturation, which loom so large over the popular experience of modernity, demands that we ask instead: are there any laws that govern this semiotic guerilla warfare in the concrete jungle of the modern metropolis?

If, in the British context, 'we can watch, played out on the loaded surfaces of . . . working class youth cultures, a phantom history of race relations since the war' (Hebdige 1979: 45), then any analysis of black hairstyle in this territory of the diaspora must reckon with the contradictory terms of this accelerated interculturation around the ethnic signifier. Somewhere around 1967 or 1968 something very strange happened in the ethnic imaginary of Englishness, as former mods assembled a new image out of their parents' work clothes, creating a working-class youth culture that gained its name from their cropped hairstyles. Yet the skinhead hairstyle was an imitation of the mid-1960s soulboy look, where closely shaven haircuts provided one of the most 'classic' solutions to the problem of kinks and curls. Every black person (at least) recognizes the 'skinhead' as a political statement in its own right – but then how are we to understand the social and psychological bases for this postimperial mode of mimicry, this ghost dance of white ethnicity? Like a photographic negative, the skinhead crop symbolized 'white power' and 'white pride'

sure enough, but then *how* (like their love of ska and bluebeat) did this relate to their appropriation of Afro-Caribbean culture?

Similarly, we have to confront the paradox whereby white appropriations seem to act both as a spur to further experimentation and as modified models to which black people themselves may conform. Once the Afro had been ingested, black Americans brought traditional braiding and plaiting styles out from under their wraps, introducing novel elements such as beads and feathers into corn-row patterns. No sooner said than done, by the mid-1970s the beaded corn-row style was appropriated by one-hit wonder Bo Derek. It also seemed that her success validated the style and encouraged more black people to corn-row their hair.

Moreover, if contemporary culture functions on the threshold of what has been called 'postmodernism,' an analysis of this force field of interculturation must surely figure in the forefront of any reconstructive rejoinder to debates which have so far marginalized popular culture and aesthetic practices in everyday life. If, as Fredric Jameson argues, postmodernity merely refers to the dominant cultural logic of late capitalism, which 'now assigns an increasingly essential structural function to aesthetic innovation and experimentation' (Jameson 1984: 56) as a condition of higher rates of turnover in consumer culture, then any attempt to account for the gradual dissolution of boundaries between 'high' and 'low' culture, between taste and style, must reckon with the dialogic interventions of diasporic, creolizing cultures. . . . So who, in this postmodern melee of semiotic appropriation and countervalorization, is imitating whom?

Any attempt to make sense of these circuits of hyperinvestment and overexpenditure around the symbolic economy of the ethnic signifier encounters issues that raise questions about race, power and modernity which go far beyond those allowed by a static moral psychology of 'self-image.' I began with a polemic against one kind of argument and have ended up in another: namely one that demands a critical analysis of the multifaceted economy of black hair as a condition for appropriate aesthetic judgments. 'Only a fool does not judge by appearances,' said Oscar Wilde, and by the same token it would be foolish to assume that because somebody wears 'locks they are necessarily dealing in peace, love and unity; Dennis Brown also reminded us to take the 'wolf in sheep's clothing' syndrome into account. There are no just black hairstyles, just black hairstyles. This [chapter] has prioritized the semiotic dimension in its readings so as to clear some ground for further analyses of this polyvocal economy, but there are other facets to be examined: such as the exploitative priorities of the black hairdressing industry as it affects workers and consumers alike under precarious market conditions, or the important question of gendered differentiations (and similarities) in strategies of self-fashioning.

On the political horizon of postmodern popular culture I think the *diversity* of contemporary black hairstyles is something to be proud of, because this variousness testifies to an inventive, improvisational aesthetic that should be valued as an aspect of Africa's 'gift' to modernity, and because, if there is the possibility of a 'unity-in-diversity' somewhere in this field of relations, then it challenges us to cherish plurality politically.

Nancy Macdonald

THE GRAFFITI SUBCULTURE
Making a world of difference [2001]

A VERY CLEAR LINE IS DRAWN between graffiti life and 'real life' and writers are expected not to cross it. Drax illustrates this below when he talks to me about the dynamics of friction and dispute:

> With graffiti, you've got an alterego, which is your tag. And, you know, it can be 'Rough' is crossing out 'Skip', 'Rough' is saying this about 'Skip', it's all graffiti chit chat which blows between people, you know. But once you overstep the boundaries of personal behaviour, graffiti behaviour and people actually start knocking on your door and punching you in the mouth and stuff with no interest in regard to, like, graffiti or tags or anything okay, then you've overstepped the boundaries of what you can afford to get away with. I mean, I can sit here and go like, 'So and so', using their tag name, 'isn't any good, so and so is this, so and so is that.' But I wouldn't add to it, 'Yeah and, like, his sister's ugly too', or something. Do you see what I'm saying? You can't overstep that kind of like boundary.

When you step into this subculture, you are expected to leave all traces of 'real life' on its doorstep. This includes your background, your identities and the baggage that may come with that. Male writers cross this threshold carrying nothing but their graffiti name and persona. On this side of the line, 'you're only based on that, you're based on what your actions are under that name' (Stylo).

By soundproofing itself against the influences of the outside world, the subculture functions as a 'liminal' sphere. This is 'a transitional place in which normal expectations of behaviour are suspended, allowing participants to take on new roles' (Murray 1989: 186). Here, real life and the issues that may divide and influence it, are put on pause. Prime, a black writer, provides a powerful illustration of this below:

I mean, I've met people that I would have never met, people like skin-heads who are blatantly racist or whatever. I can see it in them and they know we know, but when you're dealing on a graffiti level, everything's cool, everything's real cool and I go yard with them, they'd come round my house, I'd give them dinner or something.

On this liminal terrain, you are not black, white, rich or poor. Unless you are female, 'you are what you write' (Sash). And what you write determines exactly who you are and where you stand. This is clearly conveyed in the quote below. Here, Jel tells his friend Sae 6 to show me his book of graffiti sketches and designs. Jel wanted to me to see how writers perceive and define each other:

You know what backs him up, show her the book Sae. You know, when you meet a writer and they talk to you, all you have to do is whip some-thing like this out. That's your credentials right there, that speaks for you, that says what you are and what you've done.

You can become 'more' than yourself in this subculture because you escape the need to represent yourself. Your graffiti, as Jel confirms, 'speaks for you', freeing you from the features or factors that might normally hold you back. In this liminal world, an 'idiot' can be 'alright': 'Once you get good at it, and it's not as if it's hard to get good at, people will think you're alright, when actually, at the end of the day, you could be a complete idiot' (Akit). A 'weirdo' can be respected: 'He's a bit of a weirdo, but he's alright, he gets up and that. That's why I respect him, because I see him up all around' (Rate). And a 'freak' can be a king: 'You could be four foot tall with four eyes, buck teeth and a lump, but if you rocked lines and produced fresh cars, you were a king' (Prime – *Graphotism* Magazine 3).

But a woman . . . cannot easily be any of these things. She is the exception here. Unlike male writers, she comes into this subculture laden down with the baggage of her gender. She cannot penetrate this liminal world and she cannot share in its rewards. This might lead some to dismiss it as an illusion; an idealistic fantasy which helps keep the subculture alive. But this would be to ignore the very real benefits that male writers enjoy here. This subculture is not a fantasy world, it is a man's world. And as such, it can still be used as real evidence of the real rewards women miss out on.

The name is the fame of the game – missing bodies

What we begin to gain at this point is a sense of removal. If 'writers judge each other through their artwork' (Lee), then, effectively, they dissolve the relevance of their personal and physical selves. This further emphasizes the female writer's exclu-sion from this subculture, since her physicality and sexuality are generally commented upon. However, it also says something interesting about youthful vulnerabilities and the insecurities surrounding who one is and how one looks. This [chapter] will explore this theme by looking at how writers use their written 'tag' names to build a non-physical or, as I term it, 'virtual' identity.

The 'virtual' self

In Proud 2's opinion: 'You can sum graffiti up in two words, "I am." That's basically what it is, "Look at me", it doesn't matter if you look at me in a negative or a positive way, but, "Look at me." When you strip it down, graffiti writers are literally honoured for nothing more than being – for existing and demonstrating this to others, a process they call making a name for yourself' (Cavs). This saying is fitting because it conveys a sense of absence. People can make a name for themselves in any area of life – for example, she has a name as a troublemaker; he is very tough on new students, he has a name for that. When you have name, it is not a direct confirmation of you, it is your reputation. Similarly, the writer is also 'making a name' in the sense that he/she is becoming known for something. It is not the writer that stands on the street corner declaring 'I am, I exist', it is their name. When writers 'make a name' for themselves, they literally, as this quote illustrates, make a written name 'for the self': 'I mean, look at graffiti, it's a celebration of self. It's, like, this is me, Claw, this is my name, this is my art, this is me, me, me. It's a me thing and it's my identity, this is who I am and it's a total representation of me' (Claw). Claw sums it up beautifully: 'this is my name, this my art, this is me.' And Stylo and Prime depict it beautifully in their quotes below:

> Like if you paint somewhere and you go back there, you feel like you belong . . . there's a bit of you there.
>
> (Stylo)

> You like seeing your name, you like knowing that, yeah, you've left your mark. It's like you being there and other people seeing it.
>
> (Prime)

When writers spray their names on a wall, they appear to leave a part of themselves there too. Almost like a stand-in or a double, the name embodies and represents the individual who wrote it – 'there's a bit of you there', 'It's like you being there.' Zaki recognizes this relationship between a writer's written name and physical self and puts it down to the sensory experience of using a spray can:

> With a spray can it's a different way of applying things, it's, sort of like, intimate with yourself. . . . A pencil and all those tools are extensions of yourself. But, for some reason, you've got this thing coming out with air and colour at the same time, it sounds kind of corny, but it is coming from you, sort of thing. As opposed to dip in the paint brush and apply colour, with spray it's so immediate, it seems to be coming from you sometimes.

The intimacy of this medium appears to infuse an essence of the writer into his/her work. The two merge and boundaries dissolve: 'Whenever I paint, it's just a physical extension of myself' (Iz).

When writers talk about their work, the self is always prominent. Their written names offer them a substitute for the self, a representation of the self, an embodi-

ment of the self and an extension of the self. Basically, their written names appear to offer them another form of identity. Alongside a 'different' identity, removed from 'real life', writers also take on a 'virtual' identity, removed from 'physical life'. They seem to be aware of this. In the extracts below, Akit, Stylo and Zaki talk about the way writers 'know' each other on the basis of nothing more than their written names:

> There's hundreds of people all over the city who don't even know what you look like, where you come from or nothing, but they know you. It's weird.
>
> <div align="right">(Akit)</div>

> When you're first known, someone knows who you are and they don't, they don't know you, you know, who you are, but they're talking about you.
>
> <div align="right">(Stylo)</div>

> It's a great thrill to do something then come back the next day and know that people are seeing that, but, at the same time, they don't know who you are. You never get, like, personal fame, you know, your name's famous, but you're never really famous.
>
> <div align="right">(Zaki)</div>

A theme that runs through all of these accounts is the writer's known/unknown status — 'people don't know you, but they know you, you are famous, yet unknown'. Writers appear to use this contradiction to distinguish between the two identities they possess; one physical, the other virtual, the name we see written on the wall.

Virtual construction and the reinvention of 'self'

Having a virtual identity leaves one's 'real life' or physical persona very much in the shadows. As Claw sees it: 'It's like you're a mystery. You know, the last time I did a piece I wrote, "Twinkle twinkle little Claw how I wonder who you are", because people don't know.' Even one's sex, the most prominent feature of one's self, is obscured: 'It's just a name, whatever, but I'd meet people and they'd heard of Akit, but they didn't know that Akit was a girl and stuff like that and they'd be like, "Oh, you're a girl"' (Akit). Writers clearly enjoy this disguise and the phantom-like status they gain from it.

> I kind of like the fact that people don't know who I am, they know Claw. My friends were telling me that they heard this rumour that Claw is like a big black kid with one arm and then somebody also told me that Claw is this Puerto Rican 15 year old and then Claw is this other person. I always hear these rumours about who is Claw and I kind of like it.
>
> <div align="right">(Claw)</div>

Notice the way Jel refers to a picture of his name as 'his picture': 'You know what's good, when you're hanging out with all these kids and they open up a book and your picture's in there and they don't know it's you though.'

The enjoyment writers experience probably stems from the fact that this virtual identity is 'a secret one and you can become more than yourself because people don't know you' (Stylo). As a virtual being, writer can transcend their sex, appearance and other physical features and effectively reinvent themselves. This is somewhat similar to Internet users and identity formation in cyberspace (Bassett 1997). The difference between them lies in the fact that writers can enjoy these rewards without the help of technology. Older than we originally thought, this concept of 'virtual identity' can he traced back to the subculture's first ever tag, throwup, piece or message:

> What youths thought about themselves, their environment and, maybe most importantly, what they wanted to be, was reflected in their tags, throwups, pieces, messages etc. They created identities for themselves.
> (Prime – *Graphotism* Magazine 3)

Let us now look at some of the tools they use to make these creations.

What's in a name?

The tag name a writer chooses is important as this can help them stand out in a crowd: 'There's a lot of names like Sim, Sem, Cap, Kip, Cop, Ken, Cess, which are just quite irrelevant really, you have to work really hard to get those names noticed' (Drax). The names that Drax labels 'irrelevant' appear to lack a solid sense of meaning. Conversely, a 'good name' carries connotations and, as Dondi indicates, a great deal more impact: 'You just had to have a good name, good names usually made it. A lot of guys had bad names, it just didn't click. Like, Butch is a good name, wow Butch!' The name seems to work when it conjures up some form of image – not any old image though. The writer below makes this distinction:

> An example of a good name is 'ARGUE'. It looks fly [good] when written, sounds cool when spoken and conveys a combative attitude. On the other hand, 'ENEMA' (actual name) looks, sounds and conveys a shitty attitude.
> (Mark Surface – *On The Go* Magazine, December 1993)

If a name conveys an attitude, then it plays a very important role in the process of constructing an identity. Effectively, it stands 'as a communication to the world about how one is feeling about oneself and what it is about oneself one would like to advertise' (Fiener and Klein 1982: 49). First impressions count, especially in this world where they are often only impressions. Consequently, writers need to think carefully about what they want to say about themselves. Acrid talks me through his intentions:

Nancy So why did you choose your name?
Acrid Do you know what Acrid means?

Nancy Acrid, it's bitter.
Acrid Yeah, that's me.
Nancy How did you get that name?
Acrid I liked the letters and I liked the meaning . . . I just thought
what word would suit me.

Acrid chose his name because it said something about him; something he wanted to say. Drax makes this link between a writer's name and search for identity below and explains the image he strove to create through his own choice:

Nancy So the tag name's important, you choose that with care?
Drax Yeah it is important, but there's some people who change their
name every week because of problems with the police or they
don't like the letters or they can't seem to find the right iden-
tity with it or whatever . . . With mine, I was thinking, 'Yeah,
yeah, this graffiti, I like it, I must get a tag', and I wanted some-
thing that sounded quite dynamic, you know, not one of those
smooth names, Romeo or something, right. I suppose an X has
got an element of that in it, one of those harsh sounding names.
And then there's this Bond film, *Moonraker*, and there's a guy
in it whose name's 'Drax', 'Drax Industries'. It just had this
taking over the world kind of feel about it, this mad guy that
was trying to take over everything.

Writers use their names to build up their identities, and the images they choose to project are revealing. Most communicate notions of strength, power and control – 'Butch' is macho, strong and forceful. 'Acrid' denotes this strength through its associations with a bitter taste, the opposite to sweet – a shocking or disturbing experience. Likewise, 'Argue', as the writer explained, conveys this feeling through its combative undertones. Although 'Drax' as a word has little meaning, its letters, the X specifically, the actual sound of the word and its original reference, again, imparts a sense of power and dominance, as he states, a 'taking over the world kind of feel'. Not all writers use their names to inspire these typically masculine conno-tations. Another image may be more relevant; Claw – incisive, sharp and piercing: 'It really fits my personality . . . it was just a natural tag.' Futura 2000 – a visionary pioneer: 'Futura 2000, it just had that kind of ring to it that seemed to apply and it was always done at an angle, going up to the right, so it was kind of like kicking off, going to the future.' Alternatively, writers may choose not to define themselves at all and adopt a meaningless word that has private significance or is beneficial for its letters alone.

'It's not just what you say, it's how you say it' – style as a statement

Given that the physical body is not a prominent feature in this subculture, what one wears and how one looks is not of great concern. Style, however, is. Rather than

clothe themselves, writers use their lettering styles to clothe their names, their virtual selves. As Prime explains: 'You build up a style, it's like your signature, a part of you, it's you saying something about yourself and putting it somewhere and other people see it and recognize it and click.' So what does a writer's style work to say or convey? For the most part, it would seem, something assertive: 'I don't believe it's possible for the aggressive vibes of graffiti not to show in any piece of art work produced by a writer' (Shock One – *Graphotism* Magazine 2).

Most of graffiti's lettering styles have a dynamic or robust appearance, giving writers' work a certain aggressive quality. 'Wildstyle' is probably the most provocative. This script wraps the writer's name in a flurry of sharp peaks created by its angular, interlocking letters. From these, arrows project rather like guns or weapons that have been embedded to protect the name. Overall, the piece looks a bit like a powerful machine or an armoured tank, implying through this, a sense of confrontation and unstoppable motion. Buried in its imagery, the name/the self takes on these connotations. [. . .]

Like clothing, graffiti gives writers the freedom to project an alternative image of themselves. . . . Unlike clothing, it also enables them to carry off this 'new look'. A small and shy writer can use graffiti to become a big and bold writer. But a small and shy skinhead might have a few more problems:

> If they sport heavy, macho clothing (for example Hell's Angels or Skinheads), they are a walking challenge and have to be hard enough to live up to their image. They have to indicate that they 'deserve' the uniform.
>
> (Brake 1985: 178)

The skinhead has to physically support or match his/her 'look'. The graffiti writer escapes these restrictions. Until, of course, they meet another writer in person. At this point, as Prime relays, a bubble often bursts: 'There's pictures you've built up of people. Every time you meet someone it's, "Oh, I thought you were a big guy", ha, ha, ha!'

A question of location

In looking at the ways writers build up their virtual identities, the location of the name should also be considered. At a time in life when issues of power, autonomy and control are key, this feature has a lot to offer.

These writers, among many, express the satisfaction they gain from seeing their names around their environment:

> I see my name about, I feel, sort of like, cool, good about it.
>
> (Rate)

> It was a good feeling to wake up the next day, walk along the street and see your name there.
>
> (Steam)

This enjoyment perhaps comes from seeing one's name as a representation of oneself; a self that is out there in the world, exposed, alone and, as Zaki implies, irrepressibly independent:

Nancy So what is it about that, seeing it again, just that it's there, it's permanent?

Zaki Well, no, because you know that it might not last. Hmm, it's like if you do a drawing, you go away and you come back and it's there on a bit of paper, your drawing. But if you do graffiti, it's on a wall or a train or something, it's in a different element, it's on a medium that you've never seen before and it's out there in the world, sort of thing. I know it might sound stupid, but if you've done something inside, you've got on the light, it's inside in a familiar surrounding so it helps, but if it's outside, it's not natural . . . it just stands out.

A name on a piece of paper sits inside, safe in its sheltered environment. A name on a wall or train, however, enjoys none of this protection: 'It can be destroyed within hours and you're doing something that moves as well . . . it moves around and then it gets killed' (Zaki). The imagery Zaki uses here is interesting. In this 'animated' narrative, the name or virtual self resembles a hunted animal, out there alone braving the rigours and hazards that it may encounter. It earns a boldness from this, but it also acquires a guise of supremacy:

Like you usually see letters on little things and to see a word that big moving along or even stationary on a wall, it's not what you'd normally see, it's out of its normal surroundings, it's blown up. . . . You see the colour or the outpouring of graffiti, it stands out amongst all that.

(Zaki)

. . . Feiner and Klein (1982: 49) elaborate on this theme:

Names help tame the powerful. Giving something a name or label offers the illusion of controlling or limiting it. The subway's powerful machines are tamed by placing one's name on them; the name celebrates victory and possession, like one's brand on a wild steer.

The speed and motion of the train only magnify this dominance. As Lee observes: 'That was the beautiful thing about it, that these pieces moved out of your sight and you couldn't arrest it, it arrested you for the few seconds that it was in the train station, for when it went by you, then it was gone.'

 The name enjoys the same power as the machine it rides upon. It cannot be stopped. It lies beyond the control of those who see it passing. Against the force of the train, they remain impotent. They can only watch as it thunders past to its next destination. 'It's a good feeling to see your name run' (Cavs) – like the train, the name or virtual self is going places.

'Shouting on the wall' – animating the virtual self

To most people, graffiti is just background scenery, urban wallpaper if you like. To those who write it, however, it is a secret sign language – literally: 'There's conversations between people who haven't met, through writing' (Prime). As writers' names hit the wall a form of interaction begins to develop, one which mirrors, on the wall, the activities that might occur in front of it. In line with their virtual identities, writers have created a form of virtual communication. This means that 'even without the physical contact of networking with people, interaction is constantly being made between writers that don't even know each other' (Drax).

Drax presents this exchange as a substitute for face-to-face or physical interaction – a process which has been termed 'metonymy' (Marsh et al. 1978). Zaki and Series provide further evidence of graffiti's metonymic role below by describing its purpose in purely 'physical' terms:

I see tagging as *talking* to other graffiti artists.

(Zaki)

Basically it's just *shouting* all over a wall. It doesn't mean anything, it's just *shouting* all over a wall.

(Series)

I would disagree with Series here. Shouting all over a wall like this is far from meaningless. It plays a very important role. Namely, it allows writers to animate or put the virtual persona they have chosen to evoke into play. In this way, it offers them another resource with which to construct their virtual identities.

Sign language

As true as it was when Kohl (1972: 87) wrote it: 'A simple reading of wall graffiti gives one a sense of the range of irony, cynicism, ambiguity, praise and insult that is at the command of individuals.' If you watch the walls, the first thing you may notice is the way 'Graffiti attracts graffiti' (Acrid). What is happening here is 'that you're communicating with others. You'll find that you do a tag and someone else will tag next to it' (Ego). A name appears and slowly it will morph into a small congregation, as others see it and add their own. In one sense, it is a simple way of saying hello. Just like friends who meet in the street and stop for a quick chat, 'You're letting them know you've seen them there, like instead of walking past the wall, "I know you've been here"' (Acrid).

But this gesture carries more than just a polite acknowledgement. In a subculture fuelled by competition and divided by status, this greeting is also an important mark of respect. Drax explains:

If someone I've never met before happens to have placed a tag everywhere that I've done, depending on the way in which it is done, I could take that as a sign of respect. Like he's saying, 'I've seen your name, I'm, kind of like, following your spots as well.'

Positioning yourself up close to another writer's name indicates that they are worthy of your attention. In effect, it grants them some importance. But here it gets more complicated. While this homage may be suitable behaviour for a younger/unknown writer, for a more established name it is seen as unfitting. Drax explains how writers use wall space to assert their status:

> Say I place a tag on a huge big wall, nothing on it, generally speaking another accomplished or known writer will come along and place his tag somewhere indiscriminately on the wall away from mine. Even though he's obviously seen your tag, he'd be more of the attitude, 'I saw the wall, I wrote my name there, I don't even remember seeing your name there', that kind of mentality. Whereas a younger writer might give you the acknowledgement and not really worry about that kind of thing, actually deliberately putting it near your name just to, sort of like, say, 'Yeah respect, I've written here too.'

An unknown writer on a mission to be noticed has a lot more names to meet and greet before he/she can afford to be stand-offish. Knowing that 'writers will always look at their own tags when they go past again' (Drax), it pays to get as close to them as possible. He/she will need to be careful though, because mixing one's signals is, as Drax demonstrates, an easy mistake:

> If I'm doing tags, whether there's a few on the wall or whatever, if I come back and there's a tag deliberately placed above mine, sometimes it could be taken as like a friendly little challenge, but a lot of the time it is a deliberate attempt to make you look irrelevant, you know, especially if there's loads of other space on the wall.

Like any social situation, there are rules of etiquette that need to be learnt. Place your name above, rather than beside, another's and you will receive a less than warm reception. This is a plain and simple way of saying I'm above or better than you. [. . .]

Crowding another writer's name with more than one of your own literally declares, 'I'm more than you'. The surrounded writer's status is questioned because the space that supports it has been reclaimed by the other writer.

A larger name, as Drax implies, can relay a similar message:

> If you had a huge can of paint, you'd just hit the wall. You wouldn't need to sort of try and put it next to anyone, because there's no way they're going to go past and miss it. That big name could even be taken as offensive, you know. And, of course, there's the possibility that you might accidentally clip over the edge of their name.

The greatest danger of using a larger name lies in the possible contact it might make with another's. When you touch a writer's name, you break one of graffiti's most cardinal rules: 'Everyone knows from day one that if you go over the top of

someone that is a serious crime, sort of thing' (Zaki). A writer's tag is sacred and most writers . . . will go out of their way to respect this. [. . .]

If cramping a writer's space signals their insignificance, then encroaching on it to the point of touching or covering their name is an even greater insult. A writer should not make this contact 'unless you want to show a deliberate lack of respect for them. It's like you're showing, "Well I don't care about you, I'm just going to write the name on you"' (Drax). A metonymic translation of this might see the individual pushed aside or ignored.

In this case, though, there is some room for poetic licence. Acrid explains how size steps in as an influencing factor:

> As long as it's bigger and better, it's not so offensive. . . . I've done plenty of pieces over people's tags. It wasn't a sign of disrespect and it wasn't taken as that. Say I put a tag over someone's piece, that's a sign of disrespect. But if it was the other way around, it would be no big deal.

[. . .] While a name over a name can be read in different ways, a line through this offers no such ambiguity. It ignores all the rules which work to protect the name and represents the most extreme mark of disrespect. For Akit, who found her name lined out,

Akit	I was just like, 'Oh my God, fuck, oh no!' It's like the end of the world, you know.
Nancy	By lining you out what are they saying?
Akit	'You're shit, you're nothing.'

A line is taken to be a more striking attack because it is a deliberate and violent slash through one's name. If a tag over a tag is a subtle shove, then a line is a punch in the face. Supporting this translation, Drax presents a slap and a line as optional, and thus comparable, forms of punishment: 'He'd find out by getting his name crossed out or a slap in the head from someone that he'd done the wrong thing.' Additionally, the offended writer will usually use this symbol to fight back with. Retaliation is the normal response to finding one's name crossed out:

> If people go over me, diss [disrespect] my pieces, any of that, when someone disses me, I'll diss them back.
>
> (Col)

> If someone dogs [lines] me out, I just dog them out myself, see their tag, dog them out as well.
>
> (Rate)

The exact same stages of a physical fight are metonymically enacted here. A writer is insulted, assaulted or challenged and he/she retaliates to defend his/her threatened honour (Matza 1964; Polk 1994). In most cases, the 'beef' or friction will be 'squashed' by this response. In some, though, the dispute drags on.

A fight that continues or escalates is generally recognized as a 'war'. Writers use their city walls as a billboard of information, so a large 'cross out war' usually becomes a focus of interest. In the early days of my research, such a war erupted in London. Cred, a relatively young and unknown writer in the crew RCS, began to line out Drax, a figure of considerable standing within the London scene. It started, predictably, with a throwaway insult: 'Something about Drax cussing [insulting] RCS, saying they were all toys and that' (Rate). Acrid, the leader of 'RCS', gives his take on this: 'I think a lot of it was because RCS, the people that started it, were from Drax's area and were, like, younger, toy writers. In time we overtook him and he got a bit upset. . . . He couldn't outdo us.' Naturally Drax offered me a very different version of events:

> In my opinion, it started because a lot of the RCS people came from my area, and I've always done a lot of stuff here, got more exposure. . . . To use a phrase, I suppose a couple of them got out of their prams really. It's like they got jealous and rather than sort of have respect they started to just show total disrespect really, just going over my stuff, sort of like saying, 'Well we're from round here as well', sort of thing. And then I suppose I crossed out their stuff and it developed from there. . . . It just got more and more malicious really.

Whatever the initial cause or reason, it sparked a conflict that made its mark on the entire London scene. As the scale and fervour of this war intensified, others began to take sides and get involved: 'Writers that don't even know either of us in person were actually going round crossing Cred out, just because he was discrediting an accomplished writer for no reason' (Drax). Likewise, others stepped in on Cred's behalf and extended the boundaries of the war by attacking those with no direct involvement. Kilo found himself caught in the middle of this crossfire:

> 'Cred' and 'Serch' and all that lot, they all had a go, but then 'Fest' just tried to carry it a bit further by crossing out me and a load of people that were innocent, people that weren't even involved in it the RCS, PFB business.

The war raged on for a year and a half before a ceasefire was declared and calm was restored. As Kilo remembers it:

> That Cred guy must have obviously had enough because I saw a piece that he did in Hoxton, like Drax's area, and on the dedications it had PFB and all the crews that he'd messed with. So, I dunno, maybe he just thought is it worth it.

Writers will often dedicate their pieces to other writers and crews as a sign of respect. Like a handshake, then, Cred used this gesture to call a truce. Unbeknown to the rest of London, the war that had stormed within their city and fractured an entire subculture had just been brought to an end.

The virtual self: reaching the parts other selves can't reach

In the previous section we saw how writers use their graffiti to 'make a name' and literally make themselves. They adopt a virtual identity, and using a number of different tools, sculpt, shape and bring this to life. So what sort of persona are they creating here? What do they use this new identity to say about themselves? For the most part, something masculine it would seem. Many writers choose a hard or 'macho' sounding name and then write this in a visually bold or aggressive style. This style can make them look like a 'raving psychopath', a 'violent person' or perhaps just bigger and bolder than they really are. This name is then situated outside, in locations which give it a sense of fortitude, dominance and, depending on where it is placed, life. Positioned on a wall with other names, writers have the power to animate their virtual personas and communicate – greeting, challenging, insulting, assaulting, attacking and fighting with other writers. Although they have a choice over what they can say about themselves with this identity, masculine narratives of strength, power and control appear to prevail. The virtual self is clearly used as a masculine resource and an immensely powerful one at that.

The pen is mightier than the sword

Drax and Cred never actually met each other. They assaulted, insulted, attacked, fought and despised each other for a year and a half, but they never ever met in person. When a fight like this starts on the wall, it usually stays there. Using words and symbols, rather than fists and weapons, enemies 'will battle it out on the wall in paint' (Col). There are no injuries, no broken bones, no scars, no casualties. Here, you 'get a photo to show for it instead of bruises' (Prime). This is the beauty of the whole process. But it is also the point. As Willis (1990) and Marsh *et al.* (1978) also observed in their studies, the goal is not to fight as often as possible, but as little as possible:

> Nancy How do you diss [disrespect] someone?
> Col Well, usually, you just go over what they did. It's very odd that
> a writer will go up to a writer they don't like and say it to his
> face because then there'll be a regular fight.

Physical provocation invites a physical response. Virtual provocation invites a virtual response. . . . By picking up their spray cans and sticking with the wall, writers override the constraints which might otherwise tarnish their masculine displays. As Willis (1990: 104) recognizes: 'The worst . . . is to be somebody who acts hard but is really not hard "inside". Such a person creates an external persona that is unmatched by bodily force and skill.'

With graffiti you can create this image, but you do not need to live up to it. This makes it a much more powerful masculine resource, than say, sport (Messner 1987, 1991; Westwood 1990; Willis 1990), fighting (Polk 1994), bodybuilding (Mishkind *et al.* 1987) or posturing (Brake 1985). True, these physical activities can serve as constructive options when men have no others (Brake 1985; Messner 1987,

1991; Mishkind *et al.* 1987; Polk 1994; Westwood 1990; Willis 1990). After all, a man always has his body: 'One of the only remaining ways men can express and pre-serve traditional masculine male characteristics may be by literally embodying them' (Mishkind *et al.* 1987: 47). But not all men are created equal and not every man will have a body he can benefit from, no matter how hard he works at it! In graffiti, none of this matters. 'You are what you write' (Sash) in this world, which means 'Your name has to mean power' (Jel), your physical and personal self does not.

The freedom writers gain from this is enormous, and they well know it:

> It's no coincidence that graffiti is just a piece of art and that's what you get your respect for. . . . I've never been someone who wants to draw attention to myself, I've never been that confident. But, at the same time, I was doing something that put myself in the spotlight, sort of thing. But with graffiti, it's your artwork that's on show, not yourself.
>
> (Zaki)

Zaki talks about his graffiti or 'virtual identity' as if it were an actor, one that reaches the parts his other identities cannot reach. For many, graffiti is exactly that, their one and only opportunity to put their 'real' selves aside and play the role they have always wanted to play, the character they have always wanted to be. [. . .]

Individuals who are shy and unconfident find a voice through graffiti because they do not have to speak. Their name or 'virtual self' speaks for them which means they can recreate themselves and then sit in the wings and direct the performance:

> Even though what you're doing is yourself, it's being able to open up yourself without actually changing yourself. . . . The thing that sums up graffiti, it was a way for me, and probably a lot of other people, to express themselves and feel confident and feel they are part of the world, but, yet, still be me.
>
> (Zaki)

Michael Atkinson

TATTOO ENTHUSIASTS
Subculture or figuration? [2003]

T HE FIRST TIME I WALKED into a classroom to lecture without a long-sleeve
shirt (exposing my full-tattoo sleeves on each arm), I experienced the saliency
of dominant interpretations of tattooing in Canadian cultures. University students
are a relatively well-tattooed group, accounting for a significant portion of tattoo
enthusiasts in North America. I thought the students would react favourably to my
tattooed arms. With some trepidation, I walked down the steps leading to the front
of the lecture hall. What was typically a boisterous and energetic group of two
hundred students turned into a congregation of silent spectators. I heard whispers
and gasps throughout the class, and peered around to see wide-eyed students with
their mouths agape. Their collective reaction was a mix of disbelief, confusion, and
fascination. I am not sure the students heard anything I said that day, as their atten-
tion appeared to be focused on my arms and not my words. In sociological terms,
this event was a classic breeching situation, wherein my appearance as a tattoo enthu-
siast violated the conservative norms and standards of physical display expected of
a teacher in the classroom.

Following the lecture, a few students approached me as I had expected. Some
wanted a closer inspection of my tattoos, some inquired about where I had been
tattooed, while others simply wanted to ask if the tattoos were real. Following
this brief question-and-answer period, I immediately reflected on the participant
observation and interview information I had gathered on tattooing in Canada. Among
other ponderings, I started to reconsider whether or not an actual subculture or
community of tattoo enthusiasts exists in Canada. For example, all the students
who approached me were tattooed themselves, and posed questions relating to
my involvement in the practice or my personal connections with tattoo artists.
They spoke to me as fellow tattoo enthusiasts, drawing on several common terms
and expressions familiar to any individual who has participated in the practice.
Even though I had been wrestling with the idea of a tattooing subculture before this

day, I started to question seriously whether or not individuals who participate in this body project share certain subcultural activities, ideologies, identities, and relationships as a group. So I also asked myself, Is there such a thing as a tattooing subculture, at least in the way that sociologists have classically conceived what a 'subculture' means?

Based on the knowledge I have gained of tattoo enthusiasm in Canada, I believe that sociologists should reconfigure our theoretical understanding of them around Elias's (1978, 1983, 1991, 1994, 1996) conceptualization of social 'figurations.' Rather than conceiving of tattoo enthusiasts as a cohesive subculture, life-world, or scene of interacting individuals, I believe that a more empirically accurate depiction of tattoo enthusiasts is formed by employing the concept of figuration. While extant sociological constructions of the practice (e.g., Cohen 2000; DeMello 2000; Irwin 2000; Rosenblatt 1997; Sanders 1989) tend to portray tattoo enthusiasts as a distinct culture, subculture, or community, such depictions are found to be misleading when we examine enthusiasts' narratives about their tattooing experiences. [. . .]

Tattoo figurations

In developing a preliminary case for considering how and why tattoo enthusiasts constitute a figuration of interrelated social actors instead of a community or subculture, we must bracket the nature of enthusiasts' interdependencies into two major components: becoming tattooed as a process and developing of relationship chains in tattooing. In the following, an analytical overview of these components is offered as a means of initiating a larger discussion of how sociogenic transformations both inside and outside of the Canadian tattoo figuration play roles in altering enthusiasts' tattooing habits, how individuals actively choose tattooing as a redesigning body project, and how individuals construct narratives about their tattooing projects over time.

Becoming tattooed as an interactive process

. . . [U]pon first inspection, the tattoo enthusiasts I encountered over the course of my investigation appeared to share little in common other than the actual physical process of being tattooed. Still, this is the basic chain of interdependency forming the first fragments of the figuration. We could not commence an analysis of contemporary tattooing practices in Canada without this recognition – as trivial or taken-for-granted as it may seem.

The actual process of tattooing has changed only minimally over the last one hundred and twelve years. The electric tattoo machine invented by Samuel O'Reilly in 1891 has been modified only marginally, and the inks used in the process slightly diversified (i.e., range and quality of colours). For the most part, though, the ways in which tattoos are administered in Canada are barely different than in previous eras. Let's focus, as an example, on the tattoo machine, which operates roughly like a sewing machine. A needle, or a combination of needles, are soldered onto a bar that is encased in a steel tube. The tube is attached to a bar running underneath

the transistors of the tattoo machine that regulate the current supplied by the external power source.

When electric current is sent into the machine, the needles rapidly move up and down through the tube, slightly poking out of its tip. The tattoo machine is held in the hand, the artist dips the tips of the needles into colours stored in small ink caps, and the machine is moved across the skin to perform the tattooing. The needles penetrate the skin (anywhere from 50 to 3000 times per minute), and ink seeps into the subcutaneous holes created by the needles. Perforating the skin to about 1/8 of an inch, the needles are pushed deep enough into the skin to prevent the ink from bleeding out, but not so deep as to mulch the skin or mute the ink's appearance through layers of thick skin. With the exception of individuals who choose tribal methods of tattooing (i.e., hand-poking or tapping, where larger needles are inserted into the skin manually) or are tattooed in some prison contexts (i.e., using a crude variation of hand-poking or a makeshift electric 'tattoo gun'), the vast majority of Canadians are tattooed via the standard electric method administered by a professional artist. Only two of the tattoo enthusiasts I interviewed had experience with hand-poking or another method of tattooing. Furthermore, only a handful of the group were tattooed by a non-professional artist. Thus, enthusiasts share the electric experience as perhaps the most elementary tie binding them together.

However, by exploring how enthusiasts begin to interact with others who are tattooed (particularly during the initial stages of the process), we can see how they venture down a series of common interactive pathways that go beyond the simple application technique. For instance, before participating in the act of tattooing, individuals generally undertake a several-pronged fact-finding mission about the process. Most people know little about the physical process of being tattooed before they participate in the body project for the first time. Contrary to cosmetic-surgery body projects (Davis 1994, 1997; Dull and West 1991; Gillespie 1996), people do not extensively consult with the individual administering the tattoo in order to review the process in detail. Instead, clients may sporadically pose random questions about the process to close friends (or, in some cases, artists):

> I knew a bit about tattooing but couldn't tell you how it was actually done, and that worried me a bit. Truly, it did. Three of my friends have tattoos so I asked each of them about how it feels and all that stuff about healing. They couldn't tell me much. I guess it's something you have to learn as you go through it, but I just wanted to have my mind put at ease . . . especially about how much it hurt and how to take care of it [afterward].
>
> (Susan, 21)

> The first question people who are new to this ask, and I'm sure you've heard this before, is, 'how much does it hurt?' – usually right before I'm going to hit them with the needle. I get sick of answering that question, but you have to be patient with people because you understand that they're scared about needles and the pain and all that. They don't know what it feels like to be tattooed . . . They may want a tattoo but have no

idea what to expect. It's not like going to get your hair cut. People know there's blood involved, so they want to know about the pain. I tell them it's not bad, and people handle it with no major convulsions.

(Jimmy, 24)

Sometimes, travelling to a tattoo studio with a friend and sitting in while they are tattooed provides a prospective client with some preliminary knowledge about the practice:

I went down with my best friend Carmen when she had the band [barbed wire] done around her arm, and that calmed me down. I got to talk with the artist for a while and I saw what he was doing . . . a lot better than even Carmen got to see! He went through the procedure, so I knew what to expect when I was going to go in.

(Rosalyn, 22)

Almost universally, individuals commencing their quests into tattooing search for some cursory knowledge about the physical process.

Another central feature in the fact-finding mission involves locating a suitable tattoo artist. The individuals I interviewed indicated four main ways in which an artist is located and then selected.

The most common method of acquiring knowledge about a specific tattoo artist and selecting them for the project (49% of the clients interviewed) is through a referral from a tattooed friend: 'I knew about Sean [tattoo artist] because four of my friends were tattooed by him. They raved about his work and how nice he was, and I've seen their tattoos, and they're done well. There's a whole whack of shops in town, but I figured since he was highly recommended by my friends, that's good enough for me' (Kurt, 22). The second most common reason for selecting a particular artist is the rate they charge for the service. Nineteen of the clients (29%) stated that the tattoo's price, as quoted by an artist, was the determining factor. As artists vary in the amounts they charge (by the hour or the size of the tattoo), some clients engage in a considerable amount of price-shopping. This practice continues to be frowned upon by many tattoo artists, but price is a key consideration for neophyte enthusiasts nonetheless. The tattoo artist Jimmy (24) commented:

Well, if I had five bucks for every person who went down the wall of flash [in his studio] and asked, 'how much is this . . . well, how much is this one . . . okay, what about this one?' I get pissed by that, but people try to negotiate and haggle prices all the time. It's mostly people who don't know shit about tattooing, and don't realize that a thirty dollar tattoo looks like a thirty dollar tattoo . . . You get all kinds [of customers]. From teenage girls who come in with three of their friends asking if they could get a discount if they were all tattooed, or a guy who tells you one of your competitors said he'd do the same tattoo for fifty bucks less. Whatever the case, I tell them to beat it . . . I will never figure out why people try to find the best price when they're going to have their tattoos for the rest of their lives.

Compare these sentiments to Clarice's (26) words:

> Why should I pay the most for the same tattoo? . . . I mean the one I
> have isn't complicated. I really don't care how famous the artist is or
> anything like that. I thought I shouldn't be paying more than a hundred
> dollars for it, and I searched around town until I found a guy who would
> do it for under that.

The third most common route to finding an artist involves the location of the
artist's studio. Nine of the clients I interviewed (14%) chose to be tattooed in studios
that were close to their respective places of residence. Sanders (1989) suggested
some time ago that individuals will likely select a tattoo artist who operates out of
a studio in or near their neighbourhoods. Being able to learn about the studio by
walking or driving past becomes the only criterion for selection – perhaps strictly
for convenience:

> I walked past Sacred Art about five times a day, on the way in and out
> of my apartment. I live right down the block and I've looked into the
> studio hundreds of times . . . When I committed myself to tattooing, I
> just walked down the street and starting talking to the artist there. It
> was really simple and hassle free.
>
> (Yvonne, 26)

The fourth most common method of learning about and then selecting a partic-
ular artist is a personal inspection of the artist's work. Five of the tattoo enthusiasts
I interviewed suggested that the reputation (i.e., for high-quality art) of the tattoo
artist dictated their selection. Again, informal friendship networks are vital sources
of information here. More frequently, however, people will examine artists' port-
folios (readily available in the lobbies of tattoo studios) as a means of assessing their
abilities. Assessing the quality of the artwork generally involves looking to see if the
colours used in the tattoos displayed are vibrant, the designs are complex and
creative, and the lines clear and smooth:

> I know these guys [artists] probably put their absolute best work in the
> albums up front, but there's no better way to see what a guy can do. I
> wouldn't have done it any other way . . . I wanted to have some north-
> west Native Indian work on my back, and searched around until I found
> Kris. He's a master in that style, and you could tell right away from the
> pictures of his tattoos. I didn't care how much he charged, I just wanted
> my tattoos to be as good as that.
>
> (Sandra, 34)

While individuals typically participate in one of the above methods of locating
and selecting an artist, they similarly pass through *common* processes and figurational
patterns in scheduling and experiencing a tattoo appointment. For instance, while
some studios allow for 'walk-ins,' most require that clients schedule appointments
(usually one to five weeks in advance) and provide down-payments to secure their

appointment (typically 10% of the total cost of the tattoo). Clients are also regularly asked to arrive anywhere from thirty minutes to one hour before their appointments, and are asked to sign a consent waiver before the process commences:

> I ask people to sign a waiver just because you have to cover your ass
> . . . in case someone is allergic and doesn't know it, if they have some
> medical condition, or like, if their body is going to react weirdly to the
> ink. Also, it's about making them declare that they are over the age of
> eighteen . . . All the consent form is really about is just a way of making
> them sign a sheet saying they're aware of the dangers and that they're
> doing this under their own free will.
>
> (Jones, 27)

The bulk of in-depth ethnographic research on tattooing (e.g., Sanders 1989; St Clair and Govenar 1981; Steward 1990) details along these and similar lines some of the minute processes involved in securing and initially experiencing an appointment. Describing the everyday interactions unfolding in tattooing studios, the research furnishes a thick account of how individuals become first involved in the physical practice.

In the participant-observation phases of this investigation, I also noted that artists fabricate standard 'routines' for tattooing their clients. When I asked tattoo artists about the rituals involved in tattooing their clients, they agreed that standard ways of interacting with clients become conscious and unconscious habit. For instance, clients are told to sit in tattoo chairs in particular ways (depending upon what segment of the body is being tattooed), given a briefing about the technical aspects of the procedure (e.g., sterilization procedures), and provided with detailed instructions for after-care (a daily regimen to maximize the skin's retention of ink and minimize the possibility of infection). Moreover, they are spoken to frequently during the process (small talk and humour to reduce clients' nervousness), encouraged to vocalize their pain (i.e., as a means of helping clients manage their identities), advised to maintain steady and deep breaths (to avoid fainting), and given opportunities throughout the procedure to stop for a brief period (e.g., three to five minutes to rest and recoup). As a way of bolstering clients' feelings of accomplishment and pride after the process, one tattoo artist I met recited the same humorous speech to his clients: 'Congratulations, and welcome to the club. We have meetings every Tuesday night at Desperado's nightclub. Knock three times at the back door, and flash them your tattoo to get in. Just tell them shaky Pete the tattoo artist sent you' (Doug, 26). Routinely drawing upon what works well, artists create and adjust their scripts for interaction. They forge routine verbal and physical scripts, resembling what Schutz (1967) might call 'typifications' or what Garfinkel (1967) might refer to as 'objectifications,' to lead their clients through the process. Clients, therefore, experience various segments of the actual tattooing process in very similar ways. The fact that artists have concocted standard or typical ways of interacting with clients based on their cumulative past encounters illustrates the ways in which clients are connected to one another through chains of interdependency. As Atkinson (2000) noted through research on the ticket-scalping community in Canada, formulating categorical understandings of clients is a mainstay

aspect of conducting any commercial business. Each client unknowingly (and some-times knowingly) enters into a set of pre-established interdependencies and scenarios of interaction that predates their involvement in the practice.

Finally, clients also experience a common process of physical pain and healing in tattooing. While felt and expressed in varying degrees (depending on one's overall health, threshold for pain, and previous experience with tattooing – as well as the portion of the body being tattooed, size of the tattoo, number of needles used in the process, speed of the tattoo machine, and audience witnessing the event), phys-ical discomfort is relatively inescapable in the procedure. Described by clients through terms such as 'burning,' 'irritating,' 'scraping,' 'pinching,' or 'cutting,' pain is an ongoing concern for tattoo enthusiasts. While pain is a factor preventing some individuals from dabbling in the body project, once it is met and managed in the process, clients seem to be more comfortable with the practice. As a tattoo enthusiast named Jill (34) stated:

> I don't think of myself as a wimp or anything like that, but I was nervous about how much I thought tattooing was going to hurt . . . The first few lines, and maybe the first half-hour kind of smarted a bit, but after that it was pretty easy to sit through . . . Now, I don't consider the pain at all . . . That's not going to stop me from covering my body.

Artists will not mislead their clients about the pain involved in tattooing, neither downplaying nor exaggerating the physical trauma involved. Viewed as a sacred part of being tattooed and as a mark of one's commitment, the ability to endure pain is lauded by many enthusiasts: 'Tattooing is not for everybody, and probably too good for most people, and how someone deals with pain is a good indicator of how deep they will become involved. It's not too painful to sit through, so people will do it, but painful enough that a lot of people are scared away . . . It's like a Zen balancing act' (Ed, 29).

After the process is complete, and the person has managed the physical pain involved in being tattooed, a healing period (between seven and twelve days) is endured. The abrasions, cuts, scabs, and bruises quickly fade away and the skin heals. Following only the most rudimentary restrictions (e.g., no swimming, no direct exposure to the sun, washing once per day with mild soap, and applying aloe or a salve to the skin three times per day), the tattoo will heal in most cases without complication:

> Some people freak out when they start to see their skin flaking off and think their bodies are rejecting the ink or they're having an allergic reac-tion. Even though we go through the procedure for after-care with everyone, and they all receive our sheet of instructions, about three out of every ten calls that come into the shop everyday [not appointment-related] are about healing . . . whether that's a general question by someone who is thinking about being tattooed or someone who is healing and some condition they are experiencing isn't listed on the sheet I gave them . . . It's usually nothing, right. Like a pimple from all the cream, or an area where you went too deep and it's scarred up a bit.
>
> (Phil, 24)

After-care is nothing. I was all worried after my first tattoo, and treated
it like I'd been shot or something. It's so stupid, your body is so much
tougher than that. If you just use your common sense, your skin is really
resilient, so, no problems. I've been tattooed four times now, and I'm
learning what works best. A tattoo artist or one of your buddies just
can't tell you that.

(Kevin, 25)

Thus, clients commonly experience several pathways or trajectories in the
processes of arranging to be, and becoming, tattooed. Through the experience of
similar corporeal and interactive practices, preliminary links between individuals'
body-modification practices are formed. Just as individuals who participate in
cosmetic surgery are collectively tied to one another in the reproduction and reaf-
firmation of class- or gender-based codes about sexuality and corporeal aesthetics
(Dull and West 1991; Gillespie 1996), tattoo enthusiasts are linked by their common
experiences in this form of body redesign. As a series of interdependencies between
artists and their clients is created, the first strands of the figuration are forged.

Relationship chains

The loose chains formed between artists and clients through the processes noted
above are welded into tighter interpersonal bonds as relationships begin to take
shape around, or are affected by, tattooing body projects. Preliminary relationships
between artists and clients are based on the physical act of tattooing (one takes the
role of the artist and the other the role of the client). Tattoo artists and clients are
mutually dependent upon one another, since artists cannot parlay their flair for
tattooing into a profession unless clients can be secured on an ongoing basis, and
clients may not fulfil their desires to modify their flesh (in most cases) without the
expertise of a tattoo artist. Personal involvement in the practice tends to have a
ripple effect in one's relationships both inside and outside of the tattoo figuration.
Involvement in tattooing alters one's interdependencies among tattoo enthusiasts
and non-enthusiasts alike.

When an individual participates more extensively in tattooing, he or she can
become immediately recognizable to others as an enthusiast. To this end, some of
the individuals I encountered deliberately wear tank-top shirts, shorts, or other
revealing articles of clothing to show off their tattoos. Clients that I interviewed
often spoke of such display as a means of sending out a communicative beacon to
like-minded others:

When I'm out and about and people roll up on me and comment on my
tattoos I like it. I wouldn't wear sleeveless shirts if I didn't. Seeing
someone else with heavy coverage is always cool for me. I go right up
to people who are showing off their tattoos and ask them about where
they were inked and who did them . . . I kind of think about it like a
port in a storm. You're weaving your way through life and every once
in a while you meet somebody by accident and you hook up with them

immediately because you feel comfortable with how they look. After you get inside their heads, you find out they're a lot like you, they've been through the same stuff and can relate to you.

(Stu, 27)

Similarly, hanging out in tattoo studios and displaying one's 'work' to heavily tattooed others is utilized as a method of meeting fellow enthusiasts:

Sometimes I just want to talk to somebody who likes tattoos as much as me. So I go down and talk to some of the guys who go to Sacred Art. We just lean on the counter for a while and flip through tattoo magazines or something . . . Some days I really miss hanging out with the guys there, and can't wait until Saturday when I have a day off from work.

(Pete, 23)

As this process occurs, studios often become known locally for the specific types of patrons serviced, and can transform into informal hang-outs for some of these patrons. For example, one tattoo studio in Toronto is an informal meeting place for Skaters and Ravers, who share common interests in tattooing and broader world views as well:

Whenever a rave is coming to town, you can be sure that there will be ads posted [at the studio] or some kind of pamphlets or something. Most of my good friends will meet there before a rave too, and organize how we are going to get there and sort out who brings what [drugs] . . . It's a friendly place, a place where no one will judge us or hassle us for hanging around and talking about rave. Plus, like twenty of us have been tattooed there, and know the guys [artists] really well, so whenever we go in, it's like, one of us is getting tattooed.

(Davey, 22)

In this case, the tattoo studio is utilized as an interactive context in which social relationships are cultivated over time. However, not many people hang around in tattoo studios for extended periods. While some people do return on occasion to speak with artists for one reason or another, most are not regulars in the shops.

A significant portion of the contemporary groundswell in tattooing practices may also be explained through the formation of relationships inside the figuration. As enthusiasts become more deeply involved in tattooing and incorporate their corporeal transformations more centrally in their respective self-conceptualizations they typically depend upon fellow enthusiasts for positive affirmation. Existing in a state of mutual dependency, enthusiasts turn into advocates of tattooing – not as fanatics who exhibit prejudices toward non-tattooed others, but as lobbyists for increased cultural acceptance of and respect for the body project. Encouraging others to be more tolerant of tattooing, attempting to dispel long-standing cultural stereotypes about tattoo enthusiasts, and promoting future participation among current enthusiasts, tattoo enthusiasts often become lobbyists of the body project:

I don't hesitate to encourage other people to do it. I think it's the most beautiful thing you can do with your body. It's a way of making your skin into artwork that reflects your very soul . . . I never thought about it that way until a close friend of mine went through a long battle with cancer and was tattooed to reclaim her body's aesthetic spirit. I started to reflect about her and found myself fascinated with some of the art the artists are capable of now. It's amazing, it really is . . . and I tell everybody that.

(June, 45)

The increased participation of one individual (and their advocacy efforts) creates a domino effect inside and outside of the figuration. Thirty-two (49%) of the clients I ended up interviewing stated that they first began to ponder the viability of being tattooed following a discussion about tattooing with one of their tattooed friends, co-workers, or family members. These individuals did not articulate their initial contemplations about tattooing as the product of being passionately recruited by others, but instead expressed a sense of influence from others who possessed favourable definitions of tattooing. Sutherland's landmark analysis (1937) showed how favourable definitions of behaviour are disseminated through social interaction. Similarly, exposure to pro-tattooing definitions can be key in stimulating an individual to consider the body project of tattooing: 'I don't think I would have any tattoos at all unless my friends did. They were responsible for my first thoughts about tattoo art, and were my role models, really. It's not like I followed them blindly. I mean, I am my own person, but when the people all around you are tattooed, you can't help think about it all the time' (Erin, 27). The relevancy of the informal advocacy process appears in the ways in which individuals are linked together through relationship chains and networks. Thus, the number of tattoo enthusiasts in Canada may be growing as a result of the sheer number of people routinely exposed to pro-tattooing definitions of the body – with the pool of enthusiasts in Canada multiplying exponentially over time. Contrary to Shilling's (1993), Klesse's (1999), or Sweetman's (1999a) understanding of body projects such as tattooing as highly individualistic and isolated practices, enthusiasts involved in this study suggested that their involvement in tattooing is highly linked to significant others' involvement in the practice. As further evidence, seventy-six (82%) of the enthusiasts interviewed were tattooed with a close friend, partner, or fellow enthusiast present in the studio – indicating that enthusiasts tend to include other enthusiasts in their experiences with tattooing.

We may also explain the heightened interest in tattooing experiences by attending to the interpersonal relationships formed between artists in the figuration. A core subject in much of the extant sociological literature on the practice, relationships between artists are pivotal in creating a sense of community within the figuration. While DeMello (2000), Rubin (1988), and Sanders (1989) provided arguments as to how the figuration is splintered by social class, stylistic preferences, territorial competition, and artistic envy, Canadian artists seem to be a 'friendlier' and more encouraging lot. Some artists in Canada actively circulate one another's business cards to clients, post stickers in their studios advertising others' business, refer clients to one another, and find jobs for their apprentices in other studios.

They also teach one another about specific techniques, exchange 'secrets' for shading or other colouring techniques, and provide tips on how to set up shop and manage clients:

> My best friends in the entire world are other tattoo artists. I'd do any-thing for most of them . . . whatever they need in the way of promotion or anything like that. When you do this for a living, you naturally meet others in the business, and it's that much sweeter when you can get along with people who love it like you do . . . I have no problem doing a solid [favour] for one of my friends. Like last week, one of the guys at Pleasure and Pain called me up to ask if he could 'borrow' some of this new ink I'd ordered and I said, sure. He's giving me a hand building a new [tat-too] machine, which is pretty cool, so it's no skin off my nose.
>
> (Harland, 26)

By linking together efforts to promote the efficient and smooth operation of the business of tattooing, artists develop working relationships with one another. On a personal level, such relationships frequently morph into close friendships outside of the studios. A tattoo artist named Phil once told me that in order to be a successful tattoo artist, 'you have to live, eat, and sleep tattooing'. Being engrossed in the practice, artists find occasional solace in hanging around with other artists who are able to share and understand their commitment to the art. In this way, the personal relationships formed between artists provide structural pillars for the figuration. With increased collegiality among artists and collective commitment to the practice, their exuberance and devotion to tattooing is transformed into chains of professional interdependencies inside the figuration. In turn, clients enter into a professional setting characterized by communication and mutual respect.

Bonds outside of the tattoo figuration

Participation in the activity of tattooing does not always engender favourable responses from others. Any Canadian who has ever gone 'under the needle' is aware of this simple fact. For clients, in particular, venturing into the realm of tattooing may pose a series of threats to one's statuses, roles, or relationships among indi-viduals outside the figuration. Although tattooing has acquired a heightened respect (or indifference) from non-enthusiasts in Western cultures over the past twenty years, cultural stereotypes and distaste toward the tattooed body still prevent some (at least for a while) from participating in the body project:

> I waited a long time to be tattooed. I didn't want to walk through a mall and have people staring and pointing at me. I know it may sound foolish, but I couldn't get the idea that people would treat me like a carnival freak out of my head. My family all called me crazy, and asked me if I was dating a criminal whenever I discussed doing it . . . that really dissuaded me from doing it for a long time.
>
> (Sandra, 34)

Similarly, in fearing that generalized others will interpret their interest in tattooing as sadomasochism, involvement in a criminal subculture, a sign of disrepute, a corporeal abomination, or some other fanciful deviance, enthusiasts may go to great lengths to hide their tattoos from others and 'pass' (Goffman 1963) as normal:

> I've never shown my tattoos to anyone at the office. Christ, I can't even imagine how my boss would freak out, because I work with our customers and clients on a daily basis and he would probably fire me on the spot. So I'll never go into work, even on the hottest days, with short-sleeve shirts or shorts on . . . That would be crazy. If there's even the slightest chance that the tattoos might show through my clothes, I buy this skin-coloured bandage to cover them, and no one, so far, has noticed.
>
> (Gwen, 27)

The fear of presenting one's tattoos to others is mainly fuelled by the potential deleterious reactions from three main groups: family members, close friends, and superiors at work. First and foremost, enthusiasts are concerned with negative reactions from their parents, and the potential detriment to their familial relationships. Enthusiasts often described their parents as conservative, holding values that oppose body practices that permanently alter the skin in such a manner. Twenty (31%) of the clients suggested that they refrained from being tattooed for years to avoid the potential wrath of parents – waiting to become involved in tattooing until they had moved out of their parents' houses. Thirty-two (49%) of the clients interviewed stated that they concealed their tattoos from their parents for at least one month, and twelve of these individuals have never revealed their tattoo(s) to their parents. This seemed to be more applicable to female enthusiasts, as they felt more constrained by dominant cultural expectations about tattooing and by gendered codes about corporeal alteration supported by their parents:

> My dad would kill me if he ever found out. The entire time I was sitting in the chair being tattooed I cried because I thought my dad was going to hate me when he saw it . . . To this day, I won't wear a bathing suit around him because he'd see it and probably disown me. I've always been daddy's little girl and I think he'd look at me like a prostitute. He's always told me how much he hates tattoos and associates them with the guys in pool halls he used to grow up around.
>
> (Sadie, 24)

Nine of the clients interviewed (14%) stated that their increased participation in tattooing had seriously strained relationships with one or both parents, and seven of the artists interviewed (26%) experienced the complete severance of a relationship with some family member as a result of their participation in the profession:

> My mom stopped talking to me the day I told her I was quitting my job at the bank and becoming a tattoo artist. I had a couple of tattoos at the time, but she seemed to have no problems with those. To her, it's a whole other ball game now. She can't tell anybody what her son is doing

for a living, because she's ashamed of me, and says I'm throwing my life
away for a bunch of hoodlums. I know I'm practically dead to her.

(Steven, 23)

Clients and artists equally discussed how their body markings altered relation-
ships with close friends who have not partaken in the practice. Some friends met
the tattoos with a mix of fascination and confusion, others with outright condem-
nation. In most cases, enthusiasts do not hide their tattoos from their friends as they
do from parents, and thus open the door for myriad reactions. Negative reactions
were understandable yet perplexing for the enthusiasts I met. On the one hand,
negative reactions were understood if they expressed a lack of congruence between
the friend's understanding of the individual (i.e., as conservative or introverted)
and their tattooed body, or were encoded with an underlying jealousy:

Some of my friends kept on saying to me, 'I can't believe you, I can't
believe you.' They always saw me as the timid and shy girl who would
never do anything like this. But I shocked the hell out of them, by
showing them exactly who I am. This is me, this is who I am, and I
don't have to meet anyone's expectations about what I should or
shouldn't do with my body.

(Roma, 23)

My one friend Kate is so jealous, I know she is. She's always yapped and
yapped about getting a tattoo but hasn't screwed up enough courage to
go and do it . . . So, when she saw me at the bar the first weekend after
I had it done, she flipped out. I came in wearing a shirt that showed off
my stomach and because the tattoo is around my belly button you could
see it right there . . . She hasn't spoken to me in almost a year.

(Karen, 20)

On the other hand, negative reactions and the weakening of bonds between friends
were confounding when an individual believed that the negative reactions had no
basis or highlighted deep-seated ideological differences that could not be reconciled:

When my friend Art saw my Straightedge tattoo he looked at me a
couple of times right in the eyes and didn't say anything, at first. Then
he started to rip into me about being a hypocrite and all that stupidity.
He doesn't know, he hasn't been there. He hangs around with a lot of
the same guys as me, and knew what a Straightedge tattoo means. It
means that I've cleaned up my life and am not smoking drugs anymore,
no drinking, or nothing that will pollute my body. He's still into that
scene, so I think he took my statement [the tattoo] as an insult.

(Carl, 26)

Finally, the extent of enthusiasts' participation in tattooing can be dictated by
their professional aspirations or current employment situations. As tattooed bodies

are not normative in most work settings, the enthusiasts I spoke with frequently selected locations on the body to be tattooed that are easily concealed, such as the upper arm, lower back, thigh, chest, or abdomen. This precludes tattooing on the neck, hands, forearms, feet, and other locations regularly exposed in the work setting. Under the fear of reprisal from superiors or outright dismissal, the moral atmosphere at work largely influences one's involvement in the body project:

> The place where I work, we still have policies about body art. You can't have it on your face or anywhere else that's visible with 'normal' business attire. So, I'm filling in all the areas where you can't see a tattoo right away! That's not going to stop me at all, but it certainly does limit my choices . . . Sometimes, I get angry because I feel like they're breaking my constitutional right to be whoever I want to be, and do what I want with my body, but they sign my cheques so I have to dance to their tune.
>
> (Rachel, 35)

In conforming to and reproducing dominant cultural prescriptions that outline normative standards for body alteration and corporeal display, while underlining the importance of work relationships and material prosperity in Western cultures, more-involved (i.e., tattooed) enthusiasts describe their work-related responsibilities as highly constraining:

> I'm of the mindset now that I want a full sleeve of tattoos. I have two already on my back, and since I've been reading tattoo magazines I can't believe the incredible art that goes into a full sleeve, so I want one. The possibilities are endless, and it's a way to really get into the art and create something unique for yourself. Well, of yourself, I guess. The stuff is crazy cool, but there's no way I can do it because it would peek out at work and I would get in shit. Basically, I have to quit my job if I want to do it.
>
> (Ryan, 28)

In a manner reminiscent of Hathaway's research (1997a, 1997b) on managing one's usage of marijuana while on the job, or Young and Craig's discussion (1997) of the importance of concealing visible markers of one's membership in the Skinhead subculture at work, enthusiasts learn how and when to explore an interest in non-normative practices within occupational settings.

Clearly, then, relationships both inside and outside of the tattoo figuration are formed, cultivated, and altered through participation in tattooing. The lengthening or shortening of one's chains of interdependency with others' (individual and collective) participation in the body project over time may shift and redefine one's social relationships, identities, and responsibilities. By conceptualizing the body project of tattooing in this way, we begin to appreciate how a seemingly isolated and privatized act is firmly based on mutual dependence, orientation, and foresight.

The concept of interdependence calls for an alternative understanding of Canadian tattoo enthusiasm. Rather than hinging the analysis of tattoo enthusiasts

on the conceptual linchpin of subculture, one should take direction from Elias's understanding (1978, 1991, 1994) of figurations. Venturing away from much of the existing literature on tattooing in America, which tends to depict the collective of enthusiasts as an esoteric sub-group of intimate actors, the concept of interdependence provides fresh theoretical insight on how individuals' unconventional redesigning body projects may be aligned and intersubjectively meaningful in quite non-subcultural ways. Stressing that individuals are deeply enmeshed in matrices or chains of social interaction that we may refer to as figurations, Elias (1991) draws our attention to the interpersonal ties that bind seemingly isolated individuals together in social interchange. Following this line of thought, our conception of the tattooing body project is reconfigured as we explore how interdependence rather than subcultural membership forms the social mortar of this redesigning body project.

Sexed subjects

Introduction to part six

■ Ken Gelder

THERE IS SOMETHING 'DECONSTRUCTIVE' about subcultural studies, which has always turned its attention to minor examples of social difference, to those microsocial formations which are in some way distinguished from the normal, the dominant, the legitimate. In many cases, of course, subcultural studies provides its subcultural participants with a social identity that is reasonably stable and coherent (even if short-lived): as a gang member, a New Age traveller, and so on. This is often a response to public perceptions of these social groups as *incoherent*, as disorganized or 'irrational'. But even the most identity-cohering account of a subculture can allow it a deconstructive function – as Iain Borden does with skateboarders (chapter 24) and Nancy Macdonald does with graffiti writers (chapter 29), for example, turning to their 'refusals' and reading the enigmatic 'traces' they leave on public space. For others, subcultural identity can itself be deconstructed, as we have already seen in Kobena Mercer's account of hybridized, natural/artificial, African/modern black hairstyles in chapter 28. This is not to say that it then collapses back into incoherence, of course (although Dick Hebdige had moved close to this position in his account of punks and 'noise' in the late 1970s). Rather, subcultures can provide their researchers with the means and methods by which certain taken-for-granted categories of social identity can in some way come undone. Nowhere is this more apparent than in the area of subcultural sexuality.

Sexuality is subject to a powerful set of discourses that classify and regulate: most obviously, through the conventional binary of heterosexuality – to which the privileges of citizenship are directed – and homosexuality, which is routinely discriminated against. Gender works in the same way, its binary of masculinity and femininity mobilizing a set of norms through which social, cultural and sexual practices, including things like fashion, style, one's 'look', and so on, are then evaluated. Heterosexuality, homosexuality, femininity, masculinity: each of these categories

relies on a set of agreed-upon meanings and conventions. Subcultural studies, however, turns its attention to sexed and gendered social identities where something rather different happens. Researchers have certainly attended to homosexuality, as the less privileged, subordinated end of the sexual binary. But a number of contributors to this part undo even *this* category, querying its own conventional, normalizing logics. The first contribution by Laud Humphreys, from his book *Tearoom Trade: Impersonal Sex in Public Places* (1970), in fact looks at participants in a homosexual subculture who might never identify as homosexual at all. Humphreys undertook his research as a graduate student in sociology at Washington University during the late 1960s; he was also an Episcopal priest. His project involved nothing less than the observation of 'impersonal sex' between men in lavatories or restrooms ('tearooms'), acts that were identified not only as 'deviant' but also as criminal. In the extract here, Humphreys describes his ethical position as an ethnographer, listing elaborate procedures both for observing events – as a 'watchqueen' or 'voyeur' ('a role supremely suited to sociologists') – and for interviewing the participants. His subject matter and approach, as well as his non-evaluative mode of ethnography, made his research profoundly controversial. But his participants also presented a challenge to the very notion of a subculture, the impersonal and highly secretive aspects of their relationships (over half of them were married) making them marginal or even tangential to any sense of homosexuality as not just a sexual but a social practice. We can contrast Humphreys' work with the second contribution by Douglas Crimp, from his book, with Adam Rolston, *AIDS DemoGraphics* (1990) – where the aim is to produce maximum public visibility and political coherence. This is an account of the activism of a radical gay 'coalition' in New York, ACT UP, which had used a remarkable range of slogan art to protest against government inaction over the AIDS crisis in the late 1980s. AIDS generated its own subculture – the 'AIDS community', with its shared politics and intimacies – and ACT UP had worked to substantially broaden its range in this context, affiliating with drug users, sex workers, and so on, and organizing public activism. The need here is precisely to be *seen* (to the point of 'ubiquity'), and the more confrontational the slogan art, the better. Crimp describes the co-opted pink triangle, for example, an icon of Jewish persecution by the Nazis. His account of ACT UP's appropriation of images and objects ('if it works, we use it') recalls Dick Hebdige's notion of subcultural 'bricolage'; but it has political purpose as well as, in its more cheerful moments, a camp aesthetic that reflects the 'queer . . . identity most of us share'.

As Murray Healy notes in his book, *Gay Skins: Masculinity and Queer Appropriation* (1996), researchers at Birmingham's CCCS – like those from the Chicago School – had little to say about queer identities. They did indeed occasionally discuss the subject of Healy's book, the British skinhead (Hebdige 1981), but the focus was on class, not sexuality, and certainly not homosexuality. Healy's important book – a chapter of which is presented here – begins by unpicking the conventional view that 'the skinhead and the gay man are unrelated species' (Healy 1996: 4). The two are usually mythologized to represent incompatible sexual and political positions: the 'hard', homophobic working-class man with extreme right-wing views, and the 'effeminate' middle-class man who is upwardly mobile and

politically progressive. But Healy undoes this binary by looking at British skinheads who are also gay. There is a visual problem here, since gay skinheads look straight, a feature that among other things 'frustrates the requirements of gay liberation that homosexuals be visibly identifiable' (10). But by looking straight, gay skinheads also frustrate the claim heterosexuality has on 'authentic' masculinity. The extract in this part goes on to examine the intersection of homosexuality and far-right political ideologies: gay skinheads and fascism. How can homosexual men be involved in 'homophobic political movements'? Healy's account of gay skinheads and neo-Nazism during the 1980s provides a striking contrast to ACT UP's use of the pink triangle, since identification is now with the persecutors, not the persecuted. It juxtaposes the camp playfulness of queer culture with the 'semiotic fundamentalism of skinhead = fascism'.

The next two contributors, both from the United States, also examine masculinity, not as something natural or self-evident but rather as an identity that is artificially constructed or performed. Marcia Ian's chapter comes from Joel Sanders' anthology, *Stud: Architectures of Masculinity* (1996), and is an on-site examination of the bodybuilding culture at the Apollon Gym, Edison, New Jersey. In an earlier study, *Little Big Men: Bodybuilding Subculture and Gender Construction* (1993), Alan M. Klein had suggested that bodybuilding 'is a subculture of hyperbole. In its headlong rush to accrue flesh, everything about this subculture exploits grandiosity and excess. . . . There is no room for understatement in bodybuilding, no room for depth where surface rules' (Klein 1993: 3). Ian agrees, viewing bodybuilding as the achievement of a 'hyperbolic masculinity', pure muscle, without any sense of an 'interior'. The gym is both social and anti-social, since its constructed version of masculinity is predicated on the exclusion of femininity from its domain. Female bodybuilders in this account are subordinated to this position, conforming to the gym's 'one-sex model'.

Ian's account of bodybuilding at the Apollon Gym might recall Nancy Macdonald's study of graffiti writers in chapter 29: two women ethnographers charting masculine sub-worlds. For Ian, masculinity is 'built' by the bodybuilders; for Judith Halberstam, on the other hand, masculinity is a matter of acting-out, which means among other things that it need not necessarily be tied to men. Halberstam's chapter on drag kings is taken from her book, *Female Masculinity* (1998) – the title drawing together apparently incompatible categories once again, to look in this case at the ways in which masculinity is claimed by *women* (i.e. the reverse of Ian's account of the female bodybuilder who is claimed by masculinity). The drag king is the drag queen's neglected 'counterpart', emerging as 'something of a subcultural phenomenon' in the 1990s. Drag queen shows – where men perform as women – are wonderfully camp events; but for Halberstam, this is because a camp sensibility flourishes when it is attached to exaggerated forms of femininity. Masculinity, on the other hand, is usually coded as a 'nonperformative' gender: it 'just is'. She therefore reads the drag king event – women performing as men – more in terms of restraint, hyperbolic in some respects and a kind of 'understatement' or 'antitheatre' in others. A participant observer, Halberstam looks at drag king contests and drag king shows in New York and produces a taxonomy of drag

king types. These are indeed performative events, even though performance is rendered problematic here. They are also distinguished from 'dyke' cultures and from butch lesbian identities. Drag king events have a kind of ontological autonomy here, as a sometimes elaborate production that – even in its mimicry of masculinity – seems to float free from gendered categories altogether.

Recent accounts that present gender as performative, a kind of situated and signifying form of expression rather than something that is tied naturally to sexed identities as a man or a woman, owe much to the work of Judith Butler, in particular, her earlier influential book, *Gender Trouble* (1990). Indeed, Butler had famously suggested that all gender is a form of 'drag':

> The performance of drag plays upon the distinction between the anatomy of the performer and the gender that is being performed. But we are already in the presence of three contingent dimensions of significant corporeality: anatomical sex, gender identity, and gender performance. ... In imitating gender, drag implicitly reveals the imitative structure of gender itself – as well as its contingency.
>
> (Butler 1990: 137)

Of course, we need to remember – in subcultural studies – that drag always has its audiences and affiliated communities, its sites of performance, its styles and its various agendas. Is drag always connected to gay or lesbian culture? For Halberstam this remains problematic since – for example – drag kings don't necessarily identify as butch. In lesbian culture, the butch woman is coded as 'masculine'; a femme partner is coded as 'feminine'. But these identities can also slip out of the homosexual/heterosexual divide. Clare Hemming's chapter in this part, from Sally Munt's anthology *Butch/Femme: Inside Lesbian Gender* (1998), looks at the 'bisexual femme' who desires *across* this divide. The femme is 'precariously' positioned in the butch–femme relationship, since she may well be attractive to both lesbians and heterosexual men. She is, as Hemmings puts it, 'not-quite-not-straight', haunted by 'the spectre of straightness'. If the femme is also bisexual, then homosexuality and heterosexuality come together and remain distinct simultaneously: her 'subject position' depends on what she repudiates, what she invests in (sexually, culturally), at any given time. The bisexual femme may accordingly be cast as not lesbian enough or not heterosexual enough, neither one thing nor another. Bisexuality thus runs the cultural risk of being seen, by those invested in *either* homosexuality *or* heterosexuality, as 'inauthentic'. On the other hand, by querying conventional notions of sexual pairings, by refusing the 'either/or' of traditional sexual identities, bisexuality – as Marjorie Garber has suggested elsewhere (Garber 1995) – might very well provide another sexual identity that plays itself out in the world in a 'deconstructive' way.

Laud Humphreys

THE SOCIOLOGIST AS VOYEUR [1970]

IN THE SUMMER OF 1965, I wrote a research paper on the subject of homo-sexuality. After reading the paper, my graduate adviser raised a question, the answer to which was not available from my data or from the literature on sexual deviance: 'But where does the average guy go just to get a blow job? That's where you should do your research.' I suspected that the answer was 'to the tearooms,' but this was little more than a hunch. We decided that this area of covert deviant behavior, tangential to the subculture, was one that needed study.

Stories of tearoom adventures and raids constantly pass along the homosexual grapevine. There is a great deal of talk (usually of a pejorative nature) about these facilities in gay circles. Most men with whom I conversed at any length during my brief research admitted to 'tricking' (engaging in one-time sexual relationships) in tearooms from time to time.

Sociologists had studied bar operations and the practice of male prostitution by teenage gang members but no one had tackled the scenes of impersonal sex where most arrests are made. Literature on the subject indicates that, up to now, the police and other law enforcement agents have been the only systematic observers of homo-sexual action in public restrooms. . . .

Social scientists have avoided this area of deviant behavior, perhaps due to the many emotional and methodological problems it presents – some of which are common to any study of a deviant population. Ethical and emotional problems, I suspect, provide the more serious obstacles for most prospective researchers. As Hooker points out, 'Gaining access to secret worlds of homosexuals, and main-taining rapport while conducting an ethnographic field study, requires the development of a non-evaluative attitude toward all forms of sexual behavior' (Hooker 1967: 40). Such an attitude, involving divorce from one's socialization, is not easy to come by. No amount of intellectual exercise alone can enable the ethno-grapher to make such emotional adjustments, and ethical concerns . . . serve to complicate the task. . . .

This is not a study of 'homosexuals' but of participants in homosexual acts. The subjects of this study have but one thing in common: each has been observed by me in the course of a homosexual act in a public park restroom. . . .

There is probably no major city in the nation without its tearooms in current operation. These facilities constitute a major part of the free sex market for those in the homosexual subculture – and for millions who might never identify with the gay society. For the social scientist, these public toilets provide a means for direct observation of the dynamics of sexual encounters *in situ*; moreover, as will be seen, they facilitate the gathering of a representative sample of secret deviants, for most of whom association with the deviant subculture is minimal.

Neatness versus accuracy

I employed the methods described herein not because they are the most accurate in the sense of 'neatness' or 'cleanness' but because they promised the greatest accuracy in terms of faithfulness to people and actions as they live and happen. These are strategies that I judged to be the least obtrusive measures available – the least likely to distort the real world.

My biases are those that Bruyn attributes to the participant observer, who 'is interested in people as they are, not as he thinks they ought to be according to some standard of his own' (Bruyn 1966: 18). To employ, therefore, any strategies that might distort either the activity observed or the profile of those who engage in it would be foreign to my scientific philosophy and inimical to my purposes. . . .

Hypotheses should develop *out of* such ethnographic work, rather than provide restrictions and distortions from its inception. Where my data have called for a conceptual framework, I have tried to supply it, sometimes with the help of other social scientists. In those cases, where data were strong enough to generate new theoretical approaches, I have attempted to be a willing medium. The descriptive study is important, not only in obtaining objective and systematic knowledge of behavior that is either unknown or taken for granted, but in providing the groundwork for new theoretical development. If the social scientist is to move back and forth between his data and the body of social theory, the path of that movement should not be restricted to a set predestined hypotheses. (For a description of theory development at its best see Mills 1959: 73.)

The research in which I engaged, from the summer of 1965 through the winter of 1967–68, may be broken down into two distinct stages, each with its subcategories. The first was an ethnographic or participant-observation stage. This part of the research was extended over two years on a part-time basis (I was also involved in graduate study at the time).

The second half involved six months of full-time work in administering interview schedules to more than one hundred respondents and in attempting to interview another twenty-seven. Another year has been devoted to analysis of the resulting data.

As an ethnographer, my first task was to acquaint myself with the homosexual subculture. Because of my pastoral experience, I was no total stranger to those circles. While a seminarian, I was employed for two years in a parish that was known

in the homosexual world as Chicago's 'queen parish' – a place to which the homo-
sexuals could turn up for counsel, understanding priests, good music, and worship
with an aesthetic emphasis. I soon came to know the gay parishioners and to speak
their language. Seminarians who worked there called on people who lived in unbe-
lievable squalor and in houses of prostitution, so it was nothing for us to seek the
flock in gay bars as well. One of the faithful churchmen was bartender and part-
time entertainer in one of the more popular spots, and he always looked after the
seminaries and warned us of impending raids. . . .

From 1955 to 1965, I served parishes in Oklahoma, Colorado, and Kansas,
twice serving as Episcopal campus chaplain on a part-time basis. Because I was
considered 'wise' and did not attempt to 'reform' them, hundred of homosexuals
of all sorts and conditions came to me during those years for counselling. Having
joined me in counselling parishioners over the coffee pot for many a night, my wife
provided much understanding assistance in this area of my ministry.

The problem, at the beginning of my research, was threefold: to become
acquainted with the sociological literature of sexual deviance; to gain entry to a
deviant subculture in a strange city where I no longer had pastoral, and only part-
time priestly, duties; and to begin to listen to sexual deviants with a scientist's rather
than a pastor's ear.

Passing as deviant

Like any deviant group, homosexuals have developed defenses against outsiders:
secrecy about their true identity, symbolic gestures and the use of the eyes for
communication, unwillingness to expose the whereabouts of their meeting places,
extraordinary caution with strangers, and admission to certain places only in the
company of a recognized person. Shorn of pastoral contacts and unwilling to use
professional credentials, I had to enter the subculture as would any newcomer and
to make contact with respondents under the guise of being another gay guy.[1]

Such entry is not difficult to accomplish. Almost any taxi driver can tell a
customer where to find a gay bar. A guide to such gathering places may be purchased
for five dollars. The real problem is not one of making contact with the subculture
but of making the contact 'stick.' Acceptance does not come easy, and it is extremely
difficult to move beyond superficial contact in public places to acceptance by the
group and invitations to private and semiprivate parties. . . .

On one occasion, for instance, tickets to an after-hours party were sold to the
man next to me at a bar. When I asked to buy one, I was told that they were 'full-
up.' Following the tip of another customer, I showed up anyway and walked right
in. No one questioned my being there. Since my purpose at this point of the field
study was simply to 'get the feel' of the deviant community rather than to study
methods of penetrating its boundaries, I finally tired of the long method and told a
friendly potential respondent who I was and what I was doing. He then got me
invited to cocktail parties before the annual 'drag ball,' and my survey of the
subculture neared completion.

During those first months, I made the rounds of ten gay bars then operating in
the metropolitan area, attended private gatherings and the annual ball, covered the

scene where male prostitutes operated out of a coffee-house, observed pick-up operations in the parks and streets, and had dozens of informal interviews with participants in the gay society. I also visited the locales where 'instant sex' was to be had: the local bathhouse, certain movie theatres, and the tearooms.

From the beginning, my decision was to continue the practice of field study in passing as deviant. Although this raises questions of scientific ethics, which will be dealt with later, there are good reasons for following this method of participant observation.

In the first place, I am convinced that there is only *one* way to watch highly discreditable behavior and that is to pretend to be in the same boat with those engaging in it. To wear a button that says 'I Am a Watchbird, Watching You' into a tearoom, would instantly eliminate all action except the flushing of toilets and the exiting of all present. Polsky has done excellent observation of pool hustlers because he is experienced and welcome in their game. He is accepted as one of them. He might also do well, as he suggests, in interviewing a jewel thief or a fence in his tavern hangout. But it should be noted that he does not propose watching them steal, whereas my research required observation of criminal acts [see Chapter 5].

The second reason is to prevent distortion. Hypothetically, let us assume that a few men could be found to continue their sexual activity while under observation. How 'normal' could that activity be? How could the researcher separate the 'show' and the 'cover' from the standard procedures of the encounter? Masters and Johnson might gather clinical data in a clinical setting without distortion, but a stage is a suitable research site only for those who wish to study the 'onstage' behavior of actors.

Serving as 'watchqueen'

In *Unobtrusive Measures*, the authors refer to the participant observation method as one of 'simple observation' (Webb *et al.* 1966: 149). This is something of a misnomer for the study of sexually deviant behavior. Observation of tearoom encounters – far from being simple – became, at some stages of the research, almost impossibly complex.

Observation is made doubly difficult when the observer is an object of suspicion. Any man who remains in a public washroom for more than five minutes is apt to be either a member of the vice squad or someone on the make. As yet, he is not suspected of being a social scientist. The researcher, concerned as he is in uncovering information, is unavoidably at variance with the secretive interests of the deviant population. Because his behavior is both criminal[2] and the object of much social derision, the tearoom customer is exceptionally sensitive to the intrusion of all strangers.

Bruyn points out three difficulties attendant to participant observation: 'how to become a natural part of the life of the observed,' 'how to maintain scientific integrity,' and 'problems of ethical integrity.' Each of these problems is intensified in the observation of homosexual activity. When the focus of an encounter is specifically sexual, it is very difficult for the observer to take a 'natural part' in the action without involvement of a sexual nature. Such involvement would, of course, raise

serious questions of both scientific and ethical integrity on his part. His central problem, then, is one of maintaining both objectivity and participation (the old theological question of how to be *in*, but not *of*, the world). . . .

[M]y preliminary observations of tearoom encounters led to the discovery of an essential strategy – the real methodological breakthrough of this research – [which] involved mobilization of the social organization being observed. The very fear and suspicion encountered in the restrooms produces a participant role, the sexuality of which is optional. This is the role of the lookout ('watchqueen' in the argot), a man who is situated at the door or windows from which he may observe the means of access to the restroom. When someone approaches, he coughs. He nods when the coast is clear or if he recognizes an entering party as a regular.

The lookouts fall into three main types. The most common of these are the 'waiters,' men who are waiting for someone with whom they have made an appointment or whom they expect to find at this spot, for a particular type of 'trick,' or for a chance to get in on the action. The others are the masturbaters, who engage in autoerotic behavior (either overtly or beneath their clothing) while observing sexual acts, and the voyeurs, who appear to derive sexual stimulation and pleasure from watching the others. Waiters sometimes masturbate while waiting – and I have no evidence to prove that some are not also voyeurs. The point is that the primary purpose of their presence differs from that of the pure masturbater or voyeur: the waiters expect to become players. In a sense, the masturbaters are all voyeurs, while the reverse is not true.

In terms of appearances, I assumed the role of the voyeur – a role superbly suited for sociologists and the only lookout role that is not overtly sexual. On those occasions when there was only one other man present in the room, I have taken a role that is even less sexual than that of the voyeur-lookout: the straight person who has come in for purposes of elimination. Although it avoids sexual pressure, this role is problematic for the researcher: it is short-lived and invariably disrupts the action he has set out to observe. . . .

Before being alerted to the role of lookout by a cooperating respondent, I tried first the role of the straight and then that of the waiter. As the former, I disrupted the action and frustrated my research. As the latter – glancing at my watch and pacing nervously from window to door to peer out – I could not stay long without being invited to enter the action and could only make furtive observation of the encounters. As it was, the waiter and voyeur roles are subject to blurring and I was often mistaken for the former.

By serving as a voyeur-lookout, I was able to move around the room at will, from window to window, and to observe all that went on without alarming my respondents or otherwise disturbing the action. I found this role much more amenable and profitable than the limited roles assumed in the earlier stages of research. Not only has being a watchqueen enabled me to gather data on the behavioral patterns, it has facilitated the linking of participants in homosexual acts with particular automobiles. . . .

The park restrooms first become active as sexual outlets between 7:30 and 8:30 A.M., when the park attendants arrive to unlock them. The early customers are men who meet on their way to work. After 9:00, the activity drops off sharply until

lunch time. During the first two hours of the afternoon, there is another abrupt increase in activity from those who spend their lunch breaks in the park, followed by a leveling-off until about 4:00 P.M. From this time until about 7:00 in the evening, the great bulk of tearoom participants arrive. Most participants stop off in the park restrooms while driving home from work. As one respondent stated, he tries to make it to a tearoom 'nearly every evening about 5:30 for a quick job on the way home.' . . .

Sampling covert deviants

Hooker has noted that homosexuals who lead secret lives are usually available for study 'only when caught by law enforcement agents, or when seeking psychiatric help' (Hooker 1967: 169). To my knowledge, no one has yet attempted to acquire a *representative* sample of *covert* deviants for any sort of research. Polsky's efforts to secure a representative sample of 'beats,' in order to effect a survey of drug use among them, is a possible exception to this generalization, although I question whether Village beats should be called *covert* deviants.

. . . I gathered a sample of the tearoom participants by tracing the license plates of the autos they drive to the parks. . . . Operation of one's car is a form of self-presentation that tells the observant sociologist a great deal about the operator.

For several months, I had noted fluctuations in the number of automobiles that remained more than fifteen minutes in front of the sampled tearooms. My observations had indicated that, with the sole exception of police cars, autos that parked in front of these public restrooms (which, as has been mentioned, are usually isolated from other park facilities) for a quarter of an hour or more invariably belonged to participants in the homosexual encounters. . . .

In September of 1966, then, I set about to gather a sample in as systematic a manner as possible under the circumstances. . . . Random selection cannot be claimed for this sample: because of the pressures of time and possible detection, I was able to record only a portion of the license plates of participating men I saw at any one time, the choice of which to record being determined by the volume and flow of traffic and the position in which the autos were parked.

I also noted, whenever possible, a brief description of both the car and its driver. By means of frequent sorties into the tearooms for observation, each recorded license number was verified as belonging to a man actually observed in homosexual activity inside the facilities. Sometimes the numbers were taped prior to my entrance, in anticipation of what I would find inside. In most cases, however, I observed the activity, left the tearoom, waited in my car for the participants to enter their autos – then recorded the plate numbers and brief descriptions. For each of these men but one I added to the data the role he took in the sexual encounter.

The original sample thus gained was of 134 license numbers, carefully linked to persons involved in the homosexual encounters, gathered from the environs of ten public restrooms in four different parks of a metropolitan area of two million people. With attrition and additions that will be described later, one hundred participants in the tearoom game were included in the final sample. [. . .]

The talk outside

A sociologist without verbal communication is like a doctor without a stethoscope. The silence of these sexual encounters confounded such research problems as legitimation of the observer and identification of roles. As indicated above, however, it has certain advantages in limiting the number of variables that must be observed, recorded, and evaluated. When action alone is being observed and analyzed, the patterns of behavior themselves acquire meaning independent of verbalization. 'The method of participant observation,' Bruyn states, 'is a research procedure which can provide the basis for establishing adequacy at the level of meaning' (Bruyn 1966: 179). What verbal research is possible through outside interview then becomes an independent means of verifying the observations.

Despite the almost inviolate silence within the restroom setting, tearoom participants are neither mute nor particularly taciturn. Away from the scenes where their sexual deviance is exposed – outside what I shall later discuss as the 'interaction membrane' – conversation is again possible. Once my car and face had become familiar, I was able to enter into verbal relationships with twelve of the participants, whom I refer to as the 'intensive dozen.' Eight of these men are included in the final sample. Four others, although engaged in dialogue near the tearooms where I observed them, were not included in the sample. Of the eight in the sample, five (including the two 'walkers,' who had walked rather than driven to the tearooms) were contacted after leaving the scene of an encounter, and three became cooperating respondents as a result of relationships that developed from the formal interviews.

After the initial contacts with this intensive dozen, I told them of my research, disclosing my real purpose for being in the tearooms. With the help of some meals together and a number of drinks, all agreed to cooperate in subsequent interviewing sessions. A few of these interviews were taped (only two men were sufficiently unafraid to allow their voices to be recorded on tape – and I don't blame the others) but most were later reconstructed from notes. Apart from the systematic observations themselves, these conversations constitute the richest source of data in the study.

Some may ask why, if nine of these cooperating respondents were obtained without the formal interviews, I bothered with the seemingly endless task of acquiring a sample and administering questionnaires – particularly when interviews with the intensive dozen provided such depth to the data. The answer is simple: these men are not representative of the tearoom population. I could engage them in conversation only because they are more overt, less defensive, and better educated than the average participant. This suggests a problem for all research that relies on willing respondents. Their very willingness to cooperate sets them apart from those they are meant to represent. . . .

Archival evidence

The unobtrusive measures of participant observation and physical traces, combined with a limited use of open-ended interviews for purposes of correction and validation, enabled me to describe the previously unexplored area of tearoom encounters. The preliminary description of the participant population, however, began only after

the establishment of a verified sample. For this stage of the study, I turned to archival measures, 'the running record' (Webb et al. 1966: 53–87).

Identification of the sample was made by using the automobile license registers of the states in which my respondents lived. Fortunately, friendly policemen gave me access to the license registers, without asking to see the numbers or becoming too inquisitive about the type of 'market research' in which I was engaged. These registers provided the names and addresses of those in the sample, as well as the brand name and year of the automobiles thus registered. The make of the car, as recorded in the registers, was checked against my transcribed description of each car. In the two cases where these descriptions were contradictory, the numbers were rejected from the sample. Names and addresses were then checked in the directories of the metropolitan area, from which volumes I also acquired marital and occupational data for most of the sample. . . .

For fear of eliminating variables that might profitably be studied at a later date, I did not scrub from my sample those for whom the archives provided no marital or occupational data. These men, I felt, might represent either a transient or secretive portion of tearoom participants, the exclusion of which would have distorted the population. . . .

A view from the streets

Like archives, park restrooms, and automobiles, the streets of our cities are subject to public regulation and scrutiny. They are thus good places for nonreactive research (nonreactive in that it requires no response from the research subjects). Having gained addresses for every person in my sample, I spent a Christmas vacation on the streets and highways. By recording a description of every residence and neighborhood represented in the sample, I was able to gain further data on my research subjects.

The first purpose of this survey of homes was to acquire descriptions of the house types and dwelling areas that, when combined with occupational data gleaned from the archives, would enable me to use Warner's Index of Status Characteristics . . . for a socioeconomic profile of my population (Warner et al. 1949). Generally speaking, this attempt was not successful; job classifications were too vague and large city housing units too difficult to rank by Warner's criteria.

As physical evidence, however, homes provide a source of data about a population that outweighs any failure they may have as a status index. Swing sets and bicycles in the yards indicate that a family is not childless. A shrine to Saint Mary suggests that the resident is Roman Catholic in religious identification. Christmas decorations bespeak at least a nominal Christian preference. A boat or trailer in the driveway suggests love of the outdoor life. 'For Rent' signs may indicate the size of an average apartment and, in some cases, the price. The most important sign, however, was the relative 'neatness' of the house and grounds. . . .

Obtrusive measures

Realizing that the majority of my participant sample were married – and nearly all of them quite secretive about their deviant activity – I was faced with the problem

of how to interview more than the nine willing respondents. Formal interviews of the sample were part of the original research design. The little I knew about these covert deviants made me want to know a great deal more. Here was a unique population just waiting to be studied – but I had no way to approach them. Clearly, I could not knock on the door of a suburban residence and say, 'Excuse me, I saw you engaging in a homosexual act in a tearoom last year, and I wonder if I might ask you a few questions.' Having already been jailed, locked in a restroom, and attacked by a group of ruffians, I had no desire to conclude my research with a series of beatings.

Perhaps I might have had some success by contacting these men at their work, granted that I could obtain their business addresses. This strategy would have precluded the possibility of seeing their homes and meeting their wives, however, and I believed these confrontations to be important.

About this time, fortunately, I was asked to develop a questionnaire for a social health survey of men in the community, which was being conducted by a research center with which I had been a research associate. Based on such interview schedules already in use in Michigan and New York, the product would provide nearly all the information I would want on the men in my sample: family background, socioeconomic factors, personal health and social histories, religious and employment data, a few questions on social and political attitudes, a survey of friendship networks, and information on marital relationships and sex.

With the permission of the director of the research project, I added my deviant sample to the overall sample of the survey, making certain that only one trusted, mature graduate student and I made all the interviews of my respondents. Thus legitimized, we set out to interview. Using a table of random numbers, I randomized my sample, so that its representativeness would not be lost in the event that we should be unable to complete all 100 interviews.

More will be written later of the measures taken to safeguard respondents; the important thing to note here is that none of the respondents was threatened by the interviews. My master list was kept in a safe-deposit box. Each interview card, kept under lock and key, was destroyed with completion of the schedule. No names or other identifying tags were allowed to appear on the questionnaires. Although I recognized each of the men interviewed from observation of them in the tearooms, there was no indication that they remembered me. I was careful to change my appearance, dress, and automobile from the days when I had passed as deviant. I also allowed at least a year's time to lapse between the original sampling procedure and the interviews.

This strategy was most important – both from the standpoint of research validity and ethics – because it enabled me to approach my respondents as normal people, answering normal questions, as part of a normal survey. They *are* part of a larger sample. Their being interviewed is not stigmatizing, because they comprise but a small portion of a much larger sample of the population in their area. They were not put on the spot about their deviance, because they were not interviewed as deviants.

The attrition rate for these interviews was high, but not discouragingly so. Attempts were made at securing seventy-five interviews, fifty of which were completed. Thirty-five per cent were lost by attrition, including 13 per cent who

refused to cooperate in the interviews. In addition to the fifty completed schedules, three fathers of participants consented to interviews on the social health survey, as did two fathers of the control sample.

Because of the preinterview data obtained by the archival and observational research previously described, it was possible to learn a great deal even from the losses. As should be expected, the residue of men with whom interviews were completed are slightly overrepresentative of the middle and upper classes; they are suburbanites, more highly educated men. Those who were lost represent a more transient group (the most common reason for loss was that the subject had moved and left no forwarding address), employed in manual jobs. From preinterview information it was learned that the largest single occupational class in the sample was the truck driver. Only two members of this class remained among those interviewed.

The refusals also indicated some biases. These men, when pinpointed on a map, clustered around the Italian and working-class German areas of the city. Of the ten lost in this manner, three had Italian names and five bore names of distinctly German origin.

Once these interviews were completed, preparations could be made for the final step of the research design. From names appearing in the randomly selected sample of the overall social health survey, fifty men were selected, matched with the completed questionnaires on the following four categories: . . . occupation, race, area of the metropolitan region in which the party resided, and marital status. The loss here was not from refusals or lost addresses but from those who, when interviewed, failed to correspond with the expected characteristics for matching. Our procedure, in those cases, was simply to move on to another name in the larger sample.

These last fifty interviews, then, enabled me to compare characteristics of two samples – one deviant, one control – matched on the basis of certain socioeconomic characteristics, race and marital status. Although I made a large proportion of these interviews, and nearly all of the deviant interviews, I found it necessary to hire and train two graduate students to assist with interviewing the control sample. A meeting was held with the assistant interviewers immediately following the completion of each schedule – and all coding of the questionnaires was done by us in conference.

There were a number of open-ended questions in the interview schedules, but the majority included a wide range of precoded answers, for the sake of ease in interviewing and economy in analysis. In addition, the interviewers were trained to make copious marginal notes and required to submit a postinterview questionnaire with each schedule. The median time required for administering the interview sched-ules did not differ greatly between the two samples: one hour for the deviants, fifty-five minutes for the 'straights.' Even the days of the week when respondents were interviewed showed little variation between the two samples: Sunday, Tuesday, and Saturday, in that order, being the more popular days.

From a methodological standpoint, the value of this research is that it has employed a variety of methods, each testing a different outcropping of the research population and their sexual encounters. It has united the systematic use of partici-pant observation strategies with other nonreactive measures such as physical traces and archives. The exigencies of research in a socially sensitive area demanded such

approaches; and the application of unobtrusive measures yielded data that call, in turn, for reactive methods.

Research strategies do not develop *ex nihilo*. In part, they are the outgrowth of the researcher's basic assumptions. Special conditions of the research problem itself also exercise a determining influence upon the methods used. This chapter has been an attempt to indicate how my ethnographic assumptions, coupled with the difficulties inhering in the study of covert deviants and their behavior, have given rise to a set of strategies.

With the help of 'oddball' measures, the outlines of the portrait of participants in the homosexual encounters of the tearooms appeared. Reactive strategies were needed to fill in the distinguishing features. They are human, socially patterned features; and it is doubtful that any one method could have given them the expressive description they deserve.

Notes

1 My reticence at admitting I was a sociologist resulted, in part, from the cautioning of a gay friend who warned me that homosexuals in the community are particularly wary of sociologists. This is supposedly the result of the failure of a graduate student at another university to disguise the names of bars and respondents in a master's thesis on this subject.

2 The Revised Statutes of the state under study, for instance, read . . . : '. . . *The abominable and detestable crime against nature – penalty*: – Every person who shall be convicted of the detestable and abominable crime against nature, committed with mankind or with beast, with the sexual organs or with the mouth, shall be punished by imprisonment in the penitentiary not less than two years.'

Douglas Crimp, with Adam Rolston

AIDS ACTIVIST GRAPHICS
A demonstration [1990]

THE AIDS ACTIVIST GRAPHICS illustrated here were all produced by and for ACT UP, the AIDS Coalition to Unleash Power, 'a diverse, nonpartisan group united in anger and committed to direct action to end the AIDS crisis.' ACT UP New York was founded in March 1987. Subsequently, autonomous branches have sprung up in other cities, large and small, here and abroad – Chicago, Los Angeles, and San Francisco; Atlanta, Boston, and Denver; Portland and Seattle, Kansas City and New Orleans; Berlin, London, and Paris. Graphics are part of the action everywhere, but we confine ourselves to those associated with ACT UP New York as a matter of expediency. We live in New York – the city with the highest number of reported cases of AIDS in the world. We are members of ACT UP New York. We attend its meetings, join the debate, march in demonstrations, and get arrested for acts of civil disobedience here. And we're familiar with New York ACT UP's graphics, the people who make them, the issues they address. The limitation is part of the nature of our demonstration. We don't claim invention of the style or the techniques. We have no patent on the politics or the designs. There are AIDS activist graphics wherever there are AIDS activists. But ours are the ones we know and can show to others, presented in a context we understand. We want others to keep using our graphics and making their own. Part of our point is that nobody owns these images. They belong to a movement that is constantly growing – in numbers, in militancy, in political awareness.

Although our struggles are most often waged at the local level, the AIDS epidemic and the activist movement dedicated to ending it is national – and inter-national – in scope, and the U.S. government is a major culprit in the problems we face and a central target of our anger. ACT NOW, the AIDS Coalition to Network, Organize, and Win – a national coalition of AIDS activist groups – has coordinated actions of national reach, most notably against the Food and Drug Administration (FDA) in October 1988. Health care is a national scandal in the United States; the

FDA, the Centers for Disease Control (CDC), and the National Institutes of Health (NIH) are all critical to our surviving the epidemic, and we have monitored, lobbied, and fought them all. We have also taken our demands beyond U.S. borders. The Fifth International AIDS Conference in Montreal in June 1989 was *our* conference, the first of these annual, previously largely scientific and policy-making AIDS roundups to have its business-as-usual disrupted by the combative presence of an international coalition of AIDS activists. We took the stage – literally – during the opening ceremonies, and we never relinquished it. One measure of our success was that by the end of the conference perhaps one-third of the more than 12,000 people attending were wearing SILENCE=DEATH buttons.

That simple graphic emblem – SILENCE=DEATH printed in white Gill sanserif type underneath a pink triangle on a black ground [Figure 32.1] – has come to signify AIDS activism to an entire community of people confronting the epidemic. This in itself tells us something about the styles and strategies of the movement's graphics. For SILENCE=DEATH does its work with a metaphorical subtlety that is unique, among political symbols and slogans, to AIDS activism. Our emblem's significance depends on foreknowledge of the use of the pink triangle as the marker of gay men in Nazi concentration camps, its appropriation by the gay movement to remember a suppressed history of our oppression, and, now, an inversion of its positioning (men in the death camps wore triangles that pointed down; SILENCE=DEATH's points up). SILENCE=DEATH declares that silence about the oppression and annihilation of gay people, *then and now*, must be broken as a matter of our survival. As historically problematic as an analogy of AIDS and the death camps is, it is also deeply resonant for gay men and lesbians, especially insofar as the analogy is already mediated by the gay movement's adoption of the pink triangle. But it is not merely what SILENCE=DEATH says, but also how it looks, that gives it its particular force. The power of this equation under a triangle is the compression of its connotation into a logo, a logo so striking that you ultimately *have* to ask, if you don't already know, 'What does that mean?' And it is the answers we are constantly called upon to give to others – small, everyday direct actions – that make SILENCE=DEATH signify beyond a community of lesbian and gay cognoscenti.

Although identified with ACT UP, SILENCE=DEATH precedes the formation of the activist group by several months. The emblem was created by six gay men calling themselves the Silence=Death Project, who printed the emblem on posters and had them 'sniped' [pasted onto hoardings] at their own expense. The members of the Silence=Death Project were present at the formation of ACT UP, and they lent the organization their graphic design for placards used in its second demonstration – at New York City's main post office on April 15, 1987. Soon thereafter SILENCE=DEATH T-shirts, buttons, and stickers were produced, the sale of which was one of ACT UP's first means of fundraising.

Nearly a year after SILENCE=DEATH posters first appeared on the streets of lower Manhattan, the logo showed up there again, this time in a neon version as part of a window installation in the New Museum of Contemporary Art on lower Broadway. New Museum curator Bill Olander, a person with AIDS and a member of ACT UP, had offered the organization the window space for a work about AIDS. An ad hoc committee was formed by artists, designers, and others with various skills, and within a few short months *Let the Record Show*, a powerful installation work, was

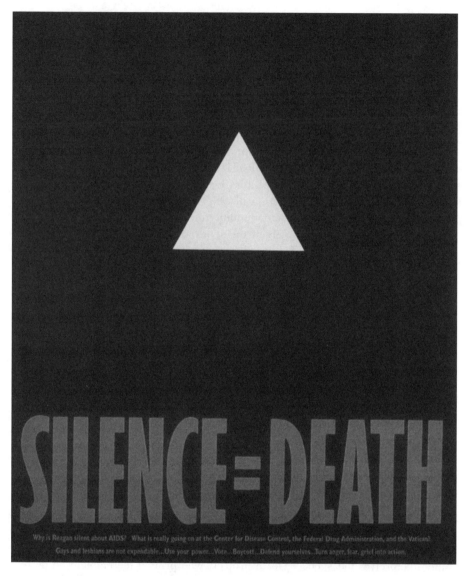

Figure 32.1 ACT UP poster 'SILENCE=DEATH'

produced. Expanding SILENCE=DEATH's analogy of AIDS and Nazi crimes through a photomural of the Nuremburg trials, *Let the Record Show* indicted a number of individuals for their persecutory, violent, homophobic statements about AIDS – statements cast in concrete for the installation – and, in the case of then president Ronald Reagan, for his six-year-long failure to make any statement at all about the nation's number-one health emergency. The installation also included a light-emitting diode (LED) sign programmed with ten minutes of running text about the government's abysmal failure to confront the crisis. *Let the Record Show* demonstrated not only the ACT UP committee's wide knowledge of facts and figures detailing government inaction and mendacity, but also its sophistication about artistic techniques for distilling

and presenting the information. If an art world audience might have detected the working methods of such artists as Hans Haacke and Jenny Holzer in ACT UP's installation, so much the better to get them to pay attention to it. And after taking in its messages, who would have worried that the work might be too aesthetically derivative, not original enough? The aesthetic values of the traditional art world are of little consequence to AIDS activists. What counts in activist art is its propaganda effect; stealing the procedures of other artists is part of the plan – if it works, we use it.

ACT UP's ad hoc New Museum art project committee regrouped after finishing *Let the Record Show* and resolved to continue as an autonomous collective – 'a band of individuals united in anger and dedicated to exploiting the power of art to end the AIDS crisis.' Calling themselves Gran Fury, after the Plymouth model used by the New York City police as undercover cars, they became, for a time, ACT UP's unofficial propaganda ministry and guerrilla graphic designers. Counterfeit money for ACT UP's first-anniversary demonstration, WALL STREET II; a series of broadsides for New York ACT UP's participation in ACT NOW's spring 1988 offensive, NINE DAYS OF PROTEST; placards to carry and T-shirts to wear to SEIZE CONTROL OF THE FDA; a militant *New York Crimes* to wrap around the *New York Times* for the TARGET CITY HALL – these are some of the ways Gran Fury contributed to the distinctive style of ACT UP. Their brilliant use of word and image has also won Gran Fury a degree of acceptance in the art world, where they are now given funding for public artworks and invited to participate in museum exhibitions and to contribute 'artist's pages' to *Artforum*.

But, like the government's response to the AIDS activist agenda, the art world's embrace of AIDS activist art was long delayed. Early in 1988, members of the three ACT UP groups Gran Fury, Little Elvis, and Wave Three protested at the Museum of Modern Art (MOMA) for its exclusion of AIDS activist graphics. The occasion was an exhibition organized by curator Deborah Wye called 'Committed to Print: Social and Political Themes in Recent American Printed Art.' Work in the show was divided into broad categories: gender, governments/leaders, race/culture, nuclear power/ecology, war/revolution, economics/class struggle/the American dream. The singleness of 'gender' on this list, the failure to couple it with, say, 'sexuality,' already reveals the bias. Although spanning the period from the 1960s to the present, 'Committed to Print' included no work about either gay liberation or the AIDS crisis. When asked by a critic at the *Village Voice* why there was nothing about AIDS, the curator blithely replied that she knew of no graphic work of artistic merit dealing with the epidemic. AIDS activists responded with a handout for museum visitors explaining the reasons for demonstrating:

- We are here to protest the blatant omission from 'Committed to Print' of any mention of the lesbian and gay rights movement and of the AIDS crisis.
- By ignoring the epidemic, MOMA panders to the ignorance and indifference that prolong the suffering needlessly.
- By marginalizing 20 years of lesbian and gay rights struggles, MOMA makes invisible the most numerous victims of today's epidemic.
- Cultural blindness is the accomplice of societal indifference. We challenge the cultural workers at MOMA and the viewers of 'Committed to Print' to take political activism off the museum walls and into the realm of everyday life.

The distance between downtown and uptown New York – and between its constituent art institutions – was rarely so sharply delineated as it was with MOMA's blindness to SILENCE=DEATH, for it was only a few months earlier that Bill Olander had decided to ask ACT UP to design *Let the Record Show*, after having seen the ubiquitous SILENCE=DEATH poster the previous year: 'To me,' he wrote, 'it was among the most significant works of art that had yet been inspired and produced within the arms of the crisis' [Olander 1987: 1]. For more traditional museum officials, however, a current crisis is perhaps less easy to recognize, since they 'see' only what has become distant enough to take on the aura of universality. The concluding lines of MOMA curator Wye's catalogue essay betray this prejudice: 'In the final analysis it is not the specific issue or events that stand out. What we come away with is a shared sense of the human condition: rather than feeling set apart, we feel connected' [Wye 1988: 10]. The inability of others to 'feel connected' to the tragedy of AIDS is, of course, the very reason we in the AIDS activist movement have had to fight – to fight even to be thought of as sharing in what those who ignore us nevertheless presume to universalize as 'the human condition'.

But there is perhaps a simpler explanation for MOMA's inability to see SILENCE=DEATH. The political graphics in 'Committed to Print' were, it is true, addressed to the pressing issues of their time, but they were made by 'bona fide' artists – Robert Rauschenberg and Frank Stella, Leon Golob and Nancy Spero, Hans Haacke and Barbara Kruger. A few collectives were included – Group Material and Collaborative Projects – and even a few ad hoc groups – Black Emergency Cultural Coalition and Artists and Writers Protest Against the War in Vietnam. But these were either well-established artists' organizations or groups that had been burnished by the passage of time, making the museum hospitable to them. The Silence=Death Project (whose AIDSGATE poster had been printed in the summer of 1987 [Figure 32.2]) and Gran Fury (who by the time of the MOMA show had completed their first poster, AIDS: 1 in 61) were undoubtedly too rooted in movement politics for MOMA's curator to see their work within her constricted aesthetic perspective; they had, as yet, no artistic credentials that she knew of.

The distance between downtown and uptown is thus figured in more ways than one. For throughout the past decade postmodernist art has deliberately complicated the notion of 'the artist' so tenaciously clung to by MOMA's curator. Questions of identity, authorship, and audience – and the ways in which all three are constructed through representation – have been central to postmodernist art, theory, and criticism. The significance of so-called appropriation art, in which the artist forgoes the claim to original creation by appropriating already-existing images and objects, has been to show that the 'unique individual' is a kind of fiction, that our very selves are socially and historically determined through preexisting images, discourses, and events.

Young artists finding their place within the AIDS activist movement rather than the conventional artworld have had reason to take these issues very seriously. Identity is understood by them to be, among other things, coercively imposed by perceived sexual orientation or HIV status; it is, at the same time, willfully taken on, in defiant declaration of affinity with the 'others' of AIDS: queers, women, Blacks, Latinos, drug users, sex workers. Moreover, authorship is collectively and discursively named: the Silence=Death Project, Gran Fury, Little Elvis, Testing the

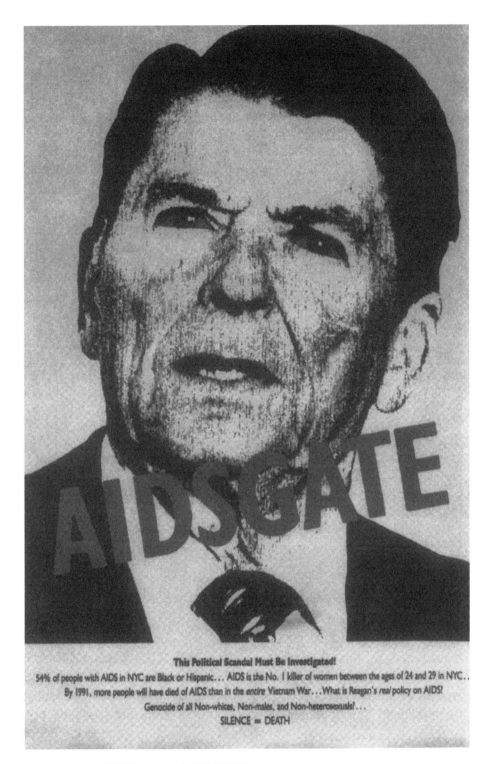

Figure 32.2 ACT UP poster 'AIDSGATE'

Limits (an AIDS activist video production group), DIVA TV (Damned Interfering Video Activist Television, a coalition of ACT UP video-makers), and LAPIT (Lesbian Activists Producing Interesting Television, a lesbian task group within DIVA). Authorship also constantly shifts: collectives' memberships and individual members' contributions vary from project to project.

Techniques of postmodernist appropriation are employed by these groups with a sly nod to art world precursors. In a number of early posters, for example, Gran Fury adopted Barbara Kruger's seductive graphic style, which was subsequently, and perhaps less knowingly, taken up by other ACT UP graphic producers. In the meantime, Gran Fury turned to other sources. Their best-known appropriation is undoubtedly the public service announcement on San Francisco (and later New York) city buses produced for 'Art Against AIDS on the Road,' under the auspices of the American Foundation for AIDS Research. Imitating the look of the United Colors of Benetton advertising campaign, Gran Fury photographed three stylish young interracial couples kissing and topped their images with the caption KISSING DOESN'T KILL: GREED AND INDIFFERENCE DO. The punch of the message, its implicit reference to the risk of HIV transmission, and its difference from a Benetton ad derive from a simple fact: of the three kissing couples, only one pairs boy with girl. If their sophisticated postmodern style has gained art world attention and much-needed funding for Gran Fury, the collective has accepted it only hesitantly, often biting the hand that feeds. Their first poster commission from an art institution was discharged with a message about art world complacency: WITH 42,000 DEAD, ART IS NOT ENOUGH. Familiar with the fate of most critical art practices – that is, with the art world's capacity to co-opt and neutralize them – Gran Fury has remained wary of their own success. Such success can ensure visibility, but visibility *to whom*?

For AIDS activist artists, rethinking the identity and role of the artist also entails new considerations of audience. Postmodernist art advanced a political critique of art institutions – and art itself as an institution – for the ways they constructed social relations through specific modes of address, representations of history, and obfuscations of power. The limits of this aesthetic critique, however, have been apparent in its own institutionalization: critical postmodernism has become a sanctioned, if still highly contested, art world product, the subject of standard exhibitions, catalogues, and reviews. The implicit promise of breaking out of the museum and marketplace to take on new issues and find new audiences has gone largely unfulfilled. AIDS activist art is one exception, and the difference is fairly easy to locate.

The constituency of much politically engaged art is the art world itself. Generally, artists ponder society from within the confines of their studios; there they apply their putatively unique visions to aesthetic analyses of social conditions. Mainstream artistic responses to the AIDS crisis often suffer from just such isolation, with the result that the art speaks only of the artist's private sense of rage, or loss, or helplessness. Such expressions are often genuine and moving, but their very hermeticism ensures that the audience that will find them so will be the traditional art audience.

AIDS activist artists work from a very different base. The point of departure of the graphics . . . and of the work in video . . . is neither the studio nor the artist's private vision, but AIDS activism. Social conditions are viewed from the perspective

of the movement working to change them. AIDS activist art is grounded in the accu-mulated knowledge and political analysis of the AIDS crisis produced collectively by the entire movement. The graphics not only reflect that knowledge, but actively contribute to its articulation as well. They codify concrete, specific issues of import-ance to the movement as a whole or to particular interests within it. They function as an organizing tool, by conveying, in compressed form, information and political positions to others affected by the epidemic, to onlookers at demonstrations, and to the dominant media. But their primary audience is the movement itself. AIDS activist graphics enunciate AIDS politics to and for all of us in the movement. They suggest slogans (SILENCE=DEATH becomes 'We'll never be silent again'), target oppo-nents (the *New York Times*, President Reagan, Cardinal O'Connor), define positions ('All people with AIDS are innocent'), propose actions ('Boycott Burroughs Wellcome'). Graphic designs are often devised in ACT UP committees and pre-sented to the floor at the group's regular Monday night meetings for discussion and approval. Contested positions are debated, and sometimes proposed graphic ideas are altered or vetoed by the membership. In the end, when the final product is wheat-pasted around the city, carried on protest placards, and worn on T-shirts, our pol-itics, and our cohesion around those politics, become visible to us, and to those who will potentially join us. Sometimes our graphics signify *only* internally, as when an ACT UP affinity group went to TARGET CITY HALL wearing T-shirts silk-screened with a photograph of the actress Cher. The group adopted the movie star's name as a camp gesture, and each time someone asked what it meant, CHER became an acronym for whatever could be concocted on the spot: anything from 'Commie Homos Engaged in Revolution' to 'Cathy Has Extra Rollers.'

ACT UP's humor is no joke. It has given us the courage to maintain our exuberant sense of life while every day coping with disease and death, and it has defended us against the pessimism endemic to other Left movements, from which we have otherwise taken so much. The adoption of the name CHER for an affinity group makes this point. A tradition of Left organizing, affinity groups are small asso-ciations of people within activist movements whose mutual trust and shared interests allow them to function autonomously and secretly, arrive at quick decisions by consensus, protect one another at demonstrations, and participate as units in coor-dinated acts of civil disobedience. ACT UP's affinity groups function in all of these ways, but our affinities, like our identities, are complexly constituted. Because being queer is an identity most of us share, one of our happiest affinities is camp. ACT UP graphics reflect that part of our politics too.

ACT UP has now become so adept at graphic production that we are able to have professionally produced posters even at 'zaps,' those small protests organized on the spur of the moment to respond to an emergency situation or a tip-off: the *New York Times* has just published a particularly damaging article; President Bush will be in town this week to speak at a Republican fundraiser; the New York City health commissioner is giving a lecture tomorrow at a health care facility. Having well-prepared visuals at such quickly arranged demonstrations is especially disarming to our opponents, who begin to fear our ubiquity. Protest movements have always had all-night poster-painting parties to prepare for such eventualities; ACT UP's inno-vation is to get the wheels of mechanical reproduction turning on equally short notice.

In addition to our large, well-organized demonstrations, ACT UP has staged hundreds of smaller protests and zaps over the past two and a half years. Most of them go unmentioned here, as do a few of our bigger demonstrations. The purpose of this [chapter] has been limited to presenting ACT UP's graphics in the context of demonstrations about major issues; we have therefore written only a partial history of a very complex political movement. One day in the future, when a far more complete history will be written, we hope ACT UP will have been just an episode – the episode compelled by the AIDS crisis – in the formation of a new mass movement for radical democratic change.

Murray Healy

REAL MEN, PHALLICISM AND
FASCISM [1996]

NEVER MIND WHETHER or not he had a swastika tattooed on his scalp or white power patches sewn on his flying jacket; thanks to the efforts of the British press and British nationalist groups such as Blood and Honour, and despite dedicated campaigning from anti-Nazi skinhead groups, by 1982 the skinhead had become a fascist symbol for many people.

The skinheads' association with fascistic violence is so strong that the same tendencies in other white working-class youth cults is often overlooked or down-played in comparison. But skins were certainly not the first and only white working-class youth culture to carry out racist and homophobic attacks: previous subcultures were also characterized by such violence. For example, the sociologist Geoff Pearson gives an account of a racist attack which took place in Accrington in 1956 by 'a large gang of about 100–200 white youths and men . . . The appearance suggested that they were "the lads".' But interestingly, Pearson, writing in 1976, has to emphasize that 'these were not skinheads . . . The style of this gang was of the latter-day teddy boy' [Pearson 1978: 52].

But since the original skinhead movement was an attempt to reassert conservative masculinity in the face of cultural change, skinheads have a particular investment in authenticity, the fixing of identity and the preservation of boundaries, which, in the current sociopolitical organization, lends itself to conservative ideologies and far-right politics. The conscription into neo-Nazi movements did not happen until the late 1970s' revival: the original skinheads did not operate through organized political movements, not even class ones. For most skinheads of voting age 'Labour would no doubt have been the most popular choice' [Marshall 1991: 36], although this is due to class loyalty rather than any socialist leanings; the tendency to the right in skinhead culture is already apparent in the 1960s. The Collingwood gang consider voting conservative an act of treacherous bourgeoisification, but when discussing immigration, say 'That's what we need – a Chinese Enoch Powell'

because 'ya don't see no blacks in China') [Daniel and McGuire 1972: 81]. In the wake of his famous, racist 'rivers of blood' speech, in which he used classical literary allusion to lend authority to his prophesy that many races living in close proximity could only result in mass murder, this far-right conservative was adopted as an unofficial skinhead figurehead. George Marshall claims that 'Many a young skinhead might have claimed old Enoch as a hero' and describes the skinhead contribution to the Great Vietnam Solidarity March of 1968: '30,000 students and related lazy bastards . . . and a few sore heads courtesy of 200 shaven-headed bootboys in Milwall colours, running along behind chanting "Enoch! Enoch!"' [Marshall 1991: 7]. And awareness of this extended beyond the confines of the subculture: a *Times* report in [16 February] 1981, trying to account for the rise of neo-Nazism among skinheads, traces right-wing tendencies among skinheads back to their first incarnation, recalling how 'In 1970 skinheads (not at his behest) formed a guard of honour for Mr Powell when he spoke at Smethwick.' The report attributes his status as a skinhead hero to his being 'a champion of nationalism and tribalism'.

Emerging from the punk scene, the new skinheads inherited the fascist symbolism punk had played with. But post-punk skins were reacting against the intellectual, bourgeois, 'art school' aspects of punk. Marshall states that 'most of the new breed of skinheads started out as little more than bald punks, who had taken shock value two steps further in a bid to distance themselves from the middle class mess punk had become' [64]. So if sporting a swastika had ever been a semiotic experiment with cultural and political symbolism, this was not to be the motivation for many skins. Susan Leigh Star's thesis that the inability of objective idealists to control the circulation and subsequent meaning of symbols will probably lead to their reinscription within the dominant is proven to be true: sporting a swastika as a fashion statement or a semiotic experiment facilitated its subsequent adoption by white working-class youths across various subcultural styles as an expression of their right-wing political allegiances.

In the late 1970s, the British Movement and the National Front sensed a swing to the right in the political climate with the Conservative Party being voted into office on a right-wing agenda in 1979. They began to run fairly high-profile recruitment campaigns for organizations outside the political mainstream, targeting young working-class males across the many youth cultures that had found themselves regenerated in the wake of punk. In 1980 the organizer for Youth National Front, Joe Pearce, boasted in an interview with *New Society* of 'widespread support among heavy metal fans and mods as well as skins' [Walker 1980: 347]. But the factors which differentiated them from the others – their particular conservatism and boundary fixation, and their status in British social memory as the most violent subculture – did seem to render skinheads predisposed to right-wing affiliation: the article countered Pearce's claim with the fact that a 'recent National Front march in Lewisham was 80 per cent skinhead', and such a spectacle was to recur throughout the 1980s. The skinhead look also appeared the most militaristic: the anti-style dress – particularly the razored hair and boots – functioned as a highly practical fighting uniform. This was perceived at the birth of the style: 1960s skins developed from 'gang mods, hard mods, who changed uniform to fight more easily' [Marshall 1991: 9]. George Marshall consciously acknowledges the function of the dress code as the 'adoption of a uniform'; in order to be 'just like an army, all copied each other in

dressing' [33]. The revived uniform underwent a transformation, though, drawing elements from punk and exaggerating elements of the original look. Jeans got tighter, DMs stretched towards the knee, the hair was completely shaved. The result was an even more terrifying appearance and 'gave out the image of an almost robot, uniformed army' [Knight 1982: 24]. And, subjected to political organization, that was just how they functioned:

> In recent years, the new National Front have tried to create a street fighting force . . . Their intention was to set up a group that appeared unconnected with the NF leadership but in reality could have their strings pulled by them. They would be used for street destabilisation, fighting at sports events and keeping up racial attacks.
>
> [Mickison 1988: 13]

The visual association of the striking skin image with right-wing demos on the streets and associated activity on the terraces was very strong. According to Peter Evans' report in *The Times*, by the winter of 1980 skinheads 'giving Nazi salutes and chanting racialist slogans' had become a common sight.

Significantly, visible reminders of the skinheads' debt to Jamaican culture were erased with their revival, as the Rude Boy elements disappeared from the skin wardrobe (Rude Boy styles were experiencing a contemporary revival with the formation of Two-Tone); the sharp, expensive tailored tonic jacket was dropped in favour of the cheaper, more practical MA-1 flying jacket. Similarly, Ska and Motown were ditched in favour of a new musical offshoot of punk, Oi! The monosyllabic musical movement was championed (and allegedly christened) in the late 1970s by *Sounds* journalist Garry Bushell, who claimed it celebrated working-classness, authenticity and inarticularity in the face of bourgeois, sophisticated intellectualism:

> Oi! was real punk. Punk had always made a big thing about being from the tower blocks and the working classes having a say. In reality it was all art school kids, posh kids from Bromley like Billy Idol. The real punk, the new punk, the Oi! bands were just working class kids.
>
> [Hibbert 1992: 6]

In erasing the last influence of black culture, the working-class identity that Oi! purported to celebrate was unequivocally white; the Kent organizer for the British Movement, Nicky Crane, famously starred on the sleeve of an early Oi! compilation.

Subjecting members of minoritized groups then became less a case of random sporadic violence than an aspect of a consistent political project. The increase in queerbashings was horrifically successful in so far as it popularized homophobia and deterred many people from adopting visible lesbian and gay identities. . . . [. . .] One gay skinhead of the time recalls,

> Straight skinheads were in gangs and everybody knew each other. A lot of them were politically motivated; they were NF, they *did* hate queers and they *did* go queerbashing and have marches and all that stuff. It was

something they sensed. Or they'd stop you and say, 'Oi, where are you from then mate?' and you'd be like frightened 'cos they really would headbutt you, they really were hard.

The event which probably cemented the relationship between skinheads and neo-Nazism was the anti-Asian violence at a gig featuring the Business, the Last Resort and the 4-Skins at the Hambrough Tavern in Southall, London in July 1981.

The polarization around the issue of race with Nazi skinheads active in an area with a high immigrant population meant that anyone who resembled a skinhead had to be viewed as a potential racist. Given the rising number of skinheads carrying out racist attacks on black and Asian people, allowing for semiotic ambiguity had become a luxury that people could not afford; this was a matter of survival. One gay man recalls the attention his skinhead appearance earned him in the spring of 1981:

> I was out with this girl and this Indian guy; we'd been to the Hambrough Tavern and we were walking back home when we came across this skinhead lying on the floor with a group of people around him, bleeding from the head. They said that three Indian guys had got out of a car and hit him across the head with an iron bar. Little did I realize that ten minutes later the same thing would happen to me. They smashed me across the head with an iron bar, and while I was lying in the road they smashed me in the face with it, so I lost my front teeth and my top lip was split completely open. I'd been on anti-racist demos and all that, I thought it was so ironic that that should happen to me.

He remembers the burning of the pub:

> It was front-page headlines in the news that weekend. I used to go there regularly 'cause I was living in Hayes, and Southall was the next place, and they used to have really really good punk groups there. They'd give you flyers telling you who was coming on, and I remember thinking, my God, the 4-Skins playing in Southall, that's a bit risky. I wanted to go to the 4-Skins 'cause I knew there'd be lots of skinheads there. But it just turned out that I went to see Siouxsie and the Banshees in Bracknell instead. This girl I knew was in the pub that night, she said that one minute they were just sitting there, the next there were molotov cocktails flying through the window. They had to get out of the toilet window to escape; the whole place was up in flames and was surrounded by local Asian people, who obviously thought they weren't going to have some skinhead group playing in their area, basically.

George Marshall is particularly bitter about the media coverage of this event [Marshall 1991: 105–8]. The press focus on skins as neo-Nazis turned 'original' skins off the subculture and attracted non-skin right-wingers to the cult. The media created a focus which activated, polarized and fixed its results through deterrence/amplification, turning the post-punk skinhead into a neo-Nazi symbol. 'The effect of the media circus around the white power scene meant that all skinheads

were seen as being racist by the general public', says Marshall, who goes to great
lengths to blame this on fascist appropriation of the image rather than skinheads'
sympathies with right-wing politics: 'The truth was that it wasn't so much skin-
heads turning to Nazism but Nazis turning into skinheads' [138]. But he concedes
that 'maybe a lot of skins were fascist at the time . . . Most kids were NF just
because it was fashionable . . . NF mods and BM trendies' [89]. Even today, 'there
can be little doubt that Blood and Honour represent a sizeable slice of the Skinhead
cake' [141]. Blood and Honour, an umbrella group uniting Oi! groups which
together formed 'the independent voice of Rock Against Communism' and which
was fronted by Ian Stuart of the neo-Nazi skinhead band Skrewdriver did much to
cement the connection between fascism and skinheads. Blood and Honour gigs
proved to be rally points for British nationalists, with far-right literature circulating
among audiences of skinheads making Nazi salutes. [. . .]

The real thing

Claims as to who represents the authentic voice of any group are always heated:
the debates on sadomasochism and gay masculinity, for example, rage over the ques-
tions of who are the authentic men, the real feminists, the truly liberated gay men,
and so on. Controlling the representations of a group by defining the terms of
constituency is a problem that has dogged radical-left identity politics, more recently
saliently played out over the question of whether male-to-female transgenderists
should be allowed in women-only spaces. This concern with border control is para-
doxically similar to that of the skinheads. Authenticity is particularly important to
skinheads as the subculture arose to preserve what was perceived to be a traditional,
authentic identity, and the challenge of skinhead identity ever since has been to
make that authenticity apparent. How ironic is the subtitle of George Marshall's
book, *Spirit of '69: A Skinhead Bible?* Given the proliferation of myths of the origin
in the wake of the politicization and factionalism of skinheads in the early 1980s,
the book proposes to set the record straight. It authenticates itself on the grounds
that it is an insiders' chronicle of the subculture, and that those insiders are real
skins. A similar tactic characterizes the promotional material which accompanied
Gavin Watson's book *Skins*, from *Spirit of '69*'s publishers [Skinhead Times
Publishing] in 1994. 'The photos were taken by a skinhead, Gavin Watson, and not
some middle class middle-aged bastard getting his kicks by living his life through
others', and those pictures 'say more about the skinhead cult than a thousand books
written by social workers will ever say about us.'

Adopting a skinhead identity is still a highly potent way for a gay man to claim
(or play with, or undo) notions of authentic masculinity. But just as in other areas
of skinhead subculture, exactly who is embraced within the group 'genuine skin' is
a controversial matter, and entails a questioning of what constitutes a gay skinhead.
Obviously the category 'gay skinhead' encompasses much diversity, as this is no
more a homogeneous group than the broader categories of 'gay' and 'skinhead'.

Within gay skinhead subculture, debates about authenticity are usually played
out around the opposition between 'real skins' and what are popularly derided as

'fashion skins'; real skinheads stake their claim by highlighting their difference from the others who only 'dress up' or are attracted to the look solely for a specific sexual purpose. This was emphasized in Mike Dow's piece on gay skins which appeared in the gay weekly *Out*, in April 1985:

> The real skin is suspicious of the poseur who is someone that dresses in boots, braces and wears his hair short solely to attract other men with the image. This upsets 'real' skins like Mitch.
>
> 'It annoys me to see poseur skins dress up to get trade. They're just taking the piss!'

Fear of 'fashion skins' is present in the straight subculture too; 'Out now,' pronounced the publicity for *Skins*, 'and not for sale to trendy wankers.' Trends are about social change; skinheads are supposed to represent an intransigent, timeless essence of masculinity. But the proof of one's authenticity as a skinhead should be apparent on sight: it has to be materialized, and that can only be through one's manner and one's dress. The skinheads' fear of trendiness is motivated by the fear that being a skinhead is in fact only a pose, only a look. So, potentially, *anyone* could be a skinhead. This motivates an emphatic disavowal of fashion: 'The skinhead is beyond fashion and cannot be assimilated', writes a skinhead in gay arts magazine *Square Peg* in 1986, 'his clothes are "anti-clothes".' In the *Out* article, Mitch removes the skinhead from the subcultural history: 'Teddy boys and mods have come and gone but they all still look as though they're wearing a fashion. Being a real skinhead has nothing to do with a fashion.'

If being a skinhead is about being authentic, then it has to be more than just dressing up, because fashion is only skin-deep. So this tangible shallowness of the skinhead's surface appearance is counteracted by abstract, deep concepts sited at a mythologized interior. 'You can't wear a feeling', says Mitch, 'that's something only your heart can explain.' Genuine skinhead identity is the expression of something unseen and internal: a sense of real commitment to the essence of skinheadism, rather than the mere donning of a fake, surface fashion. In gay subculture, this requires a commitment to a public, full-time, social street identity as opposed to a private, part-time, sexual leisure identity. 'It's my way of life', says Mitch. 'I can't wear anything else. I'm alive when I'm wearing my gear.' Although preserving the gay skinhead's subversion of the division between homosociality and homosexuality, this criterion of full-time social commitment does position homosociality as primary and the sexual aspects as secondary.

This importance of social over sexual motivation is manifest in Jamie Crofts' description of what constitutes authentic skin status.

> If you're just into the look 'cause it can help you pick up in bars, you're letting people down with that, you're not operating as part of a [skinhead] community. Being a skinhead means you can bump into another one anywhere and just start talking to them, it's a cult thing. That's definitely one of the attractions for me.

Being a gay skinhead means being part of a skinhead community as well as a gay one. Many gay skins feel no camaraderie with straight skins,

and that's what distinguishes the real skinhead from the phony ones. You meet people all the time who are standing round posing in bars. There's one in the bars round here all the time: when I first saw him, I thought great, I'll go and chat to him, but he just stuck his nose in the air and looked off, and that's not what a skinhead's about. It's sexual, yeah, but it's social too.

Some gay skinheads get hassle from straight skinheads, and I reckon that's where it comes from. Say you walk past a straight pub with a group of skinheads hanging round outside, if you walk past with your nose in the air, they're immediately going to start shouting abuse at you, 'cause you're not the real thing. If you take on the look, I believe you've got to take on that side of it as well.

The public, full-time nature of his skinhead identity is far more than a matter of wearing the right clothes: he feels he has what he terms a 'responsibility' to the reputation of skinheads. 'If you just do it as a look, you can see people failing, 'cause they can't confront what it's about.'

Significantly, those who played a prominent part in the Gay Skinhead Group (GSG) emphatically also stressed that their skinhead (social) identity is primary to, and subsequently affects, their sexuality, rather than their sexual preference dictating what they wear. One gay skin who ran GSG in the late 1980s was interviewed for *Skin Complex* in his capacity as a member of Skinheads Against Racial Prejudice, a skinhead group whose primary interest is not with sexual identity. In declaring himself 'a skinhead who just happens to be gay', mixing in predominantly straight (skinhead) circles and distancing himself from the gay 'fashion skins' who have evolved from the clone model, his hierarchy of identification places 'skinhead' above 'gay'. For him, his claim to authentic skinheadism is the primacy of his skinhead allegiance, unlike fashion skins, who only exist within the limits of gay subculture, their skinhead identity being secondary to their sexuality.

The same is true of Chris Clive, who took over the running of the Gay Skinhead Group in 1992. As someone who became a skinhead when he left school in 1969, he also had an advantage in arguments over authenticity; as his skinhead identity preceded his gay identity historically as well as ideologically. He would proudly describe himself as a 'genuine skinhead' rather than a gay man whose interest in men had lead him to fetishize skinhead imagery. Whilst accepting fashion skins into the Gay Skinhead Group, when he spoke to me on the subject, he was keen to insist that 'the members in the group, a lot of them are real skinheads, but they've got no animosity against the ones who just dress up, if you like, the fashion skins. Most of them shave their heads or just copy the image. But they're all welcome.'

'Real' skins are united by their commitment to skinheadism; motivation would seem to be the deciding factor in weeding out the fakes. But given that authentic skinhead status is highly prized amongst gay skinheads, there is much investment in authenticating oneself, and the criteria will change from person to person according to the restrictions of each participant's own identity. For example, one 'genuine' gay skin was adamant that class identity was not a deciding factor; he was middle class. This would explain the anxieties on this matter – a lot of gay men who want to be included in this grouping are afraid of their exclusion. Those who wish to

claim an authentic status but are conscious of the skinhead component of their iden-
tity as appropriation or drag are likely to assert their authenticity all the more
vociferously. In a feature on the gay skinhead scene that appeared in the gay weekly
Boyz [17 July 1993], Ian Peacock, discovering that 'some of these guys are lawyers,
doctors and students', satirized their lack of one of the primary markers of the skin-
head – working-class identity. Nevertheless, the regulars stressed the authenticity
of their skinhead identity: one interviewee said, 'We are *real* skinheads. *We're not
just impersonating them.* We're not just fashion queens with cropped hair. A lot of
these guys here are *genuine* East End boyz' (my emphasis).

Unsurprisingly, all the gay skinheads I spoke to were unambiguous about their
authentic skinhead status. But they were unable to articulate *why* the matter of
authenticity warranted so much investment and required so much evidence. My
own suspicion is that it centres on a problem around the phantom of heterosexu-
ality that haunts the skinhead even when existing within a homosexual context. Gay
skinheads have to assert the authenticity of their skinhead identity all the more stren-
uously as a disavowal of the suspicion that gay men cannot be skinheads. Some gay
skins are conscious of this. 'A friend of mine said that somebody was definitely the
real thing', said one, 'and I said, "Well, *I'm* the real thing." He assumed that if
you're gay, you're not the real thing. That's very common. That's why I make a
point of saying I'm the real thing.'

The anxieties around inauthentic masculinity that characterize straight skins'
attitudes to gay skinheads – 'They're not real, they're just copying us' – are repro-
duced within gay subculture and displaced on to the schism between real skins and
gay skins, between those who live it and those who 'imitate' or 'just copy the image'.
After all, if we consider the gay skinhead as an appropriation, that concedes that
the look did originally belong to someone else – straight lads. Chris Clive main-
tained that 'the skinhead is not originally a gay bloke at all' and tellingly distinguished
the real skinhead members of his group from 'the gay ones', the fashion skins.

Adopting *any* identity is an exercise in self-reinvention to some extent; authen-
ticating that identity entails a disavowal of its inventedness. Although signifiers of
class can be adopted or changed, biographical facts are beyond the limits of self-
reinvention. As the phrase in the *Boyz* feature, 'genuine East End boyz' suggests,
geography comes to displace class as a deciding factor in the criteria of authentic
skinhead status, because it has biographical implications. So if you cannot choose
the conditions of your upbringing, you can at least choose where you want to live.

The diversity of types of gay skinhead can be traced to the various routes by
which one may arrive at a gay skinhead identity. So a working-class gay skin who
grew up in a skinhead gang obviously has more credibility as an authentic skin than
a middle-class man who got into skinheads after a few years on the scene as a clone.
The social holds dominance over the sexual, working class is more real than middle
class. But this may lead the middle-class skin to go to greater lengths to authenti-
cate his identity. Among working-class gay skins, those who identified from an early
age as queers and were subsequently alienated by and excluded from the hard
masculinity represented by skinhead culture, who later reclaim a skin identity by
adopting the scene image, are less authentic than those who grew up in a skinhead
gang. The latter's continuity bears witness to the social primacy of his motivation:
the skinhead identity may dominate, allowing him to continue to mix in the straight

skinhead circles he grew up in. As such, this is perhaps the most 'authentic' gay skin identity – those who were always/already skinheads. In his *Boyz* article, Ian Peacock found one who became a skinhead at thirteen: 'I wasn't out then, so I used to hang out with straight skins. I used to get embarrassed when they said anti-gay things. They didn't like it much when I hit 17 and decided to come out.' Given that the look started to disappear for a second time from the early 1980s, the number of gay lads who can follow this route must be decidedly small and ever-decreasing.

A very small number of gay men, in a desperate attempt to authenticate their skinhead identity, wear swastikas, even while voicing anti-fascist sympathies. The reason for this might lie in one gay man's recollection of being a skinhead in the early 1980s: 'the object was to look as hard as possible, and fascist skinheads, the hard-core skins, were the hardest of the lot'. Notice the conflation of fascist with *hard-core*: this sites the fascist skinhead at the centre of the subculture, marginalizing other variants, authenticated in his phallic solidity. So, even though they are aware of the diversity of political allegiances within skinhead subculture, some gay skins submit to the common conception that 'real' skinheads are neo-Nazis and lay a symbolic claim to that realness. [. . .]

Of course, it may well be that the skinhead's association with fascism itself draws some gay men to the image. This fascination may be sexual, suggesting SM fantasies. Or it may be social: the sexualized masculinity of the fascist skinhead may motivate some men to become involved in the politics of the far right.

Gay fascists

Most gay skinheads speak of gay and Nazi skins as unproblematically distinct group-ings, often defining them against each other. For example, Nick, who was a member of a gay skinhead gang in London in the early 1980s when fascist skins were on the rise, said, 'Gay skinheads weren't racist. They knew about being a minority', whereas he estimated that over half the straight skinheads of the time were involved to some degree in fascist politics. The separate identities kept to their separate terri-tories, but the shared self-representational codes allowed for some overlap, a particularly useful thing for what this interviewee called 'closet gay skins'. These would be active on the straight scene but also venture on to the gay scene, the two subcultures being separate enough to keep the knowledge from straight homophobic peers. Particular geographic sites acted as points of convergence: The Last Resort, the skinhead shop in Goulston Street, was a popular hang-out for hard-core skins, both straight and secretly gay, The Craven was a similar crossover point on the gay scene. 'It was a gay club and pub near Heaven in Craven Street, upstairs with a camera entry system', remembers John Byrne.

> The skinheads moved in there in the mid-eighties; soon, about 98 per cent were skinheads or skinhead admirers. There were a lot of closet skinheads, especially in a place like the Craven, you used to get a lot of 'straight' ones as well as gay ones, but nobody cared. It only closed when they redeveloped Charing Cross station in the late eighties.

The population of this territorial overlap troubles this simplistic homogeneity of the categories gay, straight and fascist skin: 'Some of the really big fascist skinheads later came out', concedes one.

Nicky Crane, by his own admission a devout Nazi who idolized Hitler, was the organizer and recruiter for the Kent British Movement in the 1980s. At the same time he was a regular at the Craven Club. 'He used to come to Brighton on Bank Holidays too', says John Byrne.

> I think he was interested in the young skinheads. I first got chatting to him in 1984 at the Craven Club. At first, I didn't know he was a Nazi, but even when I found out, I carried on talking to him, 'cause he was very friendly. But most skinheads didn't know he was gay. I had a bit of trouble once on a Bank Holiday, because these skinheads swore blind that he wasn't, 'cause he was more renowned for being a Nazi. They told me I was making it up.

A familiar face at gay skin gatherings, Crane even starred in some gay porn videos in the mid-1980s, where he can be seen ordering other skins to lick his boots whilst shouting racist abuse. Knowledge of Crane's sexuality, if not his political activism, was fairly widespread on the gay skin scene long before he came out on [Stephen Lennhoff's documentary] *Skin Complex* in 1992. . . .

In the TV interview he confessed he had long known he was gay but had felt unable to come out, although he claims he avoided involvements in queerbashings. When he finally had sex with a man at twenty-six he 'felt like a hypocrite', although it was some time before he felt enough conflict between his homosexuality and his fascist loyalties to motivate him to leave the BM, denouncing his past and claiming conversion to liberal individualist ideology. Such stories are not uncommon: the March/April 1993 issue of *Skinhead Nation* contains a confession by a former White Power skin and 'deprogrammed Nazi' whose discovery of queer politics at seventeen led him to denounce his fascist loyalties.

These histories see an 'out-gay' identity as incompatible with far-right ideology, to the extent that the ritual of coming out entails an almost mystical ideological conversion. But, although it is a common assumption, one cannot assume gay men to be committed to left-wing politics any more than one can assume that all skinheads are automatically fascists. Being a sexual outlaw does not guarantee an essential commitment to counter-hegemonic ideology, and stigmatized subcultures may in fact intensify dominant forms of oppression, albeit unconsciously, as some claim to be the case in the prevalence of masculine codes on the gay scene.

There are obvious historical reasons why the modern understanding of identity politics sites 'gay' as a left-wing phenomenon. The dominant modern notion of gay identity is informed by the radical-left politics of counter-culture revolutionary movements of the late 1960s, and gay rights issues, like those of other oppressed minorities, have since been championed by the left. The British press, eager to secure the government's Conservative majority after it came to government in 1979, exploited this connection and consolidated it in the public consciousness by simultaneously demonizing the 'loony left' and homosexuals in a reductive tautology: the left are not to be trusted because they are all queer perverts; homosexuals are not to be trusted because they are communist subversives. . . .

In fact, despite the vociferously homophobic agenda of all right-wing political parties, homosexual identity may not necessarily be incompatible with far-right ideology. While stressing the ideological, cultural and geographic divisions between gay and neo-Nazi skins, Nick recalls that in the early 1980s

> there *were* NF skinheads that were gay, but that didn't come out till much much later, because for a lot of skinheads it was unheard of to be gay. They didn't want to come to terms with being gay and that was the way they hid it, because you could be very aggressive and nobody expected a skinhead to be gay.

There is in fact much anxiety among the far right that their political leaders engage in homosexual acts; Ian Stuart repeatedly emphasized on record that 'the leaders of the National Front were homosexual scum' [Mickison 1988: 13]. In a bid to deter skinheads from conscription to Nazism, the Gonads, an Oi! band fronted by the godfather of Oi! Garry Bushell, exploited this anxiety with the song 'Hitler was an 'Omo':

> Hitler was a homo
> A snivelling little queer
> He never got a round in
> He never bought a beer.

The band's own implication in this anxiety was disavowed by the 'humorous' lyrical context of the sentiment: according to Bushell, 'Garry & The Gonads was all joke stuff.' [Hibbert 1992: 6]

As these suspicions confirm, homosexuality and neo-Nazism may not be conflicting components of an individual's identity. But it is usually expected that an out-gay *identity* conflicts with far-right ideology. Nicky Crane, after all, claimed that once he had come out, he found his politics to be incompatible with his sexual identity: gay neo-Nazis must therefore be closets and not 'really' gay. Gay fascism is discussed in terms of disavowal and suppression: fascist homosexuals are usually 'revealed' to have gone to great lengths to 'conceal' their sexuality.

But this is not always the case. When asked about skinheads and fascism, one club promoter emphasized that 'it has to be said that a lot of skinheads are fascists. They are, one can't deny that. Not necessarily on the gay scene. Although . . .' After a pause, he continued, 'Er, I know a lot of gay skinheads who are fascists, who go on marches with the BNP. The National Front for example is very much a gay organization. There are lots of gay skinheads who are members of that.'

Regular faces on the local macho scene include the members of a group of neo-Nazi gay skins who live in Earls Court, indistinguishable from other gay skins aside from the occasional sporting of sew-on badges of fascist Oi! bands like Skrewdriver and No Remorse. For them, their homosexuality does not contradict their political ideology: they are famous locally for being aggressively defensive of their sexuality. According to a nearby resident, 'You often hear them shout things like, "Yeah, I'm queer, got a fuckin' problem with that?" at people in the street.' Two were interviewed in the front room of their basement flat in shadow for *Skin Complex*. One,

Scott, claimed that there were many gay men in the British National Party, which he felt would eventually have to drop its anti-gay stance because of this. 'I've known a lot of skins who are supporters of the BNP', says a friend of Scott, 'but I know even more who have never been skinheads in their lives who are totally right wing, have been members of the Front, who still support it, who are queens. Some are married, some aren't.' He refuses to see the naturalized opposition of homosexual identity with far-right ideology:

> It's just as likely that there are going to be gay people who'll join the SWP as there are others who'll be drawn towards the other end. The idea of the gay community is a load of crap – the idea of the Rainbow Alliance that could be created around any disaffected minority. In other words, I must have something in common with a Rastafarian, and an Asian man must have something in common with an African woman, is absolutely crap. And that is something I cannot fucking stand. It's like someone in the Anvil telling me that, as a gay man, I can't wear nation-alist patches on my bomber jacket. It's bollocks, because there is no gay community.

He too feels that British nationalist political organizations will have to drop promises to recriminalize homosexuality because of their sizeable gay support:

> They obviously can't admit to it, because they're supposed to be for law and order and the family. So they can't put 'We'll allow homosexuality' in print in a manifesto. Their agenda is, they'll look at anything to get votes. So banning poofs, they hope, is an extra vote. So that's why they won't drop it from their manifesto.
>
> But there are loads of queens on the right. And I always got the impression that as long as it wasn't obvious, they weren't worried. They still had your subscription.

Nazism and homosexuality

The fact that homosexuals were one of the persecuted social groups in Germany under the Third Reich is often used to naturalize the current organization of sociopolitics which cites support for homosexuality on the left. Gay rights *is* a left-wing issue, because the discourse of rights belongs to the radical left. But being gay does not automatically predispose one to a socialist ideology. I make this point in order to counter the glib generalization that, somehow, any fascist symbolism appro-priated to a gay context magically strips it of its fascist value. Gay fascists do not wear white power insignia because they are being ironic.

It may seem paradoxical that gay men should be involved in homophobic polit-ical movements, and those individuals themselves are usually not very good at accounting for their involvement. While they claim that there are many other gay men involved, it seems that they are all closeted: homosexual activity would seem to be rife, but homosexual identity is beyond discussion. The work of Klaus

Theweleit [1989] may shed some light on understanding why neo-Nazis do not see their sexual identity precluding their political allegiances. His complex consideration of masculinist ideology in Nazi Germany provides an explanation of how a fascist cultural organization in fact *requires* homosexual activity, while ostensibly prohibiting it.

The myth of phallic totality, solidity and closure is central to the absolute and strict imposition of the law which characterizes fascist ideologies, and in Theweleit's psychoanalytic argument, fascism is a cultural project of border-preservation and identity-fixation (not dissimilar to that of the skinheads who police local stomping grounds and football terraces against 'outsiders'). According to Theweleit, fascist ideologies see survival as a matter of maintaining the distinctness of the individual's own identity: the monolithic self has to be clearly delineated to counter the anxiety that the enemy, the other, is similar. This is evident in Nazi propaganda, which reveals a conspicuous effort in emphasizing the difference of targeted groups; that difference becomes the very grounds for their victimization.

Sexuality was perceived as hard to organize and contain, and therefore dangerous, because as a fluid form of desire, it compromised this monolithic sense of self. Theweleit goes so far as to postulate that instances of fascist violence are identity-maintenance processes which 'subsume sexual drives under drives for self-maintenance' [Theweleit 1989: 278]. Homosexuality was all the more dangerous as it involved a pleasurable embracing of sameness which compromised distinction and difference, threatening to open the borders of the self:

> Homosexuality is a danger to the *Ganzheitsleib* as it is seen as dismantling boundaries in two possible ways: a return to the original 'unformulated return of the libido' and the foregrounding of anality in a society which seeks to ensure that 'the anus, the ultimate sluice, remains persistently hidden'. . . . Anal penetration comes to represent the opening of social prisons, admission into a hidden dungeon that guards the keys to the recuperation of the revolutionary dimension of desire – 'revolutionary' in that it is a 'desire to desire'.
>
> [312–13]

But while 'it was imperative for "real" homosexuality – the potential for actual *homosexual* pleasure – to remain under lock and key' [325], Theweleit argues that the Nazi regime practised homosexual anal intercourse, paradoxically, to disempower this revolutionary potential of homosexuality as a 'desire to desire'. As a compulsive pleasure, homosexuality undid norms, but as an activity of power, anal intercourse could be used to reinforce the difference between self and other in what Theweleit refers to as an act of 'territorialization'. The strict limits within which it was allowed within the Nazi hierarchy preserved it as an exploitable tool in the maintenance of power within and between ranks: 'since "homosexuality" was never publicly sanctioned, it remained shrouded in obscurity; and it was this that allowed it to play a privileged role in the Right's internal power struggles' [337]. If Theweleit's complex thesis is correct, then it may explain why homosexual activity within organizations such as the British Movement may not be paradoxical to the participants, and for them it does not necessarily negate the organization's homophobia.

Misrecognition

Nearly every skinhead I spoke to in the course of researching this book was committed to left-wing political parties, so their sense of betrayal at the emphasis given by the makers of *Skin Complex* to fascist gay skinheads is more than understandable. As one said, 'I didn't like it because it was far too political – the usual thing, all skinheads are Nazis. I don't like that. Programmes about skinheads should be about skinheads and not Nazis.' As angry letters in the gay press in the weeks that followed attested, many felt that the object of the programme was to portray all skinheads of whatever sexual orientation as fascist or supportive of right-wing politics. To be fair, the programme never pretended to be putting the case for gay skinheads. The programme makers seemed to assume a consensus in favour of gay skins, a consensus founded on the avoidance of certain questions which it was the programme's job to articulate. But gay skinheads are rarely discussed beyond the context of fascism: even accounts of the subculture in the scene-friendly gay weekly *Boyz* address this thorny political question.

But given the strength of the skinhead-fascist association, this is only to be expected. Gay skinheads today have to face up to being mistaken for fascists, particularly those in places and times where far-right politics has some support. Michael Dover now lives in the East End with his skinhead boyfriend Steve:

> In the past couple of years, we've had a few occasions when it's been misinterpreted. Someone came rushing up to Steve one night and asked him if he was a fascist. And he said, 'Actually no, I'm not at all.' They said, 'But you've got short hair.' He said, 'The hair doesn't make me a fascist.'

In the aftermath of a BNP victory in a local election in 1993,

> quite often in the Bethnal Green area we'd have young schoolboy skinheads coming up to us and saying 'All right mate?' 'cause they actually assumed that if you have short hair you're a BNP supporter. Which is why I wear my pink triangle and rainbow flag.

At the same time, as public knowledge of gay skinheads slowly grows, they have started to become identifiable as gay men: 'We've had cars drive by with people shouting "Faggots!" at us.' Jamie Crofts tells of similar experiences.

> I know if I walk along the street, people make assumptions about me. The way things are at the moment (it didn't used to be like this twenty-odd years ago, I suppose) people think you're a fascist, which doesn't bother me, but you have to face up to that. If people confront you, as they do, you can put them right. Having to face that actually makes me think about the issue of racism a lot more than I would have done otherwise, I think.

The existence of gay skinheads in a distinct area of gay subculture does however allow space for far-right activists to move on to the scene. Venues which have come

to cater for a clone clientele tend to enforce militaristic dress codes and men-only door policies; as such they have always been open to accusations of covert fascism, particularly from radical activist groups. These venues have found in recent years that a growing number of their customers are skinheads; no doubt, they cater for fashion and fetish skins, but who can be sure that fascists are not present as well – who can tell the difference?

Several straight skinheads I spoke to claimed that, among skinheads, gay and Nazi skins are deemed to look more like each other than the other factions within the subculture; both tend to prefer completely shaved heads (fascist skinheads are commonly derided as 'boneheads'), tight T-shirts and jeans rolled up to reveal knee-high Doc Marten boots. Both these permutations emerged in the early 1980s, from a skin scene that had initially been fairly diverse. One gay skin remembers the differing skinhead tribes at the time:

> Hardcore skinheads – they were just racist, and that was their identity, a lot of hatred and stuff; and genuine skinheads, who weren't particularly racist – more like the original skinheads, because the ska revival was happening as well at the time, two-tone, a suedehead thing. The identity was different according to details. There were 8-, 14-, 24-hole Doctor Martens, and then you had people who just wore DM shoes; trousers could be cut off high jeans, bleached, or Sta Press, bomber jackets or Crombies and it all said something about the type of skinhead you were . . . 24-hole DMs, tattoos on your face and HATE and LOVE on your knuckles meant you were a hard-core skin. Quite a few of the gay guys had their faces done – rent boys went for that. It was protection; tattoos made you dead hard. If there was some twat trying to have a go, he'd think twice.

While neo-Nazi skins had a political reason to look as threatening as possible, gay men had an erotic interest in the hardest possible image too: both groups seemed to agree on what that was, resulting in an intensification of the masculinity signalled by the previous incarnation of the skinhead. According to one gay skin member of Blood and Honour, erotic interest extended to the 'straight' hard-core skins. 'Yeah, they're straight, but sexuality isn't that cut and dried. Because that particular skinhead image is an exaggeration of masculinity, anyone who adopts it . . . well, there's got to be some interest there.' At the start of the skin revival,

> if you saw a skin, he'd have a grade 4 crop and ordinary boots, that was okay then. But as it went on, the more extreme it had to be: head completely shaved, 20-hole Ranger boots – it's got to be the hardest image possible. The tattoos on the face are really a straight skinhead phenomenon. As the cult was getting more exaggerated, everyone was trying to be that much harder than the next skin. You never saw that many tattoos in the early days, unless they were roses or Mum and Dad. But then it was HATE and LOVE on the hand, bluebirds, CUT HERE round the neck, it got more and more. Earrings, too: you might have started

off with one, but then it had to be more, more extreme. Rings through the nipples: I remember seeing skinheads with nipple rings long before it became popular on the gay scene.

A number of gay skins in the mid-1980s sported tattoos on their faces to distance themselves from fashion skins, who could shed their clothes at the end of the day. It was a measure of their commitment to skinheadism to have their identity literally written on the body. [. . .]

I asked Daffyd Jenkins, the Manager of the south London uniform club the Anvil, whether he thought there was any danger that people might misrecognize a fascist skinhead as a gay skinhead. His answer was unequivocally, 'No':

> The difference is pronounced – apart from a very small percentage. You can recognize a straight skinhead with your eyes closed and your back turned. With a lot of skins, you can walk into any bar and see some sights and think, God, that's a nasty piece of work. There are a few real hard-core skinheads who are not allowed on the scene; any Nazi regalia is automatically banned by any respectable bar, we just will not allow it.

In July 1993, however, a black man was attacked by three white skinheads at another venue favoured by gay skins, the London Apprentice, which only added to the controversy over allegations that customers had been seen wearing swastikas and other fascist regalia. This led to the Lesbian and Gay Campaign Against Racism and Fascism picketing the pub, calling for its barring of women to be lifted and a strict door policy to keep fascists out. Drag star Lily Savage openly leant his support to the picket. OutRage! had campaigned over similar issues the previous year, before a meeting at which Peter Tatchell, representing the gay activist group, Vicky Pengilley, the venue's director, and the LA's customers were satisfied that allegations of racism were totally groundless.

Referring to the sighting of fascist regalia on the premises, Jenkins firmly believes that

> the incident at the LA was a one-off. No matter what checks you put on the door, people still get in. They only have to stuff a couple of arm bands in their pockets and put them on at a later time, and the venue gets accused of all sorts of things. There was an incident in the early days at my club; two guys turned up in leather coats, and when they took them off, they had SS officers' uniforms on. And the annoying thing was, these guys weren't on the scene at all, they'd just worn it as a joke. It caused no end of upset – letters to the press saying Daffyd Jenkins was a nasty Nazi bastard for allowing this, and all the rest of it. [. . .]

Get 'em off?

The emergence of scene-based masculine gay identities gave rise to a subculture characterized by sadomasochistic practices and the use of symbols which, at some level, derive their significance of power from a male context. In some cases, those symbols can be fascistic. This may be seen to validate the speculative fears of gay liberationists that masculine codes, even when recontextualized, cannot but redeploy violent patriarchal oppression. The gay skinhead identity is a locus of convergence for all three controversial aspects of the macho model's appropriation of dominant 'rough' masculinity: his role as a fetish and an accumulation of fetishes, his association with queerbashing (hence SM), and his (distantly symbolic, if not actual) association with fascism.

One answer might be for all non- or anti-Nazis, gay and straight, to abandon the skinhead look to neo-Nazi movements; after all, as one writer [in *The Times*, 22 July 1981] commented on complaints from skinheads about prejudice against them, 'Perhaps we should say that kids should not dress in a cliche style if they do not want to be treated as the worst of their kind.' If we refuse to read skinheads as anything other than fascists, those who are not may eventually cease using the code, and at least then we would really know who our enemies were on sight.

But the semiotic fundamentalism of skinhead = fascist only serves to reinforce the far right's project of social homogenization and the fixing of identity boundaries. Malcolm Quinn's analysis of the swastika shows how tautologous signification serves a fascistic purpose and warns that the continued power of the closure of its signification bears witness to the success of the German nationalist project, which constructed symbols – and races – as arrested and static, just as it fixed the characteristics it attributed to other races, whose differences this process naturalized. 'The danger of our current situation is that individual memories of Nazi terror will fade, but that the swastika will continue to be used as a racist symbol uniting far-right groups across Europe.' [Quinn 1994: 138]

The photographer and writer David Bailey presented a more ambivalent opinion . . . on *Skin Complex*, where he described queers dressing like skins as 'not fighting skinheads but stripping them visually and culturally of their identity'. Whereas confrontation consolidates differences and delineates identities, capitulating to far-right ideology, this tactic subverts those constructs. Fascist ideology is contested by open signifiers and fluid sexualities. Homosexual identity was feared in Nazi Germany precisely because its apparent ideological inability to be contained meant that it could not find space in, and therefore threatened to deconstruct, the strict gender system which relied upon heterosexuality to naturalize the distribution of labour and social hierarchy.

The tactic of appropriation is problematic, as it may provide space for those who in fact do subscribe to the dominant order. But resisting the closure of an image or identity to a single 'natural' meaning introduces a multiplicity which undoes the phallic power of closure inherent in ideologies of the natural. Skinhead images, and the related SM and macho scenes, are insulting to many people and the culture which endows such images with their oppressive significance should of course be changed. But queer appropriation, in attempting to contest their oppressive significance, may bring about such material changes.

Marcia Ian

WHEN IS A BODY NOT A BODY? WHEN IT'S A BUILDING [1996]

Healing your inner building

The gym is full of social people, and that's not even counting the pencil-necks whose main purpose in the gym is to follow thongs around – or the thongs whose main purpose is to ignore the pencilnecks and follow good-looking bodybuilders around.

[*Ironman*, October 1995]

THE BODYBUILDER LABORS to erect a building on the site that was his body. As a sport, as an art, as a compound noun masquerading as a complex concept, bodybuilding relies first and foremost on an architectural metaphor. The motivation behind bodybuilding is the will to build a better, or at least a different, body. Also implicit in this compound of 'body' and 'building,' however, is a wish to equate the two, and thereby elide the distinction between the organic and the inorganic. I would even claim that to treat the body as inanimate, to turn something merely alive into a perdurable thing, is the true purpose of bodybuilding as a 'practice.' The bodybuilder treats his own flesh as if it were material he can redesign, reconfigure, and reshape from the ground up, as if to liberate his own inner building. In bodybuilding lingo, he trains and diets in such a way as to 'shred' his muscles in order to 'tear down' the existing structure, to substitute the 'rock hard' for the soft, the monumental for the human, and the masculine for the feminine. The only natural limitation the hard-core bodybuilder – he for whom the slogan 'No Limits' is not just the logo on a brand of gymwear but also a kind of religious belief – will acknowledge is what he reverently terms 'genetics.'

The Apollon Gym is always full, even when no one is there; the Apollon Gym is always empty, even when it is full of people. It is a typical gym insofar as it functions equivocally as a social and anti-social space. In this respect the Apollon can

serve as a model gym, its form and function ideally suited to eliminate the differ-
ence, or space, between flesh and metal. Paradoxically, the gym is a space designed
to eliminate space and it does so, I would argue, by negating, or at least by denying,
interiority. By 'interiority' I refer to the inner precincts of body and mind as well
as the physical space created by the walls of a room or building. The present site
of the Apollon, in Edison, New Jersey, used to be an auto body shop; it is now a
human body shop. The building fronts a busy commercial street lined with ware-
houses; huge tractor trailers rumble up and down the street at all hours. On this
site, our flesh is both forced into dangerous proximity with senseless metal, and not
forced, because we bring our bodies there in order to make them as hard as possible,
to approximate or proximate the inanimate.

Entering the front door of the Apollon, one passes through a small vestibule
with glass on both sides. To the left is the glass door (always locked) to the tiny
pro shop, which is crammed with racks of muscle shirts and pants designed to show
off the 'gorilla physique.' The right-hand wall of the vestibule houses a display case
in which cans of protein powder and other dietary supplements (to help build the
'gorilla physique') are ranged for sale. The small office where the gym owners sit,
talk on the phone, look at magazines, and sell various beverages is located behind
this case. The office opens out via a door and a walk-up window into the main gym
area. Having passed through this area, one enters an undivided space measuring
approximately 6000 square feet, whose right-hand and rear walls are cinderblock,
painted white but almost entirely covered with mirrors. The left-hand wall is
comprised of four garage doors big enough to admit tractor trucks. These doors are
frequently opened for ventilation or to allow exercise equipment to be moved
through them, but one of them is blocked off with mirrors. Heating ducts and other
accenting structures, such as the staircase leading upstairs to the men's and women's
shower rooms, which form a second story over the pro-shop and office, are painted
the color of fresh blood, as is much of the exercise equipment. The floor is covered
almost entirely with thick, hard, black rubber matting.

Facing the back of the room, one sees an illuminated sign that also hung in the
gym's previous location, a dank basement in the nearby borough of Highland Park.
The sign is about five feet high and displays the gym's name and symbol – the car-
toonish figure of a mustachioed, dark-haired white male in a leopard-spotted circus
performer's leotard (not exactly a Greek god), who jauntily holds a preposterously
overloaded barbell that bends with the weight overhead. The word 'Apollon' is
poised above him, and he stands on the letters of the word 'Gym,' which are made
to look like cinderblocks exploding beneath his feet from the stress of his mighty
lift. Beneath the exploding block letters the sign reads, 'Established in 1975,' 'Open
7 days,' and 'Co-ed.' The term 'co-ed' is of course anachronistic and politically
incorrect; furthermore, it professes that which is manifestly not the case.

Unless it is between 5:00 P.M. and 7:00 P.M. on a weekday, I am more often
than not the only female working out. This has been true for the eight years that I
have worked out at the Apollon almost daily. (There may be a 'thong' or two, the
gym equivalent of female groupies, hanging about.) If there happen to be a few
other women there, they are most likely using the treadmills or stairclimbers, the
'butt-blaster' or chest machines, while I am the only one pursuing a serious body-
building regimen. (Diane, a female power-lifter, used to work out at the Apollon's

old location in the mornings, but I have not seen her for at least six years. And for a few months Marge, a female welder and sculptor, trained here in Edison, but I have not seen her in six months). Even on weekends the population of this gym is overwhelmingly male, 'working class' – police officers, teamsters, construction workers, sanitation workers, utility workers – and heterosexual. (Racially, however, the population is heterogeneous and amicable; race will not be an issue here.)

A sign similar to the one on the inside back wall stands outside near the road. It is an advertisement to passersby for the hyperbolic masculinity presumably available inside the body shop. The picture bears a striking resemblance to Frank, a well-built mustachioed Italian-American who used to manage, if not own, the gym. Although he always talked as if the gym were his, it was unclear whether Frank or the equally cagey, but spindly and edgy, Jewish-American Mark, or both, owned or managed the gym. Recently, Manoli and his Greek-American family bought the place from him, or from them, and the question became moot. As long as Frank and Mark were in charge, certain gym members indulged in loud lewd speculation as to what the 'real' relationship between them might have been. Since the larger of the two signed and trained new members, acquired new equipment, spun tales about improvements he planned to make, and told everyone racy anecdotes about women, while day in and day out his partner cleaned the place, swept the floor, and whined, Frank and Mark fit right into the kinds of homophobic stereotypes the 'real men' working out in the gym deployed with gusto. 'Husband' and 'wife' were the pejoratives most frequently used to describe the pair. Oddly, the objects of these remarks never seemed to mind.

By the time Frank and Mark sold the gym, it was jammed full of old and new weight-lifting equipment, machines, benches, weight racks, and so on, reputedly acquired by 'the husband' with 'the wife's' money. It is especially difficult to maneuver when the gym is crowded. Weaving in and out carefully between pieces of exercise furniture not placed far enough apart to allow me (and I am not large) to pass without banging into things while on my way from bench to rack carrying dumbbells weighing eighty pounds each, I might, for example, encounter someone similarly loaded down and *en route*. We would then have to unload, back up, or turn aside, like two water buffalo face to face on a narrow bridge. We joke and grumble about this situation as we work out; at home we discover bruises and cuts where we have banged our flesh into metal.

In gym culture it is a compliment to call someone a machine, a brute, an animal, or a monster; a behemoth, a colossus, or a fucking Greek statue. Gym language is a compendium of mixed metaphors, and the more – the bigger, the louder, the stronger, the bulkier, the more outrageous – the merrier. There is, however, a hierarchy of mixed metaphors, the highest order of which engages a vaguely classical vocabulary used to connote transcendent excellence. In the pages of muscle magazines, male bodybuilders whose physiques are particularly impressive are routinely compared to a variety of (highly masculine), aesthetic forms, among them Greek statuary, Davidian figures or Rodin sculptures, ancient gods of various persuasions, classical heroes. The titles awarded in America's most prestigious bodybuilding competition, the Mr. and Ms. Olympia, are another case in point. (The first contest I entered – and won – was the 'Neptune Classic.') Admittedly, no one ever calls another bodybuilder a building. Rather, the bodybuilder thinks of himself as a

builder, who is also the object under construction. Bodybuilders and gym rats rou-
tinely ask each other, 'Are you building?' by which they mean, 'Are you in a phase
of training where you are trying to add more lean muscle to your physique in one
target area or another?' What he is building is a machine, a rock, air animal, a behe-
moth, a colossus, a fucking Greek statue; or a building with no space left inside,
because it has been transformed, according to the bodybuilder's fantasy, into a thing
made entirely of dense, hard muscle.

In his 'classic' on classicism – the ancient and seminal text of *The Ten Books of
Architecture* – Vitruvius cites the form and mathematical symmetry of the human body
as a paradigm for design: 'Without symmetry and proportion there can be no prin-
ciples in the design of any temple; that is, if there is no precise relation between its
members, as in the case of those of a well shaped man' [Vitruvius 1960: 72]. As the
'highest' and most nearly perfect earthly creation, man's body is a natural micro-
cosm of Universal harmonies; therefore, the architect should design the temple in
the image of man. Vitruvius advises the architect to design structures in which the
proportions of part to part, and of part to whole, mimic and serve as analogies to
those obtaining among the human face, the body, the limbs, and so forth. In body-
building, however, the converse of this relation is more often the case. The well-
shaped man should resemble a building, and not just any building, but a fucking Greek
temple. Or, better yet, make that a *fucking* Greek COLUMN, made of muscle hard
as marble. Okay, with a head atop the column. A capital (*caput*-al) musclehead.

In other words, a male bodybuilder's body ideally has no interior. It is to contain
no space, but be solid, lean meat. The term 'musclehead,' a colloquial and non-
pejorative synonym for 'serious lifter,' even suggests that his head be equally dense.
The language muscleheads speak in the gym is, furthermore, low on content but
high on performativity. It is routinized and, among men, often homophobic. That
is, it is explicitly phobic about the interiors of men's bodies, such that it creates
and maintains uncrossable yet tense and tensile boundaries between the outsides of
men's bodies. The more amiable of these verbal routines take the form of terse
exchanges accompanied by hand shaking, shoulder-patting, and head-nodding
intended to greet one another upon arrival or say good-bye when leaving; exhort
one another to work harder, 'stay tight,' or pile on more weight; acknowledge the
success or failure of an attempt at a lift; or critique or mock technique, attitude,
virility, or style. This is a minimalist masculine language of gesture and gesticula-
tion that can be described as pragmatic, performative, and relatively void of content,
I take various kinds of pleasure in using it. Most of the men in the gym accept me
as a serious lifter ('Hey! you're as strong as me! Do you compete?') and will interact
with me accordingly.

At times I feel like a primatologist who is grateful that the apes she chooses to
live with accept her. Some males, however, prefer, month after month and even
year after year, to avoid acknowledging my presence in the potentially intimate
space of the gym, and instead watch me continually in the mirrors, and discuss my
progress and puzzling identity among themselves. ('What's *her* deal?') Some persist
in reminding me that I am female by commenting on my appearance, flirting or
angling for eye contact, offering various gallant services such as moving my weights
or benches for me (as *if*), or expostulating, especially if I am stronger than they,
about how strong I am 'for a girl.' (A recent example: 'That's a lot of weight for

a girl. Aren't you afraid you're going to split wide open?') Often they seek my attention in order [to] tell me how their training is going, especially if they are feeling 'weak' and want to be reassured that they will get back in the groove. They commence these narratives whether I happen to be in the middle of lifting, pacing back and forth like the big guys, or just standing there, scowling, with my walkman headphones on. I guess I have certain responsibilities as resident female.

Such ritualized exchanges contribute significantly to the atmosphere of the place, and, along with the banging of metal plates, grunts and groans, help create a hypnotic atmosphere of mechanical and repetitive physical, social, and psychological noise. Sociality in the gym, then, depends as much on repetition, ritual, provocation, and performativity, as does physical training. Gym sociality is even more repetitious than weight training. Weight training is supposed to, and can, produce 'results' in the form of a new physique and its attendant psychological effects. Gym discourse plays its part by helping to fill social 'space' in such a way as to all but eliminate social intercourse and evacuate mental space in order to make pure 'action' possible. In its unintended Zen wisdom, it prevents thinking about what one is doing to a degree that may prevent doing it. To make it through a tough work-out requires a fixed and delimited focus on one's inward or outward image or, rather, on making the inward and outward congruous and identical, canceling the space or the incongruity between them; it requires the temporary elimination of the vagaries of consciousness, and the reduction of 'reflection' to the image in a mirror.

In a bodybuilding gym, one's consciousness and the gym can become concentric non-spaces. One goes inside the gym to fill up, extirpate, or deny the inside: this is the paradoxical essence of the hyperbolic masculinity available inside the gym. Femininity is unwelcome in the gym except in its capacity as an admiring audience of the spectacle of phallic masculinity. Femininity represents the spectacle, or the specter, of interiority, a reflection of oneself as penetrable and vulnerable with which the male bodybuilder does not wish to identify. From it he must distinguish himself. Outside the gym, masculinity may be in crisis insofar as men may be discovering their feelings, their subjectivities, their rectums, all of which are signs of the 'woman' in them, as Shakespeare put it in *Hamlet*, a play about how consciousness makes a man passive enough to 'lose the name of action.' Inside the musclehead gym, however, masculinity reassures itself that it is exactly what it appears to be; a body with no interior, and no aperture. A typical 'conversation' in the gym constitutes a kind of anti-cruising, a form of verbal warning sign (Trespassing Strictly Prohibited) and goes something like this:

'Hey. What's up. What you workin' today?'
'Legs.'
'I'm doing back. I did legs Tuesday.'

Thus do we locate each other in space and time, where we are in the week's, or the day's, training ritual. More than that, we identify ourselves to each other as pure location and, therefore, as a point without dimension, a site that is a body part or, rather, a part of a body part – namely, a muscle group. Today I am legs. Tomorrow I will be chest. Therefore I am neither you nor I, at least not here, not now. So get out of my face.

Knowing your ass from your elbow: why the gym is not a male space

> First and foremost, the judge must bear in mind that he/she is judging a women's bodybuilding competition and is looking for an ideal feminine physique. Therefore, the most important aspect is shape. . . . The other aspects are similar to those described for assessing men, but in regard to muscular development, it must not be carried to excess where it resembles the massive muscularity of the male physique.
>
> [*Flex*, July 1992: 115]

The International Federation of Bodybuilding sent the advisory quoted above to the judges of the February 1992 'Ms. International' competition in Columbus, Ohio, warning them that the injunctions against masculinity in female bodybuilders would be 'strictly enforced.' These injunctions make it clear that, even in bodybuilding, the one sport and the only sub-culture that ostensibly values muscle for muscle's sake, muscle means man, while women are at best second-class citizens. It is not that women *can* not become as muscular as males – they can, and do – but that they *must* not. Male bodybuilders are supposed to emulate or concretize mythical models such as Zeus, Hercules, Arnold, or Apollon (?!), while women are supposed to incarnate a far more elusive abstraction: femininity. Femininity, equated here with 'shape,' might seem like a vacuous Platonic tautology, a category without content, except that in this case the 'content' implied by 'shape' is cushy body fat – and space, space for the phallus.

To appear solidly and massively muscular is to be masculine. Such an appearance, meritorious in a male, is by definition in 'excess' if not monstrous in a female (never mind that many outside bodybuilding consider it such in a man as well). For a bodybuilder to appear massively muscular to the judges, he must not only build muscle, but make its anatomical detail visible by dieting away as much subcutaneous and intermuscular fat as possible. (Tanning, shaving, and oiling are other, cosmetic aids to visibility.) It is the radical reduction of body fat that makes women's tits and ass shrink, and it is this particular detumescence that alarms men in bodybuilding, perhaps because they associate it with detumescence of the phallic kind.

For the male or female hard-core lifter, tumescence, or engorgement of the muscles, is without doubt the goal of every training session. Ya hafta get a good pump goin'. But it is difficult not to see the engorged muscular physique as a giant potent penis, and difficult not to think that that is precisely what it is *supposed* to be, to mean, to represent. The male physique athlete is to embody and perform 'the phallic mystery rearing itself like a whirling dark cloud,' and 'to raise a great pliant column, swaying and leaning with power' [Lawrence 1992: 308–9]. Not surprisingly, increasing numbers of female bodybuilders are getting breast implants in order to reassure the judges that they are feminine despite their muscle. Women feel obligated to hang on to or install pockets of softness that will make them identifiable as women, while men struggle to eliminate as much as possible from their own bodies the fat that in the bodybuilding world signifies the 'feminine.'

In this respect, at least, bodybuilding is certainly 'classical.' According to Thomas Laqueur, until the end of the eighteenth century the female sex was

understood as a lesser form of the male, rather than as a different kind of human. A one-sex model ruled, and that sex was male. Laqueur writes, for example:

> The learned Galen could cite the dissections of the Alexandrian anatomist Herophilus, in the third century B.C., to support his claim that a woman has testes with accompanying seminal ducts very much like the man's one on each side of the uterus, the only difference being that the male's are contained in the scrotum and the female's are not. . . . For two millennia the ovary, an organ that by the early nineteenth century had become a synecdoche for woman, had not even a name of its own.
>
> [Laqueur 1990: 4]

Male and female were seen to differ in degree, the male being 'higher' than the female because, ironically, she was flesh personified whereas he was possessed of superior cognitive and spiritual faculties. His flesh was more ethereal, less material, than hers, because less tied to reproduction. In the one-sex model fundamental to bodybuilding, the 'lesser' that must characterize the female is the smaller quantity of muscle she is allowed to possess. According to classical medicine and philosophy, 'men and women were arrayed according to their degree of metaphysical perfection . . . along an axis whose *telos* was male' [6]. In the case of bodybuilding, wherein muscle is idealized, muscularity is the physical index of metaphysical perfection. Fat, on the other hand, is its negative axis.

On the night of the 1992 Ms. International competition, a fabulously muscular British woman named Paula Bircumshaw challenged this *telos*. If this contest had been judged according to the standards for male bodybuilding, namely muscular thickness and definition, symmetry, etc., Bircumshaw would have won, or at least placed very high. But the judges followed the IFBB guidelines and considered the bodies on stage as belonging to women, not to physique athletes. They eliminated Bircumshaw from competition early on, a discriminatory act that was met by loud derision from the audience; in praise of bodybuilding's audiences, let it be said that they are there to see muscle. Enraged by her mistreatment and excited by the crowd, Bircumshaw popped back on stage when she was supposed to be gone, and apparently directed an obscene gesture at the judges. She continued mugging and gesticulating as she made a grand exit from the auditorium. (She was later suspended from the Federation for two years for her 'unprofessional' conduct.)

Writing in *Flex* about this competition, held in conjunction with the Arnold Schwarzenegger Classic, Julian Schmidt describes the event as the 'Columbus Uprising' — the occasion of a 'battle for a new world order' between, on one side, 'the very soul of political correctness,' namely the 'covetous' feminists and pro-native American protesters who were on the scene and, on the other side, a noble army of the 'hearty folk who settled this territory.' In language that sent me scurrying to the OED – this was the first time a muscle magazine ever sent this pencilneck scurrying to the OED – Schmidt first praises Arnold, host and commandant of this hearty folk army, and then slams the covetous upstarts. As for Arnold, 'what better oriflamme to lead the battle, then, than Arnold Schwarzenegger, himself a gonfalon of success who can take every one of the PC-ers' craven planks and shove it down their whining throats?' But this perfection was tainted, Schmidt writes, when:

As I took my seat for the last half of the men's contest, my stomach revolted from an aporrhoea [stench] emanating from a nearby seat. Its occupant wore a skirt, high heels and makeup. This bromidrotic [stench-ridden] beast had removed its jacket, allowing the stench to escape and revealing an upper body that would give a Mack truck fits in a pose-down. Its legs were easily the equal of those [of the men] onstage. There was no need for me to comment. The judges had already done so by their notes in the Ms. International. . . . Their message had all the subtlety of a train wreck: Women's bodybuilding must either lose its tribades [lesbians] or lose the sport.

[*Flex*, July 1992: 55–57]

There is no way for the reader to know whether the woman near Schmidt actually stank or whether the poor man was suffering from olfactory hallucinations. In any case, however, it is clearly his opinion, an opinion by no means unusual among either male or female bodybuilders, that women whose muscularity rivals that of men are not women, nor men, but beasts, things, Mack trucks, perverts. Ironically, these epithets are compliments when applied to a male bodybuilder by a muscle enthusiast.

In his book, *Little Big Men: Bodybuilding Subculture and Gender Construction*, Alan M. Klein presents what might be described as an ethnographic study of gym sub-culture based on first-hand experience in California's bodybuilding gyms and plentiful interviews with bodybuilders [Klein 1993]. The book title describes Klein's conclusions in a nutshell, and they come as no surprise: male bodybuilders by and large, he argues, are narcissistic and insecure men driven to compensate for their feelings of inadequacy by uncritically fashioning themselves into cartoonish figures of hypermasculinity. Driven by 'authoritarian personalities,' they are primitive proto-fascists who embody and enact the 'hegemonic masculinity' of our culture. The male bodybuilders Klein interviewed in California, like those at the Apollon (and at gyms in New Jersey and Virginia where I have trained), are mostly 'blue-collar' and relatively uneducated, unlike the women he met, who were more educated, more liberal, more self-aware and confident [184–85]. Most of all, says Klein, these men tend to be both homophobic and femiphobic:

The fear of appearing female, or effeminate, is what I have been calling femiphobia; it is perhaps the most important ingredient in the fashioning of hegemonic masculinity. Unlike narcissism and fascism, femiphobia is a gender-negative construction, in being a barometer of what not to be (for example, not weak, or not appearing flaccid).

[269]

Femiphobia, according to Klein, 'fuels hypermasculinity, homophobia, and misogyny,' all 'way[s] of responding to the anxiety generated in the North American male's search for masculinity' [270].

Particularly significant in the present context is the inextricability for these men of femiphobia with homophobia. Klein observes that in the bodybuilding world:

> The most prejudiced attitudes were typically reserved for women. . . .
> [F]emale bodybuilders were often seen as threatening. One judge at a
> small local contest was confronted by the parents of a woman who had
> placed low. His response to them was as candid and astonishing as I'd ever
> heard: 'She's got no tits, no ass. I wouldn't fuck her, so whadaya expect?'
>
> [224]

Another 'gym insider' remarked to Klein that he couldn't admire a woman 'like
C., whose back is bigger than mine . . . I mean, what the fuck! . . . I just don't
have the propensity for it. I mean, that would be like holding another man' [224].
Being a gym insider seems to mean being the kind of guy who can get inside the
kind of woman this kind of guy wants to get inside of. Inside the gym world as else-
where it is the woman who must connote interiority, which is in turn represented
visually by tits and ass. Muscle, by contrast, connotes exteriority, the exteriority of
the phallus. A woman with a back like a man's *is* in effect a man; the bodybuilder
is afraid of her insofar as she might turn out to be 'another man,' a penetrable man,
or one who could penetrate him. The fear of muscular women, the fear of a woman
as 'another man,' is more homophobic than it is femiphobic. This would accord
with what Klein writes about hustling in California bodybuilding gyms. Many male
bodybuilders who think of themselves as straight permit gay men to perform oral
sex on them in return for money, which they use to support the bodybuilding life
style. That this goes on is common, and common knowledge, but not much talked
about. Because there is no penetration, and thus no feminization, involved, such
sex acts do not in any way interfere with these bodybuilders' conceptions of them-
selves as straight men.

For a man to be penetrated, to have an interior, is to be a 'woman.' We know
this from prison movies; we know this from Plato; we know this from Catherine
MacKinnon. To be attentive to the inner world of feelings, emotions, sentiment,
and subjectivity, is conventionally to be feminine; to be active, interactive, objec-
tive, competitive, and outward-bound, is conventionally to be masculine.
Historically the man's world has been

> where the action is . . . where one becomes fully human or achieves
> self-realisation; it is where heroic exploits and daring deeds are done; it
> is where 'culture' flourishes in the form of abstract ideas . . . it is where
> Nature is mastered; it is where males run kingdoms and Empires, wage
> wars, conduct politics or manage businesses. . . . It is the realm of
> important things.
>
> [Crimshaw 1986: 72]

The man's world is causal; it is where he does things and things happen; it is a myth-
ical non-domestic space (though his home is his castle) of unbounded possibility.
Woman herself is supposed to *be* (her) place, a domestic space. ('Hi honey, I'm
home.') From the beginnings of Western thought woman has been identified meta-
physically with, and as, space itself. For this reason, some taint of femininity will
necessarily haunt the gym or any other supposedly 'male' space, rendering the
straight men who congregate there a tad suspicious of each other. Joke-telling and
towel-frisking may result.

Insofar as space denotes interiority, it is feminine because it denotes the negative of the masculine. It is the upward thrust, and not the inner space, of a skyscraper that makes it phallic. Luce Irigaray's discussion of the gendering of Western philosophy and epistemology by way of Plato's 'myth of the cave' has as much as proved this point [Irigaray 1985: 234–364]. As a metaphor for subjectivity – 'as a metaphor of the inner space, of the den, the womb or *hystera*' – this myth can be read 'not only [as] a silent prescription for Western metaphysics but also, more explicitly, [it] proclaims [itself as] everything publicly designated as metaphysics, its fulfillment, and its interpretation' [243]. Just as, in physical terms, space requires walls or limits to define it as form, in metaphysical terms 'the "*interior*" . . . circles back around the "*exterior*" of an invisible but impenetrable paraphragm. Plato's *hystera*, [the] closure-envelope of metaphysics' [320] is the interior that is ever defined as the potentially entrapping 'other,' capable of wrapping itself around the 'exterior' and the 'impenetrable.' Above and beyond and outside the feminine, loom wisdom, knowledge, the reflexive auto-logic of the Father, creating man in His own image, the image of an absolute beauty unsullied by the cave, the earth, by woman, by fat.

For masculinity to be sure of itself, to know itself as itself, as an identity or a recognizable sameness over time, means to be itself and not an other, an other that must also be constructed and used (like a fetish) to protect the familiarity of self. In Irigaray's argument, the potentially unpredictable and threatening fluidity of femininity (an ocean capable of eroding male identity) must be plugged up by the rigid Phallus, and subjected to, or cast under, the ontological ground of Western self-knowledge. This act, which delineates the boundaries of the subject by means of the subjection of the other, simultaneously creates the distinction between exteriority and interiority as one of its effects, institutionalizing the equivalence of the masculine with the external and the feminine with the internal.

For Irigaray this is not so much an anatomical distinction between the phallus and the womb as a form of political tyranny that justifies itself biologically. In bodybuilding subculture, as elsewhere, the subjection of woman is effected by enforcing the equivalence of femaleness (a set of physical characteristics) with femininity (a set of 'qualities' such as weakness, passivity, receptivity). In the gym, at bodybuilding competitions, and in the pages of muscle magazines, this equivalence is asserted and re-asserted *ad nauseam*. Astonishingly, few women have publicly protested this nonsense. In effect there is no livelihood for bodybuilders outside the self-promoting and self-perpetuating institutions – the gyms, the magazines, the shows that made their way into the mainstream in the 1970s – established in the late 1930s by Ben and Joe Weider and their acolytes, who run their feudalistic kingdom like a 'family,' expelling upstarts and iconoclasts. Would-be champions tend ponderously to toe the line. Paula Bircumshaw is a notable exception.

Another exception (who proves the rule) is Laura Creavalle, who has won the IFBB Ms. International title three times and the 1988 Women's World Amateur Championships, and who, according to many on-lookers, should have won last year's Ms. Olympia over Weider favorite and returning champion, Lenda Murray. Creavalle is gradually withdrawing from the bodybuilding spotlight. She and her husband now host a 'camp' on the coast of Maine for individuals and couples seeking relaxation, personal training, and nutritional counseling, and she plans to retire soon from competition. Recently interviewed in the *NPC News* [9, 1995: 51–55],

Creavalle agrees with other competitors who 'think the judging criteria should be changed or maybe . . . some of the pro judges . . . keeping three or four of the top judges and switching some others.' Creavalle, who has competed in the Olympia competition seven times, has been judged by pretty much the same people for seven years; one of them told her that he knows her physique 'with [his] eyes closed.' Creavalle points out that this means that 'he has a preconceived idea of what [her] physique is all about,' making it difficult to see how she and others may have improved or changed, let alone to revise outmoded or inappropriate ideas about women's physiques in general.

Creavalle thinks that the judges may never allow her to win the Olympia competition because her persona on stage may be 'a little bit too aggressive' for them. 'Aggressiveness seems to be good for the men, but if you're aggressive as a woman it's perceived as negative.' She seems apologetic, assuring the interviewer that she is 'not aggressive backstage towards anyone'; her friends know her to be a 'comedian most of the time.' The interviewer reminds her that 'they're supposed to be judging physique, not personality,' but this is not always easy to remember when self-assertiveness is punished. Creavalle, who says she is 'not a feminist,' nevertheless speaks pointedly about how bodybuilding continually thwarts women in the sport and insults 'females in general.' For example, the first place prize in the Arnold Classic is one hundred thousand dollars, while the women's prize in the Ms. International, its companion competition, is twenty thousand dollars. The promoters claim that this is because the men 'draw' that much more than the women, but the women are never promoted comparably. They are not offered as estimable idealizable potential role models. Female bodybuilders are almost never featured on the covers of muscle magazines, for example. The women on the covers, if not simply top-heavy models or gym bunnies, are underpaid 'fitness' competitors who perform competitive aerobics routines outfitted as gym bunnies, complete with breast augmentation, big hair, and so on, all meant to please those manly judges.

Some of these 'fitness girls' come to Creavalle for advice. She isn't sure what to tell them: 'How do you become a better fitness competitor? Is it bigger boobs or is it who can do the best back flips?' As for the current tendency to feature fitness women on magazine covers, Creavalle comments:

> I think about it a lot, I'm not a feminist. I just think that it's so sad how the more things change, the more things stay the same. You have a big guy [on the cover] and women are on their knees pulling at him. It's just women in a subservient role all over again. We're just bimbos and we just love your body. Nobody wants to look like that. . . . [It's unjust] not only to the female bodybuilders, but females in general. How are women going to have any self esteem when their self esteem has to be tied to a man's perception of them . . . It's sad for women. Just put the man on the cover alone instead of having a big boobed woman with two little pasties standing there and smiling. It's really sad that everything you do has to get approval from a male.

The 'big boobed woman with two little pasties standing there and smiling,' or on her knees 'pulling at' the 'big guy' embodies the hyperbolic femininity needed to

establish the 'normality' of the larger-than-life male bodybuilder. The cover model reassures men, in Creavalle's words, that 'we [women] just love your body,' and she does so by means of conspicuous convexities that suggest complementary and presumably enticing interiorities. In this sense, hyperbolic femininity is a cipher, a place-holder for masculinity, a mirror in which masculinity cannot see itself. This may not come as news to those of us who already think of masculinity and femininity as forms of masquerade, but to most inhabitants of the bodybuilding world it might as well be Greek.

Today it is 6:00 P.M. when I arrive at the gym; it's peak hour, and likely to be extremely crowded. It is certainly crowded on the outside. I turn into the parking lot and check along the sides and rear of the building for an available space, only to find myself pulling out of the lot onto the street again. There is nowhere to park. There is even a car (a hot little number with four-wheel drive) parked right by, and partly blocking, the front entrance. I may have to park next door in the lot of the pizza parlor. Officially, however, bodybuilders don't eat pizza much, especially since nutritional experts no longer advise bulking up during the off season (when not preparing for a competition). It could be said that bodybuilders are dedicated to not eating pizza. I try to brush aside the ethical quandary of parking in the lot of an establishment to whose existence I oppose my own. Luckily, a space opens up in the gym lot; relieved, I park the car, taking with me my wrist straps, personal stereo, and water bottle. Once inside I scan the gym and find the usual crowd of at least fifty men, some of whom I have seen almost daily for eight years, and a few women.

Does the preponderance of males in the gym make it a male space? Where 'muscle' is equated with 'maleness,' and 'space' with 'femaleness,' can there be such a thing as a male space? Can the dedication of the gym to muscle building and strength training, to the increase of physical mass and power, the continual mobilization of aggression, the sweating and swearing, the heaving and hauling of barbells and dumbbells, the hulking bulky bodies shuffling to and fro from pillar to post, from power rack to drinking fountain, *make* this a male space? Is the gym a social space, or an anti-social space, given the fact that it houses – domesticates – what is in many ways an antisocial, even anti-human, activity? Is it a 'space' at all, or a war zone where masculinity strives blindly to eradicate its own interiority?

The little toilet that couldn't

The/a woman never closes up into a volume. The dominant representation of the maternal figure as volume may lead us to forget that woman's ability to enclose is enhanced by her fluidity, and vice versa. Only when coopted by phallic values does the womb preclude the separation of the lips.

[Irigaray 1985: 239]

In its previous, basement location, the Apollon had a men's locker room just inside the front door, complete with showers and toilets, but the only facility women could use was a water closet across the corridor which men used too. It was as if

the Apollon gym were trying to enforce an antique one-sex model by offering facilities for one gender only. The Apollon Gym was enacting its femiphobia in the most crass material way. Ostensibly devoted to physical culture and the life of the body, the Apollon 'forgot' that women had bodies complete with excretory functions that it was their responsibility to accommodate. This architectural amnesia was not simply a consequence of the design of the Highland Park building; if it had been, one could have excused the lack of women's facilities as 'not their fault.' On the contrary, when the Apollon moved to its new site, Frank and Mark supervised the entire process of converting the auto body shop into a health club, and lo and behold produced another health club with no private facilities for women. The design and construction of the new gym in Edison recapitulated a femiphobic insistence upon a one-sex model in such a way as to provide an architectural objective correlative, a symptom, for the pathological atavism I am describing.

The amenities Frank promised that Apollon members would find in the new gym included complete and comfortable locker room facilities for males and females. But the new Apollon opened with no locker rooms at all. There was one private bathroom (toilet and sink) accessible from the main floor, designated as 'men's,' and nothing at all for the women. Inside and to the rear of the little office space was a bathroom intended for the gym managers who worked in the office; this the women were invited to share. The office, however, was usually occupied by the managers and an assortment of their male gym cronies who liked to hang out there with them. To make one's way through their midst to the toilet end then urinate or whatever in such close proximity, always within earshot, was willy-nilly to publicize one's private rituals. (Admittedly, exhibitionism is a 'perversion' intrinsic to bodybuilding; however, pissing for men I can't see is not my thing.)

Over the course of the next two years a kind of loft space was constructed over the front office area and was divided into men's and women's locker rooms, neither of which had lockers (although several sets of different sorts of lockers, including some painted hot pink, have since come and gone). Shower stalls appeared, though it was a *long* time before water was piped in, and eventually a couple of sinks were installed, but no toilets. I complained continually about this to Frank, explaining that the female gym members found the situation in the office embarrassing. Each time he would say, 'But I've already got the toilet! I just need someone to put it in.' (Gee. Perhaps 'putting it in' is itself the problem.) One day, almost three years after the gym had opened, a shiny new toilet appeared in middle of the shower room. There was no stall around it, nothing separating it from where it stood in the middle of the shower room – nor any door between the shower room (which therefore was not a room) and the dressing room, which was easily visible from the hall between the two locker rooms. In other words, a woman sitting on the toilet would be entirely visible to anyone passing by whenever the door to the 'locker room' (in which there were no lockers) was open.

I nagged some more; six months later, a door was installed between the shower room, in the center of which sat the toilet, and the locker room that had no lockers. The door had no knob on it, just a hole where the knob should be, and what looked like part of a locking mechanism. I inquired, and was assured by Frank that he had the knob, but needed someone to 'put it in.' Meanwhile, one day I went to use the toilet and shut the door behind me. To my dismay, it locked, and when I was done

I couldn't get out. The work-out music was blaring downstairs, so that no one could hear me banging on the door. So, naturally, I punched the door down, ripping the moulding from the wall with it, and went downstairs. Some months later, Manoli, who was working there and in the process of buying the place, replaced the door and installed a doorknob with a lock.

No toilet was installed in the men's shower room because, said the gym's one female staffer (who got pregnant and quit), 'the men are pigs, every time they take a shit they flood the toilet.' From her point of view, at least, men and women are distinguishable by their respective toilet habits, cloacal analogs for sex difference insofar as the women wanted a separate bathroom space inside the club, while the men could take their excreta outside as easily as they could whip out their dicks. One day when I walked out the front door of the gym and turned to go to my car, I saw Nick about to urinate right by the entrance – not in the back near the dumpster, not on the side where passersby on foot or in vehicles or gym members going in or out of the building would not notice him. Upon seeing me frown at him, he stuffed his cock back in his pants and sauntered with a snicker back into the gym.

Nick's dick display underscored, again in material terms, that simple-minded equivalence between masculinity and exteriority upon which the 'logic' of body-building is based, together with an exhibitionistic disdain for interiority itself. There is no room for interiority at a place like the Apollon (no matter how big the building), which represents itself as a construction site for 'straight' masculinity. The bathrooms and showers for both sexes are set up so that same-sex cruising is all but impossible – not that any one, particularly a male, would want to risk getting caught doing such a thing in so violently heterosexual an environment. Moreover, the saga of the women's toilet suggests a phobic inability to respond to the ways in which women have their own interiorities (as opposed to those that they represent to and for men) to which they need to attend. Elsewhere, masculinity may be in crisis. Here, however, in the world of bodybuilding, it is definitely in stasis, although to maintain this stasis requires herculean efforts.

Bodybuilding flaunts this stasis in the gym and on the stage as a kind of *tableau vivant*, an apotheosis of stereotype as archetype. In truth, there are not many opportunities in our culture for 'straight' men to display their flesh publicly. Men's clothing has always concealed far more than it reveals to the eye, unlike women's wear, which now more than ever constitutes a continuous soft-core advertisement for pussy (or rather, titty). Male self-expression in general is notoriously buttoned-up and out-of-touch, when it is not out of control, necessitating group excursions into the woods in search of tender feelings. But in the world of bodybuilding, where hardness is all and it is one's job to 'stay tight,' the softer side of the male is all but invisible, packed deep in a suit of fleshy armor. The bodybuilder's display exposes to view a baroquely developed exteriority . . . as if to say, 'This is all there is. What you see is what you get.'

By way of contrast, I want to talk very briefly about another site of masculine, mainly heterosexual, display and acting out – namely the heavy metal music scene. Perhaps surprisingly, it makes room for its own interiority. In lieu of a lengthy disquisition on the gender politics and poetics of metal and hard-core music, suffice it to say that, despite certain often-observed similarities between some heavy metal performance styles such as 'glam' and the stylistic practices of certain other

ex-centric performers such as drag queens, by and large metal performers and their fans embrace and express traditionally masculine qualities like explosive anger, aggressivity, egoistic self-assertion, raw impersonal sensuality, and romantic apocalyptic existential fantasy. Denizens of metal sub-cultures share these performative styles and values with that other heavy metal sub-culture known as bodybuilding. Unlike bodybuilding, however, most heavy metal, death metal, and hard-core music reveals and explores, rather than represses and denies, its own anguish and misery, its fear of and for others, its self-loathing, its dark side and its inside.

Its 'inside' is relevant here. The lyrics of several albums released in the last few years narrate and dramatize the experience of boys abused, neglected, or raped by their fathers. The music carrying these lyrics, not surprisingly, ranges and rages from the mournful to the brutal. It is by turns majestic, dreamy, bitter. Heavy metal, like most genres of hard rock, has always been 'about' resisting and contesting various authority figures and structures, including the parental, the governmental, and the environmental. The last two seem on occasion like mediated representations of the parental, targets of a symbolic yet displaced rage. Recently, however, bands such as Pantera, Life of Agony, and Korn have ripped the veils off these highly mediated representations of patriarchal power in order to accuse publicly certain perpetrators of intimate same-sex crimes.

Most heart-rending is the recent self-titled album by Korn [1994], which narrates the experience of a son anally raped from childhood on by his father, with the implied knowledge and consent of the mother. The album does not contain printed lyrics and, due to the rapidity and chaotic, strangled emotion with which some of them are delivered, it is hard to make out all of what is being said. The singer cries, sobs, screams, talks, sings, plays bagpipes. A lot of what he says is nevertheless unmistakable. He is 'just a pretty boy'; a 'pussy'; a 'faget' [a song-title, and spelled thus]: he 'rightfully' belongs to the father; his father plans to 'eat' him; he hurts; he wants to die; he hates his father; he loves his father; his mother is watching; God is not. Two vocalizations are particularly relevant here. In one song the singer screams repeatedly, 'I'm just a faget! I'm just a faget!' In another, ambiguously ventriloquizing the father or perhaps imaginatively identifying with the father, he screams, 'you'll suck my dick and fucking like it!'

I can't overemphasize the shocking and shattering emotional power of this album. Listening to it by oneself is a frightening experience. Recently, however, Korn performed this music in New York City at a small club before an audience that was mostly white, male, teenage, high on various substances, and manifestly heterosexual. They appeared to be the usual Beavis and Butthead types often known as 'dirtbags,' and I have no doubt that they were, yet many in the audience were familiar with the album and, when the singer uttered the words quoted above, they screamed along with him. A room full of teenage boys – a male space? – earnestly screamed: 'I'm just a faget! I'm just a faget!' and, 'you'll suck my dick and fucking like it!' This could not have happened ten years ago, and probably not even five years ago. It would seem that some kind of healthy psychological evolution, some kind of consciousness raising and emotional bonding, is occurring in a community all too commonly dismissed by those outside it as stupid white trash.

Korn and its audience were avowing the existence of a male interiority so secret it had to be ripped open to be shared. Vulnerability, victimization, sadness, longing,

confusion, and a kind of humbled survivalist triumph emerged along with murderous bitterness. The singer's involuntary feminization provoked and proved the existence of the very fears and feelings the world of male bodybuilding is designed to deny, a denial seemingly emblazoned on every single artifact produced by gym culture. For example, the Apollon recently began selling a plastic drinking cup (the kind with the protruding straw) decorated with the figure of a male bodybuilder drawn from the waist up. He appears to have the torso, arms, and shoulders of Arnold, topped by the head of Sylvester Stallone. He is wearing wrap-around sunglasses. Above his head, emblazoned in the heavens as it were, looms the word 'APOLLON' in bold balloon caps, while across his nether region the word 'GYM' is inscribed. On the back of the cup, in tall black capital letters that take up the whole white surface from top to bottom, appear the words, 'WHERE ONLY THE STRONG SURVIVE!'

Hey, somebody might think as he exits the gym, I survived another workout. These words would seem to imply that inside the Apollon Gym evolution is in progress; to enter is to leap into a Darwinian struggle from which only the fittest will emerge. The weak, the flaccid, the passive, and the feminine will presumably not survive. Or rather, that would seem to be the fantasy of the bodybuilder who enters the gym in order to kill off that part of himself. As the typically un-self-aware Tom Platz put it in *Ironman*, 'The discipline oozing out of every serious gym in the country would make the toughest New York S & M club look like a brownie meeting' [October 1995: 181].

Judith Halberstam

DRAG KINGS
Masculinity and performance [1998]

What is a drag king?

IN CLUBS AND CABARETS, theaters and private parties, in movies and on TV, the drag queen has long occupied an important place in the American drama of gender instability. Drag queens have been the subject of mainstream and independent movies, and straight audiences are, and historically have been, willing to pay good money to be entertained by men in drag. And not only in performance arenas have drag queens been an important part of social negotiations over the meaning of gender. In academia, ever since Esther Newton's 1972 classic anthropological study [*Mother Camp*] of female impersonators in America, scholars have been vigorously debating the relation of camp to drag, of drag to embodiment, and of camp humor to gay culture [see Bergman 1993; Meyer 1994]. But in all the articles and studies and media exposés on drag queen culture, very little time and energy has been expended on the drag queen's counterpart, the drag king. . . . [T]he history of public recognition of female masculinity is most frequently characterized by stunning absences. And the absence of almost all curiosity about the possibilities and potentiality of drag king performance provides conclusive evidence of precisely such widespread indifference.

A drag king is a female (usually) who dresses up in recognizably male costume and performs theatrically in that costume. Historically and categorically, we can make distinctions between the drag king and the male impersonator. Male impersonation has been a theatrical genre for at least two hundred years, but the drag king is a recent phenomenon. Whereas the male impersonator attempts to produce a plausible performance of maleness as the whole of her act, the drag king performs masculinity (often parodically) and makes the exposure of the theatricality of masculinity into the mainstay of her act. Both the male impersonator and the drag king are different from the drag butch, a masculine woman who wears male attire

as part of her quotidian gender expression. Furthermore, whereas the male imper-
sonator and the drag king are not necessarily lesbian roles, the drag butch most
definitely is.

In the 1990s, drag king culture has become something of a subcultural phenom-
enon. Queer clubs in most major American cities feature drag king acts: for example,
there is a regular weekly drag king club in New York called Club Casanova whose
motto is 'the club where everyone is treated like a king!' There is a monthly club
in London called Club Geezer and a quarterly club in San Francisco called Club
Confidential. Club Confidential describes itself as 'A swonderful, smarvelous, butch-
femme, fag-dyke, boy-girl, retro-glam, lounge cabaret adventure' and encourages
patrons to 'dress to impress.' This club supports lounge acts and offers lap dancing
and strippers to entertain its drag clientele. In 1994 San Francisco held its first Drag
King Contest, and in 1995 a Drag King calendar appeared with some of the contest's
top drag kings. Mr. July, for example, is the ever dapper Stafford, co-organizer
with Jordy Jones of Club Confidential; Stafford's calendar caption is a quote from
Zippy the Pinhead that reads: 'Gender confusion is a small price to pay for social
progress.' At Club Confidential and other San Francisco gender-bending nightspots
such as Klubstitute, you can find drag kings and queens, contests and shows, and a
crowd that gives the term 'gender deviant' new meaning. At one contest, Klubstitute
even featured a fake protest by fake feminists played by drag queens who disrupted
the show by waving picket signs saying 'Sisterhood, Not Misterhood,' 'Wigs Not
Pigs,' 'Bitch Not Butch' and 'Fems against Macho Butch Privilege' [see Linn 1995:
10–18]. But although drag kings seem to have become a major part of urban queer
scenes, there are no indications that drag king culture is necessarily about to hit the
mainstream any time soon. Nonetheless, at least one New York-based drag king,
Murray Hill, has made it her goal to appear on the Rosie O'Donnell show.

I know at least three people who like to claim that they, and they alone, coined
the name 'drag king.' But the truth is that as long as we have known the phrase
'drag queen,' the drag king has been a concept waiting to happen. Some scholars
have traced the use of the word 'drag' in relation to men in women's costume back
to the 1850s, when the term was used for both stage actors playing female roles
and young men who just liked to wear skirts [Drorbaugh 1993: 120–43]. Male
impersonation as a theatrical tradition extends back to the restoration stage, but
more often than not, the trouser role was used to emphasize femininity rather than
to mimic maleness. In 'Glamour Drag and Male Impersonation,' Laurence Senelick
comments on the function of the breeches role as 'a novelty' or as 'a salacious turn'
until the 1860s in America, when the male impersonator and the glamour drag
artists brought to the stage 'a plausible impression of sexes to which they did not
belong' [Senelick 1993: 82]. Much male impersonation on the nineteenth-century
stage involved a 'boy' role in which a boyish woman represented an immature
masculine subject; indeed, the plausible representation of mannishness by women
was not encouraged. Because boys played women on the Shakespearean stage and
women played boys on the nineteenth-century stage, some kind of role reversal
symmetry seems to be in effect. But this role reversal actually masks the asymmetry
of male and female impersonation. If boys can play girls and women, but women
can play only boys, mature masculinity once again remains an authentic property
of adult male bodies while all other gender roles are available for interpretation.

Male impersonation became an interesting phenomenon at the turn of the cen-
tury in America with actors such as Annie Hindley developing huge female follow-
ings [see Duggan 1993: 809]. On and off the stage, cross-dressing women in the
early twentieth century, from Annie Hindley to Radclyffe Hall, began a steady assault
on the naturalness of male masculinity and began to display in public the signs and
symbols of an eroticized and often (but not inevitably) politicized female masculin-
ity. That some male impersonators carried over their cross-dressing practices into
their everyday lives suggests that their relation to masculinity extended far beyond
theatricality. Furthermore, the cross-dressing actress represents only the tip of the
iceberg in terms of an emergent community of masculine-identified women.

The theatrical tradition of male impersonation continued and flourished for the
first two decades of this century and then declined in popularity. After the passing
of the 1933 Hollywood Motion Picture Production Code, which . . . banned all
performances of so-called sexual perversion, male impersonation died out as a main-
stream theatrical practice [Drorbaugh 1993: 124]. Some critics have traced the
careers of one or two male impersonators such as Storme DeLaverie to show that
pockets of male impersonation still existed within subcultural gay male drag culture
between the 1930s and the 1960s. However, there is general agreement that no
extensive drag king culture developed within lesbian bar culture to fill the void left
by the disappearance of male impersonators from the mainstream theater. Indeed,
Elizabeth Kennedy and Madeline Davis comment in their Buffalo oral histories that
the masculinity constructed by butches in the 1940s and 1950s was accompanied
by a 'puzzling lack of camp' [Kennedy and Davis 1993: 62]. Kennedy and Davis
observe a notable lack of anything like drag king culture in the butch-femme bar
world: 'Few butches performed as male impersonators, and no cultural aesthetic
seems to have developed around male impersonation' (75). Kennedy and Davis use
the absence of a camp or drag aesthetic to caution against the conflation of gay and
lesbian histories. The queen and the butch, they argue, do not share parallel histo-
ries. Like many other cultural commentators, Kennedy and Davis tend to attribute
the lack of lesbian drag to the asymmetries of masculine and feminine performa-
tivity in a male supremacist society. Accordingly, because the business of survival
as a butch woman is often predicated on one's ability to pass as male in certain
situations, camp has been a luxury that the passing butch cannot afford.

While it seems very likely that the lack of a lesbian drag tradition has much to
do with the need for butches to pass, at least one other reason that male imper-
sonation did not achieve any general currency within lesbian bar culture must also
be attributed to mainstream definitions of male masculinity as nonperformative.
Indeed, current representations of masculinity in white men unfailingly depend on
a relatively stable notion of the realness and the naturalness of both the male body
and its signifying effects. Advertisements for Dockers pants and jockey underwear,
for example, appeal constantly to the no-nonsense aspect of masculinity, to the idea
that masculinity 'just is,' whereas femininity reeks of the artificial. Indeed, there
are very few places in American culture where male masculinity reveals itself to be
staged or performative; when it does, however, the masculine masquerade appears
quite fragile. In TV sitcoms such as *Seinfeld*, for example, men apply comic pres-
sure to the assumed naturalness of maleness, and a truly messy, fragile, and
delegitimized masculinity emerges. In one particularly memorable *Seinfeld* episode

highlighting abject male inadequacy, for example, George confesses to Jerry: 'I always feel like lesbians look at me and say, "That's the reason I am not into men!"' Such Woody Allenesque proclamations expose momentarily the instability of mainstream fictions of fortified male masculinities.

Outside of *Seinfeld*, unfortunately, white men derive enormous power from assuming and confirming the nonperformative nature of masculinity. For one thing, if masculinity adheres 'naturally' and inevitably to men, then masculinity cannot be impersonated. For another, if the nonperformance is part of what defines white male masculinity, then all performed masculinities stand out as suspect and open to interrogation. For example, gay male macho clones quite clearly exaggerate masculinity, and in them, masculinity tips into feminine performance. And the bad black gangsta rapper who bombastically proclaims his masculinity becomes a convenient symbol of male misogyny that at least temporarily exonerates less obviously misogynistic white male rock performances. These clear differences between majority and minority masculinities make the drag king act different for different women. For the white drag king performing conventional heterosexual maleness, masculinity has first to be made visible and theatrical before it can be performed. Masculinities of color and gay masculinities, however, have already been rendered visible and theatrical in their various relations to dominant white masculinities, and the performance of these masculinities presents a somewhat easier theatrical task. Furthermore, although white masculinity seems to be readily available for parody by the drag kings, black masculinities or queer masculinities are often performed by drag kings in the spirit of homage or tribute rather than humor.

We call one of the most conventional forms of male neurosis 'performance anxiety,' and this term tells us everything about the strained relationship between heterosexual masculinity and performativity. Performance anxiety, of course, describes a particularly male, indeed heterosexual, fear of some version of impotence in the face of a demand for sexual interaction. In comic representations, performance anxiety is often depicted as 'thinking about it too much' or 'thinking instead of doing.' Clearly, in such scenarios, the performance anxiety emerges when masculinity is marked as performative rather than natural, as if performativity and potency are mutually exclusive or at least psychically incompatible. The anxiety that performance anxiety acts out, then, is not, as one might think, an anxiety about doing; it is a neurotic fear of exposing the theatricality of masculinity [Pellegrini 1996].

'Drag' and 'performance' have recently become key words within contemporary gender theory, and they are generally used to describe the theatricality of *all* gender identity. 'Drag,' as Esther Newton suggests, describes discontinuities between gender and sex or appearance and reality but refuses to allow this discontinuity to represent dysfunction. In a drag performance, rather, incongruence becomes the site of gender creativity. Newton also defines 'camp' in relation to gay male practices and gay male humor. 'Performance,' of course, emerges out of Judith Butler's influential theory of gender trouble, in which she suggests that drag parodies 'the notion of an original or primary gender identity' and that 'the action of gender requires a performance which is repeated' [Butler 1990: 140]. Butler also proposes that parodies of the notion of 'true gender identities' emerge within 'drag,' 'cross-dressing,' and 'butch/femme identities' (137). Butler's analysis, then, takes drag to be a gay male cultural practice and offers butch-femme as the lesbian

equivalent. Because drag culture in both Butler's and Newton's analyses of gender theatricality is primarily related to gay male culture, and because it has a much more complicated relation to queer dyke cultural practices, do the very different histories of male and female impersonation produce very different notions of gender performance for male and female embodiment? If we recognize that drag has not traditionally been a part of lesbian bar culture and, furthermore, that masculinity tends to define itself as nonperformative, what are the implications for a general theory of the social production of gender? Is butch-femme really the equivalent gender parody to gay male drag? What is the impact of an emergent drag king culture on theories of gender performance?

In *Mother Camp* [1972] Newton is quite clear on the point that gay men have 'a much more elaborate subculture' than lesbians do, and she admits that the relative scarcity of male impersonators 'presents important theoretical problems' (5). In a very recent essay, 'Dick(less) Tracy and the Homecoming Queen,' Newton returns to the scene of these 'important theoretical problems' and ponders anew the problems of drag and camp in relation to a so-called butch-femme aesthetic. In 'Dick(less) Tracy,' Newton interrogates a renewed interest on the part of lesbian cultural critics into the practices and meanings of lesbian camp and lesbian drag, but like Kennedy and Davis, Newton cautions against easy 'conflations of butch with drag (queen) and butch-femme with camp' [Newton 1996: 164]. Newton is concerned that a queer formulation of camp based on contemporary butch-femme styles ignores the historical fact of a lack of camp cultures within the dyke bar culture of the fifties and sixties. 'My own experience of butch-femme bar culture in the late fifties and sixties,' writes Newton, 'told me that butch-femme was not . . . ironic, not a camp, and certainly not, as Judith Butler had suggested, a parody, at least not then' [163–64]. Newton, finally, calls for more attention to ethnographic and historical materials within the production of queer theories of gender and reminds us that 'drag and camp are embedded in histories and power relations including when they are deployed in the theatrical venues so beloved in Cherry Grove, in the lesbian theatrical and film productions studies by performance theorists, or on the pages of academic journals' (166). The drag performance that Newton goes on to analyze in this article is by a butch lesbian who dresses up as a drag queen and wins a drag contest in Cherry Grove. The appearance of a lesbian in a drag queen contest allows Newton to theorize the ways in which lesbians may deploy drag and camp 'not to destabilize gender categories as such, but rather to destabilize male monopolies and to symbolize and constitute the power of the lesbian minority' (165–66). [. . .]

Drag queens, it is often said, constantly walk a thin line between revering women and femininity and expressing pernicious misogyny; but what similar boundaries do drag kings traverse? Do drag kings softly tiptoe between admiring men and hating men? If so, what are the consequences? Is male impersonation more likely to be annexed to gender transgression than female impersonation? If so, what kind of transgression, what kind of gender? Following Carole-Anne Tyler's injunction to 'read each instance of drag . . . symptomatically' [Tyler 1991: 33] as opposed to simply asserting that each is either radical or conservative, I intend in what follows to break down drag king theater into its multiple performances and meanings, to distinguish between drag king shows and drag king contests, and to produce a

taxonomy of drag king types in order to sort through the styles and performances of different women in drag.

To be real: drag king culture, 1996

I want to proceed here from Esther Newton's suggestion that we contextualize theories of performance and queer theory in general with 'ethnographically grounded social theory' [Newton 1996: 171]. Newton warns against concentrating on 'representational strategies' without 'knowing the history of lesbian/gay male relations in the community and beyond.' She queries: 'How can intellectuals skip over this ethnographic step to broad abstractions and generalities without being guilty of a misleading (and reprehensible) imperialism ("Who cares what you think your representations mean, they mean what we say they do"). There is a balance to be struck between accepting the "natives"' accounts at face value with no analysis, and discounting them completely as "fictions" or useful only to an already determined theoretical agenda' (171). In my own research for this chapter, I have conducted interviews, talked to people in the clubs, visited many different clubs, and tried to ascertain the history and progress of each drag king space.

While I believe that this methodology is absolutely crucial to the project of charting the emergence of a nineties dyke drag king culture, I also think that interviews can be a frustrating obstacle to knowledge as much as they can produce important ethnographic information. I have no desire to force drag king representations into 'an already determined theoretical agenda,' but I have also become aware through the interview process that many performers are not necessarily that interested in the theoretical import of their acts or even in identifying a larger context. Many of the drag kings gave superficial answers to questions such as 'Why do you like to dress up in drag?' They might answer, 'just for fun,' or, 'It seemed like a crazy thing to do,' or, 'I didn't really think about it.' Obviously, such answers do not really convey any interesting or useful information about drag and its motivations, nor do they get to the 'truth' of the drag king scene. Other methodological problems involved a level of what I can only describe as 'butch-phobia' among the New York drag kings whom I interviewed. Even drag kings who wore drag on- and offstage and who had very boyish or mannish appearances would not identify as butch. The scarcity of drag kings willing to identify as butch, as Newton might say, 'presents important theoretical problems.' On account of the difficulties associated with the interview process, I have blended information I have obtained from the drag kings with my own observations and theoretical framings. Moreover, I do not consider myself to be completely outside the drag king culture I am depicting here. Although I have never performed as a drag king, I always attend the club in what is received as 'drag' (suit and tie, for example), even though I do not wear male clothing as drag. I have been photographed and interviewed at the clubs as a drag king despite my nonappearance onstage. This blending of onstage drag and offstage masculinity suggests that the line between male drag and female masculinity in a drag king club is permeable and permanently blurred.

There are two main arenas of drag that I focus on here: first, a series of drag king contests that took place over the course of a year at Hershe Bar, and second,

the regular drag king shows that take place weekly at Club Casanova. The drag king contests in New York paid cash prizes and often attracted non-white and non-middle-class audiences and participants. They were marked by a notable lack of theatricality and camp and depended utterly on notions of masculine authenticity rather than impersonations of maleness. As we shall see, the Hershe Bar contests and the Club Casanova shows produce very different forms of drag king culture, although there are multiple sites of intersection and overlap between the kings who participated in the contests and the kings who perform in the clubs.

The 1995–1996 Hershe Bar drag king contests

On the night I attended my first drag king contest, I was asked on my way into the club whether I would like to compete. I thought long and hard about this question but said finally, 'No thanks, I don't have an act.' As it turned out, neither did any of the other drag kings, but this did not stop them from going onstage. I took my place in the audience and waited for the show. The club, Hershe Bar, was packed with a very diverse crowd, and the show was the center of the evening's entertainment. Finally the lights dimmed, and the evening's emcee, lesbian comic Julie Wheeler, took the stage in her own Tony Las Vegas drag and began the evening by performing an Elvis song. Soon afterward, ten drag kings filed out in various states of dress and flaunted many different brands of masculine display. Like champion bodybuilders, the drag kings flexed and posed to the now wildly cheering audience: the winner was to receive prize money of $200, and she earned the right to compete in the grand finale for a prize of $1,000. The show was a huge success in terms of producing a spectacle of alternative masculinities; however, it was ultimately a big letdown in terms of the performative. The drag kings, generally speaking, seemed to have no idea of how to perform as drag kings, and when called on to 'do something,' one after the other just muttered his name. When compared to the absolutely exaggerated performances featured within drag queen shows, these odd moments of drag king stage fright read as part of a puzzle around masculine performativity. While certainly part of the drag king stage fright had to do with the total lack of any prior role models for drag king performance, and while certainly this inertia has been replaced in recent months by lavish drag king acts, at least in these early contests, the stage fright was also a sign of the problem of masculine nonperformativity. The drag kings had not yet learned how to turn masculinity into theater. There were other contributing factors at work, though, including that many of the women onstage seemed to be flaunting their own masculinity rather than some theatrical imitation of maleness.

The drag king contest is a difficult scene to read because we need a taxonomy of female masculinities to distinguish carefully between the various types of identification and gender acts on display. I would like, therefore, to spend some time charting some of the masculine gender variations within the drag king contests. My models are quite particular to the contests and have not necessarily carried over into the regular performances. Drag king contests, it is worth noting, function less like traditional drag queen shows and have more in common with the various performances staged by the queens in *Paris Is Burning* [1990]. Like the Harlem balls

documented in this film, these drag king contests had a cash prize and drew a largely black and Latino pool of contestants. Unlike the ball scene, the drag king events do not necessarily open out into an elaborate culture of gay houses and sex work.

There are many different genres of masculine performance on display in the drag king contest, so many, in fact, that the performances tend to be incommensurable and therefore difficult to judge. For the reader to understand the kinds of performances I am describing here, this section includes photographic images of various drag kings . . . taken by New York-based artist Betsey Gallagher (aka drag king Murray Hill). Gallagher began an art project on drag king culture in the spring of 1996 as a development of an earlier project on drag queens. It soon became apparent to her that the drag kings she was photographing had a very different set of visual codes and gender systems than the drag queens. To capture something of the particularity of the drag king contest, Gallagher took posed, rather than action, shots of her drag king models. This creates a quiet, almost deadpan effect and emphasizes the continuities between being and performing for these drag kings. With the aid of these images [one is reproduced here], I want to outline at least five different forms of masculine performance at work in the drag king contest.

Butch realness

In the drag king contests, the winner would very often be a biological female who was convincing in her masculinity (sometimes convincing meant she could easily pass as male, but sometimes it meant her display of a recognizable form of female masculinity). It is not so easy to find photographic images for this category because many of the 'butch realness' participants did not necessarily identify as drag kings and thus did not want to be photographed for a drag king project. To describe the 'convincing' aspect of the butch realness look, then, I offer the example of the contestant who won on the first night I attended Hershe Bar. The butch who won was a very muscular black woman wearing a basketball shirt and shorts. In her 'sports drag' and with her display of flexed muscles, the contestant could easily have passed as male, and this made her 'convincing.' This contestant won through her display of an authentic or unadorned and unperformed masculinity; she was probably a walk-on rather than someone who prepared elaborately for the contest. Interestingly enough, the category of butch realness is often occupied by nonwhite drag kings, attesting specifically to the way that masculinity becomes visible as masculinity once it leaves the sphere of normative white maleness. Furthermore, the relative invisibility of white female masculinity may also have to do with a history of the cultivation of an aesthetic of androgyny by white middle-class lesbians. The white drag kings in this particular contest were at something of a loss: they were not at all performative in the way some of the black and latino drag kings were (dancing and rapping) and tended to wear tuxedos as part of their drag king look. Every now and then, a white drag king would attempt a construction worker aesthetic or strike a James Dean pose.

. . . Because of its reliance on notions of authenticity and the real, the category of butch realness is situated on the sometimes vague boundary between transgender and butch definition. The realness of the butch masculinity can easily tip, in other

Figure 35.1 Sean by Betsey Gallagher aka Murray Hill
Source: CheeseburgerRare Entertainment

words, into the desire for a more sustained realness in a recognizably male body. There is no clear way of knowing how many of the drag kings at this club had any transgender modes of identification, and because the whole show took place under the auspices of a lesbian club, one might assume that most identified at least in some way with the label of dyke or lesbian.

One way of describing the relationship between butch realness and male masculinity is in terms of what José Muñoz has called an active disidentification, or 'a mode of dealing with dominant ideology, one that neither opts to assimilate within such a structure nor strictly opposes it' [Muñoz 1996: 147]. Similarly, within butch realness, masculinity is neither assimilated into maleness nor opposed to it; rather it involves an active disidentification with dominant forms of masculinity, which are subsequently recycled into alternative masculinities.

Femme pretender

Butch realness is clearly opposed to femme drag king performances. These may be termed 'femme pretender' performances, and they look more like drag queen shows, not simply because the disjuncture between biological sex and gender is the basis for the gender act but because irony and camp flavor the performance. . . . [A] femme pretender who has garnered much attention in New York is Buster Hymen. Hymen has a song-and-dance act and often disrobes halfway through and transforms herself into a lounge kitten. Clearly, the performance is all about trans-formation, and it capitalizes on the idea that, as Newton puts it, 'the appearance is an illusion' [Newton 1972: 101]. Whereas a few male drag performers create drag drama by pulling off their wigs or dropping their voices a register or two, the femme pretender often blows her cover by exposing her breasts or ripping off her suit in a parody of classic striptease.

One or two femme pretenders would appear in every drag king contest, and their performances often revolved around a consolidation of femininity rather than a disruption of dominant masculinity. The femme pretender actually dresses up butch or male only to show how thoroughly her femininity saturates her perform-ance – she performs the failure of her own masculinity as a convincing spectacle. These performances tend to be far more performative than butch realness ones, but possibly less interesting for the following reasons: first, the femme drag king has not really altered the structure of drag as it emerged within gay male contexts as camp; second, the femme pretender offers a reassurance that female masculinity is just an act and will not carry over into everyday life. Many femme drag kings talk about the power they enjoy in accessing masculinity through a drag act, but they return ultimately to how confirmed they feel in their femininity. Ultimately, femme drag kings tend to use drag as a way to, as Buster Hymen puts it, 'walk both sides of the gender fence' [Pittman 1996: 4] and this tends to reassert a stable binary definition of gender. It is worth noting that the drag kings who have managed to garner the most publicity tend to be the femme pretenders. Even some gay male writers who are conversant with the gender-bending tactics of drag tend to iden-tify all drag kings as femme drag king. Michael Musto, in an article on drag kings for the *New York Post* [20 February 1997], concluded his piece with a reassurance

for his straight readers: he notes that very butch looking drag king Mo B. Dick 'happens to love lipstick as much as any girl.'

Male mimicry

In male mimicry, the drag king takes on a clearly identifiable form of male masculinity and attempts to reproduce it, sometimes with an ironic twist and some-times without. In one of the few performances of white masculinity at the Hershe Bar shows, for example, a drag king contestant performed a mock priest act that had the nice effect of exposing the theatricality of religion. Male mimicry is often at work in the femme pretender performances but actually can be performed by butches or femmes. It is the concept of male mimicry that props up an enterprise such as Diane Torr's Drag King Workshop. Although the workshop takes us a little off the topic of the drag king contests, the concept of male mimicry as produced by the workshops did influence some of the white contestants in the Hershe Bar contest. Indeed, many news articles attribute the origins of New York drag king culture to Diane Torr (as does Torr herself), and some drag kings such as Buster Hymen credit Torr with inspiring them to begin performing. Diane Torr is a New York-based performance artist who, as Danny Drag King, runs a workshop in which women can become men for a day. Torr's workshop advertisement tells potential participants that they can 'explore another identity – you will learn the basic male behavioral patterns. How to walk, sit, talk and lie down like a man.' In the work-shop, which has been written up in many different magazines and newspapers and filmed for the BBC, Torr instructs her students in the manly arts of taking up space, dominating conversations, nose picking, and penis wearing, and she gives them general rudeness skills. Torr's students become men for the day by binding and jockey stuffing, and then she shows them how to apply facial hair and create a cred-ible male look. Finally, Torr takes her charges out into the mean streets of New York City and shows them how to pass. Torr herself articulates no particular mascu-line aspirations; she, like many of her workshop participants, avows over and over that she has no desire to *be* a man; she just wants to pass as a man within this limited space of experimentation [see Wheelwright 1994: 27–28; Burnside 1995: 5]. Torr says that her reasons for cross-dressing are quite clear; she wants to experience 'male authority and territory and entitlement' [cited in Burke 1996: 147]. Many workshop women discuss the feeling of power and privilege to which the masquerade gives them access, and many are titillated by the whole thing but relieved at the end of the day to return to a familiar femininity. [. . .]

. . . The workshop, obviously, has little to do with drag kings or kinging. It is a simple lesson in how the other half lives, and it usefully opens a window on male privilege for women who suffer the effects of such privilege every day. As I suggested earlier, however, it is hard to lay claim to the term 'drag king,' and certainly we would not want to attribute the origins of modern drag king culture to a workshop that is primarily designed for heterosexual women and unproblematically associates masculinity with maleness. For masculine women who walk around being mistaken for men every day, the workshop has no allure. The Drag King Workshop empha-

sizes for me the divide between a fascination in male masculinity and its prerogatives and an interest in the production of alternate masculinities.

Fag drag

Like other forms of minority masculinity, gay male masculinity stands apart from mainstream formulations of maleness and is very available for drag king imitation. Furthermore, some lesbians in recent years have positively fetishized gay male sex culture, and some women base their masculinity and their sex play on gay male models. This may mean copying a gay male aesthetic such as the 'Castro clone.' The Castro clone refers to a popular masculine aesthetic within urban gay ghettos that depends on leather and denim and a queer biker look. That the image is already identified as a clone suggests that imitation and impersonation are already part of its construction; this makes it easy for drag kings to take on fag drag. Some of the drag kings in the Hershe Bar contest cultivated a gay male look with leather or handlebar mustaches, and they often routed these looks through a Village People type of performance of hypermasculinity.

Denaturalized masculinity

Last in my taxonomy of female masculinities, I want to identify a category that often disappears into the other categories I have outlined. Denaturalized masculinity plays on and within both butch realness and male mimicry but differs from butch realness in its sense of theatricality and hyperbole and remains distinct from male mimicry by accessing some alternate mode of the masculine. . . . Dred, who won the 1996 Hershe Bar contest, pulling off a tribute to blaxploitation macho with a butch twist . . ., is an interesting drag king because she plays the line between the many different versions of drag king theater. On the one hand, she appears in the bar contests heavily made up as Superfly; on the other hand, she also plays in staged drag king theatrical performances in a much more campy role in which she metamorphs from Superfly to Foxy Brown. Then again, she regularly performs with another drag king, Shon, as part of rap duo Run DMC. Dred represents the fluid boundaries between the many different drag king performances [and] combines appropriation, critique, and alternative masculinity in her presentation.

Denaturalized masculinity in many ways produces the most successful drag king performances. In Julie Wheeler's act as Tony Las Vegas, the emcee for the drag king contest, for example, she wore slicked-back hair and a lounge suit. Tony made sleazy asides throughout the contest, and in the show I was at, he moved in way too close on a drag king who was clearly a femme pretender, breathing in her ear and asking what she had on under her suit. He periodically called out to the audience, 'Show us yer tits,' and generally made a spectacle of slimy masculinity and misogyny. Whereas the Drag King Workshop mimics maleness without necessarily parodying it, Tony makes male parody the center of his act by finding the exact mode in which male masculinity most often appears as performance: sexism and misogyny. The drag king demonstrates through her own masculinity and through

the theatricalization of masculinity that there are no essential links between misogyny and masculinity: rather, masculinity seems bound to misogyny structurally in the context of patriarchy and male privilege. For masculine women who cannot access male privilege, the rewards of misogyny are few and far between, and so she is very likely to perform her masculinity without misogyny. But sexism makes for good theater, and the exposure of sexism by the drag king as the basis of masculine realness serves to unmask the ideological stakes of male nonperformativity. [. . .]

The drag king show

The drag king contests at Hershe Bar set the stage for the proliferation of drag king nightclub culture in New York City. Although performance artists such as Diane Torr remind us that drag king culture has existed on and off for the last decade or so in New York performance spaces, drag kings have never generated the subcultural life and popularity that they now enjoy. After the drag king contests, many of the contestants disappeared back into lesbian club life, but many others regrouped and took on drag king performances as a regular act. Drag king Mo B. Dick recalls that the Hershe Bar contests identified a pool of potential drag king performers, and she capitalized on this moment of exposure by holding drag king parties. Mo recalls: 'I started doing parties with Michael, better known as Misstress Formika, and then we decided to host a drag king contest. It was so successful that we decided then and there, with Misstress Formika's help, knowledge, and inspiration, to start a drag king club, and Club Casanova was born' [interview by the author, 10 November 1996].

Club Casanova may well be the only weekly drag king club in the country. It is an East Village club catering to a mostly white, punk, alternative crowd that combines gay and straight, queens and kings, and it is often packed with media representatives. The women of color who competed in the Hershe Bar contests have not, for the most part, reemerged in the drag king club scene. The 1996 winner, Dred, does perform regularly at Club Casanova and other lesbian bars, and she sometimes performs alongside another black drag king, Shon, but there is definitely a muted presence of women of color on the drag king scene. In the Hershe Bar contests, many of the women of color who competed . . . were not necessarily making themselves into drag kings; they were going onstage and parading their own masculinity. This may be one reason that many of the winners of the contests have not become drag king performers [see Halberstam 1997: 104–31]. Another reason may be the usual divisions of race and class that produce segregation in most urban lesbian bar scenes [Thorpe 1996: 40–61].

Although few of the women I interviewed about drag kings had much to say directly in response to the question of why so few women of color seemed to get involved in the drag king shows, many of the women had very contrary memories and opinions about the Hershe Bar contests. Obviously, I personally found the Hershe Bar contests to be very entertaining and full of the spectacle of dyke masculinity. But many of the white women who competed in the contests found them dissatisfying. Mo B. Dick compares them to a popularity contest or a beauty contest: 'If the crowd liked your look, you won,' she notes,' if they didn't, you

lost.' Mo B. Dick felt annoyed that so many of the women in the contests were not drag kings but just 'very butch women.' Performance artist and occasional drag king Shelly Mars was a judge of some of the Hershe Bar contests. Mars also felt the contests were uninteresting: 'The first one was ridiculous – no one got dressed up to do drag. Also, it is a black and Latina place, so if you are a white girl, you are not going to win.' Indeed, few white women did win the Hershe Bar contests, and while this may have much to do with the fact that the club's clientele was mostly black and Latina, it also says something about the performance of white masculinity and masculinities of color. Much white drag king performance revolves around parody and humor, and much black drag king performance has to do with imitation and appropriation; whereas a white drag king might parody a macho guy from Brooklyn (as Mo B. Dick does), a black drag king tends to lip-synch to a rap song or perform as a mackdaddy or playboy or pimp character (as Dred does), not to parody, but to appropriate black masculine style for a dyke performance. In the context of a contest, the genre of sexy appropriations of male masculinity went over much better than the genre of quick parody.

Some of the best white drag king performances and shows, however, do evolve out of a creative and hyperbolic parody. Every week, Club Casanova becomes the scene of new and outrageous drag king performances. One week the flyers for Club Casanova advertised an Elvis night: Elvis impersonators could get in free, and the crowd was to be treated to not one but three performances of Elvis, all done by different drag kings. That night, the tension built as the crowd prepared for what must be a special event in the world of male impersonation: the kinging of the King. The first Elvis, performed by Justin Kase, enacted the early Elvis. Kase, with slicked-back hair and a curled lip, sang 'Blue Suede Shoes.' The next Elvis took on the leather-clad, jet-black-hair look of the King's middle years. Lizerace, the drag king deejay at Club Casanova, performed this sixties Elvis with much hip wagging and sultry looks at the crowd. Finally, drag king Murray Hill stepped up to capture the King in his golden years. Hill wore a tight white jumpsuit with sequins and the requisite monster upright collar. He wore dark shades and sweated profusely despite the towel around his neck. As the first bars of 'I Can't Help Falling in Love with You' swelled in the background, the fat Elvis jumped back and missed his cue to start singing. This hilariously bloated performance of Elvis at his gorgeous, puffy best captures what in drag queen culture has been called 'camp' but what I am renaming here as 'kinging.' Although earlier I identified one mode of kinging as an earnest performance of masculinity, here the kinging mode is realized through the impersonation of impersonation. This kinging effect is hilariously used by drag kings in San Francisco, where the success of Elvis Herselvis has spawned Elvis Herselvis impersonators.

It seems very important to hold on to the differences between drag kings and drag queens. Within the theater of mainstream gender roles, femininity is often presented as simply costume whereas masculinity manifests as realism or as body. In her study of female impersonators, Newton describes the way that drag queens create plausible impressions of femininity through the use of props (wigs, dresses, jewelry, makeup, hormones) and through 'role playing' (1972: 109). Similarly, drag kings produce a plausible masculinity using suits, crotch stuffers, facial hair, and greased hair. In general, however, the theatrical performance of masculinity

demands a paring down of affect and a reduction in the use of props. Drag king Maureen Fischer, for example, describes how she produces drag masculinity: 'The way a woman moves is more fluid and sexy, and a man is much more tight and restrained. When I perform Mo B. Dick onstage, I have to be very conscious of my movements. Usually I move around a lot, but as a man I am much more rigid, and I hold my body a certain way, and it's much stiffer in the torso, and there's no wiggle in the hip' [interview by the author, 16 November 1996]. The production of gender in the case of both the drag queen and the drag king is theatrical, but the theatrics almost move in opposite directions. Whereas the drag queen expands and becomes flamboyant, the drag king constrains and becomes quietly macho. If the drag queen gesticulates, the drag king learns to convey volumes in a shrug or a raised eyebrow. The drag king shows at Club Casanova have provided many examples of what I call 'kinging,' or performing nonperformativity. To 'king' a role can involve a number of different modes, including understatement, hyperbole, and layering.

Understatement. Kinging can signify assuming a masculine mode in all its understatement, even as the performance exposes the theatricality of understatement. An example of this mode would be the drag king who performs his own reluctance to perform through an 'aw shucks' shy mode that cloaks his entire act. . . .

Hyperbole. Finding the exact form of masculine hyperbole can constitute another form of kinging. In the Elvis performances that I discuss, the fat Elvis played by Murray Hill clearly captured masculine hyperbole. By performing the older Elvis, Hill played Elvis playing Elvis. While femme hyperbole plays on the outrageous artificiality already embedded in social constructions of femininity, masculine hyperbole imitates itself. Murray Hill, indeed, is the master of hyperbole. His repertoire includes a range of middle-aged male icons, and Murray satirizes and parodies the forms of masculinity that these men are supposed to represent. For example, as Bela Karolyi, the Olympic women's gymnastics coach, Murray Hill parodies the image of benevolent paternalism that the coach represents. In a hyperbolic performance of Karolyi urging little Kerri Strug to make a vault despite her wounded leg, Murray yells 'You can do it!' at a limping Kerri (played by Murray's drag girl sidekick Penny Tuesdae). Murray then tells Kerri that if she makes the vault, he will let her eat, and finally he gropes Kerri and then rips her gold medal off her neck and begins celebrating his own victory. Murray Hill also performs as John Travolta.

The impact of Murray Hill's hyperbolic performance is to expose the vulnerability of male midlife crisis. Murray uses very little makeup and relies mostly on clothing to convey the image of masculinity that she parodies. She does not bind her breasts and makes no attempt to create male realness. In her most recent drag king endeavor, Murray Hill ran for mayor on the slogan 'A Vote for Murray Is a Vote for You.' Murray campaigned with flyers of Mayor Giuliani in drag and highlighted the hypocrisy of Giuliani's trying to shut down certain queer clubs when he paraded in public in drag. Murray announces: 'Mayor Giuliani has decided that only he can do drag shows.' Murray pronounced himself the 'nightlife candidate' and urged voters to work together to save New York's endangered nightlife.

Layering. When a drag king performs as a recognizable male persona (Sinatra, Elvis, Brando), she can choose to allow her femaleness to peek through, as some drag queens do in a camp act, or she can perform the role almost seamlessly. In

Figure 35.2 Murray Hill as Bela Kavolyi by Tanya Braganti
 Source: Tanya Braganti

these seamless acts, the reason that the performance looks 'real' is because if the audience sees through the role at all, they catch a glimpse not of femaleness or femininity but of a butch masculinity. So the male role is layered on top of the king's own masculinity. Drag kings such as Justin Kase or San Francisco's Annie Toon and Elvis Herselvis build their acts precisely by layering a masculine performance over a butch appearance. This form of layering often produces a very sexy drag king act that encourages lesbian audiences to applaud not the maleness they see but the dyke masculinities that peek through. Dred and Shon's rhythm and blues acts are often greeted by a crowd of screaming fans. Shon comments on this response precisely by remarking on layering: 'Well, I like getting the reaction from the women, the screaming and all that. . . . They like the show, more than I would think. . . . I didn't expect them to be this into a male image. But then I don't think it's really about that, it's about the person the image is connected to, really.'

Layering really describes the theatricality of both drag queen and drag king acts and reveals their multiple ambiguities because in both cases the role playing reveals the permeable boundaries between acting and being; the drag actors are all performing their own queerness and simultaneously exposing the artificiality of conventional gender roles. As Newton puts it: 'Female impersonators are both performing homosexuals and homosexual performers' (1972: 20). Most of the female impersonators interviewed by Newton were gay and made connections between gay life and drag life; in the case of male impersonators, however, the relationship between their drag acts and their sexual orientations is less clear. Many of the drag kings performing in New York, at least, are lesbians; some are straight, and others are transgendered. Obviously the drag king act, with its emphasis on costume and makeup, disguise and transformation, produces a certain amount of curiosity about what is under the suit. Although many queer king club goers indulge in fantasies of dominant masculinity layered over queer masculinity, mainstream coverage of the scene tends to evince the sincere hope that even though girls will be boys, they will eventually return to being very attractive girls. Indeed, nothing brings more satisfaction to mainstream observers of the world of gender bending than the kind of pseudo-drag king spread featuring Demi Moore in a recent issue of the men's magazine *Arena*. Demi wore a small goatee that she had made in authentic drag king style by gluing pieces of her own hair to her face, but as she glowered for the camera, she ripped open her shirt to reveal her bounteous breasts. The whole photo spread gave 'redundant' new meaning: her bodice-ripping act suggested, of course, that her unveiling would dispel the mystery created by her facial hair, but truth be told, she was not so convincing anyway as a man. [. . .]

The drag scenes in New York, London, and San Francisco, at least, are growing and branching out all the time. I know of at least one performer in New York, Murray Hill, who regularly performs for straight audiences at a heterosexual singles bar. But the rest of the drag king shows are confined to queer spaces and mostly take place in gay male bars on lesbian nights. Many of the drag kings talk about turning drag king performances into a career, and they wait anxiously for the breakthrough moment when a drag king will hit the jackpot and appear on prime-time TV. Murray Hill and Mo B. Dick speak of trying to appear on the *Rosie O'Donnell Show* or on *Late Night with David Letterman*. Dred and Shon cite the example of Ru Paul and suggest that they could do for drag kings what she has done for drag queens.

Shon notes: 'I think this could really fly, and whoever kicks it off could have some great opportunities.' Other kings such as Retro maintain a wait-and-see approach and view the drag king claim for fame as part of a New York mind-set. In New York, Retro says, 'Everyone has a blinding ambition to be a star.' When drag kings do hit the mainstream, and I think they will, let us hope it is not as another super-model in a mustache. Let us hope that it's Murray Hill doing an outrageous parody of male midlife crisis or Dred as a smooth mackdaddy or Shon as a teen idol or Mo B. Dick winking at the girlies and poking fun at male homosexual panic with his signature line: 'I ain't no homo!'

Clare Hemmings

WAITING FOR NO MAN
Bisexual femme subjectivity and cultural repudiation [1998]

THIS [CHAPTER] BEGINS TO TRACE a history of the relationship between the figures of the bisexual and the femme. Section One looks at how bisexuality is employed both historically and in the present to situate femme as a 'subject-in-process', always implicitly about to make a heterosexual object-choice. Section Two explores contemporary articulations of femme as repudiating heterosexual object-choice, again exploring how bisexuality functions to endorse that femme positioning. In Section Three, I suggest that a bisexual femme subject position does not only rely on notions of bisexuality as endorsing heterosexuality. I am interested in the discursive breaks that occur when bisexuality is read in terms of culture as well as object-choice, such that a bisexual femme subjectivity no longer appears to be a contradiction in terms. These three sections could also be read as charting a femme progression from a subject bound to heterosexuality to a lesbian/queer subject; linked to a bisexual progression from potential structuring heterosexuality to bisexual subject.

One: bisexual meaning and the femme 'subject-in-waiting'

Contemporary images of bisexuality mostly rely on the representation of more than one body. Charlotte Raven's 'Swap Shop' in the British *Observer Life* magazine [15 October 1995] is accompanied by a picture of two young, bald, slim, white people. The one with the 'male' face and chest has female genitals, the one with the 'female' face and chest has male genitals. Two hermaphrodites? Two transsexuals? An attempt to represent a psychic bisexuality materially, perhaps? The cover photograph of the 'bisexuality issue' of *Newsweek* [July 1995] shows two men and a woman looking confrontationally at the camera. They are young, white and dressed in black and white. The woman is cross-dressed (but not butch); the men are androgynous-looking. The

cover of the US magazine *Anything That Moves* [Winter 1996] again shows two men and a woman (holding a copy of the *Newsweek* 'bisexual issue'). The woman's dress and demeanour code her as butch; the men are both coded as effeminate gay men. The two men, one white, one black, stand either side of the woman, who in this context reads as a Latina, bringing them into the picture, establishing their three-way relationship. It is fundamental to the functioning of this bisexual representation (and to bisexual representation more generally) that the 'three' be differently sexed, gendered and 'raced'. Bisexual representations commonly produce bisexuality as 'going beyond' any number of binaries (gender, sex and 'race' in particular) such that Marjorie Garber can say that 'In a world in which a person could only be classified as male or female, black or white, gay or straight, bisexuality simply does not fit in' [Garber 1995: 156]. All three examples provide a dual reading of bisexuality. They represent both the bisexual body itself (as hermaphroditic, as dual-gendered or beyond gender), and the focus of bisexual desire. They are both bisexual subject, and the bisexual's object – presented as a decadent display of available body parts to be devoured by the bisexual gaze, feasted upon with relish as part of a bisexual bacchanalia. The bisexual subject and bisexual desire are produced in these images as a site for the fusion of oppositions, particularly sex and gender.

Given these dominant representations of bisexuality as beyond and/or inclusive of male/female and masculine/feminine, it is easy to see how a bisexual femme subject position might be read as a contradiction in terms, if not an impossibility. In the above images, femme or butch figure as incomplete parts of the sexed and gendered bisexual 'whole'. It comes as no great surprise, then, that recent writings by femmes such as Joan Nestle still code bisexuality negatively [Nestle 1992: 143], or that as an 'out' bisexual, I am frequently asked by lesbian femmes or butches 'do bisexuals do butch-femme?' The phrasing of the question itself assumes there is no such thing as bisexual butch or femme subjectivity. Even if the answer to the question is 'yes, bisexuals do butch-femme', this is an affirmation of a gender play. Bisexuals are not seen as ontologically gendered, as able to *be* butch or femme.

These dominant representations of bisexuality as 'pseudo-hermaphrodite', androgyne, or polymorphous potential that make a bisexual femme identity difficult to accept in a contemporary queer arena, are, precisely, what link the figure of the femme with bisexuality [see also Michel 1996: 55–69]. In the [early] sexological writings of Wilhelm von Krafft-Ebing and Havelock Ellis, a female subject is gendered partly in accordance with her sexual object-choice – hence a 'mannish woman' typically desires a feminine woman. The feminine woman she desires, though, presents more of a theoretical problem. If the feminine invert desires masculinity, as she appears to, why is her desire not restricted to men? Havelock Ellis circumvents this indescribability of the feminine invert by rendering her passive (object, not subject, of desire), as well as most open to being 'cured' of her perversion [Ellis 1928: 222]. The feminine invert's ability to be both 'errant heterosexual' and part of a particular class of homosexual is made possible only through a notion of bisexual human potential. Ellis's argument that 'the basis of sexual life is bisexual, although its direction may be definitely fixed in a heterosexual or homosexual direction at a very early period in life' [86] leaves open the possibility for misguided actions (the feminine invert is not particularly strong-minded) and cure. Within this canonical sexological formulation of the perverted feminine woman, Radclyffe Hall's

Mary [from *The Well of Loneliness* (1928)], to take the classic example, is always destined to be 'subject-in-waiting'. She is bound to be secondary subject to the 'mannish woman', and because she is only legible as (bisexual) 'subject-to-be-cured', her own subjectivity must always be deferred. It is no accident that Mary is presented as childlike in her desire. Mary can become a subject/adult only by making the heterosexual object-choice that has been her destiny from the start. Recent writers have pleaded the case for Mary generally in terms of greater tolerance [Nestle 1992; Walker 1993]; as Frann Michel notes, 'Mary is thus represented as essentially passive and becomes the precursor to the negative image of the bisexual woman who leaves her woman love for a man' [Michel 1996: 60]. I would argue that the writing out of Mary seems to be a sleight of hand enacted by Hall, the sexologists and lesbian literary critics combined. There is ample textual evidence for reading Mary as actively desiring Stephen (despite the latter's best efforts to ignore this). For example, in one scene where Mary and Stephen almost consummate their desire and love for one another, Mary asserts herself as the desiring agent in the face of Stephen's awkwardness, and inability to express what she wants [Hall 1928: 299–302]. And it is Mary's confession of her love for Stephen in Tenerife that finally precipitates the consummation of their lust [315ff.]. It is possible to re-read *The Well of Loneliness* and trace Mary's *unwilling* consignment to heterosexuality, and her resistance to being cast as the (bisexual) 'subject-in-waiting'.

Shifting historically to the present, the relationship between bisexuality and femme identity has been coded somewhat differently. Reading heterosexual oppression in part through the rigid codes of femininity women are expected to display and embody, US and UK lesbian feminists such as Del Martin and Phyllis Lyon and Janice Raymond in the 1970s, and Sheila Jeffreys and Julia Penelope in the 1990s, argue for the eradication of 'gender roles' [Martin and Lyon 1972; Raymond 1979; Jeffreys 1993; Penelope 1996]. What is particularly interesting to me is the way that lesbian-feminist conceptualization has changed very little over the two decades. Minnie Bruce Pratt, writing about lesbian-feminist politics of the 1970s, sketches the motivation for such conceptualizations of gender as bad:

> As women and as lesbians we wanted to step outside traps set for us as people sexed as woman, to evade negative values gendered to us. We didn't want to be women as defined by the larger culture, so we had to get rid of femininity. We didn't want to be oppressed by men, so we had to get rid of masculinity. And we wanted to end enforced desire, so we had to get rid of heterosexuality.
>
> [Pratt 1995: 19]

Early US lesbian feminism figures in Pratt's story as the primary challenge to heteropatriarchy through its insistence on both non-femininity and lack of sex with men. Femininity and desire for men are fused, though not, in this case, naturalized. Continuing in the radical feminist tradition of femininity-trashing, Julia Penelope argues emphatically, in the 1990s, that femininity is always about passing as heterosexual and internalized homophobia, and is, thus, barely distinguishable from bisexuality [Penelope 1996: 118–52]. Del Martin and Phyllis Lyon, commenting on their contemporary lesbian roles and styles, note:

We have found some interesting anomalies in the butch-femme pattern over the years. One which crops up rather consistently is women – usually divorced and, we suspect, not Lesbian at all – who pair up with butch Lesbians. In these partnerships the entire male-female dichotomy is acted out to the nth degree. The femmes insist that their butches wear only male clothing and that they appear and act as nearly like the stereotyped male as possible. . . .

Most of these femmes have been divorced more than once. It appears that they have been so badly treated by men that they can't bear the thought of re-marrying.

[Martin and Lyon 1972: 67]

Martin's and Lyon's repeated reference to 'divorce' in the above passage emphasizes these femmes' bisexual behaviour in terms of relationships with both men and women. Psychically, this bisexual femme is only capable of male/female relations: whether those are actual or transposed onto butch-femme. Martin's and Lyon's bisexual femme confirms the hegemonic link between femininity and heterosexuality, and shores up the assumption that femininity is always and only ever masculinity's closest relation. The bisexual femme makes real the fear that female/femininity craves male/masculinity for its fulfilment, settling for a butch only when a man is unavailable.

The repeated association of the femme with heterosexuality through bisexuality provokes contemporary femme writers to wrestle the femme from the hands of both the sexologists and lesbian feminists, arguing for femme identity and history as an integral part of lesbian history, rather than its demon in the closet [Nestle 1992; Kennedy and Davis 1993; Pratt 1995]. The status of the femme as lesbian is ensured only by detaching her from her 'bisexual' past, it seems. As femme writer Amber Hollibaugh suggests: 'it's absolutely critical to understand that femmes are women to women and dykes to men in the straight world' [Hollibaugh and Moraga 1981: 249]. The femme becomes a contemporary subject by insisting on her absolute difference from the bisexual.

Two: repudiating heterosexuality, or the 'not-quite-not-straight' femme

Some contemporary theorists have written on butch-femme culture and resistance from a slightly different angle: Teresa de Lauretis, Judith Roof and Judith Butler suggest that femininity and butch-femme cultures are indeed embedded within heterosexual normativity, but not wholly reducible to it [De Lauretis 1988; Roof 1991; Butler 1990]. I want to focus here on how Butler discusses ways in which butch-femme highlights rather than replicates the constructed nature of the hetero-sexual matrix. In *Gender Trouble* Butler makes her most often cited statement that:

[t]he replication of heterosexual constructs in non-heterosexual frames brings into relief the utterly constructed status of the so-called hetero-sexual original. Thus, gay is to straight not as copy is to original, but, rather, as copy is to copy.

[1990: 31]

Butler's theory of what makes butch-femme and drag so potentially subversive is their very closeness to heterosexuality, their making conscious of the mechanism of repudiation in sustaining our identities (though, of course, this is clearer in the 'masculine lesbian' than the femme) [see Butler 1993: 85–88, 234ff.]. The masculine woman repudiates 'the feminine', but remains female and thus incongruous to heterosexuality. She does not need the presence of the femme to 'prove' her non-heterosexuality. The feminine woman repudiates 'the masculine', but cannot be read as repudiating heterosexuality unless her masculine female is present. She needs the presence of a visibly non-heterosexual (masculine) subject in order for her repudiations of both masculinity and heterosexuality to make sense [see Walker 1993: 88]. Such formation of the subject through repudiation means, of course, that the repudiated other is always hauntingly present. In the Butlerian psychoanalytic scenario, 'mimicry functions as an index of [the 'real'], gesturing towards it, and maintaining a certain contiguity with it' [Tyler 1994: 235]. The non-heterosexuality of the femme, since she relies on the presence of the butch for the legibility of her heterosexual repudiation, is particularly precarious. For the femme, with her history of recuperation into heterosexuality (via bisexuality as potential), access-ing subjectivity through a repudiation that marks her as 'not-quite-not-straight' [241–43] has very specific cultural implications.

Rather than rejecting the established theoretical links between the femme and her heterosexuality, lesbian culture transfigures that relationship in terms of 'myth' – the (lesbian urban) myth of femme abandonment of her butch lover for a man. Pat Califia's femme-butch poetry foregrounds the tension between the myth of femme abandonment and the assumption that she will stay with her butch:

> And you can tell she's a femme
> Because she makes you cry
> When you can't give her everything
> You imagine she wants
> That a man could give her
>
> [Califia 1992a: 484]

The butch lover imagines herself lacking in relation to a man; her femme (who is used to this scenario, of course, structured as she is by its confines) 'makes her cry' not by leaving her (she is femme after all) but through chiding her lover for her foolishness. Califia is the femme's champion, acknowledging her bravery and the taunts she receives from 'both sides':

> Being a successful femme
> Means making a butch desire you
> And then enduring when that lust
> Turns into suspicion.
> 'If you want me,' she sneers,
> 'You must really want a man.'
> Nobody knows how much it hurts
> When you go out on the street
> And straight men tell you
> The same damned thing.
>
> [Califia 1992b: 417]

The 'successful femme' (who is, perhaps, the femme who does not fail/fall into heterosexuality) *endures* her butch's suspicion, rather than deflects or circumvents it, presumably because she knows that is an impossibility. The poignancy of the poem lies in Califia's astute perception that the straight men's and the butch's readings of the femme must necessarily co-exist. The shadow of Carole-Ann Tyler's grammatical structuring – the femme as not-quite-not-straight – lurks between these lines, echoing Califia's earlier sentiment in the same poem that she's 'a sucker' for

> . . . women who can never have what they want
> Because the world will not allow them
> To be complete human beings – that is, men.

<div align="right">[416–17]</div>

The structure of this sentiment allows multiple readings. Men are 'the world', that which prevents women having 'what they want'; or, what those women want *is* men, but the loss of human status attending such desire is too high a price to pay. The spectre of straightness that has always structured the femme is transformed in these poems into an 'operative myth' that enacts Butler's functional mode of repudiation. In Califia's poems the unconscious heterosexual object-choice that the femme must necessarily already have made becomes conscious, becomes part of the social and erotic dynamic of the butch-femme play (that both femme and butch are aware of). As a result the femme may become a contemporary subject without having to deny her historical, cultural and grammatical locatedness.

This 'resolution' of the contemporary femme's subjectivity through conscious rather than unconscious repudiation of both opposite-sex object-choice and heterosexual culture helps make sense of why it is that the bisexual femme continues to be a misnomer. Non-heterosexual sites of resistance for Butler are created exclusively by subjects formed through repudiation of opposite-sex object-choice; Califia's femme repudiates the opposite-sex object-choice she has already made. Julia Creet argues that Butler's exclusive focus on lesbian and gay contexts marks less the site of subversion of heterosexuality than it does her own anxieties of 'coming undone' [Creet 1995]. Creet discusses her own attraction to heterosexuality, and reinterprets lesbian and gay insistence on the distinctness of homosexual identity as a political 'defense against re-incorporation into heterosexuality or into the categorization of what might more accurately be called bisexuality' [186].

It is only by parodying the notion of bisexual potential that Butler and Califia can make the stereotype of the femme who will always eventually leave you for a man function as '(urban) myth'. The 'myth' functions, in other words, because (we know) the femme will not make the opposite-sex object-choice she is (bisexually) capable of. She is femme precisely because she is read as heterosexual, may even desire men, but finally (unlike Radclyffe Hall's Mary) refuses that object-choice. A bisexual femme, of course, does not necessarily refuse to act on her opposite-sex object-choice, and so calls into question the viability of the femme subject as structured only through that refusal. Acceptance of a bisexual femme subject position, then, would seem to be courting a re-enactment of the structural and personal erasure of the femme just as she is aggressively flirting with dominant cultures in order to secure her own legibility as lesbian, as queer, as a subject in her own right.

Three: bisexual femme subjectivity and cultural repudiation

What enables femme identity always to be constituted as 'about to abandon' (however parodically) her butch is the perpetuation of bisexuality as only ever a structural phenomenon. I am not suggesting that Califia and Butler are wrong to creatively manipulate particular meanings of bisexuality in order to produce a contemporary femme subject. Bisexuality as sexological and psychoanalytic potential certainly does function as a refusal of femme – historically, politically, and structurally. Indeed, such meanings of bisexuality as sex and gender merged subjects continue to circulate currently. But these are not the *only* meanings of bisexuality available. Bisexuality can also mean desire – whether acted upon or not – for both men and women (and transgendered people). Bisexual identity can be taken on as an adult sexual identity rather than pre-Oedipal potential structuring the hetero-sexual and homosexual opposition. These latter meanings are overlooked in the work of Butler and Califia. I want to pursue a line of argument that imagines the development of a bisexual femme subjectivity as closely associated with, rather than analogous to, lesbian femme subjectivity.

To return to the problematic of Butler's non-heterosexual frames, what kinds of 'parodies' become possible if we imagine bisexual femme as a non-heterosexual subject position that is unable to divorce itself from opposite-sex desire, if, in other words, the 'spectre of straightness' cannot be dismissed? What might the implica-tions for parody be if we consider the almost perfect copy (even down to sexed bodies as well as gender) that bisexuality can make of heterosexuality? What I want to look at in this section are the possibilities opened up by bisexual femme repudi-ations not of specific sexed (i.e. male) bodies, but cultural repudiations of heterosexuality. I want to explore, in other words, the possibility that non-hetero-sexuality might be read through something other than same-sex desire, such that bisexual femme subjectivity does not only figure through a (butch) same-sex lover – such that bisexual femme subjectivity can, in fact, figure at all.

Lesbian femme writers of recent years have, of course, been similarly concerned with articulating lesbian femme subjectivity independent of desire for butches. It is not unusual for lesbian femme writers' desire to be sparked by men as well as women. As a way into my exploration of bisexual femme subjectivity I want to look at what happens when the lesbian femme makes the 'myth' of opposite-sex desire into a reality.

Joan Nestle, for example, relishes the erotic component of her relationship with co-editor John Preston: '"Fondest of My Fantasies," he would greet me . . . Dearest Love Goddess, Dearest Erotic Icon of My Soul, and finally, Dear Divine Being of My Groin. How could a girl resist?' [Nestle and Preston 1994: 7] A couple of pages later, John Preston speaks of this desire as in no way qualifying the fact that he is 'totally a gay man, attracted to other gay men' [10]. Preston's confidence in this fact textually relies on his lack of desire to have sex with Nestle. Hence he is clear that 'there was never any genital intent', and that with that acknowledgement

> there is then room for play, for gentle exploration. I would never seek
> out a sexual relationship with a woman, but I could also never under-
> stand how any man – any human – could not respond to Joan's voice,

the sultriness of it, or the romance of dark eyes as they peer deeply into
yours.

[10]

What allows this passage to function as an acknowledgement of the desire between
John and Joan as not heterosexual, is Preston's emphasis on the non-genital
nature of that desire. Both his and Nestle's non-heterosexuality via repudiation of
opposite-sex object-choice remains unchallenged by a scene that might initially
seem to call same-sex object-choice into question. Both straight and lesbian/
gay desire are assumed to reside in the actualization of opposite- or same-sex
object-choice – neither writer considers the fact that even straights also desire
non-genitally sometimes. For Nestle and Preston, the writing of their (opposite-
sex) desire here only serves to reinforce the fact that they 'are so clear that each of
us is devoted to the work and love of our own gender' [10].

In *Public Sex*, Pat Califia ruminates on the reasons she does not call herself
bisexual, even though she does have opposite-sex sexual partners:

> Why not simply identify as bi? That's a complicated question. . . . A
> self-identified bisexual is saying, 'Men and women are of equal import-
> ance to me.' That's simply not true of me. . . . [W]hen I turn on to a
> man it's because he shares some aspect of my sexuality (like S/M or
> fisting) that turns me on despite his biological sex.
>
> [Califia 1994: 185]

Here Califia's opposite-sex desire is coded as not central to her lesbian identity.
Her opposite-sex encounters are marked by some factor other than biological sex,
such as the man's sexual practices (that mark him as deviant, often to gay male
culture as well), and his own attachment to a gay identity:

> I know that a gay man who has sex with me is making an exception and
> that he's still gay after we come and clean up. In return I can make
> an exception for him because I know he isn't trying to convert me to
> heterosexuality.
>
> [186]

Califia's non-heterosexual desire is clearly partly inscribed through cultural repudi-
ation. She has 'eroticized queerness, gayness, homosexuality' [185], and argues that
'[i]t is very odd that sexual orientation is defined solely in terms of the sex of one's
partners' [186]. Although it is finally her same-sex object-choices that frame her
opposite-sex ones as marginal, as not fundamental to her identity (and resistance),
Califia's sense of cultural repudiation in the production and maintenance of her non-
heterosexuality, her lesbian identity, suggests a space where bisexual femme
subjectivity might begin to articulate itself in non-heterosexual terms.

Lesbian femme desire for masculinity in FTMs or transgendered butches seems
similarly to be a focused site for questions around femme subjectivity currently.
Debra Bercuvitz, in 'Stand By Your Man', discusses the ways in which her sense
of self as lesbian femme is challenged by her desire for her increasingly butch/
transgendered lover Kris:

> My identity as femme was clear to me. But as Kris became more stone,
> then passed as a man, I realized that not only was I losing my external
> identity as a lesbian, but my own sense of self became clouded as I related
> more to Kris's masculinity. . . . I came into my femininity with her, into
> the full display of my sexy, femme glory. One clear dynamic was my
> need to give, hers to take. But, of course, not in the straight way.
>
> [Bercuvitz 1995: 90, 93]

The history of other butch-femme couples read as straight is clearly extremely
important to Bercuvitz. It is through this history that she can articulate her lover's
struggles as inextricable from her own [93–94]. Within the cultural repudiation of
heterosexuality, Bercuvitz's object-choice can be read as 'same-sex', though in
straight contexts it is less certain.

Minnie Bruce Pratt's concern about the sexual identity of the femme is in part
sparked by her desire for her transgendered lover. Throughout *S/HE*, Pratt artic-
ulates concern about the narrowness of sex and gender as categories through which
we can understand our sexual desires. Discussing how [the young Nebraskan trans-
sexual man] Brandon Teena's death was understood as the death of a lesbian rather
than a transsexual by a particular lesbian writer, Pratt suggests that:

> [t]he writer admits Brandon lived as a man, but she strips him down to
> prove that he was not. For her, everything has to match – genitals,
> clothes, pronouns. . . . [s]he decides he is a confused lesbian – her kind
> of lesbian, she writes, a butch woman who turns her on, who gets her
> hot. . . . The writer never mentions he died when he insisted he would
> chose his own pronoun.
>
> [Pratt 1995: 174]

Given the context (that Teena was 'stripped down' by his attackers before being
raped to prove to his lover he was 'female'), Pratt's words fix the lesbian writer as
yet again erasing Teena to fit her own desire. Teena is lesbian – we know, because
s/he is the lesbian writer's 'kind of [butch] lesbian'. Pratt's critique could be read
as highlighting the mis-readings that go on in order to preserve lesbian identity as
formed through repudiation of heterosexual object-choice.

So, is Pratt's sense of self as (lesbian) femme formed through cultural or object-
choice repudiation? When Pratt and her lover insist that their desire to enter
Michigan Women's Festival is legitimate, it is not because they both have female
bodies, but because they both are and have been a part of feminist and lesbian culture
and history [179–85]. Throughout *S/HE*, Pratt traces a personal and political history
of her place in and relationship to lesbian and feminist culture. In addition, Pratt's
desire is certainly not only for 'women' as that is generally understood. As her
(bisexual) friend points out, she is the lover of woman and man in one body [103],
and her lover is read as alternately man and woman. Still, Pratt is uncertain: she
questions how she might have negotiated her desire and identity if her lover were
to have transitioned from female to male, were to have unrecognizably transformed
her body to 'his body' – 'perhaps I would have left you when your voice altered
and your beard grew and your scent changed' [177]. In a sense Pratt's femme desire

in *S/HE* is for the limits of womanhood (her own as well as her lover's). She is a lover of the female form, of female history and struggle, and so part of her project is to suggest alternatives to where the boundaries of womanhood might be:

> I don't want *woman* to be a fortress that has to be defended. I want it to be a life we constantly braid together from the threads of our exist-ence, a rope we make, a flexible weapon stronger than steel, that we use to pull down walls that imprison us at the borders.
>
> [184–85]

Thus, repudiation of opposite-sex object-choice is still an important part of being femme for Pratt, but the boundaries of that same-sex (female) object are no longer assumed to be self-evident. Both Pratt's and Bercuvitz's desires might be written as repudiation of heterosexual culture *and* as opposite-sex object-choice repudia-tion, in other words (much like Califia's above).

What interests me is that none of the authors I have discussed above considers bisexuality as an intervention in the current debates about what forms non-hetero-sexual subjectivity. Even Califia, whose article expressly addresses why she does not call herself bisexual, does not consider what bisexual desire or object-choice might consist of. Her frames of reference are heterosexual acts (that she distances herself from) and 'queer' acts (that she embraces). Yet all the authors open up a way of approaching the 'problem' of bisexual femme subjectivity. Just as Pratt and Bercuvitz emphasize the cultural histories that are combined in the conjunction of (lesbian) femme and transgendered subject, bisexual femme desire might be articulated as first and foremost a cultural repudiation of heterosexuality (that would also bring other such gestures as Pratt's, Bercuvitz's, Califia's and Nestle's into focus).

To stay with the example of femme desire for transgendered or transsexual subjects for a moment, bisexual writer Marcy Sheiner's predominant concern about her relationship with her transsexual lover, Rob, also surrounds the possibility of its being recuperated into heterosexual culture, mirroring Bercuvitz's anxiety almost exactly [Sheiner 1996: 19–21]. Where the two writers differ, though, is in terms of the site of their potential loss of identity. Sheiner writes:

> It was as if his whole body became one giant cock, and I simply became cunt, opening up to receive the energy. . . . Ironically, I felt more female with Rob than I had ever felt with a genetic male. Maybe it was because I was more trusting of a he-who-had-been-she, and could therefore drop my survival skills, allowing myself to become pure, primeval woman. It felt liberating – for awhile. Eventually, of course, there was a price to pay.
>
> [20]

The 'price' Sheiner pays is being read externally as heterosexual (in particular by her family), rather than understanding losing her own sense of self because of her object-choice. Her blatant reductionism aside, the issue for Sheiner is how this particular relationship is not heterosexual even *though* it is between a man and a woman, rather than how this relationship is not heterosexual because it is *not* (in

terms of sexed object-choice) between a man and a woman. The questions posed by desire for transgendered and transsexual bodies by both lesbian and bisexual femmes are similar: What are the implications of this desire for my sense of self as femme? How is this desire (and sense of self) different from heterosexuality? How do I mark this desire as non-heterosexual? These are certainly not new questions for femmes to be asking, but I want to show how a bisexual femme subject might answer these questions differently by situating herself as non-heterosexual through the process of cultural repudiation signalled as significant by Sheiner, as well as through specific object-choices.

What is interesting about the conjunction of bisexual femme and FTM is that here we have a coupling that may be read as non-heterosexual through their combined cultural repudiation. Both bisexual femmes and FTMs may have learned, for example, the form and expression of their desire in a lesbian context – in a lesbian butch-femme context more specifically. The way that an FTM–bisexual femme couple make sense of and give meaning to their desire may, in other words, be in reference to lesbian cultural forms and histories, even though the opposite-sex form of their desire might suggest that it resonates more within heterosexuality. For these subjectivities the male-female dynamic which haunts lesbian butch-femme does not need to be banished, can thrive without the relationship always being reduced to heterosexuality.

This approach to the formation of a bisexual femme subject position raises a number of questions. I am aware that what I have chosen to focus on here is the repudiation of heterosexual culture (irrespective of object-choice). In a sense this is to overstate the case in search of (my) bisexual femme legitimation. A bisexual femme position might also differentiate itself from lesbian culture. I would suggest that a bisexual femme subject position may, in fact, be occupied through vacillating cultural repudiation of both/either heterosexual and lesbian culture, as well as repudiation through sexed object-choices. So that a bisexual femme who views herself as residing within lesbian culture might be understood as differentiating herself via a repudiation of heterosexual culture and lesbian object-choice (if she is in a relationship with a man, say); or repudiation of lesbian culture and heterosexual object-choice (if in a relationship with a woman, say). Thus the bisexual femme may gain meaning through the simultaneous utterances: 'I am a non-heterosexual' and 'I am a non-lesbian' [see also Du Plessis 1996: 22].

Such positioning of bisexual femme also opens up the possibility that, at points, she may not be differentiable from lesbian femme, too. In my article on the 'indiscretion' of bisexuality in relation to lesbian identity in Northampton, I argue that it is only through 'naming' that bisexual women's experience becomes experienced as different from lesbian experience [Hemmings 1997]. But, if a bisexual femme is at points distinguishable from a lesbian femme only in terms of her opposite-sex object-choice, can she not simply be accused of appropriation of lesbian femme culture? Such a gesture of blame marks the bisexual femme as 'inauthentic' [see Fraser 1997: 38–57], and perpetuates the notion that bisexual and lesbian femme are always separate, with the bisexual femme as the copy to the lesbian femme's original. My resistance to marking out bisexual femme subjectivity as only and always separate from lesbian femme subjectivity is, first because this would appear to misrepresent the history of their relationship both historically and contemporarily,

and, second, because there are bound to be points where the two subject positions are mutually informative, overlap, or are indistinguishable from one another. These moments do not necessarily involve the erasure of one subject over another.

My attempt in this [chapter] to imagine a bisexual femme subject position as a site of non-heterosexual resistance opens up a number of problems as well as possibilities. My attempt to extend the notion of repudiation beyond desire to include culture risks collapsing the two into one another. This move could be read as suggesting that the cultural repudiations of the bisexual femme, or the non-heterosexual subject, are unconscious ones which lead to a bisexual femme or non-heterosexual subjectivity. In fact, though, I see the bisexual femme's cultural repudiations I have been describing as social and political decisions that allow her to occupy a non-heterosexual subject position and hence offer a conscious parody of Butler's heterosexual frames. Thus we could see the bisexual femme subject I have been delineating as either a subject who chooses to inhabit non-straight cultural locations, or as one whose subjectivity is formed through both unconscious and conscious repudiations.

This perception of the bisexual femme as an unconsciously formed subject whose cultural repudiations do not directly (in)form her subjectivity can easily turn to the accusation of appropriation. This view of the bisexual femme sees her rejection of straight culture and embracing of lesbian culture as voluntaristic and wilful, as well as conscious. The bisexual femme is thus set up as the 'knowing' subject, who can pick and choose cultures as well as object-choices. What I want to suggest is that a bisexual femme's unconscious repudiation constitutes her as a sexual subject, and that her conscious repudiation constitutes her as a cultural subject. The combination of unconscious and conscious repudiation produces a bisexual femme subject capable of expressing desire and surviving in a heterosexist world. I would argue that there is no meaningful bisexual femme subjectivity that precedes its formation through cultural repudiation. There is no 'bisexual femme' waiting in the wings to take advantage of lesbian femme community, to borrow what is not hers without permission.

It is my hope that such an approach to bisexual femme subjectivity can underscore the contemporary femme desire to signify independent of opposite-gendered same-sexed objects. Bisexual femmes' (and lesbian femmes') mis-matching cultural and object-choice repudiations suggest, perhaps, a different historical and contemporary narrative of femme desire, one where Mary (as the femme who must ever be denied) is no longer a subject-in-waiting, or a failed lesbian femme, but a subject whose complex (and ambivalent) cultural and object-choice repudiations are a central part of non-heterosexual struggle.

PART SEVEN

Scenes of music

Introduction to part seven

■ Ken Gelder

THE FIELD OF POPULAR MUSIC complicates subcultural identities in all
sorts of ways. First, musical tastes are generally eclectic, more a question of
(loose) multiple affiliations than any single kind of identification, subcultural or
otherwise. Second, since music is both an industrial and commercial field of produc-
tion, tastes are often shaped in an executive way from the top down – whereas the
conventional model of subcultural identification, as we have seen, charts the deploy-
ment of tastes 'from below'. One of the binaries at work here rests on the assumption
that the industrial and commercial dissemination of popular music produces audi-
ence and producer passivity (they listen to what they're told to listen to, they produce
what they're told to produce, under the influence of commercial/industrial impera-
tives). *Subcultural* music audiences and producers, on the other hand, are imagined
as active and activating, involved in a creative, innovative use of the cultural field.
For these reasons, so the argument goes, they are therefore able to be distinguished
from industrial and executive top-down logics. A related binary contrasts the 'inau-
thenticity' of music's commercial and industrial features with the 'authenticity' of
subcultural musical tastes – which, rhetorically at least, can thus claim to be *anti-*
commercial. For the influential Frankfurt School cultural critic Theodor W. Adorno,
these binaries worked to structure the cultural field at a time – during the 1940s
and 1950s – when culture itself seemed increasingly in the service of industry and
commerce. Adorno's high modernism led him to regard prevailing cultural tastes as
a matter of standardization and rationalization, a systematic erasure of 'individu-
ality' and the capacity for critical thought. The audiences of popular musical forms
were therefore in his view not only passive, but 'retarded'. However, Adorno also
had little time for subcultural distinctions. Far from providing an 'authentic' refuge
from commercial and industrial determinants, their 'pseudo-activity' was for him
just as *inauthentic* as anyone else's. Here is Adorno on the 'jitterbugs', enthusiasts

of a form of swing dance that emerged in the 1930s in jazz band venues across the United States:

> Whenever [people] attempt to break away from the passive status of contemporary consumers and 'activate' themselves, they succumb to pseudo-activity. Types rise up from the masses of the retarded who differentiate themselves by pseudoactivity and nevertheless make the regression more strikingly visible. There are, first, the enthusiasts who write fan letters to radio stations and orchestras and, at well-managed jazz festivals, produce their own enthusiasm as an advertisement for the wares they consume. They call themselves jitterbugs, as if they simultaneously wanted to affirm and mock their loss of individuality, their transformation into beetles whirring around in fascination. Their only excuse is that the term jitterbugs, like all those in the unreal edifice of ... jazz, is hammered into them by the entrepreneurs to make them think that they are on the inside. Their ecstasy is without content.
>
> (Adorno 1991: 46)

This brittle diatribe could not be further away from the traditional perspective of subcultural studies: think, by way of contrast, of Robert E. Park's championing of 'divergent types' in the city, or Dick Hebdige's ironic, self-aware punk. The binary of inauthentic/authentic culture itself remains intact – after all, Hebdige's study of subcultures was itself high modernist, as much tied to avant-garde aesthetics as Adorno's work. The difference is that subcultural studies has traditionally turned to the latter part of the binary and invested in it.

We can see this by turning, as Adorno had, to jazz. Adorno had thought that even improvised jazz – jazz at its most creative and spontaneous – was merely another rationalized product of industrial capitalism: 'what appears as spontaneity is in fact carefully planned out in advance with machinelike precision' (cited in Negus 1996: 38). Subcultural studies, on the other hand, has been much more positive about the eccentricities and marginalities of the 'jazz community'. For Robert K. McMichael, jazz in the United States was and continues to be played by a small number of dedicated musicians in vibrant, multiracial 'scenes': it 'remained an essentially marginal form of popular culture, never climbing out of the valley it slid (or was pushed) into in the mid-1960s' (McMichael 1998: 412). The first extract in this section comes from Howard S. Becker's important study, *Outsiders*, published in 1963, a study of marijuana use among social groups which includes a chapter about dance musicians in Chicago who had also played jazz. Here, jazz is marginal enough to be cast as a form of deviance, in contrast to the commercially driven, mainstream occupation of playing dance music. Becker's study remains in the frame and methodology of the Chicago School, examining a discrete 'corner' of society that is unconventional in its interests and practices. The musicians Becker talks to define themselves *against* commercialism and the mainstream. But they also define themselves against their listeners who – in Adorno-like fashion – are regarded as tasteless, ignorant, conventional and narrow-minded: 'squares'. The central point of

Becker's study is that these jazz musicians are *self*-segregating, sliding into their own valley (to recall McMichael's earlier comment) entirely by choice. Although they are themselves a part of 'fully assimilated national groups', older, gifted and often privileged, they cast aside conventional aspects of American cultural life, expressing their sheer contempt for the commercial imperatives that otherwise rule their musical lives.

The anti-commercial aspirations of jazz were reproduced later on in punk music culture. Jon Savage has documented punk's 'anti-consumerism' in his seminal study, *England's Dreaming: Sex Pistols and Punk Rock* (1991, 2001): 'Although Punk turned into music industry business after early 1978, at its heart was a furious disgust with consumption, and the place of pop culture and Punk itself within it' (Savage 2001: xv). For Dave Laing in this section, punk music expresses its antagonistic position in the cultural field through its actual sounds: guitar, voice, melody, range. Drawing on the semiotics of Roland Barthes, Laing reads punk music for the 'voluptuousness' of its signifiers, its particular 'mode of address'. Punk is the opposite of jazz in the sense that it can seem as if anyone can play it – Laing's chapter is taken from his book, *One Chord Wonders* (1985) – and in the sense that it often blurs (rather than emphasizes) the distinctions between audience and performers. On the other hand, punk can seek to alienate or even shock many listeners. Laing carefully examines the logic of punk's shock effects and asks how – if one of its aims is to alienate – people might establish an identification with it. The punk song itself may work to distinguish punk from non-punk audiences in these terms, however. And those who can identify with punk may relish the discomfort felt by those who cannot.

Jazz in the United States has traditionally been associated with African Americans although, as I have already noted, the jazz 'scene' is commonly cast as multiracial, even integrationist (but see, for example, Panish 1997). For Dick Hebdige, punk also had a multiracial capacity, its musical influences linked to reggae, for example (think of The Clash). Paul Gilroy's ground-breaking book, *There Ain't No Black in the Union Jack* (1987), charts some of these links as it looks at the migration of 'black expressive cultures' – musical cultures in this case – east across the Atlantic and into Britain. In the extract published in this section, Gilroy describes the arrival of new sound systems from the Caribbean that underwrote the development of 'soul and reggae subscenes' in the UK during the 1970s. These subscenes give local expression to 'international networks' that Gilroy casts in a politically utopian way, built around solidarity and emancipation, for example. Through reggae and its sound technologies, the Caribbean thus provides British youth with a 'subcultural resource', utterly different in kind and effect to the mainstream influence of white American popular culture. In this respect, Gilroy retains the binary we have seen above but recasts it racially: black subcultural expression 'from below' on the one hand, and white industrialism/consumerism on the other which (think of The Police) can seem altogether detached from its subcultural origins.

Popular music does not readily accommodate the term *subculture* – because of its industrial/corporate and commercial (and heavily mediated) features, but also

because it is produced so rapidly and distributed so unevenly across place and time. Placing his analysis of rock 'n' roll in the context of postmodernity, Lawrence Grossberg has suggested that 'subject positions' in the field of popular music can thus only be 'multiple and contradictory' (Grossberg 1984: 57). Rock 'n' roll may very well be 'affirmative' and 'empowering' for its audiences; but for Grossberg, it produces not discrete subcultures but, rather, abstractly-defined 'affective alliances' and 'networks of affiliation' (57). Other commentators, however, have retained a sense of subcultural sociality in their accounts of the popular music field. In an influential article reprinted in this section, 'Communities and Scenes in Popular Music', the Canadian popular music critic Will Straw responds to Grossberg by suggesting that 'affective alliances' are always tied to particular musical practices. Straw looks at what he calls the 'sites of dissemination' of two types of popular music, alternative rock and dance. The audiences of alternative rock are, for Straw, something like a community: 'relatively stable', built around a shared musical 'heritage', localizing and encouraging 'connoisseurship' among the fans. For dance, Straw returns to the term 'scene' – but the term is now invested with a particular kind of cultural logic. The dance 'scene' is less insular, more progressive, 'polycentric', open to potentially global influences. And for these reasons, Straw casts it as more contemporary, more 'fashionable', than its alternative rock counterpart.

Popular music genres can certainly talk up, even mythologize, the local: think of rap music's generic identification with the 'hood or the 'street' (see Negus 1999). Dance music, however, is usually linked to globalized identities and transnational movement. The binary of authenticity/inauthenticity can work itself out in this context, with the local (alternative rock, rap) claiming an authentic 'street credibility' while the global (dance) is seen as mediated and commodified. Disco provides a good example of the second cultural logic. The genre itself is often cast as inauthentic, as Richard Dyer had noted in his important early essay, 'In Defense of Disco' (1979). Disco music flaunts its synthetic qualities, making it quite different in kind and purpose to, say, punk. But more to the point, as Dyer notes, both 'in how it is produced and what it expresses, disco is held to be irredeemably capitalistic' (Dyer 1990: 411). This particular claim makes it worth wondering how such a globalized dance genre might be received in – for example – a place like China. James Farrer's contribution to this section, from the journal *Sexualities* (and later republished in his book, *Opening Up: Youth Sex Culture and Market Reform in Shanghai* [2002]), looks at disco in a city like Shanghai precisely as a point of entry into global capitalism for Chinese participants. For Farrer, the disco is both a cosmopolitan and a commodified space; as they dance there, local Chinese experience what he calls 'glamorous modernity'. One of the pleasures of the Chinese disco lies in being evaluated sexually. But the models of sexuality here are 'foreign' and tied to consumerism. The Chinese disco thus sees local participants 'subjecting themselves to the evaluation of the global market'. Of course, this is no longer an example of 'history from below' in the general tradition of subcultural studies: it charts, instead, the top-down dissemination of music culture as it colonizes the local and transforms it. For Farrer, the model is thus more akin to *Gesellschaft* (society) than

Gemeinschaft (community). To describe this willing subjection to a top-down, global *Gesellschaft*, Farrer therefore uses the term *super-culture* – even though the discos themselves remain 'scenes' of subcultural activity.

The dance floor may be a subcultural and super-cultural space simultaneously. In his excellent dissection of rave and techno dance cultures, *Generation Ecstasy* (1999), Simon Reynolds writes convincingly about 'subsubgenres and microscenes' in a transnational framework (Reynolds 1999: 380). For Reynolds, rave culture is an 'investment in pleasure' – which means that, although it is non-conformist, it can be difficult to conceive of it in conventionally subcultural terms, as a form of 'resistance', etc. In the final piece in this section, from Ben Malbon's book *Clubbing* (2001), dance nevertheless remains a (sub)social experience. Providing a contemporary comparison to Becker's 1963 study of dance musicians and marijuana use, Malbon looks at dance club participants' use of the drug ecstasy (MDMA) – which generates a sense of heightened euphoria and happiness. Drawing on Freud and the work of British novelist and journalist Marghanita Laski – who had written several books on ecstatic experiences, creativity and everyday life – he describes the way 'altered states' on the dance floor produce a sense of sociality with the crowd, a 'sensation of oneness'. Ecstasy literally takes clubbers out of their bodies (*ex-statis*), allowing them to flow into the crowd around them. Clubbing, for Malbon, is thus an 'oceanic experience' – a transitory and hedonistic form of play, comparing in this way to Jock Young's analysis of drug-taking in chapter 13. It is not that ecstasy-taking clubbers are therefore out of control: the dance floor remains a place of discipline, where the subcultural values of 'coolness' prevail. But it does mean that, free from the tyranny of individuality, the rave dance floor can seem like a momentary 'earthly utopia or dream world', gaining its own logic of authenticity in the process. The ecstatic rave experience, as Reynolds also notes, provides a vacation from one's self and the pressures of everyday life (1999: 238). This perspective is worth contrasting to Farrer's account of the Chinese disco as a point of entry into a glamorous, global modernity. It also allows a very different gloss to Adorno's notion, quoted earlier, of the erasure of individuality as 'ecstasy without content'.

Howard S. Becker

THE CULTURE OF A DEVIANT GROUP
The dance musician [1963]

ALTHOUGH DEVIANT BEHAVIOR is often proscribed by law – labeled criminal if engaged in by adults or delinquent if engaged in by youths – this need not be the case. Dance musicians . . . are a case in point. Though their activities are formally within the law, their culture and way of life are sufficiently bizarre and unconventional for them to be labeled as outsiders by more conventional members of the community.

Many deviant groups, among them dance musicians, are stable and long-lasting. Like all stable groups, they develop a distinctive way of life. To understand the behavior of someone who is a member of such a group it is necessary to understand that way of life.

Robert Redfield expressed the anthropologist's view of culture this way:

> In speaking of 'culture' we have reference to the conventional under-
> standings, manifest in act and artifact, that characterize societies. The
> 'understandings' are the meanings attached to acts and objects. The
> meanings are conventional, and therefore cultural in so far as they have
> become typical for the members of that society by reason of inter-com-
> munication among the members. A culture is, then, an abstraction: it is
> the type toward which the meanings that the same act or object has for
> the different members of the society tend to conform. The meanings are
> expressed in action and in the results of action, from which we infer
> them; so we may as well identify 'culture' with the extent to which the
> conventionalized behavior of members of the society is for all the same.
> [Redfield 1941: 132]

Hughes has noted that the anthropological view of culture seems best suited to the homogeneous society, the primitive society on which the anthropologist works. But

the term, in the sense of an organization of common understandings held by a group, is equally applicable to the smaller groups that make up a complex modern society. Ethnic groups, religious groups, regional groups, occupational groups – each of these can be shown to have certain kinds of common understandings and thus a culture.

> Wherever some group of people have a bit of common life with a modicum of isolation from other people, a common corner in society, common problems and perhaps a couple of common enemies, there culture grows. It may be the fantastic culture of the unfortunates who, having become addicted to the use of heroin, share a forbidden plea-sure, a tragedy and a battle against the conventional world. . . . It may be the culture of a group of students who, ambitious to become physi-cians, find themselves faced with the same cadavers, quizzes, puzzling patients, instructors and deans.
>
> [Hughes 1961: 28–9]

Many people have suggested that culture arises essentially in response to a problem faced in common by a group of people, insofar as they are able to interact and com-municate with one another effectively [see Cohen 1955, Cloward and Ohlin 1960, Becker *et al.* 1961]. People who engage in activities regarded as deviant typically have the problem that their view of what they do is not shared by other members of the society. The homosexual feels his kind of sex life is proper, but others do not. The thief feels it is appropriate for him to steal, but no one else does. Where peo-ple who engage in deviant activities have the opportunity to interact with one another they are likely to develop a culture built around the problems arising out of the dif-ferences between their definition of what they do and the definition held by other members of the society. They develop perspectives on themselves and their deviant activities and on their relations with other members of the society. (Some deviant acts, of course, are committed in isolation and the people who commit them have no opportunity to develop a culture. Examples of this might be the compulsive pyro-maniac or the kleptomaniac, Cressey 1962). Since these cultures operate within, and in distinction to, the culture of the larger society, they are often called subcultures.

The dance musician, to whose culture or subculture this [chapter] is devoted, may be defined simply as someone who plays popular music for money. He is a member of a service occupation and the culture he participates in gets its character from the problems common to service occupations. The service occupations are, in general, distinguished by the fact that the worker in them comes into more or less direct and personal contact with the ultimate consumer of the product of his work, the client is able to direct or attempt to direct the worker at his task and to apply sanctions of various kinds, ranging from informal pressure to the withdrawal of his patronage and the conferring of it on some others of the many people who perform the service.

Service occupations bring together a person whose full-time activity is centered around the occupation and whose self is to some degree deeply involved in it, and another person whose relation to it is much more casual. It may be inevitable that the two should have widely varying pictures of the way the occupational service

should be performed. Members of service occupations characteristically consider the client unable to judge the proper worth of the service and bitterly resent attempts on his part to exercise control over the work. Conflict and hostility arise as a result, methods of defense against outside interference become a preoccupation of the members, and a subculture grows around this set of problems.

Musicians feel that the only music worth playing is what they call 'jazz,' a term which can be partially defined as that music which is produced without reference to the demands of outsiders. Yet they must endure unceasing interference with their playing by employers and audience. The most distressing problem in the career of the average musician, as we shall see later, is the necessity of choosing between conventional success and his artistic standards. In order to achieve success he finds it necessary to 'go commercial,' that is, to play in accord with the wishes of the non-musicians for whom he works; in doing so he sacrifices the respect of other musicians and thus, in most cases, his self-respect. If he remains true to his standards, he is usually doomed to failure in the larger society. Musicians classify themselves according to the degree to which they give in to outsiders; the continuum ranges from the extreme 'jazz' musician to the 'commercial' musician.

Below I will focus on the following points: (1) the conceptions that musicians have of themselves and of the non-musicians for whom they work and the conflict they feel to be inherent in this relation; (2) the basic consensus underlying the reactions of both commercial and jazz musicians to this conflict; and (3) the feelings of isolation musicians have from the larger society and the way they segregate themselves from audience and community. The problems arising out of the difference between the musician's definition of his work and those of the people he works for may be taken as a prototype of the problems deviants have in dealing with outsiders who take a different view of their deviant activities. [For other studies of the Jazz musician, see Lastrucci 1941, Cameron 1954, Merriam and Mack 1960] . . .

Musician and 'square'

The system of beliefs about what musicians are and what audiences are is summed up in a word used by musicians to refer to outsiders – 'square.' It is used as a noun and as an adjective, denoting both a kind of person and a quality of behavior and objects. The term refers to the kind of person who is the opposite of all the musician is, or should be, and a way of thinking, feeling, and behaving (with its expression in material objects) which is the opposite of that valued by musicians.

The musician is conceived of as an artist who possesses a mysterious artistic gift setting him apart from all other people. Possessing this gift, he should be free from control by outsiders who lack it. The gift is something which cannot be acquired through education; the outsider, therefore, can never become a member of the group. A trombone player said, 'you can't teach a guy to have a beat. Either he's got one or he hasn't. If he hasn't got it, you can't teach it to him.'

The musician feels that under no circumstances should any outsider be allowed to tell him what to play or how to play it. In fact, the strongest element in the colleague code is the prohibition against criticizing or in any other way trying to put pressure on another musician in the actual playing situation 'on the job.' Where

not even a colleague is permitted to influence the work, it is unthinkable that an outsider should be allowed to do so.

The attitude is generalized into a feeling that musicians are different from and better than other kinds of people and accordingly ought not to be subject to the control of outsiders in any branch of life, particularly in their artistic activity. The feeling of being a different kind of person who leads a different kind of life is deepseated, as the following remarks indicate:

> I'm telling you, musicians are different than other people. They talk different, they act different, they look different. They're just not like other people, that's all. . . . You know it's hard to get out of the music business because you feel so different from others.
>
> Musicians live an exotic life, like in a jungle or something. They start out, they're just ordinary kids from small towns – but once they get into that life they change. It's like a jungle, except that their jungle is a hot, crowded bus. You live that kind of life long enough, you just get to be completely different.
>
> Being a musician was great, I'll never regret it. I'll understand things that squares never will.

An extreme of this view is the belief that only musicians are sensitive and unconventional enough to be able to give real sexual satisfaction to a woman.

Feeling their difference strongly, musicians likewise believe they are under no obligation to imitate the conventional behavior of squares. From the idea that no one can tell a musician how to play it follows logically that no one can tell a musician how to do anything. Accordingly, behavior which flouts conventional social norms is greatly admired. Stories reveal this admiration for highly individual, spontaneous, devil-may-care activities; many of the most noted jazzmen are renowned as 'characters,' and their exploits are widely recounted. For example, one well-known jazzman is noted for having jumped on a policeman's horse standing in front of the night club in which he worked and ridden it away. The ordinary musician likes to tell stories of unconventional things he has done:

> We played the dance and after the job was over we packed up to get back in this old bus and make it back to Detroit. A little way out of town the car just refused to go. There was plenty of gas; it just wouldn't run. These guys all climbed out and stood around griping. All of a sudden, somebody said, 'Let's set it on fire!' So someone got some gas out of the tanks and sprinkled it around, touching a match to it and whoosh, it just went up in smoke. What an experience! The car burning up and all these guys standing around hollering and clapping their hands. It was really something.

This is more than idiosyncrasy; it is a primary occupational value, as indicated by the following observation of a young musician: 'You know, the biggest heroes in the music business are the biggest characters. The crazier a guy acts, the greater he is, the more everyone likes him.'

As they do not wish to be forced to live in terms of social conventions, so musicians do not attempt to force these conventions on others. For example, a musician declared that ethnic discrimination is wrong, since every person is entitled to act and believe as he wants to:

> Shit, I don't believe in any discrimination like that. People are people, whether they're Dagos or Jews or Irishmen or Polacks or what. Only big squares care what religion they are. It don't mean a fucking thing to me. Every person's entitled to believe his own way, that's the way I feel about it. Of course, I never go to church myself, but I don't hold it against anybody who does. It's all right if you like that sort of thing.

The same musician classified a friend's sex behavior as wrong, yet defended the individual's right to decide what is right and wrong for himself: 'Eddie fucks around too much; he's gonna kill himself or else get killed by some broad. And he's got a nice wife too. He shouldn't treat her like that. But what the fuck, that's his business. If that's the way he wants to live, if he's happy that way, then that's the way he oughta do.' Musicians will tolerate extraordinary behavior in a fellow-musician without making any attempt to punish or restrain him. . . .

The musician thus views himself and his colleagues as people with a special gift which makes them different from non-musicians and not subject to their control, either in musical performance or in ordinary social behavior.

The square, on the other hand, lacks this special gift and any understanding of the music or the way of life of those who possess it. The square is thought of as an ignorant, intolerant person who is to be feared, since he produces the pressures forcing the musician to play inartistically. The musician's difficulty lies in the fact that the square is in a position to get his way: if he does not like the kind of music played, he does not pay to hear it a second time.

Not understanding music, the square judges music by standards foreign to musicians and not respected by them. . . . The following conversation illustrates the . . . attitude:

> JOE: You'd get off the stand and walk down the aisle, somebody'd say, 'Young man, I like your orchestra very much.' Just because you played soft and the tenorman doubled fiddle or something like that, the squares liked it. . . .
>
> DICK: It was like that when I worked at the M—— Club. All the kids that I went to high school with used to come out and dig the band. . . . That was one of the worst bands I ever worked on and they all thought it was wonderful.
>
> JOE: Oh, well, they're just a bunch of squares anyhow.

'Squareness' is felt to penetrate every aspect of the square's behavior just as its opposite, 'hipness,' is evident in everything the musician does. The square seems to do everything wrong and is laughable and ludicrous. Musicians derive a good deal of amusement from sitting and watching squares. Everyone has stories to tell about

the laughable antics of squares. . . . Every item of dress, speech, and behavior which differs from that of the musician is taken as new evidence of the inherent insensitivity and ignorance of the square. Since musicians have an esoteric culture these evidences are many and serve only to fortify their conviction that musicians and squares are two different kinds of people.

But the square is feared as well, since he is thought of as the ultimate source of commercial pressure. It is the square's ignorance of music that compels the musician to play what he considers bad music in order to be successful.

> BECKER: How do you feel about the people you play for, the audience?
> DAVE: They're a drag.
> BECKER: Why do you say that?
> DAVE: Well, if you're working on a commercial band, they like it and so you have to play more corn. If you're working on a good band, then they don't like it, and that's a drag. If you're working on a good band and they like it, then that's a drag, too. You hate them anyway, because you know that they don't know what it's all about. . . .

This last statement reveals that even those who attempt to avoid being square are still considered so, because they still lack the proper understanding, which only a musician can have – 'they don't know what it's all about.' The jazz fan is thus respected no more than other squares. His liking for jazz is without understanding and he acts just like the other squares; he will request songs and try to influence the musician's playing, just as other squares do.

The musician thus sees himself as a creative artist who should be free from outside control, a person different from and better than those outsiders he calls squares who understand neither his music nor his way of life and yet because of whom he must perform in a manner contrary to his professional ideals.

Reactions to the conflict

Jazz and commercial musicians agree in essentials on their attitude towards the audience, although they vary in the way they phrase this basic consensus. Two conflicting themes constitute the basis of agreement: (1) the desire for free self-expression in accord with the beliefs of the musician group, and (2) the recognition that outside pressures may force the musician to forego satisfying that desire. The jazzman tends to emphasize the first, the commercial musician the second; but both recognize and feel the force of each of these guiding influences. Common to the attitudes of both kinds of musician is an intense contempt for and dislike of the square audience whose fault it is that musicians must 'go commercial' in order to succeed.

The commercial musician, though he conceives of the audience as square, chooses to sacrifice self-respect and the respect of other musicians (the rewards of artistic behavior) for the more substantial rewards of steady work, higher income, and the prestige enjoyed by the man who goes commercial. One commercial musician commented:

They've got a nice class of people out here, too. Of course, they're squares, I'm not trying to deny that. Sure, they're a bunch of fucking squares, but who the fuck pays the bills? They pay 'em, so you gotta play what they want. I mean, what the shit, you can't make a living if you don't play for the squares. How many fucking people you think aren't squares? Out of a hundred people you'd be lucky if 15 per cent weren't squares. I mean, maybe professional people – doctors, lawyers, like that – they might not be square, but the average person is just a big fucking square. Of course, show people aren't like that. But outside of show people and professional people, everybody's a fucking square. They don't know anything. . . .

The jazzman feels the need to satisfy the audience just as strongly, although maintaining that one should not give in to it. Jazzmen, like others, appreciate steady jobs and good jobs and know they must satisfy the audience to get them, as the following conversation between two young jazzmen illustrates:

CHARLIE: There aren't any jobs where you can blow jazz. You have to play rumbas and pops [popular songs] and everything. You can't get anywhere blowing jazz. Man. I don't want to scuffle all my life.

EDDIE: Well, you want to enjoy yourself, don't you? You won't be happy playing commercial. You know that.

CHARLIE: I guess there's just no way for a cat to be happy. 'Cause it sure is a drag blowing commercial, but it's an awful drag not ever doing anything and playing jazz.

EDDIE: Jesus, why can't you be successful playing jazz? . . . you could have a sexy little bitch to stand up in front and sing and shake her ass at the bears [squares]. Then you could get a job. And you could still play great when she wasn't singing.

CHARLIE: Well, wasn't that what Q——'s band was like? Did you enjoy that? Did you like the way she sang?

EDDIE: No, man, but we played jazz, you know. . . .

Somewhat inconsistently, the musician wants to feel that he is reaching the audience and that they are getting some enjoyment from his work, and this also leads him to give in to audience demands. One man said:

I enjoy playing more when there's someone to play for. You kind of feel like there isn't much purpose in playing if there's nobody there to hear you. I mean, after all, that's what music's for – for people to hear and get enjoyment from. That's why I don't mind playing corny too much. If anyone enjoys it, then I kind of get a kick out of it. I guess I'm kind of a ham. But I like to make people happy that way.

This statement is somewhat extreme; but most musicians feel it strongly enough to want to avoid the active dislike of the audience: 'That's why I like to work with

Tommy. At least when you get off the stand, everybody in the place doesn't hate you. It's a drag to work under conditions like that, where everybody in the place just hates the whole band.'

Isolation and self-segregation

Musicians are hostile to their audiences, afraid that they must sacrifice their artistic standards to the squares. They exhibit certain patterns of behavior and belief which may be viewed as adjustments to this situation. These patterns of isolation and self-segregation are expressed in the actual playing situation and in participation in the social intercourse of the larger community. The primary function of this behavior is to protect the musician from the interference of the square audience and, by extension, of the conventional society. Its primary consequence is to intensify the musician's status as an outsider, through the operation of a cycle of increasing deviance. Difficulties with squares lead to increasing isolation which in turn increases the possibility of further difficulties.

As a rule, the musician is spatially isolated from the audience. He works on a platform, which provides a physical barrier that prevents direction interaction. This isolation is welcomed because . . . [t]he musicians fear that direct contact with the audience can lead only to interference with the musical performance. Therefore, it is safer to be isolated and have nothing to do with them. . . .

Musicians, lacking the usually provided physical barriers, often improvise their own and effectively segregate themselves from their audience.

> I had a Jewish wedding job for Sunday night. . . . We decided, after I had conferred with the groom, to play during dinner. We set up in a far corner of the hall. Jerry pulled the piano around so that it blocked off a small space, which was thus separated from the rest of the people. . . . I wanted to move the piano so that the boys could stand out in front of it and be next to the audience, but Jerry said, half-jokingly, 'No, man. I have to have some protection from the squares.' So we left things as they were. . . .

Many musicians almost reflexively avoid establishing contact with members of the audience. When walking among them, they habitually avoid meeting the eyes of squares for fear this will establish some relationship on the basis of which the square will then request songs or in some other way attempt to influence the musical performance. Some extend the behavior to their ordinary social activity, outside of professional situations. A certain amount of this is inevitable, since the conditions of work – late hours, great geographic mobility, and so on – make social participation outside of the professional group difficult. If one works while others sleep, it is difficult to have ordinary social intercourse with them. This was cited by a musician who had left the profession, in partial explanation of his action: 'And it's great to work regular hours, too, where you can see people instead of having to go to work every night.' Some younger musicians complain that the hours of work make it hard for them to establish contracts with 'nice' girls, since they preclude the conventional date.

But much self-segregation develops out of the hostility towards squares. The attitude is seen in its extreme among the 'X—— Avenue Boys,' a clique of extreme jazzmen who reject the American culture *in toto*. The quality of their feeling toward the outside world is indicated by one man's private title for his theme song: 'If You Don't Like My Queer Way You Can Kiss My Fucking Ass.' The ethnic makeup of the group indicated further that their adoption of extreme artistic and social attitudes was part of a total rejection of conventional American society. With few exceptions the men came from older, more fully assimilated national groups: Irish, Scandinavian, German, and English. Further, many of them were reputed to come from wealthy families and the higher social classes. In short, their rejection of commercialism in music and squares in social life was part of the casting aside of the total American culture by men who enjoyed a privileged position, but were unable to achieve a satisfactory personal adjustment within it.

Every interest of this group emphasized their isolation from the standards and interests of conventional society. They associated almost exclusively with other musicians and girls who sang or danced in night clubs . . . and had little or no contact with the conventional world. They were described politically thus: 'They hate this form of government anyway and think it's real bad.' They were unremittingly critical of both business and labor, disillusioned with the economic structure, and cynical about the political process and contemporary political parties. Religion and marriage were rejected completely, as were American popular and serious culture, and their reading was confined solely to the more esoteric *avant garde* writers and philosophers. In art and symphonic music they were interested in only the most esoteric developments. In every case they were quick to point out that their interests were not those of the conventional society and that they were thereby differentiated from it. It is reasonable to assume that the primary function of these interests was to make this differentiation unmistakably clear.

Although isolation and self-segregation found their most extreme development among the 'X—— Avenue Boys,' they were manifested by less deviant musicians as well. The feeling of being isolated from the rest of society was often quite strong; the following conversation, which took place between two young jazzmen, illustrates two reactions to the sense of isolation.

EDDIE: You know, man, I hate people. I can't stand to be around squares. They drag me so much I just can't stand them.

CHARLIE: You shouldn't be like that, man. Don't let them drag you. Just laugh at them. That's what I do. Just laugh at everything they do. That's the only way you'll be able to stand it.

A young Jewish musician, who definitely identified himself with the Jewish community, nevertheless felt this professional isolation strongly enough to make the following statements.

You know, a little knowledge is a dangerous thing. That's what happened to me when I first started playing. I just felt like I knew too much. I sort of saw, or felt, that all my friends from the neighborhood were real square and stupid. . . .

> You know, it's funny. When you sit on that stand up there, you feel so different from others. Like I can even understand how Gentiles feel toward Jews. You see these people come up and they look Jewish, or they have a little bit of an accent or something, and they ask for a rumba or some damn thing like that, and I just feel, 'What damn squares, these Jews,' just like I was a *goy* myself. That's what I mean when I say you learn too much being a musician. I mean, you see so many things and get such a broad outlook on life that the average person just doesn't have. . . .

The process of self-segregation is evident in certain symbolic expressions, particularly in the use of an occupational slang which readily identifies the man who can use it properly as someone who is not square and as quickly reveals as an outsider the person who uses it incorrectly or not at all. Some words have grown up to refer to unique professional problems and attitudes of musicians, typical of them being the term 'square.' Such words enable musicians to discuss problems and activities for which ordinary language provides no adequate terminology. There are, however, many words which are merely substitutes for the more common expressions without adding any new meaning. For example, the following are synonyms for money: 'loot,' 'gold,' 'geetz,' and 'bread.' Jobs are referred to as 'gigs.' There are innumerable synonyms for marijuana, the most common being 'gage,' 'pot,' 'charge,' 'tea,' and 'shit.'

The function of such behavior is pointed out by a young musician who was quitting the business:

> I'm glad I'm getting out of the business, though. I'm getting sick of being around musicians. There's so much ritual and ceremony junk. They have to talk a special language, dress different, and wear a different kind of glasses. And it just doesn't mean a damn thing except 'we're different.'

Dave Laing

LISTENING TO PUNK [1985]

Voices

RECORDINGS CAN BE THOUGHT of as spaces in which the various sounds are placed in relation to each other. Conventionally, a recording will foreground one particular element, the others arranged behind or around it as supports. Typically in popular music recordings what is foregrounded is the voice. This point can perhaps be supported negatively in that the listener notices (often with a sense of frustration) when the voice 'disappears' into what significantly is called the 'backing'. The frustration comes from a problem of comprehension (not being able to decipher the words) but also from the withdrawal of the opportunity of identification with 'the voice which typically, if not in every case, provides the level of the song which engages our desire most directly' [Cubitt 1984: 211].

The amplified voice can be seen to provide a comparable object for identification to that of the screen image of the film hero or heroine. In addition, the *musicality* of the process is crucial to this sense of perfection and coherence: singing can make a voice extraordinary in a way that everyday speech cannot (though heightened, dramatic speech can – an important point for punk).

Punk voices, to start with, seem to want to refuse the perfection of the 'amplified voice'. In many instances the homogeneity of the singing voice is replaced by a mixture of speech, recitative, chanting or wordless cries and mutterings Philip Tagg has pointed out that recitatives (used here as a generic term for vocalizations that are between ordinary speech and singing) are among those forms 'where the verbal narrative seems often to be more important than the musical discourse' [Tagg 1981: 14]. This would certainly seem to be the case with many punk records which employ recitative with serious intent. . . . Virtually all the Sex Pistols tracks (with Rotten on lead vocal) and those of Mark Perry's Alternative TV are examples. The implicit logic would seem to involve the conviction that by excluding the

musicality of singing, the possible contamination of the lyric message by the aesthetic pleasures offered by melody, harmony, pitch and so on, is avoided. Also avoided is any association with the prettiness of the mainstream song, in its forms as well as its contents: . . . punk has few love songs.

Yet any hope for the pure message, vocals as reflector of meaning, is doomed. Deprived of the conventional beauties of singing as a place for identification, for distraction, the listener may shift to some other aspect of the voice. What is at stake here is that element which Roland Barthes variously called the 'third meaning' or the 'geno-song'. The latter is contrasted with the 'pheno-song' which 'describes everything in the performance which is in the service of communication, representation, expression . . .'. The geno-song, by contrast is

> The volume of the singing and speaking voice, the space where significations germinate from within language and in its very materiality. . . . It is that apex (or depth) of production where the melody really works at the language – not at what it says, but the voluptuousness of its sound-signifiers, of its letters.
>
> [Barthes 1977: 182]

This is not a distinction between form and content or signifier and signified, with special emphasis being given to form. Barthes is concerned only with the role of singing-forms – are they subordinated to the message or content, there to underline it (as is the case in most of the Stranglers' work), or are there places where elements of form 'exceed' the message, providing a different focus for the listener? Johnny Rotten's vocal style offers some examples. In 'God Save The Queen', the word 'moron' comes out as 'mo-rrrr-on-er', with an exaggerated rolled 'r' in the middle and the addition of the extra 'er' syllable at the end. As pheno-song, two readings are possible. This presentation of the word both gives added emphasis within the narrative to the description of the Queen as a 'moron', and also connotes a relish on the part of the singer in making the comparison. So the sound 'in the service of representation' informs the listener of the most important part of the lyric message and provides information about the 'character' of the singer (and in doing so links up with the extra-musical discourse on the Sex Pistols).

But . . . by refocusing, the listener can hear Rotten's 'moron' as geno-song, as pleasure in the 'voluptuousness of . . . sound-signifiers'. For there is a sense in which the emphasis on the word is gratuitous within the lyric of 'God Save The Queen'. In the next line, for instance, the word 'H-Bomb', which semantically carries greater impact in general discourse, receives no such special emphasis. . . .

It is thus possible (if difficult) to find pleasure in this celebrated punk rock song without the necessity of agreeing with its message. This is something which is conventionally the case with mainstream popular song – the listener can take pleasure from a vocal representation of suffering without sharing the emotion. But it is clearly an outcome that 'protest' type songs would try to exclude. If someone who rejects the message can still like the song, a gap has opened which was unintended.

There are especial difficulties here for the songs of subcultures. While the subculture (or more precisely its interpreters) may pride itself on its ability to subvert dominant or established meanings, a listener to a manifestly punk song may

be able to miss the point, and avoid reacting either as a punk initiate or as a shocked adherent of dominant social values. The latter should, in principle, recoil from 'Dead Cities' by The Exploited, a 'formalist punk' record. Yet, such is the frenetic pace of the piece, that the enunciation of the title can easily be heard as a kind of 'scat' singing, as 'Deh See', and enjoyed as a form of abstract (wordless) vocalizing. The point of this example is that the potential play of the signifiers will always challenge the idea of a 'pure' oppositional or subcultural music. To minimize this challenge, a subculture intent on preserving itself and its meaning must organize the context of reception (through audience dress and response) to ensure that the subcultural meaning predominates. The only place for this is the live concert; once the music is on radio or record, other meanings, inflected by other ways of listening (usually structured by the priorities of the musical mainstream) may come to the fore.

A further aspect of the recorded voice is what can be called the *vocal stance*. In his study of Abba's 'Fernando', Philip Tagg describes how the singer's mouth is 'placed nearer the listener's ear by means of mike positioning and volume level in relation to accompaniment at the final mix-down. This reflects the actual/imagined distance between two persons (transmitter and receiver) in an intimate/confidential dialogue' [Tagg 1981: 13]. This private and confidential stance is in contrast to a public and declamatory one, which reflects a greater distance between the voice singing and the ears listening. As Tagg indicates, both imply a communicative function for the voice and belong very much to the pheno-song aspect of music.

Indeed, the confidential and declamatory emphases tend to be aligned with specific genres of music, different lyric subject-matter and contrasting 'modes of address' in the lyric. . . . [T]he genres most closely associated in popular song with the confidential vocal stance are the lyric ballad deriving from the 'standard' song-writing of Irving Berlin through to Lennon and McCartney and some blues styles. The declamatory mode, by contrast, is generally rooted in mainstream soul music, the 'shouting' style of R&B singing which in turn influenced early rock 'n' roll through Bill Haley, Little Richard and Jerry Lee Lewis and a white narrative ballad style deriving via Bob Dylan from Woody Guthrie and the Carter Family.

While the descriptions 'confidential' and 'declamatory' are meant to indicate tendencies in singing, rather than hard and fast categories, it is useful to note that of the Top 50 best-selling singles of 1976 . . . nearly half were clearly confidential in tendency. . . . In general, there is a connection between the preponderance of love songs and the confidential vocal stance. . . .

Within punk rock, however, the confidential stance was very rare. The Buzzcocks' Peter Shelley was one of the few who presented lyrics in a manner approaching that of the mainstream balladeers. Within the declamatory mode as employed by punk, elements of the soul style were equally scarce: Poly Styrene of X-Ray Spex uses falsetto whoops on 'Oh Bondage Up Yours!', while among the few bands to adopt American vocal accents were The Vibrators, The Damned (on the first album) and the Boomtown Rats, where the debt to Mick Jagger's rock-American intonation was very noticeable.

Simon Frith expresses the general view of the innovation in punk accents by describing how Johnny Rotten 'developed an explicitly working-class voice by using proletarian accents, drawing on football supporter chants . . .' [Frith 1981: 161]. But the argument that punk imported extra-musical elements into the popular music

discourse tends to underplay the previous applications of similar accents in rock music [: for example, the] modified 'stage cockney' of Anthony Newley and a young David Bowie in the 1960s – an accent alluded to in The Clash's 'Safe European Home' which includes the line, 'Wouldn't it be luverly' – a quotation from the hit musical *My Fair Lady*.

That accent influenced punk rock through some of The Vibrators' singing, but several punk bands offered a flatter London accent shorn of the aesthetic 'quaint-ness' which stage cockney had acquired. Prime examples were the querulous and whinging tone of Mark P. (notably on 'My Love Lies Limp' and 'How Much Longer') and the ultra-morose Malcolm Owen of The Ruts in whose singing the word 'feel' came out as 'feeyuwuh'. But if the intention in using such voices . . . on record was to signify the 'ordinary', the language of the streets, the result was paradoxical. For, in the context of popular music, the mundane and everyday was actually the main-stream American or 'non-accented' (sometimes called 'mid-Atlantic') accent asso-ciated in 1976 with singers like Abba or Queen's Freddie Mercury. What was ordinary in the streets became extraordinary on record and on radio.

Here is one point, then, where the 'realism' claimed by [the fanzine] *Sniffin' Glue* for punk rock is connected with the exotic and unnatural element in the music emphasized by other commentators. Voices which could be strongly identified with 'real' accents acquired a colourful resonance. The more neutral connotations which were perhaps most suited to naturalistic lyrics – the transparent voice – belonged to vocals such as Joe Strummer's, where the standard mainstream rock voice was not so much replaced as *shifted*. 'White Riot' had the same phrasing as the breath-less singing of The Ramones, but without the pronunciation of key sounds which fully identify The Ramones as American. In the syllable 'White', for example, the American tendency to stretch the vowel towards an 'ah' sound (which is also char-acteristic of rock singing in general) was resisted by The Clash, who retain the short 'i' sound. And the final 't' was clipped off by the British voice, while most American rock pronunciation would keep it, in whole or in part.

Strummer's vocals share with virtually all punk rock singing a lack of variety. There are no moves within songs from high to low, soft to loud, or from one accent to another. One thing which gives the Johnny Rotten voice a special place within punk rock is its unusual practice of changing direction within a song, a verse or even a line. By 'direction', I refer to a vocal strategy, a general approach to the choice of vocal effects. In punk rock, the basic distinction at this level is between 'straight' and 'embellished' singing. Early Clash records exemplify the straight style, where the project is to subordinate the vocal method to the lyric message – a mode appropriate to Barthes' pheno-song. Now, 'Anarchy In The UK' by the Sex Pistols sets off in this mode, a staccato delivery of words with one syllable assigned strictly to one beat. But something happens to deflect that single-mindedness at the end of the second line: 'I am the Anti-Christ/I am an Anarchist. . . .' The final syllable comes out not as 'kissed' but to rhyme with 'Christ'. The embellishment shifts the attention away from the message to the rhyme-scheme and could momentarily set up an ambivalent signal about the 'sincerity' of the whole enterprise. Can anyone who changes the pronunciation of such a key political word be wholly intent on conveying the message of the lyric? This relish for the signifier emerges in other ways that have already been mentioned (the rolled 'r' etc.), and works in tension

with the punk ideal of 'straight' singing in the work of Johnny Rotten. As I have already suggested, such a tension can never be fully eliminated from any vocal performance, but it seems more central to the Sex Pistols' music than to most other punk bands of 1976–8. . . .

Words: intertextuality

. . . The titles of the Top 50 songs of 1976 reveal the predictable cluster of words around 'Love', which itself appears seven times, including thrice in one song title. This cluster includes 'heart', 'kisses', 'breaking', 'angel', 'cry'. Another, perhaps less expected, linguistic area which is well represented is that of music and dancing themselves. 'Dance' occurs four times and 'music' three; with 'rock', 'songs', 'rhapsody' and 'funky', this group of words turns up in the titles of ten out of the Top 50 and in the body of the lyrics of at least two others (Abba's 'Fernando' and 'Under the Moon Of Love' by Showaddywaddy).

Among the first five punk rock albums, the song titles of The Vibrators yield three appearances of 'heart' and two of 'baby'. None of the other bands have lyric titles including words in this 'love' area, while the only ones remotely near the music and dance field are 'Garageland' by The Clash ('garage band' being a term for 1960s punk groups) and 'Fan Club' by The Damned. Remaining at the level of the vocabulary of titles, the most outstanding clusters of words in the punk rock songs are those around violence ('kill', 'stab', 'burning', 'whips', 'hate and war', 'riot', 'wrecked') and in references to actual places and people. 'London' appears three times, along with 'Toulouse', 'USA', 'New York', 'Janie Jones', 'The Queen' and 'EMI'. Compared to this the Top 50 titles have just 'Mississippi' and 'Zaire'.

Attention to individual words as an indicator of difference in song lyrics can, however, be misleading, since the centre of meaning of the word is dependent on its context. That context is both that of the immediate statement of which it is a part, and the larger discourses (of a song and a genre) of which the statement in its turn forms a part. For example, 'killing' can be found in the mainstream romantic discourse, most notably in 'Killing Me Softly With His Song', where the word clearly has a metaphorical sense. 'Burning' is another word which is similarly used to convey an excess of feeling ('Burning Love'). The Damned's title 'Born To Kill', however, reinstates the literal meaning of the word, while Clash's 'London's Burning' ('with boredom') involves a metaphorical connection based not on overheated passion but on the effects of urban rioting.

Even this distinction between literal and metaphorical word use is less important when we recognize the 'intertextual' nature of all language statements. For instance, while 'Born To Kill' is part of a paradigm of statements using 'Kill' in a dramatic way (e.g. sensational newspaper accounts of murder trials, film titles like *Dressed To Kill*), it also connects with a group of 'Born to . . .' statements, which emphasize ideas of heredity ('born to be king') or of predestination or fate: song titles in this mode include 'Born To Be Wild', 'Born To Run', 'Born To Be With You' and 'Born To Boogie'. And each of those instances involves using the predestination form of statement to emphasize the singer's total commitment to one or other of the staple roles of rock lyrics: the wild one, the outsider, the lover, the abandoned

dancer. The weight of this aspect of The Damned's song title . . . ties it to more 'standard' areas of musical and cultural meaning than one might expect from punk rock. . . .

The kind of analysis which traces networks of connotations for a phrase like 'Born To Kill', networks deriving from similar usages in other places in the culture, and most particularly in the texts of popular culture, is based on the principle of 'intertextuality'. This term is mainly used in literary criticism, and in that field Terry Eagleton has offered one of the most cogent definitions of the process of intertextuality. If 'music' or 'lyric' is substituted for 'literary' here, the applicability of the description to popular song can be grasped:

> All literary texts are woven out of other literary texts, not in the conventional sense that they bear the traces of 'influence', but in the more radical sense that every word, phrase or segment is a reworking of other writings which precede or surround the original work. There is no such thing as literary 'originality', no such thing as the 'first' literary work: all literature is 'intertextual'. A specific piece of writing thus has no clearly defined boundaries: it spills over constantly into the works clustered around it, generating a hundred different perspectives which dwindle to vanishing point.
>
> [Eagleton 1983: 138]

Eagleton rightly points out that any text (in our case, any punk rock lyric) has 'no clearly defined boundaries'. But there are several levels at which boundaries are imposed on that text, places where, for various motives, the 'reworking' of other texts is limited. The first is a legal and commercial one: a song has to be a clearly separate entity both to take the form of a commodity to be marketed and sold, and to become a piece of intellectual property, to have an 'author' who owns a copyright in that song. . . .

Then, a text will always be presented in a context, within a discursive formation, which will attempt to impose a way of reading or listening on the consumer. For Eagleton's literary texts, the distinction between reading inside the educational formation or inside a leisure context will produce different effects. Within popular music, the dominant discursive formation is that associated with the major record companies, the charts and music radio. It emphasizes the values of what Simon Frith has called 'orderly consumption' [1981: 270] and what elsewhere I have called the 'leisure apparatus' [Laing 1978: 126]. Here, entertainment is emphasized and enlightenment excluded, leisure defined as a passive relaxation and recuperation and feeling are extolled at the expense of thought.

Further, the drive for the largest possible audience causes the narrowing down of positions to be occupied by the listener. This involves both the 'unique and vaguely defined' addressee of the [song's lyric] and a certain homogenization of music which occurs within the Top 50 system. Here very different forms of music are presented in a context of comparison and competition which can delimit the audience's awareness of their potentially radical differences. When the Sex Pistols finally appeared on the BBC TV chart show 'Top Of The Pops', how far was it a victory for 'punk' – its chance to present itself to a mass audience – or for the

dominant discursive formation, which had now presented 'punk' as just another musical trend?

The shift by the BBC from the exclusion of 'God Save The Queen' to the inclusion of 'Pretty Vacant' (the first Pistols' record to be shown on 'Top Of The Pops') typified a dilemma for the leisure apparatus. One crucial way in which the institutions of popular music try to maintain their dominance is through ignoring musics which contain elements of alien discourses (e.g. politics, obscenity, explicit sexuality), for if those elements are brought into popular music they may have a disruptive effect. When they are brought in (and here, the popular music institution is caught in an ambivalent posture, since it also feels the need for a renewing of its own discursive practice in order to replenish its products), there are procedures for incorporating those external elements (be they rhythms, hair-styles or lyric statements) to minimize their disruption of orderly consumption.

At the level of song themes, punk rock was responsible for the importation of elements not from 'real life' so much as from other discourses into popular music. Its rhetoric of social and political comment echoed much of the news discourse of the period, sometimes inflected with that of left-wing ideology. To an extent, popular music had earlier, with protest song, had to handle such themes; though here, the emphasis on violent denunciation made punk rock more of a destabilizing factor.

Even more destabilizing was that area of punk language which drew on discourses which not only had been previously absent from popular song, but which had been excluded from the mainstream media discourse of society as a whole: the area of 'pornography' and 'obscenity'. The first rock recording to include the word 'fuck' had appeared in 1969, when *Love Chronicles* by the singer-song-writer Al Stewart had included the lines: 'It grew a little less like fucking, and more like making love'. Although dutifully banned by the BBC, this usage was clearly a conservative one, and no doubt justifiable as 'artistically appropriate'. John Lennon achieved greater publicity when he transferred the swearing usage into song with his reference to 'fucking peasants' on 'Working Class Hero'. A number of other 'progressive rock' performers committed the word to wax during the early 1970s, including Joni Mitchell, Dory Previn, Buffy Sainte-Marie and Nilsson.

It was left to punk rock to introduce 'fuck' and the rest wholesale to popular music. Both the 'explicit' sexual and the expletive swearing versions were available. The Clash and the Sex Pistols went in for the latter, for example in 'All The Young Punks', an answer to subcultural critics of The Clash for 'selling out', where Joe Strummer refers contemptuously to them as 'All the young cunts'. The explicitly sexual usage was left mainly to the literal-minded Stranglers on tracks including 'Bring On The Nubiles' and 'School Marm'. The latter, and the Buzzcocks' 'Orgasm Addict' provided a 'bonus' of wordless pantings, punk rock's answer to the soft-porn sounds of the 1969 hit 'Je T'Aime, Moi Non Plus' by Jane Birkin and Serge Gainsbourg.

The Stranglers' songs mentioned have scenarios of pornographic fantasies, with strongly sadistic overtones, and elsewhere that group and the early Adam And The Ants produced litanies of detailed violent acts: 'I'll sew up your mouth', 'You kicked my cheekbones in', 'Smack your face, treat you rough, beat you till you drop'. In so far as these songs disrupted the discourse of mainstream popular music, it was through their ability to 'shock' the listener. But which kind of listener (a 'mainstream' one? a 'punk' one?) and what kind of shock?

Shock effects

The idea that music, or any other artistic form, should aim to shock is an established part of avant-garde aesthetics. Writing in the 1930s, the German critic Walter Benjamin described the effect of the Dadaists in terms of shock: 'Their poems are "word salad" containing obscenities and every imaginable waste product of language. . . . One requirement was foremost: to outrage the public' [Benjamin 1968: 239]. This attitude of *épater le bourgeois* is a time-honoured one, and a motive that is consciously present in punk rock. In interviews, a number of musicians spoke of 'shock' as an intention. But what precisely was entailed in the shock; was it simply to traumatize the recipients, or in some way to enlighten them? In Benjamin's writings, there are several approaches to this issue. His essay on the nineteenth-century poet Charles Baudelaire considers two kinds of response to shock. The context is Benjamin's discussion of the new conditions of everyday life in the metropoli of industrial capitalism where the sudden jolt or shock is a frequent occurrence. Using Freud, Benjamin distinguishes between 'shock defence' which neutralizes the power of shock and a different response which integrates the content of shock into experience by the recipient's exposing him or herself more directly to the shock effect. For this to occur, the shock must be 'cushioned, parried by consciousness'. In effect, Benjamin argues that the 'shock defence', the inability to 'digest' shock content, produces trauma [1973: 115–18]. For the audience of an artistic event, the trauma involves what Barthes calls 'a suspension of language, a blocking of meaning' [1977: 30]. The resistance of the audience to the music or other art-work makes it impossible for any meaning to be registered. The viewer or listener turns off when confronted with the film of torture or the 'tuneless' piece of avant-garde music.

Theodor Adorno, a contemporary of Benjamin and astringent critic of his ideas, discussed this kind of response to what he called the 'radical music' of Schoenberg. There the listener was faced with 'the dissonances which frighten' and 'speak to the very condition of his existence: that is the only reason why they are unbearable' [Adorno 1973: 9]. Adorno, then, imparts a direct epistemological significance to the 'shock defence' identified by Benjamin. The rejection of avant-garde music by the mass of the population means that they have refused to face up to the truth about their lives. The theme of truth-telling at all costs is a familiar one in punk rock too: 'The Clash tell the truth', said Mark P. in *Sniffin' Glue*. For Barthes, in contrast, the cause of 'shock defence' and its accompanying trauma has a semiotic explanation: the shock-photo is the one for which the reader can find no connotation, no symbolism. Once a picture of a wartime atrocity can connote 'horrors of war' or 'imperialism' it can be integrated into the reader's consciousness. If it remains a pure denotation of sadism, the 'blocking of meaning' occurs.

The distinction between the two responses to the shock-effect – the negative shock-defence and the positive response which integrates the shock-effect – recurs in Walter Benjamin's essay 'The Work Of Art In The Age Of Mechanical Reproduction'. But here, as the title indicates, the argument is placed in the context of the history of different media, rather than the general history of industrializing capitalist societies. Briefly, his thesis is that the avant-garde movements of one artistic form are the heralds of a future cultural medium, whose technologies and techniques will be quite different:

> Traditional art forms in certain phases of their development strenuously
> work towards effects which later are effortlessly attained by the new ones.
> Before the rise of the movie, the Dadaists' performances tried to create
> an audience reaction which Chaplin later evoked in a more natural way.
> [Benjamin 1968: 251–2]

Benjamin then contrasts the shock-effects of Dada and the cinema. The Dadaist work 'hit the spectator like a bullet, it happened to him, thus acquiring a tactile quality'. But it also kept the 'physical shock effect' wrapped in a 'moral shock effect' (*épater le bourgeois?*); 'By means of its technical structure', film has dispensed with the moral wrapping and presents a shock-effect which 'like all shocks, should be cushioned by heightened presence of mind' [240].

The suggestion is that Dada and other avant-garde art-forms were consciously motivated by a desire to make a negative impact, perhaps to arouse a 'shock defence' or trauma in a section of its audience through the 'moral shock effect'. Indeed, part of its success depended on achieving that negative response. But the 'technical structure' of film allowed it to make a new impact without recourse to such deliberate traumatizing. Film's shock-effects were positive, transforming the outlook of the viewer.

If Benjamin's ideas are applied to the 1970s, where does punk rock stand in the contrast between Dada and film, and in that between the two responses to the shock-effect? It seems to have contained characteristics of both a frenzied critique of established art-forms (e.g. Dada) and of the effortless achieving by new technical means of effects or results striven hard for by earlier avant-gardes. Like Dada's 'word salad', much punk use of language involved both the shock of the new (importation of obscenity, politics, etc. in to popular lyrics) and the shock of the real (justification of this importation by the assertion that this is what happens on the street). Additionally certain organizational effects of punk rock may turn out to be harbingers of a future, more widespread medium. In particular, the very small-scale 'do it yourself' world of small labels but especially of home-made taped music represented the virtual dissolution of the barrier between performer and audience that was part of the ethos of much punk activity. . . .

On the other hand, there is a perspective within which punk rock seems more like Benjamin's description of the cinema, which can evoke 'in a more natural way' things strained for by previous avant-gardes. The punk opening up of self-production and distribution represented a relatively painless achieving of something avant-garde rock bands of a few years earlier had to go through debilitating tussles with record companies to get. Punk found ways of access to audiences for new music in a manner which had totally evaded the earlier bands.

The production of shock-effects involves confronting an audience with unexpected or unfamiliar material which invades and disturbs the discourse to which that audience is attuned. The nature of the material will therefore depend entirely on the specific context. . . .

Clearly, the shock-effect actually occurs only at the point of impact on the listener. Until that moment the production of shock by the specific formal organization of musical material remains potential rather than actual. But it is possible to distinguish amongst the formal organizations between those which are more likely

to achieve the full shock-effect and those which are less likely to do so. The other active element in all this will of course be the position of the listener her or himself: there will be varying degrees of receptivity, depending on that individual's ideolect and on the context in which they hear the music.

In discussing the potential of different types of organization of musical material to produce shock-effects, it is necessary to return to Benjamin's notion of the two types of impact, the 'traumatizing' and the 'integrated'. I want to suggest that while the first type can be produced by any punk text, only some are capable of going further to achieve the second type of response, which implies the listener's increase in awareness in some form or other.

To explain this further means introducing a distinction between *local* and *structural* shock-effects. A local shock-effect occurs when just one aspect of a musical piece is composed of shock-material, leaving the overall structure intact. When the Stranglers introduce obscene or sadistic lyrics, but retain vocal stylings and musical forms acceptable to the mainstream, a 'traumatic' response to obscenity is quite possible. But for a listener who is able to 'absorb' that shock and integrate it into their consciousness, there is little likelihood of a further 'pay-off' in heightened awareness. In fact, the most likely response is that hearing the music as a whole will mean hearing it as conventionally pleasurable. The local shock-effect is neutralized by the compatibility of the structure of the whole piece with the discourse of dominant popular music.

A structural shock-effect should have a greater chance of reaching the second level of impact, since it can potentially change the whole 'shape' of a recording or performance. 'Love Like Anthrax' by the Gang Of Four includes sequences in which two vocalists simultaneously deliver different sets of lyrics, joining together at certain chorus lines. Although it is still possible to hear this as a 'normal' record – by making one vocalist the centre of attention and ignoring the other – the most probable effect is that it will force the listener into a different way of listening, a way which involves considering the relation of the two lyrics to each other, and so on. . . . How far those shock-effects work on the listener is, to repeat, in part a function of how that listener hears the music, and in particular whether and how the process of *identification* operates in the listening experience.

Systematic discussion of modes of identification in listening is very sparse, so it seems appropriate to adapt the ideas developed about looking in film theory, especially as the Freudian discourse (to which those ideas belong) indicates that the 'invocatory' (listening) drive is a basic component of the human psyche alongside the 'scopic' (looking) drive [Metz 1975: 59–61]. A primary form of identification is with that which occupies the central point of a representation, the place of the *hero*, where that term applies not just to a character but to a function which moves the 'narrative' (story or song) along and in doing so establishes itself as something . . . more perfect than the listener him or herself.

In the song, this position is most frequently occupied by the lead vocal, which as has already been remarked is conventionally mixed 'to the front' of a recording. Sean Cubitt points out that the identificatory power of this positioning is apparent from the way dancers at a disco sing along with the lead vocal line: 'We can . . . through vocal identification become the singer and produce the song as our own' [Cubitt 1984: 212].

Laura Mulvey (1981) has shown that the comparable form of identification in watching a film can *potentially* affect any listener, regardless of gender, social class or ideological position. But she adds that it is frequently problematic or in some tension with differences between a listener and the 'hero-figure' (actor or singer). This latter case can be seen in the instance of Mick Jagger's voice and the ambivalent position of certain women listeners, drawn both to identification with Jagger as the source of musical power and control and repelled by Jagger as source of a sexist, sadistic ideology expressed in the lyric.

The importance attached to the issue of identification in radical culture criticism can be traced back to Bertolt Brecht. His dramatic characterization was deliberately designed to foil any empathy between spectator and character because, he argued, such identification precluded the spectator achieving any critical awareness of the character's situation. Hence the Brechtian notion of 'alienation' or 'distanciation' whereby the actor . . . *presents* the character to the audience rather than *becoming* it for them. In this way the art-work could make the audience think rather than simply feel.

Within punk rock, this Brechtian mode of non-identification can possibly be found in three ways. The first, and most questionable, derives from Roland Barthes' distinction [noted above] between geno-song and pheno-song. Barthes' exposition of this distinction contains distinct echoes of the Brechtian theme when he describes the pheno-song as being involved in 'the ideological alibis of a period', including the 'personality of the artist' [1977: 182]. It is the presentation of the singing voice as primarily this 'personality' . . . which is equivalent to the Brechtian identification and empathy. For Barthes it produces only *plaisir*, a form of enjoyment which merely confirms the listener in his or her status quo, without changing it.

In Barthes' account, change comes through *jouissance*, the more radical form of pleasure which 'shatters – dissipates, loses – [the] cultural identity, [the] ego' [1977: 9]. *Jouissance* proves the truth of psychoanalytic theory, that the self is not a unified whole, but a shifting bundle of elements, constructed by the drives of the unconscious and by social forces. And it is the geno-song of the voice that produces *jouissance* in the listener. By hearing those elements of a singing voice which are surplus to the communication of a message, such as Rotten's embellishments . . ., the listener escapes identification with the voice as ideal ego.

Such, at least, is Barthes' argument. But the implication of Sean Cubitt's account of identification with the singing voice is that such a distinction as that between pheno- and geno-song is irrelevant. The voice needs only consistency to become a place for identification.

Punk rock's second way of frustrating the primary identification with the singing voice occurs when a reading is structured so that there is no clearly presented centre of power and control. This can take two forms. First there are various 'avant-gardist' strategies which involve mixing a record so that the lead voice is displaced from the aural focus: the Gang Of Four disc considered above is one example of a text with no single centre for identification. Cubitt mentions also the 'post-punk' all-woman group, The Raincoats, 'who mix their voices down to the same level as the instruments'.

Secondly, there is the case of the voice which repels the listener's hope for identification by its 'unpleasing' character. Historically, this is always one effect of

innovation in popular music – the introduction of material from a discourse outside the mainstream is recognized by many as 'unlistenable'. But some punk rock seems to re-double this effect by presenting itself as a *challenge* to listeners, as an act, not of a new version of the popular vocal tradition, but of defiance of that tradition's broadly ingratiating stance towards its audience. There is then a distinction between, say, early Elvis Presley, where the 'traumatizing' shock-effect was an unintended by-product of the novelty of the vocal style, and the Sex Pistols, where the provocation of the 'boring old farts' among listeners was often built-in to the structure of the record and frequently signalled in the lyrics, as the second-person addressees, as well as in the tone of singing voice.

If, then, this interdiction of identification with the singing voice as such, affected, 'shocked,' every listener, it was also the point at which a 'punk' and a 'non-punk' listener began to be constituted. While the latter suffered Benjamin's shock-defence and switched off from any attempt at comprehension, the 'punk' listener made a second-level identification – not with the sound of the voice but with the singer or band making that sound. . . .

The 'punk listener', however, is involved with another aspect. For his or her alignment with the musician's strategy of provocation must include a pleasure in the awareness of how the other, 'traumatized' listener will be discomforted. That is, the identity of punk as something different depends in part on its achieving a disquieting impact on listeners whose expectations are framed by mainstream popular music and its values. Punk is not alone here. Much 'youth' music or music of outrage depends on its fans not so much being outraged or scandalized themselves, but on their awareness of the results of unpleasant listening in other people. And, finally, we may note that it is quite feasible for the same individual to both feel the effects of shock and to observe and enjoy the disturbance thus caused. That person could well be an example of Benjamin's ideal audience, possessed of 'heightened presence of mind'.

Paul Gilroy

DIASPORA, UTOPIA AND THE
CRITIQUE OF CAPITALISM [1987]

BLACK EXPRESSIVE CULTURES affirm while they protest. The assimilation of blacks is not a process of acculturation but of cultural syncretism (Bastide 1978). Accordingly, their self definitions and cultural expressions draw on a plurality of black histories and politics. In the context of modern Britain this has produced a diaspora dimension to black life. Here, non-European traditional elements, mediated by the histories of Afro-America and the Caribbean, have contributed to the formation of new and distinct black cultures amidst the decadent peculiarities of the Welsh, Irish, Scots and English. These non-European elements must be noted and their distinctive resonance must be accounted for. Some derive from the immediate history of Empire and colonization of Africa, the Caribbean and the Indian sub-continent from where post-war settlers brought both the methods and the memories of their battles for citizenship, justice and independence. Others create material for the processes of cultural syncretism from extended and still-evolving relationships between the black populations of the over-developed world and their siblings in racial subordination elsewhere.

The effects of these ties and the penetration of black forms into the dominant culture mean that it is impossible to theorize black culture in Britain without developing a new perspective on British culture *as a whole*. This must be able to see behind contemporary manifestations into the cultural struggles which characterized the imperial and colonial period. An intricate web of cultural and political connections binds blacks here to blacks elsewhere. At the same time, they are linked into the social relations of this country. Both dimensions have to be examined and the contradictions and continuities which exist between them must be brought out. Analysis must for example be able to suggest why Afrika Bambaataa and Jah Shaka, leading representatives of hip-hop and reggae culture respectively, find it appropriate to take the names of African chiefs distinguished in anti-colonial struggle, or why young black people in places as different as Hayes and Harlem choose to style

themselves the Zulu Nation. Similarly we must comprehend the cultural and political relationships which have led to Joseph Charles and Rufus Radebe being sentenced to six years imprisonment in South Africa for singing banned songs written by the Birmingham reggae band Steel Pulse – the same band which performed to London's RAR [Rock Against Racism] carnival in 1978.

The social movements which have sprung up in different parts of the world as evidence of African dispersal, imperialism and colonialism have done more than appeal to blacks everywhere in a language which could invite their universal identification (Sheppard *et al.* 1875). They have communicated directly to blacks and their supporters all over the world asking for concrete help and solidarity in the creation of organizational forms adequate to the pursuit of emancipation, justice and citizenship, internationally as well as within national frameworks. The nineteenth-century English abolitionists who purchased the freedom of Frederick Douglass, the distinguished black activist and writer, were responding to an appeal of this type. The eighteenth-century settlement of Sierra Leone by blacks from England and their white associates and the formation of free black communities in Liberia (Geiss 1974) remain an important testimony to the potency of such requests. The back-to-Africa movements in America, the Caribbean and now Europe, Negritude and the birth of the New Negro in the Harlem Renaissance (Perry 1976; Berghahn 1977) during the 1920s all provide further illustrations of a multi-faceted desire to overcome the sclerotic confines of the nation state as a precondition of the liberation of blacks everywhere (Padmore 1956).

Technological developments in the field of communication have, in recent years, encouraged this desire and made it more powerful by fostering a global perspective from the memories of slavery and indenture which are the property of the African diaspora. The soul singers of Afro-America have been able to send 'a letter to their friends' in Africa and elsewhere. The international export of new world black cultures first to whites and then to 'third world' markets in South America and Africa itself (Wallis and Malm 1984), has had effects unforeseen by those for whom selling it is nothing other than a means to greater profit. Those cultures, in the form of cultural commodities – books and records – have carried inside them oppositional ideas, ideologies, theologies and philosophies. As black artists have addressed an international audience and blues, gospel, soul and reggae have been consumed in circumstances far removed from those in which they were originally created, new definitions of 'race' have been born. A new structure of cultural exchange has been built up across the imperial networks which once played host to the triangular trade of sugar, slaves and capital. Instead of three nodal points there are now four – the Caribbean, the US, Europe and Africa. The cultural and political expressions of new world blacks have been transferred not just to Europe and Africa but between various parts of the new world itself. By these means Rastafari culture has been carried to locations as diverse as Poland and Polynesia, and hip-hop from Stockholm to Southall.

Analysis of the political dimensions to the expressive culture of black communities in Britain must reckon with their position within international networks. It should begin where fragmented diaspora histories of racial subjectivity combine in unforeseen ways with the edifice of British society and create a complex relationship which has evolved through various stages linked in different ways to the pattern of capitalist development itself. . . .

Daddy Peckings, the proprietor of Pecking's Studio One record shop in West London, was the first person to sell reggae and its antecedents – blue beat, ska and rocksteady – in this country. He has described the gradual transformation of American musical forms, particularly jazz and jump blues, and their junction with traditional Jamaican musics. This cross-fertilization would eventually lead to modern reggae, the evolution of which can be traced through the development of 'sound systems' (Bradshaw 1981) – large mobile discos – and their surrounding culture in Jamaica and Britain. According to Peckings, the sound systems playing in the dance-halls of Kingston in the late 1940s and early 1950s – Waldron, Tom 'The Great' Sebastian and Nick – offered a mixture of bebop and swing. The big-band sounds of Duke Ellington and Count Basie were reworked by local musicians: Milton McPherson, Redva Cooke, Steve Dick and Jack Brown. Travelling to England in May 1960, Peckings set up a UK outlet for the product of legendary Jamaican producer and entrepreneur Coxsone Dodd, boss of the legendary Studio One label and the man credited not only with the discovery of modern Jamaica's greatest musical talents – The Heptones, Freddie McGregor, Jackie Mittoo, The Wailers – but with the creation of reggae itself. The fledgling sound system culture of urban Jamaica was transplanted into Britain during the 1950s and on his arrival, Peckings began to supply records to Duke Vin of Ladbroke Grove, the first sound system in this country.

The basic description of a sound system as a large mobile hi-fi or disco does little justice to the specificities of the form. They are, of course, many thousands of times more powerful than a domestic record player but are significantly different from the amplified discos through which other styles of music have been circulated and consumed. The sound that they generate has its own characteristics, particularly an emphasis on the reproduction of bass frequencies, its own aesthetics and a unique mode of consumption. The form of sound systems and the patterns of consumption with which they have become associated will be discussed in detail below. The mark of African elements can be identified on different aspects of sound system culture.

Regardless of their forms and characteristic content, it is necessary to comprehend the importance of the sound systems for both the Jamaican reggae music industry which grew directly out of their activities and for the expressive culture of black Britain in which they remain a core institution. Perhaps the most important effect of the sound systems on the contemporary musical culture of black Britain is revealed in the way that it is centred not on live performances by musicians and singers, though these are certainly appreciated, but on records. Public performance of recorded music is primary in both reggae and soul variants of the culture. In both, records become raw material for spontaneous performances of cultural creation in which the DJ and the MC or toaster who introduces each disc or sequence of discs, emerge as the principal agents in dialogic rituals of active and celebratory consumption. It is above all in these performances that black Britain has expressed the improvisation, spontaneity and intimacy which are key characteristics of all new world black musics, providing a living bridge between them and African traditions of music-making which dissolve the distinctions between art and life, artefact and expression which typify the contrasting traditions of Europe (Hoare 1975; Keil 1972; Sithole 1972). As Keil points out, 'outside the west, musical traditions are

almost exclusively performance traditions' (1972: 85). Sound system culture rede-
fines the meaning of the term performance by separating the input of the artists
who originally made the recording from the equally important work of those who
adapt and rework it so that it directly expresses the moment in which it is being
consumed, however remote this may be from the original context of production.
The key to this process is the orality of the artistic forms involved.

The shifting, specialized vocabularies of sound system culture have changed and
developed within contradictions generated by wider political and cultural processes
– changing patterns of 'race' and class formation in the Caribbean, the US and
Britain. The reliance on recorded music takes on even greater significance when it
is appreciated that for much of the post-war period, Britain, unlike the US and the
Caribbean, lacked both a domestic capacity to produce black musics and any inde-
pendent means for their distribution. At this stage, the BBC was not interested in
including African and Caribbean music in their programmes. When 'pop' charts
began to be compiled, black shops and products were structurally excluded from
the operations which generated them. This situation contrasts sharply with the posi-
tion in the US where a well-developed market for 'race records' had grown up
(Gillett 1972), with its own distributors, charts and above all radio stations as a
crucial means to spread and reproduce the culture.

Black Britain prized records as the primary resource for its emergent culture
and the discs were overwhelmingly imported or licensed from abroad. The depen-
dency of the British music scene on musics produced elsewhere has progressed
through several phases. But even as self-consciously British black forms have been
constructed, the basic fact of dependency has remained constant. The cultural
syncretism that has taken place across the national boundaries that divide the African
diaspora has involved relations of unequal exchange in which Britain, for demo-
graphic and historical reasons, has until recently had a strictly subordinate place.
The importing of music, often in small quantities, encouraged the underground
aspects of a scene in which outlets into the dominant culture were already rare.
Competition between sound system operators had been an early feature of the
Jamaican dance-halls, and was entrenched over here as sound systems jostled for
the most up-to-date and exclusive tunes imported from the US as well as the
Caribbean. In a major survey of London's black music scene of the early 1970s,
Carl Gayle explored the appeal of imported 'pre-release' records on the dance-hall
circuit:

> The youngsters today spend more than they can afford on records, but
> they want the best and the rarest. . . . 'We import our records three times
> a week from Jamaica' said a young guy called Michael. . . . 'Pre-release
> music to me and many people like Sound System men and their follow-
> ers, is like underground music. As soon as it's released it's commercial
> music. So you find to the youth of today, the ghetto youth like myself,
> pre-release music is like medicine. They'll go anywhere to hear it'.
>
> [Gayle 1974]

The identification of imported music as free from the commercialization which char-
acterized the British music industry is an important expression of the politics which

infused the roots music scene. The supposedly non-commercial status of imported records added directly to their appeal and demonstrated the difference between black culture and the pop-world against which it was defined.

The rivalry between 'sounds' over records was paralleled on the dance-floors by the intense competition between their followers. The ritual expressions of both were dance competitions and the occasional fight. In the early 1970s reggae and soul scenes, the formal competitions centred on 'shuffling' and the rivalry between different sound systems was particularly intense where operators from north and south of the river clashed, each operator and toaster striving to match the other tune for tune, rhythm for rhythm, until the system with the best tunes and the weightiest sound emerged as the victor. Carl Gayle identified the level of violence in these encounters as one factor in the decomposition of the scene into sharply differentiated soul and reggae sub-scenes during the 1970s:

> The rivalry which developed between North and South . . . was the foundation for much of the violence of the Ram Jam and other clubs and was perpetrated by the supporters of the Sound Systems – Coxon and Duke Reid in the South and Count Shelly in the North especially. This rivalry, which often erupted into violence was responsible for the division of the black music scene as a whole. . . . The clubs lost their respectability. Consequently many black youngsters dropped out of the once peaceful reggae-oriented sub-culture, opting for the more tranquil soul scene. Soul had always been popular with West Indians anyway and a lot of people just got scared of the hooliganism.
>
> [Gayle 1974]

Gayle tentatively suggests that this violence was something which made reggae attractive to white youth and that it was a significant element in the forging of links between reggae and the skinheads around common conceptions of masculinity and machismo.

At its height, the late 1960s and early 1970s club scene involved alcohol-free daytime sessions completely dominated by dance at some of the best venues. For example, the Sunday afternoon 2–6 p.m. sessions at the Ram Jam in Brixton provided an antecedent for the equally drinkless Saturday lunch time events organized by DJ Tim Westwood, which were instrumental in the spread of hip-hop in London during the 1980s. Like the hip-hop mixers of the later era the sound system DJs often removed the labels from the records which they used. This gesture combined the obvious desire to keep the information contained on the labels secret, with a comment on the distance which these sub-cultures had travelled from the commercialized, overground equivalents. The removal of labels subverted the emphasis on acquisition and individual ownership which the makers of black music cultures identified as an unacceptable feature of pop culture. This simple act suggested alternative collective modes of consumption in which the information essential to purchase was separated from the pleasure which the music created. The record could be enjoyed without knowing who it was by or where it was in a chart. Its origins were rendered secondary to the use made of it in the creative rituals of the dance-hall.

Deprived of access to the official charts, the black record sellers began to produce their own alternative indices of roots popularity in specialist publications devoted to black music and in the community's own news and political weeklies. The specialist monthly *Black Music* was launched in December 1973, at exactly the same time as minority programming of black musics was beginning to be introduced into the newly expanded local radio network. The size and distribution of Britain's black populations imposed severe limits on the amount of money which could be made from catering to their leisure needs. The communities remained diverse, small and scattered. These characteristics were important factors in the expansion of black leisure institutions and their partial adaptation to the demands of white Britons. The involvement of whites, particularly young people, in the consumption of black cultures was noted by commentators in the early 1960s. It has been discussed by other authors and by myself elsewhere (Patterson 1966; Hebdige 1979; Gilroy and Lawrence 1982). The centrality of distinctively black forms to white youth cultures was observed by Hamblett and Deverson in 1964:

> The Blue Beat is here to stay. . . . Around the dancehalls and discotheques the Blue Beat has been added to the youngsters' already overstepping dance crazes. . . . Many mods that I have spoken to say that the Mersey Sound is out and this new sound is the big thing at the moment. As one youngster put it to me 'The Beatles have been well and truly squashed and we don't dig their sound anymore'.

This mod's use of black American slang, 'dig', and the Beatles' early reliance on cover versions of material from rhythm and blues artists like Barrett Strong and Larry Williams are probably as significant as the blue beat itself in the history of how popular culture has formed spaces in which the politics of 'race' could be lived out and transcended in the name of youth.

The development of Jamaican popular music in the encounter between folk forms and American R and B picked up from radio stations transmitting in the southern states is well known (Clarke 1980; Kimberley 1982). At each stage of its progress through blue beat, ska, rocksteady and reggae it is possible to indicate shifting patterns in the involvement of young whites. For example, a white reggae band 'Inner Mind' was formed in London during 1967 and was considered good enough to back such vintage Jamaican performers as Laurel Aitken, Alton Ellis and Owen Grey. The band played at all the leading black venues of the period – Mr B's, the Q and Colombo's in London, the Santa Rosa in Birmingham and Wolverhampton's Club '67. . . . The mass marketing of Caribbean music as a pop form can be traced from Millie Small's 'My Boy Lollipop' through the reggae festival at Wembley Stadium in 1969 and into the selling of Bob Marley as a 'rebel superstar'. Simon Jones (1986) has pointed out that there were seventeen top twenty hits based on Jamaican music during the period 1969–72. The attempts of white companies to sell the music to whites also relied on the growth of minority programming within the newly established local radio network. The local stations which proliferated between 1970 and 1972 were concentrated in urban areas and each of them featured two or three hours of black music per week. This development was more significant in the history of Caribbean forms, because the pirate radio stations

and the American Forces station in Europe already carried a certain amount of soul music to British fans. Radio Luxembourg, a leading pirate, broadcast Dave Christian's 'Soul Bag' early (1.30 a.m.) on Monday mornings. The new local stations made black music available to anyone who was interested enough to tune in to the unpopular slots – usually Sunday lunchtime – in which the minority shows were programmed. In the south-east, Steve Barnard's 'Reggae Time' on Radio London became particularly influential. Having experimented with several presenters for their reggae programme, Capital Radio launched David Rodigan's 'Roots Rockers' in October 1979. This show become the most important in reggae broadcasting, extending its running time from one and a half to three hours. The power of the show and the extent to which the reggae industry depended on it were revealed in 1985 when Rodigan announced that he had been threatened and intimidated by a small minority of record producers who sought to use the show to push their own product and ensure its commercial success regardless of artistic considerations. Rodigan did not name the producers responsible for his harassment, but told his listeners over the air:

> I've reached the point of no return with these hustlers. I'm tired of the threats and I'm standing up to them from now on. I'm going to enter- tain the public, not the reggae producers. I'm not going to bow down any more. All they can do is kill me now – that's all they can do.
>
> [Rodigan 1985]

The gradual involvement of large corporations with a broad base in the leisure indus- tries in the selling of reggae stimulated important changes reflecting a conscious attempt to separate the product from its producers and from its roots in black life. Whatever the effect of the reggae film *The Harder They Come* in the Caribbean (Brathwaite 1984), in Britain, it marked the beginning of a new strategy for white consumption. The film was presented as little more than visual support for the sound-track recording made available by Island Records, an Anglo-Jamaican company. Cinemas showing the film became artificially insulated spaces in which images of black life, in this case as backward, violent, sexist and fratricidal, could be consumed without having to face the difficulties associated with sharing leisure space with real live black people. Island Records, the company who pioneered this ploy, elaborated it further in subsequent films of reggae artists in live performance and in the 'adventure fantasy', *Countryman*, in 1982. This last film, a tale of Obeah and adventure, was based on a simple inversion of the Robinson Crusoe myth. 'Friday', recast in the form of a Rasta hermit-fisherman endowed with magical powers that originated in his total harmony with the natural world, saves and protects two young white Americans who fall into his Eden as the result of a plane crash. They are unwittingly involved in the drug business but with his help are reunited with their families and sent back to the US once the villains, the military wing of Michel Manley's socialist government, have been put in their place. This plot is less significant than the fact that the film was billed as 'A tribute to Bob Marley'. This time, the soundtrack recording featured his songs.

Island Records was also at the forefront of moves to sign black performers and, having adjusted their music and image to the expectations of white rock audiences,

sell them as pop stars. The example of Bob Marley, an Island artist from 1972 until his death in 1981, provides the most acute illustration of a marketing process which was repeated by the company on a smaller, less successful scale with other lesser known (in rock terms) artists like the Heptones and Burning Spear. It was a strategy which was less productive for other rival British companies which lacked Island's roots in the Caribbean. Foremost among these was Virgin, who signed many leading Jamaican performers – the Gladiators, U Roy and the Mighty Diamonds – in the early 1970s. Marley's rise was also significant in that it facilitated the popularization of Rastafari ideology in Britain and throughout the world. The years between 1972 and 1981 saw him rise to outernational prominence and take reggae music forever into the lexicon of pop. There are good reasons to support the view that his foray into pop stardom was a calculated development in which he was intimately involved, having realized that the solidification of communicative networks across the African diaspora was a worthwhile prize. The minor adjustments in presentation and form that rendered his reggae assimilable across the cultural borders of the overdeveloped countries were thus a small price to pay. His incorporation of bluesy guitar playing and 'disco' rhythms can be interpreted not as obvious concessions to the demands of a white rock audience (Wallis and Malm 1984), but as attempts to utilize the very elements most likely to appeal to the black audiences of North America.

Marley died at the very moment when he had steered reggae to the brink of an organic and overdue encounter with rhythm and blues. His work found considerable support in the new pop markets of Latin America and Africa, where he had performed at the independence ceremonies for Zimbabwe, symbolizing the recovery of Africa for the black peoples of the new world and the recovery of the new world diaspora for Africa. Whatever the ambiguities in Marley's music and mode of presentation, he provided a heroic personality around which the international mass-marketing of reggae could pivot. His 'Exodus' album remained on the British pop chart for fifty-six consecutive weeks in the period 1977–8. Marley acknowledged his newfound white listeners with the release of 'Punky Reggae Party' also in 1977. It signified not so much the confluence of two oppositional impulses – Rasta and punk – as the durability of pop and its capacity to absorb diverse and contradictory elements. The Caribbean was becoming an increasingly important subcultural resource once white British youth began to break free of their own dependency on American images and meanings (Hebdige 1983b). By consolidating reggae's position on the charts outside novelty categories and becoming a star, Marley created a new space in pop. In the period leading up to his death, it was a space filled primarily by the 'two-tone' cult. In this movement, earlier Caribbean forms, particularly ska, which had been exposed by the serious reggae fans' search for musical authenticity behind Marley's obvious compromises, were captured and rearticulated into distinctively British styles and concerns. This fusion took several contrasting paths. The assertively 'white' reggae of London bands like Madness and Bad Manners attracted the support of young racists, whose patriotic nativism had been reborn in the revival of the skinhead style. It contrasted sharply with the work of racially mixed groups from the Midlands. Where Madness simply hijacked ska and declared it white, the Beat, the Specials and other similar outfits sought to display the contradictory politics of 'race' openly in their work. Their best efforts

acknowledged the destructive power of racism and simultaneously invited their audience to share in its overcoming, a possibility that was made concrete in the co-operation of blacks and whites in producing the music.

If Marley's excursions into pop had seeded the ground for this two-tone harvest, this era suggests that the lasting significance of his rise to prominence lies not at the flamboyant extremities of youth subculture where punks had reworked the themes and preoccupations of Rastafari around their dissent from and critique of Britishness, but in the youth-cultural mainstream. Here, the posters of Bob, locks flying, which had been inserted into his crossover product by Island, became icons in the bedroom shrines of thousands of young whites. In his egalitarianism, Ethiopianism and anti-imperialism, his critique of law and of the types of work which were on offer, these young people found meanings with which to make sense of their lives in post-imperial Britain. The two-tone bands appreciated this and isolated the elements in Marley's appeal that were most appropriate to the experiences of young, urban Britons on the threshold of the 1980s. They pushed the inner logic of his project to its conclusion by fusing pop forms rooted in the Caribbean with a populist politics. Marley's populism had been focused by the imperatives of black liberation and overdetermined by the language of Rastafarian eschatology. Theirs was centred instead on pointing to the possibility that black and white young people might discover common or parallel meanings in their blighted, post-industrial predicament. The experience of living side by side in a 'ghost town' had begun to raise this question. The Specials' song, which topped the chart as the rioting of 1981 was at its peak, asked, 'Why must the youth fight against themselves?' and cleverly entangled its pleas against both racism and youth-cultural sectarianism. The two-tone operation depended on being seen to transcend the various prescriptive definitions of 'race' which faced each other across the hinterland of youth culture. With Marley's death equilibrium was lost. One pole of the cultural field in which two-tone had formed ceased functioning. Marley's position was usurped eagerly not by the next generation of Jamaican and British artists who had been groomed by their record companies to succeed him, but by a new wave of post-punk white reggae musicians. The best known of these inverted the preconceptions of Rasta by calling themselves The Police and armed with 'Aryan' good looks and dedication to 'Reggatta de Blanc' served, within pop culture at least, to detach reggae from its historic association with the Africans of the Caribbean and their British descendants.

Will Straw

COMMUNITIES AND SCENES IN POPULAR MUSIC [1991]

I N A S U G G E S T I V E P A P E R , Barry Shanks has pointed to the usefulness of a notion of 'scene' in accounting for the relationship between different musical practices unfolding within a given geographical space (Shanks 1988). As a point of departure, one may posit a musical scene as distinct, in significant ways, from older notions of a musical community. The latter presumes a population group whose composition is relatively stable – according to a wide range of sociological variables – and whose involvement in music takes the form of an ongoing exploration of one or more musical idioms said to be rooted within a geographically specific historical heritage. A musical scene, in contrast, is that cultural space in which a range of musical practices coexist, interacting with each other within a variety of processes of differentiation, and according to widely varying trajectories of change and cross-fertilization. The sense of purpose articulated within a musical community normally depends on an affective link between two terms: contemporary musical practices, on the one hand, and the musical heritage which is seen to render this contemporary activity appropriate to a given context, on the other. Within a musical scene, that same sense of purpose is articulated within those forms of communication through which the building of musical alliances and the drawing of musical boundaries take place. The manner in which musical practices within a scene tie themselves to processes of historical change occurring within a larger international music culture will also be a significant basis of the way in which such forms are positioned within that scene at the local level.

At one level, this distinction simply concretizes two countervailing pressures within spaces of musical activity: one towards the stabilization of local historical continuities, and another which works to disrupt such continuities, to cosmopolitanize and relativize them. Clearly, the point is not that of designating particular cultural spaces as one or the other, but of examining the ways in which particular musical practices 'work' to produce a sense of community within the conditions of

metropolitan music scenes. This move – recasting powerful unities as ideological effects – is obviously a familiar and rather conventional one within cultural theory, and my intention is not that of exposing the relative status of notions of musical community. . . . Nevertheless, as subsequent sections of this chapter will argue, the cosmopolitan character of certain kinds of musical activity – their attentiveness to change occurring elsewhere – may endow them with a unity of purpose and sense of participating in 'affective alliances' (Grossberg 1984) just as powerful as those normally observed within practices which appear to be more organically grounded in local circumstances.

The ongoing debate within popular music studies over the relative primacy of production and consumption has often precluded the analysis of what might be called the 'logics' of particular musical terrains. I hope, in the sections which follow, to leave entangled three relevant prior uses of the term 'logic'. The first, drawn from Pierre Bourdieu's (1984) notion of the 'field' of cultural practices, is meant to suggest those procedures through which principles of validation and means of accommodating change operate within particular cultural spaces so as to perpetuate their boundaries. It may be argued that the complex and contradictory quality of cultural texts – to which cultural studies research has been so attentive – has prevented neither their circulation within societies nor their alignment with particular population groups and cultural spaces from following regularized and relatively stable patterns. If this predictability is the result of semantic or ideological contradictions within these texts usually being resolved in favour of one set of meanings over others, then an analysis of these more general patterns, rather than of the conflicts which unfailingly produce them, may have a provisional usefulness at least.

The specificity of these 'fields', nevertheless, is shaped in part by the 'regions' they occupy, as markets and contexts of production, relative to a given set of cultural institutions. Bernard Miège's (1986: 94) elaboration of a 'social logic' of cultural commodities, while concerned principally with processes of production, may be extended to an examination of the ways in which cultural commodities circulate within their appropriate markets and cultural terrains. If there is a specificity to cultural commodities, it has much to do with the ways in which their circulation through the social world is organized as a lifecycle, in the course of which both the degree and basis of their appeal is likely to change. Different cultural spaces are marked by the sorts of temporalities to be found within them – by the prominence of activities of canonization, or by the values accruing to novelty and currency, longevity and 'timelessness'. In this respect, the 'logic' of a particular musical culture is a function of the way in which value is constructed within them relative to the passing of time. Similarly, cultural commodities may themselves pass through a number of distinct markets and populations in the course of their lifecycles. Throughout this passage, the markers of their distinctiveness and the bases of their value may undergo significant shifts.

Finally, and in what is admittedly an act of trivialization and infidelity, I would take from the writings of Michel de Certeau (1990) the sense of a logic of circumstantial moves. The preoccupation of music sociologists with the expressive substance of musical forms has often obscured the extent to which particular instances of change might best be explained in terms of an as-yet elusive microsociology of backlashes or of failed and successful attempts at redirection within a

given cultural terrain. This is particularly true in the case of contemporary dance-music culture, where, one might argue, there is little rationality to certain 'moves' (such as the 'Gregorian House' moment of early 1991) beyond the retrospective sense of appropriateness produced by their success. The risk of an analysis pursued along these lines is that it will result in little more than a formalism of cyclical change. One may nevertheless see the logic of these moves as grounded in the variable interaction between two social processes: (a) the struggles for prestige and status engaged in by professionals and others (such as disc jockeys) serving as 'intellectuals' within a given musical terrain; and (b) the ongoing transformation of social and cultural relations – and of alliances between particular musical communities – occurring within the context of the contemporary Western city. An attentiveness to the interaction between these two processes is necessary if one is to avoid either of two traps: on the one hand, privileging the processes within popular musical culture which most resemble those of an 'art world' and overstating the directive or transformative force of particular agents within them; on the other, reading each instance of musical change or synthesis as unproblematic evidence of a reordering of social relations.

Localizing the cosmopolitan: the culture of alternative rock

By the early or mid-1980s, a terrain of musical activity commonly described as 'alternative' was a feature of virtually all US and Canadian urban centres. In one version of its history, the space of alternative rock is seen to have resulted from the perpetuation of punk music within US and Canadian youth culture, a phenomenon most evident in the relatively durable hardcore and skinhead cultures of Los Angeles and elsewhere. As local punk scenes stabilized, they developed the infrastructures (record labels, performance venues, lines of communication, etc.) within which a variety of other musical activities unfolded. These practices, most often involving the eclectic revival and transformation of older musical forms, collectively fell under the sign of the term 'alternative'. As the centrality of punk within local musical cultures declined, the unity of alternative rock no longer resided in the stylistic qualities of the music embraced within it. Rather, as I shall argue, that unity has come to be grounded more fundamentally in the way in which such spaces of musical activity have come to establish a distinctive relationship to historical time and geographical location.

Arguably, the most notable feature of alternative rock culture over the last decade or so has been the absence within it of mechanisms through which particular musical practices come to be designated as obsolete. By the middle of the 1980s, the pluralism of alternative rock culture was such that the emergence of new stylistic forms within it would rarely be accompanied by the claim that such forms represented a trajectory of movement for that culture as a whole. On the contrary, those processes by which musical forms become central poles of attraction and are subsequently rendered obsolete had largely disappeared. . . .

Within this terrain, different musical practices came to map out a range of increasingly specific stylistic combinations within an ongoing process of differentiation and complexification. Change within the culture of alternative rock, to the

extent that it was observable at all, more and more took the form of new relationships between generic styles constitutive of the canon which had sedimented within alternative rock culture since the late 1970s. It was no longer the case, as it had been in the period immediately following punk, that change would involve the regular displacement of styles as the historical resonance of each emerged and faded. The stabilization of this distinct temporality has had its most profound effects on the relationship between alternative culture and African-American musical forms, with the latter standing implicitly for a relationship to technological innovation and stylistic change against which the former has come to define itself.

To understand this condition, we may examine the role still played within the terrain of alternative rock by musical cross-fertilization and hybridization. Here, the exercise of combining styles or genres will rarely produce the sense of a synthesis whose constituent elements are displaced, or through which musical communities are brought into new alliances, as has been the case at particular transitional points within rock history. Rather, one sees the emergence of a wide variety of stylistic or generic exercises, in which no style begins as privileged or as more organically expressive of a cultural point of departure. One effect of this has been to install the individual career, rather than the culture of alternative rock as a whole, as the principal context within which change is meaningful. Moves within this culture – from punk to country, psychedelia to boogie blues, and so on – represent idiosyncratic passages across the space of alternative rock rather than attempts at collective redirection.

This characteristic of the terrain of alternative rock has both shaped and responded to the commodity forms which circulate within it. In its reliance on the institutional infrastructures of campus radio stations, independent record stores, and live performance tours, alternative rock has been allied with institutions engaged in the valorization of their exhaustivity and diversity, and in maintaining the accessibility of a wide range of musical practices. The slowness of turnover which this produces is linked to the growth in importance of performer careers, in as much as the value of a particular recording is not dependent upon its capacity to register collective change within the larger cultural space in which it circulates. In this respect, the much-discussed 'co-optation' of punk and post-punk musics by major recording firms represents, in part, a paradoxical convergence of operational logics. Of the various forms of appropriation of these musics attempted by major firms, the most successful has been the ongoing monitoring of alternative rock culture (often through the setting-up or affiliation of specialty labels) so as to discover careers susceptible to further development.

One effect of these processes has been an intermittently observed sense of crisis within the culture of alternative rock music. As suggested, the capacity of this culture to cater to the most specific of taste formations is accompanied by the sense that no particular stylistic exercise may be held up as emblematic of a collective, forward movement on the part of this terrain as a whole. . . . The organization of alternative rock culture in these terms has had two significant – and generally overlooked – consequences which any political diagnosis of that culture must confront. These extend beyond the more general (and not necessarily negative) waning of collective purpose and criteria of judgement common within cultural spaces marked by high levels of pluralism and eclecticism.

The first of these is the enshrining of specific forms of connoisseurship as central to an involvement in alternative musical culture. Here, an alternative reading of the stabilization of post-punk culture within the US and Canada suggests itself. Despite the difficulty of reconstructing this historical context, I would point to the important interaction, in the mid and late 1970s, between the terrain of punk and 'New Wave' and pre-existing connoisseurist tendencies within the culture of rock music. To a considerable extent, the institutions of New Wave within the United States and Canada came to overlap with those constitutive of a network of enterprises catering for an interest in the history of rock-based forms of recorded music – an infra-structure which had existed at least since the early 1970s. These institutions were active in the historical documentation and revival of a variety of older rock-based musical movements (such as 'surf' music or the 'garage-band' movement of the mid-1960s). From the mid-1970s through to the present, a variety of small enter-prises have involved themselves simultaneously in projects of historical revival (reissuing recordings from the 1960s and publishing fan magazines devoted to older musical forms) and in the production, distribution and sale of recordings associated with punk and those tendencies which succeeded it.

This overlapping of alternative rock culture and the cultural space of record collectors and historical archivism should scarcely be surprising, given the predictable settling of both within the sociological limits of a largely white bohemia. Part of the implicit work of alternative rock culture over the past decade has been the construction of a relatively stable canon of earlier musical forms – 1960s trash psychedelia, early 1970s metal, the dissident rock tradition of the Velvet Underground and others – which serves as a collective reference point. The substance of this canon is less significant, at this point in my account, than is the fact that the cultivation of connoisseurship in rock culture – tracking down old albums, learning genealogical links between bands, and so on – has traditionally been one rite of passage through which the masculinism of rock music culture has been perpetuated. . . .

A second consequence of the logic of development of alternative-music culture within Canada and the US is the paradoxical status of localism within it. In their reliance on small-scale infrastructures of production and dissemination, these spaces are rooted deeply within local circumstances, a feature commonly invoked in claims as to their political significance. Nevertheless, the degree to which localism remains an important component of musical meaning within the culture of alternative rock requires close examination. The aesthetic values which dominate local alternative terrains are for the most part those of a musical cosmopolitanism wherein the points of musical reference are likely to remain stable from one community to another. The development of alternative rock culture may be said to follow a logic in which a particular pluralism of musical languages repeats itself from one community to another. Each local space has evolved, to varying degrees, the range of musical vernaculars emergent within others, and the global culture of alternative rock music is one which localism has been reproduced, in relatively uniform ways, on a conti-nental and international level.

One consequence of this condition is that the relationship of different local or regional scenes to each other is no longer one in which specific communities emerge to enact a forward movement to which others are drawn. What has declined is the

sense, important at different moments within rock music's history, that a regional or local style offers the direction for change deemed appropriate to a given historical moment and provides a particular trajectory of progress which others will follow. Rather, the relationship of different local spaces of activity to each other takes the form of circuits, overlaid upon each other, through which particular styles of alternative music circulate in the form of recordings or live performances. The ability of groups and records to circulate from one local scene to another, in a manner that requires little in the way of adaptation to local circumstances, is an index of the way in which a particularly stable set of musical languages and relationships between them has been reproduced within a variety of local circumstances.

Drawing lines, making centres: the culture of dance music

. . . Dance clubs are positioned relative to others, not only along the predictable lines of musical style, age, sexual orientation and ethnicity, but in terms of a variety of less frequently acknowledged criteria: the explicitness of sexual interaction within them, the manner in which their DJ handles the tension between playing requests and retaining prestige within his peer community, the level of tolerance of deviations from expected behavioural norms and so on. Among a club's clientèle, further distinctions take shape around the degree to which people dance within disciplined parameters (as opposed to cutting loose), or such minor clues as whether or not one remains on or leaves the dance floor when a new and as-yet unpopular song is played. Most importantly, the composition of audiences at dance clubs is likely to reflect and actualize a particular state of relations between various populations and social groups, as these coalesce around specific coalitions of musical style.

The significance invested in these differences obviously works against one familiar reading of the experience of dance: as a transcendent experience of the body in motion. The difficulty of writing about dance music is very much rooted in what Jane K. Cowan, speaking of a very different context, has called 'the paradoxically double sense of engrossment and reflexivity that characterize the experience of the dancer' (Cowan 1990: xi). Discussions of dance are often able to privilege its engrossing qualities through an implicit sliding from the subjective and corporal sense of release to a notion of collective transcendence, such that the personal and the social are united under [such signs as 'youth' or 'women' or 'gay men']. Clearly, however, few cultural practices are marked so strongly by the intervention of differences which fracture that unity and render unavoidable the reflexivity of which Cowan writes. Bringing together the activities of dance and musical consumption, the dance club articulates the sense of social identity as embodied to the conspicuous and differential display of taste. As such, it serves to render explicit the distribution of knowledges and forms of cultural capital across the vectors of gender, race and class.

It is at this point that we may begin to outline certain divergences between the cultures of alternative rock and dance music. The most significant of these, arguably, has to do with the manner in which each has responded to the hierarchies and tensions produced by the aforementioned differences. The ongoing development of dance music culture is shaped by the relationship between certain relatively stable

social spaces (whether these be geographical regions or racial and ethnic communities) and the temporal processes produced and observable within that culture's infrastructures (record labels, dance music magazines, disc-jockey playlists, and so on). . . . This relationship is not one of direct mirroring. The lines of fracture which run through the audiences of dance music are normally turned into the bases of that music's own ongoing development, but in this process they are often transformed. Typically, they are restated in the language of aesthetic choice and invoked as the pretexts for moves of redirection. In the culture of alternative rock, by contrast, the most consistent development has been the drawing of lines around that culture as a whole, such that certain forms (classically soulful voices, for example) are permanently banished, or, like some uses of electronics, tolerated as part of a circumscribed pluralism. (In neither instance do they serve as the basis of a tension inviting a collective response.)

These differences may be expressed in more schematic terms. The terrain of alternative rock is one in which a variety of different temporalities have come to coexist within a bounded cultural space. There is often a distinctive density of historical time within the performance styles of alternative groups: most noticeably, an inflection of older, residual styles with a contemporary irony which itself evokes a bohemian heritage in which that combination has its antecedents. Similarly, as moves within alternative rock produce more and more detailed syntheses of style and form, they fill in the range of options between canonical styles, the latter serving . . . as . . . markers of privileged antecedents from which eclectic stylistic exercises develop outwards. This process as a whole might be described as one in which temporal movement is transformed into cartographic density.

The culture of dance music, in contrast, is one in which spatial diversity is perpetually reworked as temporal sequence. At one level, dance music culture is highly polycentric, in that it is characterized by the simultaneous existence of large numbers of local or regional styles – Detroit 'techno' music, Miami 'bass' styles, Los Angeles 'swingbeat', etc. Other regional centres – like New York or London – will be significant, less as places [for the] emergence of styles one could call indigenous, than because they occupy positions of centrality as sites for the reworking and transformation of styles originating elsewhere. Dance music culture is characterized by two sorts of directionality: one which draws local musical activity into the production styles of one or more dominant, indigenous producers or sounds; and another which articulates these styles elsewhere, into centres and processes of change monitored closely by the international dance music community as a whole. One effect of these sorts of movement is that coexisting regional and local styles within dance music are almost always at different stages within their cycles of rising and declining influence. A comfortable, stable international diversity may rarely be observed.

Further evidence of these differences may be found in the sorts of publications which circulate within each terrain. *Maximum Rock and Roll* or *Rock Around The World: The Alternative Live Music Guide* manifest the preoccupation of alternative culture with cataloguing diversity, offering dozens of 'scene' reports or touring schedules in each issue. Those publications which serve the dance music community, in contrast, are striking for their concern with registering movement, ranking records and judging styles in terms of their place within ascendant or downward trajectories of popularity. This distinction is hardly surprising – given, on the one hand, the self-definition

of alternative rock as the locus of a rock classicism, and, on the other, the observable overlap of dance-music culture with both the turbulent space of Top 40 radio and a more subcultural terrain resembling (and interacting with) the world of vestimentary fashion. More interesting, for my purposes, are the ways in which both cultures have responded to the musical diversity found in each, endowing that diversity with distinctive values and relationships to change.

The intermittent sense of crisis within the culture of North American alternative rock . . . is arguably rooted in the loss of a teleology of historical purpose of the sort which has often organized accounts of rock music's history. In its place, we find enshrined a pluralism evoked as a sign of health and vitality. Within the culture of dance music, [by] contrast, a condition of pluralism is commonly cited as the sign of imminent troubles or divisions, rather than of that culture's richness or stability. One finds, within the dance community, an investment in historical movement based almost exclusively on the ability of that movement to suggest collective purpose. Processes of historical change within dance music, as suggested, respond to shifting relationships between different (primarily urban) communities, but there is little sense that the convergences or alliances produced are permanent or constitutive steps in a movement towards a final dissolution of boundaries. Well-known moments held to be emblematic of a new unity of black and white youth cultures, like the punk-reggae moment of the late 1970s, either produce their own backlashes or appear in retrospect as temporary acts of rejuvenation undertaken by one of the communities involved.

The discursive labour of dance music's infrastructures operates implicitly to prevent the fractures and lines of difference which run through the culture of metropolitan dance music from either fragmenting that culture into autonomous, parallel traditions, or producing a final unity which will permanently paper over those lines. Like the worlds of fashion and painting, the dance music community accomplishes this by restating ongoing disagreements over cultural purpose and value as calculations about the imminent decay or emergent appropriateness of specific generic styles. One revealing example, within the recent history of dance music, is the ongoing controversy over the comparative appeal of synthesized sounds and 'real' human voices. The highly electronic acid house of 1987 and 1988 gave way, in influential corners of dance music culture, to the 'garage' house of 1988–9, a form which valorized classic, soulful and identifiable voices. In 1990, and in the context of an increased rapidity of cyclical change, synthesized and sample-dominated Italian house emerged as central, accompanied by defences which underscored its knowing cleverness. Italian house was then displaced by the slowed-down, more obviously 'classical' Soul II Soul sound, which briefly, but spectacularly, attained international success. Predictably, a backlash followed, and Italian house was newly valorized at the beginning of 1991 – the 'tackiness' with which it had been marked during its brief banishment now regarded as a creative eclecticism. These shifts, while obviously trivial and localized, nevertheless revolve at a fundamental level around the appropriate centrality to be accorded the traditions of African-American vocal music relative to those of a primarily white, European studio wizardry. Most often, however, they are given the form of oppositions of taste susceptible to regular revision: high- versus low-end sonic ranges, 'live' versus creatively manufactured sounds, the purist versus the novel, and so on. . . .

The condition of dance music described here – in particular, its rates and logics of change – has been intensified in recent years by the rise to prominence of house music. House music emerged (from Chicago) as a set of distinct styles in the mid-1980s, but its larger importance comes from its recentring of the historical movement of dance music culture as a whole. As was the case prior to the rise of house, dance music within the Western world has continued to be marked by opposed tendencies towards unity/coherence and diversity/differentiation, but the logics through which these processes unfold have become much more integrated. On the one hand, house music has drawn most dance-based musical forms into various sorts of accommodation to it. Currents within rap were compelled to adapt, most notably through an increased tempo, giving rise to forms known as hip-house and swingbeat. The Hi-NRG music associated during the previous decade with gay discos was revitalized as high-house, 'high' signalling a greater number of beats-per-minute than was the average within house music (Ferguson 1991). Older or more eclectic forms, like industrial dance music and versions of jazz, have often been drawn into a sequence of transformations within house music, as influences defining those transformations. Those dance forms which did not lend themselves to this integration, for a variety of reasons – Go-Go music from Washington, or the Minneapolis sound associated with Prince and his collaborators – have been marked with relative obsolescence, at least as far as international success is concerned.

At the same time, however, the durability and expansiveness of appeal of house music are such that these variations have come to be positioned laterally within a division of tastes running across dance music culture. The techno-pop and Hi-NRG associated with producers like Stock-Aitken-Waterman would, by the late 1980s, come to be positioned at one point within a continuum running through all forms of house music and overlapping with the terrain of international Top 40 pop. Much of Latin-based, English-language pop within the United States is now part of a complex of forms known as 'freestyle', in which one finds articulated elements of rap, house, and mainstream pop. More telling examples are those involving forms of dance music perpetuated within the space of a rock-based avant-garde. So-called New Beat music, associated principally with record labels based in Belgium, pulled elements of industrial dance rock into the overall culture of dance music, but simultaneously compelled industrial dance music to define itself in part through the vigilant maintenance of narrow boundaries between its own perceived transgressiveness and the lure of accessible, popular forms of house. One can see here the dilemma confronting tendencies within a post-punk avant-garde whose terrain has long bordered that of dance music. On the one hand, their project has derived much of its credibility from the consistent and avowedly purist exploration of a limited set of stylistic and formal figures overlapping those found within currents of alternative rock (stark instrumentation, the use of 'found' voices from television, etc.). On the other hand, the culture of British dance music has so successfully redefined the terms of credibility as accruing from participation in an unfolding sequence of musical styles that their resistance to this history risks casting them as irrelevant.

My emphasis . . . on the logics of change typical of different musical terrains is not intended to suggest that the value of such terrains is a function of their collective historical purpose. What these logics invite, however, is a reading of the politics of popular music that locates the crucial site of these politics neither in the

transgressive or oppositional quality of musical practices and their consumption, nor uniformly within the modes of operation of the international music industries. The important processes, I would argue, are those through which particular social differences (most notably those of gender and race) are articulated within the building of audiences around particular coalitions of musical form. These processes are not inevitably positive or disruptive of existing social divisions, nor are they shaped to any significant extent by solitary, wilful acts of realignment. . . . Typically, the character of particular audiences is determined by the interlocking operation of the various institutions and sites within which musics are disseminated: the schoolyard, the urban dance club, the radio format. These sites, themselves shaped by their place within the contemporary metropolis and aligned with populations along the lines of class and taste, provide the conditions of possibility of alliances between musical styles and affective links between dispersed geographical places.

There are any number of examples of this in the recent history of Canadian, US and Western European popular music: the coalescing of the original audience for disco around Hispanic, black and gay communities in the mid-1970s, or the unexpected alignment of country music and its traditional audiences with urban-based, adult-oriented radio stations in the early 1980s. The particular condition of alternative rock music culture, which I have described at length, has been shaped in part by the way in which coalitions of black teenagers, young girls listening to Top 40 radio, and urban club-goers have coalesced around a dance music mainstream and its margins and thus heightened the insularity of white, bohemian musical culture. What interests me, as someone who studies musical institutions, is the way in which these alliances are produced, in part, through the overlapping logics of development of different forms. One reason why coalitions of musical taste which run from British dance culture through black communities in Toronto and significant portions of the young female market are possible is that these constituencies are all ones which value the redirective and the novel over the stable and canonical, or international circuits of influence over the mining of a locally stable heritage. The substance of these values is less important than are the alliances produced by their circulation within musical culture. One need neither embrace the creation of such alliances as a force for social harmony nor condemn them as politically distracting to recognize their primacy in the ongoing politics of popular musical culture.

James Farrer

DISCO 'SUPER-CULTURE'
Consuming foreign sex in the Chinese disco [1999]

Cosmopolitan dance culture and cosmopolitan sexual culture

Sub-culture or super-culture?

GLOBAL FLOWS OF MEDIA IMAGES, people and commodities have produced a globalization of sexual imagery, ideas and practices. Sociologists have begun to explore the sexual dimensions of globalization (e.g. Altman 1997), but there are too few case studies of the particular social contexts in which trans-national sexual cultures are locally practised and consumed. This article describes how a particular global culture – disco (*di-si-ke* in Chinese) – serves as a localized 'cosmopolitan' context for novel forms of sexual expression by urban Chinese youth.

Dance is one of the most public and popular sites for the expression of sexual and gender identities (Hanna 1988) and forms of popular dance are among the most globalized of sexual cultures.

> One of the most important activities to analyze if we are going to under-
> stand how sexual ideology works is dancing. The dance floor is the most
> public setting for musical as well as sexual expression.
> (Frith and McRobbie 1990: 388)

Yet, despite its prevalence and rich sexual content, social dance has been the 'least theorized popular cultural activity and the least subject to the scrutiny of the social critic' (McRobbie 1984: 132). Among China scholars, the popular disco has been dismissed as 'second or third rate imitations of the West or Japan' by western proponents of traditional Chinese values and as 'bourgeois decadence' or 'slavish imitation of the West' by Chinese traditionalists (Schell 1988: 356).

Such alarmist or dismissive views of cultural imports echo early sociological critiques of cultural 'globalization' as the westernizing and homogenizing intrusion of the global capitalist system (Schiller 1976; Wallerstein 1990). This 'cultural imperialism' thesis provoked responses – typically from ethnographers – that global culture is neither exclusively western nor homogenizing (Appadurai 1996; Hannerz 1992; Pieterse 1994; Robertson 1992). First, the origins of cultural objects do not have an obvious relationship to their uses; a popular cultural form that means one thing in its place of origin may mean something different in another local context (Liebes and Katz 1990; Tobin 1992). Second, imported cultural forms may be appropriated in local resistance to global influences (Sreberny-Mohammadi 1991; Thompson 1995).

These accounts of 'appropriation', 'localization' or 'indigenization' have intellectual affinities with sub-cultural theories of youth cultures. Sub-cultural theorists emphasize how working-class youth create their own meanings out of the cultural products of a hegemonic capitalist order, express resistance, alterity and sub-group identification through music and dance (Hebdige 1979; Martinez 1997; Racz and Zetenyi 1994) or, more pessimistically, use commercial leisure as an ineffective escape from dead-end lives at school and home (Mungham 1976; Willis 1984). Despite critiques and reformulations of the sub-cultural paradigm, the questions still center on the processes of sub-group identity formation, the construction of 'resistant' and 'alternative' narratives, and the social uses of themes of resistance (Gore 1997; Redhead et al. 1997; Thornton 1995).

Disco, like some other globalized mass-commercial youth cultures, represents a problem for 'sub-cultural' perspectives because disco from its inception made almost no claims to exclusive identities, to local cultural authenticity or even to musical authenticity (Frith 1981). By replacing the live band with a DJ and a mixing board, the discotheque allowed the mixing and blending of musical styles without the average dancer even noticing. Although it had roots in diasporic black subcultures, by the late 1970s the discotheque was a global institution of borrowed sounds and symbols with no claim to a closed creative or folk community (Frith 1981). African and Latin sounds dominated, though they were often popularized by performers from core countries (Chambers 1985). Straights and gays mixed in a sexually fluid atmosphere (Dyer 1990). The culture of disco was thus opposed to the formation of exclusive sub-cultural *Gemeinschaften*, but represented entry into an anonymous and glamorous *Gesellschaft* of transnational styles and fluid sexualities.

Far from dead in the 1990s, as the culture of the discotheque circulates the globe, it has increasingly lost whatever exclusivity and specificity it once connoted. For instance, musical forms as diverse as Cantonese pop, reggae, rap and old disco standards are played in turn in Shanghai's commercial discos, where dancers seldom express a strong identification with a particular genre of music. Associated in the US with a particular variety and era of dance music, the term '*di-si-ke*' in China covers all modern 'partnerless' dances and any associated mixed or danceable music. Mass, global and commercial dance culture thus may require different sociological categories than those developed in studies of more exclusive dance 'sub-cultures' or musically sophisticated and self-consciously 'alternative' 'club cultures' (Redhead et al. 1997; Thornton 1995). The giant commercial discotheque – as it has been replicated in provincial centers throughout the world – is more a site for youth

wishing to physically and symbolically *enter* global (mass/commercial/'modern') culture than for those trying to avoid it, resist it or distinguish themselves from it through 'alternative' or 'authentic' performances and identifications.

Global disco, in its mass-culture form, is perhaps more appropriately described as a *super-culture* rather than a *sub-culture*. Rather than spaces for identifying with a particular musical culture or sub-culture, large commercial discotheques are spaces where youth experience the larger society beyond their neighborhoods and their family and work lives (Willis 1984: 38), sites for experiencing a glamorous modernity in which one does not distinguish oneself by class or locality. Walsh (1993) writes of the popularity of discotheques in Britain:

> It extends an invitation to young people to become participants in the 'high life' which the wealth of Western societies has made available to the affluent sections of its population . . . bringing it down to an egalitarian level so that more people can share in it. So everything about the discotheque is geared to this self-presentation of glamorous sophistication.
>
> (113)

The 'glamorous sophistication' which Walsh describes is now a global culture celebrating consumption, fashion and sexuality in which youth on every continent participate, reinforcing an emergent global hegemony of consumer values. It would be wrong, however, to argue that national origins are irrelevant to transnational cultural forms such as disco. In the global cultural economy, where a thing comes from becomes an important aspect of its meaning for its cosmopolitan users. For instance, 'tango' in Japan relies on its 'authentic' Latin origins despite great differences in actual practices (Savigliano 1992). Global cultural objects are thus nearly always 'localized' – used in novel ways by local people – but their global origins are an important part of their meaning and can be a source of empowerment in local practices (Friedman 1990). Nor is this merely a question of an accidental 'mixing' of cultures ('creolization' in Hannerz 1992; 'hybridization' in Pieterse 1994), but a purposeful participation in a cosmopolitan (or 'foreign') space which is intentionally kept separate from 'local' practices. In particular, people may move daily between local and cosmopolitan identifications in order to enhance their own sense of personal autonomy (Hannerz 1992). Thus the point of discussing Chinese discotheques is not to oppose an inauthentic invading global culture with authentic local cultural practices of appropriation and resistance, but to ask what participants make of their participation in this self-consciously cosmopolitan culture.

The cosmopolitan sexual culture of the disco

Substantively, I focus on the sexual culture of the disco. In early studies of sexual expression in dance culture, dance was usually described as a courtship activity (Rust 1969), as a means of getting sex (Cressey 1932), or as a male predatory activity (Mungham 1976). 'What is missing in views of this kind is the realization that dance is not just a means to sex (although of course it may well be such) but that it is or can be a form of sexual expression in itself' (Ward 1993: 22). In particular, the

dance hall can be a space for relatively 'safe' and non 'goal-oriented' sexual expression by young women (McRobbie 1984; Peiss 1986).

What is also missing in these views is an appreciation of the larger sexual culture that the dance hall spatially incorporates. Chinese discotheques are sites in a global circulation of sexual imagery and practices through commercial cultural practices – especially dance – which Savigliano (1992) describes as 'the world economy of passion'.

In addition to an increasing number of positivistic descriptions of Chinese sexual behavior and courtship practices (Jankowiak 1993; Liu *et al.* 1997), more critical research on Chinese sexuality has focused on the construction of fixed sexual identities and sexual narratives through the state-controlled media and medical establishments (Dikotter 1995; Evans 1997; Honig and Herschatter 1988). While I do not deny the influence of these semi-official discourses on individual sexual narratives, here I emphasize how Chinese youth use social space to play with temporary and contextualized identities which are deliberately kept separate from these 'serious' sexual practices and narratives outside the 'night life'. Other research on Chinese popular culture has focused on the commercial exploitation of sexual themes in public culture (Barme 1993; Zha 1995). Here I look at how these commercialized sexual themes are spatially organized and incorporated into sexual practices in a particular context. The commercialization of social life produces a proliferation of such commodified practices and fragmented social spaces. To avoid constructing a single 'grand narrative' of Chinese sexual modernity, we must be careful to study separately these commodified spaces and the forms of sexual expression that emerge in them.

The issue with which I am centrally concerned is the uses Chinese youth make of a deliberately constructed space of 'foreign' sexuality. While, as I have already suggested, the disco is not a space for 'resistance' to global cultural hegemony, nor is it a free space of cultural appropriation. The global sexual culture of disco provides particular opportunities and constraints for sexual expression. I outline the inequalities that constrain participation in this form of youth culture.

Disco in China

Studying Shanghai discos

This [chapter] is based on my ethnographic observations of Chinese discos as a participant observer. From 1993 to 1996 I frequented discos and social ('ballroom') dance halls in all price categories in Shanghai and many other towns and cities all over China, casually interacting with and carrying out impromptu and occasionally formal (sit down and take notes) interviews with staff and customers, some of whom I came to know well. As part of my larger research project, I also discussed dance with participants in focus group interviews on sexual relations in Shanghai. However, despite the usefulness of such voluminous 'talk' for writing ethnography, assigning 'meanings' to dance remains inherently difficult (Ward 1997).

One reason for the lack of research on social dance is the practical difficulty of studying dance hall interactions: the noise, bad lighting and the hostility of dancers

to the intrusive project of the ethnographer (Mungham 1976). Dancing has also been ignored by sociologists of culture because other cultural forms are more accessible to study by virtue of there being a concrete text, image, score or artifact (Ward 1993), while dance proceeds from the body and hence is perceived as 'irrational' and 'outside of society' (Ward 1997). Dance expresses meanings, especially sexual meanings, which inherently defy verbal description, and which may even be denied or avoided in verbal discourse.

Through talking with dancers and participation in dance myself I was able to access to some extent the varied and (often intentionally) ambiguous sexual meanings expressed through and ascribed to dance by dancers in the disco. The following analysis relies upon both dancers' ascriptions of meaning to dance (and other interactions in the discotheque) and my own perceptions of the sexual uses of the discotheque, situating them within the local organization of the disco culture and the larger social situations of the dancers. As such, it remains but one sociological 'reading' of sexual interactions in the disco, interactions which despite their unavoidable ambiguity, deserve much more attention from scholars interested in explaining sexual expression in contemporary societies.

The social background of Chinese disco culture

While partnered ballroom dance became popular in China before the Communist takeover, during the radical years of political mobilization (1957–77) the Party banned social dance. Along with the 'opening up' of the economy and society under Deng Xiaoping, disco dancing arrived in China in the mid-1980s, promulgated through American films like 'Flashdance' and 'Breakdance' and through the dance parties of foreign students at Chinese universities. The first specialized discotheques opened in the late 1980s in hotels restricted to foreigners. In the 1990s these restrictions were lifted and massive discotheques financed largely by Hong Kong entrepreneurs opened to a mostly local Chinese clientele. By the mid-1990s Shanghai boasted at least 10 multi-level 'disco plazas', which could accommodate about 600 customers each and charged up to 100 yuan (US$12) for admission. The remaining 80 to 100 discos in Shanghai were small neighborhood youth clubs, which charged as little as 4 yuan (US$.50) for an afternoon admission but usually about 10–30 yuan. While 100 yuan represented about a tenth of the monthly income of a Shanghai factory worker, many youth spent much of their disposable income on entertainment. Working youth could afford tickets, and even unemployed youth were occasionally able to obtain free passes to expensive discos.

Young people described going to the disco to 'get a little crazy' and 'release tension' – reasons almost identical to those given by British youth in the 1960s (Rust 1969: 171). Like these 1960s British youth, Shanghai youth still typically live at home with their parents and use dance clubs as escapes from domestic life (for arguments for the centrality of dance to contemporary UK youth culture see Thornton 1995: 14–25).

Dance was the most popular commercial leisure activity for youth in Shanghai. Moreover, in every county-level town I visited in several remote provinces of China, I was able to find some type of commercial dancing establishment. Fancy

discotheques were most common in the flourishing coastal cities of China, but lesser imitations can be found in most inland cities, with names evocative of global entertainment centers ('L.A.', 'Barcelona' and 'New York'), Hollywood fantasy locales ('Broadway', 'Casablanca'), sexual innuendoes ('Kiss', 'Touch'), regionally famous discotheques (Taipei's 'Kiss' or Shanghai's 'JJ's') or globality itself ('Galaxy', 'NASA'). In smaller locales disco and ballroom dancing were often combined by alternating the types of music or offering separate disco and ballroom dance sessions during different hours, catering to different age groups. In big cities like Shanghai, the market was more clearly divided between discotheques visited by youth (mostly aged 15–25 years) and social dance halls visited by middle-aged people (mostly 30–45 years). This article only discusses the discos, focusing on the large, metropolitan discos in Shanghai, which are the 'models' for discos elsewhere in China.

Consuming foreign sex / being consumed

The commercial disco is described by Shanghaiese (by those who go there and those who do not) as 'chaotic', where people are 'unreliable' and just 'playing around' or 'fishing for big monies'. Commercial discotheques are described as 'in society' (shehuishang) as opposed to the non-commercial venues with controlled admissions and more decorous behavior. Students and youth are advised not to go to these commercial venues before they begin work and have themselves 'entered society' (started work and started dating). Consequently, those who generally go to discos are those who have just 'entered society' and have not been 'in society' very long. In this urban Chinese 'society', which is now a market society, youth must learn to imagine themselves as having a dual nature: that of both consumers and desirable commodities. The disco is a place to 'enter society' and to test one's attractions as a sexual and social commodity in the chaotic marketplace which the word 'society' now connotes. The disco is thus a simulacrum of the market society with its chaotic mix of temptations and pressures.

Unlike the earlier generation of British dancers surveyed by Rust (1969), Shanghai youth seldom described the discotheque as a place to make friends or find a mate. Most disco patrons agreed that people one meets in dance halls were 'unreliable' or just 'play friends'. Both young men and young women dismissed those of the opposite sex in discos as 'knowing how to play too well'. Nor was a disco typically seen as a place to take a date. Men and women usually visited in groups of friends.

This does not mean that the Chinese discotheque is a sexless place. Far from it, the sexuality of the discotheque is especially visual, a chance to show oneself off in a sexualized fashion to an audience of glamorous strangers. Almost everyone puts on special clothing for their trips to the disco, including metallic mini-skirts and stomach-revealing halter tops that first appeared in discos in the 1990s before they became acceptable on the streets. Some young men's clothing is intentionally 'weird', as one trendy youth described it, including colorful shirts and stomach-revealing tops. Most young men, however, resemble the 'teddy boys' of earlier decades in the West, their sober dress reflecting emotional cool and an attempt at social sophistication. In recent years local disco girls have moved away from

traditional Shanghai standards of prettiness and taken to black lipstick, leather and metallic fabrics, also showing a new sense of urban cool. Young men and young women have different strategies of display, but for all showing off in the commercial leisure world of the discotheque is about displaying sexual self-confidence and poise in the anonymous self-reflecting gaze of the crowd. [. . .]

The cosmopolitan definition of disco culture and this culture of sexual display are related on several levels. First, there is direct imitation of foreign styles of sexual display. Styles of dress and dance are studied from western videos. Second, there is the use of the 'cosmopolitan' space of the disco for constructing an image of the sexualized self within a global market culture. Rather than creating a sense of local community, the cosmopolitan culture of the disco is a forum for exposing oneself – literally – to the anonymous gaze of a global image market, for reflecting upon the self as a modern consumer and also a prized sexual commodity.

The globality of the disco is deliberately engineered through imagery which incorporates 'foreignness' into the ideal of the cosmopolitan metropolis. Shanghai's discos strive to capture the pleasures and dangers of metropolitan life, constructing the city as the center, rather than the periphery, of a global youth culture. DJs frequently identify the space of the discotheque with the cosmopolitan metropolis, shouting in English and Chinese: 'Hello Shanghai!' The decor is Hollywood-style urban-industrial-chaos with exposed steel girders, old American cars and dayglow English graffiti. Videos are shown, including scenes of gyrating and scantily clad westerners at a beach dance club in Australia or sexy rap stars in US music videos.

A foreign (often Hong Kong or overseas Chinese) DJ is de rigueur at the biggest discos. International music dominates, though most clubs also play an occasional mix of Hong Kong and Taiwanese pop songs overlain with a disco beat. The lyrics of dance songs are typically in English and Shanghai favorites included the Village People's 'YMCA' and Ace of Bass's 'All That She Wants', which were played very regularly throughout my 3 years in Shanghai. One reason for the undying popularity of these tunes is that certain English words in the chorus are understood and repeated by the dancers, most of whom have studied English for at least 2 or 3 years. These familiar songs allow for a feeling of participation in the global culture of the disco. [. . .]

Actual 'foreigners', especially white westerners, were an important prop in the construction of this cosmopolitan sexual culture, particularly in the metropolitan discos of cities like Beijing and Shanghai. Foreign students were often let in free. One Shanghai disco manager who was trying to push his second-rate club into first-rate status urged me to bring some foreign men. 'The girls here are shy', he explained, 'but they would like to make some foreign friends'. This was not an unusual approach. Foreign men were perceived as a big attraction for local women. Young 'foreigners' in general were part of the cosmopolitan sexual atmosphere consumed by Chinese in the biggest metropolitan discos. As one young woman said about her disco experiences, 'The foreigners made it seem more modern'.

Dancing with the energetic and exotic foreign women was a dare or challenge for Chinese men, who perceived such women as difficult to attain and as sexually and socially more sophisticated than local women. For Chinese women, on the other hand, dancing with the (often sexually aggressive) foreign men represented both

sexual danger and a sudden increase in attention from other dancers. For both Chinese men and women, interactions with the foreigners thus represented excitement, a social challenge and an increase in attention. Yet these interactions were typically brief encounters, like most interactions in the disco, chances to play at being 'cool', 'desirable' and socially competent. Moreover, given the relatively smaller numbers of foreign visitors, most Chinese women and men never interacted in any depth with foreigners in discos (though conversely many foreign men pursued greater intimacies with local Chinese women). Like the videos, these foreigners were largely for visual consumption, but were even more useful as the 'global audience' for the displays of local youth, male and female. To be watched (and desired) by the foreigners was to be directly affirmed as desirable in the cosmopolitan sexual market of the disco. Actual social interactions with foreigners were occasions for displaying poise and the capacity (both social and linguistic) to deal with the dangers and sexual temptations foreigners represented. Foreigners became the objects of sexual fantasy and occasional sexual adventures, but even more so were the mirrors for the construction of a cosmopolitan sexual self-image.

Disco dance in China and the overt sexual expression associated with it derive both legitimacy and persuasiveness from this larger global culture. Rather than being merely seen as the degenerate performances of juvenile delinquents influenced by foreign 'spiritual pollution', such celebrations of sexual display can now be positively identified as the elite cosmopolitan culture of modern youth around the world. The specific forms and meanings this sex and gender display take, however, may be out of sync with global fashions even while they rely on their global origins for legitimacy. For instance, 'voluptuous dancing' which reminded one American woman of 'a striptease dance with the clothes left on' was interpreted by the Chinese woman performers quoted here as a form of pleasurable exhibitionism learned from foreign music videos. Music which would seem dated to London or New York youth was fresh and 'western' for youth in Shanghai.

This appropriation of foreign sexual passion by Shanghai youth means that what Savigliano (1992) calls 'the global economy of passion' does not always follow the pattern she describes of an over-rationalized industrial center appropriating the sexual culture of an economically backward 'primitive other'. Nor does it always take the form of the sexualization of a dominated 'other' by the peoples of the center (Wallerstein 1990: 44). Rather, in these Chinese discos, we find that dancers use dance stages, video images of sexy dancers and the anonymous crowds surrounding them to literally picture themselves in a transnational modernity of music, dance and sexual excitement. Within the disco, they become sexual 'cosmopolitans' themselves with an enlarged repertoire of sexual strategies and styles.

The sexual repertoires of the disco also extend to more intimate forms of sexual expression. The separation of disco from everyday 'real' life allows for forms of intimacy and behavior which would normally have been censored in other social spaces. The discotheque may even serve as a space for acting out 'foreign' sexual ideologies. For instance, a 24-year-old professional woman I knew well once mentioned a 'one night stand' to me, using the English expression. One day when we were alone I asked her about that experience:

That was the only time I've done that ['one night stand']! I went out with some friends, and I met him dancing. He was a really attractive man, and I really wanted to be with him. He took us out after the dancing and later I went home with him. It was very 'romantic and very wonderful'. . . . We had been drinking. Maybe if I wasn't drinking then it wouldn't have happened so quickly. . . . The next morning we got up and went to the market to buy something for breakfast. It was really romantic.

Though her use of English is unusual, her English references to 'one night stand' and 'romance' in her narrative mark the accessibility of western sexual ideologies in the framing of her sexual adventure as part of a normal range of sexual behaviors originating in the heady atmosphere of the disco. For her, the disco provided a place where foreign sexual ideologies could be enacted in a 'romantic', spontaneous and drunken encounter, a kind of behavior which would have been labeled as 'hooliganism' a mere decade earlier (and still would be condemned by most Chinese adults). In this case, though the relationship ended in a few days, she still was able to remember it fondly. Discotheques are thus spaces where youth – young women especially – can practice freedoms of sexual expression and interaction not usually allowed them in the larger society, using this cosmopolitan space for illicit sexual display and play without fear of social sanctions.

The 'one night stand' is the extreme case of the 'erotic play' of the disco but casual flirtations are more typical. Kissing with a new friend is not uncommon. It is actually because of its separation from everyday life that the disco becomes an important space for working on one's sexual self image and sense of desirability. In the more earnest environments of school and work casual liaisons and flirtations might be too costly. In the disco they can be dismissed as inconsequential. Inconsequentiality and anonymity are thus a cover for the important activities of sexual self-appraisal and self-appreciation in a kind of virtual sexual marketplace, cut off from the serious and consequential sexual marketplaces governed by family, community and friends. The separation of the disco from everyday life through its liminoid 'foreignness' increases its utility for Chinese youth exploring alternative sexual images and behaviors.

In the culture of sexual display in the discotheque competing notions of sexual desire and desirability are simultaneously promoted by videos, dancers, DJs and advertising images. Canto-pop singers croon heroically about lost love, while hip-hop artists rap explicitly about sex acts in English. In the half-hour of slow dance in many discos, young people use the physical proximity of social dance to engage in tactile sexual intimacies. In the 'voluptuous dance' young women – whose modesty had been encouraged in Chinese society – simulate sexual excitement with lithe pelvic motions. Most dancers are more modest with their hips, but not in their desire to look good. Being desirable is more important than modesty in the mutual visual consumption of the disco. But even here, there is no one standard. In their dress, traditional notions of feminine beauty and social status (pleated skirts, business suits and long hair) compete with images of urban cool (black t-shirts, halter tops and cropped hair). The cosmopolitan disco culture thus offers a varied pallette of sexual themes and a place for sexual playfulness, its transnational melange of

sounds and images marking it as a space apart from everyday life where such play is possible. Dancers use these transnational and local discourses tactically to enhance their own sense of pleasure, desirability and autonomous choice.

In summary, the disco is a deliberately engineered space of 'foreign' sexual imagery, which Chinese youth appropriate to experiment with alternative sexual styles and sexual self-images. Actual foreigners are props in the exploration of sexual desirability and emotional poise in a global sexual and social marketplace. For youth faced with an increasingly free and competitive but still very earnest sexual marketplace in the 'real world', the disco is a space apart from everyday life for proving their desirability through sexual display and casual and (usually) inconsequential flirtations with strangers. The 'foreignness' of the disco abets the construction of the disco as a space apart in which sexual display and experimentation is possible. But in general the disco is still more a space for working on the *self*, rather than for working on serious relationships.

Social inequalities in Chinese disco culture: 'cathedrals' and 'churches'

As Appadurai (1996) writes, globalization is mediated by numerous disjointed 'flows' of capital, ideas, technology, people, etc. The cosmopolitan sexual culture of the discotheque shows the importance of these global 'flows' in contemporary Chinese youth culture. Chinese pirating of cassettes and CDs makes the circulation of music particularly fluid. Dance forms are similarly passed along cheaply through pirated videos and laser discs. These digital flows of music and images are borderless and virtually uncontrollable.

There are, however, important boundaries to the flows of global culture, and we must be careful of the implications of this 'flow' metaphor, with its implied lack of conflict, borders and social agency. The social boundaries governing disco participation became obvious in conversations with customers. When asked where they like to go for fun, almost any Shanghai youth in a small cheap local disco would mention one of the elite nightspots in Shanghai where entrance prices ranged from 50 to 100 yuan. Most of the local youth did occasionally make it to these fancy clubs, but many of them spent most of their time hanging out in small dank local dance clubs with dilapidated furniture and poor sound systems. They experienced disco culture as a hierarchy of venues, with the fancy, expensive places at the top and their regular hang-outs often near the bottom. This hierarchy of venues reflects a new hierarchy of consumption standards based on price, which is a dominant feature of the emergent hegemonic market culture in China, also reflected in other areas of life such as clothing (Kunz 1996). Few of the Shanghai youth I met (very few of the working-class ones) questioned this hierarchy of consumption, and there were few signs of self-conscious subversions of consumer values or attempts to distinguish 'authentic' or 'hip' local dance venues from inauthentic 'mainstream' ones, as is apparently typical of more developed metropolitan cultural regimes (Thornton 1995).

The other division in disco participation is regional. The fanciest discotheques are in Shanghai, Guangzhou and Beijing. A Hong Kong DJ company manager I interviewed conceded that Shanghai had now surpassed Hong Kong as a place to dance.

Building on Shanghai's popular dance culture and reputation among outsiders as an erstwhile mecca of leisure and 'decadence', some entrepreneurs (often 'overseas Chinese') have used Shanghai as a base for developing national leisure companies. Working for companies like this, Shanghai DJs circulate throughout China, selling their expertise and positioning Shanghai as a new center in the global culture of dance. Even Lhasa in Tibet has a 'JJ's' disco with a DJ brought in from Shanghai. Shanghai, of course, while pretending to global stature, also lived in the shadow of acknowledged metropolitan centers such as New York and London. [. . .]

The status hierarchies between expensive and cheap discos and metropolitan and provincial discos largely reflected economic factors. While Shanghaiese may have all been economic 'peripherals' in 1980, by 1995, Shanghaiese were able to afford a ticket to the cultural center at world-class discotheques – new metropolitan cathedrals in the global cult of sexual spectacle. Rural Chinese youth, on the other hand, were absorbed at the periphery, in cheap dance halls which were dim imitations of the glitter of the metropolis – mere parish churches. Similarly, poorer urban youth spent most of their time in dingy neighborhood discos, only occasionally visiting the bigger clubs. The additional advantages enjoyed by metropolitan discotheques in terms of sound systems, money for music purchases, training of DJs, etc., meant that they were almost universally seen as superior to small local discotheques. Disco was thus a site in which a wide range of Chinese youth were able to participate in a global sexual culture, but a site to which access was increasingly structured by geographic and class inequalities and in which, for some, sexual desirability was increasingly perceived as a tradeable commodity.

Conclusion: joining the global sexual spectacle

This [chapter] describes the uses Chinese youth make of the global *super-culture* of disco. This I have proposed as a mirror for imagining an autonomous sexual self reflected against the background of a global sexual culture. In this self-portrait, music videos, foreign DJs and foreign dancers are props for entry into a global sexual market and market society in general. Although access is unequal, even in the most isolated towns pirated CDs and videos provide cheap access to some elements of this global sexual culture. The disco is thus one site where a cosmopolitan culture is made materially available for local participation. For urban youth in China the sexual cosmopolitanism of the disco allows a broad array of sexual expressions which were previously taboo in the institutional confines of state socialism.

Finally, I should add that the more exclusive dance cultures or 'club cultures' of 'acid house', 'raves', etc., had thus far failed to be developed in Shanghai in 1995 and 1996, where I found a less discriminating and musically less sophisticated audience than those described in most western studies of music and dance sub-cultures (Gore 1997; Martinez 1997; Redhead *et al.* 1997; Thornton 1995). The Chinese disco is a mass cultural form which represents itself as a site of globality rather than as a site of 'alternative' or 'authentic' sub-cultural difference. For many urban Chinese youth, entry into a new consumer modernity can be found in the marble and chrome cathedrals of the discotheque, and from the perspective of youth it is

the cosmopolitan ('foreign'), inauthentic ('only for play', 'not serious') and inclusive ('open') character of the disco which makes it accessible and attractive.

Perhaps self-defined alternative sub-cultures or 'club cultures' are already arising in urban China, but in the mid-1990s most Shanghai youth were still too busy pushing into the global 'mainstream' to have arrived at the idea of resisting it or despising it (or even to conceive of it as 'mainstream'). In this respect, they may be more like the first generation of UK 'beat' dancers described by Rust (1969) – eager to join the modern world represented by imported sex, style and music – than the present generation of deliberately 'alternative' 'ravers' described by Thornton (1995). But Chinese youth are not simply the optimistic dupes of capitalism. They are far more cynical of one another's motives than either the convivial, courting youth described by Rust or the 'tribal' rave-goers celebrated by more recent critics (Gore 1997; Thornton 1995: 111). In particular, Shanghai youth go to the large metropolitan disco to experience a glamorous, cosmopolitan 'society' rather than to emerge themselves in a 'communitas' of similarly 'authentic' people (Gore 1997). This disco 'society' – especially the sexual relations it entails – is conceived as tricky, chaotic and morally ambiguous. The disco milieu is not a place for constructing social solidarities in opposition to the global marketplace but for engaging the market through fantasies of the *self* as a desirable sexual object. [. . .]

Ben Malbon

MOMENTS OF ECSTASY
Oceanic and ecstatic experiences in clubbing [1999]

The oceanic experience

Of all the arts, music is undoubtedly the one that has the greatest capacity to move us, and the emotion it arouses can reach overwhelming proportions.

(Rouget 1985: 316)

ALTHOUGH IT USUALLY TAKES PLACE within a social context, the dancing that is so central to clubbing is a highly personal experience and yet one that is rarely evoked in writing because of its ineffable and ephemeral qualities. The contrasting moments of introversion and of complete engagement with the dancing crowd that the dancing clubber may experience . . . are impossible to convey fully through words alone. In my attempts to evoke these experiences, which I am variously conceptualising as 'oceanic' and 'ecstatic' . . ., it is thus important that the frames of reference and terminology that are used are explained as fully as is possible at the outset. . . .

At the risk of tautology, at their most basic level of conception 'altered' states of mind differ from 'normal' states of mind in being qualitatively unlike the predominant states of mind experienced during one's waking hours in the course of 'normal' day-to-day living. They involve some form of transformation in consciousness (Inglis 1989; Laski 1961; Lewis 1989). Thus, 'altered' states do not include common experiences such as euphoria, happiness or joy as experienced on an *everyday* basis, but rather only euphoria, happiness and joy characterised by a transitory, unexpected, valued and *extraordinary quality* of rare occurrence and magnitude in which an altered sense of consciousness is temporarily experienced (Laski 1961; 1980).

. . . [T]he experience of in-betweeness or liminality – of being somehow taken outside of or beyond oneself, especially while dancing – is a characteristic of many crowds and particularly of the closely packed, sensorially bombarded dancing crowds of clubbing. At its most intensive this sensation of in-betweeness can partially induce or trigger the altered state of consciousness that I am calling, after Freud (1961) and Storr (1992), the 'oceanic' experience. I use this term in evoking 'a feeling of an indissoluble bond, of being one with the external world as a whole' (Freud 1961: 65).

Drawing from work by Marghanita Laski (1961; 1980) on 'ecstasies', by Brian Inglis (1989) on altered states such as 'trance', by Anthony Story (1992) on music and the emotions, and by I.M. Lewis (1989) on 'ecstasies' and altered states more generally, I define as 'oceanic' those experiences characterised by one or more of these sensations: ecstasy, joy, euphoria, ephemerality, empathy, alterity (a sense of being beyond the everyday), release, the loss and subsequent gaining of control, and notions of escape. In her work on altered states, Marghanita Laski describes an oceanic experience (or what she calls an 'ecstatic experience') 'as being one in which all sense of self and time and the everyday world seem to vanish . . . a state of anxiety is replaced by mental tranquillity' (Laski 1980: 12–13). Pleasurable fluctuations between awareness of self and environment, between sensations of intensity and withdrawal, and between practices of interaction and reflection are foregrounded.

For Laski, oceanic experiences are usually described as indescribable, although this does not prevent people trying to describe them in some detail – they just usually never quite 'get there'. Laski also suggests that oceanic experiences might involve feelings of loss (of self, of time, of place, of limitations); feelings of gain (of unity, of 'everythingness', of oneness, of an ideal place, of release); and feelings of 'quasi-physicality' – of some form of discontinuity between the physical and emotional experience of one's own body and surroundings (Laski 1980: 14). People describing oceanic experiences often evoke their feelings by describing sensations of upness, swelling, warm flushes or glowing in the heart, feelings of warmth, of liquidity, tinglings in the head and spine, and the attainment of calm and peace (Laski 1961; 1980). Happold (1981) appears to concur with Laski in proposing that 'mystical states' (as he calls oceanic experiences) are marked by ineffability, transience and passivity, and often instil a sensation of the oneness of everything.

Laski (1961) lists three main and prior uses of the term 'ecstasy' in addition to her own use as a form of oceanic experience: first, in describing a trance-like state; second, in describing a state of madness, as in Ophelia's description of Hamlet as being 'blasted with ecstasy' [in Shakespeare's *Hamlet*, III, i, 170–71]; and third, in describing a state of being in love, particularly, Laski suggests, in advertising media. However, because of current connotations with drug consumption this latter use of the term 'ecstasy' – in advertising media – is now highly problematic and would probably be subject to some form of Advertising Standards Authority control. Of course, only two years after Laski had written her second text on ecstasy, the term had taken on a fourth and additional connotation of referring to a 'hallucinogenic amphetamine' (ISDD 1996: 2; Stevens 1993).

In contrast to the more usual considerations of the oceanic experience – where solitude appears to be a pre-condition and feelings of unity are experienced more with a 'god' or 'universe figure' than with any 'earthly' manifestation or 'thing' – I am using the concept to evoke the sensation of oneness and the liminality of

self/wider group that can be experienced within apparently diverse dancing crowds (Storr 1992). These experiences can induce highly pleasurable moments of *exstasis* (or loss of self) within individuals.

The notion of the oceanic experience is appropriate in discussing the altered states of consciousness that clubbers describe as sometimes experienced while dancing in crowds for at least four reasons. First, as I have suggested, the oceanic neatly evokes the sense of in-betweeness or liminality that characterises clubbing and particularly the practices and emotions of dancing: in-between spaces (outside/inside, inner night-life/outside everyday life, spaces of work/spaces of play) and in-between times (night/day, work/play, and even outside time, or between 'real' times). Second, the oceanic evokes the fluidity and constantly shifting socio-spatial dynamics of the dance floor – the sensory onslaught that can act to effectively remove any figure of reference (the walls merge into the darkness, the ceiling is invisible, the floor is rarely glimpsed) – and the unceasing motion of the dancers. Third, as both Storr (1992) and Lewis (1989) note, music alone rarely triggers the oceanic experience. Yet, through dancing and the embodiment of that music, through self-mastery and the use of body techniques in the expression of a dancer's understandings, the dancer is able to transcend or escape the self and strive for a realm beyond the confines of the body – 'to move one's body is to aim at things through it' (Merleau-Ponty 1962: 137). Fourth, and related to these first three points, the oceanic experiences of the clubbers to whom I have talked appear to foreground (as does Laski's concept of the ecstatic) notions of *loss* (of differences between self and others, of time and space, of words, images and the senses), as well as notions of *gain* (of unity, of timelessness and eternity, of control, joy, contact and ineffability).

I refer to oceanic experiences that are partially attained through the use of chemical triggers, in particular the dance drug ecstasy (MDMA), or similar hallucinogenic amphetamines (ISDD 1996), as 'ecstatic'. . . . The use of the term 'ecstatic experiences' to evoke the broad range of experiences of in-betweeness, *exstasis* and joy that clubbers have talked about both whilst dancing and off the dance floor would perhaps have been less confusing. However, as I mentioned earlier, in an attempt to prevent *all* such experiences being associated with the use of ecstasy (MDMA) or other drugs (a common and rather lazy misconception), I will refer only to those experiences that *do* involve drugs as being 'ecstatic' experiences. The term 'oceanic experiences' is thus used to encompass *both* drug induced (ecstatic) and non-drug induced sensations of in-betweeness. Simultaneous feelings of disassociation and of warmth and empathy towards others – sensations of introversion and meditation yet concurrent expression and *jouissance* – are facets of all crowd-based 'oceanic experiences'. 'Ecstatic experiences', on the other hand, at least in the sense that I am using the term, are those oceanic experiences in which drugs, and particularly in the clubbing experience the drug ecstasy (MDMA), are used in an attempt to trigger, prolong or intensify the experience.

The nature of the oceanic experience in clubbing

I don't know how to put it into words – forgetting oneself, no, oneself ceasing to matter and no longer being connected with everyday things,

with the commercial sort of life one lives – a feeling that for the first time you're seeing things in proper proportion – you know that the things in the women's magazines aren't worth anything compared with the leaves on the trees, say, – and time seems to stop, no, not matter, you're not anywhere, and despite not feeling anywhere in particular, feeling in unity with everything – no, not with everything, with nature, but not specifically trees, flowers, plants, everything that comes out of nature, like you might say a book was written by a man, but it's still nature – it feels to a certain extent like a great climax which has built up – this thing has been seething inside you and suddenly it comes out.

(Laski 1961: 387)

I don't know what the colour scheme is exactly, for it is continually changing. This is caused by ever-varying kaleidoscopic shafts of light – now purple, now blue, now orange, now something else – being projected in turn upon the floor from above. Everywhere light and life and colour and swift movement; the rhythmic tapping of feet; the gleam of backs as bare as they know how to be; the rustling of attenuated skirts; the throbbing of violins; and, again, the hum of laughter and talk.

(Wyndham and St J. George 1926: 49)

Before I turn to address the use of drugs such as ecstasy (MDMA) in the attaining of oceanic experiences, I want to note first a number of more general qualities of the oceanic that can be experienced without (as well as through) the use of drugs, albeit perhaps in a more fleeting fashion. Moments of oceanic contemplation in clubbing are characterised by notions of membership of the clubbing crowd, by their momentary nature, by a tension between intensity and withdrawal, and by their technical and thus contextual quality. I now briefly address each of these points.

The oceanic and crowds

In her seminal study on the experience of ecstasy, Marghanita Laski (1961: 177) proposes that the crowd is an example of what she calls an 'anti-trigger', an inhibitor to the experience of the oceanic. While recognising that the crowd can be a source of real pleasure for those within it, Laski suggests that because the crowd is such an ordinary, everyday aspect of 'normal life' – at least in cities we experience crowds on a routine, daily basis – it can impede a full sense of loss of self and reflection. Other commentators see the crowd context as centrally implicated in the experience of the oceanic. Lewis (1989), Gowan (1975) and Csikszerstmihalyi (1975a) all infer that the experience of the oceanic may also be marked by an involvement with the crowd, even if, as Lewis (1989) adds, individual experiences within that crowd will have a personal and unique quality to them. In contrast to Laski (1961; 1980) and as I intimated earlier, I am proposing that the oceanic, attained with or without the use of drugs, is not dependent upon, nor induced only through solitude. The oceanic can also be experienced, albeit in a differing form, in the dancing crowd – a crowd certainly not experienced on an everyday basis. With the exception of the use of drugs, the contexts of the dancing crowd and the loud music are, in fact, the two most significant features of the dancer's route into experiencing the oceanic.

Oceanic moments

The oceanic as experienced by those not using drugs almost invariably lasts 'an immeasurably small space of time; an instant, a moment' (Laski 1980: 14). Nevertheless, this does not prevent the moment of the oceanic often being characterised by sensations of timelessness, of time temporarily having no meaning, as I suggested earlier in my discussion of dancing. This ephemerality or timelessness is due in part to the immense difficulty of suspending the conventional notions of civility, propriety and sociability – notions of consciousness of self and one's social obligations – for anything more than fleeting moments. In addition to the 'enculturated' monitoring and consciousness 'systems' that tend to retrieve dancing clubbers from their reverie almost as soon as they find themselves 'there', there is the more prosaic need not to hit another dancer in the face with a flailing arm. Self-consciousness and a sense of location return almost as quickly as they melt away and the 'default' settings of everyday life – the timings, spacings and monitoring of the body and its presentation and the monitoring of others' bodies and their self-presentation – again re-assert themselves.

However, while the oceanic is usually described in terms of instants or moments, there is often a period of 'afterglow' that persists within the individual after the experience (Laski 1961: 59). This afterglow can prolong the sense of the oceanic having been experienced, if not the actual experience itself. The pleasurable experience of these oceanic moments thus often endures well after their temporal and far beyond their spatial epicentres.

Intensity and withdrawal

Experiences of the oceanic are clearly not identical, differing between instances even for the same individual. Laski (1961: 54–5) distinguishes two main forms of 'the ecstatic' (which, I remind you, corresponds to my notion of the oceanic): 'intensity ecstasies' and 'withdrawal ecstasies'. Laski argues that an experience that is predominantly characterised by intensity may be euphoric, intoxicating and elatory, whereas an experience in which a sense of withdrawal dominates (while still an oceanic experience) might be characterised much more by reflection, contemplation and interpretation. Both are usually intensely pleasurable.

Of course, these are only extremes – most oceanic experiences feature both moments of intensity and of withdrawal, both effervescence and introspection. The sensory overload that can characterise a state of euphoria can, through obliterating other aspects of the situation, such as gazings, speech and other aspects of situational interaction, focus the mind within, as well as overwhelm it from without. If the intensity of the situation is such that the dancer is momentarily relieved of the obligations and technical requirements of social interaction, then inner reflection and contemplation may become possible. Through focusing attention and concentrating the senses, music and the other mediations of clubbing can limit the stimulus field, distractions are temporarily eliminated and a sense of merging with the music – a loss of self or sensation of *exstasis* – can be experienced (Csikszentmihalyi 1975b).

By no means do all clubbers, dancing or otherwise, experience oceanic sensations of intensity and/or withdrawal whilst clubbing. Given the difficulty of articulating these experiences for the clubbers, particularly to someone who is not

a close friend, it is not possible to propose with any degree of certainty how many of the eighteen clubbers that assisted me in interviews and clubbing nights out had experienced oceanic sensations. However, all the clubbers attempted to evoke a 'special feeling' that they experienced at certain times while dancing. Some suggested that they were most aware of the intensity of the dance floor, that they were enjoying the massive sensory stimulation of music, closely packed bodies and semi-visibility. Others talked about dancing as providing a time to think, as allowing them to 'lose it'. . . . Still others . . . mentioned both the 'community and the isolation' of the dance floor. The nature of clubbers' experiences of intensity and/or withdrawal – and thus of the oceanic – while dancing appeared to depend, to some extent at least, upon how confident and competent they felt while dancing. . . .

Techniques of losing and gaining control

BEN: What were you thinking?

KIM: Ummm . . . in some ways I sort of switch off if you like, and not think, just . . . I prefer . . . the way I'm like responding or dancing to the music or anything. I try . . . I don't like to think about that too much because if you start thinking about what you're doing or you suddenly think 'oh, got that' and you try and . . . so like I just try to tend to let me brain . . . and saying about thinking about my CV or whether I should get my hair cut or something like that, thoughts like that often pop into my head and it's . . . it does sound really trivial but . . . one thing that I was thinking about was, and it was quite possibly because you were there and you were doing this interview and stuff, I was thinking about umm . . . the rave culture and the dance culture and everything else, and why everybody did it etcetera and I was thinking you know, like the video games, the quality of material, everything is so like, lighting, TV . . . we're getting so much stimulation, really strongly, all the time, that if you want to go out and get . . . it's going to be that hard to get . . . and about care in the community as far as giving people things to, well, giving people the opportunity to go out and enjoy themselves and all the things against it and for it . . . that sort of stuff.

Kim is clearly attempting to relate the experience of the dance floor at that moment to her everyday life and to life more generally – partially, it would appear, because of my presence. She also appears to be struggling to find the words that precisely evoke her emotions and thoughts at that moment. Apparently, Kim does not like to, nor need to, 'think' about her dancing movements, instead using the space and time of the dance floor to think about other aspects of her life. This flux between participation and introversion is common.

In the clubbing crowd, the oceanic, if experienced at all, is usually experienced through participation within the dancing crowd. Although Mauss suggests that 'underlying all our mystic states there are corporeal techniques' (1979: 336), it is

wrong to reduce the oceanic merely to the outcome of a correctly practised set of body movements in a specific social context (Rouget 1985). As with many, other aspects of clubbing, issues of competence are not as clear-cut as merely involving the practice of learnt body techniques. For one thing, notions of coolness can also affect the way – the spacings and timings – that a dancer dances. Furthermore, the timings and spacings of clubbing mean that at certain times it is cool *not to succumb* to the crowd and music and actually to resist an available route into the oceanic, perhaps by *not* dancing. At other times the music, crowd and 'e/motion' may become so intense that even experienced clubbers, regarded as 'cool' (if only by themselves), may appear incapable of resisting the summons of the music and the crowd, and thus they lose themselves to the intensity of the situation (Rouget 1985). As Crossley states: 'to have acquired a body technique is precisely to be able to adapt and apply it in accordance with the demands of particular situations' (1995: 137). Clubbers have differing understandings of when and where it is appropriate to be seen to momentarily surrender control of one's body in experiencing the oceanic.

> ROBERT: I'm not into sort of sweat-box, flutter-tops-off sort of stuff – that's just obscene! It's like, you don't want to be a fucked-up nutter in a room full of sad people! [we laugh] . . . then you come out looking like a schmuck. I mean, you want to be around . . . when you're really fucked then it's almost as if you want everyone else to be fucked too 'cos you are, but they're not [ummm]. You want everyone to be on the same sort of vibe. You're grooving to the music or whatever, kind of like more heads down and just sort of totally in your own world, your own . . . sort of head, just totally off on one sort of thing, which is cool sometimes, I mean, and other times you'll be totally more head up, totally, looking at where the DJ is and the people will be jumping around you. If everyone else is on the same buzz and fucked or whatever [um-huh] and jumping about and having a laugh then that's going to be a good night . . . crowds DO make nights.

For Robert, the surrounding crowd is evidently crucial in the success, or not, of his night. In particular, there appear to be times and spaces when being 'cool' is about demonstrating control over one's body, while at other times being 'cool' is about abandoning or relinquishing control of one's body to the crowd. From Robert's story, it is apparent that for him these different times during the clubbing experience are again related to the tension between the ways in which a clubber can experience the crowd ('crowds DO make nights'). Both modes of experiencing the crowd – as distinctive from it (individualised) and as submerged within it (anonymised) – are able to foster moments of oceanic contemplation, but the nature of the crowd around him is implicated in influencing which of these modes Robert experiences. If Robert wants to interact with the crowd, it appears important that the crowd are 'with him', that they seem on the same level as him, that they are 'on the same buzz' and display broadly similar body techniques. On the other hand, if Robert is more reflective, more 'in [his] own world', then his head is 'down' and

he is not interacting with others. Yet, this can be 'cool' too. What feels 'cool' at any one moment is thus at least partially crowd premised in an on-going and permanently unfolding fashion.

Although dancers may feel momentarily out of control of themselves, they may also experience this as a sensation of being partially controlled from *without*, by the music and the aura of the dancing crowd around them (Csikszentmihalyi 1975b). This simultaneous sense of losing and gaining control over the dancing body is complex, particularly when related to clubbers' understandings of their own techniques and competencies. As Ludwig suggests, '[r]elinquishing conscious control may arouse feelings of impotency and helplessness, or, paradoxically, may represent the gaining of greater control and power through the loss of control' (1969: 14).

It would therefore be wrong to surmise, for example from Kim's description . . . of her 'switching off', that the dancing crowd consists simply of a large number of dancers each attempting to 'lose it', to slip into automatic in their quest for pleasurable sensations. Apart from anything else, if that were the case then the dance floor would become a chaotic and dangerous situation resulting in injury. The dancers are not in a trance. Rather, the dancing crowd 'works together' in creating conditions for the positive experiencing of intensity and withdrawal, the oceanic, and, if drugs are involved, the ecstatic experiences. The body techniques of the dancers are orientated according to the changing demands of the dance floor and the social situation of the dancing crowd, as well as to their own senses of expression and release. The dancers are keen to avoid 'over-intrusive perceptual relations' with each other – hence, in Goffmanian terms, the feigning of 'disattention' and the occasional tactical use of 'involvement shields' to effectively go 'off-stage' temporarily. Yet the dancers must also – even in successfully appearing 'disattended' and experiencing the most intense moments of oceanic reflection – 'scan the scene of their action for postural, gestural and linguistic clues regarding the possible action or inaction of others, and they must provide similar clues themselves' (Crossley 1995: 138). All this 'is necessary if the distinct projects and actions of embodied agents are to be coordinated . . . within shared spaces' (Crossley 1995: 139). Differing areas of the dance floor demand different techniques of the oceanic just as differing times do, and thus the stereotypical 'abandon' of the dance floor is actually constituted through extremely complex and constantly changing socio-spatial negotiations and orderings.

Awareness of self is thus both heightened and in some way muted in the oceanic experience. Some control of the body is ceded to the music and the crowd, yet through this semi- or unconscious ceding a heightened sense of control over the body can be established. The apotheosis of this phenomenon is that clubbers can lose a sense of themselves as entities separate from the crowd – they feel lost in the crowd – yet they can use this sense of merging and harmony with the crowd as a context for interpretation and contemplation of self (Csikszentmihalyi 1975c). Dancing clubbers are thus at times almost subconsciously attentive to the changing nature of the crowd around them, very subtly monitoring others' dancing techniques and territorial spacings.

JOHN: Uh . . . the black room, the big black room downstairs, I didn't
 find that until about one o'clock in the morning and I was totally

fucking shocked when I went down there, it was mental. It was totally dark and there were just a few lasers here and there – red and black looked really good together, ummmm . . . and you didn't really get an impression of how big it was except when the lasers flashed, and then you sort of only got an impression and you couldn't really tell and that sort of gave it the impression of being a lot bigger than it really was . . . a couple of times I've done what I call 'lost it' while dancing, just totally [yeah] . . . but then I realise like five or ten minutes later, ummm . . . that you're dancing really hard and you see everyone around you dancing the same way – really hard, and actually I notice this girl looking at me like this and laughing, ummm . . . but that is the best part to me, of dancing, is when the music just builds up so much that you just go without thinking about it really, and . . . lose it. To do that it's got to be really really fast [ummm]. It just happens, you don't even notice it while it's happening and then afterwards you think 'fuck that was really good!' [yeah]. I was in the black room when Paul Oakenfold came on. It was . . . how do you describe the feelings . . . excitement, ummm, oh, contentedness [right] that, I dunno, that . . . do you know what I mean? [yeah]. I'd got something that I'd wanted almost and was just so nice – the heat, the lasers and blackness of it . . . that was awe-inspiring. It made you go huuuuuuuuuuuuuuuhhhhh [draws breath deeply inwards]. It was excellent.

John conveys here the oceanic sensation as he actually experienced it on the dance floor. John's experience of 'losing it' is partially based on the practices of the crowd around him, as well as his dancing and the building music to which he is responding. The fleeting nature of the experience is evident. Yet again, John's search for the words to evoke the feelings he experiences demonstrates the difficulty of articulating the nature of the oceanic. [. . .]

The ecstatic experience

As well as being attained through the practices of dancing and the use of the body in crowd interactions and personal expression, the oceanic sensation of euphoria, liminality and *exstasis* can be experienced, prolonged or intensified through the use of recreational or 'dance' drugs. Where chemical triggers are used by the dancer, they are usually used in tandem with the practices of dancing and bodily control on the dance floor that I have just outlined, and thus the use of drugs represents in some ways an *additional* layer of emotional and sensational 'action', as opposed to an alternative. I want to turn now explicitly to examine the role of drugs, and especially the drug ecstasy (MDMA) in the clubbing experience, with a particular focus upon their use in attaining a form of oceanic experience that I am calling the ecstatic.

Ecstasy (MDMA) and clubbing

There is a whole gamut of drugs used by clubbers in Britain. Some are thought of as 'old favourites', such as cocaine and cannabis; others are newer 'synthetics', such as ecstasy (MDMA), MDMA-related substances, such as MDA and MDEA, and the anaesthetic-like Ketamine (often referred to as 'special K' or 'vitamin K'). Still others are so-called 'legal highs' made from natural plant and herbal substances. Over the past ten to fifteen years clubbing in Britain has been increasingly pervaded by ecstasy (MDMA), and this has had a huge impact on the practices and nature of clubbing experiences. I am concentrating upon the use of ecstasy (MDMA) for two connected reasons. First, most of the clubbers I talked to who used drugs in club-bing currently used or had experience of using ecstasy (MDMA). Second, after cannabis it is the most used drug in Britain, and unlike cannabis is almost exclu-sively a 'dance drug'; that is, it is used predominantly during the practices of dancing during clubbing and raving (Saunders 1997).

'Ecstasy' is the popular name for 3, 4-**M**ethylene**d**ioxy-N-**M**eth**a**mphetamine ('ecstasy' or 'E' is slightly easier in everyday conversation). It is a compound that was originally patented by the German E Merck Company in 1912. The popular perception that it was developed as a slimming pill is almost certainly a myth (Henry 1992; Saunders 1997). Saunders suggests that MDMA 'was just one of many compounds which were patented but never marketed' and which 'next came to light . . . in 1953 when the US army tested a number of drugs to see if they could be used as . . . agents in psychological warfare' (1997: 7). A Californian chemist named Alexander Shulgin re-synthesised MDMA in 1965, and after introducing a therapist friend to MDMA in 1977 the substance quickly became popular among West Coast USA psychotherapists because of its empathic effects (ISDD 1996; Saunders 1995; Shulgin and Shulgin 1991). MDMA first appeared on 'the streets' of the West Coast of America in 1972 as, at that time, a legal alternative to MDA, which was a related substance that had already been made illegal. In Britain MDMA or 'E' was initially associated with clubs that played so-called 'Balearic' dance music in the mid-1980s, although its possession was made illegal much earlier than this through an amendment to the Misuse of Drugs Act (1971) designed to blanket-ban all amphetamine-like compounds (ISDD 1996). MDMA is thus a Class A substance (Schedule 1 in the USA, where it was banned in 1985) – a designation reserved for those drugs deemed to be most harmful.

The use of MDMA can induce a feeling of euphoria and benevolence. However, while it is believed to enhance perception, its psychedelic potential is low, at least in its pharmacologically pure state (a rare occurrence – it is almost always blended with non-MDMA 'fillers'). The positive effects of boosted energy levels, confidence, happiness and heightened empathy that MDMA can provide can be offset by blurred vision, nausea and vomiting (Release 1997; Stevens 1993). In Britain the drug is taken orally as a tablet or capsule with an MDMA content of usually between 0–150mg, although higher amounts have been reported (Saunders 1997). The street price for an 'E' (or 'pill') is currently (late 1998) between £10 and £15.

Given that our bodies express the emotional states in which we find ourselves (Frith 1996) and that we are able to feel 'oneness' or 'sympathy' (Scheler 1954) with others in certain specifically framed situations (Blacking 1973), it follows that

the use of a drug which particularly impacts upon emotional, and thus also phys-ical, states can affect the sense of identification that one may feel (or not) with a clubbing crowd. However, clinical and psychological research on the effects of so-called 'dance' drugs is still scarce. What little work has been done suggests that 'empathogens' such as ecstasy (MDMA) undoubtedly affect an individual's sense of self – both their identities and identifications – with some studies suggesting that 90 per cent of ecstasy (MDMA) users experience a feeling of closeness to others (Release 1997).

Recent studies have suggested that between 68–76 per cent of clubbers regu-larly take ecstasy (MDMA), with many others taking amphetamines (such as 'speed') and LSD or smoking cannabis or 'grass' (Mullan et al. 1997; Release 1997; Solowij et al. 1992). For example, Mullan et al. (1997) surveyed 720 people at club events between April and September 1996 – overall 92 per cent of those surveyed had used drugs, with 76 per cent having used ecstasy (MDMA). Ecstasy (MDMA) seemed to be used more on a weekly rather than a daily basis (as cannabis was), with approximately half of those having taken ecstasy (MDMA) in the previous six months taking it every week. Of those who completed the questionnaire, two out of five were using ecstasy (MDMA) every week. In the Solowij (1992) survey, 68 of 100 people (68 per cent) surveyed had used ecstasy (MDMA) more than three times, while 83 (83 percent) had tried it at least once. While the Release Survey (1997) found that 81 per cent of those in their survey (clubbers aged between 16–29 years old) had tried ecstasy (MDMA) and 91 per cent had tried cannabis, the British Crime Survey (BCS) (1994) indicated that, of the population of 16–29 year olds *as a whole*, only 6 per cent had ever tried ecstasy (MDMA) and 34 per cent had tried cannabis. This indicates the highly unusual levels of drug use that can occur at club-bing events. Interestingly, the British Crime Survey (1994) also noted that 16–29 year olds who went to pubs, clubs and wine bars were nearly twice as likely to have ever taken illegal drugs than those who did not go to these places, and three times more likely to have taken drugs in the last month – 'In essence, people who go out take more drugs than those who stay in' (Release 1997: 12). A survey by the University of Exeter (1992) suggested that 4.25 per cent of 14 year olds (24,000 young people nationally) had tried ecstasy (MDMA) – a worrying statistic that reinforces the need for effective and co-ordinated drugs awareness education to be available from a young age.

The British Crime Survey (1994) suggested that as a whole between 303,000–385,000 people were regular users of amphetamines (a group of drugs that includes ecstasy (MDMA)), and that between 2,486,000–2,696,000 people had used amphetamines at least once. Overall, 1 per cent of those under 30 years old and less than 0.5 per cent of older people were found to be regular users of ecstasy (MDMA). So while many of those who go clubbing or raving have tried and continue to take ecstasy (MDMA), it should be stressed that among the general popula-tion by far the 'norm' remains not to have tried *any* form of illegal drug *ever* (Balding 1997; cited in Druglink 1997). The media-fuelled moral panic that surrounds drug use in Britain, especially use by young people, often obscures this basic fact. [. . .]

A night on E: the use of ecstasy (MDMA) in the clubbing experience

One way in which to represent and attempt to understand the role of ecstasy (MDMA) and other dance drugs in the clubbing experience is to 'shadow' clubbers who use drugs over the course of the night out. Like the practices, spacings and timings of the night out more generally, the practices of taking drugs – whether ecstasy (MDMA) or any other drug – are complex. Skills, techniques and notions of competency and coolness in the practices of finding, buying, preparing for, taking and coping with the consumption of the drugs are important in the constitution of these ecstatic experiences.

Clubbers who do take drugs as a route into the oceanic experience will each have their own personal routines and rituals which will vary from night to night. However, there are specific practices and sensations that are commonly expressed, with the spacings and timings of drug consuming practices of the dancers taking on a relatively ritualised form. The brief schematic that follows is therefore merely an evocation of a night on E based on nights out with clubbers during the course of the research for this book. The complex and highly ritualised nature of the consumption of ecstasy (MDMA) during clubbing merits half a dozen books all of its own, and thus what follows can, in the space available, only drift lightly, yet hopefully suggestively, through the ecstatic experience.

Pre-clubbing – sorting, preparing, bonding

The period immediately prior to clubbing is always exciting – drugs or no drugs. For those intending to take drugs in the hours that follow, this excitement is often augmented by a sense of nervous anticipation and the intricacies of deciding what they want to take, where and whether they are going to get it, as well as by the less discussed worries that they may have about their forthcoming experience: Is the drug 'safe'? Is it 'E'? Will I be okay? Will I get it through the security at the door? Will my friends be alright? These latter worries will be magnified for those that haven't experienced using ecstasy (MDMA) before.

Concerns about safety are reflected in the efforts that some clubbers make to research what they will be taking. For example, the clubbing magazine *Eternity* features reviews and news of different forms of ecstasy (MDMA) tablets, giving information on the results of tests. Nicholas Saunders' Internet web-site also features up-to-the-minute news on ecstasy (MDMA) tests and 'dangerous' pills with detailed breakdowns of the chemical constitution of current types of E. This web-site was consulted up to 400 times a day during 1996 (Saunders 1996). For the extremely patient, the Drug Detection lab in Sacramento, California, does postal testing of pill samples for $100 (Saunders 1997), although the turn-around time and cost means that use of this service is extremely unlikely for British users.

> VALERIE: I'm not going to do loads because then I would worry, yeah,
> but if I did a whole pill to begin with I know I would be
> paranoid, so there's no way I'd fucking do it in the first place.

I'd be worried about how fucked I'd be. I think I'm a light-weight. It does make me laugh sometimes though, 'cos I think to myself there's like people taking three pills and here's me with my half. I think I did worry a bit about the effects on my brain when I first started taking it; long-term effects. I was concerned. When we started taking them we looked up on the Internet every bit of information on Es to find out what, roughly, the effects were [uh-huh]. We tried to work out what a safe dose was, we tried to work out what we were taking, yeah [uhmmm] 'cos there's so many different sorts. We tried to get as clued up as we could on it . . . I really insisted on it. I think everyone else was like pretty like interested, but I was definitely wanting to know what I was taking. I've realised through the last year that it's impossible to know – you just can't know. In a way, I know it sounds strange, but I get ill on them, I know it sounds a bit peculiar . . . Okay, this is the story: I take E twice in a row on weekends and I get ill, and I take E sort of every month or a little bit longer and I'm okay, so from that I've deduced that I have to be really careful with my intake.

BEN: Do you not worry about taking it at all, in that case?

VALERIE: I might do – if I have kids then obviously I won't do it while I'm pregnant, and I won't do it while I'm breast-feeding so that's like two years of not doing it . . . you know they've got those testing points in Amsterdam – they've got like 10,000 bits of data. Do you know what I mean? You could be getting anything, absolutely anything [um-huh]. I mean I think some people have all sorts of problems – liver prob-lems, whatever, and they just can't handle it. There's an amount of people that get admitted to hospital every week, not through E-ing but just through overheating.

From this quite personal exchange with Valerie, it is obvious that she clearly spends a great deal of time and effort worrying about exactly what it is that she is taking when she goes clubbing. Despite Valerie's apparently carefully regulated intake of the drug ecstasy, it is evident that, like the overwhelming majority of those in her position, she really does have no idea about what it is she is taking each time and what the long-term effects on her might be (and, realistically, how could she have?). The subsequent importance of the group-based decision-making process is also clear. For most clubbers, decisions about whether to take drugs, where to get them, how much to take and when to take them are indeed made as a group. This form of decision making appears popular because it gives the illusion of taking the responsibility for choices about taking drugs away from the individual clubbers. Of course, ultimately these choices remain individual ones. This early group involve-ment engenders sensations of 'not being alone' in both the anticipated risks and the excitements that await during the night ahead, and thus before the night has even begun, notions of group trust and bonding may be developing, particularly if (as is

usual) previously successful nights are being evoked and used as a foundation, framework or rationale for the night to come. [. . .]

'Dropping' the 'pills' – taking the drugs

It is probably safe to say that no two clubbers have the same method or go through the same mental processes in taking ecstasy (MDMA). While clubbers might take the same amount and even the same 'brand' of pill, each will approach the experience differently. Some may 'drop' part of what they intend to take even before the night has started – maybe at home or more commonly while waiting in the queue outside, particularly if it is already late or they are very near the front of the queue. However, it is most usual to 'drop' the first amount, of what might be just one but may also be two, three or even more amounts over the course of the night, within a short space of time after entering the club. It usually takes between twenty minutes and an hour to start experiencing the effects of the drug – to 'come up' on it. Conveniently, this leaves time for the clubbers to find a space and to have a drink, deposit coats and bags in the cloakroom, and wander through the club generally getting into a clubbing mood, checking out the music and perhaps meeting friends. In instances where clubbers buy the drugs ('score' them) when they get into the club, thus avoiding the risk of bringing them through the security themselves and the potential difficulties and dangers of scoring the drugs beforehand, the search for a dealer from which to 'score' may also take place in these initial stages. Occasionally, perhaps due to a later arrival, a build-up of excitement or a familiarity with the club night, clubbers will 'drop' their pills immediately on entry and go straight to the dance floor, with the nervous excitement of having just taken their pill combining with the music and their familiarity to induce an impatience to start dancing and for the night to begin.

> BEN: Everyone was going crazy already . . . at half eleven! What was going on?
>
> VALERIE: I tell you what, when I got in there, something . . . I dropped my pill because I was really eager to get my pill down me so I could come up straight away yeah . . . and ummm . . . when we got in there I started dancing straight away – it was just like I was bopping away from the moment that I got in there and I don't usually do that. I like to sit down usually. I was SO excited. I was like a fucking kid in a sweet shop!!
>
> BEN: I was a little surprised at how quickly everyone started going for it . . .
>
> VALERIE: I was really eager to just get on with it, I just wanted to get 'up there'.

This impatience that Valerie exhibits in taking the drug is common. The pre-clubbing period of playing loud music at home or in the car, perhaps smoking cannabis, and generally getting wound up for the evening inevitably leads towards two key moments in the early part of the evening. The first, and one that

characterises nearly all clubbing experiences, whether or not drugs are involved, is the initial, overwhelming and nearly always adrenaline-producing experience of the music at the club. Much louder and more powerful than anything that might be produced on a home- or car-based system, this music is as much felt by the whole body as simply heard. The second key moment is restricted to those that take drugs such as 'E', and that is the moment of actually taking the drug. This is a vital moment that results in a build-up of tension, partly because of uncertainty over what is actually in the pill the clubber is taking and partly due to anticipation of the excitement, euphoria and adventure to come.

There is no 'usual' amount that is taken, and, in one sense, it matters less how many individual pills are taken and more what the effects are. Sometimes a half or a single pill will be sufficient for the clubber to experience the sensation that they are seeking, whether or not this is an ecstatic experience. At other times clubbers may take three or four pills. One clubber with whom I went out took four within a single hour, complaining of 'poor quality'. Furthermore, the size and weight of the clubber's body and the vital issue of tolerance will influence the amount of the drug that is needed in much the same way that a unit of alcohol will affect drinkers differently.

First experience as revelatory

Clubbers often talk of their first experience of ecstasy (MDMA) and other 'dance' drugs in revelatory terms – almost as if they only now know the score or 'the secret'. It is usual for clubbers to talk about their first time with a strongly positive tone, even for those who have long since ceased to take the drug.

> SEB: I've experienced the friendliness of clubs when I danced in Glasgow, but because I wasn't into ecstasy I didn't appreciate that that was what it was. I just thought that the guys liked me, I was that naive – guys would shake my hand and I thought, 'brilliant!'. I was totally into it, I loved the music and I loved the dancing and I knew I was enjoying myself so much that I just thought they were as well, and if anything I thought that they were enjoying it more than me so that just egged me on to enjoy it harder. I didn't realise that when you drop a pill you just start smiling and it all takes over.

Seb presents a picture of *pre*-ecstasy and *post*-ecstasy; the former characterised by what he sees as his naivety, and the latter by the revelation that all was not as it seemed, that now he 'knows'.

'Coming up' – starting to lose touch

Usually, even for relatively experienced users, once the pill has been taken a short period of nervous waiting follows during which the clubber will discover firstly whether or not the pill is a 'dud' – there is no effect or unusual and unpleasant

effects – and secondly, if it proves not to be a 'dud', the strength of the pill. Feelings of nausea are not uncommon, in part due to nerves, in part to the physiological effects of the pill dissolving, and the clubber may experience a feeling not unlike 'butterflies in the stomach'. Occasionally clubbers may vomit, yet these feelings of sickness usually pass within thirty minutes and, in most cases, within an hour the clubber begins to experience an altered state of sensory perception, a surge of euphoria and elation, feelings of unbounded energy and a heightened sense of empathy with those in the crowds.

BEN: Okay, so where were we – you were telling me what E is like for you . . .

JOHN: Okay, um . . . after about twenty minutes you start to feel the edges where you start to feel something, feel slightly different, or I do anyway [um-huh]. Usually smoke a joint around then – I try to if we're at a club, hopefully we've got a joint with us – we head off to the middle of the dance floor if there's nowhere quiet – smoke it there and that brings us up. What do you notice ummm . . . uhhh . . . altered perception is what I really notice, it's the fact that I'm noticing things differently . . . something has happened ummm . . . and I start feeling very excited as well, and like light in my stomach, and light in my head as well then, and I dunno . . . it's like, here we go, it's just all starting, and that's when I start listening to the music as well and that builds up, and not this time but the time before at Banana Split, I got in there, had a pill, had a joint and then went up to the dance floor [right] and we were standing about just looking at each other as the first tune was building up and the main thing that was building up was the atmosphere between us as the tunes built up, it was very trancey sort of stuff and just everyone was looking around grinning at one another and thinking right here we go, this is going to be a quality night [right]. They know where you are and you know where you are and you both go to the same place. While I'm on the pill I feel absolutely fine, I find it very easy not to worry about anything – I've never had a paranoia attack although a few times I have been a little bit ill – felt sick, been sick and then afterwards I've just been saying to myself 'no, I'm fine, it's just me winding myself up, I got too hot or whatever, I hadn't drunk enough' [yeah, yeah] . . . ummm . . . one of the things when you're on E, you can't control your body temperature and you start to feel a little bit sick, and then if you don't immediately go into a chill-out area and try and cool down a bit . . . for me anyway . . . I start feeling it and I start thinking I'm going to throw up and once I start feeling I'm going to throw up that's it, I'm going to throw up. I think that's more attitude than the actual drug

itself – it's more me thinking 'Oh I'm going to be sick, I'm going to be sick' . . . I mean a lot of the times I go running off to the toilet, into the toilet and it's cool in there and I feel fine [yeah], or even when you do actually heave you only heave once and it's like errrrhghghghh! [making 'sick' noises]

The build-up of tension that the clubbers share in the early pre-climactic period of the night is evident in John's story. A feeling of familiarity and of sharing ('here we go again') and the sense that they will shortly be 'going' somewhere, to another 'place', plane or level, are characteristic sensations, particularly among groups of friends. The clubbers feed off the emotions of each other, developing 'the atmosphere between us'. An ethos of sharing something extraordinary evolves between those within the dancing crowd, and this provides the starting point for an ecstatic sensation.

Stripping of defences – a 'natural' state?

'It made me feel how all of us would like to think we are anyway' . . . ecstasy can act as a reminder of a kind of honesty rarely found in human relations. Certainly, nobody needs a drug to tell them of this, and it may be that the message that Adam brings is the reminder that ecstasy has always existed without it.

(Nasmyth 1985: 78)

A recurring feature of the experience of ecstasy (MDMA), as well as other *non-drug* induced oceanic experiences, is the sensation that one has witnessed the revelation of the 'true' nature of one's self and of others – the individual 'suddenly' sees how people 'really' are, their 'natural' states. Stevens describes this sensation as a 'melting [of] defenses [sic]' (1993: 488). It appears that the ecstatic experience facilitates what can seem like a fleeting glimpse of sanity or 'naturalness', as the inhibitions of an apparently rule-bound 'outside world' dissolve in the space of the dance floor and within the dancing crowd.

BEN: How do you feel about yourself when you're there on the dance floor?

VALERIE: I believe that we all have personas, yeah [uh-huh, right]. So you're a totally different person with me than you are with your mother [oh, definitely!]. Right, and . . . I think I like to believe that when I'm on an E I have no defences whatsoever, so in many ways I would say that the person I am when I'm on an E is the 'real me' right, because I feel totally open and . . . I feel clean, yeah . . . I feel cleansed of all my worldly woes.

BEN: What do you mean that you have 'no defences'?

VALERIE: I don't . . . I don't worry yeah . . . I don't, I feel like, I trust, I feel more trusting, I'm quite a trusting person

anyway, yeah. I don't . . . it's really difficult – I feel really sort of like spiritual like I don't judge, I trust, I feel cleansed, I feel . . . it's like a really sort of pure feeling.

BEN: But is that different from others parts of your personality?

VALERIE: When you're at a rave and you're with hundreds of people dancing and you're having fun, yeah; you don't worry about what your mother said to piss you off earlier that day, yeah? You're just concerned with what's going on then – there's a really happy atmosphere, a really happy vibe, and you're part of that, yeah. When you're not in that setting it's not that you've got to worry about things, but you've got to . . . not be on your guard but you've got to be aware of things yeah . . . there . . . there are people who for their own reasons are doing what they do, yeah, which are right to them, but they don't necessarily tie in to what you want, so you've got to be aware of it so that you can compromise, so that you can analyse, so that you can do whatever, yeah. When you're on an E, everyone's there to enjoy themselves.

BEN: So you feel that you're amongst like-minded people?

VALERIE: The thing is I think it's easier because you know that everyone else is also on an E, yeah, so you're getting the same sort of signals sent out, so . . .

BEN: How can you tell if others are on a drug?

VALERIE: God, I don't know? I really don't know. That's quite strange really because I don't know what people are on. Like Brian, he said people were on coke [cocaine] there, yeah . . . at Banana Split, and I hadn't noticed. He said that people going like that [makes face] . . . and I hadn't thought about it, I just assumed that everyone was really happy, so it's sort of like my perception of it more than anything else [yeah]. I perceive everyone to be happy. I mean if I smile at someone and they don't smile back I just think they're really fucked and I think enjoy it for what you're at, at that moment [yeah].

The non-confrontational, consciously open attitude that many clubbers suggest forms one of the most attractive aspects of clubbing, is discernible in Valerie's clearly carefully articulated account of the 'different' persona that she presents on the dance floor. This sensation of being able to identify a 'true' self, of finding who you 'really' are, is one that Valerie appears to value highly. 'Defences' that Valerie deploys in other social encounters appear unnecessary while dancing, for having taken ecstasy (MDMA) Valerie has no worries but rather, 'trust, I feel more trusting [. . .] I feel cleansed'. It appears important to Valerie that others within the clubbing crowd are also there for these reasons – 'everyone's there to enjoy themselves [. . .] you're getting the same sort of signals'. The notion of 'momentary time' and its relationships with identities and identifications is also further textured through Valerie's description: 'you're just concerned about what's going on then [. . .] enjoy it for what you're at, at that moment'.

Far from being concerned with some form of mindless and meaningless hedonism, then, as often portrayed in popular (mis)representations of clubbing, it seems that the experiencing of ecstatic sensations can actually be about an extraordinary and, for many, unparalleled and extremely precious experience of *their own identity*. Crucially, this experience of identity is perceived as their 'real' identity – how they really are (and/or want to be). This dramatic sensation of having one's 'true' self or 'natural' state uncovered, unveiled or released can be so powerful as to be experienced as a form of earthly utopia or dream-world. . . .

Virtual, mediated, globalized

Introduction to part eight

■ Ken Gelder

THE THREE REALMS SIGNALLED in the title to this section each pose a
problem for subcultural studies, challenging the ways in which subcultural
sociality has traditionally been conceptualized. How does a subculture interact
online? How can a subculture claim its sociality – as well as its 'authenticity' – if
it identifies primarily through (disembodied, derivative, industrialized, massified,
etc.) media forms? Is subcultural identity – even when it is transmitted face-to-face
– always and necessarily mediated anyway? How can any sense of (an alternative)
community be felt in these contexts? How can subcultures continue to be territo-
rial and distinctive under the dispersing and dislocating influences of globalization?
And how can a dissenting subculture's anti-commercialism express itself in the wake
of globalization's relentless process of commodification?

 This section begins with an extract from the American cyber-activist and
commentator Howard Rheingold's famous study, *The Virtual Community: Finding
Connection in a Computerized World* (1994) – a study that effectively transfers the
traditions of subcultural studies to the Net itself. We might think that online
communication is a disembodied and bloodless activity, signalling the *end* of
community-based identity. But for Rheingold this task has already been performed
by modern society, which has steadily and systematically alienated its subjects from
one another. The Net, on the other hand, offers up a space where a sense of
community can be recovered. Rheingold's involvement with San Francsico's *Whole
Earth* – which becomes the *Whole Earth 'Lectronic Link* (WELL) online – brings
a countercultural perspective to the Net, juxtaposing it to the mainstream, corpo-
rate interests of mass media. For Rheingold, the Net offers an alternative space
with the potential for both 'rational discourse' and 'emotional attachment'. His
account in fact characterizes it as intimate: it is a 'cosy little world', a kind of
extended family, a 'virtual village': rather like a computer-age version of Tonnies'

Gemeinschaft. The metaphors he uses to describe communication on the Net are in fact primarily organic – grassroots, plants, ecosystems – and in this respect his account also compares strikingly to Robert E. Park's conception of the modern city in chapter 1.

Rheingold's sense of the Net as a 'virtual community' has been influential, but it has also had its critics. In *An Introduction to Cybercultures* (2001), David Bell suggests that the word 'community' – when used about the Net – is 'over-freighted' (Bell 2001: 107). He also notes the tendency to slide between *community* and *subculture* in commentaries about the Net; but for Bell, the term *subculture* should be reserved for those groups of people who use computer technologies 'that subvert in some way dominant social norms or dominant formations of what technology is for' (163). We could nominate computer hackers here, who have certainly attracted their share of subcultural commentary – from Andrew Ross's 'Hacking Away at the Counterculture' (1991) to McKenzie Wark's *The Hacker Manifesto* (2003), which deliriously invests in hackers (he calls them a 'class': 'intellectual workers') as an emblem for anti-corporate, anti-commodifying, information-producing activity. The hacker is also the hero, or anti-hero, of the science fiction subgenre of cyberpunk which developed during the 1980s. David Bell's contribution to this section, 'Meat and Metal' – from a collection of essays titled *Contested Bodies* (2000b) – turns to what he calls the cyberpunk subculture, in a short meditation on the way contemporary society has thrown up two apparently contradictory responses to the body: those who want to escape it through 'immersive interaction' online, and those – like the tattoo enthusiasts Michael Atkinson had looked at in chapter 30 – who reclaim the body and develop its spectacular potential. The latter are understood here as a reaction against social alienation and (since some body ornamentation rituals can be painful as well as exhilarating) the 'numbing' effects of modernity. The former are seen as pursuing freedom from 'corporeal constraints' as they inhabit online worlds. And both are taken as utopian and essentially romantic responses to contemporary life.

The word *community* may be difficult to avoid online, however. Pierre Levy, in his important book *Cyberculture* (2001), retains this term in the wake of Rheingold, seeing cyberspace as 'the result of an authentic social movement, with its leaders (young, urban, educated), its buzzwords (interconnection, virtual communities, collective intelligence), and a set of coherent goals' (Levy 2001: 103). We have certainly come a long way since the emphasis by Chicago School sociologists and British cultural studies researchers on outsiders, deviants and the disenfranchised working class. Even so, the formation of distinct and deviating social groups continues: indeed, for David Bell the Net *encourages* 'subcultural work' (Bell 2001: 184), pluralizing the subcultural economy in a way that recalls John Irwin's sense of subcultural pluralism across America back in the 1970s. Paul Hodkinson's contribution to this section, from his book *Goth: Identity, Style and Subculture* (2002), turns to the Goth subculture and traces out its virtual activity in the wake of debates about the nature of online communities. Although he is critical of Rheingold, he shows that Goth media and virtual 'networks' do indeed produce subcultural sociality. Hodkinson's book is a work of participant observation: he is a Goth too,

from England, as well as a lecturer in sociology. He argues that Goth culture is media- and online-active, producing sites that work to give Goth identity coherence: as 'net.goths'. These sites routinely provide the Goth subculture with a sense of its own history, its geography (mapping out Goth nightclubs, handouts, shops, and so on), its style, its musical and literary tastes (since Goths are usually well educated and arts-oriented, assembling a Goth literary 'canon' of Romantic and Victorian literature as well as fantasy and horror writing), its 'attitudes', and so on. Goth websites induct Goths into all the appropriate forms of subcultural knowledge; they convey what Hodkinson calls elsewhere in his book 'a level of cultural substance, which might distinguish the Goth scene, as a *subculture*, from more fleeting, ephemeral amalgams of young people, music, and style' (Hodkinson 2002: 7).

Rheingold's keyword 'virtual community' can be used offline, too. Stephen Duncombe is the New York-based editor of *The Cultural Resistance Reader* (2002) and author of *Notes from Underground: Zines and the Politics of Alternative Culture* (1997), an extract from which is in this final part. Zines are small, amateur-produced magazines, forms of micromedia. Duncombe looks at the 'zine network' across America and sees them, as Rheingold had seen online participation, as a reaction against the alienation and loneliness of contemporary society – as well as a buoyant alternative to 'an era marked by the rapid centralization of corporate media' (Duncombe 1997: 2). Zines are anarchic and radically eclectic: Duncombe prefers the term *network* to *community* in their case because, as he sees it, zine producers and writers are linked not by commonality but by difference. His account of American zine culture is influenced by Dick Hebdige, but it also returns to Robert E. Park, paying tribute to the eccentricity of American life. Zines turn to the everyday, but in particular to the 'things they don't own'. There is a kind of home-lessness about them – so that, in Duncombe's view, they inhabit a kind of 'shadow America', underground, itinerant, almost invisible. The United States is given a poetics here, as well as a subcultural geography as zines imprint themselves idio-syncratically across the nation. Duncombe characterizes American zine culture as bohemian in this respect – so he also uses the term *scene* to describe them – but it is a bohemianism that is no longer tied to the inner city, which has itself become increasingly corporatized and gentrified. It is instead dispersed, diasporic, scattered across the nation piecemeal.

In Duncombe's study, subcultural identity is distinguished from national iden-tity: zine culture is America's other, its 'shadow'. The US sociologist Sharon Kinsella also looks at the relationship between subculture and nation in her important book, *Adult Manga* (2000), an extract from which is included in this part. Here, the nation is Japan and the subculture is built around manga or comics. Kinsella's study is ethnographic, based on fieldwork in Japan where she also worked for a manga publishing company. Manga is a culture industry, but it can be divided into profes-sional or mainstream manga on the one hand, and amateur or non-commercial manga (*doujinshi*) on the other. Like Duncombe with his zines, Kinsella turns to amateur manga production – which she interestingly notes can in fact be both less progressive and more derivative than its mainstream counterpart. An extensive subculture built itself around amateur manga production, holding conventions,

promoting cosplay (dressing up as characters, in costume), and often turning to sexual themes in the works themselves. Kinsella looks at the gender politics of amateur manga, suggesting that – unusually for Japan, perhaps – it can get close to camp; it may also work to 'feminize' Japanese culture. At the same time, the *otaku* subculture – *otaku* is a Japanese expression for an enthusiastic (and nerdy?) hobbyist – was increasingly seen as obsessed with sex and violence, and difficult to regulate. Kinsella discusses the 'moral panic' (recalling Stanley Cohen's phrase from part three) over *otaku* following a notorious serial child-murder case, the 'Miyazaki incident'. *Otaku* youth were routinely taken as antithetical to the values of Japanese society: 'family, company and nation'. Instead, they were cast as anti-social, self-indulgent, too 'individualistic'. The striking thing here is that *otaku* were not seen as *subcultural*, in spite of the *doujinshi* conventions, the shared cultural/industrial interests, and so on. We can see a version of the panic over *otaku* in Karo Taro Greenfeld's earlier book, *Speed Tribes: Days and Nights with Japan's Next Generation* (1995), an influential account of contemporary Japanese youth produced for Western audiences. For Greenfeld, *otaku* 'are a generation of Japanese kids who are opting out of the conformity of Japan' (Greenfeld 1995: 275): subculture against the nation. But his book ends melodramatically with an account of Stix, a Japanese boy who has given himself over to an amoral online world of sex and murder, without inhibitions, as if this is *otaku's* future: not subcultural at all, but socially isolated (without even a 'virtual community' to belong to), obsessive, deviant.

Yet it can seem as if *otaku* are everywhere, even in America (see, for example, Tobin 1998). We have seen James Farrer talk about the Chinese disco as a Westernized, commodified space in chapter 41; but the West can be Easternized, too, since cultural influences do not just flow one way. In the final extract in this Reader, Martin Roberts wonders what happens to the idea of the subcultural when subcultures find themselves in a globalized capitalist economy: when subcultures, we might say in response to part four in this Reader, are *de*territorialized. Roberts' essay moves well away from any sense of subcultural localness or subcultural origins, and also turns away from the Anglo-American and nation-centred biases of subcultural studies. Looking at progressive-trance music in the Indian coastal city of Goa and at Shoichi Aoki's Japanese street-fashion magazine, *Fruits*, Roberts postulates a 'global underground'. Here, the subcultural meets the cosmopolitan. Subcultural distinction thus becomes a privilege paid for by 'global elites' – a view that takes us far away from the traditional view of subcultural activity as a 'history from below' even though the concept of an *underground* is preserved here. For Roberts, subcultures are now a kind of transnational culture industry and, indeed, he speaks about the 'subcultural industry' in this context. It might seem as if we have come full circle now, as if subcultures totally inhabit Tonnies' *Gesellscahft*. The appeal of subcultures continues to lie the pursuit – more by choice now than by circumstance – of alternatives to the dominant modes of living offered by Western modernity. But subcultural activity is no less commodifying for all that. Roberts draws on Sarah Thornton's (1995) notion of subcultural capital – that subcultures generate their own microregimes of knowledge, their own hierarchies – but he takes it literally. Subcultures do indeed generate capital: they are a contributing part of

the commercial marketplace; they are, in other words, productive. We perhaps return to Georg Simmel in the model Roberts finally provides here. Subcultures are now an elite class of producers and consumers in the world economy, relentlessly seeking distinction. Their 'resistance' (e.g. to Western, or Eastern, modernity) expresses itself through the continual reinvention of styles, mixing and remixing, trying in the process to defy subcultural (or perhaps any other kind of) classification. But Roberts also returns subcultural studies to the older traditions of anthropology as he closes his account of global/subcultural commodified exotica: where, as soon as they are gazed upon, subcultures seem to disappear: as if all that is solid has melted into air.

Howard Rheingold

INTRODUCTION TO *THE VIRTUAL COMMUNITY* [1994]

'Daddy is saying "Holy moly!" to his computer again!'

THOSE WORDS HAVE BECOME a family code for the way my virtual community has infiltrated our real world. My seven-year-old daughter knows that her father congregates with a family of invisible friends who seem to gather in his computer. Sometimes he talks to them, even if nobody else can see them. And she knows that these invisible friends sometimes show up in the flesh, materializing from the next block or the other side of the planet.

Since the summer of 1985, for an average of two hours a day, seven days a week, I've been plugging my personal computer into my telephone and making contact with the WELL (Whole Earth 'Lectronic Link) – a computer conferencing system that enables people around the world to carry on public conversations and exchange private electronic mail (e-mail). The idea of a community accessible only via my computer screen sounded cold to me at first, but I learned quickly that people can feel passionately about e-mail and computer conferences. I've become one of them. I care about these people I met through my computer, and I care deeply about the future of the medium that enables us to assemble.

I'm not alone in this emotional attachment to an apparently bloodless techno-logical ritual. Millions of people on every continent also participate in the computer-mediated social groups known as virtual communities, and this popula-tion is growing fast. Finding the WELL was like discovering a cozy little world that had been flourishing without me, hidden within the walls of my house; an entire cast of characters welcomed me to the troupe with great merriment as soon as I found the secret door. Like others who fell into the WELL, I soon discovered that I was audience, performer, and scriptwriter, along with my companions, in an ongoing improvisation. A full-scale subculture was growing on the other side of my telephone jack, and they invited me to help create something new.

The virtual village of a few hundred people I stumbled upon in 1985 grew to eight thousand by 1993. It became clear to me during the first months of that history that I was participating in the self-design of a new kind of culture. I watched the community's social contracts stretch and change as the people who discovered and started building the WELL in its first year or two were joined by so many others. Norms were established, challenged, changed, reestablished, rechallenged, in a kind of speeded-up social evolution.

The WELL felt like an authentic community to me from the start because it was grounded in my everyday physical world, WELLites who don't live within driving distance of the San Francisco Bay area are constrained in their ability to participate in the local networks of face-to-face acquaintances. By now, I've attended real-life WELL marriages, WELL births, and even a WELL funeral. (The phrase 'in real life' pops up so often in virtual communities that regulars abbreviate it to IRL.) I can't count the parties and outings where the invisible personae who first acted out their parts in the debates and melodramas on my computer screen later manifested in front of me in the physical world in the form of real people, with faces, bodies, and voices.

I remember the first time I walked into a room full of people IRL who knew many intimate details of my history and whose own stories I knew very well. Three months after I joined, I went to my first WELL party at the home of one of the WELL's online moderators, I looked around at the room fall of strangers when I walked in. It was one of the oddest sensations of my life. I had contended with these people, shot the invisible breeze around the electronic watercooler, shared alliances and formed bonds, fallen off my chair laughing with them, become livid with anger at some of them. But there wasn't a recognizable face in the house. I had never seen them before.

My flesh-and-blood family long ago grew accustomed to the way I sit in my home office early in the morning and late at night, chuckling and cursing, sometimes crying, about words I read on the computer screen. It might have looked to my daughter as if I were alone at my desk the night she caught me chortling online, but from my point of view I was in living contact with old and new friends, strangers and colleagues:

I was in the Parenting conference on the WELL, participating in an informational and emotional support group for a friend who just learned his son was diagnosed with leukemia.

I was in MicroMUSE, a role-playing fantasy game of the twenty-fourth century (and science education medium in disguise), interacting with students and professors who know me only as 'Pollenator.'

I was in TWICS, a bicultural community in Tokyo; CIX, a community in London; CalvaCom, a community in Paris; and Usenet, a collection of hundreds of different discussions that travel around the world via electronic mail to millions of participants in dozens of countries.

I was browsing through Supreme Court decisions, in search of information that could help me debunk an opponent's claims in a political debate elsewhere on the Net, or I was retrieving this morning's satellite images of weather over the Pacific.

I was following an eyewitness report from Moscow during the coup attempt, or China during the Tiananmen Square incident, or Israel and Kuwait during the

Gulf War, passed directly from citizen to citizen through an ad hoc network patched together from cheap computers and ordinary telephone lines, cutting across normal geographic and political boundaries by piggybacking on the global communications infrastructure.

I was monitoring a rambling real-time dialogue among people whose bodies were scattered across three continents, a global bull session that seems to blend wit and sophomore locker-room talk via Internet Relay Chat (IRC), a medium that combines the features of conversation and writing. IRC has accumulated an obsessive subculture of its own among undergraduates by the thousands from Adelaide to Arabia.

People in virtual communities use words on screens to exchange pleasantries and argue, engage in intellectual discourse, conduct commerce, exchange knowledge, share emotional support, make plans, brainstorm, gossip, feud, fall in love, find friends and lose them, play games, flirt, create a little high art and a lot of idle talk. People in virtual communities do just about everything people do in real life, but we leave our bodies behind. You can't kiss anybody and nobody can punch you in the nose, but a lot can happen within those boundaries. To the millions who have been drawn into it, the richness and vitality of computer-linked cultures is attractive, even addictive.

There is no such thing as a single, monolithic, online subculture; it's more like an ecosystem of subcultures, some frivolous, others serious. The cutting edge of scientific discourse is migrating to virtual communities, where you can read the electronic pre-preprinted reports of molecular biologists and cognitive scientists. At the same time, activists and educational reformers are using the same medium as a political tool. You can use virtual communities to find a date, sell a lawnmower, publish a novel, conduct a meeting.

Some people use virtual communities as a form of psychotherapy. Others, such as the most addicted players of Minitel in France or Multi-User Dungeons (MUDs) on the international networks, spend eighty hours a week or more pretending they are someone else, living a life that does not exist outside a computer. Because MUDs not only are susceptible to pathologically obsessive use by some people but also create a strain on computer and communication resources, MUDding has been banned at universities such as Amherst and on the entire continent of Australia. [. . .]

The technology that makes virtual communities possible has the potential to bring enormous leverage to ordinary citizens at relatively little cost — intellectual leverage, social leverage, commercial leverage, and most important, political leverage. But the technology will not in itself fulfill that potential; this latent technical power must be used intelligently and deliberately by an informed population. More people must learn about that leverage and learn to use it, while we still have the freedom to do so, if it is to live up to its potential. The odds are always good that big power and big money will find a way to control access to virtual communities; big power and big money always found ways to control new communications media when they emerged in the past. The Net is still out of control in fundamental ways, but it might not stay that way for long. What we know and do now is important because it is still possible for people around the world to make sure this new sphere of vital human discourse remains open to the citizens of the

planet before the political and economic big boys seize it, censor it, meter it, and sell it back to us.

The potential social leverage comes from the power that ordinary citizens gain when they know how to connect two previously independent, mature, highly decentralized technologies: It took billions of dollars and decades to develop cheap personal computers. It took billions of dollars and more than a century to wire up the worldwide telecommunication network. With the right knowledge, and not too much of it, a ten-year-old kid today can plug these two vast, powerful, expensively developed technologies together for a few hundred dollars and instantly obtain a bully pulpit, the Library of Congress, and a world full of potential coconspirators.

Computers and the switched telecommunication networks that also carry our telephone calls constitute the technical foundation of *computer-mediated communications* (CMC). The technicalities of CMC, how bits of computer data move over wires and are reassembled as computer files at their destinations, are invisible and irrelevant to most people who use it, except when the technicalities restrict their access to CMC services. The important thing to keep in mind is that the worldwide, interconnected telecommunication network that we use to make telephone calls in Manhattan and Madagascar can also be used to connect computers together at a distance, and you don't have to be an engineer to do it.

The Net is an informal term for the loosely interconnected computer networks that use CMC technology to link people around the world into public discussions.

Virtual communities are social aggregations that emerge from the Net when enough people carry on those public discussions long enough, with sufficient human feeling, to form webs of personal relationships in cyberspace.

Cyberspace, originally a term from William Gibson's science-fiction novel *Neuromancer*, is the name some people use for the conceptual space where words, human relationships, data, wealth, and power are manifested by people using CMC technology.

Although spatial imagery and a sense of place help convey the experience of dwelling in a virtual community, biological imagery is often more appropriate to describe the way cyberculture changes. In terms of the way the whole system is propagating and evolving, think of cyberspace as a social petri dish, the Net as the agar medium, and virtual communities, in all their diversity, as the colonies of microorganisms that grow in petri dishes. Each of the small colonies of microorganisms – the communities on the Net – is a social experiment that nobody planned but that is happening nevertheless.

We now know something about the ways previous generations of communications technologies changed the way people lived. We need to understand why and how so many social experiments are coevolving today with the prototypes of the newest communications technologies. My direct observations of online behavior around the world over the past ten years have led me to conclude that whenever CMC technology becomes available to people anywhere, they inevitably build virtual communities with it, just as microorganisms inevitably create colonies.

I suspect that one of the explanations for this phenomenon is the hunger for community that grows in the breasts of people around the world as more and more informal public spaces disappear from our real lives. I also suspect that these new media attract colonies of enthusiasts because CMC enables people to do things with

each other in new ways, and to do altogether new kinds of things – just as telegraphs, telephones, and televisions did.

Because of its potential influence on so many people's beliefs and perceptions, the future of the Net is connected to the future of community, democracy, education, science, and intellectual life – some of the human institutions people hold most dear, whether or not they know or care about the future of computer technology. The future of the Net has become too important to leave to specialists and special interests. As it influences the lives of a growing number of people, more and more citizens must contribute to the dialogue about the way public funds are applied to the development of the Net, and we must join our voices to the debate about the way it should be administered. We need a clear citizens' vision of the way the Net ought to grow, a firm idea of the kind of media environment we would like to see in the future. If we do not develop such a vision for ourselves, the future will be shaped for us by large commercial and political powerholders.

The Net is so widespread and anarchic today because of the way its main sources converged in the 1980s, after years of independent, apparently unrelated development, using different technologies and involving different populations of participants. The technical and social convergences were fated, but not widely foreseen, by the late 1970s.

The wide-area CMC networks that span continents and join together thousands of smaller networks are a spinoff of American military research. The first computer network, ARPANET, was created in the 1970s so that Department of Defense-sponsored researchers could operate different computers at a distance; computer data, not person-to-person messages, were the intended content of the network, which handily happened to serve just as easily as a conduit for words. The fundamental technical idea on which ARPANET was based came from RAND, the think tank in Santa Monica that did a lot of work with top-secret thermonuclear war scenarios; ARPANET grew out of an older RAND scheme for a communication, command, and control network that could survive nuclear attack by having no central control.

Computer conferencing emerged, also somewhat unexpectedly, as a tool for using the communication capacities of the networks to build social relationships across barriers of space and time. A continuing theme throughout the history of CMC is the way people adapt technologies designed for one purpose to suit their own, very different, communication needs. And the most profound technological changes have come from the fringes and subcultures, not the orthodoxy of the computer industry or academic computer science. The programmers who created the first computer network installed electronic mail features; electronic mail wasn't the reason ARPANET was designed, but it was an easy thing to include once ARPANET existed. Then, in a similar, ad hoc, do-it-yourself manner, computer conferencing grew out of the needs of U.S. policymakers to develop a communications medium for dispersed decision making. Although the first computer conferencing experiments were precipitated by the U.S. government's wage-price freeze of the 1970s and the consequent need to disseminate up-to-date information from a large number of geographically dispersed local headquarters, computer conferencing was quickly adapted to commercial, scientific, and social discourse.

The hobbyists who interconnect personal computers via telephone lanes to make computer bulletin-board systems, known as BBSs, have home grown their part of

the Net, a true grassroots use of technology. Hundreds of thousands of people around the world piggyback legally on the telecom network via personal computers and ordinary telephone lines. The most important technical attribute of networked BBSs is that it is an extremely hard network to kill – just as the RAND planners had hoped. Information can take so many alternative routes when one of the nodes of the network is removed that the Net is almost immortally flexible. It is this flexibility that CMC telecom pioneer John Gilmore referred to when he said, 'The Net interprets censorship as damage and routes around it.' This way of passing information and communication around a network as a distributed resource with no central control manifested in the rapid growth of the anarchic global conversation known as Usenet. This invention of distributed conversation that flows around obstacles – a grassroots adaptation of a technology originally designed as a doomsday weapon – might turn out to be as important in the long run as the hardware and software inventions that made it possible.

The big hardwired networks spend a lot more money to create high-speed information conduits between high-capacity computing nodes. Internet, today's U.S. government-sponsored successor to ARPANET, is growing in every dimension at an astonishing pace. These 'data superhighways' use special telecommunication lines and other equipment to send very large amounts of information throughout the network at very high speeds. ARPANET started around twenty years ago with roughly one thousand users, and now Internet is approaching ten million users.

The portable computer on my desk is hundreds of times less expensive and thousands of times more powerful than ARPANET's first nodes. The fiber-optic backbone of the current Internet communicates information millions of times faster than the first ARPANET. Everything about Internet has grown like a bacterial colony – the raw technical capacity to send information, the different ways people use it, and the number of users. The Internet population has grown by 15 percent a month for the past several years. John Quarterman, whose book *The Matrix* is a thick guide to the world's computer networks, estimates that there are nine hundred different networks worldwide today, not counting the more than ten thousand networks already linked by the Internet 'network of networks.'

Real grassroots, the kind that grow in the ground, are a self-similar branching structure, a network of networks. Each grass seed grows a branching set of roots, and then many more smaller roots grow off those; the roots of each grass plant interconnect physically with the roots of adjacent plants, as any gardener who has tried to uproot a lawn has learned. There is a grassroots element to the Net that was not, until very recently, involved with all the high-tech top-secret doings that led to ARPANET – the BBSers.

The population of the grassroots part of the Net, the citizen-operated BBSs, has been growing explosively as a self-financed movement of enthusiasts, without the benefit of Department of Defense funding. A BBS is the simplest, cheapest infrastructure for CMC: you run special software, often available inexpensively, on a personal computer, and use a device known as a *modem* to plug the computer into your regular telephone line. The modem converts computer-readable information into audible beeps and boops that can travel over the same telephone wires that carry your voice; another modem at the other end decodes the beeps and boops into computer-readable bits and bytes. The BBS turns the bits and bytes into human

readable text. Other people use their computers to call your BBS, leave and retrieve messages stored in your personal computer, and you have a virtual community growing in your bedroom. As the system operator (sysop) of the BBS, you contribute part of your computer's memory and make sure your computer is plugged into the telephone; the participants pay for their own communication costs.

Boardwatch magazine estimates that sixty thousand BBSs operated in the United States alone in 1993, fourteen years after the first BBSs opened in Chicago and California. Each BBS supports a population of a dozen to several hundred, or even thousands, of individual participants. There are religious BBSs of every denomination, sex BBSs of every proclivity, political BBSs from all parts of the spectrum, outlaw BBSs, law enforcement BBSs, BBSs for the disabled, for educators, for kids, for cults, for nonprofit organizations – a list of the different flavors of special-interest BBSs is dozens of pages long. The BBS culture has spread from the United States to Japan, Europe, Central and South America.

Each BBS started out as a small island community of a few people who dialed into a number in their area code; by their nature, like a small-wattage radio station, BBSs are localized. But that's changing, too. Just as several different technologies converged over the past ten years to create CMC – a new medium with properties of its own – several different online social structures are in the process of converging and creating a kind of international culture with properties of its own.

Technical bridges are connecting the grassroots part of the network with the military industrial parts of the network. The programmers who built the Net in the first place, the scholars who have been using it to exchange knowledge, the scientists who have been using it for research, are being joined by all those hobbyists with their bedroom and garage BBSs. Special 'gateway' computers can link entire networks by automatically translating communications from the mechanical languages used in one network to the languages (known as protocols) used in another network. In recent years, the heretofore separate groups of Internet and BBS pioneers worked together to gateway the more than ten thousand computers of the worldwide FidoNet, the first network of small, private BBSs, with Internet's millions of people and tens of thousands of more powerful computers.

The Net and computer conferencing systems are converging too, as medium-size computer conferencing communities like the WELL join Internet. When the WELL upgraded to a high-speed connection to Internet, it became not just a community-in-progress but a gateway to a wider realm, the worldwide Net-at-large. Suddenly, the isolated archipelagos of a few hundred or a few thousand people are becoming part of an integrated entity. The small virtual communities still exist, like yeast in a rapidly rising loaf, but increasingly they are part of an overarching culture, similar to the way the United States became an overarching culture after the telegraph and telephone linked the states.

The WELL is a small town, but now there is a doorway in that town that opens onto the blooming, buzzing confusion of the Net, an entity with properties altogether different from the virtual villages of a few years ago. I have good friends now all over the world who I never would have met without the mediation of the Net. A large circle of Net acquaintances can make an enormous difference in your experience when you travel to a foreign culture. Wherever I've traveled physically in recent years, I've found ready-made communities that I met online months before

I traveled; our mutual enthusiasm for virtual communities served as a bridge, time and again, to people whose language and customs differ significantly from those I know well in California.

I routinely meet people and get to know them months or years before I see them – one of the ways my world today is a different world, with different friends and different concerns, from the world I experienced in premodem days. The places I visit in my mind, and the people I communicate with from one moment to the next, are entirely different from the content of my thoughts or the state of my circle of friends before I started dabbling in virtual communities. One minute I'm involved in the minutiae of local matters such as planning next week's bridge game, and the next minute I'm part of a debate raging in seven countries. Not only do I inhabit my virtual communities, to the degree that I carry around their conversations in my head and begin to mix it up with them in real life, my virtual communities also inhabit my life. I've been colonized; my sense of family at the most fundamental level has been virtualized.

I've seen variations of the same virtualization of community that happened to me hitting other virtual groups of a few hundred or a few thousand, in Paris and London and Tokyo. Entire cities are coming online. Santa Monica, California, and Cleveland, Ohio, were among the first of a growing number of American cities that have initiated municipal CMC systems. Santa Monica's system has an active conference to discuss the problems of the city's homeless that involves heavy input from homeless Santa Monica citizens who use public terminals. This system has an electronic link with COARA, a similar regional system in a remote province of Japan. Biwa-Net, in the Kyoto area, is gatewayed to a sister city in Pennsylvania. The Net is only beginning to wake up to itself.

Watching a particular virtual community change over a period of time has something of the intellectual thrill of do-it-yourself anthropology, and some of the garden variety voyeurism of eavesdropping on an endless amateur soap opera where there is no boundary separating the audience from the cast. For the price of a telephone call, you can take part in any kind of vicarious melodrama you can dream of; as a form of escape entertainment, the Minitel addicts in Paris and the MUDders of Internet and the obsessive IRC participants on college campuses everywhere have proved that CMC has a future as a serious marketplace for meterable interactive fantasies.

CMC might become the next great escape medium, in the tradition of radio serials, Saturday matinees, soap operas – which means that the new medium will be in some way a conduit for and reflector of our cultural codes, our social subconscious, our images of who 'we' might be, just as previous media have been. There are other serious reasons that ordinary nontechnical citizens need to know something about this new medium and its social impact. Something big is afoot, and the final shape has not been determined.

In the United States, the Clinton administration is taking measures to amplify the Net's technical capabilities and availability manyfold via the National Research and Education Network. France, with the world's largest national information utility, Minitel, and Japan, with its stake in future telecommunications industries, have their own visions of the future. Albert Gore's 1991 bill, the High Performance Computing Act, signed into law by President Bush, outlined Gore's vision for 'highways of the mind' to be stimulated by federal research-and-development expenditures as a

national intellectual resource and carried to the citizens by private enterprise. The Clinton-Gore administration has used the example of the ARPA (Advanced Research Projects Agency) venture of the 1960s and 1970s that produced the Net and the foundations of personal computing as an example of the way they see government and the private sector interacting in regard to future communications technologies.

In the private sector, telecommunication companies, television networks, computer companies, cable companies, and newspapers in the United States, Europe, and Japan are jockeying for position in the nascent 'home interactive information services industry.' Corporations are investing hundreds of millions of dollars in the infrastructure for new media they hope will make them billions of dollars. Every flavor of technological futurist, from Alvin Toffler and John Naisbitt to Peter Drucker and George Gilder, base utopian hopes on 'the information age' as a techno-fix for social problems. Yet little is known about the impact these newest media might have on our daily lives, our minds, our families, even the future of democracy.

CMC has the potential to change our lives on three different, but strongly inter-influential, levels. First, as individual human beings, we have perceptions, thoughts, and personalities (already shaped by other communications technologies) that are affected by the ways we use the medium and the ways it uses us. At this fundamental level, CMC appeals to us as mortal organisms with certain intellectual, physical, and emotional needs. Young people around the world have different communication proclivities from their pre-McLuhanized elders. MTV, for example, caters to an aesthetic sensibility that is closely tuned to the vocabulary of television's fast cuts, visually arresting images, and special effects. Now, some of those people around the world who were born in the television era and grew up in the cellular telephone era are beginning to migrate to CMC spaces that better fit their new ways of experiencing the world. There is a vocabulary to CMC, too, now emerging from millions and millions of individual online interactions. That vocabulary reflects something about the ways human personalities are changing in the age of media saturation.

The second level of possible CMC-triggered change is the level of person-to-person interaction where relationships, friendships, and communities happen. CMC technology offers a new capability of 'many to many' communication, but the way such a capability will or will not be used in the future might depend on the way we, the first people who are using it, succeed or fail in applying it to our lives. Those of us who are brought into contact with each other by means of CMC technology find ourselves challenged by this many-to-many capability – challenged to consider whether it is possible for us to build some kind of community together.

The question of community is central to realms beyond the abstract networks of CMC technology. Some commentators, such as Bellah *et al.* (*Habits of the Heart*, *The Good Society*), have focused on the need for rebuilding community in the face of America's loss of a sense of a social commons.

Social psychologists, sociologists, and historians have developed useful tools for asking questions about human group interaction. Different communities of interpretation, from anthropology to economics, have different criteria for studying whether a group of people is a community. In trying to apply traditional analysis of community behavior to the kinds of interactions emerging from the Net, I have adopted a schema proposed by Marc Smith, a graduate student in sociology at the

University of California at Los Angeles, who has been doing his fieldwork in the WELL and the Net. Smith focuses on the concept of 'collective goods.' Every cooperative group of people exists in the face of a competitive world because that group of people recognizes there is something valuable that they can gain only by banding together. Looking for a group's collective goods is a way of looking for the elements that bind isolated individuals into a community.

The three kinds of collective goods that Smith proposes as the social glue that binds the WELL into something resembling a community are social network capital, knowledge capital, and communion. Social network capital is what happened when I found a ready-made community in Tokyo, even though I had never been there in the flesh. Knowledge capital is what I found in the WELL when I asked questions of the community as an online brain trust representing a highly varied accumulation of expertise. And communion is what we found in the Parenting conference, when Phil's and Jay's children were sick, and the rest of us used our words to support them.

The third level of possible change in our lives, the political, derives from the middle, social level, for politics is always a combination of communications and physical power, and the role of communications media among the citizenry is particularly important in the politics of democratic societies. The idea of modern representative democracy as it was first conceived by Enlightenment philosophers included a recognition of a living web of citizen-to-citizen communications known as civil society or the public sphere. Although elections are the most visible fundamental characteristics of democratic societies, those elections are assumed to be supported by discussions among citizens at all levels of society about issues of importance to the nation.

If a government is to rule according to the consent of the governed, the effectiveness of that government is heavily influenced by how much the governed know about the issues that affect them. The mass-media-dominated public sphere today is where the governed now get knowledge; the problem is that commercial mass media, led by broadcast television, have polluted with barrages of flashy, phony, often violent imagery a public sphere that once included a large component of reading, writing, and rational discourse. For the early centuries of American history, until the telegraph made it possible to create what we know as news and sell the readers of newspapers to advertisers, the public sphere did rely on an astonishingly literate population. Neil Postman, in his book about the way television has changed the nature of public discourse, *Amusing Ourselves to Death*, notes that Thomas Paine's *Common Sense* sold three hundred thousand copies in five months in 1775. Contemporary observers have documented and analyzed the way mass media ('one to many' media) have 'commoditized' the public sphere, substituting slick public relations for genuine debate and packaging both issues and candidates like other consumer products.

The political significance of CMC lies in its capacity to challenge the existing political hierarchy's monopoly on powerful communications media, and perhaps thus revitalize citizen-based democracy. The way image-rich, sound-bite-based commercial media have co-opted political discourse among citizens is part of a political problem that communications technologies have posed for democracy for decades. The way the number of owners or telecommunication channels is narrowing to a tiny

elite, while the reach and power of the media they own expand, is a converging threat to citizens. Which scenario seems more conducive to democracy, which to totalitarian rule: a world in which a few people control communications technology that can be used to manipulate the beliefs of billions, or a world in which every citizen can broadcast to every other citizen?

Ben Bagdikian's often-quoted prediction from *The Media Monopoly* is that by the turn of the century 'five to ten corporate giants will control most of the world's important newspapers, magazines, books, broadcast stations, movies, recordings and videocassettes.' These new media lords possess immense power to determine which information most people receive about the world, and I suspect they are not likely to encourage their privately owned and controlled networks to be the willing conduits for all the kinds of information that unfettered citizens and nongovernmental organizations tend to disseminate. The activist solution to this dilemma has been to use CMC to create alternative planetary information networks. The distributed nature of the telecommunications network, coupled with the availability of affordable computers, makes it possible to piggyback alternate networks on the mainstream infrastructure.

We temporarily have access to a tool that could bring conviviality and understanding into our lives and might help revitalize the public sphere. The same tool, improperly controlled and wielded, could become an instrument of tyranny. The vision of a citizen-designed, citizen-controlled worldwide communications network is a version of technological utopianism that could be called the vision of 'the electronic agora.' In the original democracy, Athens, the agora was the marketplace, and more – it was where citizens met to talk, gossip, argue, size each other up, find the weak spots in political ideas by debating about them. But another kind of vision could apply to the use of the Net in the wrong ways, a shadow vision of a less utopian kind of place – the Panopticon.

Panopticon was the name for an ultimately effective prison, seriously proposed in eighteenth century Britain by Jeremy Bentham. A combination of architecture and optics makes it possible in Bentham's scheme for a single guard to see every prisoner, and for no prisoner to see anything else; the effect is that all prisoners act as if they were under surveillance at all times. Contemporary social critic Michel Foucault, in *Discipline and Punish*, claimed that the machinery of the worldwide communications network constitutes a kind of camouflaged Panopticon; citizens of the world brought into their homes, along with each other, the prying ears of the state. The cables that bring information into our homes today are technically capable of bringing information out of our homes, instantly transmitted to interested others. Tomorrow's version of Panoptic machinery could make very effective use of the same communications infrastructure that enables one-room schoolhouses in Montana to communicate with MIT professors, and enables citizens to disseminate news and organize resistance to totalitarian rule. With so much of our intimate data and more and more of our private behavior moving into cyberspace, the potential for totalitarian abuse of that information web is significant and the cautions of the critics are worth a careful hearing.

The wise revolutionary keeps an eye on the dark side of the changes he or she would initiate. Enthusiasts who believe in the humanitarian potential of virtual communities, especially those of us who speak of electronic democracy as a potential

application of the medium, are well advised to consider the shadow potential of the same media. We should not forget that intellectuals and journalists of the 1950s hailed the advent of the greatest educational medium in history – television.

Because of its potential to change us as humans, as communities, as democracies, we need to try to understand the nature of CMC, cyberspace, and virtual communities in every important context – politically, economically, socially, cognitively. Each different perspective reveals something that the other perspectives do not reveal. Each different discipline fails to see something that another discipline sees very well. We need to think together here, across boundaries of academic discipline, industrial affiliation, nation, if we hope to understand and thus perhaps regain control of the way human communities are being transformed by communications technologies.

We can't do this solely as dispassionate observers, although there is certainly a strong need for the detached assessment of social science. Community is a matter of emotions as well as a thing of reason and data. Some of the most important learning will always have to be done by jumping into one corner or another of cyberspace, living there, and getting up to your elbows in the problems that virtual communities face. [. . .]

Chapter 44

Stephen Duncombe

COMMUNITY
The zine scene [1997]

A club of our own

Let's all be alienated together in a newspaper.
John Klima, editor of *Day and Age*

'**THIS COUNTRY IS SO SPREAD OUT**,' 21-year-old Arielle Greenberg tells me, 'people my age . . . feel very separate and kind of floating and adrift. . . . I feel like that myself.' Arielle puts out her zine *William Wants a Doll* because she has thoughts and feelings and experiences that she wants to 'express.' She also does it because she cherishes the sense of community she gets from exchanging zines.

> It's so nice to . . . look forward to your mail and know that you're going to hear from three to four people who you've never heard from before and they're genuinely interested in what you have to say . . . it's a community. I feel really supported.

Zines are an individualistic medium, but as a medium their primary function is communication. As such, zines are as much about the communities that arise out of their circulation as they are artifacts of personal expression. People create zines to scream out 'I exist,' they also do it to connect to others saying the same thing. *Slug & Lettuce*'s Christine Boarts explains [to me]: 'Some days I pick up my mail and it's like . . . I love it . . . I go home and read through it all and it's the greatest feeling . . . just that feeling of being connected with all those people.'

But why would anybody want to be 'connected with all those people' they don't know? Part of the motivation is loneliness, pure and simple. Zine writers may not be able to communicate well face to face, but like most people they want company. A regular feature of *The NEW Bloated Tick* is the 'Letter Beggars

Department,' where publisher Paul Dion prints the names and addresses of people 'begging' for personal letters. And Chris . . . is the self-described shy and quiet weird girl who grew up estranged from the other kids in town. The popularity of newsgroups on the Internet is additional testimony to the popular desire to 'connect' with strangers via the written word.

But loneliness is never pure and simple, and the isolation that generates 'letter beggars' comes from someplace. That someplace can be the everyday grind where the demands of job and family leave little time for socializing. 'After relocating here . . . twelve years ago, and having a child over ten years ago, my social life has withered and nearly died,' writes Robert DuPree in *Notes from Earth* [Summer 1993], explaining why he is starting a zine.

> My professional friends . . . are usually working on their own projects, often at night, and socializing is both erratic and difficult. I've been *very* fulfilled by marriage and fatherhood . . . but still . . . it gets lonely. Not depressingly, unnervingly, or psychotically lonely . . . not Travis Bickle lonely, but . . . lonely.

That someplace can also be a 'no place' as it is for Chris, who writes in *Punk Pals* [March 1990] – a sort of letter beggars zine for punks – that he is 'Bored senseless! Anyone willing to write to a 17 year old in hicksville USA, then please do so.' And that someplace that loneliness comes from can be an all-too-real place – in the case of Richard Stazenski, an Arizona prison. 'I'm pleading HELP!!?' Richard writes in *Maximumrocknroll* [May 1988]:

> I need letters from punx everywhere. I need to keep in touch with what 'reality' I know. . . . My family has written me off as a mistake and my friends are living their own lives. . . . So lately all I've gotten is stuff saying 'I should find God and then go join the Marines' So, if anyone wants to write letters to a depressed 'hardcore convict' (pun intended, sarcasm meant) that's stuck in a world where racism, hate and ignorance run amok – I will write back! Also, if anyone wants art for 'zines – I do nothing but draw – I've got a whole year left before I go to the parole board.

Richard's poignant plea highlights a distinctive feature of the loneliness that motivates zine communication. The personal deprivation Richard describes is not absolute, but *relative*. Stuck inside a state pen, he certainly isn't alone. Nor has he stopped receiving letters: his parents and old friends may have abandoned him, but the evangelical Christians have found him. Instead, what he is deprived of is the 'reality' he once knew on the outside: people interested in punk rock, antiracism, and zines. Richard is surrounded by people, but none who understand him.

'The people I hang around with couldn't care less of what I have to say – about direct action, world events, vivisection, etc.,' complains Tin-Ear, the publisher of *The Happy Thrasher*, 'but by publishing my own zine I reach people that do care' [*Factsheet Five* #31, 1989]. This ideal of putting out a zine as a way of 'meeting people who have a vision similar to mine,' as zine publisher Feral Faun reiterates, is a key aspect of zines [Gunderloy 1989: 6]. The loneliness that zinesters are striving

to overcome through their zines doesn't arise from physical isolation as much as it does from their social alienation. Through their zines, writers are trying to escape the society they feel alienated from while creating a new, albeit virtual, community of friends they can feel connected to.

This has been a function of zines since their beginnings in science fiction. SF zine publisher Don Fitch explains [to me]: 'For many of us fandom was like a family in many ways, and better, because we shared significant literary and intellectual backgrounds, which most of us didn't do in the case of our "real" families.' Zines allow writers and readers to select communities of choice rather than those born of circumstance. 'Community, as I see it,' defines William Baggins in *Scream* [Fall 1995], 'is a fluid process by which individuals seek out and choose others with whom they wish to live and mutually enjoy life.' Jay McLaughlin, for example, in her comic 'Class of '83' establishes that she – unlike the teenage gang on TV's *Beverly Hills 90210* – wants nothing to do with the people she went to high school with. By publishing her story in *Bunyon* [October 1993], she implicitly shifts allegiances to her new community of zine friends. 'Whenever I get mail with some bizarre title in the return address, my wife says [it's] "something from that club you're in,"' *Pah*'s Mark Morelli writes [to me], describing how zines opened his eyes to

> just how many people – diverse and weird and vulgar and solipsistic and brilliant and funny and indulgent and angry and inventive and so on – are out there still placing their faith in the written word . . . and though I've never met any of them personally, I share the correspondence of their zines, which we all giddily delight in calling a club of our own.

Clubhouse

Communities need institutions. A community is 'a collection of people occupying a more or less clearly defined area,' according to Robert Park, but, as he elaborates, 'a community is more than that, it is a collection of institutions' [Park *et al.* 1925: 115]. A club needs a clubhouse. And when a community is not defined geographically, as the zine community is not, these institutions take on increased importance.

Every zine is a community institution in itself, as each draws links between itself and others. Many zines include extensive 'letters' columns, sometimes spreading letters throughout their zine, drawing no sharp distinction between these and other content, and most zines print reviews of other zines, telling their readers how to send away for them. Letters and reviews – and the importance that zines give to them – ensure that zines are not only the voice of an individual publisher, but a conduit for others' expressions as well.

This notion of a zine as a community institution – a clubhouse – is conspicuous in zines like Bonnie Jo's *Letter Parade* which, as her title suggests, has an impressive letters section. The issue covering the month of February 1990 includes news from:

- ND, from Pullayup, WA, on bad weather in the Northwest;
- JS, of California, with a first-person account of an earthquake there and a rant on how the media overplayed the event for ratings;

- SL, of Berkeley, CA, who has graduated (after eight years) from college, and gives more first-hand news about the earthquake;
- Susanna Campbell's slightly eccentric personal discourse and history on life-savers – the candy and flotation device;
- comix by Pagan Kenedy, on her loony Southern, Confederate ancestors;
- Cousin Mimi's update on her one-year-old son, a garden report, and mention that all her friends are moving to California;
- LY, from Madison, WI, who is graduating from college and contemplating the grim prospect of a job in the system she hates;
- LSR of Sandstone, MN, a federal prisoner who tells of his job as a clerk/typist and complains about regulations and inhumane treatment.

Letter Parade is a perzine multiplied. Reading it is like stepping into a small, unpretentious community whose diversity stretches from hipsters (Pagan Kenedy), to prisoners (LSR), to Cousin Mimi.

But Bonnie Jo's zine also constitutes a community in another way. Of the ten pages that make up her February issue, only four are written by Bonnie Jo herself. Of the remaining six, two are composed of the letters synopsized above, two are given over to an essay by R.A. Bairnes on remembering Christmas as a child, and the last couple of pages are merely reproduced clippings of odd world events compiled by C.J. Magson. (The latter includes an account of a man stopped by police for 'walking oddly' and was found to have twenty-one homing pigeons stuffed into his clothes.)

Although zines tend to be one-person shows, having multiple contributors to a zine is not unusual. But *Letter Parade* is different: contributions are not edited by Bonnie Jo to *fit into* her zine, they are reproduced and bound together to *make up* her zine. Each component – with different typeface, layout, and author – stands on its own. Bonnie Jo isn't the editor of her creation, she is an organizer of a virtual community.

This form wasn't invented by Bonnie Jo; it's derivative of an APA, a zine 'jointly written by the subscribers, each of whom prints up his own part and gets copies of everyone else's in return,' as defined in the pages of *Factsheet Five* [#13, 1984]. APA is short for Amateur Press Association, and while the form makes up only a minority of zines in the zine world today it has strong historical roots.

APAs began in the United States in the first decades of the nineteenth century as both a creation of and a reaction to the beginnings of the mass-circulation penny press. The new economy of mass media had expanded the notion of a 'literate public,' but also displaced many voices to the sidelines. In the new mass production world where one product was sold to hundreds of thousands of individuals, the creative powers of most individuals were not needed. Put in a different way, within the *Weltanschauung* of the new mass culture industry, many people's ideas and creativity were simply *unimportant*.

But these unimportant people still wrote and still created, refusing to be merely a 'market' passively consuming the culture prepared for them. Beginning as early as 1812, 'amateur papers' (in sharp distinction to the new 'professional press') were being printed, in the beginning by children but, as time went on, more and more by adults. Using both toy presses and printing equipment scavenged from the

professional press, amateur journalism grew by leaps and bounds in the post-Civil War period. An 1875 directory listed over 500 writers and editors and almost as many publications. These publications plagiarized popular authors, published corny prose, and reproduced engravings; like zines, they printed pretty much anything their publishers felt like expressing.

Michelle Rau, writing the only [unpublished, 1991] history of zines I've found, begins her history with these amateur presses. Although I prefer to set the date back and cast my net wider, I think Rau has a valid point. These amateur publishers didn't just produce papers, they created *associations*, systems of communication and distribution that are the prototypes of zine communities today. In 1876, the NAPA or National Amateur Press Association was formed, superseding a number of regional associations and giving national coherence to this growing form (as well as spawning groups like the Ladies' Amateur Press Association and a Negro APA). It was in the NAPA that the tradition of individuals sending their writings to a central mailer, who then collated and redistributed them, was first codified, and the name APA came to stand not only for the organization that produced the zine but the zine itself. The NAPA faded away, but the model of APAs as both a publication and a means of association was picked up by science fiction fans in the twentieth century as an ideal medium by which to bind together geographically scattered fans, and from here the practice entered the zine world.

While APAs take the letters section of most zines and extend it to its logical extreme, a zine of all letters, other zines expand the reviews section, creating a zine entirely made of reviews. Science fiction fans call these 'data zines,' but the more current, popular – and accurate – term is 'network zines.'

Ashley Parker Owens regularly puts out *Global Mail* – 'to help as many people connect as possible' – and lists an impressive number (343 in issue 8) of individuals seeking letters, zines looking for contributors, mail art shows looking for entries, and listings for other exchanges. 'Send me belly button fuzz, dolls, and images of Madonna, and I'll send you something special,' Patty M. writes in. Another: 'Send a postcard describing your day; a mini-journal, an odd event, where you went and who you talked to, get a day in my life in return. Paul Anonymous' [May-August 1994]. *Face*, a self-described 'networker' zine, lists eight pages of zine reviews, calls for submissions to zines and mail art shows, and concludes with a page of names and addresses with no other explanation than the word 'contacts' [#6, 1993]. But *el jefe* of network zines is *Factsheet Five*. Begun by Mike Gunderloy in May 1982, the first *FS5* was a one-page mimeograph listing six zines and sent out to – at most – fifty people. Numerous editors, fourteen years, and almost sixty issues later, it averages over 140 pages, reviews over 1,400 zines, and has a print run of over 15,000.

Early on, Mike saw the potential of *Factsheet Five* to cross-fertilize the different strains of underground publishing happening in the early 1980s, and in its earlier years zine listings in *FS5* were not categorized by genre, much less alphabetically. Asked at one point by a reader why he didn't do such a categorization, as it would make his zine easier to read, Mike responded, '[E]very time I suggest doing such a thing the readers get all upset and write me nasty letters' [#22, 1987]. Part of the objection, Mike explained, had to do with the familiar zinester distrust of *any* order. But people were also enjoying the crossover the lack of genre categories encouraged. 'I always vow to only skim through, reading titles to detect something in my

interest area,' Janet Fox writes in, 'But invariably I eventually read almost all the reviews . . . if somebody has reached a new level of consciousness raising hogs in Idaho, I certainly want to know it' [#23, 1987].

With the help of cross-pollinating institutions like *Factsheet Five*, zines began to slip their moorings as fanzines of their host cultures and take their position under a wider umbrella as zines qua zines. To zine writers and readers it seemed as if 'a true subculture is forming, one that crosses a number of boundaries,' as described by William Peschel in a personal letter to Mike. 'Christians, gays, artists, occultists, bowlers, historians, prisoners, diarists. I can't think of a place where one can be exposed to a wider range of thought.' 'It's a global network out there,' *The Sweet Ride's* Mookie Xenia concurs [in *Factsheet Five* #28, 1988], 'and I want to be part of it, expand my horizons and let my written scenarios warp or delight people.'

This conglomeration of disparate publications and publishers developed certain traits indicative of a community: a shared lingo that appears in a glossary for the first time in the thirteenth issue of *Factsheet Five*; a *Who's Who?*, Jim Romenesko's zine *Obscure*, which gives community news on the zine world and refers to a species known as 'notable zinesters'; and even a philanthropist – Tim Yohannan, the editor of *Maximumrocknroll*, who distributes the yearly profit of his zine amongst zine writers and others undertaking similar projects.

But the type of community being produced and discussed in the world of zines has novel characteristics. In fact, the word 'community' as a term is used rarely, if ever, among zine writers. 'Network' is the favored term. The ideal of a networked community is visualized in the cover illustration for *Factsheet Five*, 35 [1990], in which a punk with spiked hair hands a comic to a young black man, a bearded hippie picks up a poetry zine from a soldier in uniform, an older beatnik gets an album from a straight-looking young woman, an older Gypsy passes a zine to a trendy girl, and a businessman with a tie shares a film with a space alien. This vision of disparate individuals each in his or her separate frame, but all reaching across boundaries, is the ideal of the zine network.

If community is traditionally thought of as a homogeneous group of individuals bound together by their commonality, a zine network proposes something different: a community of people linked via bonds of difference, each sharing their originality. 'Reading ALL the reviews helps me see where our differences lie,' writes Luke McGuff in a letter to *Factsheet Five* [#22, 1987].

This model is the very essence of a libertarian community: individuals free to be who they want and to cultivate their own interests, while simultaneously sharing in each other's differences. It allows people the intimacy and primary connections they don't find in a mass society; but with none of the stifling of difference that usually comes with tight-knit communities. This type of association has long been the dream of anarchism, parallels the hopes of multiculturalism, resonates with the virtual community of the Internet, and describes the ideal of the place that is bohemia.

The scene

Networks of science fiction zine writers overlap those of personal zine writers which intersect the webs of queer and anarchist zines, but central to the greater network

that connects all zines is the Scene: the loose confederation of self-consciously 'alter-native' publications, bands, shows, radio stations, cafés, bookstores, and people that make up modern bohemia.

The name 'bohemia' conjures up images of Paris cafés, cold-water New York City walk-ups, and San Francisco poetry readings. Certainly bohemia still exists in these locales, and zines help to weave the scene together in these places. But more common than a New York or San Francisco 'scene zine' are ones like that written by Eric, who publishes to 'rave on and on about the scene back home' in Pennsylvania's Lehigh Valley; or 'scene reports' from Huntsville, Alabama [*Factsheet Five #22*, 1987]. These are bohemias in backwater towns and suburbs scattered throughout the United States.

Bohemia today is first and foremost not a single bohemia – it is many and they are widely dispersed. As C. Carr coined it, it is a 'bohemia diaspora,' and 'for the first time in 150 years, bohemia can't be pinpointed on the map' [Carr 1992: 27]. The reasons for this dispersal are multiple, foremost being the fact that bohemia followed in the shadow of mainstream society, spreading out of the cities and into the suburbs. But this dispersal is also linked to more recent phenomena: gentrification and a superheated culture market.

While the Beats of the fifties and the counterculturists of the sixties benefited from the cheap urban quarters left in the wake of the middle-class white flight to the suburbs, hipsters of the decades that followed were priced out of established bohemian locales by the return of the middle class. Young professionals, sometimes veterans of the sixties counterculture themselves, wanted the excitement and cultural vivacity that living in bohemian neighborhoods offered, and had good-paying jobs to ensure they could live where they pleased.

Priced out of traditional bohemias, new bohemians moved elsewhere . . . and were soon followed by yuppies, the process repeating itself, ad infinitum. [. . .]

Add into this equation the superheated high-art market of the 1980s and the ever-growing importance of the cultural industry to the American economy – by now the USA's second largest export – and the results for bohemia were disastrous. Immediately after inception, cultural innovations (and their creators) were thrown under the spotlight, feted and dined in Soho or on Wall Street, then bought up and moved out, or discarded as unworthy and unprofitable. The impact of these two forces on the cultural world that traditionally populates bohemia was severe: you were either up and out or down and out; you reached instant stardom or were unable to pay your ever-increasing rent. Either way the result was exodus. For the old bohemia and the healthy discontent and creativity it fostered this exodus was lethal. 'Dissent cannot happen in a vacuum', argues Carr. 'Nor can social or aesthetic movements grow in one. Community is the fabric that sustains experiment, stimulating that leap into the void and maybe even cushioning a fall' [27].

For some critics this disappearance of physical locale is irreplaceable. Russell Jacoby, bemoaning the death of the public intellectual, writes,

> Fragile urban habitats of busy streets, cheap eateries, reasonable rents, and decent environs nourish bohemias. . . . When this delicate envi-ronment is injured or transformed, the 'surplus' intellectuals do not

disappear, but disperse; they spread out across the country. The differ-
ence is critical: a hundred artists, poets, and writers with families and
friends in ten city blocks means one thing; scattered across ten states or
ten university towns, they mean something else.

[Jacoby 1987: 28]

And for Jacoby that something else signals the death of bohemia.

But bohemia has been declared dead and buried too many times for anyone to
take such pronouncements too seriously. And it is not completely true that
geographical bohemias don't exist anymore. There's the Mission in San Francisco,
Manhattan's Lower East Side and, across the river, the unfortunate Williamsburg,
Brooklyn (unfortunate for being heralded as the 'New Bohemia' every couple of
years in the Real Estate section of the *New York Times*). Seattle, Olympia, Portland,
Austin, Minneapolis, Chapel Hill, Richmond: all these locales possess bohemian
scenes. But the fact remains that there is no longer Paris – no longer one, unified
and coherent geographical bohemia.

Marigay Graña, in the preface to a monumental anthology of writings entitled
On Bohemia, writes as follows:

> In reviewing the literature for this anthology we were able to come up
> with only two characteristics of bohemianism which appear to hold
> constant over the century-and-a-half of its recognized existence: (1) an
> attitude of dissent from the prevailing values of middle-class society –
> artistic, political, utilitarian, sexual – usually expressed in life-style and
> through a medium of the arts; and (2) a café.

[Graña and Graña 1990: xv]

In the new bohemian diaspora, place no longer plays the important part it once
did. When cafés are renamed coffee bars, and a nationwide chain – Starbucks – is
profiled in the *Wall Street Journal* [8 January 1993] as one of the fastest-growing and
most profitable businesses of the year, the café as a locus of bohemia is in its death
throes. One hundred and fifty years of geographical bohemia may indeed be coming
to an end. And perhaps that is only to be expected. The world in which we live is
an increasingly mobile one and becoming ever more decentralized across space.
Besides, there was always something contradictory about nailing a name synonymous
with Gypsies and vagabonds to a fixed location.

If the characteristic of place no longer holds, the other characteristics – those
of bohemian ideas, practice and creativity – live on through nonspatial networks.
Webs of communication can offer the community the support and the feeling of
connection that are so important for dissent and creativity. One of these networks,
these virtual spaces where bohemia still exists, is the network of zines.

Asked to characterize her *Slug & Lettuce*, Christine Boarts uses rare instrumental
terms, describing it [to me] as 'providing space for communication and networking
within underground music and political scenes.' In other words, *S&L* is a virtual
café. In issue 29 [February/March 1993], Chris is the hostess who greets scenesters
with 'Some Thoughts,' a long personal editorial about living in New York City and
feeling like 'a faceless body in a crowd.' Inside, entertainment is provided by photos

of punk shows, and zine and record reviews. Back pages are given over to armchair philosophers who opine on subjects from information on AIDS to the imprisonment of Native American activist Leonard Peltier to the ever-pertinent question, what is punk? And the free classified ads that make up the bulk of *S&L* are the patrons looking for company: 'Oi, Everyone. Interested in Philippine stuff? Send me your stuff list and I'll send you mine . . .'; or 'I'm a poor little punk girl in search of someone to share thoughts with. . . . I'm chemfree, I hate homophobics, conformity, bimbos, and many other things.' Places to stay, spaces to play shows, zines looking for contributors, bands looking for members, homemade T-shirts for sale – *S&L* makes a space for it all.

The idea of zines holding a scene together is not new. . . . With coffeehouses owned by corporations and traditional bohemian neighborhoods populated by middle-class professionals, zines like *S&L* offer an invaluable service, acting as café, community center, and clubhouse that help connect these bohemians to one another, providing the 'cement' that holds together a dispersed Scene.

But if zines like *Slug & Lettuce* bind the Scene together by providing *virtual cafés*, others do it by providing tour guides to the bohemian diaspora scattered across *terra firma*. This function explains the almost ubiquitous presence in punk zines of the band tour diary. In these diaries the zine writer takes the reader on a day-by-day tour with the band: riding in vans, playing at clubs, eating bad food, crashing on couches. A member of Born Against chronicles his band's tour in *I, Yeast Roll* [October 1993]:

> *Baltimore, MD*
> *March 4, 1993*
> Spent last night here at Brooks' house, marinating in my own useless-ness. Spent the night before that in a parking lot of a Louisville Taco Bell, sleeping in the loft of my van, after having arrived many hours too late for our show with Agent Orange. I am eating reheated pasta and drinking some old Fresca . . . a coca-cola beverage, making me guilty in global corporate fascism.

A slight variation on the tour diary theme is the 'road trip,' where much the same thing is chronicled, sans the band. In *Gogglebox* [Winter 1995], Jennifer takes her reader with her as she bums rides from New York City to San Francisco. The editor of *Po* [#14, 1993] produces a map of his road trip. And in the January 1993 issue of *Crash*, after chronicling their own road trip, the writers invite readers to 'Join the Crash Network!', a network of people looking for places to crash and others offering up their floor to be crashed on.

One way to understand this regular feature of zines is as a modern extension of the great American directive: Go West, young man! Following in the footsteps of Woody Guthrie, Jack Kerouac, the Merry Pranksters, and Thelma and Louise, rebels hit the road. 'Freedom from school, freedom from [boyfriend] Brian, freedom to live for nothing except my own desires and curiosities,' writes Jenn of *Gogglebox* [Winter 1995], about to head out on her road trip. Shaking the dust from your heels, beholden only to circumstance, is a deeply American dream.

In this long boho road trip tradition, chroniclers always present *their* America. Zinesters are no different. Rarely, if ever, are the Grand Canyon, Disney World,

the Washington Monument, or other sanctified sites on the tourist trail mentioned. Instead the landmarks are the individuals the zine writers meet, the clubs where the bands play, the underground bookstores they visit, in brief, the people and places of the Scene. The tour diaries and road trips in zines bring to life the landscape of a dispersed bohemia.

The underground is not a tight, formalized, and coherent social grouping with firm boundaries; instead it is a nongeographical sprawl which must be mapped out. Publications put out by zinesters such as *Book Your Own Fuckin' Life: Do-It-Yourself Resource Guide* list state by state the zines, cafés, radio stations, alternative clubs, and so forth that make up this underground diaspora. 'We have shows in the basement,' the 700 Club in Fargo, North Dakota, advertises. 'Plenty of room for traveling bands . . . donations of beer and cigarettes accepted. Talk a lot of shit and you'll fit right in (A few couches, a shower and a kitchen).' Through the narrative of road trips and tour diaries, zine writers draw connections between these scattered sites, charting a map of the underground.

But even with the impressive list of institutions and connections listed in guides like *Book Your Own Fuckin' Life*, modern bohemia is extremely precarious. As a result of the geographical dispersion, which limits a concentration of resources, and a speculative urban real estate economy which curtails investment, there is simply not an abundance of material structures – self-consciously underground coffeehouses, bookstores, clubs – scattered throughout the country. And those that do exist are in constant danger of being 'discovered' by nonbohemians: of being gobbled up and ruined by an insatiable consumer culture industry and an all-consuming public with an always watchful eye for the new thrill. Because of the infrastructural deprivation of bohemia, zines have another function: the road trips and tour diaries map out the bohemia that can be found within the everyday. The narratives give keys to decipher a world that lies below the straight world, in front of the eyes of 'normal' society but invisible to their gaze. Zines are a shadow map of the USA.

Within the shadow map ordinary things are invested with different meanings. In *Pool Dust*'s road trip, abandoned pools and storm drain culverts become temporary skateboard parks. In other zines, Veterans of Foreign Wars halls become punk clubs, or laundromats are transformed into cafés for impromptu poetry readings. And in countless zine tales, Kinko's is a potential free printing press if you know the right scam [*Cometbus*, Spring 1994].

'There is poetry everywhere,' Rob Treinen writes in *Cramped and Wet* [n.d.] explaining why he reprints letters found on the ground and in garbage cans. Marc Arsenault describes his *Andy's Chair* [to me] as 'The journal of things missed. . . . Things forgotten.' And, as recounted in Aaron Cometbus's story of killing time in Janesville, forgotten back streets in dusty towns become special merely because they are forgotten. What is 'nothing at all' to the straight world becomes something for the underground. Even mundane items like a children's science experiment book from the 1950s take on a different meaning when recontextualized through different eyes and repackaged in a zine. As *William Wants a Doll*'s Arielle Greenberg elliptically yet accurately defines it [to me]: 'The Scene is a network of things that people who don't know the Scene wouldn't necessarily know are cool.'

In addition to reinvesting the everyday with shadow values, zines often highlight and joyfully recount out-of-the-ordinary events and places as testament to the

depth and breadth of the weirdness in the USA that lurks just below the patina of normality. Adam Bregman, Los Angeles mayoral aspirant and editor of *Shithappy*, tells tales of his travels with the Cacophony Society as they tour the Great Western Gun Show, visit booths that sell Nazi armbands next to little toy bunnies, and play the game 'Guess Who's a Serial Killer' while watching the crowd (about the time the Oklahoma City bomber was making his gun show rounds too). On another field trip, Adam and co. have lunch at the LA Police Training Academy sitting beneath the LAPD's brass knuckle collection [#3, 1993].

The shadow map is the property of people who possess very little. What they do possess is the ability to give things they don't own *new meanings*. As Dick Hebdige and others in the early days of the Centre for Contemporary Cultural Studies in Birmingham have argued, this 'semantic rearrangement of components of the objective world' gives people who are materially impoverished material with which to fashion their subcultures [Hebdige 1975: 93]. Stuck with the moniker 'loser,' zine writers transform it into an accolade; dispersed geographically without the resources to build their own physical spaces, they chart out a world of bohemianism, overlaying the straight world with one of their own. While these new bohemians do not command significant material resources, what they do have is a vast communication network and thus the ability to build, combine, and spread this bohemian shadow map of the USA. Combined with the network of people and institutions that do exist, and virtual community centers like *Slug & Lettuce*, the bohemian diaspora holds together. The Scene may not be a place, but it is a community.

Sharon Kinsella

AMATEUR MANGA SUBCULTURE AND THE *OTAKU* INCIDENT [2000]

THE RAPID ASCENDANCY of the weekly manga magazine industry during the 1960s encouraged the development of a sphere of non-commercial and amateur manga production. Artists who were excluded from recruitment or who did not want to work for the new manga magazines developed other ways of distributing their manga. It was the launch of the manga magazine industry which provided the initial impetus for the gradual bifurcation of 'mainstream' manga and 'underground' (*uragawa*, *angura*) manga, into professional manga and amateur manga. Non-commercial manga produced in the 1960s to mid-1970s was ignored by the publishing industry and the government until the late 1980s, when it began to receive belated critical attention and the interest of large publishers. While 'underground' manga of this earlier period was promoted and partially re-integrated into 'main-stream' manga, during the 1990s the contemporary amateur manga medium was simultaneously ostracized and repressed.

During the 1960s rental manga (*kashihon gekiga*) and the Osaka-based *akabon* manga publishing industries were usurped by weekly manga magazines produced by large publishers based in Tokyo. For the manga artists who managed to make the transition from periodic or monthly production cycles to weekly production cycles this switch-over had two principal effects. Manga artists had to work much faster, and the style and content of their work became more closely monitored and commissioned by publishing companies.

Rental manga publishing companies paid notoriously low wages, but manga artists experienced a great deal of leniency over the details of the series they produced. Large publishers such as Kōdansha offered rates per page which were up to ten times as high as those offered by the rental manga companies, in order to attract artists to produce weekly series for their magazines. Some experienced manga artists felt that the new mode of production was nipping the internal development of the new story manga in the bud, and that editorial production (*henshū seisan*) was

infringing upon the liberty of manga artists to draw properly. Artists argued that the personal space in which artists could express their ideas within their work had shrunk. [. . .]

Mini communications

At the beginning of the 1970s cheap and portable offset printing and photocopying facilities rapidly became available to the public. Amateur manga and literature could be reproduced and distributed cheaply and easily, creating the possibility of mass participation in unregistered and unpublished forms of cultural production. During the early 1970s the new possibilities opened up by this technology also meant that it was relatively easy for individuals to set up small publishing and printing companies. Many ex-radical students who had ruined their chances of joining a good company through their political activities, or who were turning their energies to youth culture for more specific individual reasons, set up one-man publishing companies producing small, erotic or specialist culture magazines, many of which also contained sections of more unusual manga. Others established small offset printing companies which gradually began to specialize in printing short-runs of amateur manga to professional standards for individual customers.

Using the services of the new mini printing companies, individuals from all walks of life could now print and reproduce their own work without approaching publishing companies. This twilight sphere of cultural production, spreading beneath the superstructure of mass communications, (*mass commi*) became known as the mini communications (*mini commi*). The relationship of Japanese *mini commi* to the mass communications industry corresponds in many of its aspects to the relationship between Anglo-American fanzine networks and television producers (Penley 1991). Sociologist John Fiske's characterization of these Anglo-American fanzine networks as 'shadow cultural economies' (Fiske 1992: 30) existing beneath official cultural economies, is also equatable with the structure of Japanese *mini commi*. With regard to its amateur, decentralized and open structure, printed *mini commi* might be compared to the emergence of the computer internet during the 1990s. One of the most extensive forms of mini communications in Japan was to become printed amateur manga.

Contemporary printed amateur manga are known as *dōjinshi* – a term previously used to refer to pamphlets or magazines distributed within specific associations or societies. Alongside the growth of the commercial manga industry, and following the development of cheap offset printing and photocopying facilities, the number of manga artists and fans printing and distributing editions of their own amateur manga *dōjinshi* began to increase, first slowly in the 1970s, and then rapidly during the 1980s.

Manga conventions

In 1975 a group of young manga critics, Aniwa Jun, Harada Teruo and Yonezawa Yoshihiro, founded a new institution to encourage the development of unpublished

amateur manga. The institution was Comic Market (also known by the abbreviations *Comiket* and *Comike*), a free space in the form of a convention held several times a year where amateur manga could be bought and sold. Yonezawa Yoshihiro, the current president of *Comiket*, explained how it was established in response to the changing political orientation official manga industry: 'All the independent comics and meeting places of the 1960s were disappearing by 1973 to 1974, and then *COM* magazine folded. It was a regression, from being able to publish all kinds of stuff in mainstream magazines to being able to publish only unusual stuff in *dōjinshi* underground magazines. But what else can you do, but start again from the underground?'

Large publishing companies ceased to systematically produce radical and stylistically innovatory manga series around 1972, because they no longer matched sufficiently closely the changed interests of their mass audiences. Younger manga artists and fans interested in developing the manga medium in directions other than those dictated by manga publishers, were forced to turn to amateur production as an alternative outlet for unpublishable material. The amateur manga medium rapidly developed an internal momentum, partially independent of developments in commercial manga publishing.

Between 1975 and 1984, Comic Market was held on three days a year, after which point attendance grew so large that it was rescheduled to two weekend conventions held in the Tokyo Harumi Trade Centre, in August and December. In 1995 these bi-annual weekend conventions were extended to three-day events. The first Comic Market held in December 1975 attracted 32 amateur manga circles, and 600 individuals (*Comic Market 46*: 15). Attendance grew slowly between 1975 and 1986, and rapidly between 1986 and 1992.

Comic Market became the central organization of the amateur manga medium, the existence of which encouraged the formation of new amateur manga circles, in high schools, in colleges and amongst amateur manga artists with similar interests across the country. [. . .]

Dōjinshi artists

In the second half of the 1970s when Comic Market was still a relatively small cultural gathering, a high proportion of *dōjinshi* artists graduated from amateur to professional status. Ishii Hisaichi, Saimon Fumi, Sabe Anoma, Kono Moji, Takahashi Hakkai, and Takahashi Rumiko, all produced *dōjinshi* and distributed them at Comic Market, subsequent to becoming famous, professional female artists (Takarajima 1989: 78). As the size of the amateur medium grew in the 1980s this flow of artists into commercial production decreased sharply.

. . . Amateur manga conventions are the largest mass public gatherings in contemporary Japan. The tendency towards mass gatherings evidenced at amateur manga conventions has a parallel in rave and festival culture (Glastonbury Festival to Tribal Gathering) which peaked in the United Kingdom during approximately the same time frame.

Most amateur artists and fans are aged between their mid-teens and mid-twenties – the mean age is nineteen. Although no statistics have been recorded,

Yonezawa Yoshihiro has also observed that young Japanese from low-income back-grounds, typically raised in large suburban housing projects (*danchi*), and attending lower ranking colleges, or without higher education, are the majority participants of Comic Market. The significance of this observation is not straightforward. Despite the academic and media attention given to higher education and the emergence of a universal middle-class in contemporary Japan, the majority of young Japanese do not go on to higher education, and of those that do, a large proportion attend low-ranking colleges. At the same time the majority of Japanese people now live in suburban housing complexes and apartment blocks. While this could be taken to suggest that the sociological composition of Comic Market is therefore standard and representative, the significance of this observation is, perhaps, that this is one of the very few cultural and social forums in Japan (or any other industrialized country), which is not managed by privileged and highly-educated sections of society.

This observation is particularly interesting in light of the emphasis on the accumulation of cultural information which can be observed within the amateur manga world. Although largely excluded from professional employment and grad-uate social circles, many amateur manga artists appear to seek pleasure in being specialized and well-informed. By applying Pierre Bourdieu's theory of the 'cultural economy' to Anglo-American fanzine subcultures, John Fiske has developed the theory that these subcultures operate as 'shadow cultural economies' which provide individuals typically lacking in official cultural capital, namely education and the social status with which education is rewarded, with an alternative social world in which they can get access to a different kind of 'cultural capital' and social prestige (Fiske 1992: 30). It is possible that the intense emphasis placed, firstly, on educa-tional achievement and secondly, on acquiring a sophisticated cultural taste, in Japan since the 1960s, has in fact stimulated the involvement of young people excluded from these officially recognized modes of achievement with amateur manga subculture.

Nevertheless a fraction of the rapid growth of the amateur manga medium at the end of the 1980s is accounted for by the arrival of teenage artists from privi-leged backgrounds at amateur manga conventions. These new participants, some of them the students of elite universities, are attributed to parents who were active in the counter-culture and political movements of the late 1960s, and who have passed on both their class and some of their positive attitude towards manga to their children.

The huge proliferation of *dōjinshi* production in the wake of the mini commu-nications boom which enabled many ordinary Japanese youth to start producing amateur manga, meant that by the 1980s virtually all amateur manga was being made, not by highly-skilled professional artists seeking alternative outlets for their personal work, but by young artists who had never had a relationship with the manga publishing industry at all. [. . .]

Subculture genres

The realistic, adult-oriented *gekiga* style, which arose out of anti-establishment manga subculture in the late 1950s, and had a strong influence on the genres utilized

within commercial boys' and adult manga, has not been a big influence on contemporary amateur manga. Amateur manga production has been far more influenced by girls' manga, which in turn has far greater stylistic continuity with the less politically controversial tradition of child-oriented, cute *manga* pioneered by Tezuka Osamu and his ex-assistants, including Ishinomori Shōtarō, and Fujio-Fujiko. . . . Not only do amateur and commercial manga diverge in their stylistic origins but the social networks of amateur and professional artists have become so distant that they have increasingly come to represent two virtually separate streams of the same cultural media. From amateur manga subculture have emerged new genres which are distinctly recognizable as amateur in origin.

In the early 1980s, *dōjinshi* artists began to produce not only new, original works, but a new genre of *parody* manga. *Parody* is based on revised versions of published commercial manga stories and characters. While often radically altering the content of original stories and implicitly criticizing the morality of the original themes, *parody* does not always imply a specifically humorous re-rendering of texts. The first commercial manga series to attract a whole wave of amateur parodies in the first half of the 1980s was *Spaceship Yamato* (*Uchūsenkan Yamato*). As the amateur manga medium expanded, the proportion of *dōjinshi* artists producing *parody* instead of original works increased too. By 1989, 45.9 per cent of material sold at Comic Market was *parody*, whilst only 12.1 per cent was what is aptly referred to as *original* (*Comic Box* 1989).

Most *parody* manga have been based on leading boys' manga stories serialized in commercial magazines. Stories in the best-selling boys' manga magazine, *Jump*, including *Dragon Ball, Yūyūhakusho, Slam Dunk,* and *Captain Tsubasa*, have been particularly frequent sources of *parody*. During the 1990s some political adult manga series also became the focus of interest for *parody* artists. . . . *Parody* based on animation rather than manga series, and referred to as *aniparo* (an abbreviation of 'animation-parody'), became more popular from the mid-1980s onwards. In the same period *cosplay* (an abbreviation of 'costume-play'), where manga fans dress up in the costumes of well-known manga characters and perform 'live *parody*' at amateur manga conventions, also became widespread.

Dōjinshi artists categorized their style of manga, which is dominant in both *parody* and original work, as *yaoi*. This word is a three syllable anagram, *ya-o-i*, composed of the first syllable of each of the following three phrases; '**ya**ma nashi', '**o**chi nashi', '**i**mi nashi', which mean 'no build-up, no foreclosure, and no meaning', which are frequently cited to describe the almost total absence of narrative structure, typical of amateur manga from the mid-1980s onwards (*Imidasu* 1993: 1094). The narrative or story-line, which in many ways is the only remaining link between manga and works generally understood as 'pure literature' (*jun bungaku*), has been very much abandoned to commercial manga publishers, for whom it continues to be of varied but generally substantial importance. The non-linear form of storytelling in *yaoi* work invites categorization as 'post-modern manga', but with little further explanatory effect.

Yaoi is also characterized by its main subject matter, that is homoerotica and homosexual romance between lead male characters of the work. Typical homosexual characters are pubescent European public school-boys, or lean, muscular young men with attenuated limbs and features, long hair and feminine looks. Girls'

manga featuring gay love is sometimes identified as *june mono* (after the girls' manga magazine *June*), while love stories about beautiful young men are also known as *bishōnen-ai*. Although the characters of these stories are biologically male, in essence they are genderless ideal types, combining favoured masculine qualities with favoured feminine qualities. Readers are likely to directly identify with 'gay male' lead characters, – and female readers often with the slightly more effeminate male of a pair of characters. Young female fans feel more able to imagine and depict idealized strong and free characters, if they are male.[1] [. . .]

. . . Comic Market president Yonezawa Yoshihiro sees the expansion of *parody* in manga as an attempt to struggle with and subvert dominant culture, on the part of a generation of youth for whom mass culture, which has surrounded them from early childhood, has become their dominant reality. In this context Yonezawa interprets *parody* as a highly critical genre which attempts to remodel and take control of 'cultural reality'. Manga critic Kure Tomofusa, on the other hand, believes that the highly 'personal' (*jiheiteki*) themes of *parody* manga represent, not a critical sensibility, so much as a return to the previous narrow themes of Japanese literature:

> In the 1980s people once again began to forget about dramatic social themes and manga began to move towards petty, repetitive, personal affairs, rather like the I-novels (*shishōsetsu*) of the pre-1960 period. In the 1980s new kinds of *love-comedy*, often set within *parody* works, began in and dominated the amateur manga world.

Yonezawa, representing the more open-minded approach of many independent media-based intellectuals, perceives a progressive political spirit, equivalent with that born by his own generation of the late 1960s, in the cultural activities of amateur manga subculture. Kure, however, insists on a critical appraisal of the themes of amateur manga, and finds them seriously wanting in tangible social and political content. This view is one shared by many editors and artists involved with the commercial manga medium. The implication of this criticism of *parody* manga is that the definition of 'originality' applied to manga, is something linked to the degree to which it embraces current social and political events. 'News', it appears, has a more than merely linguistic association with 'originality'. Amateur manga, whether *parody* or *original*, is widely judged to be low-quality culture, because it lacks direct references to social and political life. [. . .]

Parody manga often makes light fun of the seriousness of the masculine heroes in commercial boys and adult manga series. While on the one hand favourite manga characters are positively celebrated, on the other hand, their authority and aloofness is punctured, by inserting scatological humour or embarrassing jokes about their physical desires and distresses. The overall effect of this type of naughtiness in *parody* manga is to make popular, manga characters in serialized manga magazines more fallible, allowing readers to feel more intimate towards them. This aspect of the amateur manga sense of parody is similar to the Anglo-American sensibility of 'camp'. Both of these cultural modes are based on the subversion of meanings carried in original, and frequently iconic, cultural items. Moreover in the case of both *parody* and camp, this playful subversion is focused particularly on cultural items which contain strongly identified gender stereotypes.

In relation to American films Susan Sontag has suggested that

> Allied to the Camp taste for the androgynous is something that seems quite different but isn't: a relish for the exaggeration of sexual characteristics and personality mannerisms. For obvious reasons, the best examples that can be cited are movie stars. The corny flamboyant femaleness of Jayne Mansfield, Gina Lollobrigida, Jane Russell, Virginia Mayo; the exaggerated he-manness of Steve Reeves, Victor Mature.
>
> (Sontag 1964: 108–109)

Contrary to the simplistic notion that there is no sense of 'irony' and therefore no sense of 'camp' in modern Japan (Buruma 1985: 117), Jennifer Robertson has pointed out that the style of exaggerated *male* impersonation, referred to as *kizatte iru* or 'camping', forms the principal pleasure of, amongst other things, the all-female theatre, Takarazuka Revue (Robertson 1998: 14). There is an also modest parallel between the American camp appropriation of movie sex-symbols and the Japanese *parody* appropriation of well-known male characters from boys' and adults' manga series. Through *parody* manga young women have expressed an ambiguous preoccupation with, and a deep uncertainty about, masculine gender stereotypes, such as those typical of the characters in weekly boys' and adults' manga magazines. [. . .]

Lolita complex

Towards the end of the 1980s, however, the number of men attending amateur manga conventions increased and new genres of boys' amateur manga began to rise in prominence at Comic Market. The genre into which the majority of this male girls' manga falls is aptly referred to as *Lolicom*, an abbreviation of Lolita complex, a Japanese phrase derived from a reference to Vladimir Nabakov's novel *Lolita*. Lolita complex is widely used to refer to the theme of sexual obsession with young pre-pubescent girls which became particularly strong in Japanese culture during the 1980s and 1990s. *Lolicom* manga usually features a young girlish heroine with large eyes and a childish but voluptuous figure, neatly clad in a revealing outfit or set of armour. The attitude towards gender expressed in most amateur *Lolicom* manga is quite different to that expressed by the male fans of girls' manga, including gay love stores and parody.

The themes of *Lolicom* manga written by and for men express a complex fixation with young women, or perhaps the idea of young women (*shōjo*). The little girl heroines of *Lolicom* manga simultaneously reflect an awareness of the increasing power and centrality of young women in society, as well as a reactive desire to see these young women infantilized, undressed and subordinate. Despite the inappropriateness of their old-fashioned attitudes, many young men have not accepted the possibility of a new role, encompassing greater autonomy for women, in Japanese society. These men who are confounded by their inability to relate to assertive and insubordinate contemporary young women, fantasize about these unattainable girls in their own boys' girls' *Lolicom* manga.

For other young men, however, the infantilized female object of desire held so close has crossed over to become an aspect of their own self-image and sense of sexuality. One sub-genre of *Lolicom* manga tells the story of what might be described as the Lolitaization of young men. This *Lolicom* manga features entirely feminine, cute Lolita figures which sprout penises to reveal their hidden masculinity (Robertson 1998: 201–204). In series published by *Afternoon* magazine for young men the desire to actually become a small pretty girl, or Lolita, is expressed through more subtle and publicly-acceptable means. In *Aaah! My Goddess* the lead male character takes on some of the cute and infantile affectations of a female Lolita character and in so doing, retains the indulgence and friendship of three Lolita-esque goddesses. In *Discommunication*, another infantilized male character indulges in dressing-up in girl's clothes (Kinsella 1998: 316). This type of *Lolicom* manga discloses an infinitely more ambivalent attitude towards the ideal of infantile femininity.

Despite the differences between these particular male attitudes, the themes by which amateur manga genres are defined have in common a similar preoccupation with gender and sexuality. Amateur manga genres express a range of problematic feelings young people are harbouring towards established gender roles and, by association, established forms of sexuality. While young people engaged with amateur manga do not fit the social definition of homosexuality, they do share some of the uncertainties and modes of cultural expression more commonly associated with homosexual men in America and Britain. The sexual themes of *parody*, *Lolicom*, and *yaoi* manga hint strongly at the possibility that 'camp' is a *cultural* sensibility which is not, or is no longer, the exclusive adjunct of male homosexuality, though it may fail to receive recognition when it occurs in other circumstances. [. . .]

A serial infant-girl murderer

In 1989 amateur manga artists and amateur manga subculture became the subject of what might be loosely categorized as a 'moral panic' of the sort first defined at the end of the 1950s by British sociologist, Stanley Cohen (1972: 9). A sudden genesis of interest in amateur manga artists and Comic Market, amongst the media, began with the arrest of a serial infant-girl killer. Between August 1988 and July 1989, 26-year old printers' assistant, Miyazaki Tsutomu, abducted, murdered and mutilated four small girls, before being caught, arrested, tried and imprisoned (Treat 1993: 353–356). Camera crews and reporters arriving at Miyazaki's home discovered that his bedroom was crammed with a large collection of girls' manga, *Lolicom* manga, animation videos, a variety of soft pornographic manga, and a smaller collection of academic analyses of contemporary youth and girls culture including the work of cultural anthropologist, Ohtsuka Eiji.[2] Miyazaki was a fan of girls' manga and in particular *Lolicom* manga and animation, and it was revealed that he had written some animation reviews in *dōjinshi* and had been to Comic Market (Ohtsuka 1989: 438).

A heavily symbolic debate ensued Miyazaki's arrest, in which his alienation and lack of substantial social relationships featured as the ultimate cause of his anti-social behaviour. The apparent lack of close parenting given to him by his mother and

father, his subsequent immersion into a fantasy world of manga, and the recent death of Miyazaki's grandfather – with whom he had apparently had his only deep human relationship – were posited as the serial causes of his serial murders. Emphasis on the death of Miyazaki's grandfather implied that the decline of Japanese-style social relations represented by older generations of Japanese fulfilling traditional social roles had contributed to Miyazaki's dysfunctional behaviour. Emphasis on Miyazaki's apparently careless upbringing suggested, at the same time, that freer contemporary relationships were no substitute for fixed traditional social relationships, and that there was no real communication between modern, liberal parents of the 1960s generation and their children. Several journals described how Miyazaki's mother had neglected her son so that, 'By the time he was two years old he would sit alone on a cushion and read manga books' (*Shūkan Bunshun* 1989: 36).

Where his family had failed to properly socialize Miyazaki the media, it was suggested, had filled this gap, providing a source of virtual company and grossly inappropriate role models. While one headline exclaimed that in the case of Miyazaki 'The little girls he killed were no more than characters from his comic book life' (Whipple 1993: 37), psychoanalyst Okonogi Keigo worried that, 'The danger of a whole generation of youth who do not even experience the most primary two or three way relationship between themselves and their mother and father, and who cannot make the transition from a fantasy world of videos and manga to reality, is now extreme' (*Shūkan Post*, 1989: 33). [. . .]

Following the Miyazaki case, reporters and television documentary crews visited amateur manga conventions, and specialist manga shops. Amateur manga culture was repeatedly linked to Miyazaki, creating what became a new public perception, that young people involved with amateur manga are dangerous, psychologically-disturbed perverts.

Birth of the *otaku* generation

Otaku, which translates to the English term 'nerd', was a slang term used by amateur manga artists and fans themselves in the 1980s to describe 'weirdoes' (*henjin*). The original meaning of *otaku* is 'your home' and by association, 'you', 'yours' and 'home'. The slang term *otaku* is a witty reference both to someone who is not accustomed to close friendships and therefore tries to communicate with their peers using this distant and over-formal form of address, and to someone who spends most of their time on their own at home. The term was ostensibly invented by critic and *dōjinshi* artist, Nakamori Akio, in 1983. He used the word *otaku* in a series entitled *Otaku no Kenkyu* ('Your home investigations') which was published in a low-circulation *Lolicom* manga magazine, *Manga Burikko* (Takarajima 1989: 252).

After the Miyazaki murder case, the concept of an *otaku* changed its meaning at the hands of the media. *Otaku* came to mean, in the first instance Miyazaki, in the second instance all amateur manga artists and fans, and in the third instance all Japanese youth in their entirety. Youth were referred to as *otaku* youth (*otaku seishōnen*), *otaku*-tribes (*otaku-zoku*), and the *otaku*-generation (*otaku-sedai*). The sense that this unsociable *otaku* generation was multiplying and threatening to take over

the whole of society was strong. While the *Shūkan Post* put about the fear that: 'Today's Elementary and Middle Schools Students: The *Otaku* Tribe Are Eclipsing Society' (1989a: 32–33), Ohtsuka Eiji confirmed that 'It might sound terrible, but there are over 100,000 people with the same pastimes as Mr. M. – we have a whole standing army of murderers' (Ohtsuka 1989: 440).

The debate about the Miyazaki serial child-murders evolved into a nationwide panic about amateur manga subculture and *Lolicom* manga which helped to 'reshape the normative, attitudinal, and value landscape of society' (Goode and Yahuda 1994: 229) with regard to youth and manga. Urgent discussion amongst journalists, intellectuals and local and national government officers, about the dysfunctional social behaviour and insufficiently developed social consciousness and morality of amateur manga artists and animation fans was 'captured, routinized, [and] institutionalized' (Goode and Yahuda 1994: 225) into new laws, and a stricter system of regulating the contents of amateur and published manga (Ohtsuka 1989: 438).

Cool *otaku*

The concept of the *otaku* became so resonant within society that during the 1990s competing positive interpretations of the *otaku* generation were produced in different sections of media, by self-appointed representatives of animation and computer subcultures. . . . Ohtsuka Eiji identified *otaku* as 'the keyword of postmodern society' (Ohtsuka 1989: 241) in which cultural experience dominates over social experience. Critic Asaba Michiaki suggested as a result of being isolated from their friends and made to study relentlessly for exams in their bedrooms, children have grown-up in an environment where their principal source of socialisation and experience has been the mass media. Youth who had spent their childhoods studying hard to pass school entrance examinations, apparently formed the core of *otaku* manga and animation subculture (Takarajima 1989: 251).

In 1990 a friendly television talent *otaku* called Taku Hachiro (Taku as in *otaku*) appeared on family television. In a 'Nerd Manifesto' for young people identifying with his image, included in *Viva! Nerd Heaven (Ikasu! Otaku no Tengoku)*, Taku suggested that,

> Amidst the rapid flow of events following the serial-infant-girl-murder incident the term *otaku* became a negative keyword. In the 1990s however the meaning has changed. Now *otaku* refers to a high-information-tion handling élite. It is clear, on closer examination, that *otaku* are deeply rooted in the current times.
>
> (Taku 1992: 6)

During the 1990s intellectuals sympathetic to young people involved in amateur manga and other *otaku* pastimes continued to discuss the meaning of *otaku* lifestyle (Watanabe 1990; Kiridoshi 1995; Okada 1996; Okada *et al.* 1997), and in 1995 Okada Toshio, author of *Otakuology*, began teaching a course on Otaku Studies at Tokyo University.

Police action

The resurrection of *otaku* as a fashionable concept linked to animation, computer systems and information technology employees and subcultures did not negate the impact of the earlier 1989 to 1992 panic about amateur manga artists and fans. The moral panic about *manga otaku* criminalized and marginalized the amateur manga world. Many *dōjinshi* artists attempted to reject what was seen as an attack on amateur manga subculture by the news-media: 'If I get called *otaku* it is an insult, the word *otaku* is derogatory. At the time of the Miyazaki murder incident we got picked on by the media'. Yahagi Takako, an ex-*dōjinshi* artist who became well-known within the amateur manga world during the 1980s for her *original*, homoerotic stories asserted that the concept of *otaku* had no basis in reality: 'I don't know if I am an *otaku* or not really. What is an *otaku*? Isn't everyone *otaku* really? I am not living in a fantasy world of my own, I live in the real world. How about you?'

Manga critic and Comic Market president Yonezawa Yoshihiro suggested that the news-media debate about Miyazaki Tsutomu and *manga otaku* encouraged a suspicious attitude towards unauthorized intellectual activity in general:

> The term *otaku* is being used to single out certain kinds of people for regulation and removal from the public eye. On the other hand the broadening of the concept of *otaku* has provided certain philistine individuals with a term to describe a condition common, apparently, to academic book-worms, film buffs, rock music fans, manga artists and animation fans.
>
> (Yonezawa 1989: 84)

The practical results of the new and hostile attention directed at amateur manga were the partial attempts of Tokyo metropolitan police to censor sexual images in unpublished amateur manga and prevent their wider distribution at conventions and in specialist book shops. During April 1991 police arrested the managers of five specialist manga book shops where unpublished, amateur manga was available for sale. This activity began when six officers broke into Manga no Mori manga book shop in Shinjuku, central Tokyo, and confiscated copies of unpublished manga. Police officers collected the addresses of amateur manga circles and took their members into police stations for questioning about the legal status of the printing shops where their manga booklets had been printed. Amateur manga artists and amateur manga printers were subjected to repeated investigations and harassment throughout 1990. Police took in 74 young people for questioning over their activities in making amateur manga, arrested 40 of these individuals, and removed 1880 volumes of manga by 207 authors from Koyama Manga no Mori book shop, and 2160 volumes of manga by 303 different authors from Shinjuku Manga no Mori manga book shop (*Tsukuru* 1991: 18–21).

This scale of direct police activity represents a significant curtailment of the distribution of unpublished manga. Other than in specialist manga book shops in large cities, amateur manga is rarely on sale and is not usually available outside the social circles of young manga fans and artists. The arrest of amateur manga artists by local police forces implies that it was not only the problem of the harmful effects

of manga on young minds which concerned the police, but also the independent and unregulated movements of amateur manga artists and amateur manga. [. . .]

Regaining control of manga subculture

During the 1960s large publishing companies were able to capitalize on the incorporation of popular subcultural styles and themes into weekly mass-distribution manga magazines. Publishing companies actively recruited the most innovative and often radical manga artists to work for their magazines. By the mid-1970s attempts to engage with the manga medium by young people had expanded. The development of cheap offset printing, and the establishment of an alternative distribution mechanism in the shape of Comic Market, allowed manga fans to access the manga medium directly by producing their own manga books. The manga medium, which now offered no barriers to participation, became entirely open. The unregulated access to the manga medium meant that publishing companies were no longer able to channel the creative direction of the movement. The expansion of the medium created a huge mass of uncontrolled production. The publishing industry, linked to government and cultural agencies, no longer had complete control over the thematic influences and stylistic development of manga.

In the amateur manga world no alternative system of valuation, artistic discipline, or quality control, replaced that carried out by publishing companies. Artists who could not get their work published in manga magazines took advantage of this unregulated sphere to produce and distribute their work in amateur form. New genres of manga, driven by the strength of their popular appeal alone, emerged from the amateur medium. The same intensity of popular engagement with the manga medium which had helped to fuel the commercial expansion of weekly magazines during the 1960s, encouraged the medium to divide into two separate streams by the late-1980s.

The widespread access young people have had to the manga medium has stimulated concern amongst government agencies. Anxieties which were raised about the commercial propagation of manga and *gekiga* social dramas between 1965 and 1975, resurfaced between 1990 and 1994, when they became redirected towards amateur manga, at that point the most uncontrolled area of the medium. A sense of insecurity about unregulated new spheres of cultural activity found expression in the stereotype of the *otaku*. Yonezawa Yoshihiro suggested that, 'If anything frightful *has* come into being, it is no doubt the existence of this space itself' (Yonezawa 1989: 88).

The underlying argument explicit in the *otaku* panic was the view that amateur manga can have only a negative influence on young people, and in particular, on their sexuality. While similar opinions, held by representatives of citizens' organizations, the PTA, or government agencies, about the manga medium in general, were no longer perceived as reasonable or acceptable, more specific criticisms targeted at amateur manga were more novel and engaging. The majority of young people were persuaded by the news media that amateur manga subculture was in fact a serious social problem and not a potentially interesting activity they might like to try out.

Subculture and social disorder

The *otaku* panic also reflects many of the contemporary concerns of social scientists about Japanese society. These are powerful concerns about social fragmentation and the contribution of the mass media and communications infrastructures to this change. Since the 1970s, intellectuals have linked their concerns about the decay of a close-knit civil society to the growth of individualism amongst younger generations of Japanese. Individualistic youth culture has been accurately associated with either the failure or the stubborn refusal of contemporary Japanese to adequately contribute to society, by carrying out their full obligations and duties to family, company and nation. The independence of amateur manga subculture from the rest of society, and its growth on the back of new media technologies available to the public, made it an appropriate focus for this sense of chaos and declining control over the organization and communication of younger generations.

The absorption of youth in amateur manga subculture in the late 1980s and 1990s was perceived by many intellectuals as a new extreme in the alienation of Japanese youth from the collective goals of society. The dysfunctionality of *otaku* appeared to prove the unhealthy nature of 'individualistic' lifestyles. For the critics of amateur manga and animation subcultures, *otaku* came to represent people who lacked any remaining vestiges of social consciousness and were instead entirely preoccupied by their particularistic and specialist personal pastimes.

Like generations of youth before them amateur manga artists and fans were also diagnosed as suffering from 'Peter-pan syndrome' – the refusal to grow-up and take on adult social relations. Feminist intellectual, Ueno Chizuko, pressed this theory, asking 'Do the *yaoi* girls and *Lolicom* boys really have a future?' (Ueno 1989). Without social roles, artists and fans who dedicated their time to amateur manga had no fixed identities, no fixed gender roles, and no fixed sexuality. Ultimately they symbolized a group of young people who had become so literally anti-social they were unable to communicate or have social relationships with other people at all. The fact that amateur manga conventions were probably the largest organized public events in the world during the 1990s did not dissuade its critics from criticizing the anti-social tendencies of its participants.

At the same time, it seems that it was the domination of amateur manga subculture by young women rather than young men which provoked particular unease. In the mid-1970s early girls' manga was perceived by some left-wing critics as a reactionary cultural retreat from politics and social issues to petty personal themes. Girls manga and soft (*yasashii*) culture were associated with the decline of political and cultural resistance in the early 1970s, sometimes referred to in Japanese as the 'doldrums' (*shirake*). But by the 1990s, individualistic personal themes in girls' manga were being perceived as stubbornly self-interested, decadent and anti-social. The attitude expressed towards amateur manga genres influenced by girls' manga is reminiscent of a general distaste for other aspects of contemporary culture dominated by the activities of young women. In the words of Skov and Moeran there is: '. . . an almost apocalyptic anxiety that the supposed "pure" and "masculine" culture of Japan has been vulgarised, feminised, and infanticised to the point where it has become "baby talk" beyond the comprehension of well-educated critics' (Skov and Moeran 1995: 70). Drawing attention to the intellectual tendency to perceive girls'

culture as an unwelcome *alien* influence within Japan, manga critic, Kure Tomofusa, described how: 'When academics looked at girls' manga they were amazed. They felt like English missionaries discovering that there were different societies in Africa'. [. . .]

Notes

1 This is not an approach unique to Japanese girls' manga: fanzine subculture in the US and Britain also features a strong vein of male homosexual romance for women. Fans use material featuring homosexual love affairs as devices for staging the type of independent and free characters in which they are most interested (Jenkins 1992).

2 A comprehensive photographic survey of the rooms of Japanese youth living in and around Tokyo in the late 1980s and early 1990s confirms that Miyazaki's room, stuffed with a large collection of manga, books and videos, was in fact fairly typical (*Tokyo Style*, Tsuzuki 1993).

David Bell

MEAT AND METAL [2000]

T his chapter is an attempt to read across two contemporary subcultural responses to the body: those to be found in body-modification practices (especially so-called 'modern primitivism') and those associated with cyberpunk and posthumanism (so-called 'high-tech subcultures').[1] My argument is simple: that at the start of the twenty-first century, we are caught between two contradictory impulses, or forms of 'norm transgressing body work' (Pitts 1998: 82), figured in the embodied practices of these subcultures – the dream of 'leaving the meat behind' and living as pure bits and bytes in cyberspace, versus a nostalgic re-embodiment which stages the modified body as an expressive and sensuous medium of communication and reflexivity. As Tiziana Terranova (2000: 271) puts it, in the future '[the] human species will move either in the direction of an intensification of bodily performativity or towards the ultimate flight from the body cage'.

The subcultural groupings I focus on rely on an aesthetic and an ethic which stresses their relationship to the body in particular, contextualized ways. By sketching some elements of each subculture, I hope to tease out those aesthetics and ethics, before moving on to discuss their relative relationship to the past, present and future of the body and of embodiment. While both groupings have attracted considerable academic interest, this has tended to frame its analysis in certain ways, reading the tattooed or pierced body and the cyberbody through particular theoretical lenses. However, each subculture enacts its own form of 'expressive embodiment' (Thrift 1997) or 'body project' (Shilling 1993), which my reading aims to explore; by running these analyses alongside one another, my hope is to produce a reading across those bodies, stressing the overlapping concerns which each enunciates.

Long live the new flesh

> . . . the subjectivity of the freak triumphant as a resurgent sign of the
> return of the body from its electronic dissimulation and disappearance.
>
> (Kroker 1993: 127)

Contemporary body-modification and adornment practices – tattooing, piercing, branding, scarification – have attracted considerable media and academic commentary in recent years.[2] At once there has been a proliferation and 'mainstreaming' of modification (especially piercing and tattooing), *and* a growing visibility of forms of adornment within and across a number of countercultural communities. Prominent among these has been the growth of so-called modern primitivism, which blends stylized body modification with mysticism, shamanism and a grab-bag of cultural practices gathered from a host of so-called 'primitive' cultures (Vale and Juno 1989). While the politics of the modern primitives have attracted critique, especially in terms of their colonialist appropriation of 'nonwestern' traditions (Klesse 1999), primitivism retains its countercultural appeal, and could be said to have developed its own subculture, complete with its own ever-expanding micromedia (magazines, videos, websites) and its own 'scene':

> a burgeoning underground of urban aboriginals has revived the archaic
> notion of the body as a blank slate . . . a groundswell of interest in do-
> it-yourself body modification has swept taboo practices out of *National
> Geographic* and into youth culture.
>
> (Dery 1996: 274–5)

The stress on a kind of corporeal spiritualism (manifest in rituals, for instance) marks modern primitivism as a particular kind of body-modification subculture (Klesse 1999); it is, in fact, a subculture *all about the body*, articulating a series of corporeal discourses – discourses about ownership and control (set against alienation), about sensation (set against the 'numbing' effects of postmodern life), and, I will argue, about the relationship between the body and technology.

In the expanding body-modification literature, perhaps the most commonly cited motive for self-conscious alteration of the body is one of control. Ted Polhemus, anthropologist of the urban aboriginals, sums up this thread of argument thus: 'In an age which increasingly shows signs of being out of control, the most fundamental sphere of control is re-employed: mastery over one's own body' (Polhemus and Randall 1998: 38). One of the prevailing anxieties of our age, it is argued, is one of loss of individual and collective agency, countered not only in the body modification subculture, but in the popularity of conspiracy theories, new religious movements and self-realization groups, as well as in health, dietary and exercise regimes. Marking one's own body, then, makes a statement: '[o]ne of the core motives for being tattooed is to declare a particular relationship with one's own body. . . . The tattoo betokens a commitment to oneself and one's body' (Curry 1993: 71). As Paul Sweetman (1999a: 71) puts it, body modification represents 'an attempt to fix, or anchor one's sense of self through the (relative) permanence of the modification'. Accounts by practitioners similarly stress this func-

tion, of 'reclaiming' or 'recovering' the body, which is otherwise experienced as lost in the disorienting whirl of postmodern life (Pitts 1998; 1999). Body modification thus represents 'a revolution in claiming freedom to explore one's own body and to claim the territory discovered as one's own' (Curry 1993: 76). Part of that revolution involves *re-experiencing* the body, usually discussed in terms of pleasure and pain – against the numbing effects of a pacifying media culture and against either the state's or consumer culture's control over pleasure (and pain) giving.

In addition to recovering the sensuous body, body modification spectacularizes corporeality at a time when bodies are increasingly seen to be 'disappearing'. As Karmen MacKendrick argues, body modification 'serves a strong ornamental function, making the body the near-irresistible object of the gaze' (MacKendrick 1998: 5) – it is a body to be looked at, a body which demands to be looked at (though, paradoxically, some practitioners stress the special thrill of having piercings and tattoos which aren't on view, but which are private pleasures). This visibilizing stages the modified body as a potential site of transgression or resistance, as a 'shocking' or grotesque body (Bell and Valentine 1995; Pitts 1998). Mark Dery reads this as a response to political alienation; a claiming of the body as political territory in the face of the depoliticization of social life: 'There can be no denying that feelings of political impotence undergird modern primitivism' (Dery 1996: 277). In a post-political culture, politicizing the body through forms of marking offers an alternative to invisibilizing disengagement.

However, these aspects of modern primitivism and body modification are not my central concern here, though it is important to have in place the broader context in which this subcultural body-work takes place. What interests me is the relationship between corporeality and technology enunciated by the modified body. MacKendrick argues that tattooing and piercing signal a playful, subversive reappropriation of technology: 'Perhaps, in love with the mechanistic, we add to perfectly fine flesh the technological apparatus of ink, steel, metal boning – in an android alienation' (MacKendrick 1998: 7); technology is perverted in this union of meat and metal (or ink). This argument, then, takes us into familiar territory: the territory of prosthetics and cyborgs. The incorporation of technology into or onto the body, in order to augment it (in this case, primarily ornamentally), is a recurrent theme in writing on posthuman or cyborg embodiment – everything from car-driving to hormone replacement therapy can (and has) been theorized in terms of cyborgization (Leng 1996; Lupton 1999). This is a seductive argument, vividly played out in certain domains of the body-modification subculture which draw extensively on science fiction and cyberpunk aesthetics (Dery 1996; Polhemus and Randall 1998). But in the case of modern primitivism, certainly, the technological is obscured (or mystified) by spiritualistic and ritualistic imperatives. While not necessarily anti-technological, modern primitivism can, then, be read as making a critical intervention into the current cultural status of the body:

> modern primitivism embodies a critique of the body and the self in cyberculture that merits serious consideration . . . [C]omputer culture's near-total reduction of sensation to a ceaseless torrent of electronic images has produced a *terminal* numbness.
>
> (Dery 1996: 278)

This 'terminal numbness', as we have seen, is argued to have provoked a state of disembodiment and disengagement – Kroker and Kroker (2000) name this 'bunkering in' and 'dumbing down' – read here negatively (*contra* the positive arguments for disembodiment circulating in cyberculture, as we shall see). Loss of connection to our bodies, sensory deprivation, alienation and political impotence – if this is the terminal condition of postmodern cyberculture, then the modern primitive stands for re-embodiment, with tattooing and piercing functioning as forms of 'limit experience' which snap us back to our senses and our bodies (in the same way that bungee-jumping, 'extreme sports' and 'adventure tourism', for example, are argued to reconnect participants to embodied, sensuous thrill; see Cloke and Perkins 1998):

> the resurgence of tattooing and piercing may . . . represent a doomed attempt to re-engender feeling into bodies lost to the 'mediascape', and insulated from pain to the extent that, as corporeal-subjects, we have been turned into unfeeling spectators of our own decaying selves.
>
> (Sweetman 1999b: 182)

Being 'unfeeling spectators of our own decaying selves' is only one way of reading the way in which cyberculture and the mediascape have reshaped our experience of embodiment, of course. Alongside those who urge for a re-experiencing of corporeality in the face of its erasure, there are those who enthusiastically extol the virtues of disembodiment, who dream of quitting their own decaying selves.

Leaving the meat behind

I'm trapped in this worthless lump of matter called flesh!
(bulletin board user, quoted in Dery 1996: 248)

What I am going to call here the cyberpunk subculture is a hybrid collectivity spread, like the body-modification subculture, across a range of practices and identities. Cyberpunk as a concept emerged from the writing of a gang of *tech-noir* sci-fi authors, whose rewiring of the tropes of science fiction has birthed a burgeoning new literary genre (McCaffery 1991; Sterling 1986). As a creative critical commentary on the past, present and future of human/technological interfacing, cyberpunk has resonances which stretch far outside of its originary network. Cyberpunk writers such as William Gibson (who famously described cyberspace as a 'consensual hallucination' in his 1984 novel *Neuromancer*) have given shape to our understandings of cyberculture in the realm of representation – and, along with a host of other pop-fictional depictions of cyberspace (most notably, perhaps, those appearing in Hollywood movies), this set of symbolic resources exerts a powerful influence on the ways we experience and imagine cyberspace (Bell 2000a).

The cyberpunk genre is populated by a host of posthuman entities and identities, often hybridized meldings that cross the human/machine interface in diverse ways and blur and blend conventional boundaries of identity and the human body. In an overview of bodies and subcultures in Gibson's work, David Tomas (2000) provides a useful distinction between two forms of what he names 'technophilic

bodies', with on the one hand *aesthetic manipulations* of the body, and on the other *functional alterations* that work to enhance the body's capabilities. As we shall see, this distinction can be applied to current subcultural translations of cyberpunk. Further, Tomas explores the recycling of past subcultural forms in Gibson's 'technotribes' – a theme echoed in George McKay's critical search for the 'punk' in cyberpunk, which suggests that 'cyberpunk is . . . predicated on the past, touched by nostalgia' (McKay 1999: 51); Gibson himself refers to this as a 'kind of ghostly teenage DNA' which 'carried the coded precepts of various short-lived subcults and replicated them at odd intervals' (quoted in Tomas 2000: 177). In the aesthetic manipulations of subcultural identity in Gibson's writing, then, a bricolage of technofuturism and recycled pasts is creolized to produce new hybrid bodies (something we also see in Hollywood imaginings of 'retro-fitted' *tech-noir* futures; see Kernan 1991).

However, as Tomas notes, in cyberpunk writing '[s]ubjects of aesthetic cyborg enhancements do not . . . elicit a great deal of observation and commentary when compared to those individuals that have absorbed the hardware of information systems and biotechnology in cool fits of individualized, customized technophilia'. These 'cool fits' are the functional alterations of Gibson's characters, who become 'information processing units, enhanced nervous systems and fluid electronic fields of social action' and thereby gain 'technological edge' (Tomas 2000: 178). Central to this process of reconfiguration is the dematerialization of the body into what Tomas calls 'cyberpsychic space'. To achieve such a dematerialization, the characters 'jack in' to cyberspace:

> 'Jacking in' is the instantaneous rite of passage that separates body from consciousness. That disembodied human consciousness is then able to simultaneously traverse the vast cyberpsychic spaces of [the] global information matrix. Access therefore promotes a purely sensorial relocation.
>
> (Tomas 2000: 183)

- jacking in, therefore, as the moment of leaving the meat behind, of becoming pure data, bits and bytes.

This overview of Gibson's cyberbodies lays out the preconditions for the expressive embodiments (and disembodiments) of 'high-tech' subcultures, then. The aesthetic of these imaginary subcultures has spilled out from the pages of cyberpunk novels, and it is this transformation from text to body that interests me here. Particularly, as I have already said, I want to look at arguments around disembodiment in cyberspace, so vividly imagined in the uploading of consciousness into cybernetic systems in the future worlds of cyberpunk. How has this translated into subcultural practices currently enacted in cyberspace?

> Participants [in cybernetic communities] often attest to the significance of disembodiment in online exchanges. As one male contributor couched it, 'Concepts of physical beauty are holdovers from "MEAT" space. On the net, they don't apply. We are all just bits and bytes blowing in the phosphor stream'.
>
> (Clark 1995: 124)

While the uploading of pure consciousness into the matrix in the way Gibson imagines isn't (yet) a concrete reality for experiencing cyberspace, its hold as an idea nevertheless structures a number of subcultural responses currently circulating in cyberspace: 'The dream of cyberculture is to leave the "meat" behind and to become distilled in a clean, pure, uncontaminated relationship with computer technology' (Lupton 2000: 479). It is important to think about what 'leaving the meat behind' means here. As the BBSer quoted by Clark points out, cyberspace offers freedom from the physical, corporeal constraints and limitations of the lived body, offering up the opportunity for 'identity play', for reinventing the self – perhaps, then, as the flipside to anchoring the postmodern self through modification, this represents the liberation of the self from the body.

While this is usually described by participants in positive terms, critics are often more cautious. Anne Balsamo (2000: 490), for example, refers to this process in terms of repression: 'The phenomenological experience of cyberspace depends upon and in fact requires the wilful repression of the material body'. Moreover, we are often reminded that, despite this wilful repression, the meat is never left behind:

> Cyberspace developers foresee a time when they will be able to forget about the body. But it is important to remember that virtual community originates in, and must return to, the physical. . . . Even in the age of the technosocial subject, life is lived through bodies.
>
> (Stone 2000: 525)

While this criticism serves to temper the 'cyberhype' currently circulating, and to remind us that current cyberspace interactions are *profoundly* embodied (in that they arise from the actions of individual bodies sitting at computers, typing and reading – not to mention, in the much-hyped case of 'cybersex', masturbating; see Kaloski 1999; Lupton 2000), this line of argument is countered by recourse to Gibson's 'consensual hallucination' aphorism – that self-conscious immersion in cyberspace facilitates the shared illusion of disembodiment through the suspension of disbelief.

In order to explore the subcultural work around this notion, I want to begin by looking at the so-called 'New Edge' cybersubculture associated most prominently with the magazine *Mondo 2000* (see Sobchack 2000; Terranova 2000). Let's start with a quotation from the editor of *Mondo 2000* himself, R. U. Sirius:

> The entire thrust of modern technology has been to move us away from solid objects and into informational space (or cyberspace). Man the farmer and man the industrial worker are quickly being replaced by man the information worker. . . . We are less and less creatures of flesh, bone, and blood pushing boulders uphill; we are more and more creatures of mind-zapping bits and bytes moving around at the speed of light.
>
> (quoted in Terranova 2000: 271)

In a reflexive engagement with *Mondo 2000*, Vivian Sobchack (2000) critically summarizes the magazine's ethos, which she names 'utopian cynicism': '[i]ts *raison d'être* is the techno-erotic celebration of a reality to be found on the far side of the computer screen and in the "neural nets" of a "liberated", disembodied, computerized

yet sensate consciousness' (Sobchack 2000: 141). Sobchack gives special attention to the political implications of *Mondo 2000*'s project, characterizing its readers as 'New Age Mutant Ninja Hackers' engaged in what she calls 'interactive autism':

> Rather than finding the gravity (and vulnerability) of human flesh and the finitude of the earth providing the *material* grounds for ethical responsibility in a highly technologized world, New Age Mutant Ninja Hackers would look toward 'downloading' their consciousness into the computer, leaving their 'obsolete' bodies (now contemptuously called 'meat' and 'wetware') behind.
>
> (Sobchack 2000: 142)

In the same way that Kroker and Kroker describe cybercultural disengagement as bunkering in and dumbing down, Sobchack reads interactive autism as reflecting a similar withdrawal from what cyberspacers call RL (real life). However, her analysis of *Mondo 2000* reveals a tension between the dream of leaving the meat behind and the continued presence of (often fetishized) bodies on its pages – most visibly manifest in the magazine's obsession with virtual sex. Remembering Tomas' distinction between types of technophilic body present in cyberpunk, we can, I think, read the *Mondo 2000* New Edge subculture as primarily one of aesthetic modification, of adopting a cyberpunk style (including, as Sobchack says, a cyberpunkish writing style). While this style is accompanied by a distinct attitude – the New Edge – this is diluted by the admixing of a number of counterdiscourses (new ageism, 1960s' hippiedom, consumerism) into the magazine's philosophy.

An orientation to the functional alteration of the technobody is realized more profoundly in other subcultural groupings; most notably, perhaps, in the Extropians. As Tiziana Terranova (2000) explains, the subcultural cluster based around California's Extropy Institute is essentially an articulation of a professionalized countercultural technophilia. She quotes their FAQ file:

> Extropians have made career choices based on their extropian ideals; many are software engineers, neuroscientists, aerospace engineers, cryptologists, privacy consultants, designers of institutions, mathematicians, philosophers, and medical doctors researching life-extension techniques. Some extropians are very active in libertarian politics, and in legal challenges to abuse of government power.
>
> (quoted in Terranova 2000: 272)

Extropianism, therefore, is a particular kind of subcultural project of the self, centring on becoming positioned at the forefront of posthuman possibilities, ready to lead the way when the time is right. It represents a form of knowledge accumulation and personal transformation in many ways at odds with *Mondo 2000*'s New Edge, though both share what Terranova calls a 'rampant super-voluntarism' (275) which effaces RL social and political contexts. As two future-facing subcultural formations, then, the New Edge and the Extropians articulate particular visions of the body's fate in cyberculture, which bear clear (but differently inflected) traces of cyberpunk.

Outside of these subcultures, the dream of leaving the meat behind can be traced in online discussions among an emerging 'high-tech' subculture based around immersive interaction in cyberspace. Here, the meat is usually thought of as those aspects of the body that are limiting in RL – those 'standards of physical beauty' that Clark's BBSer refers to, for example. The freedom offered by cyberspace is the freedom to jettison one's RL identity, and to play with the (supposedly infinite) possibilities for self-invention. Problematically, as accounts of online experience reveal, the supposed mutability and malleability of identity in cyberspace is often illusory. Ann Kaloski's essay on cruising LambdaMOO, for example, describes her attempt to jettison her RL gender identity and take up instead one of the ten 'ready-packaged' genders the MUD (multi-user domain) offers participants: male, female, spivak (ambiguous), neutral, splat (a 'thing'), royal (we), egotistical (I), second, either, and plural. Participants are also invited to post a brief description of their online persona. Kaloski adopted the ambiguous 'spivak' gender assignment, and described herself thus: 'a tall, tall, creature, with long limbs. My skin is blue/green and is covered in silvery down. My eyes are deep orange and my lips are gold' (Kaloski 1999: 207). In this virtual guise, she entered one of LambdaMOO's sex chatrooms, where participants engage in (text-based) virtual sex. She met the following blunt response from someone else in the chatroom: 'If you want sex, change your gender to female'. A second attempt, with a different spivak self-description, prompted the question 'What's your rl gender?'. This, it has to be said, can hardly be read as leaving the meat behind. What Kaloski's story tells us, I think, is that some aspects of identity are less easily transcended in cyberspace. The make-overs facilitated do permit us to transform ourselves in particular ways, but the materiality of the meaty body still persists. Further, the free play of identities in cyberspace, especially it seems in the case of virtual sex, tends to fall back on stereo-typed imaginings of sexual (and racial) difference (Kaloski 1999; Tsang 2000). Drawing together these cybersubcultural threads, then, I want to conclude by thinking about the things these body-stories have to tell us about contemporary (and future) corporealities.

Trajectories of the body

What I have attempted to do in this chapter is to tell two contrasting stories through a reading of particular forms of subcultural body-work. As I said at the outset, my argument is a simple one: that the transformations brought into being by techno-culture are provoking contradictory responses at the level of embodiment – the dream of the body's disappearance in a posthuman liberation from the meat, versus the desire to recapture and re-experience the body in the face of its threatened erasure. Of course, things aren't ever that simple, and the crossovers between these impulses can be seen in, for example, the aesthetic stylization of cyberpunk bodies or in the melding of high-tech logics with primitivist mysticism in the form of so-called 'techno-shamanism' (Leary 1994) – both of which produce, we might say, techno-bodies rather than tech-nobodies. Here, and elsewhere, there is a conflu-ence of what I have suggested are contradictory discourses – a fact which muddies the argument I set out to make. But, I would argue, these co-minglings are reflec-

tive of the inevitable tension between disembodiment and re-embodiment as corpo-real strategies. They represent negotiations, uneasy articulations which speak, perhaps, of the durability of flesh. The romance of leaving the meat behind, in a consensual hallucination of consciousness-as-data, is, it seems, only ever that. Yet, at the same time, the dream of re-embodiment through modification might indeed, as Sweetman (1999a) suggests, prove to be a fatal strategy, equally romantic in its impulse to reclaim and anchor the body. It's as if we don't know what to do with our bodies, how to deal with them; it's also, of course, as if we don't know what to do with technology, either. There are seductions on both sides, but in the subcultures I have been discussing seduction demands denial – denial of the material body in the seductions of cyberspace, or denial of technology in the seductions of the modified body. Each dream is matched by its corresponding nightmare – the loss of the body or the burden of the body. In RL, as in these subcultures, we are sure to witness a continuing negotiation of these trajectories of the body; the ultimate outcome is, it seems, as yet uncertain.

Notes

1 Some commentators argue that the body-modification scene does not constitute a subculture as such. Sweetman (1999a) for example, suggests that the presence of body-modification practices in numerous different cultural contexts precludes its designation as a distinct subculture. Other writers, however, argue the oppo-site case. Victoria Pitts, for example, suggests that the internal coherence (shared codes, etc.) of the body-modification scene does mark it clearly as a subculture:

> The knowledges of subcultural members . . . are often expressed in bodily experience, marginalized social contexts, and alternative discourses and styles which are less easily recognizable by the broader group than dominant discourses. . . . Body modifiers' knowledge about body modification is not only affective . . . but expresses new, alternative and recirculated attitudes towards technology, pleasure, sexuality, cultural membership, gender, spirituality, aesthetics and beauty.
>
> (Pitts 1999: 293)

By focusing on modern primitivism here, I am to some extent sidestepping this broader argument, since the commonalities that cojoin modern primitives are more easily accommodated in the notion of subculture (Klesse 1999). There is, of course, an even wider context here, in terms of the continued utility of the very term 'subculture' itself, especially given the proliferation of hybridized styl-izations which lack the 'thickness' of classical subcultures (see Gelder and Thornton 1997).

2 There are, of course, other forms of purposeful body modification which I do not consider here, including cosmetic surgery, implants, corsetting and so on. For an interesting account of body modifications as 'touches', which includes a critical reading of the social and legal contexts surrounding them, see Bibbings (1996).

Paul Hodkinson

COMMUNICATING GOTH
On-line media [2002]

We are struck, as we use the Internet, by the sense that there are others
out there like us.

(Jones 1997: 17)

[T] HE FOCUS NOW TURNS TO THE ROLE played by on-line communi-
cations in the facilitation of the subculture, as more and more of its
participants gained access to the internet and became what were known to some
insiders as net.goths. . . . [M]y insistence that the internet might have enhanced
the autonomy and substance of the goth scene may, at first, appear open to ques-
tion. After all, as well as being linked with the most large-scale and powerful of
commercial interests, the internet is accessed every day by millions of diversely
oriented individuals around the globe. In his famous work *The Virtual Community*,
Howard Rhinegold emphasizes the potential of the internet to bring the most
diverse of individuals into 'a world in which every citizen can broadcast to every
other citizen' (Rhinegold 1994: 14). Referring to Usenet's network of on-line
discussion forums in the singular as 'arguably the world's largest conversation' (130)
he argues the case for conceptualizing the net as a mass medium: 'It is a mass medium
because any information put onto the Net has a potential worldwide reach of
millions' (130).

Meanwhile, for those of postmodernist persuasions, the diverse yet fluid nature
of the internet accelerates the breakdown of boundaries between established social
categories and, hence, the fragmentation of individual identities and stable
communities (Poster 1995; Turkle 1995). Sherry Turkle describes a 'culture of
simulation' characterized by the ability to 'invent ourselves' by moving freely
between an infinite number of potential identities and, indeed, playing out several
at any one moment in time (1995: 9–26). . . . [S]uch a perspective implies that
groupings such as the goth scene would have their distinctiveness, commitment,

identity and autonomy thoroughly dissolved by the ability of individuals to move from one virtual affiliation to another on a mouse-click. Consistent with this, Marion Leonard suggests that on the internet, 'the ease of accessing any site disrupts the concept of underground community' (Leonard 1998: 111). In line with more general postmodernist interpretations of contemporary culture, then, the implication is of the melting if not the evaporation of cultural and subcultural boundaries by a mass medium which offers a taste of everything to everyone.

In practice, however, the use of the World Wide Web and on-line discussion groups by goths couldn't have contrasted more with such a picture. Far from distracting them into other interests or dissolving the boundaries of their subculture, the internet usually functioned, in the same way as goth events, to concentrate their involvement in the goth scene and to reinforce the boundaries of the grouping. The key general point here is that regardless of the number of individuals on-line, the internet does not, in practice, function as a singular mass medium but rather as a facilitating network which connects together a diverse plurality of different media forms. Some of these are widely used and well known, as in the case of websites associated with already established media or commercial organizations, while the vast majority are smaller-scale specialist sites and discussion facilities, many of which associated with particular interest communities or subcultures. Crucially, the technical ability to engage with each specialist culture represented on the web does not mean that anyone is likely to do so. Furthermore, the means by which websites and discussion groups are accessed can have the effect of clustering them together by subject matter and of encouraging users to pursue existing interests rather than to discover new ones. It is through elaboration of this key point that we may begin to understand how websites and discussion groups related to goth were more a part of the overall subcultural infrastructure of the goth scene than they were a part of any all-encompassing, fluid internet culture.

Goth web

World Wide Web searches I conducted on the word 'goth' always resulted in pages and pages of relevant sites, the vast majority of which seemed directly related to the goth music and fashion scene in which we are interested. These goth sites ranged from personal homepages, to promotional devices for particular goth bands or businesses, to general subcultural information sites. In spite of the huge potential audience and the apparent ease with which they could have been accessed by anyone, the practical reality was that the users of goth websites tended to be involved in the goth scene. This is because more than any other medium the World Wide Web requires users to choose in advance what to view. As a result, the chances of stumbling accidentally upon specialist sites without any prior interest are rather slim. Thus, while keyword searches were an efficient way of guiding existing goth participants and initially interested potential newcomers to a wealth of material on the subculture, they were hardly likely to result in non-participants accessing goth sites by chance. Similarly, hypertext links enhanced goths' ability to navigate precisely between subcultural websites, but not their chances of contact with non-subcultural content or individuals. Put simply, the vast majority of links to goth sites were

located on other goth sites, something which meant that, collectively, they formed a specialist and relatively autonomous sub network. Furthermore, there were certain particularly well known sites, such as *Darkwave*, which acted as nodal points directing users to a variety of useful subcultural resources in the sub-network (*Darkwave*, accessed 2000).

This goth web was connected more closely to other elements of the subculture – both on- and off-line – than it was to non-subcultural parts of the web. Further exclusive 'links' to goth sites, then, were provided in the form of addresses included on printed subcultural flyers, fanzines and CD inlays and transferred from one goth to another in conversation, whether face to face, over the telephone or via personal e-mail. In addition, URLs included as part of e-mails to the goth discussion groups comprised a particularly important means by which websites were accessed because they usually appeared in the form of active hyperlinks. A number of interviewees said that links in the body of discussion group e-mails were an important way in which they discovered new websites:

> B2 (*male*): I find that a lot of the links that I follow do tend to be links that have been advertised on UPG [*uk.people.gothic* newsgroup].

All these modes of access, of course, required a clear prior involvement in the goth scene, both in terms of coming into contact with the information and having the motivation to use it. Although hard to prove empirically, then, the weight of logic suggests strongly that most users of goth websites were already interested in their themes.

Similarly, the ability to decide for themselves what content to view tended to mean that the leisure-time web use of goths themselves, consistent with their commitment to the subculture in other ways, tended to be particularly concentrated on goth sites. Many goths in the late 1990s would surely have identified with the following respondent's explanation of her keenness, when she first gained access to the internet, to investigate its goth-related contents:

> M8 (*female*): When I first went to [university] they said 'oh yes, the internet is a wonderful new research resource you can use, go and find all these sites about anthropology', and I was like 'sod that!' and typed in 'goth' and wahey!

To differing degrees, all respondents also used non-goth sites in their leisure time, from on-line newspapers or comics, to railway timetables, to on-line gaming. However, all who were asked about it said that such additional uses were less frequent than those related to the goth scene.

> M8 (*female*): the goth stuff tends to be something which you do every day, and the other stuff tends to be every now and again.

As well as functioning as yet another illustration of the practical commitment of goths to their subculture, the specialist web-use of individual goths, alongside the relative obscurity of goth pages to most outsiders, clearly emphasizes that such sites were consistent with the relative autonomy of the grouping rather than antithetical to it.

The conceptualization of goth websites as subcultural media is further reinforced by the involvement of most of their producers in the goth scene, whether the sites were personal home pages or promotional devices for subcultural events or products. The availability of free web space was conducive to considerable grass-roots participation by goths in the construction of their subculture. The ability to create as well as consume subcultural media without paper, scissors, photocopying, envelopes or a cover price led a high proportion of net.goths to create their own sites. As a rough illustration, in January 1999, out of 366 goths who left details on one respondent's website map of British goths on the internet, 156 had indicated they had their own web pages (*Net.Goth Map*, accessed 1999). Inevitably, only a relatively small number would become well known among goths, but there remained the potential for anyone to reach a significant translocal audience. Posting links to a new site on a goth newsgroup or mailing list, for example, was an effective means of encouraging potentially interested visitors. Having advertised my own hastily cobbled together website on a goth e-mailing list, I not only found that its number of visitors trebled in the following days, but that some months later, other goths on the list had placed links to my site on their own. Therefore, as well as being largely used by a specialist audience, goth websites also gave individual participants the potential to involve themselves in the construction of their subculture.

Goth discussion groups

The most significant aspect of the internet for most goths and, therefore, the construction of the goth scene as a whole, was not in fact the World Wide Web, but discussion facilities such as Usenet newsgroups and e-mail lists.

> P1 (*male*): It's mainly mail and newsgroups . . . for us, I only use the web if I want to go and find something.

Preceded by various academic and government conferencing systems in the 1980s, both newsgroups and e-mail lists consist of an ever-developing pool of posts on various issues (threads) to which any subscriber can add his or her own contribution. In other words, they are far more interactive than most websites, allowing ongoing all-to-all communication. The first goth news group, *alt.gothic*, was formed as an international, though in practice largely American-centred forum, in the early 1990s. A few years later, as the number of subscribers and posts increased, British goths formed a smaller, national group known as *uk.people.gothic*. More recently, a number of e-mail lists emerged, based on the goth scene in particular areas of Britain and Ireland. Examples included *Contaminatii* and *Tainted* (both for England's West Midlands), *Mancgoff* (Manchester), *North Goths* (North of England), *Scotgoth* (Scotland), *Iegoth* (Ireland), and *Tarts* and *Sluts* (both for London).

Subscribed to by goths, and highly participatory, these newsgroups and mailing lists, even more so than goth websites, were subcultural media. Notions of Usenet as a singular mass-mediated conversation among millions (Rhinegold 1994: 117) or a meta-community (121) simply weren't borne out by this example. Rather, the distinct and separate nature of goth discussion groups fits in to Hill and Hughes's

point that facilities such as Usenet function to reinforce existing beliefs and affilia-
tions rather than fundamentally to change attitudes and that, as a result, they 'tend
to draw people into isolated groups, conversing among themselves' (Hill and Hughes
1998: 73). Those who accessed goth newsgroups or mailing lists, then, were liable
to do so as a result of a prior interest. It was possible for outsiders to find out about
them, through Usenet's listing of groups for example. However, the likelihood of
an individual without an initial interest subscribing to a mailing list with 'goth' in
its title was surely only slightly higher than that of the same person deciding to
spend the evening in a goth pub as a result of having coincidentally walked past it.
Conversely, the following respondent, who was a member of the subculture, said
that as soon as he found out about Usenet, the first thing he did was to search for
and join a goth group:

> J11 (*male*): A friend told me about newsgroups. I looked to see if there
> was a goth one, and there was – it went downhill from there!

It seemed even more common, though, for respondents to learn directly about
particular goth discussion groups through off-line word of mouth with other goths.

> V1 (*female*): My experience [of discovering *uk.people.gothic*] is that I got
> told about it from someone else who got told about it from someone
> else who got told about it from someone else.

In the unlikely event that a non-goth *did* subscribe to a goth discussion forum,
however, the chances of their persevering for long were also relatively faint, due to
the specialist and exclusive nature of discussion, and the tendency for mistrust and
hostility towards outsiders. The ways in which internet communities tend, in the
words of Hill and Hughes (1998: 69), to 'vigorously and successfully defend their
electronic boundaries' has been a key concern of the growing body of literature on
discussion-group-based, computer-mediated communities (see Jones 1995, 1997,
1999, 2000; Smith and Kollock 1999). Nessim Watson, for example, describes ways
in which the norms and relations of an on-line group of Phish fans were informally
regulated via responses from established members. In particular, Watson empha-
sizes the role of flaming – the practice of sending aggressive messages, either to an
individual's e-mail address or to the whole group – as a means of controlling the
behaviour of newcomers and excluding outsiders (Watson 1997). Consistent with
this, the posting of inappropriate or ill-informed messages by those not sufficiently
socialized into goth discussion-group norms was liable to result in being flamed.
While sometimes goths found themselves on the end of such treatment, it was
particularly effective in excluding perceived outsiders:

> M8 (*female*): Anyone who's not really interested in goth and just starts
> posting loads of crap usually gets told to sod off.

A less direct but equally effective means by which the content of discussion groups
was regulated occurred when particular messages or individuals were completely
ignored by other members of the group. The following respondent explained that

when he was a newcomer to *uk.people.gothic*, he found it hard, initially, to get anyone to respond to his messages because he had not learned what sort of topics and modes of behaviour people were interested in:

> B2 (*male*): I made the big mistake of not finding out about UPG [*uk.people.gothic*] before posting to it and I made a least three posts before reading the FAQ and everyone completely ignored me for a week.

If the passer-by, in my previous analogy, did decide to enter the goth pub out of curiosity, it seems likely that the music and decor of the building, alongside the clothing, body language and stares of other clientele, will have created a specialist and exclusive atmosphere and made the individual feel uncomfortable. Consistent with this, in the virtual space of a goth discussion group, having one's comments ignored, receiving directly hostile replies and generally feeling unable to participate in the specialist conversations was potentially just as effective. It is, of course, possible to *lurk* on discussion groups, without disclosing one's presence to the rest of the group. However, while many goths did spend time learning the conventions of such groups before they began to take part properly, it is not at all clear why an uncommitted outsider would have wished to spend his or her time doing so.

As well as being even more internal and exclusive than goth websites, discussion groups were more interactive. As Rhinegold (1994: 130) rightly observes, 'every member of the audience is also potentially a publisher'. There is no need, therefore, to advertise one's contributions to ensure they are read, as in the case of a website, because subscribers will automatically receive the message. Any goth with net-access, then, was able to express opinions, request information, or promote events, services or websites to a specialist subcultural audience. Of course, just as certain websites became well known, some discussion group members developed a particularly high profile. The maintainer of a prominent goth-scene information website suggested that this had raised his profile on goth discussion groups:

> D3 (*male*): because I provide information . . . it has the side effect that people tend to pay a lot more attention to my opinions in posts.

However, the fact that certain individuals commanded more attention than others did not stop anybody, through his or her on-line social skills or merely the subject matter of his or her posts, from having on occasion significant influence or, indeed, developing a more permanent reputation over time.

Enhancing subcultural participation

Goth websites, then, and, even more so, newsgroups and e-mailing lists, contributed to and illustrated the autonomy and self-generation of the goth scene through their relative exclusiveness and their high levels of participation. Crucially, rather than leading to the replacement of an off-line lifestyle with an on-line one, resources and forums on the internet functioned to facilitate the subculture as a whole through providing specialist knowledge, constructing values, offering practical information

and generating friendships. In particular, due to being more up-to-date, more inter-active and easier to access than fanzines, goth on-line resources became more and more significant in comparison to their printed counterparts, during the course of my research.

First, various kinds of socially valuable subcultural knowledge could be gleaned from the internet. In-depth details about particular bands, for example, could be obtained from either official or unofficial sites dedicated to them in part or in full. For example, as well as offering practical information on gigs and releases, Faithful Dawn's official website offered a history of the band, several photographs and a section detailing the current music tastes of the two band members (*Faithful Dawn* site, accessed 1999). More independent e-zines, such as *Gothicland*, meanwhile, offered a range of articles on goth bands, clubs, fashion and various other aspects of the goth scene (*Gothicland*, accessed 2000). A number of Frequently Asked Questions sites were designed to provide basic knowledge to potential newcomers to the goth scene. The *alt.gothic FAQ*, for example, offered a definition and history of the goth scene, giving examples of past and current bands, acceptable styles of clothing, pictures, and links to other useful sites (*alt.gothic FAQ*, accessed 2000). Newsgroups and e-mailing lists also offered subcultural knowledge, opinions and values. Through reading and taking part, one might learn about new developments in goth tastes or behaviour, or gain the latest knowledge about goth bands. The following post to *uk.people.gothic*, for example, enabled readers to be 'in the know' by informing them of the recent split of a goth band. Though the news was quickly passed on to subscribers of other goth groups, many without net access were unaware of it for some time.

> Subject: The end of Nekromantik (sob weep etc)
> Go and look at the web site if you didn't already know, all the expla-nations are there apparently. Really shit to lose one of the few 'goth' bands that actually looked to be going anywhere.
> (Sneekybat 1999)

In addition to satisfying genuine interests, up-to-date knowledge was important to the development of individual subcultural capital, whether in relation to the impres-siveness of music collections and personal appearance or merely through the ability to hold one's own in conversation with other goths.

However, the material and opinions included on websites and discussion threads also played a role in the overall construction of subcultural shared tastes and values. On frequently asked questions sites, even the most thorough, open definitions overtly constructed the translocal boundaries of the goth scene and are liable to have been particularly influential for those newcomers toward whom they were often targeted. In the following short extract from the *uk.people.gothic FAQ*, partic-ular hairstyles and items of clothing and jewellery are specifically established as suitable for late 1990s goths:

> Goth fashion changed subtly [in the 1990s], with crimped hair, high ponytails and combat trousers from the Grebo/Crusty scene, long straight hair, velvet and lace from Victorian Horror, leather and rubber

wear from the fetish scene, hair bunches, zip tops and hooded tops from techno. There is also a slow take-up of tattooing and piercing . . . By far the most popular goth fashion item remains skintight black jeans.

(*uk.people.gothic FAQ*, accessed 2000)

Just to be clear, the point is not to assess the accuracy of such accounts, but merely to emphasize that by what they chose to include and exclude, they played an important gatekeeping role in reinforcing and developing the value system of the subculture.

The interactions on discussion forums are also liable to have affected perceptions of the scene's boundaries of inclusion and exclusion. Discussions about bands and items of clothing were common. The positive mention of artefacts in question by even one or two subscribers was sometimes sufficient to establish their acceptability within the subculture, even if they were not appreciated by all. In a particularly good example, the growing acceptability of male goths wearing certain kinds of skirts was reflected, and thus reinforced in a discussion on the *Contaminatii mailing list*. Below is an extract from one of the contributions:

Re: Skirts on Blokes
I quite like blokes in skirts – not the 'HEY LOOK AT ME I HAVE A PVC MINI SKIRT ON' style but more subtle longer skirts can look quite good.
 Thought [name] looked quite swish in his long skirt at Whitby. Not very keen on blokes in very short, tight mini-skirts . . .

(Hemming 1999)

If it was important for communicating knowledge and constructing subcultural tastes and values, the internet played an even more crucial role in providing everyday practical information to goths. Via discussion-group threads or relevant web pages, up-to-date details could be obtained about forthcoming events, CD releases, retailers or fanzines. Respondents emphasized that on-line information tended to be more accurate and up-to-date than was the case for even the most reputable of fanzines. Although some websites did become out-of-date, others had developed particular reputations for containing the very latest subcultural information. One site, *Helix*, had become particularly well known and trusted for providing regularly updated information about goth and 'goth-friendly' clubs and events across Britain (*Helix*, accessed 1997–2000). The author of the site explained that, as a result, much of the information had started to be posted in by promoters and bands themselves, something which further enhanced the site's accuracy:

D3 (*male*): When it first started all the information I got was people saying 'I've found a flyer that says this' . . . these days I'd say that at least half . . . comes either from the bands themselves . . . and from the promoters.

Nevertheless, it was discussion groups that were the most important on-line source of information for British goths. For this reason *Helix*'s maintainer complemented

his website by posting regular events updates to the newsgroup *uk.people.gothic* and to subscribers of his own e-mailing list. Event promoters, bands, record labels and retailers also made announcements about events or services on discussion forums. In the example below, a message to *uk.people.gothic* provides information about the opening of a new branch of a well-known goth clothes shop in London. The information is passed on by a prominent goth promoter:

> Subject: A new Black Rose emporium in Camden
> Apologies if this has already been mentioned, but . . .
> The Black Rose, London's prime outlet for clothing of the goffick variety, will shortly open a new branch in Camden. The new Rose (ha!) will be located in the Stables Market, i.e. at the top end of the market area, beyond the railway bridge.
>
> (Johnson 1999)

It was also common for participants specifically to request information on discussion groups, something which invariably resulted in a positive reply. One request on the *Contaminatii* group, for information about the forthcoming Whitby Gothic Weekend, resulted in several replies, including one which included the entire line-up for the event. The maintainer of *Helix* explained that subscribers to newsgroups and mailing lists were unlikely to avoid receiving such information due to the regularity of their participation in the groups. In illustration of the point he used the example of his regular posting of information about the Whitby Gothic Weekend:

> D3 (*male*): Every single net.goth in the UK knows that Whitby happens and they know exactly what date the tickets go on sale and every single week they have it drummed into them by Helix.

Information posted to newsgroups became even more effective, from the point of view of promoters, if it managed to spark off discussion among subscribers. For example, the aforementioned request on *Contaminatii* for information about the Whitby Gothic Weekend prompted another subscriber to ask which list members were likely to be going to the event. Below is one of the responses:

> Subject: Re: Whitby
> Let's see . . . Me, [name], [name], [name], [name] . . .
> the 20+ other Cov people who [name] has sold tickets to, and [name] from Leicester, [name] from Bristol . . . And a few I've forgotten. Last year's ticket shortage seems to have scared people into deciding early . . .
>
> (White 1999)

A collection of individuals enthusing in such a way about their intentions to attend an event was liable to attract far more additional people to it than a non-interactive, impersonal advertisement from its promoter. The interactive nature of such forums enabled something of an on-line equivalent of 'word of mouth' to take place. Its advantage over its traditional face-to-face equivalent, though, was the size of the audience for each contribution. Its effectiveness in terms of encouraging attendance

at events was pointed out by one subscriber to a goth mailing list as part of a discussion about the large number of messages the list was getting:

> Subject: Re: Toreador on Saturday
> I *like* reading lots of posts about things that are going to happen. It gets me excited, and makes me look forward to things more. It also serves to make me jealous when I don't go to events, and therefore gets me off my backside more.
>
> <div align="right">(Harvey 1999)</div>

Another important reason why many relied upon discussion forums as their source of information about events and clubs was that, as well as finding out what was going on where, there was a chance of arranging to meet up with fellow subscribers at the venues concerned. Gaining new contacts and friends with whom, ultimately, to socialize off-line was another important aspect of interactive on-line communications within the goth scene:

> J11 (*male*): I have met many people on the net. First by e-mailing them and then arranging to meet at gigs etc.

In particular, some found on-line introductions easier than approaching people in goth clubs:

> P1 (*male*): I mean . . . she's made a lot more friends . . .
> B1 (*female*): Yeah, people who I never would have spoken to . . . because in real life I'm too shy. It's a good icebreaker – you get chatting to them without you having to be face to face. You can find out about them.

While, for some users, interactive goth discussion groups constituted forums for the full playing out of subcultural friendships, for many others, interacting on-line was regarded predominantly as a facilitator of off-line socializing:

> B2 (*male*): I don't count posting to *UPG* as socializing! Posting to *UPG* and *Contaminatii* is in order to organize and meet to socialize. Socializing to me is about face-to-face stuff.

The new goth friendships enabled by on-line interactive communications not only increased the attraction of continuing to take part in goth discussion groups, but also provided further incentive for participants to attend 'real-life' goth events. The following interviewee explained how this worked for him and his friends:

> P1 (*male*): We'd have a lot less nights knowing where people are [without the internet] because people post and say 'well I'm going out' and you think 'well I haven't seen so and so for a long time so I'll go out'.

The fact that the specialist information, collective enthusing, and on-line friendships facilitated by the internet encouraged attendance at goth events was the most

significant contribution of the medium to the goth scene in general. Given the capacity of events themselves to encourage further participation, it is clear that the internet formed a key link in enhancing participants' practical commitment to the subculture. More generally this very effectively illustrates Wellman and Gulia's point that, rather than spelling the end of face-to-face interaction and community, on-line technologies can function to complement and enhance off-line social activities and affiliations (Wellman and Gulia 1999: 170). Far from being a separate social or cultural entity, the internet consists of a range of resources used to enhance, facilitate and complement distinct lives and affiliations off the screen (Kendall 1999: 60).

Martin Roberts

NOTES ON THE GLOBAL
UNDERGROUND
Subcultures and globalization [2004]

Globalizing subcultures/subcultural globalization

THIS CHAPTER RESPONDS to what it takes to be the increasing globalization of subcultures over the past decade, a process that, I contend, requires us to rethink existing theories both of cultural globalization and subcultures themselves. What happens when the *sub*-cultural is introduced into theories of globalization or cosmopolitanism, or the reverse? How might we go about theorizing, for example, the *sub*-culture industry, the *sub*-cultural logic of late capitalism, the field of *sub*-cultural production, or the global *sub*-cultural economy? Attempting to answer such questions involves bringing together theoretical discourses that until now have been operating largely independently of one another: on the one hand, postcolonial studies, globalization studies and recent theoretical reformulations of the concept of cosmopolitanism; on the other, subcultural studies, itself part of the larger scholarship on youth cultures and mass consumption. The increasingly transnational, even global nature of subcultures today, however, requires us to think these fields in tandem with one another if we are to construct adequate theoretical accounts of them.

Over the past decade, a substantial literature has emerged devoted to the cultural dimension of globalization, in all its many forms. Whereas 'culture' has historically been approached primarily in localized terms, as confined to a specific place, it has increasingly been recognized that cultures *travel* and in today's world, in particular, are increasingly deterritorialized (Clifford 1992). Accordingly, the past decade has seen a growing number of studies of cultures in transit (for example, Gilroy 1993; Clifford 1997), as well as the elaboration of new theoretical models of *how* cultures travel (Appadurai 1996). Not surprisingly, much attention has been devoted to media globalization and its cultural implications, whether these are seen in terms of homogenization (Barber 1996; Herman and McChesney 1997) or

hybridization (García Canclini 1995). Surprisingly little attention has been paid to date, however, to the place of subcultures within this global picture.

While theorizations of the global cultural economy have tended to overlook the circulation of subcultures within it, subcultural studies has to date shown a similar inattentiveness to the implications of processes of globalization – notably the impact of the Internet – for subcultural production and practices. Admittedly, the transnational dimension of subcultures has long been recognized both in ethnography (for example, Gandoulou 1989a, 1989b; Friedman 1994a, 1994b) and cultural studies (Hebdige 1979, 1987; Lipsitz 1990, 1994; Gilroy 1993), with particular interest focusing on postcolonial and diasporic contexts (Sharma et al. 1996; Maira 2002). However, while these studies have been concerned with the transnational, intercultural dimensions of subcultures, their attention has focused almost exclusively on subcultural traffic between (in most cases, English-speaking) former colonial powers and their former dominions. We still know relatively little about subcultural production, practices and identities in other parts of the world.

The Anglo-American bias of subcultural studies to date is in part attributable to the conceptualization of the subcultural itself, subcultures having been typically regarded as socio-cultural formations specific to modern societies. Yet modernity itself, it is now widely acknowledged, has long since ceased to be a Euro-American monopoly but is now definitively 'at large,' in Arjun Appadurai's (1996) phrase, so that rather than a monolithic global modernity, we need to speak today of a plurality of global modernities (Tomlinson 1999). If it follows that the subcultural is similarly at large in global modernities, subcultural studies should accordingly expand its scope to include subcultural production in non-Western modern societies, as well as partially modernized ones. The project of this paper, then, is to bring together these two discursive and disciplinary formations – globalization studies and subcultural studies – in an attempt to rethink the subcultural in an age of globalization.

The global subcultural economy

Some of the questions which arise when we consider the interrelationships between the subcultural and the global are similar to those raised when considering the global cultural economy in general: how are global subcultural identities produced, circulated and exchanged? What new meanings, functions and values do they take on in contexts often remote from their place of origin? How is subcultural capital generated and exchanged in transnational or global contexts? A larger, methodological question also arises of how far existing theorizations of cultural globalization are applicable to subcultural globalization. One must ask, for example, how applicable Arjun Appadurai's influential model of the global cultural economy (1990) is to the circulation and exchange of subcultural identities, styles and practices, or what might be called the global subcultural economy. Certainly, as soon as we begin to apply Appadurai's model to specific examples, the task begins to look a rather daunting one. How are we to account in theoretical terms for – to take just a few examples – the popularity of dreadlocks among white Californian computer hackers or Israeli trance-music fans? Of Miss World beauty pageants among a gay Islamic subculture in the Philippines? Or the practice, among Japanese teenage girls, of impersonating

African American women by adopting hip-hop fashion styles and bronzing their skin at tanning salons? While practices such as these provide ample evidence of the transnational dimension of subcultural styles today, rather than simply fetishizing them as instances of cultural hybridity, we also need to see them as articulations of a complex array of factors operating at both transnational and local levels, from particular colonial and postcolonial power structures to the expanding reach of the global media industries.

Before exploring such questions in more detail, however, we should first consider the object of study itself: what exactly do we mean when we speak of 'global subcultures'? One way of approaching this question is simply to globalize the study of subcultures in national contexts. We might consider, for example, the place of cults and other resistance movements within modern societies: in the US, Waco; in Japan, Aum Shinkriko (Murakami 2001); in China, Falun Gong (Schechter 2000). An obvious problem here is that focusing solely on national contexts ignores the transnational dimension of subcultures today, Falun Gong being a good example; one thinks also of the Hare Krishna movement, or the followers of Sun Myung Moon or other global gurus. While clearly the global dimension of subcultures encompasses a much larger field of cultural production, for the purposes of this chapter I will be confining my attention to the domain of mass consumption within global capitalist modernity – specifically, the transnational circulation and symbolic exchange of subcultural commodities within the global culture industry, and the articulation of subcultural identities through practices of appropriation and consumption.

A key question that arises when considering the subcultural in relation to the global, and vice versa, concerns the relationship between the subcultural and the cosmopolitan. Efforts have been underway for some time now to rehabilitate this concept – long an object of suspicion on the left because of its elitist associations – by re-conceptualizing it along more egalitarian lines as an actually existing condition of global postmodernity (Robbins 1993; Robbins and Cheah 1998). In an intellectual climate suspicious of universalism, it seems that at the very least we are obliged to speak of cosmopolitanism in the plural, as a multiplicity of cosmopolitanisms (Breckenridge *et al.* 2000). Academic debates about cosmopolitanism notwithstanding, what we might call a cosmopolitan imaginary – in the old-fashioned, theory-of-the-leisure-class sense of the term – has been emerging within the global culture industry, paradoxically in proportion to a waning of the very socio-economic distinction associated with it. It could be argued, indeed, that today's global tourists are in many ways re-living, often in an overtly nostalgic mode, a fantasy version of cosmopolitanism previously only available to social elites. It is, in any event, with the idea of cosmopolitanism, or what could be called a cosmopolitan imaginary, that I am primarily concerned here.

A second question I am interested in exploring concerns the relationship between the subcultural and the indigenous. One of the commonest tropes within the discourse on subcultures is that of the 'tribe'. The conflation of pre-modern, tribal societies with subcultural 'style tribes' in modern ones has tended to be treated as unproblematic and its validity unquestioned, but once we introduce the subcultural into transnational and transcultural contexts, it becomes problematic. My specific concern here is not whether aboriginal or indigenous groups in modern societies somehow 'qualify' as subcultures – not a very interesting question in any case

– but rather the appropriation and consumption by subcultural groups, typically originating from the former colonial powers, of the (in many cases commodified) symbolic systems and cultural practices of indigenous, aboriginal or otherwise 'exotic' societies.

The global culture industry

First elaborated by Adorno and Horkheimer in their 1944 work *Dialectic of Enlightenment*, the concept of the culture industry has proved central to the theorization of postmodern culture as involving a shift from the production of material to cultural commodities (Horkheimer and Adorno 1994; see also Adorno 2001). Equally well established by now is the concept of the *global* culture industry, most evident in the transnational mediascapes of cinema, television, advertising, fashion and popular music. Within this larger context, the globalization of subcultures, and the formation of new subcultural identities from a globally circulating repertoire of cultural symbols, are only one dimension of the globalization of cultural identities, musical or fashion styles. A few additional points are relevant in this context. The first is that the global culture industry today is by no means limited to the circulation exclusively of Western symbolic goods and cultural practices, the global popularity of Japanese character goods, Asian martial arts practices, or Bollywood movies being only some obvious cases in point. What is clear, however, is that the increasing cosmopolitanism of the global culture industry today greatly expands the repertoire of resources for the formation of group identities, within the West as well as outside it. The globalization of subcultures is part of this larger process, and as we shall see, subcultural identities today are increasingly characterized by a similar cosmopolitanism. A further issue which should be noted is that what may be considered mainstream in one part of the world may become subcultural in another, and vice versa: for example, whereas rock music in Western societies or *anime* in Japan occupy a mainstream position within their respective cultural contexts, they may be coded as subcultural once appropriated outside them.

The subculture industry

Following Adorno and Horkheimer, I use the term 'subculture industry' to refer to the paradoxical commercialization of subcultural production, identities and symbolic practices – paradoxical because the latter typically position themselves in opposition to the commercial mainstream represented by the culture industry itself. The subculture industry today accounts for a substantial and lucrative sector of the larger culture industry, evidenced in the mass marketing of 'alternative' music, 'independent' cinema, 'underground' comics or 'extreme' sports. The inherent contradiction in this equation is that subcultural capital – like cultural capital *tout court* – is based upon exclusive knowledge theoretically available only to those 'in the know'; once everyone has that knowledge, it is no longer worth having. A whole sector of the subculture industry, from proliferating style magazines to corporate trend-spotters, is devoted to gathering this knowledge and disseminating it to mass

audiences. So rapid has the process of incorporation become, indeed, with the concomitant devaluation of subcultural capital, that today, it would appear, subcultural capital must increasingly be sought further afield, in the cultural practices of societies other than one's own, or even outside the modern world altogether. We discern here what Fredric Jameson might see as one of the subcultural logics of global capitalism, with the subcultural frontier, as it were, a continuously receding horizon propelled by a rapacious subculture industry always seeking to commodify and incorporate cultural practices beyond itself.

The reasons for the emergence of the subculture industry are complex, and cannot be adequately addressed here. Suffice it to say that the commercial profitability of the subcultural seems related to the displacement of cultural by subcultural capital as a basis of social distinction in postmodern societies. Whereas throughout the history of modernity standards of taste have tended to be driven in a 'top-down' fashion by socio-economic elites, today the reverse is often the case, with the mythical 'street' driving creative decisions across the spectrum of the culture industry. While cultural capital in the old-fashioned sense of the term continues to function as a source of social distinction, it is 'subcultural capital' that is sought most avidly by the socio-economic elites of the younger generation (Thornton 1995). The effects of this shift can often seem contradictory: while, for example, an urban black underclass fetishizes and seeks to appropriate conventional signs of white high-cultural prestige, suburban white middle-class youth seek black subcultural capital in appropriating the hip-hop style of their emulators (the Eminem effect). While hip-hop stars conspicuously consume Gucci and Fendi, Ralph Lauren and Polo, that very personification of subcultural capital, the black DJ, has become the indispensable accessory to any white media event aspiring to be 'cool', from fashion shows and gallery openings to the Ellen DeGeneres Show.

In what follows, I focus on three forms of contemporary subcultural practice, each of which provides a starting-point for thinking about the place of the subcultural within globalization, and vice versa. As we will see, each exemplifies a particular kind of social imaginary historically associated with socio-economic elites, but now available for subcultural identity formation. The imperial imaginary, first of all, relates to the project of cultural assimilation (the so-called 'civilizing mission'), predicated on an ideology of cultural superiority, embarked upon by the Western imperial powers in their former colonies. While the term 'cultural imperialism' is today more often associated with the global media industries and their allegedly homogenizing cultural effects, global club cultures today can often be seen as engaging both discursively and actually in subcultural imperialism. In contrast to the missionary zeal of certain areas of global club culture, and second, the primitivist imaginary is characterized by a desire to escape from the modern self and an embracing of cultural otherness which ultimately involves becoming the other ('going native'). While ostensibly a more benign form of intercultural relationship between the modern, Western self and its others, it remains an essentially privileged position originating in colonial power relations. The cosmopolitan imaginary provides a third, albeit no less privileged option for today's globalized subcultures, in which the cultural other becomes an object of collecting and connoisseurship, together with the social distinction associated with this. Whereas in the colonial world each of these social imaginaries was enabled by the unequal power structures

of imperialism, in their contemporary, neocolonial manifestations, as we will see, they take place within the no less unequal economic structures of global capitalism and are primarily organized around consumption.

Subcultural imperialism

One of the most striking developments within so-called 'club cultures' (Thornton 1995) of the past decade has been their increasingly global dimension. Whether subcultural or mainstream, electronic dance musics have developed well-established circuits with a steady stream of celebrity DJs in continuous rotation around them. Dance-music and style magazines report on scenes not just in Western Europe and the United States, but worldwide, in Scandinavia, Israel, South Africa, Japan, Australia. Certain locations – Ibiza, Goa, Bali – have acquired mythical status as global dance hubs, attracting millions of visitors each year, creating new tourist economies and restructuring old ones. The notion of cultural imperialism appears of little concern to the music journalists who report on such matters, whose rhetoric of world domination seems to assume that the conversion of the world to, say, trance music stems from the universal language of killer dance beats rather than the relentless marketing of the global culture industries. Particular interest is given to vanguard scenes at the frontiers of capitalist modernity, notably China, where they are easily aligned with socio-cultural (if not yet political) emancipation (Ostroff 2002; Swenson 2002). The 'global' itself has become a rhetorical fetish, ubiquitous in subcultural discourses about such musics in magazines, CD titles and liner-notes.

Techno music, the soundtrack to the rave movement, was from the outset associated with the glamour of international travel and tourism, originating in the summer 'acid-house' parties held in the late 1980s on the Mediterranean island of Ibiza, a popular destination for downmarket package tours since the 1970s (Reynolds 1999). Over the past decade, Ibiza has reinvented itself as a kind of rave Mecca, the subject of TV documentaries and innumerable tribute albums. Although by general agreement rave has long since gone the way of many subcultures before it, co-opted and commercialized by the subculture industry, techno and some of its endlessly proliferating mutant offspring, notably trance music, have become truly globalized, spawning a host of local scenes worldwide which in turn feed back into the global mix.

Such is the context in which we encounter the 'Global Underground' series, a collection of conspicuously cosmopolitan trance-music sets showcasing exclusively white, male Anglo-American DJs. Currently numbering over twenty CDs, the sets were recorded in clubs in New York, San Francisco, São Paolo, Buenos Aires, Montevideo, London, Oslo, Amsterdam, Budapest, Prague, Athens, Tel Aviv, Cape Town, Sydney, Hong Kong and Tokyo. Whatever one may think of the music, the series gives a good idea of the scale of the globalization of dance music today, as well as of how its discourses are pervaded by fantasies of the global and the cosmopolitan. The litany of global cities, the imagery of departure lounges and cock-tail bars, evokes the familiar world of the jet set, a reminder that if mass tourism has democratized world travel, today's globe-trotting DJs have joined movie stars, fashion designers and supermodels as the cultural elite of our time. While few of

us may be able to share the cosmopolitanism of this privileged class, we can partic-
ipate in the Global Underground vicariously, the series implies, by collecting the
CDs themselves.

It might also be noted that the series identifies itself not just with the global,
but also the underground, with the subcultural signifier discursively positioning it
a safe distance from the mainstream, as well as pre-empting charges of elitism evoked
by its conspicuous cosmopolitanism. The juxtaposition of the subcultural and the
cosmopolitan in the trope of the 'Global Underground' highlights the fluidity of the
relationship between high-cultural discourses with subcultural ones in today's global
culture industries, but it also shows how both high-cultural and subcultural elites
in a certain sense each depend on the (sub)cultural capital of the other as the basis
for social distinction.

Turn on, tune in, drop out (again)

Inasmuch as it would be seen by many as belonging to the more mainstream end
of the spectrum of contemporary global dance culture, the Global Underground
series provides a good example of the commercialization of subcultural styles of the
contemporary global media industries. A very different subcultural circuit centres
on the Indian coastal city of Goa, organized around another variety of trance music
known as Goan or psychedelic trance. Known as a hippie drug paradise since the
sixties, Goa was re-discovered by the rave industry in the early 1990s and, along
with Ibiza and Miami, has since become one of the strange attractors of global dance
culture (Kaur 1999). As with Ibiza, visitors to Goa began re-creating their experi-
ence in clubs after returning home, and it has quickly mushroomed (so to speak)
into a global phenomenon, with flourishing local scenes from Scandinavia to Australia
(Reynolds 2000). These scenes in turn have mutated into multiple local 'flavours':
Goa trance has developed a large following in Israel, for example, and Israeli trance
DJs and artists enjoy an international reputation.

Although progressive trance of the type exemplified by the Global Underground
series and Goan psychedelic trance are both constructed by the familiar technolo-
gies of synthesizers, samplers and sequencers, stylistically they are very different.
The Goa-trance subculture defines itself in opposition to the mainstream repre-
sented by the progressive-trance circuit, notwithstanding the latter's 'underground'
pretensions. Demographically, the two circuits also differ: whereas progressive-
trance fans come from the cosmopolitan middle classes of global cities, those of the
Goa-trance circuit, while still largely white and middle class, represent a different
type of world traveller, whose numbers have grown to mass proportions in recent
decades: the backpacker tourist, characterized precisely by his/her avoidance of the
spaces of mainstream tourism in search of supposedly more authentic forms of
cultural experience. In contrast to the urban destinations of the Global Under-
ground, those of the psychedelic trance movement follow a more exotic itinerary:
Goa, Bali or the island of Ko Pha-Ngan in Thailand (on the latter, see Aitkenhead
2001). If the Global Underground's role model is the conspicuously cosmopolitan
1960s jet-setter, that of the Goa-trance subculture is his/her countercultural alter
ego, the hippie: it is, indeed, in many ways a nineties revival of the psychedelic

counterculture immortalized by Timothy Leary and Ken Kesey (Lee and Shlain 1986; Stevens 1998). While ecstasy is the drug of choice on the progressive-trance circuit, Goa-trancers prefer LSD and the magic mushrooms eulogized by rogue anthropologists Carlos Castaneda (1968) and Terence McKenna (1992a, 1992b). Tie-dyed clothing, glo-sticks and the trippy Goa iconography of Buddhas, Ganeshas and bug-eyed Roswell aliens enhance the altered states of perception associated with psychotropic drugs.

The Goa-trance subculture has much in common with another of the contemporary legacies of the psychedelic counterculture of the 1960s: the Burning Man festival which each year brings together thousands of largely white, middle-class media professionals and artists for six days in the Black Rock Desert of Nevada. Rave events have been a staple of the festival in recent years, and one of the best-known Goa-trance DJs, Goa Gil, is featured on a CD release of music from the 1997 festival (Gil et al. 1998). In her work on primitivism (1990, 1997), the cultural historian Marianna Torgovnick is concerned with how while Enlightenment modernity constituted itself in opposition to pre-modern societies, modern artists and intellectuals have remained fascinated by the allure of those societies and their imagined proximity to the natural world. Torgovnick's work extensively documents this fascination with the 'primitive' both in high art and popular culture, from collecting ethnographic artefacts to mimicry of ritual practices such as body-piercing in the 'modern primitive' subculture. Both the Goa-trance and the Burning-Man subcultures can be seen as postmodern versions of the primitivism Torgovnick describes. The rituals and iconography of the Goa-trance movement mimic those of imagined 'primitive' cultures, often haphazardly and in overtly exoticist forms, reproducing the familiar modern myth of the native's closeness to nature. Raves are typically held in remote natural locations such as deserts, beaches or jungles, and timed to coincide with cyclic natural events such as full moons or eclipses, equinoxes and solstices. Primitivist fashion statements such as body-painting, hair-braiding and piercing are common. In this primitivist world, the DJ becomes a shaman, leading audiences on an initiatory journey where the boundaries between self and other, individual consciousness and the natural world, seem to dissolve. The very name of the music itself – trance – is a primitivist reference, evoking the use of music in possession rituals in traditional societies, as documented in the ethnographic films of Margaret Mead and Maya Deren.

Perhaps the central irony of the Goa-trance movement is that while predicated on a wish to escape Western capitalist modernity into supposedly more authentic modes of experience, it remains inescapably a part of that modernity – not least because the 'escape' itself is orchestrated by the global tourism and entertainment industries, but also because it profits from and perpetuates colonial power relations and economic inequalities. Reporting on a three-day Goa-trance festival that he attended in a Puerto Rican rainforest, the music journalist Simon Reynolds comments that the festival's high ticket price was partly intended to prevent local teenagers from spoiling their primitivist fun (Reynolds 2000). The pattern is a familiar one: today's global raves typically involve the setting up of carefully-policed enclaves designed to keep locals out, whether these are vendors trying to make a living from the local tourist economy or gatecrashing locals. Like the bourgeois, mainstream tourists they despise, rave tourists are no less preoccupied with being 'ripped off' by

locals (Aitkenhead 2001). We see here how the global subculture industry today functions in ways typical of neoliberalism in general, occupying the territories of third-world nations around the globe, exploiting natural resources, restructuring local economies, exploiting local labour markets, often decimating local environments, and moving on when conditions are no longer favourable. From rave tourism to Danny Boyle's primitivist fantasy *The Beach* (2000), the subculture industry today follows the logics of global postmodernity, its commodities no longer the material ones of the imperial past, but the primitivist nostalgia of modernity itself.

Conspicuous cosmopolitanism

> I don't want to be Japanese. I want to be a citizen of the world. It sounds very hippie but I like that.
> (Ryuichi Sakamoto, quoted in Toop 1995: 192)

Fashion, and more particularly what has become known as 'street style,' has long been recognized as a key site for the articulation of subcultural identities. One wonders, then, what subcultural theorists might make of *Fruits*, a Japanese street-fashion magazine produced by photographer Shoichi Aoki, which for almost a decade now has been documenting the stylistic virtuosity of the 'street tribes' of the Harajuku district of Tokyo. Although *Fruits* does not focus on a specific subculture, many of the styles it documents are recognizably subcultural (punk, goth, raver, etc.). However, these constitute only one stylistic option among the much larger semiotic repertoire which includes retro fashion, uniforms, national or ethnic dress, vintage clothing, pop culture, sexual fantasy or street-fashion designers such as Vivienne Westwood or Jean-Paul Gautier. What is perhaps most striking about this repertoire is that most of its options are non-Japanese, even though elements from traditional Japanese dress are also often included. Collectively, then, the outfits on display exemplify a kind of conspicuous cosmopolitanism, where an ostentatious fluency in the language of global fashion styles appears to be the basis for subcultural capital.

On one level, the street styles documented in the *Fruits* magazine are symptomatic of the emergence of a global semiotic system that includes not only subcultural styles but the idea of the subcultural itself as a socio-cultural formation of modern societies. Reading the Harajuku street tribes in terms of cultural globalization, however, should not lead us to overlook the local cultural specificity of the *Fruits* phenomenon. Within the larger context of Japanese youth culture, they are only one example among many of the elaborate and widely popular social ritual known as 'cosplay,' in which teenage girls (and some boys) masquerade as *anime* or videogame characters at *anime* conventions and similar events (Ahn 2002).

More generally, the *Fruits* phenomenon is related to the complex role of fashion in Japanese youth culture. It has been suggested, for example, that the obsessive search for social distinction through fashion by Japanese teenagers may be paradoxically attributable to the relative socio-economic homogeneity of Japanese society (compared to, say, Britain). Within a prosperous, predominantly middle-class society, fashion offers a surrogate system of social distinction. The carnivalesque street styles documented in the *Fruits* project seem to push the logic of this system

to its ultimate extreme by reducing social distinction to a kind of degree-zero level of the personal and the individual, a cult of absolute uniqueness.

To focus solely on the subcultural content of *Fruits*, however, is to overlook the function of the book itself as subcultural commodity and object of cosmopolitan consumption outside Japan. The availability of *Fruits* in bookstores, art galleries, and Virgin and Tower Records outlets around the globe, indeed, is symptomatic not only of the globalization of popular culture but also of the increasing prominence of cosmopolitanism as the basis for (sub)cultural capital within global mass consumption. In the United States, *Fruits* is only one of a gamut of global pop-cultural commodities, from books on Hong Kong underground comics to the soundtracks of Bollywood musicals, by which North American youth culture engages in a conspicuously cosmopolitan consumption comparable to that of the street tribes depicted in the book itself. The *Fruits* book is of course only one example of the Western fascination with Japanese pop culture, from *anime* video clubs to William Gibson novels, but that fascination is not confined to Japan: the basis of cosmopolitanism, and the (sub)cultural capital associated with it, involves knowledge not just of one culture, but many. As a global commodity itself, then, the *Fruits* book is peculiarly self-referential, symptomatic of the very cosmopolitanism of global popular culture that the book itself documents.

Subcultural nostalgia

In his work *Hybrid Cultures* (1995), the Argentinean cultural theorist Néstor García Canclini is concerned with the circulation and exchange of artistic practices and symbolic systems within three domains of cultural production: the cultured, or the domain of 'high' or elite art; the popular, the domain of traditional artistic and cultural practices; and the mass-cultural, or the domain of the culture industries (García Canclini 1995: 4). Canclini's particular focus is the absorption of both cultured and popular artistic practices into mass-cultural forms by the culture industry, and the new meanings, values and social functions they acquire in this process.

Although the category of the subcultural is problematically absent from Canclini's analysis, it provides a useful framework for understanding the forms of contemporary subcultural production I have been discussing here. Concepts such as exoticism, primitivism and cosmopolitanism, first of all, will need little introduction to anyone familiar with the history of modern art. For much of the past century, these terms have been closely associated with 'high' culture: both exoticism and primitivism are defining characteristics of artistic modernism, while cosmopolitanism is equally synonymous with elite culture. The examples I have discussed, however, suggest that such categories, historically associated with socio-economic elites and 'high' culture, have moved down not only into the domain of mass culture but also into the popular and subcultural domains. The historical conditions underlying this process are complex, but may in part be attributed to the transformation of global travel into a mass-cultural phenomenon by the tourist industry, and the commercialization of the exotic and the primitive by other global culture industries. The irony here is that as previously elite categories have passed into the mass-cultural

mainstream, they have become devalued as a source of distinction for elites them-selves, even though much of their mass-cultural appeal paradoxically has to do with their aura of elite exclusivity. Thus a large sector of the tourist industry, for example, packages nostalgic fantasies of imperial power and privilege for mass-cultural consumption. The fascination with the exotic and the primitive, the belated cosmopolitanism of contemporary youth subcultures, can thus be seen as sympto-matic of the mass-marketing of elite cultural experiences, tastes and values that are characteristic of global postmodernity.

The subcultural attraction to the exotic, the primitive and the cosmopolitan can also be related to a more specific dilemma generated by the contemporary subculture industry within youth culture. In a cultural economy where it may seem that subcul-tural styles are captured and marketed almost as soon as they happen, those looking to distinguish themselves from the rest may wonder (as, of course, do subcultural marketers) where not-yet-colonized cultural practices are to be found. Two responses to this dilemma can be discerned. The first is to seek alternatives outside Western capitalist modernity altogether: from this perspective, anything or anyone non-Western, non-modern, or ideally both, becomes desirable ('cool'): gypsies and other traveller communities; ethnic or immigrant communities; indigenous or native peoples; or anything else 'exotic'. It is, of course, debatable whether many of the supposed alternatives to the global mainstream are anything of the sort: while in the 1960s it might have been 'countercultural' to move to India (Mehta 1979), today it has become just another lifestyle choice. Paraphrasing Canclini, we might say that as many societies the world over continue struggling to enter modernity, many among modern youth cultures seem equally intent on finding the exit.

The perpetual self-reinvention of the Harajuku street tribes can be seen as a second strategy of resistance to the subculture industry. The subcultural frontier in this case is not spatial but temporal, with the goal being always to remain always one step ahead of the culture industry. Among the Harajuku street tribes, subcul-tural capital and social distinction arguably lie less in the adoption of a pre-existing, identifiable style than by the continual invention of new styles through the remixing of existing ones. A parallel can be drawn here between new subcultural practices and contemporary musical practices, where the most highly regarded artists are not those working – however virtuosically – within existing genres, but those whose music precisely defies such categorization. The furious reshuffling of identities at Harajuku exemplifies a similar strategy, where the objective seems always to come up with a style for which there is not (yet) a name, and which one can therefore claim as one's own. As soon as a new style is picked up on by the culture industry, it loses interest and is discarded for another.

In her study of club cultures (1995), Sarah Thornton challenges the assumption that media reportage on subcultures is secondary and parasitic, arguing that it is in fact instrumental in constituting them. While this may have been true of *Fruits*, the magazine, *Fruits*, the book, suggests a different conclusion. Even though the street styles it documents are barely five years old, the book has an oddly nostalgic quality, reminiscent of anthropology's project of documenting vanishing cultures: the subcultural scene it depicts, the book suggests, is already in decline, no longer what it was. In part this is characteristic of fashion, of course, but it could be suggested that the book itself may have played a part in the demise of its object. While

Thornton may be right that media discourses are instrumental in constructing subcultures, she is equally right that such discourses may also serve as a 'subcultural kiss of death' by which as soon as a subcultural practice achieves widespread media exposure it loses interest for its originators. Such is the dilemma in which the subculture industry is forever caught: in the very process of capturing and commodifying its object, it simultaneously initiates its demise.

Notes on contributors

Michael Atkinson gained his Ph.D. from the University of Calgary in 2001 and currently teaches in the Department of Sociology at McMaster University, Canada. He is author of *Tattooed: The Sociogenesis of a Body Art* (2003) and also publishes on sports and subcultures.

Howard S. Becker has been Professor of Sociology at the University of California-Santa Barbara, Northwestern University and most recently the University of Washington. His books include *Outsiders* (1963), *Art Worlds* (1982), *Doing Things Together* (1986) and *Tricks of the Trade: How to Think about Your Research While You're Doing It* (1998).

David Bell is Reader in Cultural Studies at Staffordshire University. His books include *Mapping Desire: Geographies of Sexualities* (1995, with Gill Valentine), *Consuming Geographies: We Are Where We Eat* (1997, with Gill Valentine), *The Sexual Citizen* (2000, with J. Binnie) and *An Introduction to Cybercultures* (2001). He is also editor of *The Cybercultures Reader* (2000).

Iain Borden is Professor and Director of the School of Architecture at University College, London. He is author of *Skateboarding, Space and the City: Architecture and the Body* (2001) and *Manual: the Architecture and Office of Allford Hall Monaghan Morris* (2003), and co-editor of *Gender Space Architecture* (1999), *The City Cultures Reader* (2000) and *The Unknown City: Contesting Architecture and Social Space* (2001).

Gary Clarke's essay 'Defending Ski-Jumpers' was first published in the stencilled papers series at the Centre for Contemporary Cultural Studies, University of Birmingham, in 1982; it was also included in *On Record* (1990).

John Clarke is Professor of Social Policy at the Open University. His books include *The Managerial State* (1997, with Janet Newman), the co-edited *New Managerialism, New Welfare?* (2000) and *Changing Welfare, Changing States: New Directions in Social Policy* (2004).

Albert K. Cohen gained his Ph.D. from Harvard University, and taught Sociology at Indiana University and the University of Connecticut, retiring in 1988. He was President of the Society for the Study of Social Problems in 1971–72. His books include *Deviance and Control* (1946), *Delinquent Boys* (1955) and *The Elasticity of Evil* (1974).

Phil Cohen is Professor of Cultural Studies, University of East London. His books include *Knuckle Sandwich* (1981), *Rethinking the Youth Question* (1996) and, as editor, *New Ethnicites, Old Racisms* (1999).

Stanley Cohen is Martin White Professor of Sociology at the London School of Economics. His books include *Folk Devils and Moral Panics: The Creation of the Mods and Rockers* (1972) – now in its third edition – *Against Criminology* (1988) and *States of Denial: Knowing About Atrocities and Suffering* (2000).

Paul G. Cressey (1901–55) gained his MA in Sociology from the University of Chicago and went on to undertake research at New York University and to teach at Ohio Wesleyan University, Evansville College and the University of Newark. He is the author of *The Taxi-Dance Hall: A Sociological Study in Commercialised Recreation and City Life* (1932).

Douglas Crimp is Fanny Knapp Allen Professor of Art History at the University of Rochester, New York. His books include *AIDS: Cultural Analysis/Cultural Activism* (1988), *AIDS Demo Graphics* (1990), *On the Museum's Ruins* (1993) and *Melancholia and Moralism* (2002).

Stephen Duncombe gained his Ph.D. in Sociology at the City University of New York in 1996, and is a Professor at the Gallatin School, New York University. He is author of *Notes from Underground: Zines and the Politics of Alternative Culture* (1997) and editor of *The Cultural Resistance Reader* (2002).

James Farrer gained his MA and Ph.D. in Sociology from the University of Chicago and teaches in the Department of Comparative Culture, Sophia University, Tokyo. He is the author of *Opening Up: Youth Sex Culture and Market Reform in Shanghai* (2002).

T.R. Fyvel (1907–85) was a London-based writer, journalist and broadcaster. He co-edited, with George Orwell, the series *Searchlight Books* and succeeded Orwell as literary editor of *Tribune* in the late 1940s. His books include *The Insecure Offenders: Rebellious Youth in the Welfare State* (1961), *Intellectuals Today: Problems in a Changing Society* (1968) and *George Orwell: A Personal Memoir* (1982).

Ken Gelder is Professor of English and Cultural Studies at the University of Melbourne. His books include *Popular Fiction: The Logics and Practices of a Literary Field* (2004), *Reading the Vampire* (1994) and, with Jane M. Jacobs, *Uncanny Australia: Sacredness and Identity in a Postcolonial Nation* (1998). He is also editor of *The Horror Reader* (2000).

Paul Gilroy is Professor of Sociology and African American Studies at Yale University. He gained his Ph.D. at the Centre for Contemporary Cultural Studies, University of Birmingham. His books include *'There Ain't No Black in the Union Jack': The Cultural Politics of Race and Nation* (1987), *Small Acts: Thoughts on the Politics of Black Cultures* (1993), *The Black Atlantic: Modernity and Double Consciousness* (1993), *Against Race: Imagining Political Culture Beyond the Color Line* (2000) and *After Empire: Multiculture or Postcolonial Melancholia* (2004).

Erving Goffman (1922–82) gained his MA and Ph.D. from the University of Chicago. In the late 1950s, he was a visiting scientist at the National Institute of Mental Health. He went on to become Professor of Sociology at the University of California, Berkeley, and then Benjamin Franklin Professor of Anthropology and Sociology at the University of Pennsylvania. His many books include *The Presentation of Self in Everyday Life* (1959), *Asylums: Essays on the Social Situation of Mental Patients and Other Inmates* (1961), *Behavior in Public Places: Notes on the Social Organization of Gatherings* (1963), *Frame Analysis: Essays on the Organization of Experience* (1974) and *Forms of Talk* (1981).

Milton M. Gordon gained his Ph.D. from Columbia University in 1950 and is now Emeritus Professor in Sociology at the University of Massachusetts. He is the author of *Assimilation in American Life: The Role of Race, Religion, and National Origins* (1964).

Judith Halberstam is Professor in the English Faculty at the University of California, Santa Cruz. She is the author of *Skin Shows: Gothic Horror and the Technology of Monsters* (1995), *Female Masculinity* (1998), *The Drag King Book* (1999, with LaGrace Volcano) and *The Transgender Moment: Gender Flexibility and the Postmodern Condition* (2004).

Stuart Hall was Director of the Centre for Contemporary Cultural Studies at the University of Birmingham, and went on to become Professor of Sociology at the Open University, retiring in 1997. His books include the co-edited *Resistance Through Rituals* (1975), *Policing the Crisis* (1978) and *Visual Culture: The Reader* (1999), and he is author of *The Hard Road to Renewal: Thatcherism and the Crisis of the Left* (1988) and *Questions of Cultural Identity* (1996, with Paul du Gay).

Rom Harré is Adjunct Professor of Social Psychology, Georgetown University, Washington. His books include *Personal Being: A Theory for a Corporeal Psychology* (1983) and *Social Being: A Theory for a Social Psychology* (1993). He is co-author of *Rules of Disorder* (1978) and co-editor of *The Emotions: Social, Cultural and Physical Dimensions of the Emotions* (1996).

Murray Healy gained his MA in English at Sussex University, and is currently senior editor of *Pop* and a freelance editor and writer. He has been associate editor of *The Face* and managing editor of *Arena Homme Plus*, and is author of *Gay Skins: Class, Masculinity and Queer Appropriation* (1996).

Dick Hebdige is Professor of Film Studies and Art Studio and Director of the Interdisciplinary Humanities Center at the University of California, Santa Barbara. He gained his MA at the Centre for Contemporary Cultural Studies, University of Birmingham. His books include *Subculture: The Meaning of Style* (1979), *Cut 'n' Mix: Culture, Identity and Caribbean Music* (1987) and *Hiding in the Light: On Images and Things* (1988).

Clare Hemmings gained her MA and D.Phil. from the University of York and now teaches at the Gender Institute, London School of Economics. She is author of *Bisexual Spaces: a Geography of Sexuality and Gender* (2002) and co-editor of *The Bisexual Imaginary* (1997).

Kevin Hetherington is Professor of Cultural Sociology at Lancaster University, where he gained his Ph.D. He is author of *The Badlands of Modernity: Heterotopia and Social Ordering* (1997), *Expressions of Identity: Space, Performance, Politics* (1998) and *New Age Travellers: Vanloads of Uproarious Humanity* (2000).

Paul Hodkinson gained his Ph.D. from Birmingham and now teaches Sociology at the University of Surrey. He is author of *Goth: Identity, Style and Subculture* (2002).

Laud Humphreys (1930–88) gained his Masters of Divinity in 1995 and his Ph.D. (at Washington University) in Sociology and Criminology in 1968; he was an Episcopal priest, a civil rights activist and a practising psychotherapist in California. His books include *The Tearoom Trade: Impersonal Sex in Public Places* (1970) and *Out of the Closets* (1972).

Marcia Ian is Associate Professor of English at Rutgers University, New Brunswick, USA. She is author of *Remembering the Phallic Mother: Psychoanalysis, Modernism and the Fetish* (1993).

John Irwin gained his Ph.D. in Sociology at the University of California, Berkeley, and is now Emeritus Professor at San Francisco State University. In 1969 he founded Project Rebound, which helps ex-offenders get to college. His books include *The Felon* (1970, 1987), *Scenes* (1977), *Prisons in Turmoil* (1980) and *The Jail: Managing the Underclass in American Society* (1985).

Tony Jefferson is Professor of Criminology at Keele University. He is co-editor of *Resistance Through Rituals* (1975) and *Policing the Crisis* (1978), and author of *The Case Against Paramilitary Policing* (1990) and *Doing Qualitative Research Differently* (2000, with Wendy Hollway).

Sharon Kinsella gained her Ph.D. from Oxford University in 1996 and was Assistant Professor of Sociology at Yale University until 2004. She is author of *Adult Manga: Culture and Power in Contemporary Japanese Society* (2000) and is currently a freelance researcher based in Britain.

Dave Laing is a writer and lecturer based in London. His books include *The Sound of Our Time* (1969), *Buddy Holly* (1970), *One Chord Wonders: Power and the Meaning of Punk Rock* (1985) and *The Faber Companion to 20th Century Popular Music* (1995, with Phil Hardy). He is also editor of the *Continuum Encyclopedia of Popular Music of the World* (2003, ongoing).

Nancy Macdonald gained her Ph.D. from Middlesex University and is currently Research Director at 2cv:research, London. She is the author of *The Graffiti Subculture: Youth, Masculinity and Identity in London and New York* (2001).

Angela McRobbie is Professor of Communications at Goldsmiths, University of London. Her books include *Feminism and Youth Culture* (1991, 2000), *Postmodernism and Popular Culture* (1994) and *British Fashion Design: Rag Trade or Image Industry?* (1998).

Michel Maffesoli is Professor of Sociology at the Centre d'études sur l'actuel et le quotidien, Université Sorbonne Paris V. Some of his many books are available in English: *The Shadow of Dionysus. A Contribution to the Sociology of the Orgy* (1993), *The Time of the Tribes, The Decline of Individualism in Mass Societies* (1995), *The Ordinary Knowledge* (1995) and *The Contemplation of the World: Figures of Community Style* (1996).

Ben Malbon is an Account Planner in a London-based advertising agency. He is the author of *Clubbing: Dancing, Ecstasy and Vitality* (1999).

Peter Marsh is a Chartered Psychologist and Director of MCM Research Ltd (since 1987) and The Social Issues Research Centre (founded with Kate Fox in 1997). His books include the co-authored *Rules of Disorder* (1978) and he is author of *Tribes* (1988, with Desmond Morris) and *Eye to Eye: How People Interact* (1988).

Kobena Mercer gained his Ph.D. in Sociology from Goldsmiths College, University of London, in 1984. He has taught at the University of California, Los Angeles, New York University and Middlesex University, where he is currently a Research Associate in Film and Visual Cultures. He is author of *Welcome to the Jungle: New Positions in Black Cultural Studies* (1994) and *Keith Piper: Relocating the Remains* (1997), co-author of *James Van Der Zee* (2003, with James Van Der Zee) and editor of *Black Film/British Cinema* (1988).

Robert E. Park (1864–1944) gained an MA in Philosophy from Harvard University and a Ph.D. in Sociology, Philosophy and Psychology at the University of Berlin. Having worked as a journalist and as publicist and then Director of Public Relations at the Tuskegee Institute, he joined the Department of Sociology at the University of Chicago in 1914. He became a Professor of Sociology in 1923, retiring in 1933.

Park is author of *The Immigrant Press and Its Controls* (1921), *Old World Traits Transplanted* (1921, with Herbert A. Miller) and *The City* (1925, with Ernest W. Burgess and R.D. McKenzie) *Race and Culture* (1950) and *Human Communities* (1952), collections of his writings, were published posthumously.

Ned Polsky (1928–2000) was a graduate student at the University of Chicago and went on to become Professor of Sociology at the State University of New York – Stony Brook, retiring in 1983 and becoming an antiquarian bookseller. He is the author of *Hustlers, Beats and Others* (1969).

Howard Rheingold has been involved in the WELL conferencing system and was editor of *The Whole Earth Review* and editor in chief of *The Millennium Whole Earth Catalogue*. In 1996 he founded the web community *Electric Minds*. His many books include *Exploring the World of Lucid Dreaming* (1990), *Virtual Reality* (1991) and *The Virtual Community* (1993), a new edition of which was published by MIT in 2000.

Brian Roberts is a Principal Lecturer in Sociology at the University of Huddersfield. As well as contributing to *Resistance Through Rituals* (1975), he has published widely on issues of criminology, ethnicity, community and identity, oral history and biography.

Martin Roberts gained his Ph.D. in French Literature from Cambridge University and has been teaching in The New School in New York since 1997. He has also taught at New York University, MIT and Harvard University. He has published widely on ethnography and surrealism, world music, and national and transnational identities.

Elizabeth Rosser is co-author of *Rules of Disorder* (1978).

Will Straw is Associate Professor of Communication Studies at McGill University, Canada. He is co-editor of *Popular Music: Style and Identity* (1995), *Theory Rules: Art as Theory, Theory as Art* (1996), *Canadian Identity: Region/Country/Nation* (1998) and – with Simon Frith and John Street – *The Cambridge Companion to Rock and Pop* (2001).

Samuel J. Surace gained his MA in Sociology from the University of California, Los Angeles, and his Ph.D. from the University of California, Berkeley. He taught at the Department of Sociology at UCLA from 1961 to 1989, retiring as Emeritus Professor. He is author of *Ideology, Economic Change and the Working Classes: The Case of Italy* (1966) and *Towards a Sociology of Borders: The U.S.-Mexican Case* (1969).

Sarah Thornton published her Ph.D. as a book called *Club Cultures: Music, Media and Subcultural Capital* (1995) and was co-editor of the first edition of *The Subcultures Reader* (1997). She used to run the MA in Media Studies at Sussex University and has since undertaken participant observation in an advertising agency and is currently writing an ethnography of the contemporary art world.

Frederic M. Thrasher (1892–1962) was Professor of Educational Sociology at New York University and author of *The Gang: A Study of 1,313 Gangs in Chicago* (1927) and *Okay for Sound: How the Screen Found its Voice* (1946).

Andrew Tolson is Principal Lecturer in Media Studies at De Montfort University. He is author of *The Limits of Masculinity* (1977), *Mediations: Text and Discourse in Media Studies* (1996) and *Talk Shows: Discourse, Performance Spectacle* (2001).

Ralph H. Turner gained his Ph.D. from the University of Chicago and went on to teach in the Department of Sociology at the University of California, Los Angeles, retiring as Emeritus Professor in 1990. He is the author of *Collective Behaviour* (1957, with Lewis M. Killian), *The Social Context of Ambition* (1964), *Family Interaction* (1970) and *Waiting for Disaster: Earthquake Watch in California* (1986, with Joanne M. Nigg and Denise Heller Paz).

William Foote Whyte (1914–2000) was an Emeritus Professor in the Cornell School of Industrial and Labor Relations, and co-founder and later Research Director of Programs for Employment and Workplace Systems. He taught at Cornell from 1948 to 1980. His many books include *Street Corner Society: The Social Structure of an Italian Slum* (1943), *Human Relations in the Restaurant Industry* (1948), *Money and Motivation: An Analysis of Incentives in Industry* (1977), *Learning from the Field: A Guide from Experience* (1984), *Participatory Action Research* (1990) and *Participant Observer: an Autobiography* (1994).

Paul E. Willis gained his Ph.D. from the Centre for Contemporary Cultural Studies at the University of Birmingham in 1972, remaining there as a senior researcher until 1981 and then moving on to teach at the University of Wolverhampton. He is currently a part-time Professor of Social/Cultural Ethnography at Keele University, and also holds a number of consulting posts. He is author of the often-reprinted *Learning to Labour* (1977), *Profane Culture* (1978), *Moving Culture* (1990), *Common Culture* (1990, with S. Jones, J. Canaan and G. Hurd) and *The Ethnographic Imagination* (2000). He founded the journal *Ethnography* in 2000.

Jock Young is Distinguished Professor of Sociology at the John Jay College of Criminal Justice, City University of New York. His books include *The Drugtakers* (1971), *The Manufacture of News* (1973, with Stanley Cohen), *Losing the Fight Against Crime* (1986, with R. Kinsey and J. Lea) and *The Exclusive Society: Social Exclusion, Crime and Difference in Late Modernity* (1999).

Bibliography

Abrams, M. (1959) *The Teenage Consumer*, London: London Press Exchange Ltd.

Adorno, Theodor W. (1973) *Philosophy of Modern Music*, London: Seaburg.

Adorno, Theodor W. (1991) 'On the Fetish Character in Music and the Regression of Listening', in *The Culture Industry: Selected Essays on Mass Culture*, intro. J.M. Bernstein, London and New York: Routledge.

Adorno, Theodor W. (2001) *The Culture Industry*, intro. J.M. Bernstein, London and New York: Routledge.

Ahn, Jiwon (2002) 'Animated Subjects: On the Circulation of Japanese Animation as Global Cultural Product'. Paper delivered at the conference 'Globalization and Popular Culture: Production, Consumption, Identity', University of Manitoba, Canada, 19–21 October 2001.

Aitkenhead, Decca (2001) 'Lovely Girls, Very Cheap', *Granta* 73: 127–50.

Althusser, Louis (1969) *For Marx*, New York: Allen Lane.

Althusser, Louis (1971) 'Ideology and the State', in *Lenin and Philosophy and Other Essays*, London: New Left Books.

Altman, Dennis (1997) 'Global Gaze/Global Gays', *GLQ: A Journal of Lesbian and Gay Studies* 3: 417–36.

Anderson, Nels (1923) *The Hobo: The Sociology of the Homeless Man*, Chicago: University of Chicago Press.

Aoki, Shoichi (2001) *Fruits*, London: Phaidon Press.

Appadurai, Arjun (1990) 'Disjuncture and Difference in the Global Cultural Economy', in Mike Featherstone, ed., *Global Culture: Nationalism, Globalization and Modernity*, London and Newbury Park, CA: Sage.

Appadurai, Arjun (1996) *Modernity at Large: Cultural Dimensions of Globalization*, Minneapolis: University of Minnesota Press.

Appadurai, Arjun (ed.) (2001) *Globalization*, Durham, NC: Duke University Press.

Arnold, David O. (1970) *Subcultures*, Berkeley, CA: The Glendessary Press.

Asbury, Herbert (2002) *The Gangs of New York*, London: Arrow Books. (First published 1928, New York: Alfred A. Knopf.)

Ashe, Geoffrey (2000) *The Hell-fire Clubs: A History of Anti-morality*, Phoenix Mill: Sutton Publishing.

Atkinson, Michael (2000) 'Brother Can You Spare a Seat? Developing Recipes of Knowledge in the Ticket Scalping Subculture', *Sociology of Sport Journal* 17.

Atkinson, Michael (2003) *Tattooed: The Sociogenesis of a Body Art*, Toronto: University of Toronto Press.

Bacrach, P. and Baratz, M. (1962) 'The Two Faces of Power', *American Political Science Review* 56.

Bakhtin, Mikhail (1984) *Rabelais and His World*, Bloomington: Indiana University Press.

Balding, J. (1997) *Young People in 1996*, Exeter: University of Exeter Press.

Balsamo, A. (2000) 'The Virtual Body in Cyberspace', in David Bell and Barbara M. Kennedy, eds, *The Cybercultures Reader*, London: Routledge.

Barber, Benjamin (1996) *Jihad vs. McWorld: How Globalism and Tribalism are Reshaping the World*, New York: Ballantine Books.

Barme, Geremie (1993) 'Soft Porn, Packaged Dissent and Nationalism: Notes on Chinese Culture in the 1990s', *Current History* 93.

Barme, Geremie and Javin, Linda (eds) (1992) *New Ghosts, Old Dreams: Chinese Rebel Voices*, New York: Times Books.

Barnes, Richards (1980) *Mods!*, London: Eel Pie Publishing.

Barthes, Roland (1971) 'Rhetoric of the Image', *Working Papers in Cultural Studies 1*, University of Birmingham: Centre for Contemporary Cultural Studies.

Barthes, Roland (1972) *Mythologies*, New York: Paladin.

Barthes, Roland (1977) *Image-Music-Text*, London: Collins.

Bassett, Caroline (1997) 'Virtually Gendered: Life in an On-line World', in Ken Gelder and Sarah Thornton, eds, *The Subcultures Reader*, London and New York: Routledge.

Bastide, R. (1978) *The African Religions of Brazil*, Baltimore and London: Johns Hopkins University Press.

Beal, Becky (1995) 'Disqualifying the Official: An Exploration of Social Resistance Through the Subculture of Skateboarding', *Sociology of Sport Journal* 12, 3.

Becker, Howard S. (1963) *Outsiders: Studies in the Sociology of Deviance*, New York: The Free Press.

Becker, Howard S. (1973) *Outsiders: Studies in the Sociology of Deviance*, second edition, New York: The Free Press.

Becker, Howard S. *et al.* (1961) *Boys in White: Student Culture in Medical School*, Chicago: University of Chicago Press.

Beier, A.L. (1985) *Masterless Men: The Vagrancy Problem in England, 1560–1640*, London and New York: Methuen.

Belknap, Ivan (1956) *Human Problems of a State Mental Hospital*, New York: McGraw-Hill.

Bell, David (2000a) 'Cybercultures Reader: A User's Guide', in David Bell and Barbara M. Kennedy, eds, *The Cybercultures Reader*, London: Routledge.

Bell, David (2000b) 'Meat and Metal', in Ruth Holliday and John Hassard, eds, *Contested Bodies*, London and New York: Routledge.

Bell, David (2001) *An Introduction to Cybercultures*, London and New York: Routledge.

Bell, David and Valentine, Gill (1995) 'The Sexed Body: Strategies of Performance, Sites of Resistance', in S. Pile and N. Thrift, eds, *Mapping the Subject: Geographies of Cultural Transformation*, London: Routledge.

Benjamin, Walter (1968) *Illuminations*, New York: Harcourt, Brace and World.

Benjamin, Walter (1973) *Charles Baudelaire: A Lyric Poet in the Era of High Capitalism*, London: New Left Books.

Bennett, Andy (1999) 'Subcultures or Neo-Tribes? Rethinking the Relationship Between Youth, Style and Musical Taste', *Sociology* 33, 3: 599–617.

Bennett, Andy and Kahn-Harris, Keith (eds) (2004) *After Subculture: Critical Studies in Contemporary Youth Culture*, Houndmills: Palgrave.

Bennett, James (1981) *Oral History and Delinquency*, Chicago: University of Chicago Press.

Bercuvitz, Debra (1995) 'Stand By Your Man', in L. Newman, ed., *The Femme Mystique*, Boston: Alyson.

Berger, Bennett (1963) 'The Sociology of Leisure', in E.O. Smigel, ed., *Work and Leisure*, New Haven: College and University Press.

Berger, P. and Luckmann, T. (1964) 'Social Mobility and Personal Identity', *European Journal of Sociology* 5.

Berghahn, M. (1977) *Images of Africa in Black American Literature*, London: Macmillan.

Bergman, David (ed.) (1993) *Camp Grounds: Style and Homosexuality*, Amherst: University of Massachusetts Press.

Berque, A. (1982) *Vivre l'espace au Japan*, Paris: PUF.

Besant, Walter (1912) *East London*, London: Chatto & Windus.

Bibbings, L. (1996) 'Touch: Socio-cultural Attitudes and Legal Responses to Body Alteration', in L. Bently and L. Flynn, eds, *Law and the Senses: Sensational Jurisprudence*, London: Pluto Press.

Blacking, J. (1973) *How Musical is Man?*, Seattle: University of Washington Press.

Borden, Iain (2000) 'Thick Edge: Architectural Boundaries in the Postmodern Metropolis', in Iain Borden and Jane Rendell, eds, *InterSections: Architectural Histories and Critical Histories*, London: Routledge.

Borden, Iain (2001) *Skateboarding, Space and the City: Architecture and the Body*, Oxford: Berg.

Bourdieu, Pierre (1984) *Distinction: A Social Critique of the Judgement of Taste*, trans. R. Nice, Cambridge, MA: Harvard University Press.

Bourdieu, Pierre (1990) *In Other Words: Essays Towards a Reflexive Sociology*, Oxford: Polity.

Bourdieu, Pierre (1991) 'Did You Say "Popular"?', in *Language and Symbolic Power*, Oxford: Polity.

Bourdieu, Pierre (1993) *The Field of Cultural Production*, New York: Columbia University Press.

Bradshaw, P. (1981) 'A Big Sound System Splashdown', *New Musical Express*, 21 February.

Brake, Mike (1985) *Comparative Youth Culture: The Sociology of Youth Cultures and Youth Subcultures in America, Britain and Canada*, London: Routledge and Kegan Paul.

Brathwaite, E.K. (1984) *History and the Voice: The Development of Nation Language in Anglophone Caribbean Poetry*, London: New Beacon Press.

Breckenridge, Carol A. (2000) 'Cosmopolitanisms', *Public Culture* 12, 3: 577–89.

Breckenridge, Carol A., Pollack, Sheldon, Bhabha, Homi K. and Chakrabarty, Dipesh (eds) (2002) *Cosmopolitanism*, Durham: NC: Duke University Press.

Breckinridge, S.P. (ed.) (1912) *The Child in the City*, Chicago: Department of Social Investigation, Chicago School of Civics and Philanthropy.

Breward, David (2004) *Fashioning London: Clothing and the Modern Metropolis*, Oxford and New York: Berg.

Brown, Peter (1981) *The Cult of the Saints: Its Rise and Function in Latin Christianity*, Chicago: University of Chicago Press.

Bruyn, Severyn T. (1966) *The Human Perspective in Sociology*, Englewood Cliffs, NJ: Prentice Hall.

Burgin, Victor (1996) *Some Cities*, London: Reaktion.

Burke, Phyllis (1996) *Gender Shock: Exploding the Myths of Male and Female*, New York: Doubleday.

Burnside, Anna (1995) 'Walk Like a Man', *Scotland on Sunday*, 24 May.

Buruma, Ian (1985) *A Japanese Mirror: Heroes and Villains of Japanese Culture*, London: Penguin Books.

Butler, Judith (1990) *Gender Trouble: Feminism and the Subversion of Identity*, London and New York: Routledge.

Butler, Judith (1993) *Bodies That Matter: On the Discursive Limits of 'Sex'*, London and New York: Routledge.

Califia, Pat (1992a) 'Diagnostic Tests', in Joan Nestle, ed., *The Persistent Desire: A Femme-Butch Reader*, Boston: Alyson.

Califia, Pat (1992b) 'The Femme Poem', in Joan Nestle, ed., *The Persistent Desire: A Femme-Butch Reader*, Boston: Alyson.

Califia, Pat (1994) 'Gay Men, Lesbians, and Sex: Doing It Together', *Public Sex: The Culture of Radical Sex*, San Francisco: Cleis Press.

Cameron, William B. (1954) 'Sociological Notes on the Jam Session', *Social Forces* 33 (December): 177–82.

Carr, C. (1992) 'Bohemia Diaspora', *Village Voice*, 4 February.

Carter, Erica (1979) 'Alice in Consumer Wonderland', in Angela McRobbie and Mica Nava, eds, *Gender and Generation*, London: Macmillan.

Castaneda, Carlos (1968) *The Teachings of Don Juan: A Yaqui Way of Knowledge*, Berkeley: University of California Press.

Chambers, Iain (1985) *Urban Rhythms: Pop Music and Popular Culture*, New York: St Martin's Press.

Clark, N. (1995) 'Rear-View Mirrorshades: the Recursive Generation of the Cyber-body', *Body and Society* 1: 113–34.

Clarke, Gary (1981) 'Defending Ski-Jumpers: A Critique of Theories of Youth Subcultures', in Simon Frith and Andrew Goodwin, eds, *On Record*, London and New York: Routledge. (First published by the Centre for Contemporary Cultural Studies, University of Birmingham, 1981.)

Clarke, John (1975) 'Style', in Stuart Hall and Tony Jefferson, eds, *Resistance Through Rituals* (1993), London: Routledge.

Clarke, John (1978) 'Football and Working Class Fans: Traditions and Change', in R. Ingham *et al.*, eds, *Football Hooliganism: The Wider Context*, London: Interaction Imprint.

Clarke, John *et al.* (1993) 'Subcultures, Cultures and Class', in Stuart Hall and Tony Jefferson, eds, *Resistance Through Rituals*, London and New York: Routledge. (First published in 1975 in *Working Papers in Cultural Studies* 7/8.)

Clarke, M. (1982) *The Politics of Pop Festivals*, London: Junction Books.

Clarke, Sebastian (1980) *Jah Music*, London: Heinemann.

Clifford, James (1992) 'Travelling Cultures', in Lawrence Grossberg, Cary Nelson and Paula Treichler, eds, *Cultural Studies*, New York and London: Routledge.

Clifford, James (1997) *Routes: Travel and Translation in the Late Twentieth Century*, Cambridge, MA: Harvard University Press.

Cloke, P. and Perkins, H. (1998) '"Cracking the Canyon with the Awesome Foursome": Representations of Adventure Tourism in New Zealand', *Environment and Planning D: Society and Space* 16: 185–218.

Cloward, R. and Ohlin, L. (1960) *Delinquency and Opportunity: A Theory of Delinquent Gangs*, New York: The Free Press of Glencoe.

Cohen, Albert K. (1955) *Delinquent Boys: The Culture of the Gang*, New York: The Free Press.

Cohen, Anthony (1985) *The Symbolic Construction of Community*, London: Routledge and Kegan Paul.

Cohen, Phil (1972) 'Subcultural Conflict and Working Class Community', *Working Papers in Cultural Studies 2*, University of Birmingham: Centre for Contemporary Cultural Studies.

Cohen, Phil (1979) 'Policing the Working Class City', in B. Fine *et al.*, eds, *Capitalism and the Rule of the Law*, London: Hutchinson.

Cohen, Phil and Robins, Dave (1978) *Knuckle Sandwich: Growing Up in the Working Class City*, Harmondsworth: Penguin Books.

Cohen, Stanley (1972) *Folk Devils and Moral Panic: The Creation of Mods and Rockers*, London: Granada.

Cohen, Stanley (1980) 'Symbols of Trouble', *Folk Devils and Moral Panics*, second edition, Oxford: Martin Robertson.

Cohen, T. (2000) *The Tattoo*, London: Greenwich Editions.

Collin, Matthew (1997) *Altered State: the Story of Ecstasy Culture and Acid House*, London and New York: Serpent's Tail.

Comic Box (1989) 'Comic Market 15 Nenshi', November.

Comic Market 46 Sanka Moshikomusho Set (1993) Printed by Comiket Junbikai, October.

Corrigan, Paul (1979) *Schooling the Smash Street Kids*, London: Macmillan.

Cousins, M. and Hussain, A. (1984) *Michel Foucault*, London: Macmillan.

Cowan, Jane K. (1990) *Dance and the Body Politic in Northern Greece*, Princeton, NJ: Princeton University Press.

Cowie, C. and Lees, Sue (1981) 'Slags or Drags', *Feminist Review* 9.

Crane, Jonathan (1986) 'Mainstream Music and the Masses', *Journal of Communication Inquiry* X, 3.

Creet, Julia (1995) 'Anxieties of Identity: Coming Out and Coming Undone', in M. Dorenkamp and R. Henke, eds, *Negotiating Lesbian and Gay Subjects*, New York and London: Routledge.

Cressey, Donald R. (1962) 'Role Theory, Differential Association and Compulsive Crimes', in A.M. Rose, ed., *Human Behaviour and Social Process*, Boston: Houghton Mifflin Co.

Cressey, Paul G. (1932) *The Taxi-Dance Hall*, New York: Greenwood Press.

Cresswell, T. (1996) *In Place/Out of Place*, Minneapolis: University of Minnesota Press.

Crimp, Douglas (1990) *AIDS DemoGraphics*, Seattle: Bay Press.

Crimshaw, Jean (1986) *Philosophy and Feminist Thinking*, Minneapolis: Minnesota University Press.

Crossley, N. (1995) 'Body Techniques, Agency and Intercorporeality: on Goffman's "Relations in Public"', *Sociology* 29, 1: 133–49.

Csikszentmihalyi, M. (1975a) *Beyond Boredom and Anxiety: The Experience of Play in Work and Games*, San Francisco: Jossey-Bass.

Csikszentmihalyi, M. (1975b) 'Measuring the Flow Experience in Rock Dancing', in *Beyond Boredom and Anxiety: The Experience of Play in Work and Games*, San Francisco: Jossey-Bass.

Csikszentmihalyi, M. (1975c) 'Politics of Enjoyment', in *Beyond Boredom and Anxiety: The Experience of Play in Work and Games*, San Francisco: Jossey-Bass.

Cubitt, Sean (1984) 'Maybellene: Meaning and the Listening Subject', in R. Middleton and D. Horn, eds, *Popular Music: A Yearbook: Performers and Audiences*, London: Cambridge University Press.

Curry, D. (1993) 'Decorating the Body Politic', *New Formations* 19: 69–82.

Da Matta, R. (1983) *Carnaval, bandit et héros*, Paris: Seuil.

Daniel, Susie and McGuire, Peter (1972) *The Painthouse: Words from an East End Street Gang,* Harmondsworth: Penguin Books.

Davis, K. (1994) *Reshaping the Female Body: The Dilemmas of Cosmetic Surgery*, London: Routledge.

Davis, K. (1997) 'My Body is My Art: Cosmetic Surgery as Feminist Utopia?', *European Journal of Women's Studies* 4.

De Certeau, Michel (1990) *L'invention du quotidien. 1. Arts de faire*, Paris: Gallimard (Folio).

De Lauretis, Teresa (1988) 'Sexual Indifference and Lesbian Representation', *Theatre Journal* 40, 2: 155–77.

DeMello, Margo (2000) *Bodies of Inscription: A Cultural History of the Modern Tattoo Community*, Durham, NC and London: Duke University Press.

Dery, Mark (1996) *Escape Velocity: Cyberculture at the End of the Century*, London: Hodder and Stoughton.

Desforges, Luke (1997) 'Checking Out the Planet: Global Representations/Local Identities and Youth Travel', in Tracey Skelton and Deborah Chambers, eds, *Cool Places: Geographies of Youth Cultures*, New York: Routledge.

Dikotter, Frank (1995) *Sex, Culture and Modernity in China: Medical Science and the Construction of Sexual Identities in the Early Republican Period*, Honolulu: University of Hawaii Press.

Dionne, Craig (1997) 'Playing the "Cony": Anonymity in Underworld Literature', *Genre* 30, Spring/Summer.

Douglas, Mary (1967) *Purity and Danger: An Analysis of the Concepts of Pollution and Taboo*, Harmondsworth: Penguin Books.

Douglas, Mary (1984) *Purity and Danger: An Analysis of the Origins of Pollution and Taboo*, London: Ark/Routledge and Kegan Paul.

Douglas, Mary and Isherwood, Baron (1979) *The World of Goods: Towards an Anthropology of Consumption*, London: Allen Lane.

Drorbaugh, Elizabeth (1993) 'Sliding Scales: Notes on Storme DeLaverie and the Jewel Box Revue, the Cross-dressed Woman on the Contemporary Stage, and the Invert', in Lesley Ferris, ed., *Crossing the Stage: Controversies on Cross-dressing*, London and New York: Routledge.

Druglink (1997) 'Rash of Surveys Confirm that Two in Five Teenagers Take Drugs Across the UK', *Druglink: Newsletter of the ISDD*, May-June.

Dublin, R. (1962) 'Industrial Workers' Worlds', in A. Rose, ed., *Human Behaviour and Social Processes*, London: Routledge and Kegan Paul.

Duggan, Lisa (1993) 'The Trials of Alice Mitchell: Sensationalism, Sexology, and the Lesbian Subject in Turn-of-the-Century America', *Signs* 18, 4 (Summer).

Dull, D. and West, C. (1991) 'Accounting for Cosmetic Surgery: The Accomplishment of Gender', *Social Problems* 38.

Dumont, F. (1982) *Cultures populaires et sociétés contemporaines*, Québec: Presses de l'Université du Québec.

Duncombe, Stephen (1997) *Notes from Underground: Zines and the Politics of Alternative Culture*, London and New York: Verso.

Du Pleissis, Michael (1996) 'Blatantly Bisexual: or, Unthinking Queer Theory', in D. Hall and M. Pramaggiore, eds, *RePresenting Bisexualities: Subjects and Cultures of Fluid Desire*, New York and London: New York University Press.

Durand, Gilbert (1983) *La Foi du cordonnier*, Paris: Denoel.

Durand, Gilbert (1986) 'Le Retour des immortels' in *Le Temps de la réflexion*, Paris: Gallimard.

During, Simon (1993) *The Cultural Studies Reader*, London and New York: Routledge.

Durkheim, Emile (1964) *The Division of Labour in Society*, New York: The Free Press.

Dyer, Richard (1990) 'In Defense of Disco', in Simon Frith and Andrew Goodwin, eds, *On Record*, London and New York: Routledge.

Eagleton, Terry (1983) *Literary Theory*, Oxford: Blackwell.

Eco, Umberto (1972) 'Towards a Semiotic Enquiry into the Television Message', *Working Papers in Cultural Studies 3*, University of Birmingham: Centre for Contemporary Cultural Studies.

Eco, Umberto (1973) 'Social Life as a Sign System', in D. Robey, ed., *Structuralism: The Wolfson College Lectures 1972*, London: Cape.

Elias, Norbert (1978) *What is Sociology?*, London: Hutchinson.

Elias, Norbert (1983) *The Court Society*, Oxford: Basil Blackwell.

Elias, Norbert (1991) *The Society of Individuals*, Oxford: Basil Blackwell.

Elias, Norbert (1994) *The Civilizing Process*, Oxford: Basil Blackwell.

Elias, Norbert (1996) *The Germans: Studies of Power Struggles and the Development of Habitus in the Nineteenth and Twentieth Centuries*, Oxford: Polity.

Ellis, Havelock (1928) *Studies in the Psychology of Sex*, 3rd edition, Philadelphia: F.A. Davis Co.

Ellis, John (1982) *Visible Fictions*, London: Routledge.

Engels, Friedrich (1958) *The Condition of the Working Class in England*, ed. and trans. W.O. Henderson and W.H. Chaloner, Stanford, CA: Stanford University Press.

Ernst, Max (1948) *Beyond Painting and Other Writing by the Artist and His Friends*, New York: Sculz.

Euromonitor (1989) *The Music and Video Buyers Survey: Tabular Report and Appendices* (November).

Euromonitor (1990) 'Leisure Spending Among the Young', *Market Research Great Britain* 31 (June).

Evans, Harriet (1997) *Women and Sexuality in China*, New York: Continuum.

Fainstein, Susan (1994) *The City Builders*, Oxford: Blackwell.

Fairchild, Henry Pratt (ed.) (1944) *Dictionary of Sociology*, New York: Philosophical Library.

Farrer, James (1999) 'Disco "Super-Culture": Consuming Foreign Sex in the Chinese Disco', *Sexualities* 2, 2.

Farrer, James (2000) 'Dancing through the Market Transition: Disco and Dance Hall Sociability in Shanghai', in Deborah Davis, ed., *The Consumer Revolution in Urban China*, Berkeley: University of California Press.

Featherstone, Mike (1990) *Global Culture: Nationalism, Globalization and Modernity*, London and Newbury Park, CA: Sage.

Feiner, J. and Klein, S. (1982) 'Graffiti Talks', *Social Policy* 12, 3: 47–53.

Ferguson, Dean (1991) 'HiNRG/Eurobeat', *Dance Music Report* 24: 38.

Ferrell, Jeff (1993) *Crimes of Style: Urban Graffiti and the Politics of Criminality*, New York and London: Garland Publishing, Inc.

Fiske, John (1992) 'The Cultural Economy of Fandom', in Lisa Lewis, ed., *The Adoring Audience*, London and New York: Routledge.

Foucault, Michel (1978) *The History of Sexuality: An Introduction*, trans. Robert Hurley, Harmondsworth: Penguin Books.

Foucault, Michel (1979a) *Discipline and Punish: The Birth of the Prison*, trans. Alan Sheridan, New York: Vintage.

Foucault, Michel (1979b) 'On Governmentality', *Ideology and Consciousness* 6.

Foucault, Michel (1980) *Power/Knowledge: Selected Interviews and Other Writings 1972–1977*, New York: Pantheon.

Foucault, Michel (1982) 'The Subject and Power', in H. Dreyfus and P. Rabinow, eds, *Michel Foucault*, Brighton: Harvester.

Foucault, Michel (1986) 'Of Other Spaces', *Diacritics* 16, 1: 22–27.

Fraser, Mariam (1977) 'Lose Your Face' in Bi Academic Intervention, eds, *The Bisexual Imaginary: Representation, Identity and Desire*, London: Cassell.

Freud, S. (1961) *Civilisation and Its Discontents: Standard Edition Vol.xxi*, trans. James Strachey, London: Hogarth Press.

Friedman, Jonathan (1990) 'Being in the World: Globalization and Localization', in Mike Featherstone, ed., *Global Culture: Nationalism, Globalization and Modernity*, London: Sage.

Friedman, Jonathan (1994a) 'Globalization and Localization', in *Cultural Production and Global Process*, London: Sage.

Friedman, Jonathan (1994b) 'The Political Economy of Elegance', in *Cultural Production and Global Process*, London: Sage.

Friedman, Jonathan (1999) 'Indigenous Struggles and the Discreet Charm of the Bourgeoisie', *Journal of World Systems Research* 5, 2: 391–411.

Frisby, David and Featherstone, Mike (eds) (1997) *Simmel on Culture: Selected Writings*, London: Sage.

Frith, Simon (1981) *Sound Effects: Youth, Leisure, and the Politics of Rock 'n' Roll*, New York: Pantheon.

Frith, Simon (1996) *Performing Rites: On the Value of Popular Music*, Oxford: Oxford University Press.

Frith, Simon and McRobbie, Angela (1990) 'Rock and Sexuality', in Simon Frith and Andrew Goodwin, eds, *On Record*, London and New York: Routledge.

Fromm, Erich (1967) *Man for Himself*, Greenwich: Fawcett.

Frow, John (1987) 'Accounting for Tastes: Some Problems in Bourdieu's Sociology of Culture', *Cultural Studies* 1, 1.

Fyvel, T.R. (1961) *The Insecure Offenders: Rebellious Youth in the Welfare State*, London: Chatto & Windus.

Fyvel, T.R. (1963) *Insecure Offenders: Rebellious Youth in the Welfare State*, revised edition, Harmondsworth: Penguin Books.

Gabriel, Trip (1987) 'Rolling Thunder', *Rolling Stone*, 16–30 July: 50–52.

Galbraith, J.K. (1962) *The Affluent Society*, London: Penguin Books.

Gandoulou, Justin-Daniel (1989a) *Au Coeur de la sape: moeurs et aventures de Congolais à Paris*, Paris: L'Harmattan.

Gandoulou, Justin-Daniel (1989b) *Dandies à Bacongo: le culte de l'élégance dans la société congolaise contemporaine*, Paris: L'Harmattan.

Garber, Marjorie (1995) *Vice Versa: Bisexuality and the Eroticism of Everyday Life*, New York: Simon & Schuster.

Garchik, Leah (1994) 'The Urban Landscape', *San Francisco Chronicle*: posted on DansWORLD, www.dansworld.com/urban.html.

García Canclini, Nestor (1995) *Hybrid Cultures: Strategies for Entering and Leaving Modernity*, trans. Christopher L. Chiappari and Silvia L. López, Minneapolis and London: University of Minnesota Press.

Garfinkel, H. (1967) *Studies in Ethnomethodology*, Englewood Cliffs, NJ: Prentice-Hall.

Garnham, Nicholas (1993) 'Bourdieu, the Cultural Arbitrary and Television', in C. Calhoun *et al.*, eds, *Bourdieu: Critical Perspectives*, Oxford: Polity.

Garnham, Nicholas and Williams, Raymond (1986) 'Pierre Bourdieu and the Sociology of Culture', in R. Collins *et al.*, eds, *Media, Culture and Society: A Critical Reader*, London: Sage.

Gayle, Carl (1974) 'Survey', *Black Music* 1, 8.

Geertz, Clifford (1964) 'Ideology as a Cultural System', in D.E. Apter, ed., *Ideology and Discontent*, New York: The Free Press.

Geiss, Imanuel (1974) *The Pan-African Movement*, London: Methuen.

Gelder, Ken and Thornton, Sarah (eds) (1997) *The Subcultures Reader*, London and New York: Routledge.

Gibson, William (1984) *Neuromancer*, London: HarperCollins.

Giddens, Anthony (1964) 'Notes on the Concepts of Play and Leisure', *Sociological Review* 12, 1.

Gil, DJ Goa *et al.* (1998) *DJ Goa Gil/Ceiba/Kode IV: Live At Burning Man*, Ceiba Records.

Gilfoyle, Timothy (2004) 'Street-rats and Gutter-snipes: Child Pickpockets and Street Culture in New York City, 1850–1900', *Journal of Social History* 34, Summer: 853–82.

Gillespie, R. (1996) 'Women, the Body and Brand Extension in Medicine: Cosmetic Surgery and the Paradox of Choice', *Women and Health* 24.

Gillett, C. (1972) 'The Black Market Roots of Rock', in R.S. Denisoff and R.A. Peterson, eds, *The Sounds of Social Change: Studies in Popular Culture*, Chicago: Rand McNally.

Gilroy, Paul (1987) *There Ain't No Black in the Union Jack*, London: Unwin Hyman.

Gilroy, Paul (1993) *The Black Atlantic: Modernity and Double Consciousness*, Cambridge, MA: Harvard University Press.

Gilroy, Paul and Lawrence, E. (1982) 'Two-Tone Britain: Black Youth, White Youth and the Politics of Anti-racism', in H.S. Bains and P. Cohen, eds, *Multi-Racist Britain* (1988), London: Macmillan Education.

Girard, René (1979) *Violence and the Sacred*, Baltimore: Johns Hopkins University Press.

Girard, René (1986) *The Scapegoat*, Baltimore: Johns Hopkins University Press.

Goffman, Erving (1961) *Asylums*, New York: Anchor Books, Doubleday & Co.

Goffman, Erving (1963) *Stigma*, Englewood Cliffs, NJ: Spectrum.

Goffman, Erving (1971) *Relations in Public*, London: Allen Lane.

Goode, Erich and Yahuda, Ben (1994) *Moral Panics: The Social Construction of Deviance*, Oxford: Blackwell.

Gordon, Milton M. (1947) 'The Concept of a Sub-Culture and its Application', *Social Forces* 26 (October).

Gordon, Milton M. (1964) *Assimilation in American Life*, New York: Oxford University Press.

Gore, Georgiana (1997) 'The Beat Goes On: Trance, Dance and Tribalism in Rave Culture', in Helen Thomas, ed., *Dancing in the City*, New York: St Martin's Press.

Gowan, J.C. (1975) *Trance, Art, and Creativity*, Northridge, CA: privately published.

Gramsci, Antonio (1971) *Selections from the Prison Notebooks*, New York: Lawrence and Wishart.

Graña, Cesar and Graña, Marigay (1990) *On Bohemia*, New Brunswick: Transaction Publishers.

Green, Arnold W. (1946) 'Sociological Analysis of Horney and Fromm', *The American Journal of Sociology* 51 (May).

Greenfeld, Karl Taro (1995) *Speed Tribes: Days and Nights with Japan's Next Generation*, New York: HarperPerennial.

Grossberg, Lawrence (1984) 'Another Boring Day in Paradise: Rock and Roll and the Empowerment of Everyday Life', *Popular Music* 4: 225–58.

Gunderloy, Mike (ed.) (1989) *Why Publish?*, Albany, NY: Pretzel Press.

Halberstam, Judith (1997) 'Mackdaddy, Superfly, Rapper: Gender, Race, and Masculinity in the Drag King Scene', *Social Text* 15, 3/4 (Fall-Winter).

Halberstam, Judith (1998) *Female Masculinity*, London: Duke University Press.

Halbwachs, M. (1968) *La Mémoire collective*, Paris: PUF.

Hall, Radclyffe (1928) *The Well of Loneliness*, London: Jonathan Cape.

Hall, Stuart (1977) 'Culture, the Media and the "Ideological Effect"', in J. Curran *et al.*, eds, *Mass Communication and Society*, London: Edward Arnold.

Hamblett, Charles and Deverson, Jane (1964) *Generation X*, London: Tandem Books.

Hanna, Judith Lynne (1988) *Dance, Sex and Gender: Signs of Identity, Defiance and Desire*, Chicago: University of Chicago Press.

Hannerz, Ulf (1992) *Cultural Complexity: Studies in the Social Organization of Meaning*, New York: Columbia University Press.

Happold, F.C. (1981) *Mysticism: A Study and an Anthology*, revised edition, Harmondsworth: Penguin Books.

Hathaway, A. (1997a) 'Marijuana and Tolerance: Revisiting Becker's Sources of Control', *Deviant Behaviour* 18.

Hathaway, A. (1997b) 'Marijuana and Lifestyle: Exploring Tolerable Deviance', *Deviant Behaviour* 18.

Hawkes, Terence (1977) *Structuralism and Semiotics*, London: Methuen.

Healy, Murray (1996) *Gay Skins: Class, Masculinity and Queer Appropriation*, London: Cassell.

Hebdige, Dick (1975) 'The Meaning of Mod', in Stuart Hall and Tony Jefferson, eds, *Resistance Through Rituals* (1993), London: Routledge.

Hebdige, Dick (1979) *Subculture: The Meaning of Style*, London: Methuen.

Hebdige, Dick (1981) 'Skinheads and the Search for White Working Class Identity', *New Socialist* 1.

Hebdige, Dick (1983a) 'Posing . . . Threats, Striking . . . Poses: Youth, Surveillance and Display', *SubStance* 37.

Hebdige, Dick (1983b) 'Ska Tissue: The Rise and Fall of Two-Tone', in P. Simon and S. Davis, eds, *Reggae International*, London: Thames and Hudson.

Hebdige, Dick (1987) *Cut'n'Mix: Culture, Identity and Caribbean Music*, London: Comedia and Methuen.

Hebdige, Dick (1993) 'Redeeming Witness: In the Tracks of the Homeless Vehicle Project', *Cultural Studies* March-May.

Hemmings, Clare (1997) 'Bisexual Theoretical Perspectives: emergent and contingent relationships', in Bi Academic Interventions, eds., *The Bisexual Imaginary: Representation, Identity and Desire,* London: Cassell.

Hemmings, Clare (1998) 'Waiting for No Man: Bisexual Femme Subjectivity and Cultural Repudiation', in Sally R. Munt, ed., *Butch/Femme: Inside Lesbian Gender*, London: Cassell.

Henriques, Fernanda (1953) *Family and Colour in Jamaica*, London: Secker & Warburg.

Henry, J. (1992) 'Ecstasy and the dance of death', *British Medical Journal* 305, 4 (July).

Herman, Edward S. and McChesney, Robert W. (1997) *The Global Media: The New Missionaries of Corporate Capitalism*, London and Washington: Cassell.

Hetherington, Kevin (2000) *New Age Travellers: Vanloads of Uproarious Humanity*, London: Cassell.

Hibbert, Tom (1992) 'Who the Hell Does Garry Bushell Think He Is?' *Q*, September.

Hill, K. and Hughes, J. (1998) *Cyberpolitics: Citizen Activism in the Age of the Internet*, Oxford: Rowman & Littlefield.

Hirst, Paul (1981) 'The Genesis of the Social', in *Politics and Power*, London: Routledge.

Hoare, I. (1975) 'Mighty, Mighty Spade and Whitey: Soul Lyrics and Black-White Crosscurrents', in I. Hoare *et al.*, eds, *The Soul Book*, London: Methuen.

Hodkinson, Paul (2002) *Goth: Identity, Style and Subculture*, Oxford and New York: Berg.

Hoggart, Richard (1957) *The Uses of Literacy*, London: Chatto & Windus.

Hollibaugh, Amber and Moraga, Cherrie (1981) 'What We're Rollin' Around in Bed With: Sexual Silences in Feminism', in Joan Nestle, ed., *The Persistent Desire: A Femme-Butch Reader* (1992), Boston: Alyson.

Honig, Emily and Herschatter, Gail (1988) *Personal Voices: Chinese Women in the 1980s*, Stanford, CA: Stanford University Press.

Hooker, Evelyn (1967) 'The Homosexual Community', in J.H. Gagnon and W. Simon, eds, *Sexual Deviance*, London: Harper & Row.

Horkheimer, Max and Adorno, Theodor W. (1994) 'The Culture Industry: Enlightenment as Mass Deception', in *Dialectic of Enlightenment*, New York: Continuum.

Hughes, Everett C. (1961) *Students' Culture and Perspectives: Lectures on Medical and General Education*, Lawrence: University of Kansas Law School.

Huizinga, Johan (1969) *Homo Ludens: A Study of the Play Element in Culture*, London: Paladin.

Humphreys, Anne (1977) *Travels into the Poor Man's Country: The Work of Henry Mayhew*, Athens: University of Georgia Press.

Humphreys, Laud (1970) *Tearoom Trade: Impersonal Sex in Public Places*, Chicago: Aldine.

Hutnyk, John (2000) *Critique of Exotica: Music, Politics and the Culture Industry*, London: Pluto Press.

Huxley, Aldous (1959) *The Doors of Perception and Heaven and Hell*, Harmondsworth: Penguin Books.

Ian, Marcia (1996) 'When is a Body Not a Body? When it's a Building', in Joel Sanders, ed., *Stud: Architectures of Masculinity*, Princeton, NJ: Princeton Architectural Press.

Imidasu (1993) Tokyo: Shueisha.

Inglis, Brian (1989) *Trance: A Natural History of Altered States of Mind*, London: Grafton.

Irigaray, Luce (1985) *Speculum of the Other Woman*, trans. Gillian C. Gill, Ithaca: Cornell University Press.

Irwin, John (1970) 'Notes on the Status of the Concept Subculture', in David O. Arnold, ed., *Subcultures*, New York: The Glendessary Press.

Irwin, John (1977) *Scenes*, Beverley Hills, CA: Sage.

Irwin, K. (2000) 'Negotiating the Tattoo', in P. Adler and P. Adler, eds, *Constructions of Deviance*, Belmont, CA: Wadsworth.

ISDD (1996) *Drug Notes 8: Ecstasy*, London: ISDD (Institute for the Study of Drug Dependence).

Ivy, Marilyn (1995) *Discourses of the Vanishing: Modernity, Phantasm, Japan*, Chicago: Chicago University Press.

Jacoby, Russell (1987) *The Last Intellectuals: American Culture in the Age of Academe*, New York: Basic Books.

Jameson, Fredric (1984) 'Postmodernism, or the Cultural Logic of Late Capitalism', *New Left Review* 146.

Jankowiak, William (1993) *Sex, Death and Hierarchy in a Chinese City*, New York: Columbia University Press.

Jeffreys, Sheila (1993) 'Butch and Femme: Now and Then', in Lesbian History Group, eds, *Not a Passing Phase: Reclaiming Lesbians in History, 1840–1985*, London: The Women's Press.

Jenkins, Henry (1992) *Textual Poachers: Television Fans and Participatory Culture*, London and New York: Routledge.

Jenks, Chris (2005) *Subculture: The Fragmentation of the Social*, London: Sage.

Johnson, Richard (n.d.) 'The Blue Books and Education 1816–96: the Critical Reading of Official Sources', Centre for Contemporary Cultural Studies, University of Birmingham (undated stencilled paper).

Jones, Simon (1986) *White Youth and Jamaican Culture*, unpublished Ph.D. thesis, Centre for Contemporary Cultural Studies, University of Birmingham.

Jones, Steve (ed.) (1995) *Cybersociety: Computer Mediated Communication and Community*, London: Sage.

Jones, Steve (1997) 'The Internet and its Social Landscape', in Steve Jones, ed., *Virtual Culture: Identity and Communication in Cyberspace*, London: Sage.

Jones, Steve (ed.) (1999) *Doing Internet Research: Critical Issues and Methods for Examining the Net*, London: Sage.

Jones, Steve (ed.) (2000) *Cybersociety 2.0*, London: Sage.

Jones, Steve (2002) 'Music That Moves: Popular Music, Distribution and Network Technologies', *Cultural Studies* 16, 2: 213–32.

Judges, A.V. (ed.) (1930) *The Elizabethan Underworld*, London: George Routledge & Sons Ltd.

Kaloski, A. (1999) 'Bisexuals Making Out With Cyborgs: Politics, Pleasure, Con/fusion', in M. Storr, ed., *Bisexuality: A Critical Reader*, London and New York: Routledge.

Kaufmann, J.C. (1988) *Le Repli domestique*, Paris: Méridiens Klincksieck.

Kaur, Raminder (1999) 'Parking the Snout in Goa', in Raminder Kaur and John Hutnyk, eds, *Travel Worlds: Journeys in Contemporary Cultural Politics*, London and New York: Zed Books.

Kaur, Raminder and Hutnyk, John (eds) (1999) *Travel Worlds: Journeys in Contemporary Cultural Politics*, London and New York: Zed Books.

Keil, Charles (1972) 'Motion and Feeling Through Music', in Thomas Kochman, ed., *Rappin' and Stylin' Out: Communication in Urban Black America*, Chicago: University of Illinois Press.

Kendall, L. (1999) 'Reconstructing "Cyberspace": Methodological Considerations for On-line Research', in S. Jones, ed., *Doing Internet Research: Critical Issues and Methods for Examining the Net*, London: Sage.

Kennedy, Elizabeth Lapovsky and Davis, Madeline D. (1993) *Boots of Leather, Slippers of Gold: The History of a Lesbian Community*, New York: Routledge.

Kernan, J. (ed.) (1991) *Retrofitting Blade Runner*, Bowling Green, OH: Bowling Green State University Popular Press.

Kessel, N. and Walton, H. (1965) *Alcoholism*, Harmondsworth: Penguin Books.

Kimberley, N. (1982) 'Ska: How Jamaica Found a Sound of its Own', in Tony Russell, ed., *The Encyclopaedia of Rock*, Avenel, NJ: Crescent Books.

Kinsella, Sharon (1998) 'Japanization: Babe Power Goes West', in C. Branizagli, ed., *Nightwave 1997*, Milan: Coasta & Nolan.

Kinsella, Sharon (2000) *Adult Manga: Culture and Power in Contemporary Japanese Society*, Richmond: Curzon Press.

Kiridoshi, Risaku (1995) *Omae ga Sekai o Koroshitai Nara*, Tokyo: Film Art Sha.

Klesse, C. (1999) '"Modern Primitivism": Non-mainstream Body Modification and Racialized Representation', *Body and Society* 5: 15–38.

Klein, Alan M. (1993) *Little Big Men: Bodybuilding Subculture and Gender Construction*, Albany, NY: SUNY Press.

Knight, Nick (1982) *Skinhead*, London: Omnibus Press.

Kohl, H. (1972) *Golden Boy as Anthony Cool: A Photo Essay on Naming and Graffiti*, New York: The Dial Press.

Kostelanetz, Richard (2003) *Soho: The Rise and Fall of an Artists' Colony*, London and New York: Routledge.

Kristeva, Julia (1974, trans. 1984) *The Revolution in Poetic Language*, trans. Margaret Walker, New York: Columbia University Press.

Kroker, Arthur (1993) *Spasm: Virtual Reality, Android Music and Electric Flesh*, New York: St Martin's Press.

Kroker, Arthur and Kroker, Marilouise (2000) 'Code Warriors: Bunkering in and Dumbing Down', in David Bell and Barbara M. Kennedy, eds, *The Cybercultures Reader*, London and New York: Routledge.

Kunz, Jean Lock (1996) 'From Maoism to *Elle*: The Impact of Political Ideology on Fashion Trends in China', *International Sociology* 11, 3: 317–35.

Laing, Dave (1969) *The Sound of Our Time*, London: Sheed and Ward.

Laing, Dave (1978) 'Interpreting Punk Rock', *Marxism Today* April.

Laing, Dave (1985) *One Chord Wonders*, Milton Keynes: Open University Press.

Lane, Christopher (1994) 'The Drama of the Imposter: Dandyism and Its Double', *Cultural Critique* 28, Fall: 29–52.

Laqueur, Thomas (1990) *Making Sex: Body and Gender from the Greeks to Freud*, Cambridge, MA and London: Harvard University Press.

Laski, Marghanita (1961) *Ecstasy: A Study of Some Secular and Religious Experience*, London: The Crescent Press.

Laski, Marghanita (1980) *Everyday Ecstasy*, London: Thames & Hudson.

Lastrucci, Carlo (1941) 'The Professional Dance Musician', *Journal of Musicology* 3 (Winter).

Law, J. (1994) *Organizing Modernity*, Oxford: Blackwell.

Lawrence, D.H. (1992) *The Plumed Serpent*, New York: Vintage.

Leary, Timothy (1994) *Chaos and Cyberculture*, Berkeley, CA: Ronin.

Le Bon, Gustave (1960) *The Crowd*, New York: Viking.

Lee, Martin A. and Shlain, Bruce (1986) *Acid Dreams: The Complete Social History of LSD, the CIA, the Sixties, and Beyond*, New York: Grove Press.

Lee, Stephen (1988) 'The Strategy of Opposition: Defining a Music Scene'. Paper given at the International Communication Association Conference, New Orleans, 2 June.

Lefebvre, Henri (1969) *The Explosion: Marxism and the French Revolution*, New York: Monthly Review.

Lefebvre, Henri (1971) *Everyday Life in the Modern World*, trans. Sacha Rabinovitch, New York: Harper & Row.

Lefebvre, Henri (1976) *The Survival of Capitalism: Reproduction of the Relations of Production*, New York: St Martin's Press.

Lefebvre, Henri (1982) *The Sociology of Marx*, New York: Columbia University Press.

Lefebvre, Henri (1984) *Everyday Life in the Modern World*, London: Transaction Publishers.

Lefebvre, Henri (1988) 'Toward a Leftist Cultural Politics', in Cary Nelson and Lawrence Grossberg, eds, *Marxism and the Interpretation of Culture*, London: Macmillan.

Lefebvre, Henri (1991a) *Critique of Everyday Life, Vol. 1: Introduction*, London: Verso.

Lefebvre, Henri (1991b) *The Production of Space*, Oxford: Blackwell.

Lefebvre, Henri (1995) *Introduction to Modernity*, London: Verso.

Lefebvre, Henri (1996) *Writings on Cities*, Oxford: Blackwell.

Lemert, Edwin (1964) 'Social Structure, Social Control and Deviation', in M. Clinard, ed., *Anomie and Deviant Behaviour*, New York: The Free Press of Glencoe.

Leng, K.W. (1996) 'On Menopause and Cyborgs: or, Towards a Feminist Cyborg Politics of Menopause', *Body and Society* 2: 33–52.

Leonard, Marion (1998) 'Paper Planes: Travelling the New Grrrl Geographies', in T. Skelton and G. Valentine, eds, *Cool Places: Geographies of Youth Cultures*, London and New York: Routledge.

Levi-Strauss, Claude (1969) *The Elementary Structures of Kinship*, London: Eyre and Spottiswood.

Levy, Pierre (2001) *Cyberculture*, London and New York: Routledge.

Lewis, I.M. (1989) *Ecstatic Religion: A Study of Shamanism and Spirit Possession*, London: Routledge.

Liebes, Tamar and Katz, Elihu (1990) *The Export of Meaning: Cross-Cultural Readings of Dallas*, New York: Oxford University Press.

Linn, Amy (1995) 'Drag Kings', *San Francisco Weekly*, 27 September-3 October.

Lippard, L. (1970) *Surrealists on Art*, Hemel Hempstead: Prentice-Hall.

Lipsitz, George (1990) *Time Passages: Collective Memory and American Popular Culture*, Minneapolis: University of Minnesota Press.

Lipsitz, George (1994) *Dangerous Crossroads: Popular Music, Postmodernism, and the Poetics of Place*, New York: Verso.

Liu, Dalin, Ng, Nan Lun, Zhou, Li Ping and Haeberie, Erwin J. (1997) *Sexual Behaviour in Modern China: Report on the Nationwide Survey of 20,000 Men and Women*, New York: Continuum.

Ludwig, A.M. (1969) 'Altered States of Consciousness', in C.T. Tart, ed., *Altered States of Consciousness: A Book of Readings*, New York: John Wiley & Sons.

Lukes, S. (1974) *Power: A Radical View*, London: Macmillan.

Lupton, D. (1999) 'Monsters in Metal Cocoons: "Road Rage" and Cyborg Bodies', *Body and Society* 5: 57–72.

Lupton, D. (2000) 'The Embodied Computer/User', in David Bell and Barbara M. Kennedy, eds, *The Cybercultures Reader*, London and New York: Routledge.

Lyman, S. and Scott, M.B. (1970) *A Sociology of the Absurd*, New York: Appleton-Century-Crofts.

McCaffrey, Larry (ed.) (1991) *Storming the Reality Studio: A Casebook of Cyberpunk and Postmodern Fiction*, Durham, NC: Duke University Press.

Macdonald, Nancy (2001) *The Graffiti Subculture: Youth, Masculinity and Identity in London and New York*, Houndmills: Palgrave Macmillan.

McKay, George (1996) *Senseless Acts of Beauty: Cultures of Resistance Since the Sixties*, London and New York: Verso.

McKay, George (ed.) (1998) *DiY Culture: Party and Protest in Nineties Britain*, London and New York: Verso.

McKay, George (1999) "'I'm So Bored With the USA": The Punk in Cyberpunk', in Roger Sabin, ed., *Punk Rock: So What?*, London and New York: Routledge.

MacKendrick, K. (1998) 'Technoflesh, or "Didn't That Hurt?"', *Fashion Theory* 2: 3–24.

McKenna, Terence (1992a) *The Archaic Revival: Speculations on Psychedelic Mushrooms, the Amazon, Virtual Reality, UFOs, Evolution, Shamanism, the Rebirth of the Goddess, and the End of History*, San Francisco: Harper.

McKenna, Terence (1992b) *Food of the Gods: The Search for the Original Tree of Knowledge: A Radical History of Plants, Drugs, and Human Evolution*, New York: Bantam Books.

McMichael, Robert K. (1998) '"We Insist – Freedom Now!": Black Moral Authority, Jazz, and the Changeable Shape of Whiteness', *American Music* 16, 4 (Winter).

McRobbie, Angela (1984) 'Dance and Social Fantasy', in Angela McRobbie and Mica Nava, eds, *Gender and Generation*, London: Macmillan.

McRobbie, Angela (ed.) (1989) *Zoot Suits and Second-Hand Dresses*, London: Macmillan.

McRobbie, Angela (1991) *Feminism and Youth Culture: From Jackie to Just Seventeen*, London: Macmillan.

McRobbie, Angela (1994) *Postmodernism and Popular Culture*, London: Routledge.

McRobbie, Angela and Garber, Jenny (1993) 'Girls and Subcultures', in Stuart Hall and Tony Jefferson, eds, *Resistance Through Rituals*, London and New York: Routledge. (First published in 1975.)

Maffesoli, Michel (1985a) *Le Connaissance ordinaire. Précis de sociologie compréhensive*, Paris: Librairie des Méridiens.

Maffesoli, Michel (1985b) *L'Ombre de Dionysus, contribution a une sociologie de l'orgie*, Paris: Librairie des Méridiens.

Maffesoli, Michel (1996) *The Time of the Tribes: The Decline of Individualism in Mass Society*, trans. Don Smith, London: Sage.

Maira, Sunaina Marr (2002) *Desis in the House: Indian American Youth Culture in New York City*, Philadelphia: Temple University Press.

Malbon, Ben (2001) *Clubbing*, London and New York: Routledge.

Malinowski, Bronislaw (1926, 1954) 'Myth in Primitive Psychology', in *Magic, Science and Religion*, New York: Doubleday Anchor Books.

Mannheim, Karl (1954) *Ideology and Utopia*, New York: Harcourt Brace.

Marcus, Greil (1989) *Lipstick Traces: A Secret History of the 20th Century*, Cambridge, MA: Harvard University Press.

Marcuse, Herbert (1956) *Eros and Civilisation*, London: Routledge and Kegan Paul.

Marcuse, Herbert (1964) *One-Dimensional Man*, London: Routledge and Kegan Paul.

Marsh, Peter, Rosser, Elizabeth and Harré, Rom (1978) *The Rules of Disorder*, London: Routledge and Kegan Paul.

Marshall, George (1991) *Spirit of '69: A Skinhead Bible*, Dunoon: Skinhead Times Publishing.

Martin, Dell and Lyon, Phillis (1972) *Lesbian/Woman*, New York: Bantam Books.

Martinez, Theresa A. (1997) 'Popular Culture as Oppositional Culture: Rap as Resistance', *Sociological Perspectives* 40, 2: 265–86.

Marx, Karl (1938) *The German Ideology*, London: Lawrence and Wishart.

Marx, Karl (1964) *The Economic and Philosophical Manuscripts of 1844*, London: Lawrence and Wishart.

Marx, Karl (1976) *Capital: A Critique of Political Economy, Vol.1*, Harmondsworth: Penguin Books.

Matza, David (1964) *Delinquency and Drift*, New York: Wiley.

Matza, David and Sykes, G. (1961) 'Juvenile Delinquency and Subterranean Values', *American Sociological Review* 26.

Mauss, M. (1979) 'Body Techniques', in *Sociology and Psychology: Essays*, trans. Ben Brewster, London: Routledge and Kegan Paul.

Mayhew, Henry (1968, rpt. 1985) *London Labour and the London Poor*, intro. John D. Rosenberg, 4 vols, New York: Dover Publications, Inc.

Médam, A. (1979) *Arcanes des Naples*, Paris: Editions des Autres.

Mehta, Geeta (1979) *Karma Cola: Marketing the Mystic East*, New York: Vintage Books.

Mercer, Kobena (1994) *Welcome to the Jungle: New Positions in Black Cultural Studies*, London: Routledge.

Merleau-Ponty, M. (1962) *Phenomenology of Perception*, London: Routledge and Kegan Paul.

Merriam, Alan and Mack, Raymond (1960) 'The Jazz Community', *Social Forces* 38 (March): 211–22.

Merton, Robert K. (1938) 'Social Structure and Anomie', *American Sociological Review* 3 (October): 672–82.

Messinger, Sheldon (1962) 'Life as Theater: Some Notes on the Dramaturgic Approach to Social Reality', *Sociometry* (March).

Messner, M. (1987) 'The Life of a Man's Seasons: Male Identity in the Life-course of the Jock', in M. Kimmel, ed., *Changing Men: New Directions in Research on Men and Masculinity*, Newbury Park, CA: Sage.

Messner, M. (1991) 'Masculinities and Athletic Careers', in J. Lorber and S. Farrell, eds, *The Social Construction of Gender*, Newbury Park, CA: Sage.

Metz, Christian (1975) 'The Imaginary Signifier', *Screen* 16, 2.

Meyer, Moe (ed.) (1994) *The Politics and Poetics of Camp*, New York: Routledge.

Michel, Frann (1996) 'Do Bats Eat Cats? Reading What Bisexuality Does', in D. Hall and M. Pramaggiore, eds, *RePresenting Bisexualities: Subjects and Cultures of Fluid Desire*, New York and London: New York University Press.

Mickison, Amanda (1988) 'Little Skins Talking Tall', *New Society*, 5 February.

Miège, Bernard (1986) 'Les logiques a l'oeuvre dan les nouvelles industries culturelles', *Cahiers de recherche sociologique* 4, 2: 93–110.

Mills, C. Wright (1959) *The Sociological Imagination*, New York: Grove Press.

Mintel (1988) *Mintel Special Report: Youth Lifestyles*.

Mishkind, M., Rodin, J., Silberstein, L. and Striegel-Moore, R. (1987) 'The Embodiment of Masculinity: Cultural, Psychological and Behavioural Dimensions', in M. Kimmel, ed., *Changing Men: New Directions in Research on Men and Masculinity*, Newbury Park, CA: Sage.

Morin, E. (1986) *La Méthode, vol. 3: La Connaissance de la connaissance/1*, Paris: Seuil.

Morin, E. and Appel, K. (1984) *New York*, Paris: Galilée.

Muggleton, David (2000) *Inside Subculture: The Postmodern Meaning of Style*, Oxford and New York: Berg.

Muggleton, David and Weinzierl, Rupert (eds) (2003) *The Post-subcultures Reader*, Oxford and New York: Berg.

Mullan, R. *et al.* (1997) *Young People's Drug Use at Rave/Dance Events*, Edinburgh: Crew 2000.

Mulshine, Paul (1987) 'Wild in the Streets', *Philadelphia Magazine* 78, 4 (April).

Mulvey, Laura (1981) 'On *Duel in the Sun*: Afterthoughts on "Visual Pleasure and Narrative Cinema"', *Framework* 15–17. Reprinted in Laura Mulvey (1988) *Visual and Other Pleasures*, Bloomington: Indiana University Press.

Mungham, Geoff (1976) 'Youth in Pursuit of Itself', in G. Mungham and G. Peterson, eds, *Working Class Youth Culture*, London: Routledge.

Muñoz, José (1996) 'Famous and Dandy Like B. 'n' Andy: Race, Pop, and Basquiat' in José Muñoz *et al.*, eds, *Pop Out: Queer Warhol*, Durham, NC: Duke University Press.

Munt, Sally R. (ed.) (1988) *Butch/Femme: Inside Lesbian Gender*, London: Cassell.

Murakami, Haruki (2001) *Underground*, trans. Alfred Birnbaum and Philip Gabriel, New York: Vintage International.

Murdock, G. and McCron, R. (1976) 'Consciousness of Class and Consciousness of Generation', in Stuart Hall and Tony Jefferson, eds, *Resistance Through Rituals* (1993), London: Routledge.

Murray, K. (1989) 'The Construction of Identity in the Narratives of Romance and Comedy' in J. Shotter and K. Gergen, eds, *Texts of Identity*, London: Sage.

Napier, Susan J. (2001) *Anime: from Akira to Princess Mononoke. Experiencing Contemporary Japanese Animation*, New York: Palgrave.

Nasmyth, P. (1985) 'MDMA We're All Crazy Now: Ecstasy's Arrival in Britain', in R. Benson, ed., *Nightfever: Club Writing in The Face, 1980–1997* (1997), London: Boxtree.

Negus, Keith (1996) *Popular Music in Theory: An Introduction*, Cambridge: Polity.

Negus, Keith (1999) 'The Business of Rap: Between the Street and the Executive Suite', *Music Genres and Corporate Cultures*, London and New York: Routledge.

Nestle, Joan (1992) 'The Femme Question' in Joan Nestle, ed., *The Persistent Desire: A Femme-Butch Reader*, Boston: Alyson.

Nestle, Joan and Preston, John (1994) *Sister and Brother: Lesbian and Gay Men Write about Their Lives*, San Francisco: HarperSanFrancisco.

Newton, Esther (1972) *Mother Camp: Female Impersonators in America*, Chicago: University of Chicago Press.

Newton, Esther (1996) 'Dick(less) Tracy and the Homecoming Queen: Lesbian Power and Representation in Gay Male Cherry Grove', in Ellen Lewin, ed., *Inventing Lesbian Cultures in America*, Boston: Beacon Press.

Nilsson, N.G. (1971) 'The Origin of the Interview', *Journalism Quarterly* Winter: 707–13.

Noschis, K. (1983) *La Signification affective du quartier*, Paris: Librairie des Méridiens.

Odzer, Cleo (n.d.) *Goa Freaks: My Hippie Years in India*, New York: Blue Moon Books.

Ohtsuka, Eiji (1989) 'M. Kun no Naka no Watashi, Watashi no Naka no M. Kun', *Chuo Koron* October: 438–44.

Okada, Toshio (1996) *Otakugaku Nyumon*, Tokyo: Ohta Shuppan.

Okada, Toshio *et al.* (1997) *Otaku Amigos*, Tokyo: Soft Bank.

Olander, William (1987) 'The Window on Broadway by ACT UP', in *On View* (handout), New York: New Museum of Contemporary Art.

Ostroff, Joshua (2002) 'Wall of Sound: China's Youth Shake Their Heads to the Beat of a New Cultural Rave-olution', *Mixer*, March: 62–63.

Otto, R. (1921) *Le Sacré*, Paris: Payot.

Padmore, G. (1956) *Pan-Africanism or Communism*, London: Dennis Dobson.

Panish, Jon (1997) *The Color of Jazz: Race and Representation in Postwar American Culture*, Jackson: University of Mississippi Press.

Park, Robert E. (1950) *Race and Culture*, Glencoe, IL: The Free Press.

Park, Robert E., Burgess, Ernest W. and McKenzie, Roderick D. (1925) *The City*, Chicago and London: University of Chicago Press.

Parker, Howard (1974) *View from the Boys*, Newton Abbot: David and Charles.

Parkin, F. (1971) *Class Inequality and Political Order*, London: McGibbon and Kee.

Parsons, Talcott (1964) *Essays in Sociological Theory*, New York: The Free Press.

Parsons, Talcott *et al.* (1951) *Introduction Toward a General Theory of Action*, New York: Harper & Row.

Patterson, O. (1966) 'The Dance Invasion', *New Society*, 15 September.

Pearson, Geoffrey (1976) '"Paki-Bashing" in a North East Lancashire Cotton Town: A Case Study and Its History', in G. Mungham and G. Pearson, eds, *Working Class Youth Culture*, London: Routledge and Kegan Paul.

Pearson, Geoffrey (1978) 'Goths and Vandals: Crime in History', *Contemporary Crises* 2, 2: 119–39.

Peiss, Kathy (1986) *Cheap Amusements: Working Women and Leisure in Turn-of-the-Century New York*, Philadelphia: Temple University Press.

Pellegrini, Ann (1996) *Performance Anxiety*, New York: Routledge.

Penelope, Julia (1996) 'Passing Lesbians: The High Cost of Femininity', in L. Mohin, ed., *An Intimacy of Equals: Lesbian Feminist Ethics*, London: Onlywomen Press.

Penley, Constance (1991) 'Brownian Motion: Women, Tactics and Technology', in Constance Penley and Andrew Ross, eds, *Technoculture*, Minneapolis: University of Minnesota Press.

Perniola, Mario (1982) *L'Instant éternal*, Paris: Librairie des Méridiens.

Perry, M. (1976) *Silence to the Drums: A Survey of the Literature of the Harlem Renaissance*, London: Greenwood Press.

Phipps, Peter (1999) 'Tourists, Terrorists, Death and Value', in Raminder Kaur and John Hutnyk, eds, *Travel Worlds: Journeys in Contemporary Cultural Politics*, London and New York: Zed Books.

Piccone, Paul (1969) 'From Youth Culture to Political Praxis', *Radical America*, 15 November.

Pieterse, Jan Nederveen (1994) 'Globalization as Hybridization', *International Sociology* 9, 2: 161–84.

Pittman, Kimberly (1996) 'Walk Like a Man: Inside the Booming Drag King Scene', *Manhattan Pride*, June.

Pitts, V. (1998) '"Reclaiming" the Female Body: Embodied Identity Work, Resistance and the Grotesque', *Body and Society* 4: 67–84.

Pitts, V. (1999) 'Body Modification, Self-mutilation and Agency in Media Accounts of a Subculture', *Body and Society* 5: 291–304.

Plunkett, John and Wieners, Brad (eds) (1997) *Burning Man*, San Francisco: Hardwired.

Polhemus, Ted and Randall, Housk (1998) *The Customized Body*, London: Serpent's Tail.

Polk, K. (1994) 'Masculinity, Honour and Homicide', in E.Stanko and T. Newburn, eds, *Just Boys Doing Business: Men, Masculinities and Crime*, London: Routledge.

Polsky, Ned (1967) *Hustlers, Beats and Others*, Harmondsworth: Penguin Books.

Poster, Mark (1995) *The Second Media Age*, Cambridge: Polity.

Poulantzas, N. (1973) *Political Power and Social Classes*, London: New Left Books.

Poulat, E. (1977) *Catholicisme, démocratique et socialisme*, Paris: Casterman.

Pratt, Minnie Bruce (1995) *S/HE*, Ithaca, NY: Firebrand.

Prus, Robert C. (1997) *Subcultural Mosaics and Intersubjective Realities*, Albany: State University of New York Press.

Public Culture (2000) 'Cosmopolitanism', 12, 3.

Quinn, Malcolm (1994) *The Swastika: Constructing the Symbol*, London and New York: Routledge.

Racz, Josef G. and Zetenyi, Zoltan (1994) 'Rock Concerts in Hungary in the 1980s', *International Sociology* 91, 1: 43–53.

Raymond, Janice (1979) *The Transsexual Empire: The Making of a She-Male*, Boston: Beacon Press.

Redfield, Robert (1941) *The Folk Culture of Yukatan*, Chicago: University of Chicago Press.

Redhead, Steve, Wynne, Derek and O'Connor, Justin (eds) (1997) *The Club Cultures Reader: Readings in Popular Cultural Studies*, Oxford: Blackwell.

Release (1997) *Release Drugs and Dance Survey: An Insight into the Culture*, London: Release.

Reynolds, Simon (1999) *Generation Ecstasy: Into the World of Techno and Rave Culture*, New York: Routledge.

Reynolds, Simon (2000) 'The Wide World of Trance', *Groove* #64: www.groove.de/ groove_special/64/main.html.

Rheingold, Howard (1994) *The Virtual Community*, New York: HarperPerennial.

Robbins, Bruce (1993) 'Comparative Cosmopolitanisms', in *Secular Vocations*, London: Verso.

Robbins, Bruce and Cheah, Pheng (eds) (1998) *Cosmopolitics: Thinking and Feeling Beyond the Nation*, Minneapolis: University of Minnesota Press.

Roberts, Martin (2004) 'Notes on a Global Underground'. Paper delivered at the 'Globalization and Popular Culture: Production, Consumption, Identity' conference, University of Manitoba, 19–21 October 2001.

Robertson, Jennifer (1998) *Takarazuka: Sexual Politics and Popular Culture in Modern Japan*, London: University of California Press.

Robertson, Roland (1992) *Globalization: Social Theory and Global Culture*, Newbury Park, CA: Sage.

Rodigan, David (1985) Interview, *Time Out*, 16–22 May.

Rodney, Walter (1968) *The Groundings With My Brothers*, London: Bogle L'ouverture.

Rogers, Pat (1972) *Grub Street: Studies in a Subculture*, London: Methuen.

Roof, Judith (1991) *A Lure of Knowledge: Lesbian Sexuality and Theory*, New York: Columbia University Press.

Rosenblatt, D. (1997) 'The Antisocial Skin: Structure, Resistance' and '"Modern Primitive": Adornment in the United States', *Cultural Anthropology* 12.

Rosny, E. (1981) *Les Yeux de ma chevre*, Paris: Pion.

Ross, Andrew (1991) 'Hacking Away at the Counterculture', *Strange Weather: Science and Technology in the Age of Limits*, London and New York: Verso.

Rouget, Gilbert (1980) *La Musique et la Transe: esquisse d'une théorie générale des relations entre la musique et la possession*, Paris: Gallimard.

Rouget, Gilbert (1985) *Music and Trance*, trans. Brunhilde Biebuyck, Chicago: University of Chicago Press.

Rowbotham, Sheila (1973) *Woman's Consciousness, Man's World*, Harmondsworth: Penguin Books.

Rubin, Arnold (1988) *Marks of Civilization: Artistic Transformations of the Human Body*, Los Angeles: Museum of Cultural History.

Rust, Frances (1969) *Dance in Society*, London: Routledge.

St Clair, L. and Govenar, A. (1981) *Stoney Knows How: Life as a Tattoo Artist*, Lexington: University of Kentucky Press.

Salgado, Gamini (1972) *Cony-catchers and Bawdy Baskets*, Harmondsworth: Penguin Books.

Sanders, C. (1989) *Customizing the Body: The Art and Culture of Tattooing*, Philadelphia: Temple University Press.

Sanders, Joel (ed.) (1996) *Stud: Architectures of Masculinity*, Princeton: Princeton Architectural Press.

Saunders, Nicholas (1996) *How the Media Reports Ecstasy*: www.obsolete.com/ecstasy. media.html.

Saunders, Nicholas (ed.) (1995) *Ecstasy and the Dance Culture*, London: Neal's Yard Press.

Saunders, Nicholas (ed.) (1997) *Ecstasy Reconsidered*, London: Neal's Yard Press.

Savage, Jon (1988) 'The Enemy Within: Sex, Rock and Identity', in Simon Frith, ed., *Facing the Music*, New York: Pantheon.

Savage, Jon (1991, 2001) *England's Dreaming: Sex Pistols and Punk Rock*, London: Faber and Faber.

Savigliano, Marta E. (1992) 'Tango in Japan and the World Economy of Passion', in Joseph J. Tobin, ed., *Re-made in Japan: Everyday Life and Consumer Taste in a Changing Society*, New Haven, CT: Yale University Press.

Scannell, Paddy (1989) 'Public Service Broadcasting and Modern Public Life', *Media, Culture and Society* XI,2.

Schechter, Danny (2000) *Falun Gong's Challenge to China: Spiritual Practice or 'Evil Cult'?*, New York: Akashic Books.

Scheler, M. (1954) *The Nature of Sympathy*, trans. Peter Heath, London: Routledge and Kegan Paul.

Schell, Orville (1988) *Discos and Democracy: China in the Throes of Reform*, New York: Pantheon.

Schiller, F. (1793, 1967) *On the Aesthetic Education of Man, in a Series of Letters*, Oxford: Clarendon Press.

Schiller, Herbert (1976) *Communication and Cultural Domination*, White Plains, NY: International Arts and Science Press.

Schutz, A. (1967) *The Phenomenology of the Social World*, Evanston, IL: Northwestern University Press.

Senelick, Laurence (1993) 'Boys and Girls Together: Subcultural Origins of Glamour Drag and Male Impersonation on the Nineteenth-century Stage', in Lesley Ferris, ed., *Crossing the Stage: Controversies on Cross-dressing*, London and New York: Routledge.

Sennett, Richard (1992) *The Conscience of the Eye*, London: W.W. Norton.

Serres, Michel (1991) *Rome: The Books of Foundations*, Stanford, CA: Stanford University Press.

Shanks, Barry (1988) 'Transgressing the Boundaries of a Rock 'n' Roll Community'. Paper delivered at 'First Joint Conference of IASPM-Canada and IASPM-USA', Yale University, 1 October.

Sharma, Sanjay, Hutnyk, John and Sharma, Ashwani (eds) (1996) *Dis-orienting Rhythms: the Politics of the New Asian Dance Music*, London and New Jersey: Zed Books.

Shaviro, Steven (2003) *Connected: or What it Means to Live in the Network Society*, Minneapolis and London: University of Minnesota Press.

Shaw, Clifford (1930) *The Jack-Roller*, Chicago: University of Chicago Press.

Shaw, Clifford (1931) *The Natural History of the Delinquent Career*, Chicago: University of Chicago Press.

Shaw, Clifford *et al.* (1938) *Brothers in Crime*, Chicago: University of Chicago Press.

Sheiner, Marcy (1996) 'What?', *Anything that Moves: The Magazine for the Bisexual-at-Large*, 10 (winter): 19–21.

Sheppard, E. *et al.* (1875) *The Story of the Jubilee Singers with Their Songs*, London: Hodder and Stoughton.

Shibutani, Tamotsu (1955) 'References Groups as Perspectives', *American Journal of Sociology* 56.

Shilling, Chris (1993) *The Body and Social Theory*, London: Sage.

Shūkan Bunshun (1989) 'Miyazaki Tsutomu no Chi to Niku Himitsu', 31 August: 35–38.

Shūkan Post (1989) 'Otaku-zoku', 25 September: 32–42.

Shulgin, A. and Shulgin, A. (1991) *PIHKAL (Phenethylamines I Have Known and Loved): A Chemical Love Story*, Berkeley, CA: Transform Press.

Simmel, Georg (1971a) 'The Stranger', in D. Levine, ed., *On Individuality and Social Forms*, Chicago: University of Chicago Press.

Simmel, Georg (1971b) 'The Metropolis and Mental Life', in D. Levine, ed., *On Individuality and Social Forms*, Chicago: University of Chicago Press.

Simmel, Georg (1974) 'Problems de la sociologie des religions', in *Archives des sciences sociales des religions*, Paris: CNRS, no.17.

Simmel, Georg (1977) 'Les Sociétés secretes', in *Nouvelle Revue de Psychoanalyse*, Paris: Gallimard.

Sithole, E. (1972) 'Black Folk Music', in Thomas Kochman, ed., *Rappin' and Stylin' Out: Communication in Urban Black America*, Chicago: University of Illinois Press.

Skelton, Tracey and Chambers, Deborah (eds) (1997) *Cool Places: Geographies of Youth Cultures*, New York: Routledge.

Skov, Lisa and Moeran, Brian (eds) (1995) *Media, Women and Consumption in Japan*, London: Curzon Press.

Slobin, Mark (1993) *Subcultural Sounds: Micromusics of the West*, Hanover: Wesleyan University Press.

Smith, Marc and Kollock, Peter (eds) (1999) *Communities in Cyberspace*, London: Routledge.

Sobchack, Vivian (2000) 'New Age Mutant Ninja Hackers: Reading *Mondo 2000*', in David Bell and Barbara M. Kennedy, eds, *The Cybercultures Reader*, London and New York: Routledge.

Solomon, Carl (1959) 'Report from the Asylum', in G. Feldman and M. Gartenberg, eds, *The Beat Generation and the Angry Young Men*, New York: Dell Publishing Co.

Solowji, N, Hall, W. and Lee, N. (1992) 'Recreational MDMA Use in Sydney: A Profile of "Ecstasy" Users and their Experiences with the Drug', *British Journal of Addiction* 87: 1161–72.

Sontag, Susan (1964) 'Notes on "Camp"', in *A Susan Sontag Reader* (1983), London: Penguin Books.

Sontag, Susan (1966) 'Notes on "Camp"', in *Against Interpretation*, New York: Farrer Straus Giroux.

Sreberny-Mohammadi, Annabelle (1991) 'The Global and the Local in International Communications', in James Curran and Michael Gurevitch, eds, *Mass Media and Society*, New York: Edward Arnold.

Sterling, Bruce (ed.) (1986) *Mirrorshades: The Cyberpunk Anthology*, New York: Arbor House.

Stevens, Jay (1993) *Storming Heaven: LSD and the American Dream*, London: Flamingo.

Stevens, Jay (1998) *Storming Heaven: LSD and the American Dream*, New York: Grove Press.

Steward, S. (1990) *Bad Boys and Tough Tattoos: A Social History of the Tattoo with Gangs, Sailors, and Street Corner Punks*, New York: Haworth Press.

Stone, A.R. (2000) 'Will the Real Body Please Stand Up? Boundary Stories About Virtual Cultures', in David Bell and Barbara M. Kennedy, eds, *The Cybercultures Reader*, London and New York: Routledge.

Storr, Anthony (1992) *Music and the Mind*, London: HarperCollins.

Straw, Will (1991) 'Systems of Articulation, Logics of Change: Communities and Scenes in Popular Music', *Cultural Studies* 5, 3.

Strecker, Edward A. (1940) *Beyond the Clinical Frontier*, New York: W.W. Norton.

Sullivan, Nikki (2001) *Tattooed Bodies: Subjectivity, Textuality, Ethics, and Pleasure*, Wesport, CT: Praeger.

Sutherland, Edwin (1937) *The Professional Thief*, Chicago: University of Chicago Press.

Sutherland, Edwin and Cressey, Donald (1960) *Principles of Criminology*, 6th edition, Philadelphia: J.B. Lippincott.

Sweetman, P. (1999a) 'Anchoring the (Postmodern) Self? Body Modification, Fashion and Identity', *Body and Society* 5: 51–76.

Sweetman, P. (1999b) 'Only Skin Deep? Tattooing, Piercing and the Transgressive Body', in M. Aaron, ed., *The Body's Perilous Pleasures*, Edinburgh: Edinburgh University Press.

Swenson, Kylee (2002) 'A Sleeping Giant Awakes: Guangzhow Goes West', *Mixer*, March: 60–61.

Tagg, John (1981) 'Power and Philosophy', in Tony Bennett *et al.*, eds, *Culture, Ideology and Social Process*, Stony Stratford: Open University Press.

Tagg, Philip (1981) *Fernando the Flute*, Gothenberg: University of Gothenberg Press.

Takarajima (1989) *Otaku no Hon (The Nerd Book)*, Tokyo.

Taku, Hachiro (1992) *Ikasu! Otaku no Tengoku*, Tokyo: Ohta Shuppan.

Taylor, I. (1971) '"Football Mad": A Speculative Sociology of Soccer Hooliganism', in E. Dunning, ed., *The Sociology of Sport*, London: Cass.

Taylor, I., Walton, P. and Young, J. (eds) (1975) *Critical Criminology*, London: Routledge and Kegan Paul.

Taylor, Laurie (1976) 'Strategies for Coping with a Deviant Sentence', in Rom Harré, ed., *Life Sentences*, London and New York: Wiley.

Terranova, T. (2000) 'Post-human Unbounded: Artificial Evolution and High-tech Subcultures', in David Bell and Barbara M. Kennedy, eds, *The Cybercultures Reader*, London and New York: Routledge.

Theweleit, Klaus (1989) *Male Fantasies, Vol.2*, trans. Chris Turner and Erica Carter, Cambridge: Polity.

Thomas, L.-V. (1985) *Rites de mort*, Paris: Fayard.

Thompson, E.P. (1980) *The Making of the English Working Class*, Harmondsworth: Penguin Books.

Thompson, E.P. and Yeo, Eileen (1973) *The Unknown Mayhew*, Harmondsworth: Penguin Books.

Thompson, Hunter S. (1966) *Hell's Angels: A Strange and Terrible Saga*, New York: Random House.

Thompson, John B. (1989) *Ideology and Modern Culture*, Cambridge: Polity.

Thompson, John B. (1995) *The Media and Modernity: A Social Theory of the Media*, Stanford, CA: Stanford University Press.

Thornton, Sarah (1995) *Club Cultures: Music, Media and Subcultural Capital*, Cambridge: Polity/Wesleyan University Press.

Thorpe, Rochella (1996) '"A House Where Queers Go": African-American Lesbian Nightlife in Detroit, 1940–1975', in Ellen Lewin, ed., *Inventing Lesbian Cultures in America*, Boston: Beacon Press.

Thrasher, Frederic M. (1927) *The Gang: A Study of 1,313 Gangs in Chicago*, Chicago: University of Chicago Press.

Thrift, N. (1997) 'The Still Point: Resistance, Expressive Embodiment and Dance', in S. Pile and M. Keith, eds, *Geographies of Resistance*, London and New York: Routledge.

Tobin, Joseph J. (ed.) (1992) *Re-made in Japan: Everyday Life and Consumer Taste in a Changing Society*, New Haven, CT: Yale University Press.

Tobin, Joseph (1998) 'An American *Otaku* (or, a Boy's Virtual Life on the Net)', in Julian Sefton-Green, ed., *Digital Diversions: Youth Culture in the Age of Multimedia*, London: UCL Press.

Tolson, Andrew (1990) 'Social Surveillance and Subjectification: The Emergence of "Subculture" in the Work of Henry Mayhew', *Cultural Studies* 4, 2.

Tomas, D. (2000) 'The Technophilic Body: On Technicity in William Gibson's Cyborg Culture', in David Bell and Barbara M. Kennedy, eds, *The Cybercultures Reader*, London and New York: Routledge.

Tomlinson, John (1999) *Globalization and Culture*, Chicago: University of Chicago Press.

Tonnies, Ferdinand (1955) *Community and Association (Gemeinschaft und Gesellschaft)*, trans. Charles P. Loomis, London: Routledge and Kegan Paul.

Toop, David (1995) *Ocean of Sound: Aether Talk, Ambient Sound and Imaginary Worlds*, London: Serpent's Tail.

Torgovnick, Marianna (1990) *Gone Primitive: Savage Intellects, Modern Lives*, Chicago: University of Chicago Press.

Torgovnick, Marianna (1997) *Primitive Passions: Men, Women, and the Quest for Ecstasy*, New York: Alfred A. Knopf.

Treat, John Whittier (1993) 'Yoshimoto Banana Writes Home: *Shojo* Culture and the Nostalgic Subject', *Journal of Japanese Studies* 19, 2: 353–87.

Tsang, D. (2000) 'Notes on Queer 'n' Asian Virtual Sex', in David Bell and Barbara M. Kennedy, eds, *The Cybercultures Reader*, London and New York: Routledge.

Tsukuru (1991) *Yugai Comic: Mondai wo Kangaeru*, Tokyo: Tsukuru Shuppan.

Tsuzuki, Katō (ed.) (1993) *Tokyo Style*, Tokyo: Kyoto Shain.

Tucker, Robert C. (ed.) (1972) *The Marx-Engels Reader*, New York: W.W. Norton.

Turkle, Sherry (1995) *Life on the Screen: Identity in the Age of the Internet*, London: Phoenix.

Turnbull, G. (1936) 'Some Notes on the History of the Interview', *Journalism Quarterly* Fall: 272–79.

Turner, Ralph H. and Surace, Samuel J. (1956) 'Zoot-Suiters and Mexicans: Symbols of Crowd Behaviour', *The American Journal of Sociology* 57, 1.

Turner, Victor (1967) *The Forest of Symbols: Aspects of Ndembu Ritual*, London: Cornell University Press.

Turner, Victor (1969) *The Ritual Process: Structure and Anti-structure*, New York: Aldine de Gruyter.

Tyler, Carole-Anne (1994) 'Passing: Narcissism, Identity and Difference', *Differences: A Journal of Feminist Cultural Studies* 6, 2/3.

Uneo, Chizuko (1989) 'Kyuju Nendai no Sexual Revolution', in Takarajima, *Otaku no Hon (The Nerd Book)* Tokyo.

Vale, V. and Juno, Andrea (eds) (1989) *Modern Primitives*, San Francisco: Re/Search.

Van Gennep, Arnold (1960) *Rites of Passage*, Chicago: University of Chicago Press.

Venturi, Franco (1972) *Les intellectuels, le peuple et la révolution. Histoire du populisme russe au XIXe siecle*, Paris: Gallimard.

Vitruvius (1960) *The Ten Books of Architecture*, trans. Morris Hicky Morgan, New York: Dover.

Walker, Ian (1980) 'Skinheads: The Cult of Trouble', *New Society*, 26 June.

Walker, Lisa (1993) 'How to Recognise a Lesbian: The Cultural Politics of Looking like What You Are', *Signs: Journal of Women in Culture and Society* 18, 4 (Summer).

Wallerstein, Immanuel (1990) 'Culture as the Ideological Battleground of the Modern World System', in Mike Featherstone, ed., *Global Culture: Nationalism, Globalization and Modernity*, Newbury Park, CA: Sage.

Wallis, R. and Malm, K. (1984) *Big Sounds from Small Peoples*, London: Constable.

Walsh, David (1993) '"Saturday Night Fever": An Ethnography of Disco Dancing', in Helen Thomas, ed., *Dance, Gender and Culture*, New York: St Martin's Press.

Ward, Andrew H. (1993) 'Dancing in the Dark: Rationalism and the Neglect of Social Dance', in Helen Thomas, ed., *Dance, Gender and Culture*, New York: St Martin's Press.

Ward, Andrew H. (1997) 'Dancing Around Meaning (and the Meaning around Dance)', in Helen Thomas, ed., *Dance in the City*, New York: St Martin's Press.

Wark, McKenzie (2003) *The Hacker Manifesto*, Cambridge, MA: Harvard University Press.

Warner, Lloyd W. *et al.* (1949) *Social Class in America*, Chicago: Science Research Associates.

Watanabe, Kazuhiro (1990) *Otakudama*, Tokyo: Ohta Shuppan.

Waters, Chris (1981) 'Badges of Half-formed, Inarticulate Radicalism: A Critique of Recent Trends in the Study of Working Class Youth Culture', *International Labour and Working Class History* 19: 23–27.

Watson, Nessim (1997) 'Why We Argue About Virtual Community: A Case Study of the Phish.Net Fan Community', in S. Jones, ed., *Virtual Culture: Identity and Communication in Cyberspace*, London: Sage.

Webb, Eugene *et al.* (1966) *Unobtrusive Measures: Non-Reactive Research in the Social Sciences*, Chicago: Rand McNally.

Weber, Max (1978) *Economy and Society*, vol.2, Berkeley: University of California Press.

Wellman, B. and Gulia, M. (1999) 'Virtual Communities as Communities', in Marc Smith and Peter Kollock, eds, *Communities in Cyberspace*, London: Routledge.

Westwood, S. (1990) 'Racism, Black Masculinity and the Politics of Space', in J. Hearn and D. Morgan, eds, *Men, Masculinities and Social Theory*, London: Unwin and Hyman.

Wheelwright, Julie (1994) 'Out of My Way, I'm Man for a Day', *Independent*, 11 November.

Whipple, Charles (1993) 'The Silencing of the Lambs', *Tokyo Journal* July: 35–41.

White, Shane and White, Graham (1998) *Stylin': African American Expressive Culture from its Beginnings to the Zoot Suit*, Ithaca, NY and London: Cornell University Press.

Whyte, William Foote (1943) *Street Corner Society*, Chicago: University of Chicago Press.

Williams, Raymond (1963) *Culture and Society*, Harmondsworth: Penguin Books.

Williams, Raymond (1985) *The Country and the City*, London: Hogarth Press.

Williamson, Judith (1988) *Consuming Passions*, London: Marion Boyars.

Willis, Paul (1977) *Learning to Labour: How Working Class Kids Get Working Class Jobs*, Aldershot: Gower Publishing.

Willis, Paul (1978) *Profane Culture*, London: Routledge and Kegan Paul.

Willis, Paul (1984) *Learning to Labor: How Working Class Kids Get Working Class Jobs*, New York: Columbia University Press.

Willis, Paul (1990) *Common Culture*, Milton Keynes: Open University Press.

Winkin, Y. (1982) *La Nouvelle communication*, Paris: Seuil.

Wirth, L. (1966) *The Ghetto*, Chicago: University of Chicago Press.

Wittel, Andreas (2001) 'Toward a Network Sociality', *Theory, Culture & Society* 18, 6: 51–76.

Wodiczko, Krzyztof (1999) *Critical Vehicles: Writings, Projects, Interviews*, Cambridge, MA: The MIT Press.

Wolfe, Tom (1968) *The Pump House Gang*, New York: Bantam.

Wye, Deborah (1988) *Committed to Print: Social and Political Themes in Recent American Art*, New York: Museum of Modern Art.

Wyndham, H. and St J. George, D. (1926) *Nights in London: When Mayfair Makes Merry*, London: The Bodley Head.

X, Malcolm (1966) *Autobiography of Malcolm X*, Harmondsworth: Penguin Books.

Yablonsky, Lewis (1965) 'Experiences with the Criminal Community', in A. Gouldner and S.M. Miller, eds., *Applied Sociology*, New York: The Free Press.

Yang, Jeff (1997) *Eastern Standard Time: A Guide to Asian Influence on American Culture from Astro Boy to Zen Buddhism*, New York: Houghton-Mifflin.

Yonezawa, Yoshihiro (1989) 'Comiket: sekai saidai no manga saiten', in Takarajima, *Otaku no Hon (The Nerd Book)* Tokyo.

Young, Jock (1971) *The Drugtakers: The Social Meaning of Drug Use*, London: Paladin.

Young, K. and Craig, L. (1997) 'Beyond White Pride: Identity, Meaning and Contradiction in the Canadian Skinhead Subculture', *Canadian Review of Sociology and Anthropology* 34.

Young, Kimball (1946) *Social Psychology*, New York: Crofts and Company.

Zha, Jianying (1995) *China Pop: How Soap Operas, Tabloids, and Best Sellers are Transforming a Culture*, New York: New Press.

Index